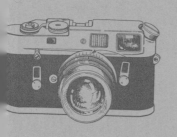

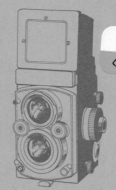

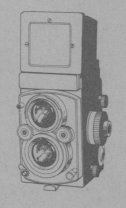

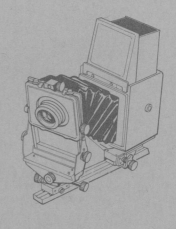

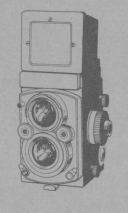

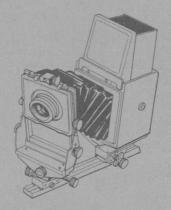

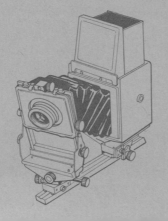

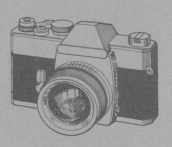

TED JENSEN

FIELD PHOTOGRAPHY

FIELD

PHOTOGRAPHY
Beginning and Advanced Techniques

Alfred A. Blaker

W. H. Freeman and Company
San Francisco

Library of Congress Cataloging in Publication Data

Blaker, Alfred A 1928–
 Field photography.

 Bibliography: p.
 Includes index.
 1. Nature photography. I. Title.
TR721.B55 778 75-33382
ISBN 0-7167-0518-4

Printed in the United States of America

9 8 7 6 5 4 3 2

I suppose if one were to find an appropriate epitaph which attempted to summarize my life, a comprehensive one might be: 'He looked for the simple answers.'

The Wind and Beyond: Theodore von Kármán

. . . but I didn't always find them.

Alfred A. Blaker

Preface

Immediately after the publication of *Photography for Scientific Publication* (W. H. Freeman and Company, San Francisco, 1965), I realized that there were large numbers of scientists and other people whose photographic needs and interests were concerned with the outdoors and what happens there. Since I had concentrated mainly on laboratory practices and subjects, my book obviously did not serve the needs of this group very well.

At about the same time, my own photographic interests became more strongly oriented to the outdoors. This occurred partly in response to an increased number of requests for work requiring techniques suited to field conditions, partly as a matter of purely personal interest, and partly because I began teaching photography particularly as it is related to field biology. A search of the available literature revealed the existence of a large number of books and articles that could provide an excellent background for a person with access to a good library and the time to search through it. However, there was no single book integrating the available knowledge into a compact, easily comprehended, logically arranged, and generally useful handbook for the scientist and interested layman.

Having had quite long experience in teaching biological field photography as well as in its practice, I have come to a number of conclusions that have guided me in the preparation of this book. One of the major ones is that most of the people who want to learn this branch of photography come to it because of their interest in recording those aspects of nature that concern them, rather than because of a wish to expand their existing photographic interests into the "nature field." (There are exceptions, of course, but I think

that basically this statement is correct). Most such people either have no background in photography beyond snapshotting, or have a background that is very spotty and largely acquired through self-teaching. This book, except when it is used as a course text by a qualified teacher, will represent another self-teaching aid.

With all due regard to anyone's ability to teach himself (after all, I am mostly self-taught), it is a lot easier to teach yourself if the text that is being used assumes very little about your existing background, is so written as to be clear to the beginner yet adequate for the needs of the more advanced, and is aimed at the specific needs of those who are attracted by its title. This is not to say that it cannot prove useful to such people as professional photographers wishing to enter new markets, or advanced amateurs newly aware of nature and its pictorial possibilities. I only wish to make clear my initial bias.

As the idea of writing this book burgeoned, it seemed best to divide it into categories of wide scope, working to establish broadly applicable principles and then explaining them in such a manner as to allow an easy transference of methods and ideas from one subject area to another. Although many of the subjects and situations that are covered have naturally required different organizational approaches, there is a conceptual core common to both this and my earlier book. Very simply, it is that photography, as applied to nature and science, is both simpler and more complex than generally thought—simpler, in that all photography is based upon the same series of easily related variables; more complex, in that the variety of choice in both subject matter and approach is nearly infinite. Indeed, the common variables are more readily explainable than is often realized, and the infinite number of subject-matter choices can be reduced to manageable proportions by dealing with classes of characteristics, rather than by treating specific subjects. Thus, once the techniques described are mastered and the principles on which they are based are understood, they can be applied to any likely subject without confusion.

There are, of course, a number of areas requiring especially detailed treatment, but for the most part the discussions in this book are as general as possible. Most of the specific subjects covered serve mainly as examples, and readers are directed to suitable specialized writings when it is obvious that they may feel a need for greater detail than is warranted in the context of a comprehensive work.

The purpose of this text is the same as that of *Photography for Scientific Publication*—to help interested persons to improve the

quality of the photographs they may need, and to enable them to take photographs under unusually difficult or unfamiliar circumstances, in order to illustrate factual presentations more effectively. The limitations are also similar: the main consideration is black-and-white print and color-transparency still photography, using normal or at least easily obtainable photo equipment, materials, and supplies. The approach remains pragmatic: the knowledge *needed to perform a given task* is emphasized, and theory is discussed at length only when necessary to provide the understanding necessary for the transfer of technique from one subject area to another.

This book is divided into three sections. The first presents the general background of field photography, its tools, and its materials; the second provides a review of general photographic technique, for those who need it; the third concerns specifically field-oriented techniques and related matters. Within each subdivision of the second and third parts sufficient information should be found to enable a careful reader to do the photographic work necessary to produce illustrations suitable for publication.

I make no claim to complete knowledge of field photography, nor to have originated all of the techniques that are described. This book is a compendium abstracted from printed or other publicly available sources, from discussions with better photographers than myself, and from personal experience and experimentation. I have originated relatively little, but much that I originally read, or heard about from others, has been modified by my own efforts. The only claims made here are that I am responsible for the method and scope of organization and presentation, and for the authenticity of the illustrations.

Not the least important portion of this book is the bibliography, which has been carefully compiled in order to include material of various degrees of complexity: entries have been annotated to indicate points of special interest. The sources vary from scholarly texts to articles from journals and popular magazines. What they have in common is that each reference offers something of significance. This text, then, is a work of synthesis that depends, in very large part, upon what I have learned from others, either directly or through extensive reading. The size of the bibliography is a measure of the debt I owe, and its presence is a way of acknowledging that debt as well as of indicating sources for more intensive study by readers. To all who are represented there I give sincere thanks.

This book is *not* intended to serve as a text for the scientific explanation of the physical and chemical bases of photography. (A

physicist or chemist would probably find occasional apparent errors of emphasis or interpretation, since the word usages and jargon of photographers are not necessarily the same as those of physicists and chemists.) Neither is it intended to serve as an advanced text for students of photography who are already highly educated in the subject, although I believe that it contains much that can prove both interesting and profitable to them.

The emphasis throughout this book is pragmatic, and it is strongly "how-to" in orientation. My intention is to help any interested person to learn how to do a particular type of photography economically and efficiently, with a reasonably full understanding of what he or she is doing. If I succeed in providing such help I will be satisfied.

A sizable number of people have contributed personally and directly to the production of this work. Victor G. Duran, who was my supervisor for five years at the Scientific Photographic Laboratory, University of California, Berkeley, did a great deal for my early development in this field—perhaps even more than he realizes. The late Sam Ehrlich, who was my successor at the University, was surely one of the great human resources in all aspects of scientific and technical photography, and he never failed to respond constructively to my cries for help. Zev Pressman of the Stanford Research Institute was the technical reviewer of my original manuscript, and his voluminous remarks were responsible for many worthwhile changes. David Cavagnaro and Philip Hyde, both noted photographers, were also prepublication readers, and their carefully considered appraisals were of great value. Others whose work and words have been especially influential include George Lepp, Stennett Heaton, Nate Cohen, Ronn Patterson, and Dr. Ron Branson. Time and again, Don Harvey and Jim Hendel heard me out patiently, as I constructed and reconstructed the organization of this book, and I am sure they will recognize their influences. And finally, there is my long-suffering wife, Sally, who in listening with great patience to endless hours of talking has acted as a sounding board whose reverberations have given body and tone to the ideas herein expressed. To all, my thanks.

Alfred A. Blaker

Walnut Creek, California
October, 1975

Contents

Illustrations

FIGURES

BLACK-AND-WHITE PLATES

COLOR PLATES
(*Follow page 208*)

FIELD PHOTOGRAPHY

PART I

Background

Scientists engaged in field work often regard with suspicion the suggestion that they should try to become proficient in field photography. It is entirely natural for scientists to feel that their business is zoology (or botany, entomology, or geology), rather than photography, and that any time and thought spent on outside subjects detracts from their other training and energies. There is a common feeling that to go into the subject far enough to do any good would remove them too far from their prime concerns—and that a knowledge of photography can be gained only by taking time from the pursuit of other, more pertinent, material.

This feeling is a misconception, of course. Photography in these circumstances is not an end in itself, but one of a number of useful tools an adequate knowledge of which can only re-

sult in the expansion of one's ability to observe, collect, record, and communicate data. The camera is no more a luxury or an encumbrance than any scientist's ubiquitous notebook, a microscope or pocket magnifier, or the equipment for the physical collection of specimens.

Used with judgment and restraint, photography is a time and effort saving method of scientifically accurate data recording, and in fact data can often be observed and recorded photographically that could not be collected in any other way. Of course, a load of camera gear can be a nuisance to carry around. It can weigh one down, sap energies, and soak up time and money. So can any other field equipment. But good advance planning can cut down on the disadvantages and more than repay any effort spent, by photography's unique abilities.

By its very nature, a photograph carries the weight of objectivity and veracity. Photographers can lie in captions, distort pictorial meanings by misuses, and cause all sorts of general mischief, if so minded, or just careless, but the camera itself tells the truth. It is a special sort of truth, to be sure. In most uses, photographs are two-dimensional views of four-dimensional matter (time being the fourth dimension). Color may be absent, and replaced by an at first confusing series of grey shades. Still, each of these limitations can be bypassed to some degree, and most can be turned into positive advantages. By the use of stereo photography, the third dimension can be retained. The shutter's ability to either slice or smear time can itself be of great importance. Color can be retained, or color filtering can be used to select the wavelengths of light to be recorded, thereby either aiding analysis of the data or increasing the visibility of subtle effects.

However, the primary point is that if material is shown in a photograph that has not been subsequently altered, then it was there in front of the camera when the exposure was made, subject only to the optical and other physical limitations imposed at the time by the medium and by the picture maker. If these limitations are understood, and if the picture maker suitably records them and states all such pertinent information in his or her final presentation, then a potentially highly relevant and revealing piece of readily interpreted evidence has been put before his or her peers. Little more can be reasonably expected of any device or method that a scientist uses.

Well planned and executed photographic records can extend the initial scientific value of any field trip, whether it all transpires in a few hours close to the laboratory, or is a major effort of months or years, involving thousands of miles of travel. (As an example, consider the incalculable value of the photographs made on the moon during the Apollo program—this was a remarkably well planned photo field trip situation.) Further, good pictorial records can easily extend the utility of a scientific report in time. Photographic evidence can bring new insights, and make possible new comparisons long after its written accompaniment may have been rendered historical by later work.

On a more mundane level, not to be ignored in days of ever increasing costs, fund raising for new and more expansive researches can be materially aided by the presentation before interested parties or agencies of good photographic records of earlier activities. Relations with the general public, which ultimately finances much of what is done in science today, are also aided by these means. In all good conscience, no scientific enterprise can ignore this use of photography, since the widest possible distribution of knowledge is in the direct interest of both science and the public at large.

Staffing, Training, and Operations

Whether the matter of personnel is limited to appraisal of the self, or is extended into the more general field of administrative affairs, it should be obvious at once that any photographic field trip requires the services of some person or persons *previously trained* in the craft as it applies to the subject matter to be studied. In either case this is not just a matter of being roughly familiar with the general practices of simple snapshot taking. Whoever is to do photography for scientific purposes must understand not only the particular mechanical and technical requirements of the subject area, but also the type of pictorial presentation appropriate to that field. Photography for purely scientific purposes has relatively little place in it for nonrelevant aesthetics, and almost none for

the exercise of freely creative pictorial imagination. The purpose of scientifically oriented photography is to inform without prejudice or embellishment, usually within rather narrow and specific limits, not primarily to grip the eye or enthrall the senses. This is not to say that all such work must be dull and boring, deliberately or otherwise. A great part of the subject material to be considered later in this book lends itself very well to pleasing, and even exciting, presentation without compromising the scientific objectives involved. In fact, the more aesthetically interesting the photograph the better the resulting communication—if the interest is relevant. It is only that people should keep clearly in mind the final uses of their photographs. Obviously, pictures intended for public relations use may be different in concept from those to be used for journal or textbook illustration, and photographs made entirely for aesthetic purposes have no such constraints.

TECHNICAL EDUCATION

Training in scientifically oriented field photography is not the easiest thing to come by. For a large enterprise, hiring a fully trained person may be desirable, the question then being whether this can be done readily. To be suitable, a photographer needs to be familiar not only with the appropriate equipment and techniques, but also with the nature and habits of the subject matter with which he or she will be expected to deal. The recently instituted program of certification of biological photographers by the Biological Photographic Association should ultimately help in recruiting qualified people.

If good people are available, and hiring is financially practical, fine. Employing a professional photographer often seems to be considered an extravagance, even by administrators who would not consider hiring an untrained and unqualified laboratory technician. Actually, it not only frees highly trained research people for their own work, but should also be a genuine financial economy. Amateur photographers, for the most part, do amateur quality work, and require an amateur's time schedule for doing it.

Regardless of the desirability of employing professionals, this may not always be possible. Administrative policies may not allow it, the amount of work to be done may not justify a full-time employee, or the nature of the work may be such that only the researcher, personally, is qualified to make the photographic decisions. If such hiring cannot be done, then at least one receptive member of the research group should be deliberately trained in photography. This is especially important if there is to be an extended expedition. In *no* case should equipment be purchased on the eve of departure, with the expectation of learning how to use it in the field. Field time is too valuable to waste on self-training projects. The demands of operations will mean that such training will almost certainly be both incomplete and insufficient, and the possibility of damage to equipment through misuse is high. Such a practice will inevitably be accompanied by myriad lost opportunities, and consequent regrets. It will probably also include many opportunities lost and not even missed, due to lack of a basic awareness of photographic possibilities.

The first requirement for a person intending to do this kind of work should be a good understanding of basic photography—not the more casual photography of the neighborhood amateur or even that of the camera clubs, but that

of solid professional practice. The difference is partly one of the motives involved, and partly in the attitude toward photography itself. That is, you are photographing not for pleasure but for a purpose, and there is the clear understanding that photography is a tool and not an end in itself. It is not harder to do the one rather than the other, only not the same.

The second need is for a knowledge of the specialized technical requirements of the specific work to be attempted. Only rarely are the techniques involved especially difficult to learn, but finding a good teacher may sometimes be a problem.

Both requirements can be fulfilled through independent study if the student is well motivated and determined, and especially if he or she is guided well in the choice of reference materials. Matters can be eased, and time better used, by taking special study courses of an appropriate nature. A good institutional administrator will see to it that some significant portion of its operating personnel have some useful special knowledge, and will see that the right people take advantage of all worthwhile training available on a continuing basis.

Good basic photographic instruction is often available in high school evening programs, or in college or university extension courses. It may also be sponsored by camera clubs or offered by independent photographers. Advanced technical courses can also be found in many areas. These may be professional advancement courses given under the direction of groups such as the previously mentioned Biological Photographic Association. Again, they may be special programs offered by a university extension division or its equivalent. For examples of this last see recent and current catalogs for University Extension, University of California, Berkeley, which offers courses in and near Berkeley and San Francisco. For full time study, the Rochester Institute of Technology, Rochester, New York, offers a two year program in biomedical photography. Eastman Kodak publishes a 55 page summary of instruction possibilities in this field called *A Survey of Motion Picture, Still Photography, and Graphic Arts Instruction,* publication T-17, by Dr. C. William Horrell. In it Dr. Horrell lists 605 institutions above high school level in the United States, and 22 in Canada, which offer at least one such course. There is obviously no lack of courses, though not all institutions or all areas offer a complete range. Some institutions offer periodic short courses lasting from three to seven days and concentrating on tight areas of specialization. These may be worth traveling considerable distances to attend. Instructors of such short programs are often well established experts in the subject being taught who normally do little or no regular teaching, so the opportunity to study with them may be both infrequent and worthwhile. For some people, particularly ecologists and geologists, the occasional courses in landscape photography given at Yosemite National Park by the eminent photographer Ansel Adams, and his staff of unusually well qualified assistants, may be very beneficial.

REFERENCE LIBRARY

For personal reference and self-training, any person or institution using any form of scientific photography as an aid in research and reporting should establish and maintain a carefully selected library of photographic books and periodicals. There are a large number of periodicals in the field of photography (large enough to warrant a separate listing in the Bibliography of

this book). Many of these are technical and informative in nature, and well worth regular reading even by people who make only occasional use of photography in science.

There are a few quarterly (or other infrequently published) journals which offer an unusual wealth of good articles. Probably the foremost is the *Journal of the Biological Photographic Association.* The association began publication in 1931, and has published a steady stream of informative writing ever since. Although it is predominantly medical in orientation, it has also published a sizable number of nonmedical articles on all aspects of biological photography. Since there is a cumulative index that is well planned and conveniently executed, finding applicable articles in any subject area is quick and easy. Many research libraries have complete collections of all issues. This journal is abstracted in the *Biological Abstracts,* and indexed in *Index Medicus.* The association maintains and provides a reprint service at a moderate cost.

In addition to those publications classifiable as journals, there are a sizable number of technical photographic magazines, as well as several mass circulation photo magazines. Since few of these publish a satisfactory cumulative index, and since all of them publish useful material at least now and then, the most practical method of preserving useful articles is to read with a razor blade in hand. Whenever an item or article of special interest is found, it should be cut out and filed in a folder of similar articles, and the collection of folders then filed by subject. Thus, instant access can be had to a sizable and constantly growing bank of information. These files should be reviewed at intervals, and especially bulky folders should be subdivided and refiled. I find it very useful to be able to refer to several articles on the same subject in order to compare the various approaches, check one

against another for errors or omissions, etc. These articles often cover subjects almost untouched in bound book form, and so have great potential value. I find that the more sources I have on a given problem the more options I have in finding a good solution to my particular variation of the problem. And some solutions may be syntheses of two or more printed sources.

Another valuable source of published information on photography is the manufacturer of material or equipment. Most such manufacturers publish useful information beyond operational manuals and data sheets, and a few do so in impressive quantity and quality. For instance, the Smith-Victor Company, maker of photographic lighting equipment, will provide an excellent pamphlet on portrait lighting upon request (at this writing). A great many such special information publications are available if inquiries are made and advertising columns are watched. Surely the world champion in such publication is the Eastman Kodak Company. This company publishes an annual bibliography of its own publications called *Index to Kodak Information.* Its 1974 edition ran to 36 pages, was subdivided into 25 subject areas, and listed 786 pamphlets, booklets, and books. Most were very cheap, prices running from a few cents in most cases up to a few books, mostly in the $7–10 range. These Kodak publications have a deserved reputation for authority and readability. They are reviewed and revised frequently. The *Index* makes special note both of new additions to the list and of major revisions. When replacing any such publication I find it useful to keep the older one, as there is a tendency to drop some information when adding new in order to keep the particular source about the same size. This is both understandable and frequently desirable, but once in a while the information dropped may be the information needed. (At this point I should re-

mark that I have *no* connection with Eastman Kodak.)

For reference and assistance in problem solving in the field, any extended field trip or expedition should include in its field library the most applicable photographic texts, as well as copies of the most useful published articles. It may be best to maintain a special collection of such material specifically for expedition use. If so, the materials therein should be logged at each use in order to determine which are really the most useful and which can be removed or replaced. The Bibliography of this book could serve as a beginning guide to anyone wishing to establish such a collection.

OPERATIONS

Photographic field operations of almost any scope can be greatly assisted by encouraging and training personnel to work in pairs. A variety of benefits can be produced, among them the following:

1. Two scientific specialties often can be serviced with the same equipment and at little extra cost in time, possibly also broadening the experience of both parties and increasing the possibilities of cross-fertilization of ideas both in and peripheral to photography.

2. Two people can carry and keep track of twice the amount of equipment, thereby increasing technical options, or they can share out what is to be taken, thus lessening individual loads.

3. Two people have four hands, assisting and speeding up difficult operations (whether photographic or not).

4. Two people have two pairs of eyes and two consciousnesses, thereby cutting dangers and increasing possible applications.

Photographic field operations will also be greatly assisted if certain rules are followed with regard to equipment:

1. Equipment should be chosen for the job according to its merits and capabilities, with due caution observed in believing manufacturers' claims—even when reputations are of household-word status. (Most manufacturers are honest, but they are naturally partial to their own ideas and products and are, after all, engaged in selling goods.) Impartial expert advice should be sought *prior* to selection and purchase (it is sought afterward in an amazing number of cases).

2. Where practical, specialized items should be adaptable to more than one task, and (if possible) chosen to supplement one another so as to produce possible other options for use.

3. Both new and old equipment should be thoroughly checked by trained repairmen before any extended or unusual field use, and should be rechecked upon return (this is to cut down the possibility of undetected malfunctions having an effect on the interpretation of data). Needed spare parts, such as extra flash cords or special adapters, should be taken along.

4. Field personnel, the actual users, regardless of previous experience, should make themselves thoroughly familiar with all equipment to be used on the particular trip, no matter how simple that equipment may appear to be, *prior* to going into the field. There is no substitute for adequate planning and preparation.

ECONOMICS OF EQUIPMENT

No book on photographic field operations in science would be complete without due consideration of the economics of photographic equipment. A common approach here is to buy as little equipment as possible, of as cheap a make as will be at all usable. This is false economy. Compared to the cost of many types of experimental and recording devices now in common use (such as linear accelerators, electron microscopes, computers, and electronic readout devices), even the best of photographic items are cheap, and their useful life will be long enough (if they are well maintained) to render them cheaper yet in a cost accounting sense.

Many people have quite distorted views of the nature of photographic equipment. Among factors that contribute to this ignorance and misinformation is the all-pervading presence of advertising in modern life. One common misconception relates to price. *It should not be thought* that the *best* photo equipment is *al-ways* the most expensive. This is often not the case, especially where unusual uses are contemplated. I can think of instances where the cheapest available unit in a given field is equal to anything to be had at any price, but only rarely is this so. And not infrequently the most expensive *is* best. This confusion can only be sorted out by consulting practicing experts prior to any substantial purchase. If large scale equipping is being done, and especially if long term objectives are in view, two or more such expert opinions should be obtained, and in some way reconciled, before purchase.

For really good scientific recording only the best is good enough, or even economical, in the long run. In this, as in other respects, individual or institutional purchasers should first consider the utility, versatility, and durability of the item, and second, that their own or their institution's reputation in the pursuit of scientific excellence may depend in part on how well visual evidence has been recorded and presented.

CHAPTER 2

Equipment and Materials

In photography, as in many other areas, the question of what is to be used breaks down immediately into two categories: equipment and materials.

I. EQUIPMENT

Any discussion of photographic equipment in book form is bound to be frustrating because it is certain to be out of date before publication, and cannot (in any case) cover all of the available types. As an example of the latter, a recent general photographic catalog listed, among other things, 80 makes and models of single lens reflex cameras, 22 twin lens reflexes, 72 range-

finder 35 mm cameras (not including rapid wind, half-frame, and other special types), 14 press cameras, 34 view cameras, 91 makes and models of light meters, and 121 different electronic flash units. This was only one of a number of such catalogs, none of which listed all of the currently available equipment, and all of which listed some items not in the others. And this proliferation of hardware in many cases has annual model changes like automobiles, some for the usual cosmetic reasons and some substantive. Since no one person is likely to even know of the existence of all types and items—much less see, handle, and test them—it is immediately obvious that any useful discussion must be conducted in general terms.

CAMERAS

The basic hardware item is the camera. All else is subsidiary. This is a simple enough statement, but the choice of what camera is to be used— and especially what *type* of camera—cannot be answered satisfactorily unless the first question to be considered is the nature of the subject matter to be photographed.

Manufacturers' claims to the contrary notwithstanding, there is no such thing as the single universal camera that is best suited to all types of work. Photographers, too, are subject to prejudice and to the workings of ingrained habit, and will tend to prefer the equipment with which they are most familiar unless reminded of the demands of subject matter when entering a new area of photography.

It is nearly always better, and remarkably it is often cheaper, to buy separate cameras for dissimilar jobs than it is to attempt to buy one "perfect" camera which will then require an endless series of special adaptors or additional gadgets to enable it to do jobs that the basic

camera was simply not originally designed to handle. In some cases such special additions can affect the picture making capabilities of the camera adversely. Some cameras are indeed inherently highly versatile, and every photographer should probably have one such camera. In choosing it, attention should be paid to the degree of adaptability that it does have, and to how readily it can accept accessories available on the market that were not built by the same manufacturer. In 35 mm cameras, the most important point of interest here is the lens mount. There are a small number of "standard" mounts for which many manufacturers make a wide variety of accessories. Among these are the Leica and Pentax threaded mounts, and the Exakta and Nikon bayonet mounts. If the camera chosen for purchase will not accept one of the common standard mounts, accessories for it will tend to be difficult to obtain and/or expensive. From a manufacturing point of view, the smaller the potential market the higher the unit cost. This situation has been somewhat eased recently with the marketing of accessories designed for "T" mounts. These are intermediary mounting devices designed to make it possible to market, for example, a lens, without regard to the camera it is to fit. By buying the correct "T" adaptor it is possible to fit the same lens to any of a wide variety of cameras. This is accomplished by making the basic lens mount too short for any known camera, and then making adaptors to fill the requisite space in order to mate with the appropriate camera body.

The matter of which camera to choose as the basic one should be decided by the nature of the commonest type of work that will be attempted. An entomologist wanting to photograph live insects in their natural habitats will most likely be satisfied with a small, highly maneuverable single lens reflex camera. An ecologist needing to record good-sized areas in

very great detail, with the expectation of being able to identify all the elements of a subject scene, will probably get best results with a statically mounted camera of large film size. Anyone needing to do significant numbers of both types of jobs would be wise to consider owning one of each applicable type of camera. If the need is there, this is not an extravagance.

Of course, all still cameras that are usable for general scientific photography possess the same general components. It is the design and arrangement of these common components that distinguishes one type of camera from another, and makes them especially suited to one or another of the varieties of uses. These common components are:

1. a *lens,* usually consisting of several glass and air elements, to form the image and put it on the film;

2. a *means of focusing* this lens on subjects at various distances;

3. a *viewfinder* of some sort to allow image composition—this may be a separate device, or simply a ground glass at the film plane which can be removed or displaced for the insertion of the film holder;

4. a *shutter* to keep the image-forming light off the film until the desired moment, to control the time that the light is on the film and thereby assist correct exposure of the film and to determine the degree to which motion is "stopped";

5. an *iris diaphragm,* which controls both the amount of light reaching the film (in conjunction with the shutter) and the amount of depth-of-field in the image; and

6. a *light-tight container* to hold the film ready for exposure—this may be a separate item, or it may be part of the larger light-tight mechanism which holds the other components together and which is, in total, the camera.

The inter-relationships among the various components are under the control of the photographer, and their handling makes up the technique of camera operation. This is discussed in detail in the latter half of the book. This section describes the constructional features and the operational advantages and disadvantages of the commonly used types of cameras. Part II of the book, which is devoted to the discussion of approaches to the various subject matter areas, includes specific camera and other equipment recommendations.

Well, then, what are the commonly used types of cameras, and how are they differentiated? They are:

1. the *rangefinder* camera, today most commonly using a 35 mm film, but in a sense including press cameras—described in catagory 5—which come in larger sizes;

2. the *single lens reflex* camera, usually using either a 35 mm or $2\frac{1}{4} \times 2\frac{1}{4}$ inch film, but occasionally using film as large as 4×5 or even 5×7 inches;

3. the *twin lens reflex* camera, in common use is nearly always found in the $2\frac{1}{4} \times 2\frac{1}{4}$ inch film size, but they are also available in film sizes that range from 35 mm, through the $1\frac{5}{8} \times 1\frac{5}{8}$ inch "superslide," up to 4×5 inches;

4. the *view* camera, using films that range in size from $2\frac{1}{4} \times 3\frac{1}{4}$ inches up through 4×5, 5×7, and 8×10 inches, with larger sizes to be had without great difficulty; and

5. the *press* camera, which in design is a combination of the rangefinder camera with some features of the view camera. Traditionally, it has been a 4×5 inch camera, but it is now

commonly found in the $2\frac{1}{4} \times 3\frac{1}{4}$ size, and is available in sizes up to 5×7.

Each of these types of cameras has its special virtues and certain limitations, so any decisions of choice are properly dependent on the functions that are to be performed.

Frequently, published articles come out in support of the larger film sizes on grounds of better quality. The basic premise is correct. The use of larger film formats requires less subsequent enlargement to yield prints of a given size. Therefore, there will be less degradation of image quality due to the enlargement of film grain structure, and other artifacts. However, in their enthusiasm the authors often overdo things by using the area method of calculating magnification—they use a concept that has more to do with the computer-related notion of packing "bits" of information into an area of space, rather than with any reasonable thoughts on photographic magnification.

In terms of area magnification, a frame of 35 mm film ($1 \times 1\frac{1}{2}$ inches) has $1\frac{1}{2}$ square inches of usable film area, while $2\frac{1}{4} \times 2\frac{1}{4}$ inch film has just over 5 square inches; a 4×5 has 20 square inches, and 8×10 has 80. But in terms of *linear* magnification, which is what affects the visibility of grain structure and other image artifacts, $2\frac{1}{4} \times 2\frac{1}{4}$ film is precisely 50 percent larger than the long dimension of 35 mm. Even the long dimension of the 4×5 is only $3\frac{1}{3}$ times larger, and that of the 8×10 is $6\frac{2}{3}$ times larger rather than the 53 times that is calculated using the area method.

In my opinion, it is not worthwhile to change to a larger film size solely for quality reasons of this sort until you can at least double the film dimension. I do tend to use the largest practical film sizes for quality reasons, but I don't like to see the issue unnecessarily confused.

The Rangefinder Camera

This type of camera, formerly more readily available in a variety of sizes and forms (including what used to be known as "vest pocket" and "hand-and-stand" cameras), is now most commonly seen in the 35 mm format, the film coming in cassettes containing either 20 or 36 exposures. Some manufacturers still market larger forms. The single best known rangefinder camera is the 35 mm Leica (Germany). Other well known makes include the Fujica and Canon (Japan), as well as many other 35 mm makes. The Koni-Omega "M" (Japan) and the Linhof 220 (Germany), which are also classifiable as types of press cameras, are representatives of $2\frac{1}{4} \times 2\frac{3}{4}$ inch designs. (Specific makes listed are examples only, and such listing does not imply endorsement.)

Basically, these are box-body cameras with an optical rangefinder mounted on top (or on the side), interconnected with the focusing mechanism and usually incorporating the viewfinder window. A typical arrangement, representing no particular manufacturer's model, might look like the camera shown in Figure 1.

This type of camera is held so that the eye peers through the rear rangefinder port, the eye port. The viewfinder, usually the same port, frames the approximate area recorded by the lens upon the film. As the lens focusing mechanism is moved, a small section of the viewed image (produced by additional optics, and usually colored by a pale filter) moves relative to the larger surrounding image. The exact focus is obtained when the two overlapping images coincide at the decided plane of focus.

A variation of rangefinder camera has a horizontal, diagonal, or vertical split dividing the two images. The focus is correct when lines at the chosen plane of focus cross the line without

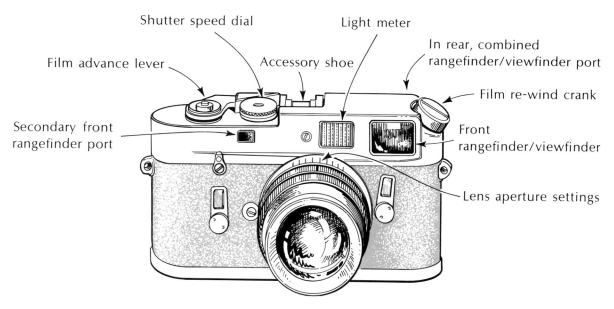

Shutter speed dial

Film advance lever

Accessory shoe

Light meter

In rear, combined rangefinder/viewfinder port

Film re-wind crank

Secondary front rangefinder port

Front rangefinder/viewfinder

Lens aperture settings

FIGURE 1
A typical 35 mm rangefinder camera.

any displacement. Appropriately, this is called a *split-image rangefinder*.

Most rangefinder cameras have a leaf-type shutter mounted between the glass elements of the lens. A few have a curtain-type shutter located just in front of the film plane. The former is called a between-the-lens shutter; the latter, a focal plane shutter. Between-the-lens shutters allow ready synchronization of flash lighting arrangements at all shutter speeds, but interchangeable lenses tend to be expensive because each lens must have its own separate shutter. Some cameras have achieved cheaper interchangeability by exchanging only the front element of the lens, but this feature limits usable lens designs to those patterns that can use the same rear element. And of course owners of these cameras are limited to lenses built expressly for that camera.

Focal plane shutters allow complete inter-changeability of lenses, which is limited only by the availability of the proper threads or other mounting arrangements between the lens and the camera body. However, curtain shutters limit flash synchronization. As soon as a leaf shutter opens, light falls on the entire negative area and continues to do so throughout the entire time of shutter operation. A curtain shutter exposes the film through a slit that opens to a preset width and then travels across the film. The speed of exposure is controlled by the width of the slit. The entire breadth of the film is exposed simultaneously only at the very slowest shutter speeds. Thus, flash synchronization with short duration sources is possible only at these slower speeds. The problem is most pronounced with electronic flash, which has an exceptionally short flash duration. But even normal flash bulbs offer similar problems, and synchronization is really dependable only with special flash bulbs

that have unusually long maximum light peak characteristics. Fortunately, such flash bulbs are now much more common than was once the case, owing to the wide use of curtain-type focal plane shutters in today's very popular single lens reflex cameras.

The special advantage of rangefinder cameras lies in photographing people and fast moving events, which make focusing on a ground glass a serious distraction. They are small and light, fast in operation, relatively inconspicuous in use, and the shutter action is usually very quiet. These cameras, as a group, are rather poorly suited to either very close up or extreme telephoto use, except with the addition of quite expensive and cumbersome accessories. In addition, the viewfinder window is located somewhat off the central axis of the lens so that the lens and viewfinder do not see quite the same thing, especially when the subject is at all close. This effect is called *parallax*. The more expensive rangefinder cameras have built-in parallax correction. This operates only down to moderately close distances, and provides "correction" only for main subject viewing. It cannot take into account the differing foreground-background relationships in a two-subject viewing situation.

Rangefinder cameras often show somewhat less in the viewfinder than will be recorded on the film, in order to allow for viewing inaccuracies. Thus there may be some difficulty in making really efficient use of the available film area—a matter of some importance in a 35 mm camera where the total size of the film frame is only 24 \times 36 mm (1 \times 1$\frac{1}{2}$ inches). Still, some of the very finest photojournalism has been, and continues to be, done with rangefinder cameras.

For telephoto use (see the section on lenses [p. 26] for full definitions and descriptions of lens types), many rangefinder cameras have luminous lines within their viewfinders that correspond to the areas recorded on the film by lenses of longer-than-normal focal lengths. Another solution for this problem is to provide detachable special viewfinders for each lens. Such viewfinders are frequently used in conjunction with shorter-than-normal focal length (wide angle) lenses.

Extreme closeup and extreme telephoto usage requires the introduction of a cumbersome and expensive reflex housing in order to ensure the correct framing and focusing of living or moving subjects, thereby converting the rangefinder camera into a rather awkward form of single lens reflex. For the price of such a housing you could buy a single lens reflex camera of satisfactory quality.

All this should not be construed as saying that the rangefinder camera is no good. Rather, the intention has been to emphasize that the real advantage of this camera lies in the intermediate distance range, and particularly in the recording of fast-moving human events. An example of the best use of this equipment is in the work of Henri Cartier-Bresson.

The Single Lens Reflex Camera

Probably the most widely used type of camera today is the single lens reflex. Most commonly it uses 35 mm film in the 24 \times 36 mm format, but there are several popular makes in 2$\frac{1}{4}$ inch film sizes. This type of camera can also be had in 4 \times 5, or even in 5 \times 7 inch sizes. The very best 35 mm versions include those made by Nikon (Japan), Zeiss (Germany) and Alpa (Switzerland). Other good makes include the Leicaflex and Exakta (Germany), and the Pentax, Topcon, and Minolta (Japan). In small sizes there is a 126 size made by Kodak (United

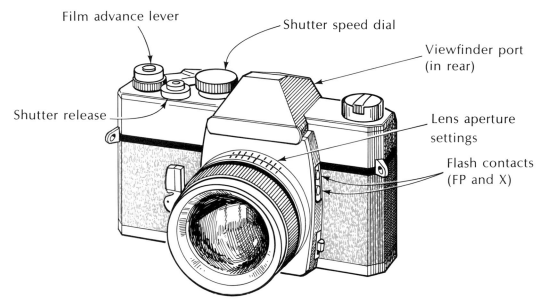

Film advance lever

Shutter speed dial

Viewfinder port
(in rear)

Shutter release

Lens aperture
settings

Flash contacts
(FP and X)

FIGURE 2
A typical 35 mm single lens reflex camera.

States), and single-frame, 18 × 24 mm formats, on 35 mm film are used by, among others, Petri (Japan). The best known $2\frac{1}{4} \times 2\frac{1}{4}$ inch versions include the Hasselblad (Sweden), the Bronica (Japan), and the Rollei SL66 (Germany). Slightly larger in format are the new 6 × 7 cm cameras, such as those made by Mamiya and Pentax (Japan). Other large versions are the Plaubel and Arca cameras from Europe, and the 4 × 5 inch single lens version of the Gowlandflex (United States). A typical 35 mm single lens reflex camera might appear as shown in Figure 2.

The single lens reflex camera is so called because the lens used to make the picture also serves, through the interposition of a moving mirror (in at least one instance, a stationary mirror), as rangefinder and viewfinder system. The method of accomplishing this is diagrammed in Figure 3. The word "reflex" refers to the reflecting of light, which is done in the viewing system. As seen in Figure 3, when a

scene is viewed and brought into focus, the light from the lens is directed to a ground glass or to an air-image* viewing position by the mirror, and from there to the eye by way of the prism. The prism serves to reverse the image reflected from the mirror into the correct left-right configuration as well as to allow eye-level viewing. When the shutter release is pressed the mirror swings up out of the light path, and the focal plane shutter opens, which allows the image to be recorded on the film. In most modern designs, the iris diaphragm in the lens mount (this is discussed in the text following page 89) is "set" at the desired opening prior to focusing, but actually remains wide open until the shutter release is pressed. Then, just prior to the opening of the shutter, the iris automatically closes down to the chosen setting for the duration of

* An air-image is an image formed in the air, using no actual viewing screen, and viewed by using an auxiliary eyepiece.

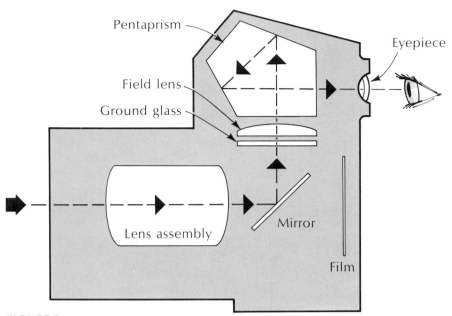

FIGURE 3
The light path in a typical pentaprism reflex camera.

the exposure. In most cases, the mirror comes back down and the iris reopens automatically as soon as the shutter closes, in order to restore viewing at once. Thus, direct viewing of the subject is interrupted only for a split second, allowing virtually constant monitoring of subject activities. This automatic diaphragm feature was a major advance in camera design when introduced, and greatly eases closeup photography, as well as wildlife photography in general. Thus, in modern single lens reflex camera designs, the pressing of the shutter release sets off a whole train of mechanical activity. Although the single lens reflex has the most complicated mechanical design of any common camera type, the dependability of nearly all such cameras is remarkably good.

The single lens reflex camera is inherently highly versatile. Since viewing and picture making are accomplished with the same lens, there is no parallax problem. Extreme closeup, very long telephoto photography, and a wide inter-

changeability of lenses are all readily accomplished. Meanwhile, the basic camera approaches the small size, lightness and speed of operation of the rangefinder camera. Indeed, most 35 mm versions have a small variation of the split-image rangefinder built into the viewing screen to speed up and assist focusing.

As for disadvantages, it is slightly more conspicuous in use owing to the noise generated by the combination of the focal plane shutter and the moving mirror, and in a few very critical uses "mirror-flop" can introduce unwelcome vibrations. (These latter will be most detectable if slow shutter speeds are being combined with high magnification, as with extreme telephoto photography.) A few single lens reflex cameras have provision for locking the mirror up, manually, prior to exposure, to avoid the problem. This is useful when the subject is motionless. In the smaller sizes, the single lens reflex shares with the 35 mm rangefinder camera the disadvantage of small film size. However, in the bet-

ter designs this is partially compensated for by their very exact framing characteristics, which allow absolutely full use of the available film area. In the production of color slides for any critical or important use, this last point is worthy of close consideration. My personal preference in 35 mm cameras is for the single lens reflex over any other type; and, if I had to be content with only one camera for all uses, I'd choose some sort of high quality single lens reflex.

The special subject area where the 35 mm single lens reflex camera excels is in field photography of small, live, moving objects, such as insects. It is poorest (though still far from useless) in photomicrography and in the ultimate-detail recording of "grand views" (landscapes). Flash synchronization with this camera type suffers from the same limitations as it does with those rangefinder cameras using curtain-type focal plane shutters; and the more so, since the majority of single lens reflex cameras have this type of shutter. A few have a leaf-type focal plane shutter which is not quite so limiting, but the gain is only one or two shutter speeds higher. Fortunately, with presently available flash units and techniques the problem is usually more theoretical than real. Interchangeably fine results can be had with either electronic or bulb flash units, as long as the camera is properly adjusted.

An indication of the popularity and versatility of single lens reflex cameras is the reported statistic that approximately 90 percent of all photo journalists now use this type of instrument. I think this percentage would be close to accurate for scientific and nature photographers, too.

The Twin Lens Reflex Camera

The twin lens reflex camera was the mainstay of magazine photographers for many years,

being used by such well known and respected photo journalists as Margaret Bourke-White. To this day, it remains a very popular type of camera with both professional and amateur photographers. It is most commonly used in the $2\frac{1}{4} \times 2\frac{1}{4}$ inch format. It can be had in formats as small as 35 mm or as large as 4×5 inches. The classic $2\frac{1}{4} \times 2\frac{1}{4}$ is the Rolleiflex (Germany), with other well-known versions in the same format being made by Mamiya and Yashica (Japan). Agfa has made a 35 mm version, and 4×4 cm ($1\frac{5}{8}$ inches square) versions have been made by Rollei, Yashica, and others. The Gowlandflex (United States) is the best known 4×5 inch version.

The Mamiyaflex and the Gowlandflex each offer a limited interchangeability of lenses, with pairs of matching lenses being mounted on a single interchangeable front plate. The Koni-Omegaflex "M" (Japan) offers this feature in the $2\frac{1}{4} \times 2\frac{3}{4}$ inch format. Obviously, lens interchangeability with these cameras is limited to lenses made for the specific camera, and is expensive because of the matched pairs of lenses that are necessary.

The twin lens reflex camera has some variations in shape and proportions, but a typical design is shown in Figure 4. The name "twin lens reflex" is derived from the design, of course. Basically, this type of camera is two box-body cameras placed one atop the other, with the focusing of the two lenses controlled by a single interconnected mechanism. The lower lens, called the "taking" lens, forms the image directly on the film, while the upper lens has its light path deflected upwards onto a horizontally mounted ground glass viewing screen. This screen is usually provided with a collapsible hood to prevent stray light from obscuring the image. Located within the hood is a folding magnifier, which aids in accurate focusing when it is swung into position over the ground glass. In operation, the photographer holds the cam-

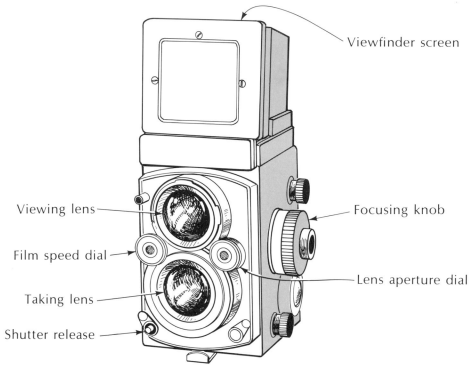

Viewfinder screen

Viewing lens

Film speed dial

Taking lens

Shutter release

Focusing knob

Lens aperture dial

FIGURE 4
A typical twin lens reflex camera.

era at waist or chest level, looks into the top of the camera while framing and focusing the image, and makes the picture when ready. Certain twin lens reflex cameras are equipped with a prism or mirror viewing device that allows eye-level viewing, but this is somewhat of a rarity.

As with the single lens reflex, the word "reflex" refers to the mirror which reflects the viewing-lens image up to the viewing screen. A simplified internal diagram of a twin lens reflex camera is shown in Figure 5. There is no shutter, and usually no iris diaphragm, on the viewing lens. The shutter mechanism on the taking lens is of the between-the-lens leaf type, and has the diaphragm incorporated in it. The twin lens reflex combines certain features of both the

rangefinder and reflex designs. In one way of thinking it is a rangefinder camera with an exceptionally large viewfinder. It can also be thought of as a modification of the reflex design, but with the mirror moved up out of the taking lens light path, so that it requires its own image forming lens.

The twin lens reflex is not an inherently versatile camera, but it does have certain advantages. It is an exceptionally easy camera with which to learn basic photography. Most people find it easy to handle and pleasant to operate. The shutter is almost noiseless, and the waist-level viewing position makes it quite inconspicuous to use. (For instance, it is well out of sight from the side when hanging by its neck strap between the flaps of an open coat or jacket.) The

negative is usually significantly larger than 35 mm, a distinct advantage from the point of view of quality. The shutter is readily synchronized to any type of flash at any speed. The viewfinder is usually large and brilliant.

Disadvantages crop up in several areas. Most models come with lenses of only one focal length and are without provisions for interchanging. A very few types have interchangeability among several focal lengths, but the necessity of changing both lenses makes the arrangement both cumbersome and expensive. The romantic picture of the professional photographer notwithstanding, it is an annoyance to

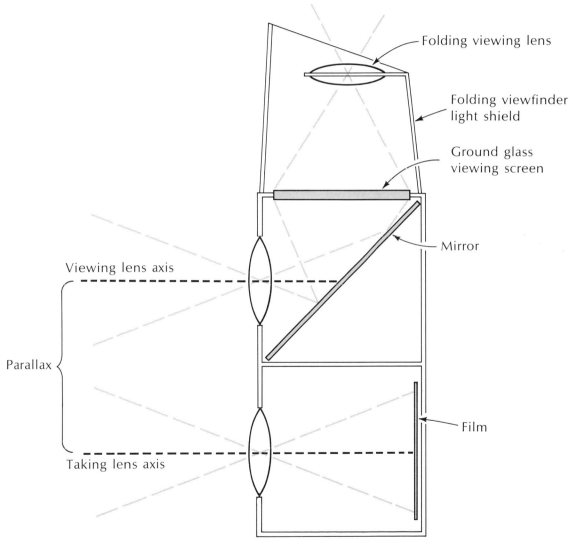

FIGURE 5
The light path in a typical twin lens reflex camera.

have more than one camera hanging about one's person at any given time; and doing so requires care in order to prevent damage by banging them together. So having two complete cameras with different lenses is less than satisfactory, as well as being expensive.

Depth of field cannot be checked directly on the ground glass unless a diaphragm is on the viewing lens—and this is seldom the case. Waist-level viewing results in "seeing the world through one's navel," and often this is not a suitable angle of view. In addition, the simple mirror-type viewer of most twin lens reflex cameras reverses the image laterally. This left-right reversal reverses the apparent direction of cross-axis movement, which makes the following of fast motion quite difficult. This angle-of-view problem can be partially corrected by the use of a "sports viewfinder," a simple open frame and peepsight device built into the viewer hood. A few twin lens reflex cameras can be equipped with a prism or other optical system, which erects the image to allow eye-level viewing, and corrects the lateral reversal, in order to facilitate the following of subject motion. The first solution is likely to lack accuracy of framing while removing all possibility of judging the depth of field, and the latter solution involves increasing the weight, bulk, and cost of the camera.

Photography of really close-up subjects is possible only by using slip-on supplementary lenses. However well made these lenses are, they tend to degrade the image, and usually require additional special devices to aid in accurate composition and focusing. With the viewing and taking lenses being separated in space, there are two separate angles of view. The resulting image displacement is referred to as "parallax," as mentioned earlier. There is no difficulty in long distance viewing, and relatively little at intermediate distances. But there is too much parallax in the twin lens viewing system for accurate viewing at really close distances. The more expensive cameras feature built-in parallax correction; the viewing lens is canted forward so as to include the same *field* of view in the plane of prime focus as the taking lens. This still does not provide an identical *angle* of view, and thus the foreground-background overlaps will differ in viewing and on the film. Even where correction is provided, and where it remains satisfactory in use, it is usually operative only down to about three feet from the lens. At closer distances the only real way to avoid parallax problems is to make use of a vertical-shift device on a tripod after composing and focusing, in order to place the taking lens in the former position of the viewing lens before exposing the film.

Since this takes time, it is of doubtful value where the subject can move, such as during the photography of insects. But, even with all its inherent disadvantages, I was quite happy with a twin lens reflex camera for many years, and can still find many perfectly appropriate uses for it today.

The subject area where the twin lens reflex camera is most at home is in the photography of people and their surroundings. As stated earlier, it has done noble service in magazine illustration, and has been responsible for very fine work, in the hands of such photographers as Margaret Bourke-White, Fritz Henle, and Philippe Halsman. It has also done yeoman service in field ethnology in the last several decades.

The View Camera

The view camera is simultaneously the most optically flexible camera, and, of necessity, the

most statically mounted general-use camera. Seldom seen and little understood by amateurs, it is known by professionals as capable of the highest quality photography, within its practical areas of subject matter. Its most outstanding characteristic is extreme adjustability. All portions of its structure are movable, in three dimensions, with respect to one another.

The view camera consists of four basic structural parts:

1. the *bed,* either a dual-track framework as found in the "flat bed" type, or a single rail or tube, as found in the "monorail" type, this bed being the support on which the other parts rest and move,

2. the *front,* consisting of various mechanisms to adjust the lens in three dimensions and support it,

3. the *back,* incorporating a spring-mounted ground glass viewing screen, which moves out as a unit to accept and hold in place a film holder, the whole unit having the same freedom of movement as the front, and

4. the *bellows,* made of a pleated leather or synthetic material, which provides a light-tight connection between front and back no matter how they are adjusted or displaced with respect to one another.

Both the back and front can be traversed along the bed, both to focus and to control the point of balance of the camera and the amount of image magnification. They can both be raised and lowered, rotated about the horizontal and vertical axes, and slid to either side of a center position. By moving the front and back along the bed in an appropriate manner, the photographer can center the weight of the camera over the tripod head for any length of bellows

extension, and can have the choice of focusing by moving either end. In normal use, after setting everything up satisfactorily, any necessary minor adjustments in the image scale can be effected by moving the front backward or forward. Final exact focus can then be achieved without significant further alteration of scale by focusing at the back. Rotation about a vertical axis ("swing") and about a horizontal axis ("tilt") allow two types of control over the image. Swinging or tilting the *front* allows control over the apparent depth of field by aligning planes of focus with the plane of the ground glass for subjects that are not perpendicular to the main camera axis. Swinging or tilting the camera *back* allows control over the image by changing the degree of apparent diminishing perspective. Transverse motion, vertical "rise-and-fall," or sidewise "shift," of either front or back allow changes in image placement on the ground glass. Use of these movements in controlled fashion is dependent upon having the camera firmly mounted on a tripod or other support, in order to provide a secure position to work from, and a standard optical axis from which to deviate. Details of use of shifting lenses are given on page 385, but you should understand here that the value of the movements can be great. Learning their use is not difficult. A typical view camera would appear as shown in Figure 6.

View cameras come in a wide variety of film formats. The smallest common film size that is used is $2\frac{1}{4} \times 3\frac{1}{4}$ inches. Camera formats of 4×5, 5×7, 8×10, and 11×14 inches are all available. These have closely equivalent metric sizes in Europe and elsewhere. A 35 mm view camera, the Ilford K.I. Monobar (England), has been discontinued. A special purpose view camera in 8×20 inch format is available. Called a *banquet camera,* it is useful wherever there is a

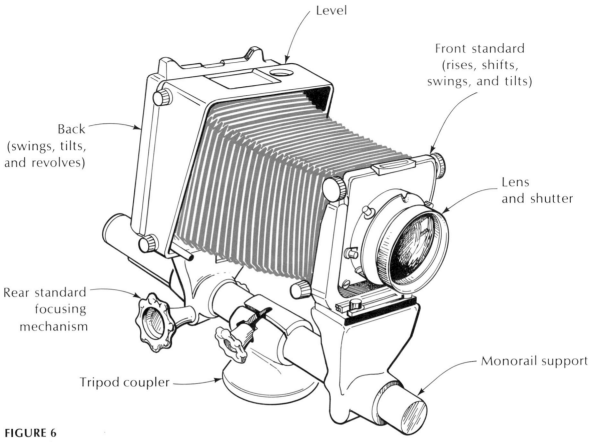

Level

Front standard
(rises, shifts,
swings, and tilts)

Back
(swings, tilts,
and revolves)

Lens
and shutter

Rear standard
focusing
mechanism

Monorail support

Tripod coupler

FIGURE 6
A typical view camera.

frequent demand for very wide pictures of no great height.

A quite recent entry into the view camera field, lending itself to a wide variety of uses, is a combination of the standard view camera bed, bellows and front with a single lens reflex back. It is available in $2\frac{1}{4} \times 3\frac{1}{4}$ and 4×5 inch sizes. Usually, the reflex back can be adapted easily to become a straight single lens reflex camera. A typical camera of this type appears as shown in Figure 7.

Common makes of view cameras include Burke & James, Calumet, and Deardorff (United States), Linhof, and Plaubel (Germany), and Arca-Swiss (Switzerland). Reflex/views can be

had from both Plaubel and Arca-Swiss. A rather limited version of the reflex/view is made in $2\frac{1}{4} \times 2\frac{1}{4}$ inch size by Rolleiflex (Germany).

View cameras derive their name from their commonest early usage, being originally designed to produce landscape "views." They are very useful in any case where the ultimate rendition of fine detail is needed, and especially where the larger film sizes are being used. The optical controls built into these instruments make them especially good for photographing large or small scale landscapes, architecture, archeological digs, and for definitive photography of any human artifacts or other individual objects. Much of the best work of such well

known photographers as Edward Weston, Ansel Adams, and Eliot Porter has been done with view cameras.

There are two outstanding disadvantages in using view cameras. The lesser of these is that the image on the ground glass is upside down. It is annoying at first, but not particularly hard to get used to. It is compensated for by the fact that the image so seen is the image that will be recorded on the film, without any sort of alteration. Viewing is done by opening the shutter and observing the image formed on the ground glass, which is placed directly in the film plane. When a satisfactory image has been obtained by using all the appropriate camera adjustments, the shutter is closed, a film holder is inserted in the film plane, displacing the viewing screen, and the exposure is made.

Traditionally, the view camera's great disad-

vantage has been its lack of mobility. Of necessity, it has been operated from a fixed tripod, with some difficulty attending any attempt at handheld use. The development of the reflex/view camera has greatly reduced the problems of view use. Reflex viewing with a pentaprism erects the image and thereby solves the first problem noted above. The second disadvantage is also eliminated by this design, since a reflex/view is readily picked off the tripod at a moment's notice, and used in the same way as a handheld single lens reflex camera. Obviously, the cost of a reflex/view is higher than that of either type of camera separately, but may be less than that of two separate cameras of limited capabilities. However, the reflex/view combination is a bit more cumbersome than either, separately.

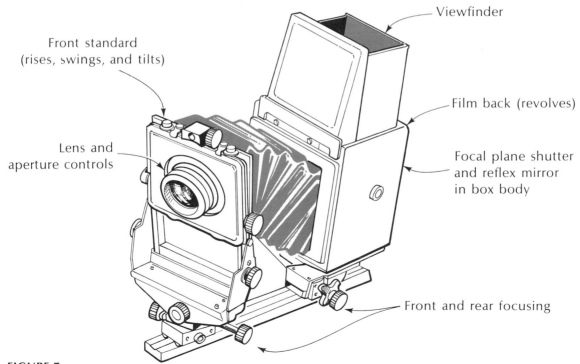

Viewfinder

Front standard
(rises, swings, and tilts)

Film back (revolves)

Lens and
aperture controls

Focal plane shutter
and reflex mirror
in box body

Front and rear focusing

FIGURE 7
A typical single lens reflex/view camera.

The Press Camera

The press camera is derived from what used to be called the "hand-and-stand" camera, a medium camera that could be handheld or tripod-mounted. As the newer name implies, frequent use of this type of camera has been made in newspaper photography, where the combination of versatility with fairly large film size and relatively light weight brings economies in terms of both purchase price and speed of operation.

The press-type camera can be considered a hybrid that combines the main aspects of the rangefinder camera with some view camera capability. It can take various forms, especially in the smaller sizes, but the commonest one is a box body whose forward panel folds down to become a supporting bed for an extending bellows and camera front. A camera of this type usually appears as illustrated in Figure 8.

In handheld use, the weight of the camera is carried by the left hand (either by holding the left side of the box through a handstrap, or by means of a contoured grip mounted on the camera body) and the controls are operated by the right hand. A rangefinder coupled to the camera front is mounted on the top or right side of the body. With a little practice the camera can be operated accurately with considerable speed. When it is mounted on a tripod, it can be used similarly to a view camera, with composition and focusing done on a ground glass screen permanently mounted at the back. Focusing is done by moving the front only, as are most of the other movements. (However, some types allow swings and tilts of the back.) Almost all types allow a backward tilt of the lensboard and a sideways shift. Forward tilt is usually accomplished by means of a "drop" of the bed, which allows the bed to be bent below the horizontal lock. Front swing is present in some models.

Almost all press cameras normally use leaf-type shutters in the lens mount, but some also have a focal plane shutter in the rear of the body, which allows the subsidiary use of any lens that can be put on the body, whether self-shuttered or not.

The most used film size for press cameras has traditionally been 4 × 5 inches, with sheet film being used in holders containing from two to twelve sheets each. Most makes also allow the use of roll film holders, usually making $2\frac{1}{4} \times 2\frac{1}{4}$ or $2\frac{1}{4} \times 3\frac{1}{4}$ inch pictures on 120 size film. Smaller press cameras using the $2\frac{1}{4} \times 3\frac{1}{4}$ format or the somewhat short 6 × 7 cm "ideal" format on both sheet and roll film are growing in popularity. In earlier times, the "quarter plate" or $3\frac{1}{4} \times 4\frac{1}{4}$ inch size was widely used, but in the past three decades has largely passed out of use in the United States. At least one manufacturer produces and finds a limited market for a 5 × 7 inch press camera. Metric equivalents of all the above listed sizes are widely used in Europe and elsewhere.

Probably the most widely known versions of the press camera are the various models of the Graphic (United States), including the Speed, Crown, and Century types (these models have been recently discontinued, but are still available through used camera stores). Next most popular would be the versatile but often rather heavy Linhof (Germany), followed in various order by such makes as the Horseman (Japan), the Burke & James (United States), and the Mamiya (Japan). The 4 × 5 inch Mark VIII, made by Micro Precision Products, Ltd., is a good English make. Recently, Linhof introduced the Technika-Flex mirror reflex attachment which can be coupled to the 4 × 5 inch Linhof Super Technika press-view camera, thereby transforming it into a quite good twin lens reflex camera. There are too many types and makes to list in detail,

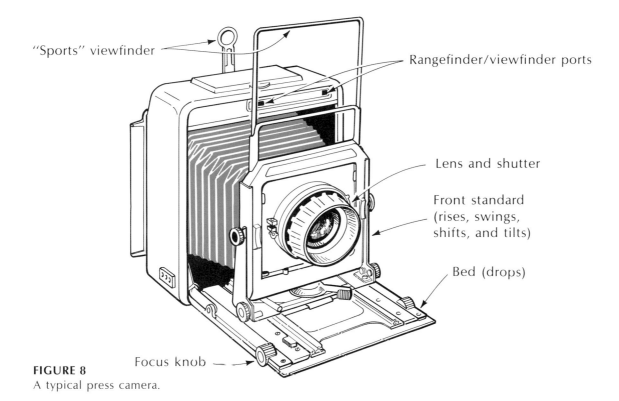

"Sports" viewfinder

Rangefinder/viewfinder ports

Lens and shutter

Front standard
(rises, swings,
shifts, and tilts)

Bed (drops)

Focus knob

FIGURE 8
A typical press camera.

but the models just mentioned give a good idea of what is currently available.

Because of its versatility, it is hard to specify areas of special competence for the press camera. After the single lens reflex, it is the second most versatile type of camera made. Anything that can be done on any other rangefinder camera, plus much of what a view camera is designed for, can be done with a press camera. It uses film that is comparable in size to that of most view cameras, and therefore larger in size than that of most rangefinder types. This film size makes retention of photographic quality quite easy even in difficult working situations.

The greatest disadvantage of the press-type camera is its inability to follow fast-moving small subjects, such as living insects, where the image magnification makes careful composition and critically accurate focusing an absolute necessity. It is clearly outclassed here by the small single lens reflex. In most other areas, the press camera stands well to the fore as a potential choice.

In recent years the press camera has been dropping in popularity even among journalists, losing out to the versatility and speed of operation of the small single lens reflexes. Although the latter offer many attractions, they are not necessarily the best choice in all situations. In my opinion, the 4 × 5 press camera should be part of the equipment inventory of any well thought out photographic enterprise, and is as useful in the field as in the laboratory. It can be used for static specimen studies at high magnifications, is easy to adapt to photomicrog-

raphy, performs well in field ethnology, and does very well in recording ecological settings. Failing to give it consideration because it is currently a bit out of fashion might be an error.

Special Purpose Cameras

Although, in a general sense, as has been noted in the previous section, all cameras are somewhat special in purpose, there are some types which are very specialized. The reason for this specialization may be the function to be performed, or it may be related to the conditions under which the work will be carried out. In the first category are cameras for high quality photo-copying, oscilloscope photography, photomicrography, or fingerprint photography. The second grouping includes those cameras designed for aerial photography and underwater work. An outstandingly useful example of a camera in this latter catagory is the completely self-contained submersible Nikonos (Japan). A combination of the two classes might be represented by the precisely designed cameras used for exacting aerial mapping (photogrammetry). Extremely specialized uses will normally require extremely specialized equipment. Operation of this equipment is usually so constrained by the controlling photographic conditions that it is inappropriate to go far into the subject here. Some special camera types are discussed in this book where it is deemed necessary, but only in the more general applications.

SUBSIDIARY EQUIPMENT

There is a great variety of subsidiary photographic equipment available. Some equipment is of great importance, some is definitely useful, and some equipment just amounts to frills. In purchasing, the effort should always be to have enough, without unnecessary skimping, but to avoid overdoing things. In any given area, the number of such subsidiary items in your possession should be limited to those actually needed or potentially of important capabilities, partly for economic reasons and partly to avoid clutter and confusion. But you should seriously consider the purchase of anything that will make the work go easier or quicker, or that will raise the quality of the final product. Which items are musts, and which are not, will best be determined by the nature of the work to be done. Sharply specialized work will probably need a relatively small stock of items. Work of a more general nature will require a greater variety of equipment.

Lenses

The heart of all cameras in general use is the lens, the primary image-forming device. Many factors are of importance with regard to lenses, but our first consideration is focal length. A full explanation of all facets of focal length requires much more space than I am going to use. A short and sufficient definition (for now) is as follows. For a thin, single element lens, of symmetrical configuration, the focal length is the distance between the center of the lens and the image projected by that lens, when the lens is focused at infinity (or, practically, on a very distant object).

This matter is actually more complicated in practice because nearly all cameras have lenses that are made up of more than one element. Different types of glass having various shapes and optical qualities are played off against one

another to produce lenses with various desirable characteristics. Among these are relative freedom from certain defects, or aberrations, that are inherent in single element lenses.

Since it is possible to place the point from which the focal length is measured (called the rear nodal point) at any of a variety of locations along the optical axis, and since it is easy for us laymen to become lost in a sea of technical terms, I will refer to this point as the "optical center" of the lens. It should be understood tht this is a term of convenience rather than accuracy, and readers wanting to investigate these matters more fully are referred to texts on optics.

Lenses are divided into three basic types by the relationship of the focal length to the film size being used:

1. those of shorter than normal focal length, called *wide angle,*

2. *normal,*

3. those of longer than normal focal length, called either *telephoto* or *long-focus,* depending upon their optical design.

These terms are only approximate, but they are quite well understood among photographers. For any given film size a "normal" lens will have a focal length approaching the length of the diagonal across the usable film format. In the case of the 35 mm camera, where the format is 24 × 36 mm, a diagonal measure is approximately 43 mm. In practical terms there is quite a bit of leeway, and lenses with focal lengths of from about 40 to 58 mm are generally considered to fall within the normal range. The most commonly seen normal focal length in 35 mm cameras is the 50 mm lens. (To clear up a possible confusion by anticipating a matter that is covered later, cameras are described by the film size used, lenses by their focal lengths. A "35 mm" camera uses a roll of film having an overall width of 35 mm. Most cameras using this film have an individual frame size of 24 × 36 mm, which is two frames—18 × 24 mm—in motion picture use. This film was originally a standard motion picture size with frames of 18 × 24 mm, and was adapted to still camera use in the larger format. Thus such a camera is properly called a double-frame camera. Still cameras using the smaller 18 × 24 mm format are properly called single-frame cameras. These cameras are sometimes incorrectly called "half-frame" cameras, however, because their format is half that of a standard 35 mm frame. Double-frame cameras are simply called 35 mm cameras.)

Assuming the same camera and subject positions, variations from the "normal" focal length produce images of lesser relative magnifications (equivalent to a wider angle of view) when the focal length is shorter; and images of greater relative magnifications (equivalent to a narrower angle of view) when the focal length is longer. Wide angle lenses are optically constructed to produce a larger image circle than would ordinarily be the case, in order to cover the whole film area. If this were not done a short focal length lens would throw a small circular image on the film, leaving the rest of the frame area unexposed, and therefore dark on the print. However, a longer focal length lens can be of any optical configuration. It could be a normal or even a wide angle lens intended for use with a camera of larger film size. For instance, I have a lens of $8\frac{1}{4}$ inch focal length—normal for 5 × 7 inch cameras—which I use as a wideangle lens with an 8 × 10 inch camera, and which I also use as a long-focus lens on my 35 mm camera. A true telephoto lens is one whose design places the optical center of the lens *forward* of

the physical center of the lens. In many cases it is forward of the lens in its entirety. The result is a shorter, more compact lens mount that presents fewer problems of balance and handling in use. The analogous case with short focal length lenses is the retro-focus wide angle lens, which has its optical center in back of the physical center. Such lenses are often used with single lens reflex cameras, where room must be saved behind the rearmost element of the lens for the moving mirror.

Many things are tied to the focal length of a lens. For instance, *relative aperture* (f-number) can be thought of as the ratio between the focal length and the diameter of the aperture. A lens whose aperture diameter is one-eighth of its focal length is said to be an f/8 lens, and so on. Another relationship is *image magnification*. If the camera-subject distance is kept constant, the linear magnification of the image will vary directly in proportion to the focal length of the lens used. Double the focal length and you double the image magnification.

Related to both the image size and the focal length is the *angle of view*. If the distance from the subject and the size of the film are kept constant, the change in image magnification that accompanies a change of focal length can also be seen as a difference in the amount of the scene recorded on the film. There is, then, a change in the angle of view that the film area encompasses.

Finally (for our consideration here), the *working distance* (camera-to-subject distance) and *backfocus* (distance from the lens to the film) are both related to the focal length. At an image magnification of ×1 (pronounced "times one"), or actual size, working distance and backfocus are both always double the focal length (assuming a thin lens of symmetrical configuration). As previously mentioned, a lens of very short focal

length may require a retro-focus design in order to allow room behind the lens mount (sufficient backfocus) to clear the moving mirror of a single lens reflex camera.

Several purposes are served by possessing several lenses, each having a different focal length:

1. If a subject cannot be approached closely enough to have its image fill the film adequately, a telephoto or long-focus lens will assist by increasing magnification; if you cannot back off far enough to include all of the desired area in the picture, a wideangle lens is needed.

2. In photography there is an effect known as *depth of field.* The term refers to the amount of fore and aft depth of subject matter that will be in acceptably sharp focus at a given plane of prime focus, diaphragm opening, and image magnification. If the image magnification is reduced by using a shorter focal length lens, while remaining in the same place and using the same lens aperture, the depth of the area that is rendered acceptably sharp will increase. If the magnification is increased by using a longer focal length lens, again from the same camera position and using the same lens aperture, the depth of field will decrease. Depth of field changes can also be made without lens changes, simply by varying the aperture size or by changing the camera-to-subject distance, but there may be reasons why these solutions are not practical. Change in focal length is a useful tool for image control, and this subject is covered in more detail, particularly on pages 348 and 382.

3. Altering the focal length, while simultaneously retaining a given image magnification, requires altering the distance between

the camera and the subject. This will produce certain effects upon the perspective appearance of the image. For instance, if an unusually short focal length lens is used to fill the film with the image of a three-dimensional subject the result will be a considerable difference in the image magnifications of the near and far portions. In a full face human portrait, the nose may appear unnaturally large, compared to the more distant ears. If the lens is longer in focal length than normal, the opposite effect will be apparent. There will not be sufficient difference in size to indicate the various distances of such features from the camera. Thus the distances to various parts of the subject will appear compressed. Either of these effects may or may not be desirable or important. They also may or may not be avoidable. But the photographer should be aware of the possibilities.

Lenses for 35 mm cameras have been produced in an extraordinary variety of types and focal lengths in recent years, to suit the explosion of popular interest in this type of camera. However, the camera has remained basically a glorified box camera, in the sense that no view camera type adjustments have been possible. In response to requests for changes which can solve certain problems that recur in technical photography, some new types of lens mounts have been introduced in the last decade. Nikon (Japan) was one of the first here, with their 35 mm PC-Nikkor ("Perspective Control") wideangle lens. It is designed to allow a lateral displacement of the lens, up to a maximum of 11 mm off center. The lens mount rotates continuously (with click stop reference points every 30 degrees), so this lateral displacement can be a continuously variable vertical, horizontal, or diagonal movement. In particular, this displace-

ment can greatly assist the photographer doing architectural and apparatus photography, but it is not without its uses even in landscape or forestry photography. Schneider (of Germany), noting that this lens would fit only the Nikon lens mounting attachment, has since come out with their 35 mm PA-Curtagon lens, similarly displaceable, but to a maximum of only 7 mm. Although the amount of adjustment possible is less, the lens can be mounted on a wide variety of 35 mm single lens reflex camera makes. Nikon has now introduced a new PC-Nikkor in a 28 mm focal length.

In another development, one of considerable significance if your needs run in this direction, someone decided that just a lateral shift movement was not sufficient, nor was the primary limitation to the single focal length of 35 mm satisfying to all. So, a series of lenses in 50, 65, 90, 100, and 135 mm focal lengths are now on the market, all mounted so that they can be shifted laterally 25–30 mm off center, as well as tilted 30 degrees off axis, in any direction. This will provide full view camera control of the image if correctly used. These lenses, trade named Varioflex in these mounts, are made in Germany (mostly by Schneider), and are set in their special mounts in Austria. Three of them can be had to fit either 35 mm or $2\frac{1}{4} \times 2\frac{1}{4}$ inch single lens reflex cameras. The 65 mm focal length will fit only the 35 mm cameras, while the 135 mm lens will fit only $2\frac{1}{4} \times 2\frac{1}{4}$ inch cameras. In his article "Tilting Lens Makes 35 mm SLR into a View Camera" (see the bibliography), Hanns Gutenstein shows a way of making your own tilting/shifting lens mount from standard industrial pillow blocks, by relatively simple machining.

The most recent lens offering of this type is the 35 mm f/2.8 S.S.C. Canon TS lens, which incorporates a rotatable mount similar to Nikon's PC lens, but which shifts 11 mm *to ei-*

ther side of center at any angular setting. Furthermore, it provides an 8 degree tilt to either side, the tilting mount rotating along with the shift in a plane at 90 degrees to that of the shifting motion. This lens supplements the Varioflex line in that it is of shorter than normal focal length, while the Varioflexes are of normal or longer focal lengths.

As a final note on shifting and tilting lenses for 35 mm cameras, a degree of interchangeability exists. Nikon cameras will accept the Nikon, Schneider, and Varioflex lenses, but not the Canon. Both Canon and Miranda cameras will accept all of the others. See your dealer about fittings, if you have another make of camera. (There is a good introductory article on the uses of these lenses, "Does It Pay to Tilt & Shift with 35 mm?", by Herbert Keppler, p. 114, November, 1974 *Modern Photography*.)

In recent years the widespread introduction of the "zoom" lens has sometimes made it unnecessary to have a whole series of focal lengths in one's possession. A zoom lens is designed in such a way that several of its glass elements can be moved with respect to one another, so that its focal length can be continuously changed throughout a fairly wide range. The usual range is either from somewhat wideangle to somewhat telephoto, or from a short to a longer telephoto. This can be a great convenience when the photographic situation is changing so rapidly that there is little or no time for changing lenses. However, zoom lenses do have their disadvantages. So far as I know, no zoom lens yet manufactured has quite the ability to resolve fine detail of a good quality fixed focal length lens of comparable focal length. As the zoom ratio increases, this becomes truer. Also, it is no doubt true that each zoom lens will have an optimum focal length, probably somewhere in the middle of its range. If such a lens must be

used where quality of image assumes great importance it would be well to know in advance, through careful testing, what that optimum focal length would be, and use it. Although the optical quality of the best of these zoom lenses is now very good, in general they should not be used where resolution is of prime importance, but their use should be restricted to situations where the pace of events demands their presence. With true zoom lenses, image magnification cannot be increased by adding camera extensions. However, tele-converters are a limited but practical supplement for both closeup and distance photography. (See especially page 364.)

Lenses, as discussed so far, have been assumed to be of normal construction, in that they are refracting instruments, with all their glass elements being lenses. For especially long telephoto use there is another type of construction that, in essence, is a reflecting telescope with a "folded" light path that incorporates one or more refracting elements (called "correcting" lenses) to yield a flat image in the film plane. In photographic use, these lenses are called mirror optics or, more correctly, catadioptric optics. A pure reflecting system is unusually free of optical aberrations of most sorts, but it cannot produce a flat image, its image naturally being a portion of a sphere. Thus, correcting lenses of some type must be introduced to help out here. Two representative designs for catadioptric systems are shown in Figure 9.

These designs have a number of advantages, in addition to their potentially fine optical quality. They are unusually compact and light in weight, they focus rapidly over considerable distance ranges, they are usually of very long focal length, and they frequently have a fairly wide aperture for such a focal length (they are slow as compared to normally constructed

(A) Schmidt-Cassegrain

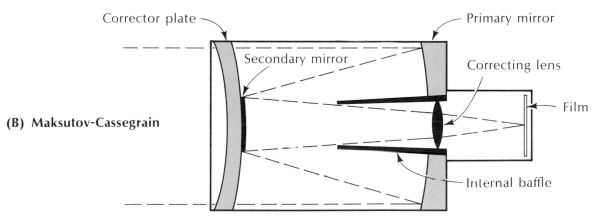

(B) Maksutov-Cassegrain

FIGURE 9
Representative catadioptric optical systems.

lenses of the short to medium focal length range, but often compare favorably in speed to very long refracting lenses). Their overall lengths are as short as 7–8 inches (17.8–20.5 mm). Their common focal lengths in photographic use start at about 500 mm and go up to 2000 mm or more, and their relative apertures range from about f/4 to about f/11. A very few of the truly telescopic designs noted below may have operating apertures as slow as f/16 or f/22. Apertures of such lenses, owing to the basic nature of the optical design, are fixed, so the depth of field and the control of light intensity cannot be varied with a diaphragm, as is done in normal refracting lenses. However, in practice this is seldom troublesome, since very long telephoto work rarely involves a need for great depth of field, and exposure can be controlled by other methods.

The extreme image magnification introduces two major limiting factors in obtaining good images:

1. Any movement or vibration of the camera will blur the picture.

2. Convection currents and other air movements between the lens and the subject will badly degrade the image.

Control of movement and vibration must be very carefully worked out to eliminate most or all such effects during such photography. The use of maximum apertures in any long tele work may be necessary to maintain the highest possible shutter speeds in order to control such motions. Atmospheric conditions may require that most such work be done in the early hours of the day, when air movement is at a minimum. Techniques of telephoto photography are covered in detail (following page 346).

There are certain disadvantages associated with catadioptric optical systems. These include:

1. Photographs made with them will characteristically display a very shallow depth of field, because of the combination of high image magnification and a fixed, rather wide aperture.

2. Exposure control is a little abnormal, in that the aperture is fixed, and control is exercised by varying the shutter or film speed; or, in a few cases, by using neutral density filters provided for the purpose. Only rarely can exposure control be exercised in increments of less than a full stop.

3. The less expensive versions, and occasionally the others, may give poor image quality because of the inherent necessity for exceptional accuracy in their mechanical assembly. Maladjustments of a degree scarcely noticeable in refracting optics may be critical here, and such maladjustments may be hard to identify by nonspecialists.

4. Best image quality is usually had at camera-to-subject distances on the order of 100 times the focal length. Image quality is likely to decrease rapidly at distances of less than 40 times the focal length. Thus, good quality, "long distance closeups" may be hard to obtain. Telephoto photography at distances of 20–30 feet, or less, is almost always done best with lenses having a more normal optical design.

Nevertheless, photographs of birds and other small, hard-to-approach wildlife can be remarkably good, and well worth the effort needed to obtain them. In addition, refracting lenses equal to the longer catadioptric types may be simply impossible to obtain in any usable form.

Such lenses, in one form or another, are made by Zeiss (Germany), Nikon and Accura (Japan), Celestron (United States), and others. Related designs of truly telescopic proportions—though still remarkably small and light—are made by Questar, Tinsley, and Celestron in the United States, and a good Maksutov-type design, which is optically similar to the Questar, is produced in the Soviet Union.

Supplementary Lenses

There is more than one way to skin a cat, and there are also more ways than one to obtain a larger or smaller image magnification than an unaided camera and lens is designed to produce. If a weak, single-element, positive (convex) magnifying lens is placed in front of a camera lens, it acts to shorten somewhat the focal length of that camera lens. The camera may no longer be able to focus out to infinity, but it will be able to focus closer than normal, and

thereby will produce images that are enlarged more than normal. (If the camera construction allows the infinity focus to be retained, as in a view or press camera, mild wideangle effects can also be had.) These single-element lenses are readily available, and are often sold in sets of three, each with a different strength. A method is therefore available for obtaining larger than normal magnification with cameras that do not have either interchangeable lenses or provision for attaching extension tubes or bellows (about which more later). Such supplementary lenses are frequently called "portrait" lenses, since they allow the photographer to fill the film frame with the head of a person, or other relatively small subject.

An interesting variation of this type of supplementary lens is made by Tiffen, and consists of a line of such lenses of varying strengths, which have been cut in half across a diameter. Placed over the camera lens, these allow one half of the picture to be a closeup and the other half to be simultaneously focused at any other distance.

Another type of lens, which has been used more in the past than at present, is the negative-power (concave) supplementary lens. This is a reducing lens, and if a lens of this sort is placed over the camera lens, the focal length of the latter will be increased, and the image magnification will be increased in that manner rather than by approaching the subject closer as with the positive variety. Use of these is not practical with most common small cameras today, as they require that the lens be extended further out from the film plane than normal. This requires a bellows on the camera. But if you have a bellows they will certainly work.

Simple supplementary lenses, such as are described above, are easy to use, in the less powerful versions, because they do not require any change in basic exposure. For those who wish to do moderate image enlargement without the necessity of exposure compensation they have value. They do have their problems, though, the main one being that they introduce optical aberrations into the system. In order to avoid such difficulties, as far as is possible, you must close down the aperture of the camera lens, and this is not always desirable, for other reasons.

Extreme versions of supplementary lenses can also be had quite readily. Since they use more complex optical designs and have more need for complex mounting mechanisms, they are more expensive. But they also tend to be much more versatile. The best known complex supplementary lens is the tele-converter, or telextender. These increase image magnification by 2–3 times while maintaining the same camera-to-subject distance, a point worth remembering. Tele-converters are not single glass elements, but are constructed of from two to four glass components in order to raise the optical quality. They are designed to be placed between the camera body and the lens of a single lens reflex camera, and are available with mounts for fitting a wide variety of such cameras. Most have provision for retaining the automatic diaphragm operation, and some have built-in compensation for the extra exposure time that is needed, complete with interconnections for built-in light meters. Tele-converters require extra exposure in order to compensate for the extra dispersion of light in the system, the amount of which depends directly upon the power of the converter. Some optical aberrations are introduced, though not as much as by simple supplementary lenses, and the best overall sharpness is obtained by closing the diaphragm quite far. Best center sharpness will be

had if the diaphragm of the camera lens is closed to its optimum sharpness position, which is best determined by careful photographic testing. Curvature of field will cut corner sharpness at the wider apertures, but this is often of little importance in the field photography of wildlife. Tele-converter use will be covered in considerable detail later in the text. (See the text following page 364—and see page 296 for other, nontelephoto, uses.)

Complex wideangle converters are available, too, the best known being the most extreme, the "fisheye" adaptor. These screw directly onto the front of the camera lens, and when used with a normal focal length lens yield a field coverage of 180 degrees, the picture being a view of the entire hemisphere in front of the camera shown in a circular format on the film. By this means, it is possible to make "whole sky" photographs to facilitate atmospheric studies. The horizon will encircle the image, when the lens is pointed to the zenith. Prime lenses offering this 180 degree view are available also, but the supplementary version offers the possibility of attachment to nearly all common makes of camera as well as the ability to attach it to any focal length of lens and thereby achieve a variety of visual effects, depending on which prime lens is used. The optical characteristics of this supplementary wideangle lens are such as to allow unique depth of field. It is possible to have in focus a foreground that actually touches the surface of the lens, and have a background that gives a 180 degree view of that subject's surroundings. No other type of lens, to my knowledge, can accomplish this feat, or anything approaching it.

Although they are not really classifiable as supplementary lenses, it is possible, when unusually great telephoto effects are needed, to connect any telescope or binocular to your camera, either with or without the camera lens in position, and thereby achieve a considerable image enlargement, which you might not otherwise be equipped for. And, of course, it is likewise possible to photograph through any microscope. These are special techniques, although not especially difficult, and are covered in the text following page 372.

The advantages of simple supplementary lenses are quite apparent. Prices are quite low, and there is no need to provide exposure compensation in order to obtain the desired visual effects. In the more complex supplementaries the prices, though higher, are still usually considerably less than for new prime lenses of comparable capabilities. And they have quite a lot of versatility in use, as we will see later. Exposure correction is needed, but in many cases the correction is built into the system. With telescope, binocular, or microscope photography, exposure calculation must be worked out.

The disadvantages of supplementary lenses should not be forgotten. In photography, as in other areas of life, you seldom get something for nothing. In all cases that have come to my attention, the use of supplementary lenses has had some detrimental effect upon image quality, particularly out toward the edges of the field. In order to get some measure of relief from introduced aberrations, it is necessary to close down the camera lens diaphragm somewhat. The more extreme the use, the more the closing down. Even so, relief is only partial. The degree of difficulty will vary with the quality of the optical design. With good tele-converters you need not lose more than approximately 10 percent of the basic lens quality if your technique of handling the camera is good. But a prime lens of equivalent character and quality will exceed a supplementary lens in quality of image formation. They are not, then, appropriate for use

when absolute resolution, flatness of field or freedom from distortion are required.

Nevertheless, there are many times when the use of supplements is very worthwhile. For instance, I have used a mild positive supplementary lens on a view camera lens to provide a usable and needed wideangle effect when I was caught with no other alternative and I *had* to have wider coverage. For sky studies and other similar purposes the fisheye supplementary is not only adequate, but has qualities not present in any prime lens that I am aware of. When greater telephoto effects are needed and you do not have suitable prime optics, a tele-converter will often provide an image which is better than that obtainable by the extreme enlargment of a portion of a negative obtained with a prime lens of inadequate focal length. Furthermore, tele-converters lend themselves to remarkably good photomacrography in a way that will allow far greater camera-to-subject distance than any prime lens system (see page 296). In short, the quality may not always be absolutely tops, but it can be quite good; and a usable picture always beats no picture at all.

Camera Extensions

Most lenses used in small single lens reflexes can only focus down to about 2–3 feet from the camera. The exceptions to this rule are the relatively common "macro" lenses, which are designed with extra-long focusing mechanisms that allow a very close approach to subject matter. These lenses are discussed in greater detail on page 289. However, with lenses of normal configuration, closer focusing, and the larger image magnification that results, is best achieved by moving the lens further from the film than the lens mount was originally de-

signed for. Therefore, some sort of extension accessory must be used. The devices most commonly used are *extension tubes* or *supplementary bellows*. Such extensions are designed to fit between the camera body and the lens. Note that, owing to optical peculiarities of true zoom lenses, camera extensions cannot be used with them.

Extension tubes normally come as a series of three or four metal tubes with connecting ends. Each tube is of a different length, in order to provide the largest possible number of lengths either alone or in combination. Used in these various combinations they will permit continuous focusing, with no gaps, from the normal closest focusing position of the lens down to a very few inches. The closest position, which is obtained by using the full set of tubes in combination with a lens of normal focal length, usually gives an image magnification of about ×1 (the same size as the subject). If higher magnifications are needed, two (or more) such tube sets can be stacked. Tubes have two inherent advantages over bellows:

1. They are relatively, often very, cheap.

2. If they are well made, they form a very rigid connection between the camera body and the lens.

Many current models offer the additional advantage of preserving the automatic diaphragm operation of single lens reflex cameras at all positions. Since every type of extension works by moving the lens further from the film, there is a concomitant loss of light intensity, and it becomes necessary to provide exposure compensation. Some extension tubes preserve the coupling of internal exposure meters, and thus make this compensation automatic for existing-light situations. The only real disadvantage

of tubes as extenders is that changes in the length of extension are relatively slow. Although bayonet twist-lock connectors are faster to operate than are threaded connectors, they are sometimes less rigid. Some manufacturers, notably Nikon, combine the two. Figure 10 illustrates some of these designs.

Supplementary bellows normally consist of a small pleated bellows, made either of leather or a synthetic material, which is supported on a

Lens fitting

Camera body fitting

(A) Extension Tubes (Different lengths allow flexibility of magnification; the tubular construction is rigid, simple, and light.)

Lens fitting

Bellows

Camera body fitting

Rail lock screw

Rear standard

Front standard

Adjustment knobs

Traversing rack

Tripod/centering block (not always present)

Monorail support (usually folds)

(B) Supplementary Bellows (Less rigid, but more easily adjustable.)

FIGURE 10
Extension tubes and supplementary bellows.

collapsible (for storage) single or double rail bed. Rack-and-pinion focusing of the front standard is always provided. There is provision for manual movement of the rear standard, and for turning the camera body to either horizontal or vertical positions. Some models have a sliding support block with a tripod-screw hole for centering the weight of the camera/bellows combination over a tripod. A few models have some view camera movements built in. There is said to be one that preserves coupling of the automatic diaphragm, but I have not seen it. Bellows units usually allow a normal focal length lens to achieve a magnification of about ×2. Lenses with shorter or longer focal lengths will achieve greater or lesser magnifications, respectively. Engraved on the supporting rails of nearly all bellows devices are magnification and exposure compensation data for the more commonly used focal lengths of lenses.

The chief advantage of a bellows extension unit over a set of tubes lies in the speed with which magnifications can be changed. The longer basic length also allows higher magnification without additions. The comparative disadvantages are several:

1. Purchase cost is higher than for tubes.

2. Rigidity is usually less.

3. Cost, size and weight will nearly always increase with the increasing rigidity, versatility, greater bellows length, and reliability of the better grade units.

4. Many bellows units do not allow the lens to travel continuously between its normal closest focus point and the highest magnification. There is often an area of low magnification that is uncovered because the bellows simply cannot shorten enough. Some manufacturers market "short-mount" lenses of slightly longer than normal focal length, but these give less magnification at the high end of the scale.

5. In field closeup work, a bellows unit will be nose heavy because of its greater length and weight.

6. In field use, the usual inability to retain the automatic diaphragm operation is very trying.

7. Although bellows offer the advantage of speed in making magnification changes, they are cumbersome and slow to use in other respects.

For all of the above reasons, I tend not to recommend the use of bellows for field photography.

Filters

At this point I will consider filters only from the equipment point of view. (The techniques of filter use are discussed after page 144.) Filters are highly useful devices for the selective absorption and transmission of light, and for the alteration, in several ways, of the action of light on film. Good photography in any field requires knowledge of their capabilities and characteristics, and failure to use them when appropriate is one of the leading differences between first rate and second rate work.

Filters come in three physical forms, each having its own advantages and reasons for use:

1. as thin transparent sheets of gelatin or plastic,

2. as such sheets cemented between, and protected by, two sheets of flat glass,

3. as pieces of flat glass that have had chemicals added to produce the desired optical characteristics in the glass itself.

In laboratory use, filters can also be composed of liquids, or even of gases, but these are not practical in field work.

Gels have the advantages of low cost, very wide variety, and the finest optical quality. (They are the thinnest of filters, and the thinner a filter is, the less optical difficulty it will bring into the system.) They can be tailored to needed sizes and shapes with scissors, and can be placed inside cameras, between lens elements (recommended only in very special circumstances), or in any other places requiring small bulk. However, they are water soluble, easily abraded and scratched, and fingerprints or other applied dirt cannot be removed. I keep them intact longer by framing them very simply in cardboard.

Sandwiched filters are more durable and more easily cleaned than gels, but dropping them can easily cause them either to shatter or become uncemented. Polarizing material is available as plastic sheets; but, for most photographic purposes, it is used in the form of a glass sandwich. If the glass is of good quality, a sandwiched filter of any sort is quite expensive. If it is not, its optical quality should be suspect.

Solid glass filters are the least easily damaged type, but are quite costly. There are some types of filters that can only be had in this form, owing to physical and optical necessity. Among these are didymium, ultraviolet-transmitting, and heat-absorbing filters.

In summary, wherever the highest optical quality is a prime need, and their physical characterstics allow it, gels are to be preferred. In addition, their low cost allows ready replacement, the possibility of maintaining an extremely varied collection of types, and even the stocking of spares as a routine practice. Polarizing filters are best as glass sandwiches. In a few cases glass or glass-sandwich filters may be used in part to protect the camera lens from damage, as from sea spray, windborne sand, or other corrosive or abrasive materials, but this should not be a regular practice. Camera lenses are optically designed to work best when they are naked, and adding anything to the optical system without an adequate reason is a poor policy. Filters should be used only to contribute to the photographic results, unless rigorous environmental necessities develop.

Light Meters

Under ordinary outdoor conditions it is quite possible to get good photographic exposures by following the simple directions printed on the data sheet packed in almost every package of film. Even simpler, in bright sun conditions, is to remember the rule that at f/16 the correct shutter speed equals the ASA speed of the film. This is accurate enough to be used as a meter check. But if really consistent results are to be had under all lighting conditions, it is necessary to have and make informed use of a good light meter. A number of types of meters using a variety of principles have been developed over the years, but only the most common photoelectric types, using selenium, cadmium sulphide, or silicon cells, are considered here.

A photoelectric light meter is essentially a highly sensitive galvanometer accompanied by a circular computation scale for the interpretation of the needle reading. In selenium cell meters, the old standard of the trade, the light generates a small amount of electric current in the selenium cell, and this is what moves the galvanometer needle. In the more recently developed cadmium sulphide (CdS) meters, there is a difference. The electric current that is required to swing the meter needle is supplied by a small storage cell, and its action on the needle is *modified* by the CdS cell. In either case, the

needle movement is proportional, to a known degree, to the amount of light falling on the CdS cell. The most recent market entry is the silicon cell light meter, usually seen in advanced models of single lens reflex cameras as a through-the-lens meter. It has similarities to both of the foregoing meter types. It operates like a selenium cell meter in that it generates electric current in proportion to the amount of light received. But, like the CdS meter, it requires a power cell. However, it is unique because the power cell is there to operate a tiny electrical amplifier. Its main advantages over the earlier meter designs are that it is supersensitive like the CdS meters, but has a quicker reaction time. In addition, a silicon cell is more sensitive to ultraviolet and infrared radiation than are CdS cells, and is thus potentially more practical for making readings in those regions, when suitably filtered (see pages 105, 191 and 211 for further details). Selenium cell meters more accurately duplicate the spectral sensitivities of the human eye and of panchromatic films. CdS and silicon meters can be made so that they are more sensitive at low light levels. However, if the light read is of one color it may be necessary to make corrections in the interpretation of the resultant reading. Choices between meter types must be based upon needs and intended uses. The Spectra-Combi 500 meter incorporates both selenium and CdS cells in one unit.

Light meter dials tend to look complicated, but they are actually quite simple to use. There are two variables in the initial input, the amount of light falling on the cell and the speed (or basic sensitivity to light) of the film being used. In practice, the sequence of operation is:

1. The meter is set for the correct film speed by moving one of its dials.

2. The meter cell is pointed toward the light that is of interest (usually light reflected from the subject), and a meter reading is obtained.

3. This meter reading is transferred to the place provided for it on the calculator by moving a second dial.

4. A variety of correct shutter speed/diaphragm opening combinations will then be displayed on the calculator.

Any of the combinations displayed will yield an approximately correct exposure, subject to interpretations introduced by the photographer. The combination that is used will depend upon the relative importance of the action stopping ability of the shutter vs the depth of field control that will be exercised with the diaphragm.

The exact arrangement of dials and scales varies from make to make, but the principle remains the same. There are on the market quite a few simplified designs of meters with which you need only set the speed of the film and then match a manual needle with the galvanometer needle. This is really only a change in the mechanical method of transferring the needle reading from one scale to another. Further details of exposure computation are discussed in the text following page 101.

Recently it has become increasingly common to build light meters directly into cameras, so that no separate meter need be carried. In some cases there is no actual operative connection between the meter and camera, but in most the meter is mechanically interconnected with the shutter and diaphragm controls. In this latter case, the photographer sets the film speed indicator when the camera is loaded, and readings are usually made by lining up a needle (in or near the viewfinder) with a reference mark to get a correct exposure. This alignment can usually be accomplished by moving either the shutter speed dial or the diaphragm control. Most designs provide for a manual over-ride so

FIGURE 11
A typical light meter.

that either light or dark areas in the scene can be emphasized at will.

There are some designs in which simply pointing the camera and activating a switch will change the camera settings by means of tiny electric motors. With these it is often impossible to change matters manually except by changing the film speed dial, and even then one may not be able to chose which control is changed. Certain camera designs use only specially cassetted films which have a notch on the cassette whose placement varies with film speed. When the camera is loaded, this notch engages a lever in the camera and thereby automatically controls the film speed setting of a coupled, built-in light meter in such a manner that no manual override is possible. These cameras are rightly designed for people who want pictures, but who do not want to do photography: which is legal and even proper. But no person intending to do serious photography should use a camera that does not allow manual over-riding of any automatic feature with complete flexibility of choice. To do so is to abdicate control of your most useful camera manipulations.

The most interesting new development in small camera design is "through-the-lens" metering in single lens reflex cameras. A built-in light meter is so designed that the light which is being measured has passed through the taking

lens and would actually become part of the image. The reading may be made at or near the mirror position, or by a probe located behind the mirror and just in front of the film plane. Some models integrate a reading of the entire picture area. Some do that but also "weight" the central area, and others use only the light that falls in a central circle. There are about as many variations as there are manufacturers. All of them work, but like all other meters, all of them require some interpretation of the reading by the photographer, in order to get the best results. The type of interpretation that is needed will depend in part on what type of meter is being used. Through-the-lens metering is especially useful with long telephoto lenses, or when photographing close up, at magnifications (photomacrography), or when photographing

through such instruments as telescopes or microscopes. For general photography their utility is about the same as any other built-in meter.

For field photography, some sort of interconnected built-in light meter is very handy. A separate instrument is a nuisance, since it is always subject to impact damage and likely to be mislaid. Built-in meters also allow continual monitoring of exposure information, usually even while watching a subject through the camera viewfinder. Under conditions of changing light this feature is invaluable. Given a choice, I would use through-the-lens metering with a center-weighted overall reading, with a design that allows the meter to be removed in case of a need for repairs. (That way you need not take the whole camera to the repair shop.) Nikon offers this combination of features.

Meter needle (indicating correct exposure).
The right shoulder of the vee indicates $\frac{1}{2}$ stop underexposure, and the left shoulder $\frac{1}{2}$ stop overexposure.

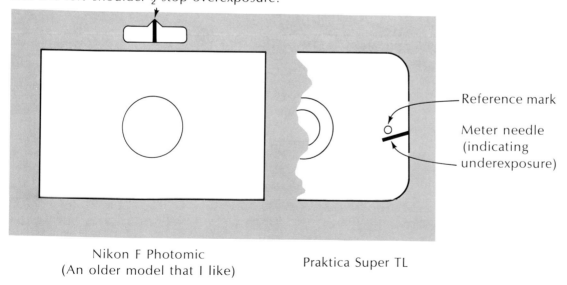

Nikon F Photomic
(An older model that I like)

Praktica Super TL

Reference mark

Meter needle
(indicating
underexposure)

FIGURE 12
Two types of viewfinder that allow constant meter monitoring.

Press and view cameras have also been included in the through-the-lens metering idea, too. At least two manufacturers produce meters that can be placed in the back of such cameras like a sheet film holder. One, the Sinar 6, made in 4×5, 5×7, and 8×10 inch sizes, has a movable probe that can read a small circle, which is placeable almost anywhere in the image area. I consider this to be a most useful feature. The other, made by Hoffman in either $2\frac{1}{4} \times 3\frac{1}{4}$ or 4×5 inch size, takes an overall reading of a $2\frac{1}{4} \times 3\frac{1}{4}$ inch area, with center weighting. These types of meters make photomicrographic light-level readings, once a real chore, a snap. They are also very good for any other work likely to be done with the larger tripod-mounted cameras. See the text following page 108 for further details.

Similar in aim to the first meter just described, are certain handheld light meters (such as the Mechanics Illustrated meter or Gossen Lunapro, with attachment) that use a probe on a cable to make spot readings on a ground glass, or to take readings in otherwise inaccessible places.

There is a method by which any adequately sensitive meter* can be used to make spot readings anywhere on the ground glass of any $2\frac{1}{4} \times 2\frac{1}{4}$ inch or larger camera, without the need for probes or special attachments, as long as there is access to the ground glass. This method is described in the technical section on exposure calculation following page 108.

Lastly, it is also possible to make spot readings of very small portions of a scene that is to be photographed by means of a specially designed separate handheld instrument. These meters are made for use where critically accurate readings are needed when the subject cannot be approached closely. They usually incorporate a small reflex viewing screen that approximates the view seen through a camera viewfinder with a center aiming circle indicating the area actually being read. The light acceptance angle of this type of meter might be as small as a very few degrees, as opposed to an acceptance angle of about 50 degrees for the normal lens of most cameras. These may well be a very useful equipment item for a bird photographer, for instance, or for anyone else photographing small subjects against any significantly contrasting background.

Flash Meters

All of the foregoing has referred to the measuring of light from steady light sources. Sources having a short duration, such as flash lighting, cannot be measured with standard light meters. Although locally the light produced may be as bright as or brighter than the ambient sunlight, the ordinary meter cannot respond quickly enough, or in the right way, to obtain a reading. Therefore, if flash exposures are to be metered, specially designed instruments must be used.

The special requirements of a flash exposure meter include the following:

1. The meter must respond accurately to an instantaneous, very bright flash of light.

2. It must integrate two factors, the strength of the light energy and its duration, so as to record the total light energy to be used on the film (normal meters record only the first item).

3. It must at the same time ignore the ambient light from steady sources (whether dim roomlight or bright sunlight).

*A meter is "adequately sensitive" if you can obtain a noticeable needle movement under your conditions.

4. The reading so obtained must be held locked on the meter dial, so that it can be conveniently read.

5. For additional convenience, the final dial reading should be expressed directly as the f-number needed for a correct exposure, thus eliminating need for further calculation.

Flash meters have been produced with various special purposes in mind. One type, intended for use with flash bulbs, reads through the synchronized shutter, thereby taking into account its light-chopping action. Like other light meters, flash meters can be designed to read incident light, reflected light, or the light at the ground glass. The present tendency is to provide for most or all such possibilities in a single instrument. Choose a make or model according to your needs and intent.

Camera Supports

In photography for scientific purposes, one of the most prized attributes of a picture should be sharpness of image. Only when a picture is as sharp throughout its important areas as circumstances will allow, will the maximum information content be carried. Much more than most people realize, the commonest source of general unsharpness in pictures is camera movement during exposure.

I find that almost any picture that I expose at shutter speeds slower than 1/125th of a second will be more or less noticeably unsharp, if the camera was handheld. Where possible, I prefer to work at 1/250th or 1/500th of a second when handholding, and I'm not really confident of the greatest sharpness unless I'm working at 1/1000th of a second. And it should be obvious that such speeds demand flash lighting if there is to be significant depth of field, and if slow, fine-grained films are to be used. My conclusion has been that if pictures exposed by natural lighting at slower shutter speeds are to be sharp enough to suit me, I must use some sort of camera support. It is possible, of course, to press a camera against a tree or post, or set it on a boulder, but I don't often find such readymade supports in just the right place. So we come to mechanical supports.

The old standard camera support is the tripod. Not just any tripod will do, however. A really useful tripod should have a number of features:

1. It should fold into a decently compact package, yet should extend to a reasonable height (I prefer it to extend to slightly above my standing eye level).

2. The head should tilt forward to a vertical position, and backward to about 30–45 degrees; side-to-side it should go to at least 90 degrees one way, and to a lesser degree the other; and the whole head should have a 360 degrees panning movement.

3. There should be an extension center post to allow vertical adjustment of the camera position—whether manual or geared is not usually important, but this center post should be reversible to allow working very close to the ground, among the tripod legs.

4. The legs should be individually adjustable for length, and it would be nice if they were individually adjustable for angle of spread and firmly lockable at any such angle. The feet should combine rubber pads with retractable spikes, for firm footing on any surface.

5. All movements should operate smoothly, release readily, lock positively without binding, and remain free of corrosion; all extensions should be free of wobble at their fullest extension.

6. The whole affair should be light enough so that it can be carried for several hours without unduly burdening the photographer (or a long-suffering assistant).

If you know of any tripod combining *all* of these features, please let me know. There are a number of makes available on the market that are quite satisfactory, although usually compromises have been made in one direction or another. The choice of a particular make and model must depend upon individual judgment concerning the relative importance of various features for a given use.

There will be times when a given tripod will prove to be inadequate and shaky, and yet be the only available choice. The usual method of steadying a shaky tripod is to overload it. This can be done by suspending a large rock or a plastic bag of sand or water by a string under the head. Usually the weight should be directly under the camera, unless the camera is out on a horizontal extension. A correctly overloaded tripod can be absolutely free of vibration, even under adverse conditions, but overloading must not, of course, extend to the point of collapse.

For occasions when some mechanical support is desirable but weight, or lack of mobility, would make a tripod impractical, you might consider a monopod. This is just what the name implies: a single-legged support of variable length, with a camera mount on one end. After mounting the camera on it and setting the monopod in the right place, stability is achieved by pressing down on the camera. There will be very little vibration and not much wavering—just don't let go, or it will fall over. Monopods are, of course, not suitable for use with view cameras, but can be quite handy for a small rangefinder or reflex camera. They can do dual service as a hiking stick. I have even seen an ad for a British shooting stick that had a tripod screw on it.

Two other devices for mechanically supporting cameras are worth mentioning here. One is a C-clamp with a small tripod head attached to it, which can be fastened to any handy sapling or tree branch. The other is a lever-actuated vacuum clamp that can be stuck to a car window or other smooth surface. The latter device is particularly handy for photographing wildlife that will allow an automobile to approach closely, but would flee if the occupant were to dismount. For good results, of course, the car motor must be turned off, in order to avoid vibration.

A simple sandbag rest is very useful where long telephoto lenses are being used to photograph mobile subjects, such as birds or other shy wildlife. A nonporous bag about three-fourths full of coarse sand can be used, by putting it in a suitable tree crotch or other location of the right height and placement. In fact, putting it on top of the tripod, and resting the camera on it, may be more vibration-free than fastening the camera directly to the tripod. Whichever way the bag is used, it will absorb most of the troublesome vibrations and will carry the weight, but will not restrict any camera movement needed for tracking a moving subject.

There are also various methods for steadying cameras without actually supporting them mechanically. The simplest way of doing this is to have a length of light chain with a loop in one end and a tripod screw on the other. The photographer places one foot in the loop and then pulls up on the camera to stretch the chain taut. This will dampen the shakes and vibrations of camera or photographer, but it won't stop wavering. Some photographers like to use a gunstock mount for cameras when they are tracking running animals or flying birds. Al-

though it is a good method for people used to using shotguns, I personally prefer the plain unmounted camera for that purpose. There is one item on the market that I completely disapprove of, and that is the so-called chestpod. It is a support arrangement that rests its base against the photographer's chest, thus transmitting to the camera all bodily function movements, such as breathing, heartbeat, etc. The most elaborate means of camera stabilization involves the use of an electrically powered gyroscope attached to the bottom of the camera. An example of this is the Kenyon Stabilizer, which can be purchased or rented from motion picture supply houses. This type of device is most useful when photographing from light aircraft or helicopters. The power source can be the aircraft's own electrical supply, or it can be operated from a battery pack.

Any method that will damp vibrations and cut down on random camera motion will assist in making pictures sharper. The important thing is to remember that the problem exists.

Flash Equipment

Sooner or later every serious photographer comes to a need for an artificial lighting source to supplement or supplant the ambient natural lighting. Perhaps the natural lighting will be too high in contrast and thus a supplementary "fill" light will be needed to provide shadow detail in the picture. Or, perhaps something altogether stronger, locally, than the natural lighting will be required. The natural lighting might be coming from the wrong direction for a given purpose, or it might have insufficient intensity for adequate film exposure. For persons working in field circumstances, flash is the most convenient type of artificial lighting, and is the only type

to be discussed in this text. Only the *nature* of flash equipment will be covered here. Techniques of use are described in the text following pages 116, 322, 336, 380, and 415.

Although the possible sources of flash illumination are numerous and include electric sparks, and magnesium powder or ribbon, only the conventional flash bulb and the somewhat newer electronic flash lamp are detailed here. These two types of light source share a number of useful qualities. These include portability, known and very consistent color characteristics and light output, and a known duration for the flash of light. Bulbs for color work have a blue coating that very accurately balances their light output to the spectral sensitivity of daylight color films. Electronic flash units, although consistent, produce a light that is a little too blue for daylight color films, thus requiring a minor yellow filtration for accurate color rendition. Sometimes this is provided as part of the unit, but more often it is not, regardless of manufacturers' claims to the contrary. If the flash tube, or its plastic shield, is not definitely yellow in color, filtration is almost always needed. In my opinion, based upon comparative testing, the 81B filter recommended by film makers is not enough. I recommend use of a CC20Y filter. Different units may possibly require slightly different filtering.

There are some basic differences between bulb and electronic flash that are of concern chiefly in this section, as it is your consideration of these differences that will determine which type is best suited to what use.

The first basic difference lies in the method of light production. Flash bulbs consist of a glass envelope containing an igniter and a filamentary mass of spun metal. Ignition of this metal is by means of an electric current supplied (usually) by one or more small storage cells. The electric

circuit is completed, in most cases, by the closing of a contact during shutter operation. Such bulbs burn only once, and are then discarded. Flash cubes, a fairly recent innovation, are simply flash bulbs that are quad-mounted in disposable, rotatable, built-in reflector units.

The power supplies for most bulb flash units fall into two general classes. The power to fire the bulb is either drawn directly from storage cells, or as a rapid discharge from a capacitor that has received the electric current as a trickle charge from a storage cell. The former is both simple and cheap, but is relatively subject to power failure. The latter, called a battery-capacitor (BC) unit, uses a slightly more complex circuit, but its battery life is longer, the firing of the bulb is surer, and the basic power supply can be smaller. Although the initial cost is slightly higher, I prefer the BC design for its reliability. The electric circuits are diagrammed in Figure 13.

A third class of power supply that has been introduced recently is represented by flash-cube and camera combinations in which a spring-actuated device produces ignition by impact. Stored electricity is not involved. Although these devices are widely used in amateur snap-shooting, they have found little or no use in advanced amateur or professional circles.

Since most flash bulbs are electrically actuated, it is obvious that there are other practical methods of firing them. For instance, flash units that make use of a manually spun generator to charge a capacitor have been marketed. Bulbs can also be operated by line current from a wall plug. But in semiprofessional field photography the two methods initially described are the most likely to be used.

Electronic flash units are quite different in operation. The lamp here is a glass or quartz envelope filled with xenon gas, and can be reusable up to about 10,000 times. The voltage required to produce a flash luminescence of the xenon in these lamps is quite high, and so direct drainage from storage batteries is not feasible. Power from storage batteries, or from a low voltage DC power supply driven by AC line current, is allowed to flow into an electronic circuit which converts it into high voltage (800–1000 volts) current, which is used to charge a capacitor. When the capacitor is fully charged, the stored electric current is dumped through the lamp circuit by a shutter-contact operation and the action of a triggering circuit. The sudden

(A) Direct Battery Operation

(B) Battery/Capacitor (B-C) Operation

FIGURE 13
Bulb flash unit operation.

(A) AC Operation

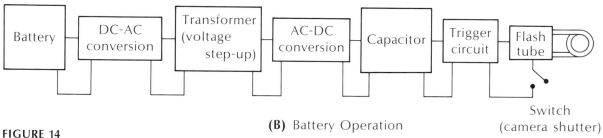

(B) Battery Operation

FIGURE 14
Electronic Flash Operation.

flow of energy excites a brief but brilliant luminescence of the xenon gas, and this light is used to make the picture.

The next flash must await the complete recharging of the capacitor. Fully charged capacitors are required to produce the full rated light output of an electronic flash, and this recycling requires time—usually not less than two seconds, and often around 8–10 seconds. The recycling time lengthens as the storage batteries are depleted, and toward the end of a battery's useful life, a charge as long as 30 seconds may be required.

Some electronic flash units use nickel cadmium (NiCad) rechargeable batteries. Once these batteries are depleted they must be connected to a power supply and recharged. With many units the time required for recharging them can be as little as 15 minutes for a partial charge, or up to 14 hours for a full charge. Small units frequently use nonrechargeable power cells that can be replaced at will. These are the most practical types to use for field work, where there is no line current and no recharge plug. Where line current can be used batteries are not needed, and so there is no occasion for recharging or changing them. In these, electricity is drawn from the AC line source and converted to high voltage DC either in an external power supply or within the unit's circuitry. Many flash units have provision for both AC and battery operation. The use of line current, where it is available, saves the batteries for field work. The AC recycling time is constant.

The amount of light output, the duration of the flash, and the recycling time are all determined by the nature and design of the capacitor and its attendant circuitry. (There may be more than one capacitor in a flash unit, but for simplicity I am treating it as one.) The modes of electronic flash operation are diagrammed in Figure 14.

Another basic difference between bulb and electronic flash is that of flash duration. With conventional flash bulbs the flash duration is relatively long, exposure time being controlled by the light-chopping activity of the camera shutter. (See Figure 15.) With electronic flash the duration of the flash is very short, in most portable units being somewhere between 1/500th and 1/3000th of a second (Figure 15). Thus, in most uses the exposure time is effectively that of the flash duration, with the shutter action serving to trigger the flash and to exclude the majority of other ambient light. The exact flash duration of any given unit is part of the information supplied to the purchaser by manufacturers in their enclosed specification sheets.

The choice of whether to use bulb flash or electronic flash will vary with the prevailing conditions and the preference of the photographer. Ideally, both types should be available, with usage determined by the circumstances. High speed action can be stopped equally well by either type of flash unit, up to the limits of shutter speeds versus duration of flash. The most common controlling factor in the choice of which unit to purchase is its relative cost in large scale use. Here the electronic flash will win. But when weight is a factor and a moderate number of flashes will be used, and where both a large light output and a moderately fast rate of flashing are needed, bulb flash can be used to advantage. For instance, a lightweight folding-fan-type flash unit with a supply of 144 M3 type bulbs would weigh less than two pounds. A good two-cell BC unit with the same bulbs would go to about 2.5 pounds. With electronic

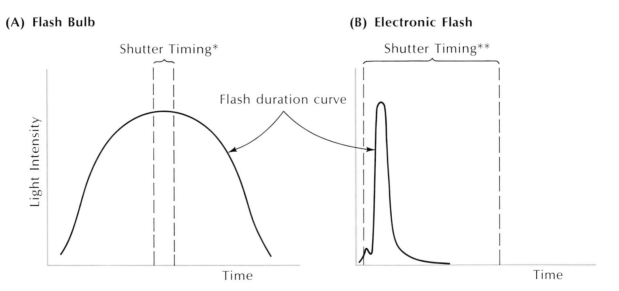

(A) Flash Bulb

Shutter Timing*

Flash duration curve

Light Intensity

Time

*Exposure level is controlled
by the time the shutter is open.

(B) Electronic Flash

Shutter Timing**

Time

**Exposure level is controlled by
flash duration, with shutter used
to trigger the flash and to limit
the interference of ambient light.

FIGURE 15
Flash duration vs shutter speed.

flash units, light output is proportional to weight. An electronic flash unit with a light output equalling the foregoing bulb units, and which is capable of an equal number of flashes on one charge, would (at this writing) weigh close to ten pounds. And, at that, the interval between flashes in the latter half of the charge capacity would be substantially longer than the time required for bulb changes.

Fully rechargeable electronic flash units of more moderate power weigh from one to two pounds, and at this writing provide perhaps 40 to 80 flashes per full charge, enough for two to three rolls of 35 mm film. It is then necessary to have a power source in order to recharge the batteries. It is actually less the time of recharging than the necessity for a line current power source for doing so that limits the field use of these units.

Very light, low power electronic flash units that require complete replacement of batteries for reuse have been available for some years. But, until recently, these have been rather unsatisfactory, due to the small number of flashes per set of batteries. (These units usually take two or four "AA" cells per set.) Recent developments in solid state electronic circuitry, coupled with new manufacturing and marketing techniques, have made it possible to obtain units that have adequate power for most field uses, which weigh half a pound or less complete, and offer 150 flashes, or more, per set of power cells. Using alkaline power cells, it is frequently possible to get as many as 400 flashes per set, *if* the unit is turned off between flashes and if the batteries are removed for storage after each photo session. The reliability of these very inexpensive flash units is now very good, with the prime source of failure now being the synchronization cord. Spares should be carried.

The most recent item on the market is the 6 or 9 volt Mallory Flat-Pak battery, a rectangular package weighing about 1.2 oz., which measures about $\frac{1}{4} \times 1\frac{3}{8} \times 1\frac{7}{8}$ inches in size. The first electronic flash unit that I have seen advertised as using this power supply is the Vivitar Model 50, a very low-priced unit a little over one-third the bulk of comparable units using "AA" cells. This unit synchronizes by means of a "hot-shoe" direct camera contact, rather than with a synch cord. It is thereby a little less versatile than I'd like, but it is possible to obtain hot-shoe cord adaptors. It is only the first of what will unquestionably be a sizable group of new flash unit designs worth looking for.

Although they do not have the light output potential of bulb units or of the large professional electronic flash units, these small flash devices should not be lightly dismissed. They are especially well suited for field work with plants and insects, but can be highly useful wherever really large amounts of light are not mandatory. I have even used them with complete satisfaction as the sole light source for full scale professional portraiture and other studio lighting purposes. Satisfactory small electronic flash units can be bought for $15–20, or less. Since the weak link in their reliability, as stated above, is the synchronization cord, never buy a unit with a fixed, nonreplaceable cord.

Turning to disadvantages, and primarily those attached to bulb flash use; if you use lightweight, folding-fan units, you should remember that the blades of the collapsible reflector are easily bent, and this adversely affects the evenness of light distribution. Another problem is waste disposal. Spent flash bulbs (and other photographic waste such as film boxes, Polaroid tabs, etc.) should *never* just be discarded by the wayside. Such littering is a major cause of the poor standing of casual photographers with the rest of the general public. It is the responsibility

of any field photographer to dispose of all wastes properly. They are no heavier to carry out than to take in. So help the ecology by not littering.

A third problem stems from the fact that most bulbs have a definite peaking of light output, and may not synchronize perfectly with all shutters at all shutter speeds. Their optimum use may require either adjusting the shutter for synchronization at a chosen speed, or a testing program to determine the optimum shutter speed with a given piece of equipment. Even the choice of a different make of synchronization cord can make a difference in the correctness of synchronization. However, severe problems from this cause are relatively infrequent (see Color Plate V, top).

The initial cost of first rate bulb flash units is very much less than that of fully comparable electronic flash devices, and tends to be close to that of the cheaper lines of small electronic flash units. However, once they are in use, the cost of bulbs—even at quantity prices—rapidly catches up. Since each bulb is used only once, the unit cost per flash is much more than for any electronic flash.

Not to be one sided, I should remind you that electronic flash has synchronization problems, too. With leaf-type shutters it is usually possible to synchronize at any shutter speed, but with the focal plane shutters common in small single lens reflex cameras synchronization is possible only at speed settings where the entire shutter opening is in use—that is, at the slowest speeds (see Color Plate V, bottom). There are cases where ambient light is bright enough to give a blurred secondary image overlaid on the sharp, action-stopping electronic flash image, but in field photography these situations occur quite infrequently.

In closing this section, I should mention one rather new type of electronic flash unit of interesting capabilities. This is the self-quenching automatic feedback type. It has a sensing cell that picks up and measures its own reflected flash burst. If overexposure is indicated, it automatically shortens the flash duration. In very generalized simple flash use this frees the photographer from flash calculations. And if you work at very close distances it is thereby possible to achieve astonishing action stopping. At maximum quench the flash duration of these units is about 1/50,000th of a second, enough to freeze a hummingbird's wings in place. However, the sensing device cannot think, and it is possible to make some devastating exposure errors when a small near subject is seen against a distant background (overexposure), or when the sensor picks up light from a near surface and the subject is more distant (underexposure). On all such units that I know of there is a button that turns off the automatic sensing circuit, and the unit can then be used like any other small electronic flash unit. In its manual mode, the flash duration is about 1/1000th of a second. These devices are somewhat more costly than other electronic flash units of similar basic capabilities, but in some uses they can be well worth it. In deliberate maximum-quench use, they are by far the cheapest commercially available really high speed unit. Potentially, the newest versions provide a very large number of flashes per charge. Formerly, the full capacitor load was used for each flash, with the quenched portion of the electricity dissipated. The best new units take electricity from the capacitor only for that portion of the flash which is used. The rest is retained, and the capacitor recycles faster and with less battery drain.

You may well ask what I do myself, in the face of all the foregoing pros and cons. I compromise by using more than one type of equipment,

according to prevailing circumstances. I have several small, lightweight electronic flash units for field use. These have replaceable power cells. I have one electronic flash unit that is somewhat more powerful, and has a rechargeable battery plus an AC capability. I use it indoors, or on short field trips where its charge capacity will not be exceeded. In addition I have a choice of three bulb flash units, all inexpensive. One is a good BC unit, and another is a folding-fan type for greater compactness. These use the same type of bulbs, and I buy them in case lots to save cash. For extra portability, as a back-up device for other equipment and for a few special purposes, I have a really tiny flash cube adaptor. It has quite surprising utility, and when used with hi-power cubes has a very worthwhile amount of light output. In short, no flash unit known to me is perfect for all uses. I use whatever will satisfy my needs in a given set of circumstances.

Miscellaneous Field Use Items

Although not usually thought of as equipment, there are a number of odd items that will prove to be of considerable use in field photography. No exhaustive list is possible, because special methods or personal preferences will affect the choice, but it is worthwhile to put down a few of the more commonly useful things.

Holding devices have a great number of uses. The photographer may need to fasten a background card or a reflector in place, inhibit the wind motion of a plant, or attach two pieces of equipment together in some unusual manner. Various tapes and containers will also find their way into your camera bag for all sorts of reasons. Probably the simplest procedure is to tabulate some of these items opposite descriptions

of the more likely uses (Table 1). Where appropriate, suggested quantities of each item have been included. This table may serve to stimulate you to conceive yet other uses.

Nutrition should not be ignored. A canteen of water is an obvious necessity for any but short walks. I also carry a small supply of salt tablets. Quick-energy food is good for even short pack trips, the type carried being based upon your personal tastes and specific bodily needs, as shown by experience.

Other items commonly needed are a lightweight first-aid packet including a snakebite kit, and perhaps one of the recently introduced plastic emergency blankets, which weigh very little, are very compact, conserve body heat, and some even reflect radar. These blankets consist of a two-layer Mylar sandwich with an aluminized coating between (newer variants have additional layers of these and other materials). Being shiny, they make quite good field-use reflectors for throwing light into dark subject areas, for photography or for other purposes. Or, if strung up taut between two trees, they will serve as a reflecting surface for bounce flash lighting (see page 126).

Some items are obvious to the point of banality, and such a list could go on forever, but my point here is that such miscellania are a real part of any photographer's needs in the field. I suppose that mentioning note-taking materials would be unnecessary to a person with scientific intentions, but that should go along, too. One of my acquaintances even fastens a small, battery powered tape recorder to the back of one shoulder with the microphone and switch at one lapel. He then finds that his notes are fuller and more translatable. Each of us must choose miscellania according to individual needs. And once such a selection is made, a multiple-copy checklist should be made *and*

TABLE 1
Miscellaneous items of field equipment and some of their uses

ITEM	TYPICAL USES
Spring clothespins, wood (4)	Anchoring focusing cloth to view camera; clipping background or reflector cards in place; fastening bracing stick to spindly plant.
Alligator clips, electrical (2 large, 2 small)	Smaller scale versions of the above; for use when metal teeth are needed for a good grip.
Black thread (10 feet)	Tying branches back; holding plant parts against wind movements.
Cotton twine (30 feet)	Larger scale tying jobs.
Cotton clothesline, or nylon cord (50 feet)	Fastening equipment to pack frame; transporting equipment up or down rock faces.
Scotch "Magic" tape	Attaching labels to containers; fastening plastic to plastic (holds very well, will take pen or pencil writing, is *not* waterproof).
Black photographic tape	Patching holes in bellows; making film boxes light tight; holding filters in place; fabricating special-use lenshoods (this is the single most useful item listed—I carry it everywhere—it is flexible, light tight, and water resistant).
Plastic electrical tape	Repairing broken synch cords; sealing plastic bags; fastening equipment items together (virtually waterproof, flexible and even stretchy, excellent insulator for electricity, holds very tightly, somewhat reusable).

used, to avoid leaving behind that one special item you might forget.

Spares

Stepping out the door of the camera shop is inherently risky, as something may even then have been forgotten or mislaid. Still, the step must be taken, so some thought must be given to what is likely to fail in use, get lost readily, or otherwise be likely to need early replacement. There are, of course, the usual requirements of film and flash bulbs. Table 2 includes some of the more obvious other needs.

TABLE 2
Spares

Flash synchro cords, one for each unit taken

Flash bulb adaptors (several), if used

Flash cord tip adaptor, if used (2)

Batteries, a full set for each battery-powered piece of equipment, including light meters, flash units, etc.

Tripod screw assembly (or a $\frac{1}{4}$-20 stove bolt with a wing nut)

The foregoing should probably suffice for ordinary field work, but for long expeditions the list would obviously have to be longer, both in

TABLE 1 (*continued*)

ITEM	TYPICAL USES
Plastic bags	Watertight and dust-tight containers for film and equipment; containers for collected specimens or for food; sandbags for weighting tripods or steadying long lenses; adaptable as watertight protectors for cameras when working in rain or spray.
Film cans, plastic vials	Containers for small collected specimens; containers for small useful accessories; use as match safes. Some 35 mm film cans are gasketed and are fully water- and airtight.
Black velvet (1 square foot)	A guaranteed *black* background for photographic purposes (deep pile rayon is best).
Colored cards or plastic sheet	Several pieces in colors such as light blue, light green, tan, and white—sizes as needed—for backgrounds.
Pack frame, with step at the bottom	To carry it all on. An off-center load, such as a shoulder bag or hand-carried box, tires one very rapidly. More weight can be carried with less strain on the back.
Binoculars	Invaluable for locating and examining possible subjects (even insects), and for surveying the route ahead. I prefer 8 × 30 center-focus glasses, coated optics, adjustable interpupillary distance, one eyepiece separately focusable. Sufficient magnification, coupled with light weight, small size.

In addition to the above, I carry a few thumbtacks, several rubber bands, a Swiss Army type pocket knife with multiple-use attachments including scissors, and a small pair of pliers.

numbers of items and in numbers of each taken along. A genuine expedition to remote areas should duplicate every important piece of equipment (such as two of each type of camera, two light meters per user, two shutters for each view camera, two flash units). To do otherwise can be very false economy indeed. And packing—both for initial shipment to the area of operations, and for daily use—should be arranged so that the loss of any single unit of packaging will not wipe out the total supply of any single item, including spares. Major items can be rented in many cases, so carrying major equipment spares is not always prohibitively expensive.

Darkroom Facilities

In this day of quick and relatively easy communications, there is less need for the field processing of films than there was in the past. For trips to the nearer points of interest there should be no such need at all. If attention has been paid to adequate training for all personnel using photographic equipment, exposures should seldom be in doubt. And if reasonable care is taken of the film when it is in transit there should be little danger of image degradation between exposure and final development.

There is one recent matter that does affect this. The danger of aerial hijacking has made the

X-raying of parcels and luggage quite common. Unexposed, or exposed but undeveloped, film should be separately packed and very clearly marked "FILM—DO NOT X-RAY." Stickers for this purpose are now available.

The danger to undeveloped films from airport X-raying is primarily from the cumulative effect of repeated doses. But even with the low intensity X-ray machines now in use a single pass through might still be detrimental. At earlier dates it was sufficient to tell attendants that you did not want your luggage X-rayed, and to request an actual luggage inspection instead. Recently I have begun to hear reports of individuals being refused passage unless their bags were X-rayed, with requests for a hand search being refused quite summarily. The latest counter to this is the sale in camera shops of lead-lined bags for film. I see this as leading to the prospective passenger being detained for a hand search, on the plausible grounds that a relatively large X-ray-opaque package must be opened. You could conceivably miss a plane this way, if you were running late.

Even though there need not be a darkroom at every investigation site, there should be some access to processing facilities within reasonable reach, so that progress can be kept under control. Expeditions into remote areas would be well advised to set up or contract for a reasonably well equipped photographic laboratory at some accessible location. Good running water and dependable electricity are highly desirable. Exposed black-and-white films, and some types of color film, can then be dropped off periodically for development, either by base camp personnel or by a local photographer who has been given a contract for the service. Color films, suitably marked, can be air shipped to any of a large number of competent processing laboratories scattered well over the world. Addresses of recommended establishments can usually be had from manufacturers and suppliers of film. Such finished pictures as are needed to further the work of the expedition can be forwarded to the field party by normal communications. Elapsed time between exposure of film and return of pictures should be within reasonable limits if expedition planning has been adequate.

However, even with these handling methods, there will surely have to be at least a black-and-white darkroom at the home institution, and possibly one at the base camp or at some other, more forward, location. Its facilities need not be luxurious, but they should be adequate to whatever technical needs are required. Film and equipment manufacturers can supply literature on darkroom design, and (in many cases) will be happy to provide assistance in the detailed planning of any scale of field or home-based darkroom upon request.

The base camp facilities should include provision for developing each type of black-and-white film that is being used, as well as for the contact printing of all negatives as they are produced, and for the production of limited-scale enlargements, as needed. All films that are developed should be processed, handled, and stored with the utmost care, as they are original (and sometimes irreplaceable) documents. However, it will seldom be necessary or desirable to make final reproduction or exhibition grade prints at such a location. To attempt to do so will waste valuable fieldwork time. Printing, then, should be on an information-content basis. The field party should be provided with complete sets of contact prints of all the photography that has been done as soon as it is practical—whatever the location of the darkroom—in order that any repeat photography that will be necessary will be known to be necessary before it is too late.

Returning to the form of the forward facility, there is no absolute requirement for hot and cold running water, or even electricity, but work will be speeded up and considerably eased if they are available. In the past, some really primitive arrangements have been used with success, but there is no virtue in hardship for its own sake. Field time is too valuable and expensive to be wasted through insufficient pre-expedition planning, or because of unnecessary hardships introduced by false economies.

An adequate base camp darkroom should have a good-sized sink, five to eight feet long, about two feet wide, and about six inches deep. It can be made rudely of wood, and waterproofed by lining it with heavy duty plastic sheeting, or by coating it with several applications of epoxy paint. Chemical trays could be made the same way, but inexpensive, light, and serviceable plastic trays are readily available in any size likely to be needed. Adequate ventilation should be provided, since stuffy darkrooms lead to lowered work output and a poorer quality of results.

The field equipment should, of course, include the tanks and trays needed for handling all of the sizes and types of film to be used; storage tanks for the chemicals involved (ready-mixed chemicals are now available in plastic sacks enclosed within cardboard containers—these can be tapped when needed and used without further decanting, thus serving as both storage tanks and ready-use supplies, thereby also eliminating the time, effort, and mess of mixing); adequate and *tested* safelights (a safelight is a light that is filtered so that it is safe to use with light-sensitive materials, and is specific in what it is safe for—testing confirms its safety); timers and temperature-control devices; a graduate for measuring chemicals; a contact print frame large enough to allow simultaneous printing of a 20 exposure roll of 35 mm negatives—an 8 × 10 inch frame is standard; and an enlarger capable of taking all of the negative sizes for which field enlargement would be required. An easel to hold and position the paper under the enlarger, and an enlarger magnifier, sometimes called a grain-focuser, will also be needed. Other items can be added, according to individual preferences and special needs.

For home institution use, more attention should be paid to the quality of the general facilities and the convenience of their use. For easy maintenance and long life, sinks should be made of stainless steel, fiberglass, or other durable material. Trays and other processing equipment should be made of stainless steel. Sinks and trays should be large enough to allow reasonably easy handling of the largest prints likely to be processed. Some form of enlarger equipment should be available for all the sizes of film that are used, including the largest sheet films. Excellent enlargers are on the market that are individually capable of handling all formats between 35 mm and 4 × 5 inches. For larger sheet films, the camera itself, provided with a suitable light-head, may be the easiest and cheapest arrangement. Useful light-heads can be fabricated quite readily in the form of a small bank of fluorescent lamps. Fluorescent lamps are electrically and photographically efficient, and work well in this use.

The darkroom itself should be designed carefully to eliminate unnecessary dust catchers, and to allow easy cleaning. If filtered ventilation is provided in such a manner as to maintain a slightly higher air pressure inside than exists outside, dust will be much less of a problem, as it will tend to be pushed out rather than drawn in. Light colored walls and ceilings, used with suitable safe lighting, will increase visibility and ease operations.

Attention should be paid to getting value for money spent on enlarger equipment. Enlarger lenses, especially, may require unusual care in procurement. In this field there is no inherent guarantee that a high price or a large advertising expenditure will mean good quality. If anything, in late years the quality control of some lens manufacturers who formerly had good reputations seems to have slipped. If possible, the best way of getting good enlarger lenses is to arrange to procure several lenses of a given type for comparative testing prior to purchase. In any case, there must be a clearly understood return privilege for any equipment found unsatisfactory. The latter is standard business practice, the former can be arranged with some firms.

Money spent on good darkroom equipment and facilities is a good investment, as the upkeep cost is relatively low, the need for replacement rather infrequent, and the capacity for production is high. Except for replenishing supplies of chemicals and paper, there should be relatively little continuing expense.

A good basic setup should last for many years, if the initial planning has been farsighted enough to foresee future service requirements with reasonable accuracy, and if the initial purchasing has been wise. Maintenance of a high degree of cleanliness is the best guarantee of long service. Slopped chemicals are responsible for most of the depreciation of poorly kept establishments. They either corrode things directly, or evaporate and become fine, loose, chemically active dust. For this reason it will pay an institution to hire a good professional darkroom technician, to do the most important darkroom work, supervise (with sufficient authority) that work which is done by nonprofessionals, and be responsible for the upkeep of the facilities. A free-for-all, multiple-use darkroom will look like one in a month, and the quality of the output will tend to start low and fall. A supervising professional should assist everyone else in maintaining and improving quality.

II. MATERIALS

All replaceable supplies fall under this heading, but our attention here is concentrated on films and papers for purely photographic use.

FILMS

Cameras and such are all very nice, but they aren't of much use without film in them. As with cameras, there are a variety of types of film, and once again your choice should depend upon your intended use. First, let us consider the basic characteristics of photographic films in general, and then proceed to the particulars.

For our purposes here, films can be defined as light-sensitive materials that have been coated onto a supporting medium, and which are cut and packaged in rolls or sheets in standard sizes for use in cameras. They come in either black-and-white or color-recording types, and their use can be tailored to perform a wide variety of tasks, many of which are often only dimly understood by the amateur.

Black-and-white films are so called because they render the naturally colored image that is projected upon them by the lens as a monochromatic image composed of an infinitely shaded series of greys whose local lightness or darkness corresponds to the brightness of the light reflected from the subject in those areas. Such films consist of a sandwich. First there is

the *film base,* or support medium—usually a flexible plastic, but occasionally glass or a rigid plastic. The *emulsion* is deposited upon this as any of a number of light-sensitive compounds that are suspended within a transparent, water-absorbent gelatin. Included in the sandwich are layers of dyes. Some of these dyes absorb the stray light from scattering within the emulsion and film base (the *anti-halation coating*), and others are light-filtering dyes that determine the basic color sensitivity of the completed film.

Exposure to the light that has been focused on the film by the lens of the camera causes physical changes in the emulsion which establish a *"latent" image,* detectable to the eye only after the film has been chemically developed. In the development process the emulsion absorbs the developing agents, and the portions of the light-sensitive compounds in the emulsion that were affected by exposure to light are chemically reduced to grains of metallic silver. In size and distribution these clump together roughly in proportion to the amount of light that struck a particular part of the film. After development, the resulting visible image is made permanent by chemical *fixing,* which also removes unexposed light-sensitive materials from the emulsion. At one stage or another, all this chemistry also removes the anti-halation layer and the color-sensitizing dyes. The result, after washing and drying, is a reversed-tone, translucent image on the film, now called the *negative.* By the use of special processing techniques, it is possible to develop the image as a direct-positive transparency instead of as a negative, but in general photography this is rather rarely done in black-and-white. In color photography it is common.

So called "color" films are similar to the above, but have three or more layers of emulsion, each sensitized and filtered so as to record only certain wavelengths of light. In the course of processing, the silver grains forming the various layered images are dissolved out and are replaced by appropriately colored dyes. The result can be a color negative, with all colors the chromatic reverse of those that will appear on the color print; or, reversal processing can provide a direct-positive transparency—what we call a color slide.

The chemistry of films and their development is obviously much more complex than this. In addition, there are wholly new types of film processes in various stages of practicality which, for instance, do not form a silver image, and develop by heat rather than through chemical soaking.

The foregoing descriptions are only meant to be a summary, and assume the use of the most common materials now being used. Specific directions for using and handling films and developers are provided following page 215. Readers with a need or desire for more detailed information about photo-chemistry are referred to the Bibliography.

Films are available in a wide variety of types, carrying a number of variable characteristics designed to provide for many kinds of uses. Some of these characteristics are speed, grain, contrast, and color sensitivity.

Speed

One of the three basic variables in photographic exposure (the others being the aperture setting of the lens, and the timing of the shutter) is the speed of a film: its degree of response to a given amount of light. Exposure, as such, is considered in detail following page 85. For our purposes here, it will be enough to state that general-use films vary in speed from slow (ASA 6 to about

50), through medium (ASA 64 through about 200), to fast (anything above ASA 200, up to a top speed, at this writing, of about ASA 3000). The cutoff points in speed levels are arbitrary, but correspond to normal practice.

The ASA prefix refers to the American Standards Association, which set such standards. (Recent changes in organization have resulted in a new name, the American National Standards Institute, and a new abbreviation—ANSI—but for reasons of familiarity and continuity I will follow common usage and stay with the ASA designation in this text.) There are several other systems of film speed classifications in use, primarily in other countries. These are all directly comparable to each other. A conversion chart is given in Appendix 1.

Grain

Grain is a descriptive term for the visible random clumping of the minute silver grains that make up the image in a negative. The individual grains themselves are much too small to see in any normal photographic usage, so the term is a slight misnomer resulting from a sort of verbal shorthand.

Generally speaking, grain is tied to film speed in one of photography's characteristic compromise situations. Briefly put, faster films have coarser grain structure and slower films have finer grain, other conditions being equal. In cases where the natural appearance of the photographed subject is of prime importance, fine grain is to be desired. Where processes and actions are more important than their detailed appearance, grain can be tolerated, to whatever degree necessary, in order to be able to operate where available light is an inhibiting factor. The point to remember is that although grain is an inherent part of photographic image structure,

it is no part of the subject itself. Therefore, visible grain in a final print is to be avoided wherever possible in pictures meant for scientific use. It is important to remember that a film's inherent grain structure cannot be made smaller, but it can be made larger by improper handling of the film in use and in development. Thus, within limits, visible grain size in any given type of film is somewhat controllable through careful exposure and development.

Contrast

This is the term used to describe the range of subject tones that a film is capable of encompassing within its own range of tonal gradation. Films able to show a wide range of detail-filled tones are said to have low contrast (or a "long scale of gradation"). Those which can, in any one exposure, show only a portion of the tones represented in an average scene are called high in contrast (or "short" in scale). As with grain, contrast is also associated with film speed. High speed films tend to be low in contrast. Slow films tend to exhibit higher contrast. In general photography this matter of basic film contrast is often not noticed by the amateur because the recommended developer and developing time for a given film is intended to compensate in part for this effect. Within some limits, the contrast of a given film can be altered by the choice of developer, by the manipulation of exposure-development ratios, by the length of development, or by the temperature of the developer. These matters of control of both grain and contrast through exposure and development are covered in somewhat greater detail where appropriate, but for definitive exploration of the various techniques the Bibliography should be consulted.

Color Sensitivity

The basic color sensitivity of films is a matter of considerable interest and importance in photography generally, and especially so in photography for scientific purposes. Films can be divided conveniently into five light-sensitivity groups:

1. *Blue sensitive* (or noncolor-sensitized): these films have only that spectral sensitivity that is inherent in the basic photo-responsive emulsion, being limited almost entirely to the shorter wavelengths of light. Reds, for instance, would not record on this film, and would thus appear black on the print.

2. *Orthochromatic:* ortho films, as they are known, have had the basic characteristics of the emulsion altered, so that somewhat longer wavelengths can be recorded. They will record greens and yellows well, but are also almost totally blind to reds.

3. *Panchromatic:* the basic emulsion sensitivity of pan films has been extensively altered, and can record the entire visible spectrum, in terms of relative brightness, in a manner fairly similar to the brightness response of the human eye. The use of a medium yellow filter (K-2, or Wratten 8) brings the brightness response even closer to that of the eye (as shown in Plates 1 and 2).

4. *Color:* color films, which provide remarkably good full-color renditions of normal scenes, are themselves subdivided into sensitivity classes, depending upon the prevailing type of light that they are intended to be used with. Transparency films are marketed in the following forms:

 Type A—for use with flood lamps that burn at a color temperature of 3400° Kelvin. (The subject of Kelvin temperatures is mentioned on pages 64 and 159.)

 Type B—for use with 3200° Kelvin lamps.

 Daylight type—for use in normal daylight, which is described as a combination of direct sunlight and reflected skylight and is assumed to be about 5500° Kelvin. Blue flash-bulbs and electronic flash are both used with Daylight film, with the latter requiring some corrective filtration for the most accurate color rendition.

 Each type can be used with the other light sources, if corrective filtration is used, but you cannot mix different color temperatures on the same frame of film without having it show badly.

5. *Infrared* (*IR*): in black-and-white, this is a special purpose film which, when used without filters, closely resembles a standard panchromatic film in capabilities. But if a very deep red filter is used to exclude virtually all visible light, it will do an excellent job of recording infrared effects that are beyond the ability of the eye to perceive.

There is a color infrared film—more properly known as a "false color" film. It operates by dropping out the shorter wavelength (blue-violet) sensitivity band entirely. Each layer of the film is then moved up one in the direction of the longer wavelengths, and the layer that normally records the visual reds is sensitized to record only infrared. The result is sensitivity in two layers to visible light and in one to infrared. This combination produces effects and records information outside the capabilities of black-and-white infrared film. In fact, copying color infrared film into black-and-white does not produce the equivalent of original black-and-white infrared either. Color infrared film is normally used with a Wratten 12 yellow filter.

In general field photography, the more exotic films designed for really special-purpose uses—of which there are a sizable number—will not often be needed. At present, roll film users are limited, in black-and-white, almost entirely to panchromatic or infrared films. Blue-sensitive or orthochromatic films can be had in common roll sizes only with difficulty, usually by special order and in long rolls, and sometimes not at all. In sheet films, however, almost anything can be had quite readily in most metropolitan areas. Once out in the hinterlands, though, sheet film availability rapidly shrinks to only the most commonly used types and sizes. With the use of the correct color filters, any pan film can be converted to almost any color-sensitivity range that is needed—if you have the right filters with you, and you are able to live with the emulsion speed losses that such filter use entails. For instance, a Wratten 44A filter will convert panchromatic film to orthochromatic sensitivity, but its use requires approximately ten times the normal exposure. In many situations that could be a crippling limitation.

No discussion of films is complete these days without mention of the remarkable Polaroid Land films. In black-and-white forms these films range in speed from ASA 50 to 3000. Most types available produce a finished print only, but the P/N type produces both a print and a high quality negative. Another type, available in both medium and high contrasts, makes neither a print nor a negative, but instead produces a positive transparency that can be mounted in a snap-together plastic frame for quick, easy projection in $3\frac{1}{4} \times 4$ inch projectors. A finished slide can be projected about two minutes after exposure. Portions of such a transparency can be scissors-cut to size, and mounted in standard 2×2 inch (50×50 mm) mounts for projection in the 35 mm projectors now almost universally used. Other specialized Polaroid Land emulsions include two forms of color print films. A color transparency film is said to be in the works, but has not yet been marketed at this writing.

Although only the P/N version offers the quality and versatility of use inherent in normal black-and-white sheet films of comparable size, each of the Polaroid Land films has its own special area of preferred use in which it is hard to beat. But for field work P/N film has the disadvantage that, to save the negative, you must use great care in taking it out and placing it in a container of a liquid film cleaner and fixer for storage. (See the directions provided with the film.) In teaching, it is invaluable to have the ability to show a finished print after a total processing time (darkroom-free) of less than a minute. It is particularly useful in demonstrating effects that are transient, depend upon careful or special lighting, or require the use of filters. As a public relations device, when working in the field with or near people who are somewhat less than enthusiastic about one's aims or presence, these films can be enormously helpful.

Polacolor film has been a disappointment in scientific photography, both because of relatively poor resolution capability, and its characteristically pastel color rendition. In its original version it gave very good color fidelity in showing skin tones and other normally pastel subjects, but really bright colors were not rendered accurately; reds tended to be brickish in color, and black became a dark brown. Pictures did

PLATE 1 ▶
Film emulsion sensitivity. Mixed deciduous and conifer trees. (a) Photographed with panchromatic film, no filter. (b) Photographed with orthochromatic film, no filter.

not appear critically sharp regardless of the lens used, or the care taken in focusing. At this writing a new Polacolor film is about to be marketed, said to be much improved.

Another recent introduction is the SX-70 color film. It offers increased sharpness, improved color brightness, and is almost completely free of the usual Polaroid plethora of waste materials to dispose of. It is durable to the point of indestructability, whereas other Polaroid Land films all have delicate surfaces. It also requires the purchase of a special camera, since its development processes are incompatible with those used in all other Polaroid Land films. With both types of Polacolor, there is a field use difficulty, in that the ambient temperature is a controlling factor for obtaining a correct exposure and developing it properly. To a degree this is true of all Polaroid Land films, but it is especially so for this one.

Polaroid Land films must be used either with cameras made by the manufacturer, or with adaptors that are mounted on cameras made by others. Most such adaptors fit only the larger cameras, such as 4 × 5 press or view cameras, but there is a growing tendency to provide Polaroid adaptors for various $2\frac{1}{4}$ inch cameras, such as the Hasselblad and the Mamiya RB-67. The 35 mm manufacturers have mostly not attempted this, but a notable exception is Nikon. Their adaptor, called the Speed-Magny (Figure 16) is an arrangement of ungainly appearance,

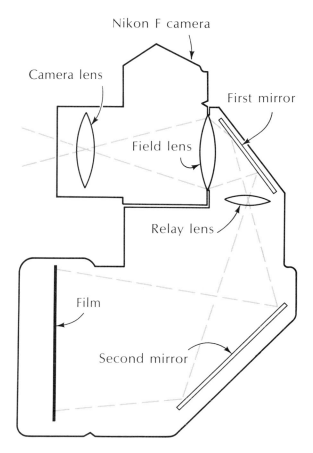

FIGURE 16
Polaroid-Land Speed-Magny adaptor by Nikon.

considerable expense, and unusual optical design; but, it can be very useful. It fits the standard Nikon-F camera, and produces a standard-sized Polaroid print by way of an integrally designed tandem camera-lens arrangement. A lens inside the adaptor photographs the air image at the normal 35 mm film plane, and reproduces it, enlarged, at the Polaroid film plane. It is available in two versions, to take different types of film packaging.

All tandem camera-lens devices lose much of their light through inherent optical inefficiency, and this is no exception. If exposure

◄ **PLATE 2**

Film emulsion sensitivity. Forest floor of a Redwood grove in the California Coast Range, in midwinter. The overall color is green, except for the light tans and greys of a few bare sticks. Mosses, lichens, and flowering plants all contribute various shades of color. The effect shown was obtained with orthochromatic film, without filtering.

times are to be kept reasonably short, it is best to use only the ASA 3000 film with it. In one of the Speed-Magny versions, however, it is possible to use normal sheet and roll-film holders as well, and I have seen very nice $2\frac{1}{4} \times 3\frac{1}{4}$ inch color transparencies made this way.

Other black-and-white films designed for specialized use, but of particular interest to natural scientists, are the 35 mm and 120 size types that are intended for document copying. Such films combine very high contrast with extremely high resolution and a grain structure that is describable only as microscopic. For situations where a relatively slow film speed can be tolerated, it is possible to use them with small cameras to obtain negatives of such high quality that even quite large enlargements will closely resemble contact prints from large negatives.

Special developers are used to lower the film contrast to the range of general use. Obtaining optimum quality results then will depend upon impeccable technique in camera handling, exposure, processing, and printing. Only the very best optics on both camera and enlarger will allow the full achievement of the quality inherent in the film. Examples of such films, from various countries, are Kodak High Contrast Copy, Fuji Microfile, and H & W Control VTE Pan and Ultra Pan films. These films are all panchromatic in basic sensitivity. Several do have somewhat less red sensitivity than general-use panchromatic films. There are a number of developers that will lower the film contrast. However, my tests indicate that the best combination of effective film speed (ASA 10 with all but H & W VTE Pan, which is about ASA 32–40, depending on use), and lowered contrast, coupled with good retention of shadow detail and the maintenance of good quality throughout,

will be had with H & W Control 4.5 developer. This product is made by the H & W Company of St. Johnsbury, Vt., is nationally advertised, and quite widely sold. Detailed instructions for this kind of work appear in the text, following page 271.

No common films are made that are specifically sensitive only to ultraviolet radiation, but all normal black-and-white and color films can record the longer wavelength ultraviolet (called the nearer UV), if visible light is filtered out, and suitable light sources are used. The glass of the lens is likely to be the limiting factor, as glass absorbs all but the longest ultraviolet wavelengths. Special lenses for recording the ultraviolet are made, but they are expensive. Color films, of course, will record ultraviolet as a shade of blue. There will be no other color in the picture, except in the case of excited fluorescences (visible light emitted by materials illuminated by ultraviolet radiation).

Color films can do a remarkably good job of simulating the colors of the subject being photographed. Absolute color fidelity is not possible with present technology, but for their most common uses the available films do very well, if the type of light corresponds to the type of film being used. Balancing the film to the lighting depends upon a basic understanding of the implications of the concept of "color temperature."

The color temperature concept assumes, first of all, that the light source is incandescent, with light production achieved by heating a substance until it glows. Incandescent sources include the sun and filament-type light bulbs. The Kelvin temperature of the light, as it is called, is derivable from the Celsius temperature (formerly called centigrade and still abbreviated as

°C) of the source simply by adding 273 to the Celsius temperature. If a theoretically perfect emitter of radiation, called a "black body," is heated to incandescence, the color of the light given off is directly related to the Celsius temperature at any point, and is identified by referring to its numerical Kelvin temperature. In photographic usage this temperature is written as so many "degrees Kelvin" or "°K." (For more complete information on color temperature theory, see the text following page 159, or consult the Bibliography.)

It is not possible to make a color film that will yield correctly appearing colors with any and all light source temperatures, so color films are made to match one of several standard light sources. As noted, the common color film types are Daylight (optimized for a source temperature of [balanced for] about 5500°K), Type A (balanced for 3400°K), and Type B (balanced for 3200°K). Correct looking results may be obtained when using one of these types with incandescent sources of other Kelvin temperatures by using correction filters, as specified by the manufacturers of films and filters. It should be noted that this does not take into account the intense monochromatic colors (spectral emission lines) emitted by some glowing substances (such as gases), nor does it allow for fluorescent lamps, which, because of the nature of their light emitting phosphors, have no true correspondence with color temperature. For these sources, corrective filtration can give satisfactory results in some cases, but rarely will it be as good as if a suitable incandescent source were originally used. It is quite possible to balance them out quite accurately for a particular setup, and then to have the color of a newly introduced pigment be rendered entirely incorrectly. For best results

with fluorescent lighting, the manufacturers' recommendations should serve as the starting point for fine-calibration experimentation. A particularly useful source of information about corrective filtration, as well as for other filtering problems, is Kodak publication B-3, *Kodak Filters For Scientific and Technical Uses,* available in most large camera stores.

PAPERS

Most photographs for scientific use are produced and displayed as prints on photographic printing paper. As with film, these are available in both black-and-white and color. Obviously, color prints cannot be made from black-and-white negatives in any normal sense (setting aside the possible but complex methods of color printing via several black-and-white negatives, each recording a separate color [separation negatives]). However, color negatives can be printed as black-and-white quite readily. If color negatives are printed on normal photo papers, there will be considerable changes in the color brightness to grey-tone rendition, due to the inability of such papers (similar to that of blue-sensitive films) to record all colors of visible light. Still, the results may be satisfactory for some uses. If all of the color tones are to be recorded in greys that are comparable in tone to those which result from printing a panchromatic negative, a panchromatic printing paper must be used. Fortunately, these are available. A special safelight must be used in the darkroom, as those which are usually used with normal printing papers will "fog" (that is, par-

tially expose) panchromatic papers, just as they would a panchromatic film.

Black-and-White Printing Papers

These come in two basic types, a very slow (or relatively insensitive) type referred to as "contact" paper, and a much faster paper that is used for projection printing with enlargers. In contact printing, the negative is placed in direct contact with the printing paper, usually in a glass-fronted frame called, appropriately enough, a printing frame. It resembles a display picture frame, but is ruggedly made and has a spring loaded back, which allows quick access. The paper is exposed by shining white light through the negative. The varying densities of the negative provide, after development, varying grey tones on the print paper, and a positive print is the result. The light used can be the overhead lighting in the room, the light thrown by an enlarger, or even daylight. For photographers who do a lot of contact printing, there is available a contact-printing box that speeds up the whole process. It has a glass top, a spring-mounted lid, and an on-off switch for an array of light bulbs contained in the bottom of the box. When small cameras are being used, their small negative sizes call for printing with an enlarger, in order to obtain prints of any usable size. Projection printing allows the photographer to make prints of any size, and, if it is desirable, to do so using only a portion of the image on the negative. The negative is placed in the enlarger, a light in the enlarger head is turned on, and the enlarger lens projects the image onto the paper, which is held below it in an easel. Since the light on the easel is not very intense, because it is spread out over a relatively large area, a faster printing paper is required.

A basic characteristic of photographic papers is contrast. Because contrast among negatives varies, it is necessary to have papers that also vary in contrast, in order to produce prints with a uniform appearance. There are two common ways of achieving contrast variation in printing paper. In one method, papers are produced in "grades" of contrast, numbered from 0 (zero) to 6. Low numbers indicate low contrast, and vice versa. Number 0 paper is very low in contrast, and is intended for the printing of very high contrast negatives. "Normal" negatives are printed on number 2 paper, and very low contrast negatives go on number 6, which is itself very high in contrast. The second method of achieving contrast changes in a printing paper is to have a "variable contrast" paper. These papers have double emulsions, one of high and one of low contrast. The photographic image is projected through filters of various colors, and the two emulsions are sensitized in such a way that a change in the color of light causes a contrast change in the print. An almost infinite range of contrast variation can result, including the possibility of having different contrasts on different parts of the same print. With variable contrast papers it is the filters that are numbered. Different manufacturers use different numbering systems for the filters, but the system is similar—low numbers give low contrast, and high numbers high contrast. Although the variable contrast papers have a somewhat narrower contrast range than graded papers, it is enough for most uses. Variable contrast papers are especially useful in low-use darkrooms where it would be uneconomical to stock separate packages of all the different grades. When I stock a darkroom in this way, I also usually have a small package each of a couple of the highest contrasts of graded papers on hand, in order to handle the relatively infrequent need for drastic treatment. Unfortunately, the need does arise.

Color Printing Papers

Conditions in color printing are quite different, so these papers neither have nor need much contrast variation, but have almost infinite color variation when they are used with the appropriate color correction (CC or CP) filters. There are a variety of types and makes of color printing papers. So far, none is as simple to use as black-and-white paper, but the difference is more a matter of tedium than of real difficulty. If the directions for color filtering, and for processing the paper, are read carefully, and are as carefully followed, anyone familiar with ordinary photographic practices can produce satisfactory color prints, in any but the most primitive darkrooms. However, I consider all currently available color printing methods too time-consuming and too needful of frequent practice to be really practical in small volume operations, where time economy is important. Many people find it a stimulating and rewarding avocation, but economic practicality is quite another matter. If volume warrants, it can be worthwhile to invest in the equipment and training that is necessary in order to obtain consistently high quality in quantity production. For small users, with an infrequent need for color prints, it is usually more economical in both time and money to send the work out to a professional laboratory that specializes in color.

The sole exception to the foregoing is Polacolor, in which processing is a fully automatic single step, carried out in the camera itself. The largest available size is slightly under 4 × 5 inches, and the subsequent production of any additional prints is essentially a sophisticated full-scale copying process. However, within its limitations it has its uses. For instance, it is possible to invert a Polaroid Land film holder under an enlarger, and project color transparencies directly onto it, thereby achieving single-step reversal printing in a form useable for handouts, without involving yourself in any complex procedures. In this usage it is necessary to convert the tungsten-light color temperature to daylight levels. An approximate conversion, from 3200°K to 5500°K, can be done with an 80A conversion filter. If the lamp burns at a lower temperature—and it could be as low as 2800°K with some enlarger bulbs—fine tuning can be done with CC filters (see the text following page 161). Or, the less well known #820 or #840 blue filters (available by special order) can be used.

PART II

Basic Photography

No matter how specialized the area of photography that a scientist enters, the first prerequisite is a reasonable understanding of the basics. The subject matter must be comprehended within the context of the medium of photography, with selections made for inclusion and rejection. Everything to be included must be composed as a picture, according to the needs of the project as a whole. No usable photograph will ensue unless due attention is paid to the interrelations among the mechanics of camera work (choice of film type and speed, and of lens aperture and shutter timing). Indeed, the photographic record will not even be permanent unless the film processing is done correctly, all the way through to the finished print or transparancy.

Comprehension of the Picture

Attaining a full conception of the picture is a procedure that involves a number of steps. Too often these steps are either taken unconsciously or are incompletely worked out. I will present them in what I consider to be a logical sequence.

ETHICS AND ACCURACY

Before presenting a picture as evidence in a scientific report, or for use in any other purportedly nature-related situation, let us first examine its admissibility. In my experience, the vast majority of people who live and work with nature are very honest and upright citizens who would not knowingly misrepresent a situation; and yet there is reason to call attention to certain practices. There are at least four situations

that are likely to produce what is frequently called "nature faking," and these are described in turn. And then there is legitimate reconstruction.

Ignorance

Any person who acts in an unfamiliar subject area is in danger of committing sins of ignorance. The state of ignorance is not itself reprehensible, but remaining ignorant while purporting to illustrate facts is at best unwise and quite possibly iniquitous.

Sins of ignorance include such things as inadvertently photographing an insect on a plant that it normally avoids, and then calling it typical. I have also seen, for example, a meat-eating wasp photographed with a drop of honey placed on its mouthparts for pictorial effect. There are books and there are libraries. Many colleges and universities offer to the general public, as well as to the specialist, all sorts of applicable courses. At the very least you can be aware of the possibility of error, and frankly call it to the attention of the viewers of your pictures.

Frustration

We have all had the experience of wanting to photograph something that was beyond our technical abilities of the moment. The simplest cure is to go to some source of information and learn the needed technique, but the impatient among us may take more immediate steps. A surprising percentage of photographs of butterflies, for instance, are of dead insects placed on a flower for pictorial effect. Sometimes the specimen used is from a collection and is taken out for the purpose; otherwise, it may be one found at the scene, either already dead or killed by the photographer for operating convenience. Other methods of avoiding technical difficulty include anaesthetizing the creature or—with cold blooded specimens—cooling it. These two latter methods may turn out to be necessary in some situations, but I think only rarely so.

You can work best by acquainting yourself as thoroughly as possible beforehand with knowledge of the creature, its habits and habitats, and its food. Then, educate yourself in the photographic techniques needed. With insects or small amphibians and reptiles, the closeup-flash techniques described in the text following page 310 are invaluable. For special applications see pages 201, 322, 324, and 336. We tend to think too often that a wildlife photograph is a one-of-a-kind opportunity, and that if we miss it the chance is gone forever. This is seldom actually the case. Get to know the subject and you can arrange to be presented with innumerable opportunities.

Ambition

The old sin of misguided and impatient ambition has lead many a person down the garden path. I have seen invalidating evidence in a photograph removed by the simple expedient of cutting it off with scissors. I have also seen an experimenter resort to the debatable practice of using the same microscope section to illustrate both the control and the experimental situation, by just moving over a little between exposures. When called to account the usual excuse is that the picture as shown is accurate; either the removed material was an unimportant artifact (ah, but was it?), or a true experimental-control situation would look exactly like the result shown.

In the words of the noted psychiatrist, Lucy

(see the cartoon strip "Peanuts," by Schulz), "Don't kid yourself." My own belief is that honesty in reporting is an absolute. It doesn't take that much longer to do things with full honesty. And then you sleep better, with no morning problems at the shaving or makeup mirror.

Design

I have the least respect of all for the photographer who got the picture through outright planned misrepresentation. We've all seen the upland gunnery picture of the pheasant being shot in flight. I understand that such picture taking sometimes involves throwing into the air an already dead bird, and exposing when all the compositional elements are considered "right." Unfortunately, there are many similar examples.

The first question to be asked in these situations is whether you might not be able to get an editorially acceptable picture by other means. The next might be whether the particular picture is needed in the first place. I know all of the arguments regarding the economic necessities of professional photography, but I'm not impressed. If you can't compete without fakery you are either in the wrong branch of photography, or are wrongly in photography, and should really try something else. The incompetent workman blames his tools; the misrepresentational photographer blames the editor or the art director—and then poses as a very clever fellow.

Reconstruction

In the house of photography there are many mansions. There are times, especially in full scale experimental biology, when the best way of photographing a subject is through the use of a reconstructed environment. This may have to be the case when exceptionally scarce or shy subjects are to be photographed, or where the particular "environment" is by necessity a part of an extended research investigation.

There are certain well-known photographers of nature subjects who specialize in this approach, and it is well that they do. Only a research-oriented specialist can do this sort of thing accurately. The thing to remember here is that the burden of accuracy—in all respects—lies squarely on the shoulders of the practitioner. If any portion of the result is later found to be a misrepresentation, there is only one place to look for the culprit. Therefore, review extensively the real need for the approach, and then proceed with great care.

SCIENTIFIC SIGNIFICANCE IN PHOTOGRAPHS

Every scientific photograph has a purpose, and the existence of a purpose implies a significance. Few photographers do much analytical thinking about the *nature* of this significance. Many times the significance is so obvious as to scarcely require mentioning, yet there will be times when its consideration will affect how the photography is to be done or even how an experiment should be organized. More thought in this direction might also tend to improve scientific photography by shaping and sharpening the photographer's ideas at the time of the picture's conception. Table 3 is an outline of one form of categorization of significance in scientific photographs. It is not exhaustive, nor is it necessarily the best method of classification, but it is suggestive of the possibilities. Note that the third and fourth level listings are examples, and could easily be expanded (see also Plates 3–6).

TABLE 3
Scientific significance in photographs

I. Appearance of subject matter
 A. Simple
 1. Typical stance
 2. Color pattern
 3. Structural features
 4. Morphological adaptation
 B. Comparative
 1. Normal *vs* abnormal
 2. Young *vs* old
 3. Varieties of color patterns
 4. Size differences
 5. Speciation

II. Processes
 A. Development
 1. Life history
 2. Process of change
 a. Seasonal
 b. Metamorphic
 3. Progress of disease
 4. Erosion
 5. Regeneration
 B. Activities
 1. Locomotion
 2. Protective reaction
 3. Food gathering
 4. Sex habits
 C. Procedures
 1. Technical method
 2. Surgical operation
 3. Social organization

III. Time linkage
 A. Time passage
 1. Amount of movement in lapse between exposures
 2. Smeared movement shows path of action

B. Time chopping
 1. Allows motion analysis in detail
 2. Records appearance of transient events

IV. Relationships
 A. Internal
 1. Chemical/physical
 2. Intracellular
 3. Organic
 B. External
 1. Intraspecific
 a. Social status
 b. Sexual
 c. Family
 2. Interspecific
 a. Mutual benefit
 i. Symbiosis
 ii. Flower/pollinator
 iii. Predator frees host of parasite
 iv. Animal eats fruit, distributes seeds
 b. Single benefit—nondestructive
 i. Carrion feeding (nonpredatory)
 ii. Saprophytes living on organic refuse
 iii. Wind distribution of spores, seeds, etc.
 c. Single benefit—destructive to one party
 i. Predator/victim
 ii. Parasite/host
 iii. Thermal, chemical, or other environmental pollution
 iv. Chemical or other inhibition of growth of competing organisms

PLATE 3 ▶

Scientific significance in pictures. There are a great number of ways in which scientific significance shows in pictures. These pictures are representative: (a) Puss moth larva photographed to show its form and characteristic color pattern, which closely resembles a rolled leaf, as found in natural circumstances. (The image magnification on the film was ×1, and it was enlarged in printing to ×6.25.) (b) Water striders copulating, photographed to illustrate the activity itself. The photography was done with a 105 mm lens from a distance of 40 inches (about one meter), on color slide film later copied to black-and-white. (The print magnification is about ×5.)

a

b

PREVISUALIZATION OF SIGNIFICANT FEATURES

The concept of "previsualization" comes from the field of aesthetic photography, and was evolved by such well-known photographers as Ansel Adams and Edward Weston. In that context it involves esoteric matters of tonal qualities, as well as of composition. In this context I relate it principally to the latter.

Previsualization is simple enough to understand, and paying close attention to it is very worthwhile. It is simply the thorough thinking out of the pictorial presentation in advance of photography. Though occasionally dictated by circumstances, photographs made by chance procedures are unlikely to be the most succinct, or conceptually economical, of records. You have to think out in advance just how you are going to put things together. The importance of previsualization becomes obvious when you consider that making a really first rate visual presentation of a scientific idea may require choosing, at the outset, a particular experimental set up or procedure from the available possibilities. Thus, the earlier that the final method of presentation enters into the thinking behind the scientific process, the more likely it becomes that, at the end, the subject will be represented well and fully. Obviously, the concern with visual presentation must not dominate other aspects of the research. However, what is not quite so obvious is that how well you present your evidence (whether photographically or textually presented for that matter) can have a decided effect upon its acceptance by your peers, and upon its ultimate acceptance by the world of science. In short, think ahead. After all, the necessary change might not be any more than choosing to use a different type of culture dish.

COMPOSITION

In the art world this is a subject that is often fraught with controversy, and subject to constant reevaluation. Fortunately, in science things are a little simpler. The aim should be to have your say concisely and without ambiguity. And that is not automatic.

The Place of Aesthetics

Nowhere is it written that a photograph made for scientific purposes must be dull to look at. In fact, all other things being equal, the more attractive a picture is to the viewer, the more likely it is that it will be successful in carrying its maker's message. Therefore, it is worthwhile to be acquainted with both current and historical aesthetic photography, in order to accustom the eye and mind to thinking in these terms. To contrive an elegant work of art is not the aim; to present the viewer with a vista sufficiently attractive to avoid instant coma *is* (see the book jacket illustration).

PLATE 4 ▶

Scientific significance in pictures. It is necessary to pay close attention to backgrounds, as these natural-light pictures of lodgepole chipmunks show: (a) The animal was baited in to a predetermined location with commercial bird seed. A good angle of lighting by the sun shows the head striping and the feeding posture, while the deeply shaded background prevents visual confusion. (b) This chipmunk, probably the same individual, was photographed at a slightly greater distance a few minutes earlier, eating seeds from a pine cone. The very confused background prevents a good differentiation of much of the animal and its food. Also, the lighting angle is not very good. Nevertheless, the overall color pattern is quite well shown. In a color photo some of the pattern confusion would be less troublesome. Both (a) and (b) were photographed with a 105 mm lens, supplemented by a 3× tele-converter.

a

b

Economy of Expression

In laboratory photography it is a common compositional ploy to place the subject squarely in the center of the picture and then remove all traces of background detail. This is the ultimate in economy of expression, reduces ambiguity, and can be very effective. Unfortunately, it can also be very boring unless the photography is unusually well done, the printing quality is adequate, and the subject is inherently interesting.

Field photography rarely can be done with such spareness, even in cases where it might be especially desirable. Practical considerations intervene. However, almost any photograph made for educational purposes will be at its best when the picture area includes all elements needed to make a given point, and little or nothing else. Extraneous matter is mostly just visual clutter that is at best unnecessary, and at its worst is an intrusion that tends to introduce ambiguity. It is appropriate to be ambiguous when data are open to more than one interpretation, and where this is indicated (as it should be) in the accompanying text. Accidental ambiguity is a sign of sloppy thinking, and is basically inadmissable in evidence supporting a scientific argument.

When studying field photographs for compositional effect, and to see if I have allowed extraneous material to intrude on my intended message, I use a "subtractive" method of viewing. After placing the picture where I can easily see it as a whole, I hold up a thumb and use it to block out first one and then another of the picture elements. If the picture is visually "stronger" with an element so "removed," it probably should not have been included. If the picture is rendered visually weaker, it needs to be left in. Some elements may be neutral. Information about composition, so gained, may be useful only the next time around, but late information is better than no information.

Establishment of Internal Relations

In a photograph made for scientific purposes there will be two types of relations internal to the picture:

1. the factual relations between the various subject components (such as the ecological relation of subject to its background, and the relation of the parts to the whole, or to other parts), and

2. the pictorial or compositional relations between and among the lines, edges, and masses that make up the picture, visually.

The recording of the former should be among the main reasons for making the picture in the first place. The arrangement of the latter is not necessarily inherent in the situation, and usually must be planned. This planning need not be time consuming or even especially conscious, if thinking on the subject has been done earlier. The primary aid here is realization of the need. If the mind has been trained to perceive what the eye sees, that should be enough.

PLATE 5 ▶

Scientific significance in pictures. This series, showing the emergence of an adult damsel fly from its nymphal form, was done in the laboratory by closeup flash. A card background was used, in order to prevent visual confusion, but it was, of necessity, placed so close to the subject that some shadowing is present. It was originally photographed on color slide film, and was later copied to black-and-white.

With subject matter that must be taken as it is found, as is often the case in scientific field work, the primary method of making these arrangements is by varying the camera position, either as to its angular approach to the subject or with regard to distance. In the latter case, it may be desirable to vary the focal length of the lens used, in order to keep the main subject's image size reasonably constant while varying subject-to-camera distance for the purpose of changing foreground-to-background image size relationships. This method of image control was discussed in more detail earlier, on pages 28–29.

Among the things that should be watched for as possibly being detrimental to the internal relationships in a picture are:

1. ambiguous edges, where one portion of the subject blends with something before or behind it because they are rendered as similar shades of grey,

2. unfortunate chance reflections on background material that may attract the eye unduly,

3. crossovers of subject matter that obscure needed information, and

4. unbalanced areas of very light *vs* very dark masses, which divide the composition visually in ways that are irrelevant to the pictorial intent.

Framing

Closely related to the establishment of relations among internal picture elements is the establishment of similar relations between those internal elements and the basic delimiting factor of the frame edge. Let it be understood that there is no picture—no composition at all—until frame limits have been established.

This is a two-step process for most photographers who make black-and-white pictures in print form. First, the scene is composed within the boundaries of the camera viewfinder. Then any corrections that are necessary are made at the enlarger easel while printing, so that only a portion of the film image is printed, with various parts being "cropped" or cut off. It is beneficial, from the standpoint of negative and print quality, to frame the image as closely as possible in the camera. The excessive enlargement required to use only a small section of the negative will normally produce a welter of film grain patterns on the print, thus obscuring fine detail by breaking up the optical image. However, since relatively few compositions will be optimum within the exact confines of standard film sizes and proportions, some cropping in printing is normal. The idea is to hold it to a practical minimum. Ideally, only a portion along one side should need to come off the picture area to make the composition suitably more nearly square or more linear, as the case may be (see Plates 7 and 8).

PLATE 6 ▶
Scientific significance in pictures. (a) Western skink with a twice-regenerated tail. In this picture by natural lighting, the background shows the natural habitat without confusion with the subject. The subject is shown at about its actual size. This is another copy from a color slide. (b) Insect larva, several times actual size. Obscuring shadows have resulted from an overly close background card. (c) The same subject, with the background card moved back so that the shadows fall to one side and out of the picture area.

a

b

c

It is useful to study not only your own pictures but also those of others, to train the eye in creative deletion. In an extension of the application of the subtractive viewing method described earlier, I use two pieces of L-shaped cardboard laid over the photo print so as to serve as adjustable frame edges. By using them to frame or "crop" a photograph to a smaller size and/or to different proportions, I can check to see whether the composition as a whole would be visually stronger in that new format. After such determination, I can either cut the existing print or make a new print to conform to the newly established optimum size and proportions. Cropping can be done also on the enlarger easel during printing, but this method requires more experience in dealing with photo images, inasmuch as the image tones are reversed at this stage. Color slides can be cropped by placing opaque pressure sensitive tape on the base side of the film over the offending portions. This works well, and is unobtrusive in projection if not carried to excess. I do it quite frequently. An especially good choice of tape for this purpose is Leitz Special Silver Slide Binding Tape, which has very straight edges, does not become gummy with heat, and reflects excess heat away from the slide film. Similar Mylar tapes also on the market usually are less satisfactory; some gum up, and some have wavy edges that are not suitable for masking purposes.

Among the things that should be considered detrimental when framing a picture are the inclusion of unnecessary blank space, the accidental cutting off of portions of the subject, and putting horizontal framing around an inherently vertical subject. Most 35 mm cameras have horizontal framing when the camera is held in the usual position. You'd be surprised to know how many photographers fail to consider turning the camera 90 degrees.

◄ **PLATE 7**

Composition. This otherwise satisfactory view-camera study of a snow plant in the California Sierras was spoiled in a classic way by the presence of an unnoticed out-of-focus stick, which appears to "grow" out of the top of the plant, similar to the telephone poles that traditionally grow out of people's heads in snapshots. I failed to examine the ground glass image carefully with the lens at the taking aperture, and the stick was not visible when the aperture was wide open for viewing. My only excuse is that a storm was coming up, and rain was starting. The subject is shown actual size.

PLATE 8 (overleaf) ►

Composition. A carefully composed view camera study of Snow Creek in Yosemite National Park, in midsummer. View camera movements, both swings and tilts, were used to maximize the apparent depth of field. Exposure was adjusted to give good differentiation in the highlights and middle tones, with no attempt made to register detail in the deep shadows. A very dramatic effect resulted.

CHAPTER 4

Exposure

In photography, the word "exposure" refers both to the act and to the result of exposing the film to light that has passed through the lens to the film, on which it forms a latent image that can be made visible and permanent through chemical development and fixation. This section summarizes the basic processes for doing so. A basic description of films and their sensitivity to light has been given earlier, following page 56.

THE NATURE OF PHOTOGRAPHIC EXPOSURE

This is a subject of some complexity, which is most easily understood by fragmenting it into

reasonably small parts to be taken like pills—one at a time.

The Effect of Light on Film

Simply put, when a standard, silver-process film (either black-and-white or color) is exposed to light in the form of an image projected upon it by a camera lens, there is a physical change imposed upon the light-sensitive components of the emulsion. This change, undetectable by the eye until chemical processing renders it visible, is proportional to the amount of light that has struck the film at each point, and is described as the formation of a "latent" (potential but undeveloped) image. Because the effect of exposure is thus proportional to the amount of light striking each part of the film, the density after development is greatest where the light was strongest, and so the developed image is reversed in tone and is called a "negative." The effects of development will be described separately, later, but exposure and development—taken together—disclose a clear relationship of exposure to negative density that can be graphed to produce a characteristic curve. This curve is called the H & D Curve (after F. Hurter and H.C. Driffield, for work published in England in 1890). In this curve (also called the $D \log E$ curve), shown in typical form in Figure 17, negative density (D) is shown to increase roughly in proportion to the logarithm of the exposure time increase ($\log E$). For a given film, the slope of the curve, which indicates basic film contrast, can be changed by changing the conditions of development. This is a commonly used method of photographic control.

Film Speed Variability

The basic sensitivity of a given film to light, called film speed, has been described on page

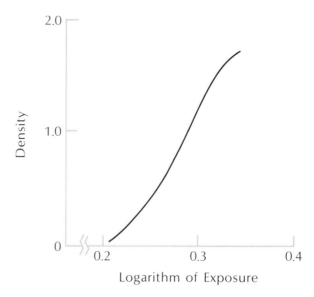

FIGURE 17
Typical H & D curve.

57. Each film type has a threshold level of sensitivity. Exposure to light below this level gives only a little or no latent image formation. In normal practice the speed of an emulsion cannot be raised by changing development methods. However, it can be lowered quite easily, especially by any of several types of mishandling such as excessive aging, exposure to excessive heat (as in the glove compartment of a car in desert heat), or by development in chemicals not designed to yield the optimum speed characteristics. This last may be done purposely, upon occasion, in order to obtain other changes in the film characteristics, which occur concurrently.

So-called "pushing" of film speeds to higher levels by increasing the development time, or through the use of special chemistry, rarely raises the threshold exposure sensitivity level. (If the necessary physical change has not taken place in the film emulsion, it cannot be made visible by processing.) Rather, it may increase

image contrast or density, introduce into shadow areas of the film image a spurious density called "developer fog" through the development of unexposed silver grains, or otherwise act to produce effects that render a basically underexposed film more acceptable in appearance, or more easily printable. If relatively minor development changes could really lower the threshold of film sensitivity (raise its speed) without producing undesirable changes in any of the other characteristics of an emulsion, it would be greatly to the commercial advantage of the film manufacturers to provide for them— and they surely would.

The real result of most attempts at "pushing" film speed is loss of shadow detail, through underexposure. And underexposure reduces image contrast. Overdevelopment to compensate for underexposure increases film grain size, and higher contrast printing methods to compensate for reduced film contrast makes this greater grain size all the more visible on the print. You may want to do it, for all sorts of reasons, but you should be aware of the actualities.

Laws Affecting Exposure

Although in the larger sense photography is a complex procedure involving many physical effects, there are two principles that have major effects with regard to exposure calculation. These are the *principle of reciprocity* and the *inverse square law*. Because they affect exposure calculation in very different ways, they are discussed separately in the next two sections.

Reciprocity Photographic exposure practices all depend upon a very important principle, the law of reciprocity. Lens diaphragm and shutter settings, and the useful interpretation of light meter readings, depend upon it. A simple definition of reciprocity is as follows: a long exposure with a small diaphragm opening is equivalent to a short exposure with a large opening, with a given film, provided that the two exposures are balanced so that each passes to the film the same total amount of light. This relation is diagrammed in Figure 18. This works well in all normal photography, but with unusually long or short exposure times there is a problem called "reciprocity failure." With either very long exposures (more than about 10 seconds for black-and-white films, or more than about 1/5th of a second for color transparency films), or very short exposures (anything much less than 1/1000th of a second for either type of film), the effect is of insufficient exposure. In both cases you must expose the film for somewhat longer than has been calculated as being correct. With black-and-white films the cure is relatively simple—either increase the exposure time or open the diaphragm by a corresponding amount. But with color films, things are complicated by the fact that the three or more light sensitive layers in the film emulsion all have different reciprocity failure characteristics, especially with long exposures. This means that there will be color shifts, if exposure time is to be unusually long.

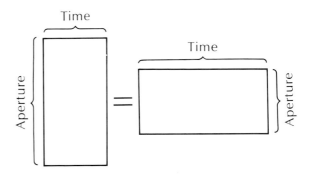

FIGURE 18
The reciprocity law.

Corrective color filters will then be needed, which, in turn, will require an increase in exposure in order to correct for the absorption of light by the filter. Color shifts with very short exposures are so slight as to be negligible in practice, so in this case only the actual exposure compensation needs to be carried out. Manufacturers can provide useful reciprocity information; but, for the maintenance of really accurate color balance, additional testing will be required. Whenever it is possible, when using color films it is a good idea to avoid the problem by not using very long exposure times, unless the nature of the basic photographic situation absolutely requires it. One way of doing this is by substituting flash lighting for inadequate natural or tungsten lighting.

Inverse Square Law This law is an expression of the natural attenuation of the intensity of light over the distance between a small source (or a lens) and the surface that the light falls upon. Briefly put, the intensity of the light from a source diminishes in proportion to the inverse square of the distance. That is, if you double the distance between the light source (or lens) and the receiving surface, you will wind up with one-quarter of the original light intensity per unit of area. Triple the distance and you will have one-ninth the intensity, and so on. This can be easily visualized if the light emitted from the lens or point source is thought of as an expanding ray bundle. As projection distance increases, it must cover more area with the same amount of energy, as illustrated in Figure 19. The inverse square law becomes particularly important when calculating exposures in two situations:

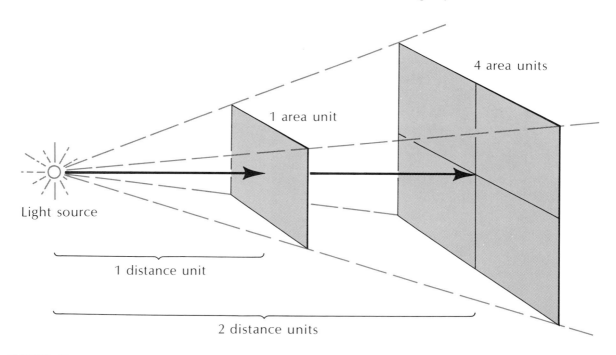

FIGURE 19
The inverse square law.

1. in flash photography, where exposure is usually not measured directly by metering, but is calculated by formula according to guide number, distance and aperture, and

2. in closeup photography and photomacrography, where the distance *between the lens and the film* is extended beyond normal limits, and it becomes necessary to compensate for the resultant light loss.

Methods of exposure calculation involving the inverse square law are described in detail where appropriate in the text to follow. In order to be reasonably versatile in photography, you must have a clear understanding of this law.

Shutter and Diaphragm Functions

Between them, the camera shutter and the lens diaphragm perform a number of functions. The most important ones are:

1. control of the time element in photography,

2. control of depth of field in the image, and

3. control of film exposure level.

Although this section is primarily concerned with exposure matters, the speed of the shutter and the amount of subject material to be kept in acceptably sharp focus are both critical to the nature of the finished picture. Since they are inseparable from the exposure control effects, they also must be presented here.

Shutter Speed Shutter speed is the factor that determines whether the motion of the subject of a photograph will be rendered as sharply as if it were motionless, or whether, by spreading the exposure over a finite time period, the mov-

ing portions of the image will be "smeared" across the film. In most photographs made for scientific purposes, it is desirable to do a reasonably good job of "stopping" motion, because the primary interest lies in the appearance of the subject matter. At times, however, information can be recorded through noting either the path of motion or the amount of distance a point on an object travels during a known time period (see Plate 9).

Short time exposures will record the path of motion nicely, and will do so especially clearly if the background is noticeably darker than the moving subject. Speed of motion can be recorded either by smearing it with such a time exposure and measuring the length of the smear, or by successively making two or more very short exposures—preferably, but not necessarily, on the same film frame—and measuring the result. This latter can be done by using a series of timed-interval flashes during a longer time exposure, of course, but simple multiple exposure is perfectly satisfactory when the subject movement is relatively slow.

Since the actual shutter speeds of most cameras are rarely absolutely accurate as marked, it is necessary to make frequent checks of the actual shutter speeds when the shutter is being used as a time recorder. You don't have to have an accurate shutter as marked, but you do have to know the degree and direction of the inaccuracy. Camera repairmen and some camera sales outlets possess very accurate machines for making shutter speed determinations.

Table 4 shows the approximate shutter speeds for doing a reasonable job of "stopping" various degrees of motion as indicated, in general photography. When in doubt, use a higher speed.

Diaphragm Opening Within the lens mount, usually placed between two glass elements, is

TABLE 4
Action stopping by shutter speed[a]

SPEED OF MOTION IN MILES/HOUR (KM/HR)	CAMERA-TO-SUBJECT DISTANCE IN FEET (METERS)	SHUTTER SPEED (IN SECONDS) REQUIRED TO "STOP" MOTION[b]		
		TOWARD OR AWAY FROM THE CAMERA	45 DEGREES DIAGONALLY PAST CAMERA	90 DEGREES ACROSS CAMERA AXIS
3 (5)	6 (1.8)	1/125	1/250	1/500
3 (5)	12 (3.6)	1/60	1/125	1/250
3 (5)	25 (7.5)	1/30	1/60	1/125
10 (16)	12 (3.6)	1/250	1/500	1/1000
10 (16)	25 (7.5)	1/125	1/250	1/500
10 (16)	50 (15)	1/60	1/125	1/250
50 (80)	25 (7.5)	1/500	1/1000	1/2000
50 (80)	50 (15)	1/250	1/500	1/1000
50 (80)	100 (30)	1/125	1/250	1/500

[a] These recommendations are for small cameras having a lens focal length of two inches (50 mm). Longer focal length lenses exaggerate motion effects. For use as a rule of thumb, assume that doubling the focal length is similar in effect to halving the distance to the subject.

[b] These speeds are approximations. The actuality depends on how thoroughly the motion must be "stopped." The figures given would show no more than barely detectable image point elongation in a ten times printing enlargement, assuming that there was no camera motion.

an iris diaphragm consisting of several metal leaves that move so as to vary the size of the lens aperture. Aside from exposure control, its primary function is to control the image depth of field.

The effects of aperture size are related to the focal length of the lens, as has been described earlier on page 28. Lens diaphragm opening sizes are also described as "relative aperture" or "f-number," the terms being interchangeable in use. Relative aperture is determined by dividing the diameter of the internal lens and diaphragm opening into the focal length of the lens. Lenses are classified for "speed" according to the size of their maximum opening. Thus, a two-inch (about 50 mm) focal-length lens having a widest aperture of one inch (about 25 mm) is said to be an f/2 lens. If the lens iris is closed down to one-quarter of an inch (about 6 mm) the relative aperture will then be f/8; and so on. A lens is said to be "fast" if its largest aperture is relatively big—f/2.8 or larger. A "slow" lens, such as might be used on a view camera, might have a maximum aperture of f/6.3 or f/8. Note

PLATE 9 ▶

Shutter functions. Middle Fork of the Tuolumne River, California, in spring flood (copies made from color slides): (a) A high shutter speed (1/500th of a second) stops water motion in some areas, resulting in a glass-like solid look. (b) A slower speed (1/5th of a second) averages the flow pattern. In recent years this effect has been a popular aim in pictorial work. Note that each method gives a dramatic result. The high speed technique is currently out of fashion in pictorial photography, but is useful, and often attractive.

that as the actual size of the aperture gets larger, the f-number gets smaller, and vice versa.

Depth of field, the degree to which portions of the subject near and far from the camera look sharply focused, is determined by two factors:

1. image magnification (in normal photography with any given lens, this is determined by the camera-to-subject distance), and

2. lens f-number.

At any given image magnification, the larger the lens aperture, the less will be the depth of field. It is a common error to say that wideangle lenses, having relatively short focal lengths, have greater depths of field than normal or longer focal length lenses. This would be true only if the camera-to-subject distance were kept the same. In this case, the image magnification would be less, so that for a given aperture the depth of field would indeed be less. But if, after changing to a shorter focal length of lens, the camera were moved in to retain the original image size—as is very often the case—the depth of field at any given aperture would remain the same.

At any point of focus there is only a single plane, passing through the subject at a right angle to the lens axis, that is truly "in focus," regardless of aperture setting. This is known as the *"principal plane of focus."* However, narrowing the lens aperture also narrows the angle of acceptance for the bundle of light rays that will make up the image at any one image point. Each point on the image is actually a tiny blurred circle, called the *"circle of confusion."* This is most easily demonstrated when the image is that of a point light source, such as a star, against a dark background. No lens could actually bring it into focus as an infinitely small single point of light. If the circle of confusion is very small (about 1/500th of an inch for a

35 mm camera lens), the image will be called "sharp." With a very narrow acceptance angle for each ray bundle, there will be a measurable distance along its axis where the circle of confusion will remain that diameter, or smaller, so that the projected image will still appear "sharp." Figure 20 illustrates this point.

This exercise of control over depth of field is very important to the final appearance of the photograph, so f-settings are not just arbitrary. Every choice of shutter and diaphragm setting combinations will thus represent a compromise between action stopping needs and depth of field needs.

There are two basic ways of determining whether the depth of field in an image is sufficient for one's purpose.

1. You can close down the diaphragm while observing the effect upon relevant parts of the ground-glass image. If the image is to be enlarged in printing, be sure to take this into account.

2. You can refer to standard depth of field tables. With any given set of circumstances (such as the size of a subject, the degree of subsequent enlargement, and the desired size of the circle of confusion on the final print), these tables can help you to obtain the desired appearance in the print. Most small cameras have depth of field scales engraved either on the lens mount or on the camera body. See your camera instruction booklet for details of its use.

In most cases, the first method is sufficient, but if your work frequently involves the use of depth of field tables you may want to own a copy of *Official Depth of Field Tables for 35 mm Cameras* (prepared by the Amphoto Editorial Board, Amphoto, New York).

Whatever method you decide to use, there is

P = Principal plane of focus
A, A', B, B' = Circles of confusion of equal size

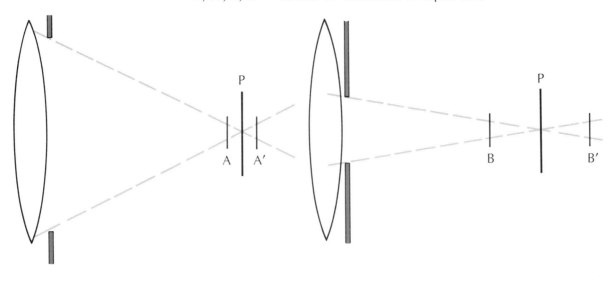

(A) Large Aperture **(B)** Small Aperture

FIGURE 20
Depth of field.

a rule of thumb for optimizing the use of depth of field. Briefly put, at normal photographic distances you should focus (using a large aperture) about one-third of the way into the total area that you need to have sharp, closing the diaphragm down to the proper f-number after focusing. For very closeup work, focusing should be done at about the center of the zone of sharpness. For work much exceeding the actual subject image size on the negative, theoretically you should focus a little past half way into the area that is needed sharp. However, depth of field is so limited at high magnifications that I find it best just to use a trial-and-error version of the first method described above, being very careful to observe all important image points on the ground glass with a magnifier, with the diaphragm closed to the intended use position. With the larger ground-glass-backed cameras, any good magnifying lens of sufficient strength will suffice. With 35 mm single lens reflex cameras, there are special auxiliary eye-piece magnifiers available to fit most makes. (Such auxiliary magnifiers can only view the center of the image area. Therefore they are made to flip out of the way, so as to let you compose the whole image before and after focusing.)

Exposure Control Effects The shutter and diaphragm are used in combination to control the amount of light allowed to affect the film. The usual aim is to make a correct exposure, according to the speed rating of the film and to the photographer's interpretation of the light meter reading, or other method of exposure determination. Deliberate under- or overexposure may be used for various purposes, but is not commonly done. Actual methods of exposure calculation are covered later, since this section is concerned only with setting the camera adjustments. (See the text following page 99.)

Cameras and lenses are marked with standard diaphragm and speed settings that are pretty much the same worldwide at present. In the past, other systems of settings have been used—most of which differ mainly in their starting points, being based upon the same method of calibration. Some very old systems used a different method of calculating f-numbers, but this would probably concern only an antiquarian. Table 5 lists two sets of setting combinations, one current and the other obsolescent but still frequently used.

After calculating the basic exposure, setting the adjustments involves choosing from a number of optional available settings, according to action stopping and depth of field needs. Re-

TABLE 5

Common shutter and diaphragm setting combinations[a,b]

CURRENT		OBSOLESCENT[c] (BUT STILL SEEN)	
SHUTTER[d] SPEED (IN SECONDS)	DIAPHRAGM	SHUTTER[d] SPEED (IN SECONDS)	DIAPHRAGM
1	f/1	1	f/3.5
1/2	1.4	1/2	4.5
1/4	2	1/5	6.3
1/8	2.8	1/10	9
1/15	4	1/25	12
1/30	5.6	1/50	18
1/60	8	1/100	24
1/125	11	1/200	36
1/250	16	1/400	
1/500	22	1/800	
1/1000	32		
1/2000	45		
	64		
	90		

[a] Pairings of shutter and diaphragm markings are not invariably as shown, but these pairings are common. A light meter calibrated in one system above can be used with a camera of the other one by using the nearest setting. For instance, f/11 is a close-enough equivalent to f/12, and 1/100th of a second is close enough to 1/125th.

[b] In this table, figures at the top of each list let in the most light, those at the bottom let in the least.

[c] These settings are fewer in number because cameras using them usually had basically slower lenses and more limited adjustments.

[d] For convenience of memory, note that each shutter speed is approximately double its predecessor; but each *second* f-number doubles, in both systems.

member that, according to the principle of reciprocity, a short exposure with a wide aperture is equal in effect upon the film to a long exposure with a small aperture, if the total light admitted is equal.

Making the choices is made easier by the fact that the proportion of light admitted as the shutter and diaphragm settings are changed varies by the same amount and can thus complement one another. As the speed of the shutter settings increases, each succeeding setting lets in 50 percent less light. As the shutter speeds slow, each setting in the sequence lets in 100 percent more light than its predecessor. For example, 1/125th of a second lets in half the quantity of light of 1/60th of a second, and 1/250th of a second has double the exposure effect of 1/500. As examples with diaphragm openings, f/5.6 allows half as much light in, compared to f/4, and f/22 has double the exposure effect of f/32. And so on, up or down either scale. In common usage, following a very old custom, an f-number is also called an f-stop, and the difference between any two sequential settings of either the shutter or diaphragm is called a "one stop" difference.

Suppose that in one picture it was important to have depth of field and there was no action to be stopped. Suppose further, that the available light and film speed combined to give a correct exposure at f/32 and 1/30th of a second. If the lighting conditions and the film speed remained the same, and a second picture was wanted that involved stopping fast action occurring in a shallow plane that involved no special depth of field considerations, the required shutter speed might be 1/1000th of a second. As shown in Table 5, these speeds are five settings (five stops) apart. By applying the reciprocity principle, we can see that a five stop readjustment of the diaphragm must be made in the direction of increased light entry. This would require opening up the diaphragm from f/32 to f/5.6, in this case. Both film frames would then have received the same amount of light for exposure purposes.

Let us now suppose that, with the light conditions and film remaining the same, we now wish to photograph a subject moving at moderate speed through a moderate depth of field. Starting with our settings of f/32 and 1/30th of a second, we will have to change both of them in order to arrive at a good compromise. If we determine by reference to Table 4 that the most advisable shutter speed would be 1/125th of a second, we will have to increase the speed setting by two stops, thus requiring a compensitory increase in exposure using an aperture opening that is two stops larger than f/32, which is f/16. This would again expose the film to the same total amount of light and all three negatives will have the same basic density after equivalent processing.

General photography requires a constant series of such choices, most of which are compromises between obtaining adequate action stopping ability and retaining enough depth of field. If you *must* have both high action-stopping ability and great depth of field simultaneously, you can do so only by raising the light level (perhaps by using flash), or by increasing the film speed (and accepting the concomitant increase in grain size).

Effects of Under- and Overexposure

Under- and overexposure effects with black-and-white films are discussed first, followed by a discussion of color films and their special characteristics.

Black-and-White Films In any normally lit scene, the first and foremost effect of under-

exposure will be an immediate loss of detail in shadow areas. In fact, if you find upon examining a negative that there is a failure to record wanted detail in the darker subject areas (that is, the areas least exposed and therefore least dense in the negative) you have—by definition—underexposed. Even one stop of underexposure is important because it is irretrievable. In pictures where retention of shadow detail is essential, but where exposure accuracy is a problem, making multiple exposures (bracketing exposures) is a good idea. This is explained in detail on page 97.

Another effect of underexposure is a loss of contrast, first in the darkest areas, and then in the middle tones as the underexposure becomes more severe. Low negative contrast due to underexposure can be corrected at least in part by printing to higher contrast. In extreme cases, chemical intensifiers can be used on the negative. These deposit any of several chemicals upon developed grains of silver in the film emulsion, and have the effect of increasing both density and contrast (and, of course, film grain size) in the negative. Higher contrast printing and the chemical intensification of negatives will only enhance those contrasts and densities that have been weakly recorded and will not supply detail that has not been recorded at all through underexposure. However, they may very well completely salvage a negative that is basically underexposed, but where shadow detail is either simply lowered in contrast or is dispensable.

Overexposure is less immediately critical in most negatives. In fact, in cases where exposure readings cannot be exact and where underexposure would be definitely detrimental, it is a good idea—especially in nonrepetitive events—to deliberately overexpose slightly. A one stop overexposure in black-and-white is usually quite tolerable, and it is sometimes possible to print satisfactorily some negatives that are four stops or more overexposed. But it usually isn't advisable. It is a common practice among writers who are concerned with 35 mm work to warn against any slightest overexposure on the grounds that it increases film grain size. Well, it does. But the change is so slight as to be hardly detectable in most cases. I worry much more about loss of shadow detail.

The most noticeable effect of overexposure is the loss of contrast in the lightest areas of the picture—the *highlights,* as they are called. This is detrimental to the preservation of pleasant skin tones in portraits, for instance. In extreme cases, highlights may print as undifferentiated and "muddy" looking grey tones, with little or no internal detail. They are then said to be "burned out" or "blocked up," and the negative is essentially not printable.

Correction of overexposure by printing to higher contrast is usually undesirable, because it renders the darker tones unpleasantly heavy, and important shadow detail may be submerged and thus lost. It is possible to "reduce" a negative chemically (that is, reduce the density of the negative by dissolving some of the developed silver grains). However, it is rather difficult to do this evenly, without streaking effects. I prefer not to use reducers, except in very rare and special cases.

By now you may be wondering why contrast gets decreased in shadow or highlight areas because of exposure inaccuracy. It all goes back to the H & D curve shown in Figure 17. An exaggerated H & D curve is shown in Figure 21, with its parts labeled for explanatory purposes.

Remember that the slope of the curve represents the basic negative contrast. To explain further, the steeper the angle of the curve the higher the negative contrast, and vice versa. The

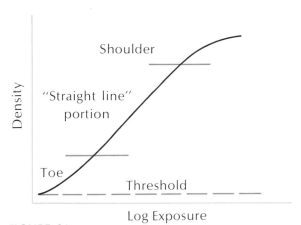

FIGURE 21
Exposure inaccuracy effects in the H & D curve.

top of the curve, having the greatest negative density, records the highlights and is called the "shoulder." The bottom, with the least density, records the shadow tones and is called the "toe." The "threshold" is the point where photographic detail is first recorded. There is a small but measurable film density below this point, due to light absorption by the film base material plus what is called "fog"—a spurious effect caused by a slight overall development of unexposed light-sensitive compounds in the emulsion. Density below the threshold level does not contribute to image formation.

As Figure 21 indicates, there is a flattening of the curve in both end zones (exaggerated here for visual clarity). If the negative is underexposed, the image crowds down into the low contrast toe zone. If it is overexposed, the image moves up into the low contrast shoulder. A correct exposure places most of the image tones in the straight line portion of the curve, and yields the best obtainable image quality because of a clearer separation of the tonal qualities. In most cases one need not get fanatic about it, but reasonable exposure accuracy is a real plus in picture quality.

The best way of avoiding inaccuracy in tricky lighting circumstances is by making multiple exposures, as was noted earlier. Wherever accurate exposure determination is difficult, either because of technical problems or through simple inexperience, "bracketing" or "straddling" of exposures is a good idea. That is, you make one exposure at the calculated correct level, and then you progressively make others at one-half or one stop intervals above and below that level. Usually, this is not possible where fast action in nonrepetitive patterns is present. However, where this method is practical, it is a good way of guaranteeing both an optimum exposure level and a choice of possible printing effects.

The question of how to choose the optimum negative from a bracketed strip of alternatives now arises. Place the negative strip on a light box (such as an X-ray viewer). Examine each frame with a magnifier lens, so that all significant detail can be seen. Find the frame that has sufficient shadow detail coupled with reasonable highlight contrast, and print it. If you are not perfectly right the first try, you should not be more than one frame off and a choice for reprinting can be made easily. The direction of the choice should be obvious. The print will either lack shadow detail or highlight contrast. If the former, choose the next most dense negative; if the latter, choose the next least dense one.

Color Films Color materials, because of special characteristics, do not respond in the same way to underexposure and overexposure as black-and-white. My experience has shown that color-print films (that is, color negatives) have great exposure latitude. It is relatively harder to notice exposure inaccuracy.

Color transparency films have quite different characteristics, and need to be considered separately. They are referred to as "reversal" films,

because, instead of the usual two-step process of negative and print, they are reversed in tone directly, during normal processing. The basic image is still a negative with the usual backward tonality, but in the course of processing these tones are returned to that of the subject material as a part of the process of development. Thus, each exposure—called a slide—becomes an original positive image, with no intermediate negative remaining.

In reversal films, the effects of underexposure and overexposure are approximately opposite to those of negative materials. Underexposure leads to a dense, dark slide, but one in which the image may still be made visible, if enough light is put through it. On the other hand, any significant overexposure renders light areas chalky white, with no salvage possibilities. Reversal films require very accurate exposure to insure quality results. Therefore, whenever it is possible, most professional photographers routinely bracket exposures. When I wish to be certain of obtaining really optimum exposures I use a three or five shot bracket, in half-stop increments. (In a three shot bracket, one is on the calculated exposure and the other two are placed above and below by one-half stop. In a five shot group, two are used in each position, so that there is one full stop of range both above and below.) This assures a choice that will preserve all possible nuances of color and tone.

Although overexposure results in complete loss of the lightest tones, underexposure has salvage possibilities. There are chemicals available that will allow bleaching of underdone slides for exposure correction, and some allow it to be done one color layer at a time, so as to give color correction possibilities. It is also possible to salvage a quite badly underexposed color slide by copying it into black-and-white. I have done this quite successfully with slides so dense as to be virtually opaque by normal viewing methods.

Therefore, if in doubt about exposure in a nonrepetitive situation, it may be wise, with color transparency films, to edge toward slight underexposure—the opposite of black-and-white negative film practice (some black-and-white films can be processed by reversal also, and where this is done much of the foregoing applies to them, too).

Fogging

There are two usable ways of affecting exposure by fogging the film prior to development. One results in a definite real increase in emulsion speed, the other in an enhancement of shadow detail and a possible small speed increase. The former is tedious and very specialized; the latter is simple and generally applicable in field work.

For Film Speed Increase More suitable for laboratory work than for field use, but something worth knowing about all the same, is post-exposure "fogging." In this technique the film is exposed to a very dim green light over a rather extended time period, after the picture has been made, but before development. (The time needed varies with the circumstances, but is likely to run to several hours.) Properly done, the effect is not an actual fogging or overall developable exposure of the emulsion, but is instead a physical intensification of the latent image, a so-called "latensification." The result, after development, is a film speed increase on the order of about two stops (see Zev Pressman, *J. of SMPTE*, in the Bibliography). This may be just enough sometimes to render the impossible possible.

For Enhancement of Shadow Detail More practical for everyday field photography is pre-exposure fogging. The purpose here is to fog the entire film gently, in order that barely detectable shadow detail may be rendered printable. This is done in cases where the overall lighting contrast is high, and where areas of figured shadow detail—though visible on the negative—would be too low in the toe of the H & D curve if the overall scene were exposed so as to print well. (This method is *not* recommended where there is no visible detail at all in the shadows, as it will simply result in a "milky" appearance in what should be areas of unrelieved black.)

In this case, the fogging exposure is a short one, and should be done just prior to making the picture exposure, by exposing the film (through the lens) to an out-of-focus 18 percent grey card (a standard exposure measuring device that is available from Kodak) at about four stops *less* than a correct exposure for "middle greys" in the scene. In Ansel Adams' well-known "Zone System" of photo exposure, it should be a Zone II exposure, where middle greys are represented by Zone VI. (The Zone System is described in the text following page 110.) The effect, after development, is to increase substantially the negative density in the shadow areas, while middle and highlight areas are scarcely affected—in terms of percentages—by the additional amounts of light they receive. This method works quite well with standard negative films and reversal color films. (See *The Negative*, Ansel Adams, Morgan & Morgan, Inc., pp. 109–110, and also Adams' *Camera and Lens*, pp. 134–137.)

Compensatory Development

Contrary to a rather popular belief, simple over-development will not compensate, in any real sense, for underexposure. Nor will underdevelopment correct a basic overexposure. If the exposure is basically wrong, you are stuck with the result. However, it is possible to use deliberate changes in development time to affect the *contrast* of an image, and doing so may make it advisable, for reasons of density control, to change the exposure slightly. Briefly put, development times that are longer than the recommended normal tend to increase contrast, and underdevelopment has the opposite effect. On the whole, it is not especially wise for the beginner to deviate from recommended times, but special circumstances can alter cases.

There are established relationships between exposure and development, and the appearance of the finished image is affected—often adversely—by significant deviations from them. Do not try experimenting in this area until you are really well informed about the subject in general. Commercially available films and developers are linked in a series of recommended exposure time, development time, and development temperature situations. I have seen many supposedly valuable photographic records spoiled by photographers who failed to follow the directions in one way or another.

EXPOSURE DETERMINATION

Before you adjust the camera settings, you must obviously come to some decisions about what the correct level of exposure is, with a given film under a given set of circumstances. There are three ways to do so. You can read and apply the information supplied by the film manufacturer, you can estimate exposure from knowledge of film characteristics and their response to standard lighting situations, or you can use a photoelectric light meter. Each method has its virtues.

Manufacturers' Information Sheets

Virtually every package of film has a sheet of paper (or a section of the carton) printed with a variety of information concerning the exposing and processing of the enclosed film. Almost universally, this information sheet is discarded when the film is loaded into the camera. Among professional photographers, however, there is a saying that goes, "When all else fails, consult the panic sheet." It seems almost too banal to point it out, but on that sheet you will find information that will allow you to make correct exposures under most normal field conditions. It fails only when you enter enclosures, such as buildings or caves. I make it a practice to keep in my possession an up-to-date information sheet on every type of film that I use. You should, too. If you drop your meter, then you will still have some way of getting the picture.

Estimation

As was pointed out on page 38, there is a rule of thumb for outdoor exposure. At a diaphragm setting of f/16, the ASA speed of the film equals the correct shutter speed, in normal bright sun. Thus, Ektachrome-X film, with an ASA speed of 64, will be correctly exposed at settings of f/16 and 1/60th of a second. Other speed or diaphragm settings can be derived by reciprocity. That is, if a wider aperture is wanted, a faster shutter speed must be selected, and so on. The use of Table 6 will allow reasonably correct exposure estimation, under the lighting circumstances covered in most film information sheets. If greater accuracy is needed, bracket your exposures around the suggested placement.

For those using the Zone System, estimation is also possible. With the light values listed in Table 6, consider that "middle greys" are placed on Zone VI at the settings indicated. Other zonal placements then can be effected at will, with quite reasonable accuracy, by changing the exposure one stop for each zone change desired.

Exposure estimation should not be ignored as a working technique. As long as the lighting conditions conform to the listed standards, exposure is remarkably consistent. As noted on page 38, this method can even be used to check a doubtful light meter.

If greater accuracy is desired with nonmetered photographic exposure estimation, or if certain unusual photographic situations are encountered where metering is impractical or impossible, refer to the *American Standard Photo-*

TABLE 6
Exposure estimation, at f/16 (Assuming a location in middle geographic lattitudes.)

LIGHTING CONDITIONS	EXPOSURE TIME
Normal bright sun	Equal to ASA film speed
Hazy sun (soft shadows)	Minus one stop
Cloudy bright	Minus two stops
Open shade or heavy overcast	Minus three stops
Bright sun, sand, or snow	Plus one stop

graphic Exposure Guide (a 45 page paperbound booklet published by the American Standards Association, New York, 1966). This guide provides detailed information on standard sky conditions and light values, and takes into account geographical latitude and other factors. In addition to daylight photography, this source also covers photography by moonlight, corrected for lunar altitude and the phases of the moon. Other subjects covered include the photography of rainbows, lightning, the Aurora Borealis (and Australis), and lunar and solar eclipses.

Table 7, basically derived from this guide but subjected to my own interpretations, offers some recommended trial exposures for photography in unusual existing light situations. In most cases, these are starting points only, since they are affected by such factors as geographic latitude, atmospheric clarity, or the elevation of the sun or moon above the horizon. Therefore, exposure bracketing is often appropriate.

Another useful guide is the Kodak booklet *Adventures in Existing-Light Photography* (number AC-44). Dealing mostly with human activities and architectural concerns, it offers much helpful advice on photographic methods other than just exposure, such as how to deal with light sources of more than one color temperature in one color picture. It has several good tables, the one on suggested exposures being duplicated in a removable pocket-sized version meant for field use.

A slide-rule-form calculator for night photography, to be cut out and assembled, was printed in *Popular Photography* magazine in both the March, 1962, and April, 1968, issues. This calculator, similar in emphasis to the one in publication AC-44, mentioned earlier, was called the "Jiffy Calculator For Night-Light Exposures," and was made up by Stephen P. Martin. (At that time he offered ready made

versions for sale through Activity Research & Development, Box 85, Trumbull, Connecticut, 06611.)

For solar photography, see *A Professional Guide to Photographing the Sun,* Donald G. Carson (Carson Astronomical Instruments, Inc., Valencia, Calif., 1973). This source offers much more complete information on solar recording than any of the more general references.

Light Meter Use

On pages 38–42 there is a comprehensive description of the various common types of photoelectric light meters, with basic information on the mechanics of their use. Neither that coverage nor what follows here is exhaustive as to all the possible types that are available, or their various uses. In the following sections, the most commonly used types of meters are listed, and a number of good ways of using them under field conditions are described.

Selenium Cell Meters The selenium cell meter, the most widely used type of photoelectric light meter prior to the relatively recent introduction of the cadmium sulphide meter, is still a versatile and dependable instrument. Its spectral sensitivity closely resembles that of panchromatic films, and it has no power cells to give out at critical moments. Its durability is good, though (as with any other such electrical meter) rough handling can knock the needle off its bearings or otherwise damage it. (I have seen far too many people walking along swinging a meter or even an expensive camera at the end of its neckstrap. To avoid any such temptation, and to avoid the possibility of snagging the strap accidentally and thereby dragging the instrument to its doom, I remove such straps from my

Landscapes by Full Moon[a]

ASA	EXPOSURE TIME (IN SECONDS)	APERTURE
400	2	f/8
1600	1/2–1	f/8

The Moon (Elevation Above 40 Degrees)[b]

LUNAR PHASE	ASA	EXPOSURE TIME (IN SECONDS)	APERTURE
Total eclipse	1600	1/4	f/4
Crescent moon	32	1/15	f/5.6
Half moon	32	1/30	f/8
Gibbous moon	32	1/60	f/8
Full moon	32	1/125	f/8

Solar Eclipses

PHASE	ASA	FILTER	EXPOSURE TIME (IN SECONDS)	APERTURE
Partial				
Disc delineation	400	ND 5.00	1/250	f/16
Limb darkening	400	ND 5.00	1/1000	f/45
Total				
Prominences	400	None	1/125	f/11
Inner corona	400	None	1/60	f/5.6
Outer corona	400	None	1/30	f/4

WARNING: The neutral density (ND) 5.00 (.001 percent transmission) filter recommended for photography is *not* sufficient to protect the eyes when viewing the solar disk, even when is is almost completely eclipsed. For viewing, use two thicknesses of black-and-white film (such as Kodalith or x-ray film) that has been completely exposed to light and then developed to maximum density. Do *not* use color film, as it passes harmful wavelengths. **Failure to observe suitable precautions will result in permanent eye damage.**

TABLE 7 (*Cont.*) *103*

Lightning

ASA	EXPOSURE TIME[c]	APERTURE[d]
32	Shutter open	f/4
400		f/16

Rainbows

	AGAINST CLOUDS		AGAINST SKY	
ASA	EXPOSURE TIME (IN SECONDS)	APERTURE	EXPOSURE TIME (IN SECONDS)	APERTURE
32	1/30	f/11–f/16	1/30	f/16
400	1/250	f/16–f/22	1/250	f/22

Floodlit Buildings and Monuments[e]

ASA	EXPOSURE TIME (IN SECONDS)	APERTURE
400	1/8	f/4
1600	1/30	f/4

Distant Cities, at Night[f]

ASA	EXPOSURE TIME (IN SECONDS)	APERTURE
32	15	f/5.6
400	2	f/8
1600	1	f/11

Note: These are starting points for bracketing of exposures.

[a] For daylight appearance. If a moonlit appearance is desired, expose three stops less.

[b] For elevations of 20–40 degrees, open up one-third of a stop.

[c] You cannot anticipate lightning with short exposures, so the shutter must be left open in hopes of catching a flash.

[d] Rough approximation only, as the brightness varies widely.

[e] Take direct meter readings, if possible.

[f] If sky and water effects are wanted, double expose, making the first exposure two to three stops under an indicated meter reading at dusk, followed by a second as above, later.

meters. And I recommend that others do the same. When not actually in use, the meter should be safely stowed away in a protected pocket or camera bag.) The selenium cell meter is a very good choice for broadly general photography. I have three light meters, and two of them are of this type.

Cadmium Sulfide (CdS) Meters CdS meters are inherently more sensitive to low levels of light than are selenium cell meters, since less light is required to modify the amount of current flowing in the circuit than is needed to generate enough to move a needle. These meters are superb when very low levels of light are to be measured. They are a type often preferred for through-the-lens metering, and for readings to be made on the ground glass of press or view cameras, because they are capable of giving dependable readings in any reasonable lighting circumstances, even when the lens aperture is closed down. Some can read bright moonlight. I find it useful to swing the meter needle to the higher end of the scale prior to making a very low level reading (by momentarily pointing it to a brighter light source), in order to avoid an inaccurate reading due to mechanical inertia. This can be overdone, resulting in a temporary sensitivity change in metering, but with reasonable care it is a good technique. The general durability of CdS meters is comparable to that of selenium cell meters.

CdS meters are especially subject to two problems. The first is that they require a small internal power cell to provide the operating current. Though these cells are typically long lasting, with a sharp cutoff point rather than a gradual decline in power, they can produce inaccurate readings at low temperatures. (Most power cells will show reduced output in really cold weather.) And when they do fail from old age, you can bet your bottom dollar there will

be no camera store next door. I carry spares at all times, having been caught out when two CdS meters gave out simultaneously far from photographic civilization. In a recent publication on winter photography, Kodak has suggested the replacement of the PX-13 power cells often used in CdS and other meters (and other photographic equipment, as well) with PX-625 cells, in cold weather (see page 268 for allied information).

The second problem is that the sensitivity to colors of CdS meters does not match the spectral sensitivity of panchromatic films as closely as does that of selenium cells. Furthermore, there is no definite direction of trend in spectral sensitivity among meters from different manufacturing batches. Therefore, if you must frequently read light from colored sources, if you must meter exposure for subjects possessing predominant colorations, or if you wish to read exposures through color filters on the camera lens, you must make tests in order to determine what effect the various individual colors will have on metering accuracy, and compensate accordingly. Otherwise you will find frequent unexpected exposure inaccuracies when all originally appeared well.

Silicon Cell Meters The latest entry in through-the-lens built-in light metering is the silicon cell meter, where a miniature electronic circuit operates to amplify the amount of current generated by light striking a silicon cell—the cell itself now operating somewhat similarly to a CdS cell. These meters react to light more quickly than CdS meters, and are approximately their equal in low light sensitivity. Silicon cell through-the-lens meters share the two main problems of CdS meters: they require power cells, and suffer from similar wavelength sensitivity imbalances. (The basic sensitivity of silicon cells is greater than the CdS cells in sensitivity

to both infrared and ultraviolet, and—depending upon the individual meter design—are potentially more useful for metering reflected radiation in these regions of the spectrum.)

These problems should not deter you from using a CdS or silicon meter. They are very useful instruments, and are capable of giving very consistent results. I wouldn't care to be without one. Just be aware that areas of doubt can exist, and of the circumstances that may require your careful attention. The great utility of through-the-lens or other image plane readings makes these extremely sensitive meters a boon to the technically oriented photographer. They are a near necessity for any use where low light levels are frequently encountered.

Reflection Readings Probably the most widely used (and most widely useful) method of light meter reading is by reflection. That is, the light being read is that reflected from the subject. The meter is pointed at the subject (or at a portion of it), and the reading is taken directly. This method of exposure metering reads not only the amount of light present, but also the relative brightness of colors, and the degree to which surface textures affect the amount of light reflected from the subject. It does not, of course, separate these qualities. But it does give an integrated reading that takes all of these factors into account at once, a very useful way of approaching exposure control. I use this method far more frequently than I use incident readings, though I use the latter also, whenever they are appropriate to my goals. The Zone System of exposure control is based on reflection exposure readings.

Incident Light Readings Incident light readings are measurements of the amount of light falling upon a subject. The reading of incident light requires the use of meters adapted to the method, most generally by the use of a translu-cent white hemisphere (an "integrating sphere") placed over the sensing cell. The cell itself may be either selenium or CdS. Many current models of light meters allow both reflection and incident readings to be made with the same instrument, through the agency of a movable integrating sphere (see Figure 22 on p. 111).

To measure incident light, the meter is placed next to the subject, or well within the scene to be photographed, and the integrating sphere is pointed toward the main light source for the reading. Alternatively, it can be pointed at the camera, in cases where the main light source is not too far off the camera axis. (See your instruction booklet for details of recommended practices for specific instruments.) Perhaps the most accurate incident light metering method is a way of averaging two readings called the "duplex" method. In this case, one reading is made with the cell pointed at the light source, and a second is made pointing at the camera. The camera settings chosen for use should fall at the midpoint between these two readings. (See J.F. Dunn's *Exposure Manual,* John Wiley & Sons, New York, 1958, the most comprehensive source that I know of concerning photographic exposure, for details of this and other exposure matters.)

Since they do not consider the nature or color of the subject surface, incident light readings are especially appropriate where standardization of method is an aim, or where subject tones are to be compared in successive pictures. If all other factors (such as film choice and processing) are standardized, an evenly lit standard grey card will photograph in the same manner, whenever the meter indicates a correct exposure, and the other tones will be lighter or darker in comparably useful ways.

Incident light readings are useful in photocopying, where the evenness of light is essential, and where the photographer seeks to expose in

a standard way in order to be able to reproduce the subject tones predictably. If several incident light readings are made at different locations over the surface of the subject, it is possible to determine whether the lighting is really even, and at what exposure level. Specifically because the method ignores the varying tonality of the subject surface, it then becomes possible to reproduce those tonal changes accurately. With a reflection meter it is substantially more difficult to determine evenness of lighting, since a standard grey card has to be moved around with the meter.

The Range of Tones Many scenes to be photographed in the field have a considerable variation in the natural lighting intensity in the area that will be recorded. It may be difficult, therefore, to come to a decision about the correctness of an exposure calculation. It will be a help to look at the scene and analyze it proportionally. You may find that all of the important elements are either in brightly lighted areas, or in the shadows. If so, the decision is easy. Simply read (by reflection) the light in those areas of importance, and do what the meter says, ignoring the other areas. If important detail is to be recorded in both very light and very dark areas, things may not be so simple.

If a reflection reading of the very brightest highlights is made, and another reading is made of the very darkest shadows, a scene of "average" contrast will be found to cover a brightness range of about eight stops. That is, the indicated correct exposures will vary by this much. A normal film, if correctly exposed and processed as directed, will yield a negative printable on "normal" grades of printing paper so as to show just discernible detail in both highlights and shadows.

Most light meters are designed to average out the tones of a scene, on the assumption that light and dark areas are roughly equal in extent. If they are significantly unequal, something else may be needed. You can "average" the exposure yourself in a manner slewed to emphasize the most important areas. If more than half of the scene is made up of large shadow areas, more exposure may be needed than the meter indicates. Conversely, if more than half the scene is in very bright areas, exposure should be cut. Since the basic exposure correctness is not affected by these considerations, such slewing will mean that the less important areas—being either under- or overexposed—will print less well. But the more important areas should print somewhat better.

I use this method primarily when I am pressed for time, and don't feel justified in stopping to work things out more carefully. My way of doing it is to make the exposure one stop off calculations, above or below the meter calculation according to whether I am emphasizing shadows or highlights. Where practical, I use a two-shot bracket with one exposure as the meter indicates and the other one a stop up or down according to my best guess. Then I print the one of the pair that turns out better for my purposes.

If readings of lightest and darkest areas reveal a contrast range greater than eight stops you are getting beyond the range of "normal" photography. And if shadow detail is wanted that constitutes more than "just discernible" tones, as is often the case in photographs made for scientific purposes, even this normal range of contrasts may be too great. You may have to consider that anything over a range of four to six stops is too high a lighting contrast for some uses.

Lowering the negative contrast, so that all subject and lighting tones can be carried to the

print, can be done to some extent simply by choosing a film of lower basic contrast. Thus, you may find it advisable to use a very fast film under conditions of harsh, bright light, where other considerations would suggest the use of slower films. Negative contrast is affected even more strongly by the choice of developer, and by the circumstances of its use. For relatively mild contrast reduction, it may be sufficient to use a fast film, and then to shorten the developing time a little—perhaps also mildly overexposing to retain negative density and to assure full recording of shadow detail. If stronger measures are called for, there is a whole range of low contrast developers. The formula that comes first to mind with most people is Kodak's D-23. A specialized application of this, involving the use of high contrast films and low contrast developers to achieve high resolution capability in 35 mm photography, is given in the text following page 271.

Notably reduced subject contrast, such as distant hazy landscapes, or subjects in deep shade, which receive exceptionally nondirectional lighting, require opposite measures. And, with these scenes, it is desirable to avoid overexposure caused by failure to recognize the meter's built-in assumption of normal lighting contrast. To obtain mild increases in negative contrast under these circumstances, you might well expose a stop less than the meter reads and increase development time by about 20 percent. You can also use slower films that are inherently higher in contrast, and more vigorous developers such as D-11. However, do not make the common error of confusing low light levels with low lighting contrast. Very dim lighting may be also very directional and thus of high contrast, because it may come from one or more small, distant light sources. Meter readings of both light and dark areas will indicate by their separation the degree of lighting contrast present.

You should realize that a light meter designed for "normal" photography places the deepest differentiated shadow tones about four stops below what will be the middle greys, out of a total range of about eight stops, and gives "correct" exposure readings in the center of that range. If the actual range of tones present is only six stops, that center point will overexpose shadow areas by about one stop over what would usually be expected. And if the actual range is four stops, shadows will be overdone by two, which is why photographic writers frequently speak of a gain in effective film speed in circumstances of flat, even lighting. You don't actually gain film speed; you just don't have as much range of shadow detail to cover. This relative overexposure of shadow detail may not be undesirable in all cases, and scientists especially may want to ignore it as a technical problem since it assures unusually rich shadow detail. But you should be aware of it. In dark, but evenly lit places, you may want to use the available extra stop or two to gain shutter speed or greater depth of field—and you can do so by setting your light meter for a higher film speed.

Averaging Readings A simple method of exposure control that tends to place the middle tones of a subject midway along the H & D curve is the averaging of shadow and highlight readings. If a shadow reading indicated on the meter scale an exposure of, say, 1/8th of a second at f/8, and a highlight reading indicated 1/500th of a second at f/8, a good exposure should result if the camera were set at 1/60th of a second at f/8, or at any equivalent combination of settings. Such a setting should give adequate exposure to both shadows and highlights, as indicated by the material in the preceding section.

Substitute Readings The actual subject being photographed may be both out of reach and surrounded by dissimilar material, making a correct exposure reading hard to come by. If the subject is not *too* distant, an accurate exposure will result from metering any nearby subject of similar characteristics that is similarly lit. For subjects at distances so great as to involve atmospheric haze, such as in long telephotography, such readings may result in overexposure by about a stop, because of lowered overall tonal contrast and the addition of light scattered by the haze.

Spot Readings The ability to read exposure on very small portions of distant subjects used to be limited to those few who had access to relatively expensive photometers made for the purpose. Recently, however, reasonably priced spot meters and spot meter attachments have become available. Most reflection light meters have a light acceptance angle in the neighborhood of about 50 degrees, corresponding to the acceptance angle of lenses of normal focal length. Spot meters have acceptance angles of from as much as 20 degrees to as little as one degree, depending upon make and type.

Some through-the-lens meters built into 35 mm cameras are primarily sensitive to a spot approximately three-eighths of an inch in diameter in the center of the 1×1.5 inch image area. With a 50 mm lens in place this gives an acceptance angle of about 12 degrees. With a 135 mm telephoto lens it reduces to about four degrees. This is a very respectable spot reading capacity. Furthermore, built-in meters that average the whole film frame area can be used as limited-range spot meters if the lens used for reading exposure is significantly longer in focal length than the one used for making the picture. For instance, if the picture is made with a 35 mm wideangle lens, but a 200 mm tele lens is used for metering, the acceptance angle reduces from about 65 degrees to about 15 degrees. And, of course, any time that ground glass readings are made on the larger cameras they are spot readings. My system reads a three-eights of an inch circle anywhere on my 8×10 inch ground glass, equivalent to less than a four degree angle.

Why is a spot meter useful? It makes substitute readings unnecessary, and it makes both averaging and the determination of tonal range (as for Zone System, for instance) a lot easier. (See *"Fishback On Spot Metering"*, in the Bibliography.)

Image Plane Readings Metering the light at the image plane has obvious advantages. It takes into account factors such as the light transmission of a lens, the accuracy and placing of aperture settings, and light losses through image magnification or the use of lens attachments. If the system has been checked for spectral sensitivity, image plane readings allow you to forget about filter factors. Since all such factors affecting exposure are accounted for by the fact that you are reading the light intensity after they all occur, you are reading only for the exposure time. Through-the-lens metering, as is available on many small cameras, is image plane metering. So, of course, is any reading made at the ground glass of any camera, large or small. Since built-in through-the-lens metering is specific to the make of camera, and full instructions for operation come with purchase, I will say no more here about such systems.

Ground glass exposure metering is different primarily in that the meter is separate from the camera, and in that the light dispersion of the glass itself may be a factor. There are meters made for image plane light measurements that place a probe just in front of the ground glass, and thereby avoid this problem. (The Sinar-six is an adaptation of the Gossen Lunapro and has

a small, movable probe; Hoffman's Photo-master-10 is similar; the Calumet company offers a model that fits like a film holder and meters the whole film area.) However, meters of this latter type are usually specific for film size, and tend to be unnecessarily expensive. Any sufficiently sensitive CdS light meter can be calibrated for ground glass readings with a little ingenuity. Gossen makes an accessory probe for their Lunapro meter than can be so used directly, but it isn't really needed. Detailed instructions for obtaining ground glass exposure readings on any camera with unobstructed access to the glass, using Gossen Lunasix or Lunapro meters (without any accessory attachments) are as follows:

Object:

To determine only the exposure time to be used, since readings at the ground glass automatically include compensation for bellows extension, diaphragm setting, and filter factors. (Use with filters in place requires prior testing; see item 4 under *cautions*.)

Camera:

Use any camera with unobstructed access to the ground glass. Set the magnification as desired; focus and compose the image; close the diaphragm to the desired setting. Taking note of caution 4, place color filters on the lens and check the focus.

Metering:

1. Check light meter for zero correctness.
2. Set ASA speed of film to be used.
3. Swing the meter needle to the opposite end of the scale from the expected general area of the reading, to allow for needle inertia.

4. Place the reflected-light opening of the meter on the desired reading point on the ground glass (see below for choosing that point). Shield the ground glass and the meter from stray light.

5. Using the low-light button, take the reading, allowing ten seconds time for the needle to settle before locking it. (At low light levels the needle is slow to settle.)

6. Transfer the needle reading to the circular calculator in the normal manner.

7. Obtain the correct exposure time by looking opposite:
 a. Lunasix Model I f/1.4
 b. Lunasix Model II f/2
 c. Lunapro f/1

Cautions:

1. If the meter reads below 3 on the low-light scale, doubt its accuracy. Open the diaphragm to a wider aperture, reread, then reclose the diaphragm, while doubling the exposure time for each stop.

2. Each meter used should be calibrated, using metering instruction 7 *as a trial point.*

3. If the exposure time exceeds normal limits (more than about ten seconds for black-and-white or about one-fifth of a second for color reversal films), correction must be made for reciprocity failure. (See the manufacturers' recommendations.)

4. Cadmium sulphide meters do not respond the same as panchromatic films all across the spectrum. With *my* Lunasix-I, if the area sensed is red, I must add one stop of exposure. If it is orange I must add one-half stop. Other meters, even of the same make, may have different color responses. Testing is needed.

Choosing the area to read:

1. With black-and-white films, read the darkest significant area. This will give a "textured black" (Zone II) in that area. If more detail is wanted in dark areas, add one stop more exposure.

2. With reversal color films, place a standard grey card at the subject position, and read that area on the ground glass. If that is not practical, read the middle tones of the image. A good exposure will result. (Kodak makes standard cards that are 90 percent reflectance white on one side and 18 percent reflectance grey on the other, for use in exposure calculation. In very dim light you use the white side, and then multiply the exposure reading by five. See your dealer.)

Processing film:

Follow the manufacturers' recommendations.

The foregoing method has been found very accurate and very consistent over large amounts of photography in varied circumstances, from landscape photography to photomicrography. Readings are directly comparable to those obtained with the Sinar-six and other similar meters. The method is recommended to Zone System photographers. Figure 22 is provided for reference.

Although Figure 22 depicts an older model meter, it is one that is still in general use, and new models differ only in detail. To calibrate other meters for ground glass exposure readings, operate the meter basically as described above. Make a number of otherwise identical exposures, using the time shown opposite each of the wider aperture designations, while keeping full records. After processing the films, determine the apparent correct exposure. Refer to your notes to see which aperture designation it was. Use the meter to determine the exposures for another group of pictures, of varying subjects, using the information gained in the first test. After processing this group, adjust your information as needed in order to be able to obtain repeatable accuracy. Finally, to test for color anomalies, make exposures of subjects of various strong colors, to determine how much correction (if any) is needed for each when it is a predominant hue. Tabulate the results on a sticker to be kept on the meter case.

The testing process is simple and not time consuming, and the metering method is a good one. Some models of CdS light meters are built with the sensing cell out on a flexible probe; others have a probe available as an accessory. With these probes, you can make selective ground glass readings on any 35 mm single lens reflex camera with an accessible viewing screen, as is the case with waist level viewfinders. Some $2\frac{1}{4}$ inch cameras have removable shields around the viewing screen, and these allow especially easy access.

Zone System A number of years ago, the famed landscape photographer Ansel Adams rationalized photographic exposure technique under the term "Zone System." It is thoroughly explained and demonstrated in his very fine book, *The Negative.* Other writers and photographers, notably Minor White, Arnold Gassan, Dowdell and Zakia, and Fred Picker, have variously interpreted and elaborated the method (see the Bibliography), but the basic principle has remained the same. Several other systems for exposure control have been developed, but there is very wide acceptance of the Zone System as probably the best and most complete method of exposure/development control so far devised.

To the beginner it has a way of looking com-

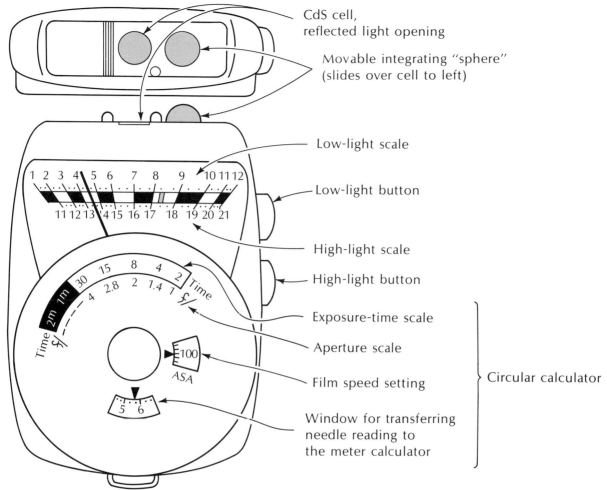

CdS cell,
reflected light opening

Movable integrating "sphere"
(slides over cell to left)

Low-light scale

Low-light button

High-light scale

High-light button

Exposure-time scale

Aperture scale

Film speed setting

Window for transferring
needle reading to
the meter calculator

} Circular calculator

FIGURE 22
Diagram of the Gossen Lunasix, Model I.

plicated, but actually, in principle, it is very simple. It does take some initial work to calibrate your equipment, materials, and techniques to the system. The late S.G. Ehrlich, the highly regarded scientific and legal photographer, has described it aptly as "simple, but not easy." However, no matter what the purpose of your photography is, learning the Zone System can be well worth the effort. And, it is nowhere nearly as time consuming to apply in the field

as has sometimes been implied. Although a summary of the principles of the procedure follows, those who wish to put the Zone System into practice are urged to work from the original sources, which were noted above.

The basic premise of the Zone System is that the photographer will "previsualize" the final print from the appearance of the original scene, in terms of the capabilities of the photographic medium, and of his or her own chosen view of

it. This requires a full understanding of the relations between and among all portions of the process, from the first look at the subject matter right through to the completion of the final print. This is really no more than asking you to understand what you are doing. Actually, all other photographic exposure methods involve the same series of understandings, but because they are likely to be less clearly worked out, they are likely to be less successful.

For the sake of ease of understanding and convenience of operation, the actually infinite series of tones in a black-and-white photograph are in the Zone System divided into ten "zones." The first, representing dead black in the print (no exposure of the negative), is called Zone 0 (zero). The others are designated in Roman numerals, from Zone I (the threshold of negative exposure) through Zone IX (dead white in the print). In terms of exposure, the zones are one stop apart, and each zone represents the stand-ard appearance in the grey scale of a common type of subject matter, as shown in Table 8.

If exposure and development are worked out correctly, the ten zones in the negative will just fill the reproduction capacity of the normal grade of printing paper. In scientific photography, where full detail is important throughout most subjects, unrelieved black or white are seldom desirable except as backgrounds. Therefore, we are primarily concerned with the print tones represented by Zone II (textured black) through Zone VIII (textured white). Zones I and IX are available for use on the negative, but are not occupied by tones of the chosen subject. But the principle remains exactly the same as in Adams' presentation.

The fullest implementation of the Zone System requires the use of sheet film, so that each exposure can be developed separately. Why? Because by varying the development time, the scale of greys in the negative can be expanded

TABLE 8
"Zone System" zonal print values[a]

Zone 0	Dead black (film base + fog) in the print.
Zone I	Exposure threshold of the negative, unstructured black in the print.
Zone II	Textured black.
Zone III	Black clothing, to show creases.
Zone IV	Shadows in sunlit landscapes, portraits; dark foliage.
Zone V	Middle grey (the tone of a standard 18 percent Grey Card).
Zone VI	Average Caucasian skin tone; shadows on sunlit snow.
Zone VII	Snow in grazing light; very light skin.
Zone VIII	Lightest differentiated tones.
Zone IX	Pure white (of the printing-paper base).

[a] These are typical values only, and are to be visualized as they are normally seen in conventional photography. You may place any subject tone in any Zone at will, in order to get special effects.

or contracted. Thus, a scene whose basic contrast range is, for example, six stops, can be expanded through corrective development to fill the tonal range of the print to seven or more zones. Conversely, a scene in which the metered brightness range exceeds the normal can be contracted to fit into the printing zones as desired.

The purpose of linking exposure to development by way of the Zone System is:

1. to expose a given subject luminance value so as to cause it to appear at a previsualized tonal value in the print; and

2. to develop the negative so that all other subject luminance values will be compressed or expanded so they just fill the full tonal scale of the print, in the previsualized manner. (It is understood that the photographer may choose to allow high and/or low zone tones to run off the ends of the print scale, thus printing them as white or black.)

Assumed in this theory are the following:

A. that in the finished negative the intended Zone I will represent, as nearly as possible, the exposure threshold of the film;

B. that Zone I in the negative will be printed as Zone I;

C. that your chosen subject luminance value will then appear at the previsualized printing zone, as in step 1 above; and

D. that all other subject luminance values will then fall as they will in the print, subject only to generalized contrast control through devopment, as in step 2.

With roll film, it is not possible to develop each exposure separately. Using single sheet films it might be possible to aim at printing all negatives on the same grade of paper. But with roll film the options may be more limited, and so more use of different grades of printing paper may be required to substitute in part or whole for the lost control over variability of negative contrast. Other things being equal, then, it may be an advantage in 35 mm work to load and use special short rolls in order to simplify matters. In short, with roll films exposed by the Zone System, one of two methods must be followed:

1. you must restrict the photographic contents of any given roll of film to a single development requirement,

 a. by changing to scenes of varying subject contrast only when changing to a new roll of film, or

 b. by using interchangeable camera film backs (or separate cameras), if available, with the film in each designated for a specific development, and the back to be used selected for each exposure according to the luminance value range of the subject;

or

2. you can develop so that the ten zones of the single most contrasty scene will be compressed, as a group, to no more than the full range of a given grade of printing paper—and then use the higher contrast graded papers to allow for the existence of lower negative contrasts in the remaining pictures. (This second choice is little more than is normally done when the Zone System is not used at all.)

Development of films for expansion or contraction of the overall tonal scale in the negative requires first that a "normal" development time be determined for each type of film to be used. The recommended method of doing so is to

photograph an evenly lit 18 percent reflectance Kodak Neutral Grey Card, using the Zone exposure system with your meter, and reading at Zone V. Develop the film according to the manufacturer's instructions, with the developer of your choice. Print this resulting negative on normal contrast paper so that the Zone 0 area (an adjacent blank frame on roll film, or an unexposed area on a sheet film) is exposed just long enough so that it just barely prints to a maximum black for the given paper. Make a graded series of print exposures, test strip style, to be sure of getting an accurate exposure time. At this exposure time, print the image of the 18 percent grey card. After processing and drying, this resulting grey tone should match that of the original card. If it does not (and it probably won't), the film development time must be altered. If the print appears too dark, increase the time. If too light, decrease it. Repeat as necessary until you succeed in obtaining a match. Things will be speeded up and accuracy increased if a number of films are exposed in one session, all identically, and the films held for processing at various development times, according to need. After establishing the "normal" development time, hereafter referred to as "N," you are prepared to undertake plus and minus development, in order to achieve contrast control in a rational manner.

To *increase* negative contrast by one zone (for instance, so that a five-stop contrast range will print as six zones of print values), develop $N + 1$. This is equal to the normal developing time *multiplied* by 1.4, or 40 percent more than normal. To increase print contrast by two zones, develop the negative to $N + 2$, by multiplying the $N + 1$ time by 1.4.

To *decrease* negative contrast by one zone (for instance, so that a six-stop contrast range will print as five zones of print values), develop $N - 1$. This is equal to the normal developing time *divided* by 1.4. It is not recommended to process below $N - 1$ unless special techniques are used, but two-bath development will allow minus processing as far as $N - 4$ (see Dowdell and Zakia, *Zone Systemizer*—in the Bibliography—a booklet and dial calculator combination, for one of the clearest accounts of plus and minus development).

Testing of other variables may be needed if your results are to be really consistent. You may need to test for true film speed, accuracy of shutter and/or diaphragm calibration, and so on. Such testing is not especially difficult, but is a little tedious. But before you doubt the desirability of all this, check the quality of the superb photographs made by Adams, White, *et al.*, against that of nonusers.

The Zone System can be used satisfactorily with any negative material, including color negative film and Polaroid Land materials. Using Polaroid films, the plus and minus development procedures are somewhat less cut-and-dried, because the "normal" development time is affected by the ambient temperature. Since development is done not in a darkroom but in the field, when the photographs are made, this temperature may vary uncontrollably over a considerable range. (See Ansel Adams' *Polaroid Land Photography Manual*—in the Bibliography.)

Color transparency materials are a bit different. Their development times are relatively inflexible. For most people it is entirely out of their control, being done by a commercial processor. Exposure is also relatively inflexible, since there can be no monkeying around with highlight tones. Correct exposure is essential, because any overexposure loses all of the highlight detail, which results in a chalky look without any information content. Underexposure darkens and muddies highlights and, if it is at all

extreme, loses shadow detail. The Zone System can be used only to place the highlight tones accurately—a minor modification of the method.

Modified Zone Systems For a variety of reasons a number of modified zone systems have been developed, each offering a degree of control over final results; some methods being better than others. Some of the reasons for the development of these systems have been: simple ignorance of the existence or nature of the Adams system; limitations of materials, as noted above; facilities limitations, where the photographer has imperfect or no control over processing; an urgent need to work quickly; a degree of unwillingness to do the required full range of testing; plain human laziness; or a feeling that possibly the Adams version is too complex, too cumbersome for practical use, or not in accord with personal findings. Some modifications are described in the next three sections.

Glen Fishback Exposure System. Probably the best known and least drastic modification of the Adams Zone System is taught at the Glen Fishback School of Photography in Sacramento, California. It is called the Glen Fishback Exposure System, and the main alteration is that it uses seven zones instead of ten. The basis for the change, according to Mr. Fishback, is that while using the Zone System he found that the majority of scenes did not span ten zones of one stop each, but—centered on an 18 percent grey card—spanned seven zones from black to white, covering an actual usable tonal range of six stops. He therefore developed a new system to coincide with this finding. In order to avoid confusion with the Adams Zone System, he designated the steps in his grey scales as "values" rather than zones. The Fishback System

places somewhat less emphasis on corrective processing, although it does not ignore it. On the whole, there is less testing involved.

In black-and-white photography, the Fishback System relies in part on reading the exposure on an 18 percent grey card, and interpreting that reading according to the nature of the scene and of the photographer's intentions. The use of a Honeywell 1°/21° Spotmeter is recommended. For color transparency work, a white card reading—or its equivalent—is used, the exposure chosen for use being $1\frac{1}{2}$–2 stops less than that indicated by the card, according to the degree of color saturation that is desired. The system works well, and those desiring additional information are referred to Mr. Fishback (see the Bibliography).

Two-Zone Zakia and Todd System. A more limited method is the two-zone system of Richard D. Zakia and Hollis N. Todd (explained in *101 Experiments in Photography*—see the Bibliography). This system aims at printing all negatives on a single grade of paper, through measuring the light reflected from both the darkest and the lightest significant subject areas, determining the difference between the two, and then developing so as to expand or compress the contrast index to 0.60. (Refer to the recommended source for a full explanation of the system and its terminology.)

Although this system will guarantee getting all of the subject tones exposed usably on the film, I do not feel that it offers the fine control of the Adams and Fishback systems over the total aesthetic impression of the print. This can be just as important in scientific work as it is in art photography.

Single-Zone System. For some years I have used a rather crude looking but quite workable

single-zone system of exposure measuring, when using black-and-white sheet films and, in some cases, with roll films. I have found it especially appropriate in photomicrography, where the darkest tones are frequently very important and the lightest bright areas—being merely background—are negligible. But it has also been very useful in landscape photography.

This single-zone system is based upon reading the brightness of the darkest significant area of the ground glass image in the manner described following page 108. Exposed directly as read, this yields a print value equivalent to Adams' Zone II for this area. Negative contrast is determined by film choice, all exposures from a given session usually being developed in the same bath, at a single "normal" developing time. If the scene or subject is very high in lighting contrast I use a fast film, which is inherently low in contrast. If the scene is low in contrast I use a slow, and therefore inherently contrasty, film.

There is an apparent contradiction in the system when it is used in the field, in that I often use fast films (of low contrast) in bright sun and slow films (of higher contrast) in the shade, in order to achieve contrast control. In practice this upset of speeds is unimportant as long as there is relatively little subject motion to be stopped in shadowed scenes. I do not use the system for action photography in any case.

In extreme cases of need, additional contrast control can be exercised by using plus or minus development, by using a more or a less active developer, or by choosing films with unusual contrast characteristics, such as Contrast Process Pan or Contrast Process Ortho film. With this exposure system, I make no special attempt to aim at printing all negatives on a single paper grade. However, most of the negatives that are so exposed do, in fact, print on normal grades. As was just noted, the method is most suitable for relatively static subjects. It is also especially useful where shadow detail and other dark tones are of overriding importance, as is often the case in scientific photography. This is not my only method of exposure determination, but I frequently find it to be convenient.

EXPOSURE BY FLASH

So far, we have been dealing with the problems of exposure when continuous light sources are used. These are sources, such as sunlight, indirect daylight or the common types of artificial lighting, that can be readily measured with ordinary light meters. This section of the book consists of a discussion of flash lighting, with its special techniques for exposure determination.

Nature of Flash Lighting

Before we actually go into problems of exposure determination as such, I would like to make mention of some of the conceptions and misconceptions about the nature of flash lighting that exist in people's minds. Flash photography, defined here as artificial lighting by means of short-duration sources, is one of the most used and least understood modes of photography. There are various types of flash equipment, the two most common being electronic flash (often mistakenly called "strobe"), and bulb flash, which uses nonreusable flash bulbs, or cubes (small multiple reflector devices containing four built-in flash bulbs, which are capable of being rotated so that each bulb is fired separately). We will not go into the distinction between the two, or other descriptive matters, except where they are essential to the explanation, since these matters were presented earlier. (See "Flash Equipment," pages 45–51.)

Light Is Light The primary concept to keep in mind in flash photography is that light is light. Other than the relatively short burning time of flash sources, there is no substantive difference between flash illumination and any other light source of the same approximate color qualities, as far as its effect upon the appearance of the picture is concerned.

Lighting Contrast Characteristics Many people feel that the "quality" of light produced by flash is somehow different in nature from other light. I have heard some people say that it is harsh and contrasty, and others go to the other extreme and call it flat-looking and uninteresting. Certainly many flash photographs show one or the other of these characteristics. However, these appearances are not inherent in the equipment. They result from improper usage.

Probably the vast majority of all flash photographs, whether using bulbs or electronic flash, are made with the flash unit securely fastened directly onto the camera. This is easy and convenient and (if simple directions are followed) will result in satisfactory exposures. Satisfactory, that is from the point of view that there will be no deep obscuring shadows in the picture, and that the negatives will be printable. But, because the light travels parallel to and very close to the optical axis of the lens, the lighting is directly frontal. This gives a most unnatural appearance, with little or no indication of subject shape or surface texture. It is through the interplay of highlights and shadows that you get good modelling. Ringlights, small circular electronic flash units that surround the camera lens, are notorious for producing flat lighting effects. In addition, with ringlights half of the light comes from below the camera axis. Since such lighting in nature is very rare, the unnatural appearance of the photograph is increased.

In order to counteract this unattractively flat lighting effect, many articles have appeared in the photographic press urging people to "get the flash off the camera." This is good advice, and many photographers have responded to it. However, when you do remove the flash unit from the camera (retaining, of course, the synchronization cord connection), you must learn a little about lighting. Human beings are perverse. They often take advice partially, doing only the easy part and ignoring that which requires any effort. So they move the flash unit away from the lens axis randomly, paying no attention to the resulting lighting angles, getting horribly contrasty pictures with harsh shadows in all the wrong places, and then blaming the equipment. If you take a moment's thought, you will see that it is actually very easy to predict the results of any lamp position. Place one eye next to the flash unit, and look at the subject. Everything that you can see with that eye will be lit; everything that you cannot see will be in shadow.

There are many literary sources having to do with photographic lighting. No matter what your subject matter, you can find help. There are a number of booklets available from Kodak having to do with various lighting problems (see their *"Index to Kodak Information,"* an annual publication), and a number of good books on the subject. (One of the better of these is Bomback's *Manual of Photographic Lighting*—see the Bibliography. Other good sources are Ansel Adams' *Artificial-light Photography*; and, for small object lighting, my own earlier book *Photography for Scientific Publication*.)

Presumed Special Character of Electronic Flash When it was first introduced a number of years ago, electronic flash came as a first hint of the new complexity of the coming electronic age. Apparently this bemused some early users, because a couple of mildly peculiar beliefs devel-

oped, and have shown remarkable tenacity over the years.

As a result of the first of these, it became quite widespread practice to give additional development to negatives exposed by electronic flash, on the odd grounds that electronic flash produced lighting that was "soft" and of low contrast, thus requiring extra processing time to return it to normal. I believe that this belief was a response to the results of the improper use of these flash units due to a failure to understand their characteristics. By coincidence, each of the common misunderstandings resulted in mild underexposure, with its consequent lowering of negative contrast. Overdevelopment, though it did not correct the underexposure, did raise negative contrast, and thereby made the negatives easier to print.

Early electronic flash units had very short flash durations, thus introducing underexposure due to reciprocity failure. Photographers were familiar with the long-exposure reciprocity failure, but few of them were thoroughly familiar with the short-exposure failure, not having been exposed to it before. In addition, photographers were often not sufficiently aware of the need to allow sufficient recycling time between flashes in order to get full light emission. A few photographers may also have been caught out when the exposure information supplied by some manufacturers turned out to be a little optimistic. Standardization came late to this field. All of these factors, singly or in combination, result in the same effect—underexposure.

Another misconception commonly held was that electronic flash was better than bulb flash, in that it was less likely to overexpose foregrounds and underexpose backgrounds. It was said to have a "more even reach". That is, lighting distribution over distances was said to be more even. This is a violation of the inverse square law of light intensity falloff, and hence

is not very likely. Nevertheless, photographic writers who should have known better have put this misconception into print, either directly or by implication. To repeat an earlier statement, light is light. It obeys the same laws of physics regardless of source.

I suspect that this second myth came into being because most of the early commercial electronic flash units were quite large. (The many very small units now available are a recent development.) They were designed to provide a sizeable light output, and consequently they had fairly large guide numbers. Larger guide numbers result in longer basic flash distances, and longer flash distances—as will be seen—result in relatively less light falloff over a given distance of subject matter. A photographer using a powerful electronic flash unit in lieu of flash bulbs of lower power might come to believe that the observed result was a characteristic of the type rather than of the size. In justice, I should say that I have seen this second myth less often than the first.

The lesson is that it pays to know both your equipment and the basic physical principles by which it operates. (Those who are really curious about electronic flash should consult Edgerton's *Electronic Flash, Strobe*—see the Bibliography.)

Special Flash Lighting Problems

There are two generally occurring problems that are likely to trouble users of flash lighting in photography. Their causes are unrelated to one another.

Pink Eye When flash photography of living animals or people is done with the flash unit attached to the camera or with a ringlight around the lens, a common problem called "pink eye" can occur. If the subject is looking

directly at the camera, and the light is next to the lens axis, light passes directly into the subject's eyes by way of the pupil, and is reflected strongly back to the camera. In color photography this is seen as a pink or red spot in the center of each eye—the interior of the eye being primarily red in color. In black-and-white photography, the effect is of white pupils, instead of the expected black. In either case it is quite disturbing in the picture.

There are two cures for pink eye. The simplest is to take a photograph only when the subject is looking a little to one side of the camera lens; however, this is not always practical. The best method is to move the flash unit significantly away from the lens axis. Kodak's latest small cameras for amateur use come provided with a post which elevates the flash bulb away from and above the lens axis, thus alleviating what had turned out to be a bothersome design difficulty. You can buy or make a similar spacing bracket for use with any flash unit on any camera, or you can simply hold the flash unit away from the camera with one hand, retaining only the necessary flash synchronization cord between flash and camera. Ringlights, too, can be dismounted from the camera and used like any other flash unit, if pink eye is a problem.

Ghost Images In many flash photography situations there is the possibility that light sources, or bright reflections, in the picture area will be strong enough to record as images on the film, even though the general ambient light level is too weak to be recorded. These secondary image effects are called "ghost images," because they frequently take the form of rather amorphous white or light smears across the picture. This happens relatively less often with bulb flash, because the light-chopping action of the shutter makes the effective exposure duration the same for both shutter and flash. Only at unusually long shutter times would ghost images be likely to occur. However, things are different when electronic flash is used with the common 35 mm cameras that are equipped with focal plane shutters. The flash duration that provides the subject illumination is very short, but the shutter speed is relatively slow. Thus, any ghost images are smeared by camera or subject movement so as to produce the classic ghost effect. Particularly troublesome are things such as the headlights of a moving automobile, which will be smeared across an otherwise black background in a night flash picture.

Probably, the best cure is simply an awareness of the problem. You can try to see that such disturbing elements cannot enter the subject area during an exposure, or you can at least put the camera on a tripod so that camera movement will not complicate matters. When in doubt, try to meter the brightness of possible interfering elements and adjust the shutter speed, diaphragm opening, and flash distance so as to underexpose the most likely visual disturbances. Eliminate ambient light sources from the picture area wherever possible. For those equipped with the Pentax 6 × 7 cm camera, there is a Takumar lens mounted with a leaf-shutter, which is designed to surmount this problem through by-passing the focal plane shutter entirely. Certain other cameras can take advantage of similar arrangements. (See your dealer for details.)

Fortunately, ghost images are relatively infrequent in natural science work, being much more likely to occur in night sports or police photography.

Insufficient Coverage Should you need to do wideangle photography at night, in caves, or under other circumstances requiring flash lighting, you will probably find it necessary to make use of a technique called "painting with light."

Most flash units have a beam angle (spread of light) approximately equal to the acceptance angle of normal focal length lenses. A few have special attachments that spread the beam to equal the coverage of a 35 mm wideangle lens, with a stated correction in the guide number to account for covering this larger area with the same amount of light energy. In wideangle photography, if your flash unit does not have such an attachment, or if you are using a lens with an even greater acceptance angle, only the center of the picture area will be correctly exposed.

In order to handle this situation, you can cover the subject area with light by means of a number of separate but slightly overlapping flashes. If you have the equipment, you can set several flash units in place so as to cover the subject simultaneously. (Some years ago, as an advertising demonstration, Sylvania Electric Co. did a series of night flash photographs including one of an entire town and another of a whole ocean liner, using as many as 5000 simultaneously fired flash units.) If you do not have the equipment, a single unit can be flashed serially, moving it as many times as needed, during a short time exposure. (I have used as many as 15 separate flashes in one architectural interior photograph.) There should be no visible lack of evenness if some overlap in the sequentially illuminated areas occurs. Most flash units have some falloff in light intensity near the beam edges, so this overlapping tends to compensate for this deficiency.

To estimate the number of flashes needed to cover a given area, assume that a normal flash unit will cover a width of subject area equal to about 80 percent of the flash-to-subject distance. Use the viewfinder to determine the exact area to be covered. You will then be able to work out quite easily the number of flashes, and the necessary pattern for "painting" the whole subject area with light. Set the camera on the tripod as desired, open the shutter, and walk around firing flashes as you've calculated, being sure to keep the flash-to-subject distance constant. Do not stand between the camera and the particular portion of the subject being lit at each flash, or you will register on the film as a series of silhouettes. Stand to one side, and aim the flash unit at an angle at the subject area. As an example, a 35 mm focal length wideangle lens, used with a 35 mm camera (or any other equivalent proportion—that is, a lens having 70 percent of the normal focal length) will require four normal flashes, in a square pattern.

A simpler way of increasing the area of a subject that is covered with light is to increase the flash-to-subject distance until the needs of the particular wideangle lens are met. As this distance is increased, the expansion of the cone of rays from the flash unit will naturally allow the light to cover a larger area. However, you must then accept a lower light level at the subject position because of inverse square law effects. And you must be careful to avoid throwing the shadow of the camera and/or operator across the subject. With low powered electronic flash units and slow speed films this solution may not be practical.

Light painting can also be done with a continuous light source such as a photoflood lamp, but a correct, even exposure is somewhat more difficult to work out.

When using a flash unit in light painting, the correct exposure is not difficult to determine. It is the same as for normal flash use, since you are just increasing the area that is lit, rather than the light intensity. I find it most useful first to decide what lens aperture is to be used, the depth of field being an important matter in most cases. Divide the guide number by the f-number

to be used, and you have the necessary flash distance to the subject, in feet.

Unusual Flash Lighting Sources

Although most field photography in the natural sciences will involve only the conventional flash equipment mentioned earlier, there are circumstances that require the use of less common devices.

Stroboscopic Lighting There are times when it is desirable to record on one film frame a series of high speed flash images of a fast moving subject, in order to show its path, speed of progression, or the characteristics of its locomotion. (Well known examples of this type of work include the widely published photographs by Gjon Mili, of such things as golfers in action.) The subject is shown against a nonreflective black background, and is lit by the repetitive flashes of a stroboscopic lamp. This is a specialized form of electronic flash unit, which incorporates a control device that usually allows flash repetition rates of from 1 to 60 or 100 flashes per second. The repetition rate is controllable by the photographer. Ordinary electronic flash units will generally not recycle quickly enough for this use; and if they did, they would overheat very rapidly. Therefore, special equipment is required. A few generally available electronic flash units do have limited strobe ability, notably a unit provided by Nikon to operate in conjunction with their motorized camera. For a limited time, it will fire at a rate of four flashes per second, synchronized with the four exposures per second of the camera. A few other makes also offer similar capability.

If you need a relatively small number of flashes in circumstances where knowing the exact rate of flashing is less important than recording such things as the paths of subject progression, you can improvise a workable setup using several of the inexpensive small electronic flash units that are now readily available. Make up a trough which has on its bottom the required number of electrical contact plates. In the trough you place a rocker capable of completing the circuit. In use, you open the camera shutter, rock the rocker as the action takes place, and thereby create a sequential flash operation. The rate of flashing varies with the speed of the rocking motion, and can be quite high. Variations on this theme include using electrical sequence switches, or keyboards, for firing, as well as the use of automatic flash units (at a higher basic cost) so as to achieve shorter flash durations. (For some ideas on this subject see Farber's "Photo-tronics" column, *Modern Photography*, March, 1974. Edgerton, in *Electronic Flash, Strobe*, offers many ideas in more complex veins—see the Bibliography.) Stroboscopic photography is a very useful analytic device. I leave the possible applications to your imagination.

Magnesium, Powder or Ribbon Before the invention of selfcontained flash bulbs, the most widely used source of flash illumination was flash powder. Composed primarily of finely divided magnesium, flash powder was placed in a holder similar to a bricklayer's mortarboard. This was held up like one of today's flash units, and was electrically ignited at the decisive moment. The result was an audible "whoomp," accompanied by a blinding flash of photographically useful light, which was followed by a large cloud of white smoke and a perceptible fallout of magnesium oxide. Occasionally, secondary fires were started. (Photography was more exciting back in the good old days.)

Crude though this method may seem, flash powder was very useful, and many fine pictures were produced with it. More than that, believe it or not, magnesium lighting is still of occasional use today. Magnesium ribbon, and sometimes magnesium powder, is probably most often used in lighting exceptionally large underground caverns, where available flash units would be too weak to provide the needed energy levels or where residual dampness might short out the more complex electrical connections needed. It does involve the disadvantage of having to wait 30 minutes or so between exposures, for the smoke to clear. But there may be no more practical means at hand. (For examples of exceptionally fine cave photography, and a description of cave photo technique, see Bögli and Franke, *Luminous Darkness;* for more on photo techniques in caves, including the use of flash powder, see Kinne's *Nature Photography*—see also John's *Photography on Expeditions,* which includes exposure data.) Flash powder will give a fairly short flash duration. Ribbon will burn progressively, and thereby allow time exposures. Both are poor for use with color film due to color imbalance, but do well with black-and-white.

WARNING: Flash powder is dangerous, as each charge amounts to a small bomb. Handle with great care.

Flash Exposure Techniques

There are two basic ways of determining exposure with flash. The light can be metered; or, by knowing the light output of the flash bulb or electronic flash unit, the correct exposure can be calculated.

Flash Metering As was noted in the equipment section, normal light meters do not respond to pulsed or flash lighting, so a special flash meter is used. Although internally they are very different and operate on quite different principles, flash meters bear an external similarity to other light meters. The mode of operation depends on whether the meter will be used for measuring incident or reflected light, whether shutter operation will be taken into account, whether ground glass readings are needed, or whether one flash will be recorded or several integrated. Since, at the time of this writing, there is less constructional standardization in flash meters, I will not attempt to go into operational details here. As far as the principles of use are concerned, flash meters are used much like other light meters.

Flash meters are especially useful when your lighting technique is a little nonstandard, making calculation of exposures by guide number difficult. This might be the case when an unusual or multiple lighting setup is being used, when the light output of flash powder is being calibrated, or when diffusing screens are being used in front of your lamps.

In the September, 1974, issue of *Petersen's PhotoGraphic,* there is an article describing a means of "flash metering" using ordinary light meters, by means of calibrating an incandescent light source to a given flash unit. The method is quite practical. (See "How To Meter Electronic Flash," p. 29—no author is listed.)

Exposure by Calculation Although light meters are considered standard equipment in normal photography, flash meters have been only recently introduced, and are not yet in wide use. Therefore, in the vast majority of all flash photography, exposure determination is by calculation. This is true, whether the handy calculator found on the case of virtually all electronic flash units is used, or whether things are being

worked out a little more laboriously for a complex lighting setup. Fortunately, individual flash units now have little or no flash-to-flash output variations. Variables are few, and anyone doing much flash photography of any given type rapidly gets to the point where all the relevant calculations for his or her particular setup have been worked out and put into tabular form. (If you don't tabulate your calculations you are wasting a lot of time.) The calculation of exposure for flash photography uses a simple arithmetical formula involving the relation of the inverse square law to the light energy output of the flash source by means of what is called a "guide number." (See the text following page 87, and Figure 19, for related material—for convenience much of this material is repeated here.)

The Inverse Square Law. With a light source of relatively small size, the light is assumed to radiate equally in all directions. Because of this, the same amount of energy must cover an ever larger area as the distance from the source increases. Therefore, its delivery of energy to a subject of the same size decreases with distance. This *relative energy decrease* is constant over linear distance, and is described by the inverse square law as diminishing in proportion to the inverse square of the distance. That is, if a given source-to-subject distance is doubled, the light intensity falling upon that subject will be only one-quarter as strong. Triple the distance, and the light intensity diminishes to one-ninth. Quadruple the distance, and the light energy falls to one-sixteenth. And, of course, if you reverse direction, the light intensity on a given subject area will increase in the same proportion, as the distance decreases.

Although flash lighting sources are not infinitely small, and the reflector does affect matters, the inverse square law applies with sufficient accuracy in this context to form the basis for all calculated flash exposures. (See Plate 10 for an example.)

The inverse square law is applicable whenever light radiates from a point. This includes the light projected by a lens—in this case the center of the optical system is considered as being the point source. Thus, it can be used to calculate the effects of changing lamp distances with any source, flash or continuous; and it is used to determine light intensity changes when the lens-to-film distance is changed dramatically, as in photomacrography, or when changing the projection scale of a slide projector or a photo enlarger. These matters are dealt with as they arise, later in the text. (See especially the text following page 288, on closeup photography and photomacrography.)

Guide Numbers. In order to calculate exposure changes over varying flash-to-subject distances, it is first necessary to know the basic light output of the source. The method used to provide standard information of this nature is to assign a "guide number." This is a value indicating the amount of effect that the source will have on a film of a given speed, under specified standard circumstances.

Electronic flash units will have one guide number for each film speed unless there is more than one power setting. The instruction booklet accompanying the unit at purchase usually lists only one or two guide numbers, for specific films. There is a formula that will allow the determination of other guide numbers when only one is known, which is usable when your flash unit has no calculator dial. Simply expressed, you multiply the known guide number by the square root of the product of the ASA speed of the new film divided by the ASA speed of

FORMULA A
Deriving flash guide numbers from a comparison of film speeds

SYMBOLS	DEFINITIONS	EXAMPLES
A	Known guide number	45
B	New film ASA number	160
C	Old film ASA number	32
D	New guide number	? (unknown, to be calculated)

Formula

$$D = A \times \sqrt{\frac{B}{C}}$$

$$D = 45 \times \sqrt{\frac{160}{32}}$$

$$D = 45 \times \sqrt{5}$$

$$D = 45 \times 2.2 = 99$$

(As references, see Kodak publication AC-37 and GE publication P1-63P.)

the old film. Sound confusing? Not really. To take the curse off, let me remind you that, for a given flash source, you only have to figure it out once if you tabulate the results. Let's reduce it to terms, and look at Formula A. Using this formula is made easier if a table of common square roots, such as Table 9 (page 126), is provided.

If your flash unit has a calculator dial you need not go through all that. To figure a new guide number, or to obtain a guide number for a unit whose instruction book is missing, simply follow these steps:

1. Set the film ASA on the calculator.

2. Look for the f-number opposite the ten foot distance mark.

3. Your guide number is equal to the f-number times ten.

With flash bulbs, guide numbers vary with the camera shutter speed as well as with the film speed, since in effect the shutter is chopping the basic light output of the bulb into segments. Therefore, it is necessary for the manufacturer of the bulb to provide a table of information. Each package of bulbs has this table printed on it. (Comprehensive tabulations for all available bulbs are available in booklet form, such as GE publication PI-63P—see the Bibliography.)

Before going into the purposes and uses of guide numbers, I would like to call your attention to the word "guide" and to my use of the phrase "specified standard circumstances" in the first paragraph of this section. This number

PLATE 10 ▶

Flash exposure technique. A Western Garter Snake at Mendocino, California, in motion among grass blades, shown here five times actual size. (The original image magnification was ×$\frac{1}{2}$; the original Kodachrome slide was enlarged when it was copied into black-and-white.) This photograph, with good depth of field and with action stopped, was made by using an M3B flash bulb, synchronized at 1/1000th of a second, with a lens aperture of f/32.

TABLE 9
Table of Common Square Roots

NUMBER	ROOT	NUMBER	ROOT
2	1.41425	12	3.464
3	1.7322	14	3.74
4	2	16	4
5	2.236	18	4.24
6	2.45	20	4.47
8	2.828	25	5
10	3.16	30	5.477

is just that—a guide. Conditions of use can change it up or down. When the suggested guide numbers are being calculated, it is usually assumed that the full rated output is being received from power cells, and that nearby reflecting surfaces, such as walls, are present. You may find that this information is inaccurate, and therefore a poor "guide," if you use a flash unit under circumstances other than those that the manufacturers have assumed in their calculations, such as in an unusually close approach to the subject, where there is a lack of nearby reflecting surfaces, or if you have weak or worn out power cells. Don't be too quick to blame the manufacturer for poor results. Look first for conditions that differ from the standard, and, if there is one, correct for it.

Procedure of Calculation. Once the guide number of the flash source is known, exposure calculation is simple. Measure, or estimate, the flash-to-subject distance, in feet. (Although this is not necessarily going to be the same as the camera-to-subject distance, you can use the focusing scale of the camera as a range finder at normal distances.) Then divide the guide number by this measured distance. The result is the f-number that will yield a correct exposure (assuming that the subject matter has normal reflective characteristics). Again, let's formulate it and provide an example (Formula B).

If you decide at this point that a greater (or lesser) depth of field is needed, you must determine the f-number needed, and then reverse the formula. For an example, use the same terms, assume a need for f/11, and use Formula C.

If you are using an electronic flash unit that has a dial calculator on it, it is even easier since the calculator is direct reading. Simply set the ASA speed of the film being used and look opposite the proper distance mark in order to find the correct f-number. No arithmetic is necessary. In order to find the flash-to-subject distance without calculation, just reverse the process and use the distance that appears next to the desired f-number.

Variations There are some very useful ways of using flash photo technique that are not as straightforward as the methods described so far. Following are some suggested elaborations.

Bounce Lighting. The most frequently used method of countering the harshness of off-camera flash is to bounce the light off a suitable reflecting surface. The result is a directional but soft effect of lighting. If used correctly, it has a very pleasant appearance. Contours and surfaces are well modeled, shadow lines are indistinct, and shadow areas are lit sufficiently to reveal detail. Background shadows are lighter and less disturbing to the eye.

The methodology used is somewhat variable. The simplest technique is to make use of an existing light-colored wall or ceiling as a reflecting surface. In field work, a nearby stone face might serve. A more versatile method is to use an umbrella with a white or silvered interior. The flash unit is pointed into the interior of the

FORMULA B
Calculation of flash exposures with guide numbers (Solving for f-number)

SYMBOLS	DEFINITIONS	EXAMPLES
GN	Guide number	45
FD	Flash-subject distance	8 feet
f	f-number	? (unknown, to be calculated)

$$\text{Formula} \quad f = \frac{GN}{FD}$$

$$f = \frac{45}{8}$$

$$f = 5.6$$

umbrella, and the umbrella handle is pointed toward the subject, from the desired lighting angle. It is most effective with a fairly strong unit. When first introduced, umbrella flash was strictly a studio technique, both flash and umbrella being quite heavy items. However, smaller, lighter umbrellas are now easily available, and are adaptable for use with any flash unit. The primary advantages of umbrella flash are that you are not dependent upon the presence of an existing surface, you are not subject to problems relating to the color of that existing surface, and you can place the umbrella so as to get maximum efficiency from the bounce lighting, from any lighting angle.

There are two matters that affect the exposure calculation when using bounce flash. First, the flash-to-subject distance must be measured, or closely estimated, in an additive two-step manner. That is, from flash unit to reflecting surface, and from that surface to the subject. The flash-to-subject distance is the sum of the two, as shown in Figure 23. This obviously results in a longer than normal flash distance, and therefore a wider lens aperture, all other factors remaining equal.

The second exposure calculation problem is that the reflecting surface, because it also acts as a diffuser, diminishes the light intensity by a considerable amount. The light loss is equal to about two stops. Depending upon the nature of the surface, it could be slightly more or less. Allowance must be made for this effect in the final exposure calculation, or the picture will be hopelessly underexposed.

Other than loss of light energy, the primary pitfall in bounce flash is the possibility of significant color in the reflecting surface. If that surface is noticeably tinted, light reflected from it will be similarly colored. From a scientific point of view, it does not take very much tinting

FORMULA C
Calculation of flash exposures with guide numbers (Solving for flash distance)

$$\text{Formula} \quad FD = \frac{GN}{f}$$

$$FD = \frac{45}{11}$$

$$FD = 4 \text{ feet}$$

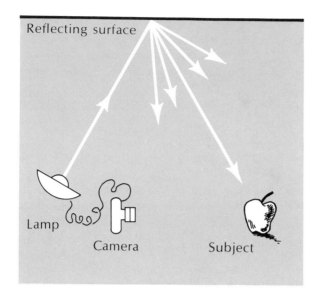

Reflecting surface

Lamp

Camera

Subject

FIGURE 23
Bounce flash.

of this nature to be destructive to color accuracy.

On the whole, even with a total exposure disadvantage of some three stops, bounce flash is a real plus in the technical bag of tricks.

Diffused Lighting. Another method of achieving soft lighting effects, frequently less cumbersome than bounce flash, is to diffuse the light. In its simplest form, this involves wrapping a single layer of thin white cloth or cleansing tissue around the flash head. For greater diffusion, hang a good-sized sheet of white tracing tissue between the flash unit and the subject. The former method is a very useful field technique, yielding moderate control; the latter, although it offers more control, depending upon the relative size and position of the diffuser sheet, is less usable outdoors, owing to possibly adverse wind effects, and the need for support.

Exposure is always adversely affected by diffusion lighting methods. One layer of thin white cloth or tissue over the flash head involves about one stop of light loss. Interposing a large sheet of tracing tissue between lamp and subject loses two to three stops of light, depending upon the distances between the lamp and diffuser, and the diffuser and subject. A flash meter would be very useful here. Otherwise, some experimentation is in order. Or, if haste is involved, exposure bracketing will cover you.

Bare-Bulb Flash. If soft lighting of shadows is to be combined with distinct modeling of subject contours and textures, if there are light-colored surrounding surfaces for reflection, and if you are using a bulb flash, or an electronic flash unit with a removable reflector, then you might try bare-bulb flash.

In this technique, the lamp reflector is removed and light is allowed to reflect onto the subject from all the surrounding surfaces. Yet, at the same time, the bulb itself serves as a point source of light, providing the distinct subject modeling characteristic of the technique. It works well when all the circumstances are as described.

A useful field application of bare-bulb flash is in the photography of very shiny beetles, and the like. With no reflecting surfaces around, only the bulb itself lights the subject. Being nearly a point source of light, its specular reflection on the shiny surface of the subject is very small, and is thereby less disturbing to the eye in the final picture. Large sources, or diffused lighting setups, produce specular reflections large enough to obscure a significant amount of detail, unless they are handled with unusual skill.

Exposure is affected adversely by removal of the lamp reflector. With reflecting surfaces around the subject to help out, the light loss

is only about one stop. With no reflecting surfaces, the light intensity on the subject drops by about two stops. Again, I'd suggest either some advance trials or a little exposure bracketing.

Multiple Flash for Exposure Buildup. Flash bulbs and electronic flash units come in a wide variety of strengths and sizes, but most of us are strictly limited in what we have available for use at any given time. This is especially true in the field, where you simply cannot take everything along that you might like to. (The most powerful electronic flash unit that I ever had in my custody was designed for field use, but required a four-engined aircraft to carry it.) And even with the most powerful flash gadgetry, there will be times when the available light output will not be strong enough. The need for such exceptionally great power output is not especially frequent, but it could occur where you were working at high magnification with slow film and a small lens aperture. Or you might be doing night telephotography of an unapproachable subject. One thing that you can be sure of, the need will eventually arise.

Fortunately, there are ways of taking maximum advantage of what we do have. We can repeatedly fire the same flash unit, until the correct exposure builds up, if our subject will hold still. For moving subjects, there are two other solutions. If we have more than one flash unit we can fire several of them simultaneously, or if we are using flash bulbs we can use one flash unit to fire a number of bulbs all at once. In all cases mentioned here, remember that we are lighting the same area with all of the flashes being used, solely to increase the light energy acting upon the film. (On page 135 and again following page 415 we discuss balanced-ratio flash, a method whereby several units can be used together from varying angles, in order to improve the overall lighting balance; that is a totally different matter.)

In the first method, serial firing, we are just keeping the camera shutter open and repeatedly firing, laying one flash illumination atop another until the total light reaching the film is sufficient for an exposure. In the second, it is a matter of massing several flash units together, with electrical connections used to fire them simultaneously by way of shutter synchronization.

The third method is an old press photographers' trick—now largely forgotten in this age of sophistication. This is useful with flash bulbs only. It appears crude, but works well. In a single flash reflector you insert one flash bulb in the normal manner. This is your trigger circuit. All the other bulbs are then placed radially around it, with their bases facing radially outward. Each bulb should be fastened with transparent tape so that its glass envelope is *touching* that of *the trigger bulb*. (It is irrelevant whether subsidiary bulbs touch each other, but they *must* all touch the trigger bulb if they are to fire simultaneously, as shown in Figure 24.) In use, the camera shutter is opened and the flash is fired manually, or by a delayed circuit. The trigger bulb is ignited by electricity in the normal manner, and all others touching it ignite by heat transfer through the contacting glass envelopes. You cannot synchronize this resulting "whopper" flash with the shutter, because there is a delay between the firings while the trigger bulb is heating up the others enough for them to burn. The main group burn in the same time scale as a single bulb, and have a short enough flash duration to stop moderate motion (10–15 milliseconds, depending upon the type of bulb being used). As with other "open flash" methods, ambient light levels must be quite low, or ghost images may result. But the method

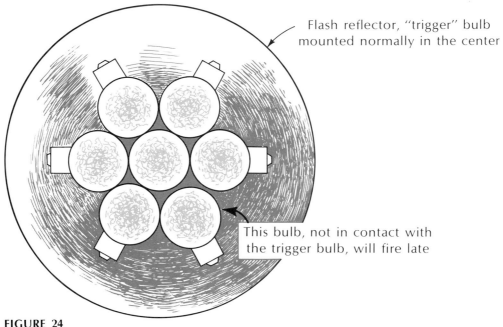

Flash reflector, "trigger" bulb mounted normally in the center

This bulb, not in contact with the trigger bulb, will fire late

FIGURE 24
The "whopper" flash.

does provide a considerable increase in light output. This method does not work dependably with the larger bulbs, such as the #5 or FP-type designations, but it does work very well with AG-1's and M3's.

There is a recently marketed commercial device that allows the simultaneous firing of from one to five AG-1 bulbs, mounted on GE Flash Bars, in full synchronization with the camera shutter. The number of bulbs to be fired is controlled by a simple push button contact. This gadget is called the Kalimar Select-O-Flash. (See your dealer for details of price and availability.) With a little ingenuity, I see no bar to using more than one of these attachments at a time if you want to use more than five bulbs. Just add a multiple socket adaptor to the PC-connector. The Select-O-Flash unit also has an exposure calculator on it.

The basic exposure calculation problem is the same for all three methods of multiple flash described above. Because the exposure relationships in photography are logarithmic rather than linear, you cannot just add one bulb for each additional stop of light needed. You have to use the same system of doubling in use in other exposure calculations. Depending upon how you prefer to approach the problem, there are three ways of working out how many flashes (or bulbs) are needed in given circumstances, or, conversely, how to determine what the aggregate guide number will be.

The most direct and widely useful method (derived from GE publication Pl-63P—see the Bibliography) uses a formula to determine how many bulbs or flashes will be needed. The mathematics are easy, being simple arithmetic. The procedure is as follows:

1. Determine the needed guide number, by multiplying the flash-to-subject distance (in feet) by the f-number that you wish to use.

2. Divide the needed guide number by the known guide number, and square the result to get the number of flashes needed. This is shown in Formula D.

Another method (listed in *"Flash Photography,"* Kodak publication AC-2—see the Bibliography) involves a determination of the new guide number as you increase the numbers of bulbs or flashes. Using it, you can empirically figure what you will need to use without resort to the foregoing formula. To learn the aggregate guide number with this method, multiply the guide number of the flash unit or bulb that is available, by the square root of the number of bulbs or flashes used. (See Table 9, page 126, for a table of common square roots.) Thus, if you are using two bulbs, multiply the single-bulb guide number by 1.41425, the square root of two. If you are using five bulbs or flashes, multiply that original guide number by 2.236, the square root of five, and so on.

Perhaps the simplest looking approach (listed in the *"Thomas Strobemeter Manual"*—see the Bibliography) is as follows:

1. Determine the number of stops of exposure between that available with one flash, and that needed.

2. For each additional stop needed, double the number of flashes.

In short, if you need one stop more light, use two flashes instead of one; if you need two stops more light, use four instead of one; if you need three stops more, use eight instead of one, and so on.

These modes of calculation are roughly equivalent, each providing information in a slightly different way. You may want to use any or all, according to what you intend to do at any given time.

There are, as is usual in photography, pitfalls. If the number of separate repetitive flashes is very high, it will be found that reciprocity failure tends to produce some underexposure. One of the ways in which reciprocity failure shows itself is that the effect upon the film gained by using a series of short exposures is not quite equivalent to that gained by using one long exposure of the same aggregate length. So, testing may

FORMULA D

Determining the number of flashes needed for multiple flash

SYMBOLS	DEFINITIONS	EXAMPLES
GN_n	Guide number needed	1200
GN_a	Guide number available	400
X	Number of flashes required	? (unknown, to be calculated)

$$\text{Formula} \quad X = \left(\frac{GN_n}{GN_a}\right)^2$$

$$X = \left(\frac{1200}{400}\right)^2$$

$$X = 3^2$$

$$X = 9 \text{ flashes}$$

be in order in extreme cases. And, in the clustering of a number of bulbs in one reflector, as in the "whopper" flash, there may be some lessening of light output by reflector inefficiency. This occurs because most of the bulbs used in the reflector are off center and, with metal base bulbs, the bases block off part of the reflector. However, all of the methods described do generally work.

Projected Flash. The technique called projected flash is allied to the thrust of the previous section, in that the intention is to increase light energy at the subject position. This is useful when you have only one flash unit, or a limited budget for flash bulbs, or if you need to reach out to a great distance with your light. The aim is to maximize light efficiency by narrowing the beam spread of the light emitted by your flash unit. This will raise the guide number of your unit considerably, at the cost of greatly reducing the size of the subject area covered. However, it is especially useful when synchronized flash is being used with telephoto lenses for photographing small, moving subjects at considerable distances. Photography of birds or small mammals is greatly aided, especially when working in forests, at dusk, or in other low light situations (see Plate 11).

A method of projected flash that you can put together yourself from readily available components was developed in Germany by Hermann Eisenbeiss and published in this country by Ed Scully (see the Bibliography). Briefly put, a plastic fresnel lens* with about an eight to twelve inch focal length is placed in front of a bulb

*A fresnel lens is a lens whose bulk and weight have been reduced by, in effect, cutting concentric segments out of the convex curve of the lens and applying them to a thin base as concentric ridges. Such lenses are poor image formers, but good light projectors.

or electronic flash unit. If the flash-to-fresnel lens distance is correct, a very narrow-angle beam of light can be projected. This distance is critical, and small changes make considerable exposure differences. You must determine the guide number by experimentation, making exposures at one stop intervals over a wide range, and then deciding which is correct after processing the film. Use of color transparency film makes this judgment easier, because of its relatively narrower exposure latitude.

Once a basic guide number is arrived at, and as long as the flash-to-lens distance remains the same, subsequent exposures can be calculated for various subject distances in the usual way. Even though the beam has been narrowed, the inverse square law remains in operation. With this type of unit about a $5\frac{1}{2}$ stop increase in the guide number is obtainable. See black-and-white Plate 11 for examples of the results.

This distance from the face of the electronic flash unit, or from the flash bulb, to the back

PLATE 11 ▶

Projected flash. By using a plastic fresnel lens to narrow the beam angle of a standard flash unit, it is possible to increase beam intensity by about $5\frac{1}{2}$ stops, maximum. This is useful in many telephoto problems. (a) A plum, deeply shaded in a tree, by natural lighting, f/16 at 1/60 second, the best speed I could achieve with my Celestron 5 1250 mm mirror lens under the given circumstances (at a 35 foot distance). This lens has a photographically effective speed of f/16. (b) The same situation, but with projected electronic flash added. (The white lines in both pictures are out-of-focus spaces in the foliage, which let sunlit grassland show through.) (c) A young Scrub Jay photographed in shade at 40 feet, using projected flash with the same Celestron 5 mirror lens. Without the flash, the bird would have been only a silhouette, unless a very slow shutter speed had been used. Only the use of a projected high speed flash rendered the picture both sharp and adequately lighted. Without projection, the required lens aperture with the film and flash unit used would have been f/2, at the 40 foot distance—an impossibility with the nonadjustable Celestron lens.

surface of the fresnel lens should be somewhat over the focal length of that lens, the exact distance depending upon how narrow the beam is to be. By flashing at a target while moving the lamp back and forth, you can set its width to your taste. With a lens of 12 inch focal length, a distance of about 14 inches yields a very tight beam. Most small electronic flash units have a grid-type fresnel lens over the flash tube in order to increase efficiency. If your unit projects an uneven pattern because of this grid, cover it with a single sheet of fine-grained tracing tissue. The projected flash beam efficiency is not as great as it would be if a point light source were used, but is still good enough to be useful out to 75–300 feet or so, even when relatively low powered basic light sources are used. "Reach" is, of course, strongly affected by the aperture of the lens, and the speed of the film. The smaller the actual source the better the efficiency, and the tighter the beam. Therefore, if you are using bulb flash, remove the flash reflector if possible (or fold up the fan of a fan-type reflector).

A commercially available (by special order) device is made in France, and is called the Camera 7 Maxiflash (at this writing the address of the manufacturer was Camera 7, 7 Rue La Fayette 75, Paris 9e, France). This device consists of a light-weight, asymmetrical mirror, with a clamp to fit most small electronic flash units. The flash unit is placed in front of the mirror, pointing up and back at it. The mirror, basically a segment of a paraboloid, condenses the light into the required narrow beam and projects it forward over the top of the flash unit. There is an exposure calculator dial on the back of the mirror. A recent U.S. introduction is the Norman 200-B, which attains a 12 degree spot effect with a parabolic reflector. At 200 watt/seconds input, a guide number of 800 is claimed for ASA 400 film. (Manufacturer: Norman Enterprises, 2627 West Olive Ave, Burbank, California 91505.)

Obviously, the narrow beam angle of projected flash requires careful aiming, and cannot be used with lenses of normal configuration (they are for telephoto use only). Though all sources I have seen show these devices mounted directly on the camera, with consequent danger of pink eye, (see page 119 for a definition) there is nothing to prevent you from having the flash off the camera, as long as the use of camera and flash are properly coordinated, and a suitably long shutter synchronization cord is used. You can place the flash on a second tripod or other support for a static setup, or you can have an assistant carry and aim the flash at a moving object. One advantage of the very high guide numbers of these devices is that the accuracy needed in judgment of flash-to-subject distance is a little less than usual. If the correct flash distance was 100 feet, everything between about 87 and 125 feet distance would be within plus or minus one-half stop of the correct exposure. (There is a fuller discussion of light falloff effects with flash lighting on p. 140 in the section called "Light Falloff Across Deep Subjects.") With a narrow angle of projection, it takes a greater distance for a significant exposure error to be produced.

Cross-sectional diagrams of two of the projected flash systems just described are shown in Figure 25.

When electronic flash is used in projected light systems, it is generally a little lower in relative light output and beam efficiency than is bulb flash, because of the larger size of the source and the probable need for a diffusing screen. However, electronic flash offers a shorter flash duration at full output. If high shutter speeds are synchronized with flash bulbs, the guide number drops rapidly as speed goes up.

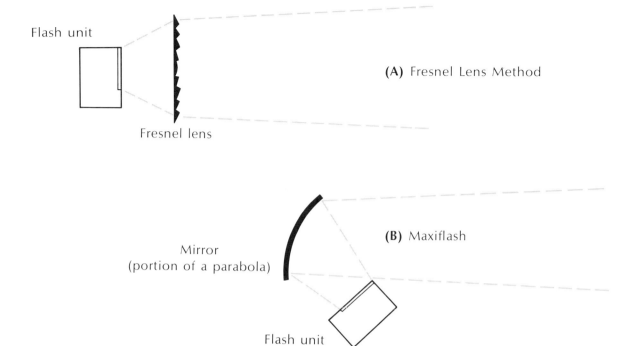

Flash unit

Fresnel lens

(A) Fresnel Lens Method

Mirror
(portion of a parabola)

(B) Maxiflash

Flash unit

FIGURE 25
Projected flash techniques.

Once again, the choice of which to use depends, in part, upon the nature of the work to be done.

The calculation of the initial exposure change, when a projected flash is being used, is simplified if you use the inverse square law as follows. If, at a ten foot distance, your flash unit normally covers a ten by ten foot square, and you set it up for projection so that at ten feet it now covers a square two feet on a side, you have reduced the coverage from 100 to four square feet. The light intensity at the subject position should now be about 25 times greater. Using the doubling method of calculation, you will find that the gain will amount to about $4\frac{1}{2}$ stops. (Since each additional stop equals twice the amount of light, a change of two stops equals four times, three stops eight times, four stops

16 times, and five stops 32 times the original intensity.) A $4\frac{1}{2}$ stop increase of light intensity approximately equals a "whopper" flash of 25 or more bulbs, or some 25 separate electronic flashes. By aiming the flash unit at a wall, and watching the target area without blinking, you will find it quite easy to see, and even measure, both flash areas.

As a final note, you will find it a help to build into your setup a sight that is centered on the middle of the flash area at the distance of most common use. This can be as simple as a piece of small diameter tubing.

Balanced-Ratio Flash. All of our flash calculations so far have assumed that we are ignoring the existing ambient light, and are calculating

solely for the effect of one flash source. (For exposure purposes, all examples of multiple flash have been figured as an aggregate single source.) Balanced-ratio lighting allows you to set up known lighting contrasts using two or more sources, one of which is a main light, while the others serve to cut shadow contrasts to printable levels. This allows great flexibility in choosing the basic lighting angle, and introduces the possibility of achieving genuinely creative lighting effects. With this method two or more flash units can be used together, or one or more flash units can be balanced to one or more other light sources, such as sunlight, or tungsten lights. Using one flash unit as a subsidiary source to lighten the shadows of a sunlit subject is called "fill-in" or "synchro-sunlight" flash, and is a commonly recommended technique. Of course, fill-in flash can be done with any steady light source, but the common assumption is that sunlight is involved. "Balanced-ratio" is a more general term for a method that uses techniques capable of producing a broader range of effects, and offering a wider variety of choices. Fill-in flash is only one form of balanced-ratio lighting. (See Plates 12 and 53 for examples of balanced-ratio flash technique.)

When more than one light source is used, the first matter to be worked out is the lighting ratio, the degree to which one source supplements another. For the sake of simplicity, the use of only two light sources is assumed throughout this presentation because, once you have grasped the principle, it is readily applied to any number of lights.

In multiple-light setups there is always one source called the "main" light. This source, in conjunction with the position of the camera and the angle of the subject, decides the basic shaping and modelling of the subject as it is seen in the final picture. The main light determines the direction in which shadows fall, and illuminates the main highlight areas. Other sources are called "fill" lights. (In professional portraiture, some fill lights have been given such names as "kicker" lights, but basically they are fill lights.) They serve primarily to add enough light to the areas shadowed by the main light so that the negative will print to a preconceived level of overall contrast.

The lighting imbalance at the subject position is expressed as a ratio, such as 1:2 or 1:4. Any ratio can be used, from 1:1 (equality), to about 1:10 (approximately the limit of useful lighting contrast in photography). The ratio is an expression of relative strength; 1:2 means that one light is one-half the strength of the other (one stop weaker), and 1:4 means that one is one-quarter the intensity of the other (two stops weaker). In a 1:1 ratio, there are no shadows. In a 1:10 ratio, shadows are nearly black. A 1:2 ratio has shadows that are definitely present, but which are not obtrusive. Going to a 1:4 ratio gives quite distinct shadows, but still provides printable detail in those areas. The ratio to be used is determined by the appearance you want to have in the final print. In scientific photography, quite low ratios are the general rule, in order to be sure that shadow detail will be visible to provide significant information, even after

PLATE 12 ▶

Balanced-ratio flash. It is possible to use lighting in balanced ratios to solve a wide variety of photographic problems. (a) Bull Thistles, by natural lighting. The strong side lighting and obtrusive background effects combine to make a visually confusing picture. (b) The same plants, with a flash cube providing frontal lighting, with the exposure balanced so that the natural lighting was two stops underexposed. Thus, the background was rendered dark, but not black.

a

b

reproduction by way of the press. High ratios are reserved for presentations where a dramatic appearance is wanted, or where they cannot be avoided.

If all the light sources that are being used are identical, calculating the ratios is made easier—although sources with different intensities can also be used. Using sources with the same intensity, a 1:2 ratio is achieved most easily by having the lamp-to-subject distance of the fill light about 50 percent greater than that of the main light. A 1:4 ratio results when it is 100 percent greater (twice the distance). You can use your lens f-number scale to help here. For example, if you choose to use a main lamp distance of four feet, look at f/4. One stop less exposure would be f/5.6, so you set your fill lamp 5.6 feet from the subject to get a one stop exposure difference (a ratio of 1:2). Or you can set it at eight feet to get a ratio of 1:4 (f/8 being two stops smaller than f/4, and 1:4 being a two stop difference in intensity of light); and so on.

This method will work when all light sources are either all photofloods or all flash units. With photoflood lamps, the exposure calculation is done with an exposure meter, in the normal manner. With flash, a flash meter can be used, or the exposure can be calculated in the normal manner, using the guide number of the main light and ignoring the fill. Lighting ratios can also be set by metering the lamps separately, providing that you use the incident light mode of your light or flash meter.

Varying the lamp-to-subject distance is not the only way to work out ratios. Another method that works well is to use a direct main light, but to diffuse the fill light. This makes a different and often very attractive lighting effect. If the two lamps are of equal intensity, and the diffuser over the fill light absorbs one stop of

light you get a 1:2 effect when both subject-to-lamp distances are equal.

Should you have to use two or more lamps having different basic outputs, these differences must be determined and figured into all calculations. It will affect the comparative flash-to-subject distance. Using light meters or flash meters will ease matters. A comparative incident light reading will sort it all out. Just meter each source, with the others not working.

Synchronizing flash to go with an existing steady source, as in normal fill-in flash, is basically comparable to the foregoing, but requires a somewhat different procedure, which is necessarily sequential, and is outlined as follows.

1. The intensity of the existing light is metered normally, by the incident method, and a choice of shutter speed and diaphragm opening is made.

2. The lighting ratio to be used is decided upon.

3. Flash distance is then calculated from the known guide and f-number, by Formula C, page 127.

Since the flash distance must come out in the correct ratio, provision for this must be made in the above calculation. Assuming that the steady source is to be the main light and the flash is to be the fill, and therefore of lesser strength, there are two ways of working this out:

1. Use Formula C to get a normally correct distance; then use a 50 percent greater distance to get a 1:2 ratio, or a doubled distance to get 1:4.

2. Alternatively, according to your taste, substitute *in your calculation* a larger f-number than the one actually to be used. An f-num-

ber one stop larger gives a flash ratio of 1:2, and an f-number that is two stops larger gives a distance that yields a 1:4 ratio.

I prefer the first method, as being less confusing, but some people like the second. Suit yourself.

In cases where the steady light source is to be the fill, and the flash is to be the main light, the sequence of exposure calculation is the same as listed on page 138, but the steady light source reading must allow for an underexposure according to the desired ratio. With the f-number to be used known by this reading, figure a flash distance without correction.

An equal (1:1) ratio does not require correction in either direction. Just figure both exposures normally.

Note that meter readings made to agree with flash distance calculations should be made by the incident light method, as has been noted in the text above, because the guide number method of flash exposure computation is itself equivalent to an incident light determination. If a reflection type meter must be used, read on an 18 percent grey card. This also corresponds to an incident light reading.

Pitfall time is here. In flash synchronization work, remember that the choice of shutter speed is not always a free one. Leaf-type shutters often allow a great choice of shutter speed, no matter what type of flash unit is being used, but focal plane shutters, used with electronic flash, limit exposure times to the slower shutter speeds. (See the instruction booklet for your camera for exact details.) This may require tripod use, in order to avoid blurring the ambient light portion of the image. Of course, the use of slow shutter speeds limits the action stopping possibilities in a scene. Therefore, I prefer to use bulb flash rather than electronic flash for flash/steady-source combinations, because with FP, or certain other types of flash bulbs (including flashcubes and M3, AG1, and number 5 bulbs) you can synchronize the focal plane shutter at most or all speeds, with most 35 mm single lens reflex cameras, thereby greatly increasing the flexibility of operation.

Because flash-to-subject distances will vary considerably, and will do so independently of camera-to-subject distance, the use of extension flash synchronization cords is necessary. Fortunately, these are quite inexpensive, and are readily available in a variety of lengths. I always carry a couple in my camera bag, just in case.

Another pitfall of balanced-ratio flash technique is that not all portions of a given subject will reflect light to the camera in the same way. Multiple or supplemental flash calculations may have to take this into account. For example, suppose that you are doing a portrait of a person having long, dark hair, and you wish to use a fill light to show details of the hair arrangement. (This could be an ordinary portrait, or a solution to a common ethnological recording problem.) Dark hair constitutes what is known as a "light sink;" it absorbs great quantities of light. You might have to decrease the fill light distance to one-half or one-quarter normal to get significant exposure of the hair. Of course, if you do this, you must keep this light on the hair only, or you will grossly overexpose all normally reflective surfaces. You might have to use one fill light at the normally calculated fill light distance for general shadow fill purposes, and a second one much closer for the hair only. Appropriately, in commercial photography this would be known as a "hair light." Elaborate hair arrangements might require as many as two or even three hair lights, quite aside from the normal main and fill lighting, in order to show all features. I fairly

commonly use as many as five flash units when doing careful portraiture. (I didn't say that life would always be easy.) Most uses do not require more than a couple of units.

If complex setups are done with synchronized flash, all units must fire at once in order to avoid possible multiple images from subject or camera movement. There are two ways of achieving this: slaving, or wiring together. A "slave" unit makes use of a built-in or attached photoelectric cell, which detects the light put out by the flash connected to the camera, and immediately fires the unit to which it is itself attached. Thus, no wires trail around to get in the way. Slaves are designed to be triggered only by pulsed light, so that steady sources do not set them off. Flash units synchronized by means of slaves need not be identical.

For my own use, in most situations I personally prefer wire connectors. For a five-lamp setup I put a Y-connector on the camera and connect two main extension cords to it. One of these has a second Y-connector at its other end, and the other has a triple connector. The five separate flash units are then plugged into these, using additional extension cords as needed. The use of multiple extension cords can be a nuisance, unless care is taken to avoid tangles and trips. It is essential to check the circuitry before taking any photographs, in order to be sure that all the connectors are properly seated, and that all the flash units are on and ready to fire. This can be done by removing the Y-connector at the camera and shorting across it for a trial firing. Used with five small, inexpensive electronic flash units, this makes a remarkably able, compact and versatile lighting kit of great dependability. Fortunately, the needed connectors are quite cheap, and are available in most camera stores. For best dependability, flash units that are to be wired together like this should

be of identical construction. Dissimilar units may misfire. In my experience, wired setups are both cheaper and more reliable to use than are slaves. But the wires do trail around a bit.

Countering Inverse Square Law Effects Although the inverse square law is the basis for predictable exposure results in flash photography, it does occasionally provide some practical problems. The purpose of this section is to deal with some of these.

Light Falloff Across Deep Subjects. In photography by sunlight it does not matter, from an exposure point of view, how deep the subject is from front to back. The light everywhere has basically the same intensity. This is because the source, the sun itself, is very far away and no subject is large enough to present a relative distance problem. However, flash photography, which is done with relatively weak light sources aimed from rather short distances at subjects of finite size, does have just this problem.

For example, let us suppose that we are photographing a subject with a fore-and-aft depth of three feet. We are using a flash unit that provides a basic flash distance of seven feet, when the lens aperture is small enough to give sufficient depth of field in the image. If the flash unit is placed seven feet from the center of the subject, the forward edge of the subject will be about one stop overexposed and the rear edge will be about one-half stop underexposed, as compared to the center, an overall range of $1\frac{1}{2}$ stops. It would obviously be helpful to do something to even out this lighting imbalance.

The reason for the uneven effect on either side of center is the halving nature of the inverse square law. To even out the falloff to best advantage, the flash unit should in this example be placed about six inches further from the

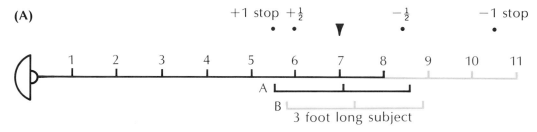

Key: A = original subject position vis-à-vis flash
B = changed position (flash moved back a little)

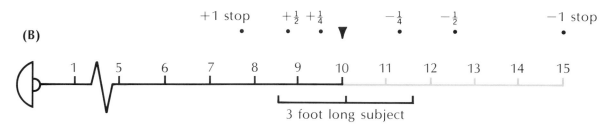

FIGURE 26
Maximizing the efficiency of flash unit positioning. (A) Positioning for maximum efficiency at a given distance. (B) Effect of increasing flash-to-subject distance.

subject center. This will become clearer if we diagram the situation (see Figure 26,A). If the flash unit is moved backwards by as little as six inches in a seven foot calculated distance, the light intensity on the whole subject will fall within a one stop exposure differential. Corrective exposure in printing can handle this. No part of the subject will be over- or underexposed more than one-half stop.

A slightly more effective solution to exposure falloff is to increase the flash distance used. This can be done by using a stronger flash unit or a more powerful flash bulb, by using a faster film, or (with flash bulbs) by slowing the shutter speed. (All of these solutions assume that opening the aperture would be undesirable, because of depth of field considerations.) However, if bulb flash is available, slowing the shutter is the quickest and easiest field alternative. I will assume that, for this example, a film and bulb combination having a guide number of 125 at a shutter speed of 1/125th of a second is initially used at a flash distance of seven feet from the same three foot subject. Slowing the shutter speed one stop, to 1/60th of a second, raises the guide number to 180. At the same lens aperture, this changes the correct flash-to-subject distance to ten feet. Figure 26,B shows that, with the calculated flash distance measured from the center of the subject, the whole subject now lies within a flash falloff of about three-quarters of a stop from front to back, instead of the $1\frac{1}{2}$ stops of the initial setup. The problem is thereby reduced by half in one step.

Another method of handling this situation, where lighting angle requirements allow it, is to

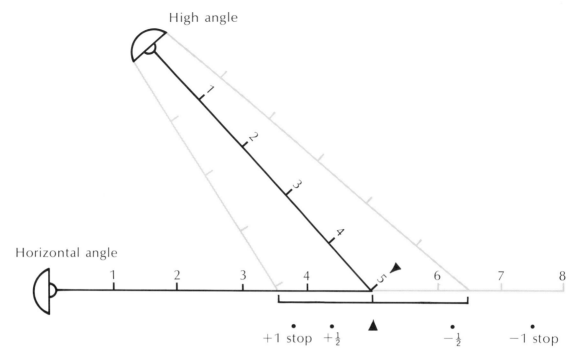

High angle

Horizontal angle

+1 stop +½ −½ −1 stop

FIGURE 27
High-angle flash.

raise the flash lamp high and bring it forward as shown in Figure 27. This way there is relatively less problem with light falloff. In the example illustrated, a three foot subject is being lit from a flash distance of only five feet. Here the horizontal lighting angle allows about 1½ stops of exposure falloff across the subject. The use of the high angle that is illustrated cuts falloff to about one stop, a clear gain even at this relatively close flash distance. Had the subject been sloping upwards toward the rear, a common circumstance, falloff might thus have been cut to practically nothing.

Background Light Loss. Allied to the foregoing is the problem of background light loss in flash pictures. This is especially apparent in flash work at very short distances, where the flash unit may be only a few inches or a foot from the subject. (This flash technique, used for closeup photography of very small subjects, is described in detail on page 310.) Although the subjects are small enough so that exposure falloff across them is negligible, the natural background is frequently so distant (in comparison) that it receives too little light to affect the film.

The simplest solution is to make the resulting dark or black background a contributing element in the picture—a way of isolating the subject, visually. However, if you need a background, either to show typical surroundings or to provide a light area against which a dark

subject will stand out, you can often place a natural or artificial background of the appropriate type close enough behind to pick up light. Suitable artificial backgrounds might consist of light-colored cards in muted shades of blue, green, or brown. (Vivid colors are inappropriate to most nature subjects, and tend to be visually disturbing in the picture.) Winged insects, for example, whether aloft or alight, look right against blue or green. Ground dwellers are appropriate against green or brown, according to their normal habitats. The intent with artificial backgrounds is not to try to duplicate nature, but rather to avoid inappropriate colors.

Filters in Photography

In photography the word "filter" refers to a translucent device placed so as to transmit light selectively, in terms of color, wave motion, or amount, in order to affect the film in predetermined ways. In the following sections I describe, in some detail, the nature of light and filtration, and some of the methods of using filters in general field photography. (Suggested basic references on filters include Kodak publication B-3, and Clauss & Meusel's *Filter Practice*—see the Bibliography.)

OPTICAL NATURE OF FILTERS

Without some basic understanding of the optical characteristics of filters, their use cannot be

rational. By nature, all filters are subtractive. That is, they remove some of the light passing through them, and thereby modify what happens to the film during exposure. The way in which they do so is determined by their absorptive and reflective character, and by their refractive capacity. I will not go in definitive detail into the basic physical nature of light itself, but will restrict myself to describing effects. (See the Bibliography for references on physical optics.)

Absorption, Reflection, and Transmission of Light

The primary characteristic of most photographic filters is absorption of light. Light is propagated by a source in various wavelengths, seen by us as different colors. Visible light is, of course, only a small portion of the electromagnetic spectrum; the portion that can be detected by the human eye. In photography, we can move into the larger spectrum to include and use portions beyond both ends of the visible part—at the short wavelength end going into ultraviolet, and at the long end into infrared. (See Figure 28, for diagrams of the electromagnetic and visible spectra.)

Color Effects Filters that are visibly colored have the purpose of wavelength discrimination. Sunlight is made up of all colors of the visible spectrum in combination, and is called "white" light. For photographic purposes, it is practical to divide the white light of the visible spectrum into three sections—blue, green, and red—and to say that yellow filters absorb blue light, green filters absorb red and blue light, and red filters absorb blue and green. This is diagrammed in Figure 29. In an outdoor scene photographed in

black-and-white, a yellow filter over the lens will cause the blue sky to appear darker in the final print. (Absorption of blue light will allow less exposure of the film in areas of blue sky tones. Therefore, the negative will have less density in those areas, and thus the print will be darker there—all other tones remaining equal, in theory.) This selective light absorption will be the basis for filter choice in all of the filter uses that are described, except for polarization and neutral density filtering.

Exposure Effects Since the act of filtering is subtractive in nature, it naturally follows that the use of filters carries with it an exposure penalty. This penalty, however, is not entirely due to light absorption by the filter. A portion of it comes from the reflection of light from filter surfaces. Thus, the light transmitted by a given filter is that light which is neither reflected nor absorbed. The amount of light reflected from a surface of a filter is small in the center, but relatively larger at the edges, due to the different angles of incidence of the light rays involved. The difference is unimportant if only one filter is in use, but can become a problem if filters are "stacked." I describe this effect on page 148.

An increase in exposure is necessary when filters are used in photography, in order to compensate for the light that is not transmitted by the filter. This exposure compensation is usually done by computing from a "filter factor." A factor is expressed as a number related to the decrease in exposure effect of the particular filter. The numbering system follows the doubling plan of other exposure compensation methods. A filter factor of 2, for instance, requires doubling the exposure (opening the diaphragm by one stop, or slowing shutter speed by one stop). A factor of 4 requires four times

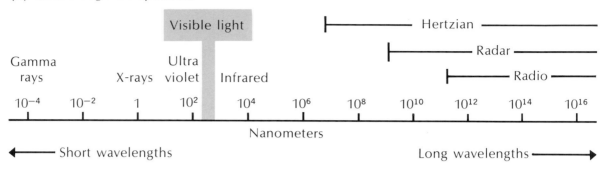

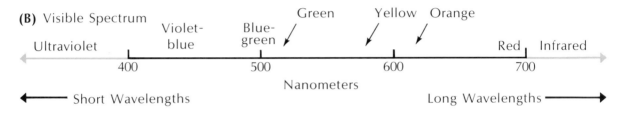

FIGURE 28
The Spectrum. (A) The Electro-magnetic spectrum. (B) An expanded view of the visible spectrum:

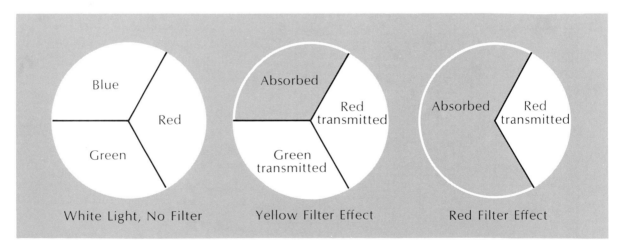

FIGURE 29
Color absorption by filters.

as much exposure. (You open up two stops, slow the shutter two stops, or do one of each.) A factor of 8 requires eight times the otherwise correct exposure. (Open up three stops, slow the shutter three stops, or use any combination of shutter and diaphragm changes that total three stops.) Or you multiply the exposure time by the filter factor. Tables of filter factors are provided in the following text for all recommended filters, as we come to them. Table 10 lists the degree of exposure change needed for various common filter factors.

The matter would be simplified if all filters had standard factors assigned, and if there were no variables in the situation. Unfortunately, we don't get off quite that easily. In the first place, light sources differ, so there are different factors for daylight and for tungsten lighting. Since the variety of wavelengths present in the light differs, the filters do not transmit the same percentages. Secondly, many colored filters fade with time and exposure to light. This obviously affects the filter factor, but in an unpredictable

way. As a consequence, filter factors given by the manufacturer must be guides for general use only. If stringent circumstances exist, with great accuracy needed, you may have to make tests to determine the actual factors for given filters. And, you may have to repeat these tests after a period of time. Thirdly, some filters, especially those made for esoteric scientific uses, do not have an assigned factor, owing to the unknown nature of the intended use. Some exposure information can be gained by applying mathematics to given light transmission figures. However, most practical applications will require testing in order to be accurate.

To test for a filter factor, photograph an evenly lit 18 percent grey card on black-and-white film, first without a filter, and then with it in place. In the latter case, make a number of exposures at half-stop increments, carrying on until you are well past the estimated level of correction. After processing, compare the strip of negatives taken with the filter on with the no-filter frame. The filter-on frame that matches the appearance

TABLE 10
Exposure change for common filter factors

FACTOR[a]	NUMBER OF STOPS INCREASE	FACTOR	NUMBER OF STOPS INCREASE
1.2	$\frac{1}{3}$	6	$2\frac{2}{3}$
1.5	$\frac{2}{3}$	8	3
2	1	10	$3\frac{1}{3}$
2.5	$1\frac{1}{3}$	12	$3\frac{2}{3}$
3	$1\frac{2}{3}$	16	4
4	2	20	$4\frac{1}{3}$
5	$2\frac{1}{3}$		

[a] Adjustments of less than a full stop should be made by approximating positions between f-number markings. Not all camera shutters will work correctly if set between speed markings.

of the no-filter frame is the correct one. Referral to your notes will then produce the correct filter factor. For most purposes, visual comparison is quite adequate, but scientific uses requiring great accuracy demand the use of a densitometer for these measurements, and probably a second series of trials at smaller increments of difference for the final calibration.

When you use more than one filter at a time, the filter factor for the combination is obtained by multiplying together the individual factors. Thus, if one filter has a factor of 2.5 and the other a factor of 4, the combined factor will be 10. From this, you can see that using more than two filters could have a prohibitive cost in terms of exposure, because the factors would multiply again, as each additional filter is put on.

Optical Effects of "Stacking" Filters Filters should not be "stacked" (that is, placed over a lens more than one at a time) unless necessary, for one or more of a number of reasons. Among them is the cumulative effect of one of the aspects of reflected light. Light is reflected from surfaces according to its angle of incidence. When a light ray strikes a transparent surface— as when passing from air to glass—from the perpendicular, relatively little is reflected, but when it strikes at a lesser angle a higher percentage is reflected. With any one surface this effect is small, and it is not noticeable, in practice, with just one filter. But if you place several filters over a lens (each filter with two such reflecting surfaces) the effect of the resultant light loss upon exposure may become important. Furthermore, there is a tendency for such light to be reflected repeatedly inside the filter, between its two surfaces. This light, now disturbed from its original image-forming path, may finally end up inside the camera, showing up as internal flare that lowers image contrast.

Because of the angles of incidence involved, these effects will be more noticeable with wide-angle lenses.

Cumulative effects can be quite important. If filters *must* be stacked, special care must be taken to assure the absolute cleanliness of all surfaces, in order to avoid additional contrast-cutting flare from dirt or fingerprints. Reflections from and within filters will also be reduced if the filters involved have antireflection coating, as do photographic lenses. The alignment of all filters must be exact when they are put on the lens, or problems due to misalignment will be increased by the numbers involved. (See page 149 for a coverage of mounting problems.) In addition, filters of any significant thickness are likely to introduce curvature of field into the image. (An image focused at the center will then be out of focus at the edges.) Stacking may increase this effect, too. It is a good general rule to use no more than two filters over a lens unless the reasons for using more are compelling.

Refraction of Light

As an effect secondary to absorption, filters also refract or bend light. This has consequences that should be considered.

Image-Quality Effects Camera lenses are designed to operate best with no other objects between them and the subject, or at least with no consideration of such. When filters are placed in front of a lens, the image formation can be disturbed. The amount and type of disturbance depends upon the flatness of the filter, the parallelism of its surfaces, its thickness, and the accuracy of its placement in the optical path.

To a degree, a filter acts like an additional lens

element. If the surfaces of a filter are not flat it indeed acts as a lens, bending the light according to the curvatures that are present. This will definitely degrade the image. If the two surfaces are not parallel, it will act somewhat as a prism, dispersing light according to its wavelength. A glass filter also changes the focal length of the lens according to its thickness, tending to defocus the image slightly. And, if it is placed in the optical path at an angle other than 90 degrees to the lens axis, there are further image disturbances.

Desirability of Filter Use The advantages of filter use far outweigh the disadvantages, if due precautions are observed. Photographic ends are served best if the following points are considered:

1. A filter is used *only* when it serves a positive purpose.

2. The type of filter is properly chosen to suit that purpose.

3. At purchase, attention is paid to quality of manufacture (cheap glass filters can be a poor bargain).

4. The filter is correctly mounted on the lens.

5. With ground-glass and reflex-type cameras, the final focusing is done with the filter in place on the lens.

Choice of Filter Type Filters are available in various forms, such as gelatin squares, gelatins cemented between glass, and glass filters. A few special filters are available only as glass filters with the desired properties as part of their physical structure. In this case, there is no choice of type, except where the quality of manufacture or their thickness is involved. A general rule of

purchase is that the quality and thickness of a glass filter should be specified, and that it should be no thicker than is required for its function. Whatever the use, I buy all-glass filters only when I cannot get gelatins. Some neutral density filters come only as glass, coated with an exceedingly thin layer of metal which has been evaporated and condensed upon them.

Cemented gel-glass sandwiches are excellent for most field uses that require durability coupled with some provision for cleaning. (To clean filters, lightly brush off all discrete dust particles and then clean by breathing on the glass and lightly polishing with a soft lint-free cloth or lens tissue—just as with lenses.) But they are rather expensive, may break or separate if dropped, and if carried in quantity, they may be of noticeable bulk and weight. Polarizing filters are nearly always in the form of glass sandwiches.

For general color filter use, I prefer gelatins. They are so thin that optical problems are few. They are inexpensive, will last quite long with ordinary care, and large numbers can be carried with very little weight or bulk. However, they cannot be cleaned, and are subject to easy damage from such things as fingerprints and scratching. Also, if you need to work in the wet, remember that gelatin is water soluble.

Mounting Filters on Lenses Since any failure to hold the filter perpendicular to the lens axis can be assumed to be detrimental, mounting methods become important. In the past the most common way of mounting glass or glass sandwich filters was by way of a two-piece metal frame, which both sandwiched the filter and had a friction-fit slip-on device to fit over the outside of the lens mount. This method was satisfactory, if the unit was correctly assembled

and properly seated on the lens mount. It is still used with some types of equipment. Most single lens reflex cameras in use today have the front of the lens mount internally threaded for screw-in filters. Many such lenses have deeply recessed front elements, so this mounting method is beneficial since it gets the filter closer to the lens. There is no easy way to misalign this type of filter.

Gelatin filters can be mounted in a variety of ways. For years, Kodak has provided a sheet metal assembly for holding gelatins (Figure 30,A). The filter is sandwiched between two parts of a frame, which is then slipped into a frame holder that mounts on the lens with standard adaptor rings. Tiffen has recently introduced a similar arrangement that will also simultaneously accept square gelatins and round screw-in glass filters (Figure 30,B). Both of these devices will hold filters in good alignment. In any instance where more than one filter is used, special care must be taken in order to avoid

misalignment. If the filters are not correctly aligned, their optical defects will become more apparent and exposure may be affected by the cumulative effects of surface reflections.

In many uses it is not necessary to mount gelatin filters directly on the lens. It can be satisfactory simply to hold them up against the lens mount during the exposure, as long as the positioning is correct. I don't especially recommend the procedure, but I do it a lot.

In order to protect gelatin filters, and to provide greater durability in handling, I mount them in cardboard frames made from the folders that they come in. Each gelatin filter comes enclosed in a folded card stiffener inserted in a paper envelope. I cut out the center of the stiffener (as shown in Figure 31), sandwich the filter gel in it, bind the open edges with tape, and keep it stored in its own envelope. Mark filter factors on the frame. Filters mounted in this manner will fit into the Kodak and Tiffen frame holders. Of course, the filters should always be handled by the cardboard frame.

There are still other ways that gelatin filters can be mounted. The square filter that is supplied by the manufacturer can be cut to any shape with scissors. Once cut, it can be mounted in round screw-in adaptors, or taped across the back element of the lens. Use this latter method only where clearance within the camera is adequate, and be sure that the filter cannot fall off and jam the works. The latter method is valuable in aerial photography from light aircraft, where filters are almost always needed to cut haze but where wind would be likely to tear off a normally mounted gelatin. Again, this is a practice that I don't especially recommend, but it is quite widely used; and, I sometimes do it myself.

(A) Kodak Model **(B)** Tiffen Model

FIGURE 30
Gelatin filter frame holders.

Focus Shift Filters of any considerable thickness present a minor focusing problem. They

FIGURE 31
Cardboard framing of gelatin filters.

shift the focus of the lens by one-third of the filter thickness. Used in front of the lens they shift it toward the subject. In normal use this shift can be ignored, but at close focusing distances, as in photomacrography, it can be significant. Used behind the lens, as in certain large-camera methods, filters shift the focus so as to put the point of prime focus behind the film by an amount equal to one-third of the filter thickness. Here, the effect is often great enough to put the image definitely out of focus. Gelatin filters are so thin that there is little problem, but glass or glass-mounted filters are troublesome.

The best solution to the focus shift problem is simply to make the final focus after the filters are in place, if it is possible. Where filters are so dense that visual focusing would be difficult, you can substitute other filters of the same thickness during focusing. (Kodak even makes clear glass of filter thickness for this purpose.) In high magnification work it is best to avoid the problem entirely by filtering between the light source and the subject, rather than at the camera lens.

VALUE OF FILTERS IN PHOTOGRAPHY

Scientific illustrations must nearly always be reproduced in print in black-and-white, because of economic considerations. Frequently, the quality of such reproduction is rather indifferent. The responsibility for obtaining quality in the illustration is thus put upon the original photographer. The picture must be good enough to survive publication. Whatever it lacks will be accentuated in publication. So a scientific field photographer should use all methods that will assist in the attainment of a clearer presentation.

Filters serve a wide variety of light-modification purposes, and their appropriate use is often the factor that separates first rate from mediocre photography. This is especially so in scientific field work. The following sections outline some of the appropriate uses for each of the major kinds of filters.

Color Filters with Black-and-White Films

A variety of roles exist for color filters. The possibilities include such simple aims as emphasizing cloud structures in sky areas, and extend through to the most difficult and complex tone differentiations in photographs.

Relative Brightness/Contrast Effects The use of color filters with black-and-white films is based on the fact that the various colors of original subjects will be reproduced in the print as shades of grey corresponding to the relative

brightness, or reflective power, of those colors. There is no known innate correspondence between an actual color as it is perceived by the eye and brain, and the shade of grey that will be seen in a print. Very frequently, two very different colors will reproduce as closely similar grey tones. Differentiation between them depends upon the photographer learning to perceive these colors in terms of their relative brightness, in order to be able to choose filters that will selectively absorb and transmit wavelengths, and thereby produce in the print sufficient contrast of tones to set them apart visually. The relevance of this to scientific field photography is that it allows the photographer to emphasize or de-emphasize almost any portion of a given scene or subject in which there are differing colors. Once you realize that you can and must learn this process of brightness perception, you can learn to look through a given filter and form an accurate judgment of what its effect will be on a film, with regard to any particular subject matter. Almost all color differentiations in the black-and-white medium depend upon this.

A large proportion of your photographic subjects will have their internal and external tonal relationships enhanced by the use of color filters. To fail to use this tool when it is needed is to lose a portion of the pictorial clarity. I do not consider it practical or worthwhile even to try to list all the possible filter choices for all possible subjects. An example should suffice, if the general explanation is understood.

If a brown snail is photographed on a green leaf with no filter, the snail may tend to blend with the leaf, if the two colors are of approximately equal relative brightness. Use a green filter and, relatively speaking, the leaf will be lighter in tone and the snail will be darker. The subject can thus be made to contrast favorably with its surroundings.

The choice of what color filter should be used in a given case may be eased by referring back to Figure 29, on page 146, which shows the colors that are absorbed by each filter. However, to someone not familiar with optical physics, it may be easier to decide on an initial filter choice by resorting to a theoretically incorrect, but functionally practical, makeshift model. It is the complementary-color wheel we were all told about in grade school, and is illustrated in Figure 32. This is not a perfect tool, being based upon a different mode of color interpretation in a physical sense, but, in most cases, it does accord in a reasonably correct way with practical photographic reality.

Simply assume, in terms of the final black-and-white print, that if the exposure is adjusted to compensate for the light not transmitted by the filter, a color filter will lighten its own color and darken its complement, relative to a standard grey in the subject area. A red filter will lighten the tones of a red subject. A green filter will darken them. To complete the system, filters with a deeper hue will have a greater effect than lighter ones of the same color. The most obvi-

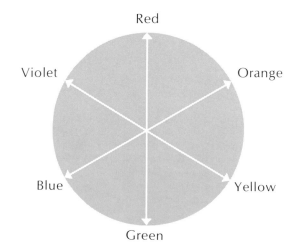

FIGURE 32
Filter-choice color wheel.

ous breakdown in the system is that there is no satisfactory violet filter, so yellow must be assumed to be opposite to blue.

A less obvious defect, but one of real importance to field photographers and landscapists, is due to the Wood Effect, in which most green vegetation, as seen in red light (through either a red filter on panchromatic film, or on infrared sensitive film) will appear white or very light, owing to the internal structure of leaves. This effect is first apparent with orange filters, and becomes stronger with red filtration of panchromatic films. It is strongest with very deep red filtering of infrared-sensitive film. (See Clauss & Meusel, pp. 63–65, for more detail.) Do not make the mistake of believing that the Wood Effect is due to the green color of the leaves. Rather, it results from an internal structural aspect of living leaves, having to do with their ability to reflect red or infrared radiation specifically. Thus, subjects that have been colored with green ink, dye, paint, or other pigmentation, will probably respond as is predicted by the color wheel.

In general photography, if the above deviations from the color wheel model are kept in mind, and if the initial selection of a filter is confirmed by looking through it at the subject so as to see the effect it has on relative brightnesses, the system works very well and will solve most filter choice problems.

The foregoing description of filter effects is based upon the assumption that the film to be used is panchromatic in sensitivity. This is because nearly all 35 mm and 120 sized films are panchromatic, and very few photographers use either orthochromatic or blue-sensitive films. The choice of filters for use with orthochromatic films is affected by the relatively limited wavelengths to which these films are sensitive. In field photography I prefer to limit my use of ortho films to subjects requiring no filtering other than that built in by this sensitivity range. Looking through a Wratten 44A filter will give a good visual impression of the effect upon the print of using ortho film. I use it as a viewing filter primarily, and on the camera only with 35 mm, where ortho films are hard to get. Blue-sensitive films are not suitable for field photography. But ortho films do a fine job of recording green vegetation.

In order to give myself real flexibility in field photography, I like to carry a considerable variety of colored filters. And these filters all have filter factors for exposure compensation. Table 11 is a list of recommended filters, arranged by color, along with filter factors for both panchromatic and ortho films, in both sunlight and tungsten lighting. Not all photographers will want to use this many filters, but at least one or two from each color group should always be carried. And the more choice you have, the more discriminating will be your photography.

Sky Effects In black-and-white photography, obtaining suitable sky effects often depends upon the use of filters that absorb blue light, since the unclouded sky is blue. The absorption of blue light by the filter causes the sky areas to print darker than would otherwise be the case. Filters suitable for this purpose include the various shades of yellow, orange, and red. The effect is moderate with yellow, more obvious with orange, and very strong with the reds. (See the sections on polarizing filters (page 171), and on infrared technique (page 192) for additional filter recommendations for this purpose; see also Plate 13.)

It is not always necessary to use filters to show a satisfactory gradation of sky tones, or a dramatic and detailed rendering of clouds. If the atmosphere is very clear, the blue of the sky will probably be deep enough to reproduce as a pleasing shade of grey, without any filter. Also,

TABLE 11
Filters for black-and-white films

| | | | FILTER FACTORS[b] | | | |
| | | | PAN FILM | | ORTHO FILM | |
COLOR	WRATTEN NUMBER	LETTER EQUIV-ALENT[a]	DAY-LIGHT	TUNG-STEN	DAY-LIGHT	TUNG-STEN
Deep Red	29	F	10	8	—[c]	—
Medium Red	25	A	8	5	—[c]	—
Red-orange	23A	—	6	3	—[c]	—
Orange	22	E	4	2.5	—[c]	—
Light Yellow	6	K-1	1.5	1.5	2	1.5
Medium Yellow	8	K-2	2	1.5	2.5	2
Deep Yellow	12	—	2	1.5	3	2.5
Very Deep Yellow	15	G	2.5	1.5	5	3
Yellow-green	11	X-1	4	4	—[d]	—
Medium Green	13	X-2	5	4	—[d]	—
Deep Green	58	B	6	6	8	5
Light Blue	80B[e]	—	3	3	1.5	1.5
Light Blue	38	—	4	4	1.2	1.2
Deep Blue	47	C-5	6	12	3	4
Blue-green (ortho)	44A	—	10	10	—[d]	—

[a] The Kodak Wratten numbering system is approaching industry-wide acceptance as a standard nomenclature. Some people may prefer to use the older letter designations, so they are provided where appropriate.

[b] Derived from standard tables in most cases—otherwise the result of my own tests with individual filters. (See Table 10, p. 147 for f-stop equivalents.)

[c] Filter factors are not given for red filters because orthochromatic films are insensitive to red wavelengths. Use of red filters will result in little or no exposure.

[d] No factor is given here because ortho films are not sensitive to the wavelengths that these filters absorb; hence they serve no purpose.

[e] This is a Color Conversion filter designed for color film use, but I like to put it to double service as a very useful pale color filter for black-and-white work.

PLATE 13 ▶

Filters—Sky effects. The basic sky filtering effect is illustrated. (a) Clouds against a pale blue sky, no filter, printed to high contrast on #4 Kodabromide paper. (b) The same clouds, photographed on the same roll of film with a Wratten 25 medium red filter, similarly printed. Note that the greater overall contrast is accompanied by enhanced internal structural detail.

a

b

if there are large and significant areas of white or brilliantly reflective surfaces in the general scene, the blue sky portion will be relatively less bright. The sky will then be printed as a light or middle grey simply as an artifact of printing the negative long enough to record tonality in the light areas of the scene. In this instance, the use of filters might then render the existing shades of blue too dark in the print for the pictorial purpose.

On the other hand, should the blue sky appear very pale and full of glare, a very deep-red filter might be required to produce any significant change of grey tone in the sky areas of the print. You might then expect that areas of green vegetation in the foreground of such a scene would photograph very dark under strong red filtration, were it not for the Wood Effect. With most such vegetation the deeper red the filter, the lighter the vegetated areas will appear in the print, relative to other tones. However, the effect is not equally strong in all types of vegetation. The structure of the needles of conifers is different from that of broad-leaved plants, and they reflect and absorb light differently. The Wood Effect may be scarcely detectable with some species, and especially if the needles are old. (See Plate 14.)

One of the more difficult filtering problems in field photography occurs when the foreground and middle distance are made up largely of dark green conifers, perhaps with a desirable degree of aerial perspective to set off the distance planes; yet the sky is pale blue and full of glare, but with scarcely visible cloud forms that should show clearly in the print. It is possible to obtain "graded" glass filters; usually these are yellow but may sometimes be neutral grey. They either grade off to no color (or tone) evenly across their whole width, or they are evenly colored in one half, with no color in the

other, and have a relatively quick grading off at the center division. The latter type is perhaps more generally useful, even though the horizon line in a photograph is not always across the center. Neutral grey graded filters come in glass only, and are available in a variety of densities, for the accurate control of tones. Grey filters do not emphasize cloud forms, as do colored filters, but merely cause a degree of underexposure. They are best used with cloudless blue skies.

If gelatin filters are used, you are in better shape. You can place an unframed gel so that it is covering only the sky area, or you can even cut it so that its edge roughly follows the horizon contour. This edge, being near the lens, will be out of focus, so the dividing line across the film will be indistinct.

This use of a graded or cut filter, without allowing for the filter factor, will provide a darker sky from simple underexposure of that area, as well as from the color filtering effect. The excess glare from the sky should then be countered.

Of course, if the sky is completely overcast, there will be no blue tones to emphasize and a sky filter would be useless.

Haze Penetration Blue distance haze is produced by the same mechanism that causes the sky to appear blue, namely the scattering of short wavelengths of light from fine particles of water and other material suspended in the at-

mosphere, and from the air molecules themselves. The ability to penetrate this haze optically, and to allow the material concealed by it to appear in the photographic print, is enhanced by use of the same filters as those that have already been recommended for sky effects generally.

Again, filters are not always appropriate. It may be desirable to retain part or all of the haze effect to emphasize distance and size relationships by what is called "aerial perspective." Remember also, that if the water drops or other suspended matter are large enough to scatter the longer wavelengths of light, filtering will no longer be effective. No filter can cut through fog or smoke.

Simulation of Orthochromatic Film Sensitivity

As noted earlier, it is difficult to obtain orthochromatic film in 35 mm and 120 sizes. Nevertheless, it is sometimes very useful to have orthochromatic sensitivity in field photography, particularly when photographing a scene consisting almost entirely of green vegetation. A close approximation of orthochromatic film sensitivity is obtainable by using a Wratten 44A filter with panchromatic film. Unfortunately, this filter has a daylight factor of 10. Therefore, the use of ortho film itself is preferable, if it is available.

Ultraviolet-Absorbing Filters in General Photography

Sunlight is rich in ultraviolet radiation, which may be an unwanted intrusion in the photography of general subjects in the field. Although blue light visibility to the eye cuts off at about 400 nanometers (nm) in wavelength, glass lenses will usually transmit wavelengths as short as 360 nm. Color films will record about that far into the ultraviolet, and black-and-white films of all types will record quite far into it. Thus, photographically, the near-ultraviolet grades imperceptibly into visible blue, with an area of some ambiguity present. There are several ways in which filters designed to drop out ultraviolet are useful in field photography.

High-Altitude Photography At high altitudes—commencing as low as 7–8000 feet—excess ultraviolet radiation may become visible in color photographs as an overlying magenta tint on some types of neutral grey rocks. At low altitudes this excess ultraviolet is absorbed by the atmosphere, but in the thinner air of the mountains much more gets through. Here an ultraviolet-absorbing filter really comes into its own, and a Wratten 1A, or in the more extreme cases a 2C, filter will absorb the ultraviolet that is causing the problem. The 1A is the familiar Skylight filter, in very common use.

Haze Penetration Some high-altitude distance haze is caused by the atmospheric scattering of near-ultraviolet radiation. While it is not visible to the eye, it is registered by the film as an additional blue haze. With color films, the 1A is normal correction and the 2C may also be appropriate, as above. In aerial color photography, where haze penetration may be critically needed, HF-4 or HF-5 filters may be needed. (These should always be accompanied by the HF-3, a color-adjustment filter that has been designed to be used with these particular ultraviolet-absorbing filters.) In black-and-white work, any yellow filter absorbs ultraviolet along with the visible blue; but, where no significant yellow color filtering effects are wanted, you may get some haze penetration effects using the Wratten 2A or 2B filters.

Color-Warming Effects Color photography in open shade under a blue sky, or on lightly clouded days, results in an unpleasantly blue color cast in the pictures, due to the excessively high color temperature of the light. The Wratten 1A Skylight filter will correct this effect. This is the most widely sold ultraviolet-absorbing filter, and is available in nearly all camera stores under the Skylight designation.

Lens Protection Because it is of optical quality, and because its color-warming effect is largely masked by the bright colors of sunlit or flash photography, many camera sales people sell the glass Skylight filter as a protective device to be kept on the camera lens semi-permanently. This is a good idea where there is salt spray, rain, dust or other material in the air that might damage an unprotected lens. However, it is unnecessary under most conditions; and, where it is not needed, it does your image quality no particular good. I keep one around to use in extremely bad conditions, but actually use it rather seldom. After all, camera lenses *can* be cleaned.

Exposure Compensation for Ultraviolet-Absorbing Filters Since the radiation being absorbed is ultraviolet, and is not being measured by most light meters, little or no exposure compensation is needed when using ultraviolet-absorbing filters. When in doubt, simply read the exposure through the filter.

Color Balancing with Filters

Color balancing filters for use with color films are very specific in their color response, and are made to be used with only one basic color balance of light per film type. There is none of the built-in tolerance for changes in the color of ambient light that is inherent in the eye/brain combination; and, for that matter, the eye/brain is unwilling to allow the same tolerance in viewing a color slide that would be routine when viewing the original scene. Therefore, it is necessary to do the needed color balancing on the film through the use of filters. In this text the primary emphasis is given to the widely used Kodak system, in which three types of filters are used, according to the degree of correction needed. There is a secondary notation of the less well-known (in the United States) systems such as Mired. Regardless of the filtering method used, any understanding of the effects of the filters used for correcting the color balance is dependent upon a prior understanding of the nature of color temperature.

Color Temperature The color qualities of color films are matched to the same standard that governs the rating of the color values of incandescent lamps and other similarly radiating light sources. This *color temperature*—as it is called—is expressed in the Kelvin temperature scale (°K). Kelvin scale temperatures are equal to the heat temperature of the radiating body in degrees centigrade, now called Celsius, (°C), plus 273. In Kodak publication B-3, color temperature is defined (p. 16) as:

> . . . a measure which defines the color of a light source relative to the visual appearance of the light radiated by a theoretically perfect radiator, or blackbody, heated to incandescence.

There are many ramifications to color temperature that are not described here. (For an expanded coverage, see the Bibliography, particularly Kodak publication B-3. Also, Laurance's article, "The Kelvin Scale" is a fine layman's reference and is accompanied by excellent graphics.) Table 12 lists the color temperatures

TABLE 12
Color temperatures of common light sources[a] (compiled from a variety of sources)

SOURCE	TEMPERATURE (°K)	FILM TYPE	BALANCE (°K)
Sunlight (mean noon)	5400	Daylight	5500
Skylight	10–18,000	Type A	3400
Electronic flash[b]	about 7000	Type B	3200
Blue flash bulbs[b]	5100–6300		
Photo-flood lamps[bc]			
3400 K photographic	3400		
3200 K photographic	3200		
Projection lamps[bc]	about 3200		
Household light bulbs[bc]			
200 watt	2980		
100 watt	2850		
75 watt	2820		
Candles[d]			
Standard British	1930		
General household	about 1500		

[a] Actual daylight color temperatures vary wildly, according to the time of day and atmospheric conditions.

[b] Artificial light sources can vary somewhat from one make to another, and tend to drop in temperature with age and use.

[c] The color temperature of continuous artificial light sources depends upon their being burned at their rated voltages. If the voltage is low, so is the color temperature; if the voltage rises, so does the temperature.

[d] For some color photography you may not want to completely correct an unbalanced color temperature, in order to retain the impression of the source—as with candlelight, which seems to be perceived by most people as being yellow.

of some common light sources which have been chosen to represent the types most likely to be encountered in field photography, and the temperatures to which common types of color films are balanced. As can be seen, no source is absolutely accurate. Fortunately, the human eye and brain do make some allowances in viewing color photographs, and, for that matter, are themselves subject to error and failure to discriminate to a degree. To stay within the perceptual limits of the eye/brain, proper color balance must be maintained within about 100° K at the lower temperatures of incandescent lights, but can be quite far off at the higher readings without too much likelihood of detection.

Not all artificial light sources bear any direct relation to color temperature. This is especially obvious to photographers when they are photographing fluorescent lamps, television screens,

and the like. These are sources whose light comes from the excitation of phosphors, rather than from heated filaments. Scientific field photography does not directly involve work with these sources, but subsidiary operations in such places as laboratories and museums may. Therefore, basic recommendations are provided.

Color Conversion Filters The first of the three types of filters that are intended for color balancing in photography is a group designed to take care of the common gross changes that occur when a color transparency film is used with an unsuitable light source.

Intended Use. There are three main types of spectral balance in color slide films: Daylight, Type A, and Type B. For instance, if a Type A color film is used in sunlight without a filter, the scene will appear much too blue in the finished picture. A Color Conversion filter is needed to assure a natural appearance in the final slide. And the same is true of a Daylight-type film used with incandescent lighting, except that without the filter the scene will appear too orange. Table 13 lists the Kodak Color Conversion filter recommendations.

Color negative film can be assumed to be of Daylight sensitivity. Although the capability of color correcting this film in printing exists, on the whole it is better to do it at the time of exposure. If you use commercial processing, notify the processor of any filtering that has been used.

Use as Color Filters with Black-and-White Films. Because Conversion filters are in the form of pale shades of blue (the 80 series), or orange (the 85 series), they are also useful as weak color filters for achieving subtle effects with black-and-white films. For instance, the pale blue 80B is very good for slightly increasing the effect of aerial perspective in distant landscapes. It is also useful as a contrast filter in photomicrography.

Light Balancing Filters Where the degree of color imbalance is less extreme than previously discussed, but still in need of correction, Light Balancing filters are the next step.

Matching Off-Balance or Nonstandard Continuous Light Sources. If the light source is nonstandard (other than one of those listed in Table 13), it can be brought into balance with the standard color films by using a Light Balancing filter of the 81 or 82 series. These are very pale yellowish in color (the 81 series), or pale bluish (the 82 series). An example of their use is where the light source was a desk lamp, rather than a photoflood bulb. Table 14 lists some recommendations.

Use with Electronic Flash. As mentioned in footnote c of Table 13, electronic flash can be considered as being a nonstandard light source. The filters recommended could then be classed as Light Balancing. The nomenclature is unimportant, but the need to filter is often serious. If ignored, it can lead to inaccurate recording, and possibly to inaccurate later conclusions. Testing may be in order. This will be discussed in more detail in the section on closeup flash photography, following page 310, and, to a lesser extent, in the next section.

Color Compensation Filters In critical color photography there is frequently a need for great care in balancing the light source to the film emulsion sensitivity as exactly as possible. In order to do this, Color Compensation filters (often called CC filters) are used. These come in six basic colors, and in a wide variety of densities. The colors are cyan, magenta, yellow,

TABLE 13
Kodak Color Conversion filter recommendations

LIGHT SOURCES	FILM TYPE			FILTER DATA		
	DAYLIGHT	TYPE A	TYPE B	FILTER	FILTER FACTOR	f-STOPS CHANGE
Daylight[a]	no filter	85	85B	80A	4	2
Blue flash bulbs	no filter	85B[b]	85B[b]	80B	3	$1\frac{2}{3}$
Electronic flash[c]	81A or 81B	85B[b]	85B[b]	81A[f]	1.2	$\frac{1}{3}$
3400 K floods[d]	80B	no filter	81A	81B[f]	1.2	$\frac{1}{3}$
3200 K floods[e]	80A	82A	no filter	82A[f]	1.2	$\frac{1}{3}$
				85	1.5	$\frac{2}{3}$
				85B	1.5	$\frac{2}{3}$

[a] Assumed to be a mixture of direct sunlight and skylight, and to be "mean noon sunlight" at about 5500 K. Light early or late in the day is likely to be quite far from this color temperature, thus producing sunrise or sunset color effects—usually in lower Kelvin temperatures.

[b] Film and flash unit manufacturers usually agree that the best results will be with Daylight films, and that other film types should be used only when necessary.

[c] Basic electronic flash tubes emit light at about 6-7000 °K, and require filtration to get a close match to Daylight films. However, some makes have built in filtering. Thus, if the tube has a distinct yellow cast, usually no additional filter is needed.

[d] A standard 500 watt photoflood lamp.

[e] A 500 watt 3200 K photoflood lamp.

[f] The 81 and 82 series filters overlap in use. They are classed as Color Conversion filters here, but as Light Balancing filters in the next section. It depends upon their use.

TABLE 14
Suggested Light Balancing filters[a]

LIGHT SOURCES	FILM TYPE[b]		FILTER DATA		
	TYPE A	TYPE B	FILTER	FILTER FACTOR	f-STOPS CHANGE
200 watt household bulb (2980 °K)	82C	82B	82B	1.5	$\frac{2}{3}$
100 watt household bulb (2850 °K)	82-82C	82C	82C	1.5	$\frac{2}{3}$
75 watt household bulb (2820 °K)	82-82C	82C	82-82C	2	1

[a] These recommendations are approximate, but are close enough for most purposes. As bulbs age, their light gets more orange. If they are burned at higher than their rated voltage their light will be too blue, if at a lower voltage it will be too orange.

[b] Daylight-type films are not recommended here. But, if they are used, the additional correction indicated in Table 13 must also be used—with its additional filter factor.

red, green, and blue. The first three are complementary to the second three, in the order given. In terms of wavelengths of light absorption:

cyan absorbs red,
red absorbs blue and green;

magenta absorbs green,
green absorbs blue and red;

yellow absorbs blue,
blue absorbs red and green.

There is a second cyan series, called Cyan-2, but its use is generally limited to printing from color negatives.

Color Compensation filters can be made to any density required, up to a point, but are usually seen in a series of standard calibrations. These run from .05 through .50, with density and color saturation increasing as the number grows larger. Note that a .40 density in one color does not necessarily mean that it has an exposure equality with a .40 density in another color. The filter factors, therefore, vary with color. The nomenclature is normally abbreviated in the following way; a Color Compensation filter of yellow color and a density of .40 is called a CC40Y, and so on. Exposure compensation is tabulated in Table 15.

Color Compensation filters are normally supplied as gelatin squares, and can be used either on the camera lens, or to color the light before it gets to the subject. They should not be confused with the basically similar, but optically inferior, Color Printing (CP) filters, which are made of acetate film and are not intended for use over a lens. The uses of CC filters follow.

Fine-Tuning Light Balance with Ordinary Sources. It is quite easy for ordinary incandes-

cent light sources to be slightly off in their color balance. CC filters provide the fine adjustment capability that is needed to match a light source to a given film. No recommendations are given, as such fine adjustments must always be a matter for testing, and in any case these adjustments are unlikely to be required in field photography.

Correcting for Fluorescent Lighting. One of the more frustrating color photography situations is working with fluorescent lighting. Black-and-white photography is no special problem. Light intensity with fluorescents is a measurement situation like any other. The lighting is quite even, and the brightness level is usually quite high. But color work is a problem because fluorescents do not emit light by radiation from a glowing filament, and so there is no true color temperature.

The light from these sources is emitted as fluorescence when phosphors coating the inside of the glass envelope are struck by ultraviolet radiation. In turn, the ultraviolet radiation is produced by the glow of mercury vapor inside the tube, which has been excited by an electrical discharge. Instead of generating a fairly regular curve of light emission reasonably evenly across the visible spectrum, as do incandescent lamps, fluorescents emit light that forms a curve dominated by several strong single-wavelength lines. The glowing phosphors produce the curve, and the mercury arc inside produces the strong emission points which penetrate the phosphor coating and contribute to the general light output. The combined result is a form of light that looks all right to the eye, but which photographs badly in color—usually with an overall greenish cast. Things are complicated because there are at least eight kinds of fluorescent lamps commonly manufactured, plus at least six forms of high intensity discharge

lamps that may be encountered. (Good sources of complete filter recommendation data are "Camera Filter Recommendations . . .", from General Electric Co., in *Industrial Photography*, November, 1969, and Sylvania publication 0-334—see the Bibliography.)

The usual way of working toward a correct color rendition is to use CC filters, singly or in combination, to bring the color of photographic results to a balance that approximates the way the eye would see the subject in daylight. Generally this works quite well, but there is always the possibility that one or more pigments in the subject scene will respond entirely differently than expected, and appear off-color or even as a totally different color from that seen by the eye. (I once photographed a gold coin against a red cloth background, by fluorescent lighting and using the recommended filters; the coin came out fine, but the cloth photographed as olive-green.)

The multiplicity of filter combinations covering all likely sources and all likely films has presented a daunting view to the layman. (The GE figures, mentioned previously, list 14 light sources and 16 films, resulting in 224 filter recommendations—and that for still camera films only, since cine films were tabulated separately.) Kodak's present practice is to recommend filter combinations for film types only (and not for

TABLE 15
Exposure factors for CC filters[a]

COLOR	DENSITY	FILTER FACTOR	STOPS CORRECTION
Cyan	.05/.10/.20/.30	1.2	$\frac{1}{3}$
	.40	1.5	$\frac{2}{3}$
	.50	2	1
Magenta	.05/.10/.20	1.2	$\frac{1}{3}$
	.30/.40/.50	1.5	$\frac{2}{3}$
Yellow	.05	—	—
	.10/.20/.30/.40	1.2	$\frac{1}{3}$
	.50	1.5	$\frac{2}{3}$
Red	.05/.10/.20	1.2	$\frac{1}{3}$
	.30/.40	1.5	$\frac{2}{3}$
	.50	2	1
Green	.05/.10/.20	1.2	$\frac{1}{3}$
	.30/.40	1.5	$\frac{2}{3}$
	.50	2	1
Blue	.05/.10	1.2	$\frac{1}{3}$
	.20/.30	1.5	$\frac{2}{3}$
	.40	2	1
	.50	2.5	$1\frac{1}{3}$

[a] These values are derived from Kodak publication B-3, which cautions that they are approximate. Testing may be required for critical work.

TABLE 16
Color Compensation (CC) filters for fluorescent lighting[a]

	LAMP MANUFACTURERS' RECOMMENDATIONS OF FILTERS FOR FILM TYPES[b]					
	DAYLIGHT KODACHROME-II		DAYLIGHT EKTACHROME-X		DAYLIGHT HIGH SPEED EKTACHROME	
LAMP TYPE	SYLVANIA	GENERAL ELECTRIC	SYL-VANIA	GENERAL ELECTRIC	SYLVANIA	GENERAL ELECTRIC
Daylight	30R	30M + 20Y (1)	20R	40M + 40Y ($1\frac{1}{3}$)	30R	not listed
Cool White	20M + 20R	30M + 10Y (1)	none	20M ($\frac{1}{2}$)	20M + 20R	not listed
Deluxe Cool White	none	20C + 10M ($\frac{2}{3}$)	20C	10C + 10M ($\frac{2}{3}$)	20R	not listed

	KODAK FILTER RECOMMENDATIONS[c]	
	DAYLIGHT FILMS	TYPE A FILMS
Daylight	40M + 30Y (1)	85B + 30M + 10Y (1)
Cool White	30M ($\frac{2}{3}$)	50M + 60Y ($1\frac{1}{3}$)
Deluxe Cool White	30C + 20M (1)	10M + 30Y ($\frac{2}{3}$)

[a]Approximations that may need testing for critical results. Parenthetical number below filter designations, where present, are exposure corrections, in f-stops needed.
[b]Recommendations are specific for film, for tube rating, and for tube manufacturer.
[c]Kodak offers more generalized recommendations, without reference to the lamp brand.

specific films), and for six types of fluorescent lamps. (See Kodak publication AE-3 in the Bibliography.) In compiling Table 16, I have restricted the number of fluorescent lamps mentioned to the three types most commonly seen at present. But I have included the filter recommendations of more than one manufacturer so that you may choose for yourself according to whose materials you will be working with. I have also chosen to list only three films, all made by Kodak, because I feel that these represent the most likely choices for readers of

this text. Feel free to go to original sources for more complete data, if it is needed.

In search of greater simplicity, several filter manufacturers (including Spiratone, Tiffen, and Vivitar) are now producing two filters for the generalized correction of fluorescent lighting. These are designated FL-D (for Daylight films), and FL-B (for Type B films). Of course, given the large number of tube types available, these offer only an approximate correction, unless you happen upon the exact type of tube they completely correct for, if any, (and which I have not

seen listed), but using them is certainly better than not filtering at all. For many purposes they may be quite close enough.

The latest information that I have offers a helpful thought if your circumstances are similar to Jim Seymour's in "A Little Heresy Under Fluorescents"—see the Bibliography. Seymour found that most modern classrooms, offices and stores using fluorescents were using cool daylight tubes. He also found that he got best results using High Speed Ektachrome film, in the Type B emulsion rather than the Daylight type films usually recommended. Additionally, since light levels are usually lower than he cares for, he recommends the one-stop-push development recently made commercially available by Kodak. This allows working at a film speed one stop faster (ASA 250) than the film is normally rated for (ASA 125). His filter recommendation is 50M + 60Y, with $1\frac{1}{2}$ stops exposure correction, which is derived from Kodak's figures, and is similar to Kodak's recommendation, as listed in Table 16.

The obvious feature of all the foregoing discussion of photography under fluorescent lighting, as yet unstated, is that you must know the particular tube classification and manufacturer before you can hope to attain really good color correction. If you are in a position to influence such matters, see to it that all tubes in any place where you photograph frequently are of the same make and type—and preferably of a type that requires only a single filter to be balanced for the film that you prefer to use.

Photographing Television Screens. Again, black-and-white photography is less troublesome than color. If the set is a color TV, and if you wish to photograph it in color, Kodak recommends the use of a CC40R filter with a one stop exposure increase (see publication AC-10), using High Speed Ektachrome Daylight film at ASA 160. Of course, the accuracy of the color in the final picture will depend upon the television set being properly adjusted for color balance before photography.

Use with Electronic Flash. Earlier, I noted that electronic flash units whose flash tubes are not distinctly yellow in color, or that do not have other built-in filtering arrangements, usually require filtration to match the color balance of Daylight-type color films. I have yet to see an instruction booklet for a small electronic flash unit that did not claim a color temperature that is acceptable for use with Daylight films. But, every clear-tube unit that I have tested has required a filter in order to avoid a steely-blue look in the color pictures taken with them. Kodak and other film and filter manufacturers recommend the 81A or 81B Light Balancing filters. My own experiments have indicated to me that, with all the small units that I have tested and found to need filtering, the closest color match is obtained by using a CC20Y gelatin filter placed directly over the face of the flash unit. This requires a one-third stop exposure correction (a filter factor of 1.2).

My method of testing is to make color transparency exposures on Daylight-type film at approximately noon (11 A.M. to 2 P.M.), by natural sunlight, of a small subject. Then I duplicate these pictures on the same film, using the camera at a very small f-stop and exposing by the electronic flash unit being tested, at a flash distance close enough to overpower the sun locally. (See the section on closeup flash, following page 310.) If the color balance fails to match in the finished slides, I use a filter over the flash head in a new trial. The CC20Y filter has been right for all small units tested (except those that already had built-in filtering). Some very large

studio-type units have required other correction. But similar testing can be done with these.

Some background should be provided to support the previous remarks. Although most, if not all, small flash units claim a color temperature of daylight level, usually said by the manufacturers to be about 5500°K, few (if any) actually emit at that temperature, as I have stated previously. Common flash units have as their light source a glass or quartz envelope filled with xenon gas, which is heated to the glow point by a high voltage electric pulse. Xenon gas so heated emits light at various color temperatures according to the electrical input, but small commercial units normally emit in the 6–7000°K area—most at the latter level. Some few may emit light as high in temperature as 9000°K, the level of open-shade skylight. The spectral energy distribution charts in the published sources (see Edgerton's book, *Electronic Flash, Strobe* and the article by Goncz and Newell—in the Bibliography), show that the highest emissions are in the visible spectrum in the blue area— with high emission peaks in both the near ultraviolet and in the infrared, about which more will be said later. Obviously, some yellow filtration is indicated. If the unit is to be used in conjunction with sunlight, as in most field photography, the filter should be on the flash unit rather than on the lens, as noted above.

For best light output with black-and-white films, where color temperature is less important, the filter should be removed. Note also that the calculator dial on the unit will not be quite accurate while the filter is on. A correction of two-thirds of a stop for the CC20Y filter, or of one-third of a stop for the 81A or 81B filters must be made to avoid slight under-exposure.

Correction for Lens Coloration. If critical color work is being done using several lenses, made by various manufacturers, to produce a group of color slides that will be viewed in close succession, you may find that detectable color balance differences are introduced by particular lenses. These can be corrected with the appropriate CC filters.

All modern lenses have coatings on them for the purpose of reducing surface reflections, and these coatings sometimes have a faint coloration. This will cause no problem in normal photography, unless two lenses should happen to introduce a marginal off-color effect in opposite directions; for example, if one should tend toward yellow and the other toward blue. Slides of identical subject matter might then visibly differ. If you do find pictures differing in this manner, and you cannot find another cause, test your lenses. No recommendations can be given concerning the specific filters that should be used for correction. You have to work it out for your own equipment.

To test, place a representative group of slides on a light box so that they can be compared directly. Choose one slide as a standard, by its demonstrated good color balance. Mark the slide, and then check your notes to determine which lens was used to make it. Place suspected slides next to this standard, to see if there is significant color deviation. Check to determine which lens was used to make all slides that appear to deviate. If a pattern of lens use develops, you are on the right track. The next step is to place a deviating slide next to your standard. View it successively through various CC filters until you get an approximate match to the standard slide. Then make a series of new pictures of the identical subject matter through your various lenses, using the indicated CC filters on such lenses as have been producing off-color results. Choose a typical slide made by the lens that made your original standard, and

use this as your new standard. Compare the pictures made by the other lenses, which were filtered in photography, and see if they now match in color balance. Repeat these tests as needed until the results from all lenses used are free from color deviation, then record and use the filter information. To be completely valid, each comparative test should be completed on one roll of film. If more than one roll must be used, make sure to use film of the same emulsion number, processed in exactly the same manner, and preferably in the same development batch.

Correcting Film Color Balance. Color films are made in batches under conditions of stringent industrial quality control. In order to keep these batches standardized within close limits, the manufacturers work to keep each production variable within close plus-or-minus tolerances. In most uses, the results from batch to batch are remarkably consistent. But when really critical color photography is underway, the very small differences within the accepted normal tolerances may become apparent when direct comparisons are made. This is the first source of slight color imbalance in films.

Correction for existing imbalances from one color film batch to another is done with CC filters. Batches are numbered on each package of film with what is called an emulsion number. Certain "professional" films—usually only the sheet films—are pretested for exact balance by the manufacturer, and corrective filtration information is enclosed in each package. Films in mass use have no such corrective information supplied, so testing must be done to determine what it should be.

Another source of color imbalance in films is age. The color image in a film is produced by very complex organic chemistry, and color films can be said to be in a condition of very slow constant chemical change throughout their lives. This rate of change, and its direction, is predictable, to a degree. Therefore, the usual practice is for a manufacturer to produce a film that is slightly off-balance, expecting time to carry it through the proper region of color balance, and to have it go on to an opposite imbalance later. As it approaches the correct color balance, within the plus-or-minus tolerances of the process, it is released for sale. The expiration date on the package includes a safe margin at the opposite end. Knowing this, professional photographers engaged in critical color work buy films in quantity, specifying that all packages in a given order be of the same emulsion number. The first rolls (or packages of sheet film) are carefully tested for color balance, and the rest are kept under refrigeration until use. Why refrigerate? Chemical activity proceeds more quickly at higher temperatures, and more slowly when the temperature is dropped. Keeping film cool is a way of keeping its color balance more consistent over longer periods of time. No film should be stored where it will be subjected to significant heating.

In closing, note that the foregoing imbalance is unimportant in general scientific field photography, since manufacturers' tolerances are very close. It becomes worthy of notice only when critical comparative color photography is to be done. In normal use, buy film in reasonable quantities, according to your expected levels of use. Keep the main supply refrigerated (a household refrigerator will do), and prevent the overheating of your unrefrigerated ready-use supplies. Usually, no other precautions are needed.

The Mired and Other Systems In Europe, and to some extent in the U.S., there is another widely used system of control filtering, called the Mired system. The name is an acronym,

which comes from the term *"micro-reciprocal degrees."* The basic Mired value is equal to 1,000,000 divided by the Kelvin color temperature. Mired filters come in two groups, an R (reddish) series and a B (bluish) series. To explain the theory and practice of Mired filter use would take as much space as I have already given to the Kodak system. Those who wish to use this system are referred to the Bibliography. (Clauss & Meusel offers a complete coverage; Kodak publication B-3 offers information and a useful nomograph for using Kodak filters according to the Mired method.)

Other well-known filter correction systems are purveyed by Gevaert and by Harrison & Harrison. (See Clauss & Meusel for a comparative table that lists equivalent values for all four systems.) Each manufacturer can provide a purchaser with complete information on uses.

All color correction systems work about equally well, and are quite comparable in practice. The choice of a system may well depend upon where you live and what is readily available. The systems differ much more in details of nomenclature than they do in principle. I have concentrated here on the Kodak Wratten system because of its very wide distribution, and because (in all probability) it is the system that will be most readily available to the majority of my readers.

Neutral Density Filters

These are filters whose purpose is simply to cut down the amount of light as a whole. A perfect neutral density (ND) filter would transmit all wavelengths of light equally, so there would be no color tinge; hence, the name. Actual filters do have minor transmission discrepancies, but these are too slight to be detectable in normal photography. Thus, neutral density filters can be used equally well with color or black-and-white films. There are four basic types:

1. Thin layers of metal evaporated onto glass or quartz (Kodak ND filters of this type use Inconel alloy—iron, nickel, and chromium). These filters are the best quality for all around use.

2. Dyes and small particles of carbon in gelatin (Kodak Wratten 96 filters, available in many densities). These are all right for use on lenses, in visible light.

3. Large particles of carbon in gelatin (Kodak M-type Carbon Density Filters). These transmit visible light, the near ultraviolet, and the near infrared, but should not be used on camera lenses.

4. Photographic silver particles in gelatin. These are the least expensive type, and can be made simply by exposing and developing photographic film. They are not suitable for use on lenses, but will serve to attenuate light at the source.

Commercially available neutral density filters are made in a wide variety of densities, calibrated for light transmission in steps related to photographic exposure needs. Table 17 lists them as they apply to needs most likely to be encountered in field photography (I have not listed density increments of less than one-half stop light absorption).

Some neutral density filters are primarily reflectors of light. Others absorb or scatter it. In practice, the method of limiting transmission is less important than the degree of density and the neutrality of color. Suggested uses for neutral density filters in field or field-related photography are found in the following sections.

Exposure Effects Neutral density filters have several applications which use their light ab-

sorption qualities directly in the act of photography.

To Blur Action. There are times when it is desirable to use a relatively slow shutter speed in order to indicate movement, or to show its path. If a fast film is in use in bright light, or if a wide aperture is needed to limit depth of field, the correct exposure might ordinarily require an undesirably high shutter speed. By referring to Table 17, you can use an appropriate neutral density filter in order to arrive at any desired shutter speed.

To Reduce the Effect of Transitory Events. Long time exposures can "remove" from a picture all moving objects. That is, if you are photographing a building or site under circumstances where passing automobiles, pedestrians, or site workmen might be unwanted picture elements, the use of a long exposure will delete such transitory presences. They will not be in one place long enough to record on the film. The most effective working method is to combine a slow film and a small aperture with a neutral density filter to obtain an exposure time lasting anywhere from minutes to hours, or even days. Correct exposure must make an allowance for reciprocity failure.

To Reduce Depth of Field. By keeping the shutter speed unaltered when neutral density filters are introduced, the lens aperture can be opened so as to reduce the depth of field in the image. The use of shallow depth of field tends to visually isolate the subject, because everything not in the principal plane of focus will be unsharp.

To Prevent Overexposure of Fast Film. In very bright light, you may find it impossible to avoid overexposing a very fast film, especially with the very large and relatively slow shutters found on view camera lenses. (These frequently limit fast speeds to no more than 1/125th or 1/250th of a second.) Occasionally, you might find yourself with only one type of film remaining unused at the end of a day of work, with a job that re-

Table 17
Common neutral density filters

DENSITY	PERCENT TRANSMISSION	FILTER FACTOR[a]	EXPOSURE INCREASE[a] (IN STOPS)
.15	75	1.5	$\frac{1}{2}$
.3	50	2	1
.5	32	3	$1\frac{1}{2}$
.6	25	4	2
.7	20	5	$2\frac{1}{2}$
.9	13	8	3
1.2	6.3	16	4

[a] Approximations suitable for photographic exposure purposes.

SOURCE: Compiled from information given in Kodak publication P-114, *Kodak Neutral Density Attenuators* and from Clauss and Meusel, *Filter Practice* (see the Bibliography).

quires slower films. Neutral density filters will attenuate the light entering the camera so as to allow greater exposure flexibility.

Film Speed Equalization Rather than to provide a simple attenuation of light during a given exposure, you may find it useful to use neutral density filters to bring two or more films of differing sensitivities to a common effective film speed.

To Standardize Exposures of Differing Films. When trying to work quickly and accurately with relatively unfamiliar materials, it may be beneficial to use neutral density filters to bring all the films in use to the same effective film speed, simply to avoid confusion. I have seen hospital-patient photography that required basically identical photography using normal black-and-white panchromatic film, color film, and films filtered to ultraviolet and infrared sensitivities, in order to facilitate comparisons. To avoid delay in photography, and to keep action stopping and depth of field characteristics consistent throughout, it is useful to use identical lens and shutter settings. In such a practice, determine which film has the slowest basic sensitivity when it is used as needed. This one is used without neutral density filtering. All others can then be brought to the same effective film speed by choosing and using the proper neutral density filter. Obviously, this sort of arrangement should be worked out in advance, and the correct filter placed next to the various film holders, ready for use.* In any use where the exposure is made with neutral density filters on the lens, it is necessary to use filters of optical quality. It is also best to use a single filter of

the required density, both to avoid confusion in use and the optical problems that are associated with the stacking of filters.

To Test Difficult Camera or Lighting Setups, Using Polaroid Land Films. Many photographers make use of Polaroid Land rapid-access films to check the accuracy of setups involving such things as critical depth of field requirements, exact exposure, or careful composition. This method is quicker, more flexible, and less subject to error if the Polaroid Land test film and the film to be used for final photography are of the same effective speed, so that you do not have to make last minute changes. If the two films are not so matched to start with, you can use neutral density filters, as described in the previous section, to equalize them. (A most complete coverage of this technique, complete with tables of equivalency and clear explanations, is found in Eisendrath's article, "Polaroid Land 4" —see the Bibliography.)

The single greatest problem in using this system with any type of Polaroid Land material is that the exposure equivalents should be tested in advance, and the temperature at the time of development recorded. With Polaroid Land films, the film speed (and other characteristics) can vary considerably if the processing temperature is not standardized. If varying temperatures are likely to be encountered, do advance testing to establish equivalency at a variety of likely temperatures, and tabulate the results for later use in the field.

Polarizing Filters

Polarizers differ profoundly from all the other filters that have been described so far. They do not discriminate among wavelengths as color

*Personal communication from S.G. Ehrlich.

filters do; they transmit all colors of visible light approximately evenly. Instead, their photographically interesting filtration is based upon a different physical principle—the selective absorbtion or transmission of the various vibration planes of light.

Nature of Polarization of Light In photography by polarized light, the wavelength of a light ray is of secondary importance; the plane of vibration of the transverse wave motion of that light ray is the matter of prime interest. Because of the wavelike character of light, the planes of vibration of those transverse waves that travel along the same line (a ray) radiating from a source such as the sun are randomly oriented in all directions around the linear axis of the ray, with their direction of propagation being along that axis. Because there is no preferred plane of vibration—as there is, for instance, when wave motion is generated along a rope—this sort of light ray is said to be unpolarized. But when certain effects occur that cause all but one plane of vibration to be extinguished, the ray is said to be plane polarized, as shown in Figure 33.

There are a variety of ways in which light can become polarized, some occurring regularly in nature, and some that can be induced artificially. In field photography there are two ways that stand out. One is the natural partial polarization of light by scattering, as in sky and haze effects. The other is a polarization by reflection from surfaces. These are described later, as are those aspects of induced polarization likely to be encountered in photography allied to field work. (The foregoing is necessarily incomplete and oversimplified; for other, more thorough coverages of polarization, see the Bibliography—for theory, Strong's *Concepts of Classical Optics,* or Wood's *Physical Optics;* for the layman, Shurcliff & Ballard's *Polarized Light.*)

The Filter Polarizing filters designed for use on camera lenses consist of a plastic sheet called Polaroid (made by the Polaroid Corporation), or of basically similar material made by other firms, capable of limiting the transmission of light to, or close to, a single plane of polarization. The polarizing material is sandwiched between glass, and is usually encased in a screw-in filter frame in such a way that the filter can be rotated after it is mounted on the lens.

For uses requiring larger pieces, Polaroid is also available in unprotected sheets of varying sizes and proportions. For normal uses, Polaroid's H-sheet is the most widely used material; but if the material is to be placed in front of incandescent lamps or in other hot locations, K-sheet should be used instead (see Shurcliff & Ballard). (For a coverage of the nature and uses of polarizers, including specifications of the presently available types of Polaroid, see *Polarized Light,* a 12-page illustrated booklet published by the Polaroid Corp., Cambridge, Massachusetts, dated 3/70.)

In field photography, the natural polarization of light affects only a part of the light that forms the image. Unpolarized light is transmitted by a Polaroid photographic filter at a standard rate of about 40 percent, regardless of the rotation. However, light that is already naturally polarized is transmitted at rates of from 40 percent down to as little as one or two percent, depending upon the angle of rotation of the polarizing plane of the filter with respect to the plane of polarization of the light. That is, when the filter's plane of polarization is parallel to the plane of vibration of the light, the polarized beam is affected no more than is unpolarized light. But when the filter is rotated away from this alignment, the percentage of transmission diminishes until, at a 90 degree angle to the plane of vibration, absorption of the polarized portion of the

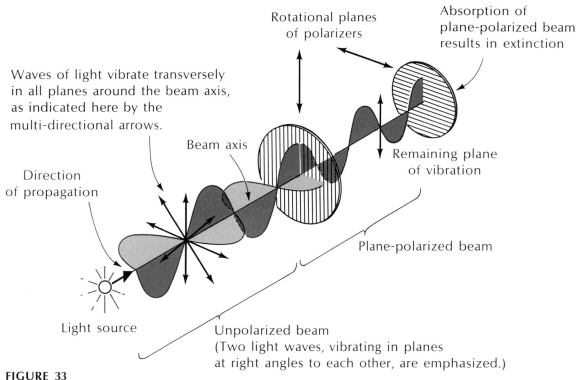

Rotational planes
of polarizers

Absorption of
plane-polarized beam
results in extinction

Waves of light vibrate transversely
in all planes around the beam axis,
as indicated here by the
multi-directional arrows.

Beam axis

Remaining plane
of vibration

Direction
of propagation

Plane-polarized beam

Light source

Unpolarized beam
(Two light waves, vibrating in planes
at right angles to each other, are emphasized.)

FIGURE 33
Polarization of light by a polarizing substance.

light by the filter is very nearly complete. A polarizing filter can also be used to polarize a previously unpolarized beam, as is also shown in Figure 33. Photographic polarizers recently made by firms other than the Polaroid Corporation may have a basic light transmission of 25 percent, or even less, so exposure factors are less standardized than before. However, these relatively denser filters may also be more efficient in cutting out all polarized light, when crossed.

The following sections describe various aspects of the practical use of polarizing filters in field photography.

Natural Polarization—By Scattering A ray of unpolarized light that strikes a molecule of air or other very tiny particle, and is scattered by

that obstruction, becomes plane polarized perpendicular to the direction of propagation of the incident ray. Thus, this polarization is apparent to the photographer to a degree that depends upon the angle between the direction of the original incident ray and the line of sight of the viewer. If your view is along the line of propagation of the ray, and you are looking through a rotating polarizing filter, there is no polarization effect to detect. But if your view is perpendicular to that line the effect will be at its maximum, and the sky in that direction will darken when the rotation of the filter is correct. The maximum effect occurs on the clearest days; approximately 80 percent of the scattered rays will be plane polarized, with the extent of polarization of the remaining 20 per-

cent of the scattered rays either being reduced or eliminated by effects due to multiple scattering. On hazy days there is more multiple scattering, and hence less remaining polarization.

Sky Effects. The light of the blue sky is partially polarized by the same scattering that produces the blue color. If a polarizing filter is used to absorb the polarized rays, the blue color becomes noticeably darker. Because of the directional aspect noted above, the effect is greatest perpendicular to the direction of the sun, and nil looking directly toward or away from it. At sunset, the skylight at the zenith is strongly polarized, as is the skylight at the north and south horizons. At midday, strongest polarization is near the horizon and toward east or west, as shown in Figure 34.

Maximum polarization effects are seen on very clear days, with hazier skys giving progressively less effect, as multiple scattering of the light increases.

The practical effect of this is that by using a polarizing filter it is possible to darken parts of the sky without the color effects of yellow or red filters. Thus, emphasis can be given to the sky in a color photograph, or in black-and-white when no color filtering effects are wanted. Pictorially, the greatest disadvantage is that if you are not looking at right angles to the sun line you get little or no effect. And, if you are using a wideangle lens to obtain a panoramic view, you will find that the sky tones will grade off as the angle of view across the picture becomes less than 90 degrees to the sun line. Therefore, depending upon the relative angles of the sun line and the lens axis, the sky may appear much darker at one end of the picture than at the other end. Or, the sky might be dark at the center and light at the ends, or vice versa. Nevertheless, the sky effects that are obtainable may be very desirable. And in color photography, the only other filter that can be used to obtain them is a graded neutral density sky filter. With black-and-white film, a color filter could be used with a polarizer to obtain a greater effect than either could give alone. If your needs along these lines are frequent, you can special-order polarizing filters that have one of the cover glasses so colored as to be the color filter of your choice, thus cutting down the number of air-glass surfaces and their attendant problems (see Plate 15, page 177).

The easiest way to determine the visual effect of the light absorption of a polarizing filter is to look at the subject through it while rotating the filter. The effects will be visible and very apparent. When the desired degree of effect is obtained, place the filter on the lens at the same angle of rotation. With single lens reflex cameras, or other ground glass viewing cameras, you can place the filter on the lens at the start, and look through the camera view finder in order to observe the effects of rotation. Manufacturers of some twin lens reflex cameras provide an interlocked double polarizer that has a filter for each lens, so that the rotation of one produces a comparable rotation of the other.

If you wear Polaroid sunglasses while doing field photography, you will see nothing at all when you rotate the camera filter to a 90 degree angle to the polarization plane of those glasses. Take off the glasses and all will be well. Note also that, in an emergency, grey-toned Polaroid sunglasses can be used as a makeshift polarizing filter for photographic use.

Haze Effects. Just as a portion of photographable atmospheric haze is due to the scattering of both blue light and ultraviolet radiation, yet another portion is due to the polarization

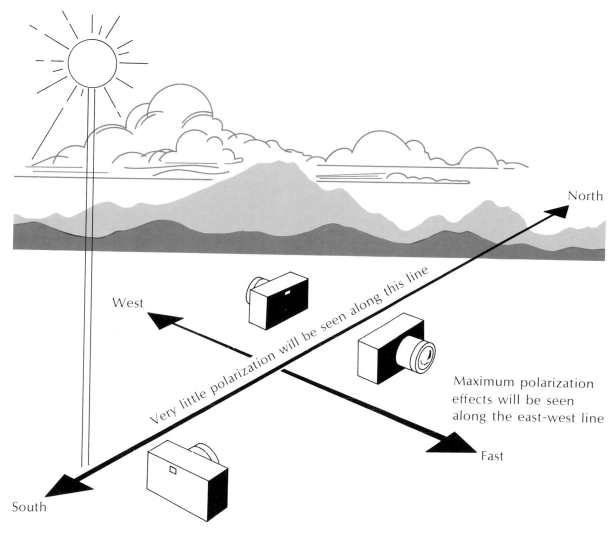

West

North

Very little polarization will be seen along this line

Maximum polarization effects will be seen along the east-west line

East

South

FIGURE 34
Idealization of noon sky polarization effects.

of light produced by the scattering process. Therefore, the penetration of distance haze can be maximized by using ultraviolet and blue-absorbing filters, supplemented by a polarizing filter. The usefulness of the polarizer is limited by direction, as it is with the sky effects described previously, as shown by Figure 34. And, the hazier the day the less use a polarizing filter will be, in a percentage sense, due to the depolarizing effects of multiple scattering.

Natural Polarization—By Reflection Light striking a smooth surface is reflected from it at an angle equal to and opposite from the angle of incidence, as shown by Figure 35.

Nonmetallic Surfaces. Some surfaces, such as mirrors, reflect a very high percentage of the light that strikes them. Others reflect some and absorb some. With dielectric (nonconducting) materials, a portion of the light that is reflected

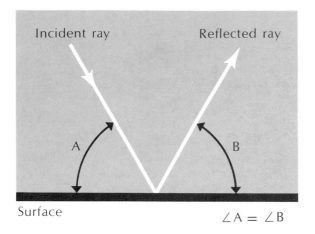

Incident ray Reflected ray

A B

Surface

∠A = ∠B

FIGURE 35
The reflection of light from a surface.

is polarized, by what Wood describes as "coherent scattering." (See the Bibliography—Wood's *Physical Optics*.) The plane of polarization is parallel to the reflecting surface. Polarization is strongest at what is called the "Brewster angle," and diminishes rapidly as the angle changes. The Brewster angle varies according to the nature of the material reflecting the light, but for most substances it is between 30 and 40 degrees. Reflected light so polarized can be absorbed by a properly oriented polarizing filter. Thus, reflections or glare on many surfaces can be partially or completely eliminated, as shown in Figure 36, and Color Plate IX.

The controlling factor in the elimination of reflections, if the effect is to be maximized with a polarizing filter, is the necessity of using the reflection angle of the material involved as the angle of view of the camera. Thus, if the angle of strongest polarized reflection from the water is 37 degrees, then the camera angle must also be 37 degrees, or the control of the polarized reflection will only be partial. This is often not desirable, and occasionally not even practical. So this mode of control is not perfect.

Metallic Surfaces. Although the vast majority of materials likely to be encountered in field photography have the property of being able to plane polarize light by reflection, as described previously, metals do not. The physical mechanism behind this ability, or the lack of it, is not well understood and is subject to some argument at present; but, it is related to the electrical characteristics of the reflecting material and to the fact that polarization is one of the characteristics of the electrical vector of light waves. Fortunately, in the present context, the effects are more important to us than a complete theory. It is enough to say that the reflection of an unpolarized incident light beam from a smooth metallic surface does not produce plane polarization, and so polarizers can not eliminate such reflections.

All is not lost, however. If the incident beam is already plane polarized when it strikes the metallic surface, as is the light from various portions of the sky, it will remain plane polarized after reflection, and the strength of the reflection can be altered by a polarizing filter in the normal manner. For, just as a metal surface will not plane polarize a beam by reflection, so it will not depolarize it.

Opposing Surfaces. There are occasions when two surfaces, oriented at an angle to one another, both reflect light toward the camera lens

a

b

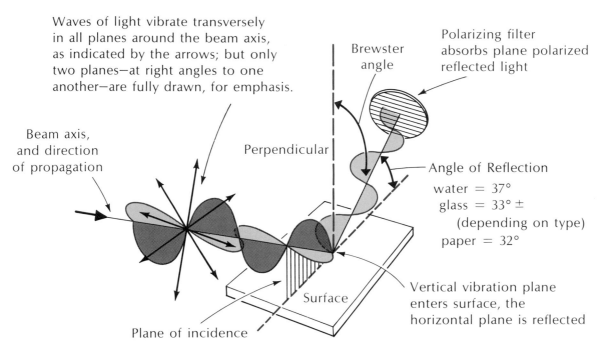

Waves of light vibrate transversely in all planes around the beam axis, as indicated by the arrows; but only two planes—at right angles to one another—are fully drawn, for emphasis.

Brewster angle

Polarizing filter absorbs plane polarized reflected light

Beam axis, and direction of propagation

Perpendicular

Angle of Reflection
water = 37°
glass = 33° ±
 (depending on type)
paper = 32°

Surface

Vertical vibration plane enters surface, the horizontal plane is reflected

Plane of incidence

FIGURE 36
Polarization by reflection.

at approximately the Brewster (polarizing) angle. Because the planes of polarization of the two reflections are parallel to the reflecting surfaces, as shown in Figure 36, only one at a time can be maximally absorbed by a polarizing filter. If the angle between the two surfaces is 90 degrees, the filter will be least effective for one reflection just when it will be most effective for the other, and vice versa. The best overall effect can only be partial.

Induced Polarization The use of deliberately induced polarization is by no means limited to the laboratory. Any material that can be used to sort out polarization after the fact can also be used to induce polarization. Instead of using a polarizer only as a filter at the lens, you can use two—one to do the initial polarization of

the light (the "polarizer"), and the other to make the effects visible (the "analyzer").

Either natural light or the light from artificial sources can be polarized. Polaroid H- and K-sheet is available in standard 16 × 20 inch sizes, and in other sizes according to your special order. Sheets as large as 20 × 20 inches are listed in the current catalogue from the Edmund Scientific Company. (See their ads in magazines.) It is also possible to obtain glass-mounted Polaroids large enough to place in front of flash units. I have two of those.

Reflection Control. Reflections can be eliminated from almost any surface if the incident light is already polarized before it touches the subject. If natural light is used, interpose a sheet of polarizer between the source and the subject,

being sure that it is large enough to cover the whole subject area. Place the usual polarizing filter on the camera lens, rotate it until the reflections disappear, and make the picture. If flash lighting is being used, and the angle of polarization of reflections can only be guessed at, line up the axes of the two polarizers. Most polarizers have the axis of polarization marked on them. If yours do not, look through them both while rotating one. At the point of maximum extinction of light the axes are at 90 degrees, as was shown in Figure 33. Mark the axes for future reference. The lamp polarizer axis should be at 90 degrees to the axis of the lens filter in order to gain maximum reflection control.

If you are going to use two light sources, both must be polarized. To align two such lamp filters visually, set them up separately. Place a polarizing sheet in front of one light source, and rotate the lens filter until all the disturbing reflections are gone, and turn off that lamp. Then turn on the second lamp. *leaving the lens filter untouched,* rotate the polarizing sheet over the second lamp until the reflections produced by that source are gone. Both sheets will now be correctly oriented, relative to the lens filter.

Reflection control, using deliberately induced polarization, is more versatile and complete than that done with light that has been naturally polarized by reflection. In this use, the angle of the camera axis is not critical, as it is when neutralizing naturally polarized reflections.

It is not always desirable to eliminate every last trace of a reflection, or even to do any modification at all. Some reflections are desirable in themselves, for what they show and how they show it. If you are dealing with reflections that conceal detail on naturally wet surfaces, you may find it best only to lessen the strength of the reflection, rather than do away with it

completely. Total elimination will remove the impression of wetness, and thereby will alter the characteristic appearance of the subject. It may also be desirable to leave some trace of a covering transparent surface. I titled this section "reflection *control*", simply because it is sometimes best to stop short of complete reflection elimination.

Transmitted-Light Effects. Most often, transmitted-light polarization technique is a laboratory matter, but the need for some field use cannot be entirely discounted.

In this usage, the practice is to use two polarizers, one on each side of a transparent or translucent subject. The one on the side nearer to the light source is called the polarizer, because its function is to plane polarize the light before it gets to the subject. The one nearer to the camera lens is usually called the analyzer, because its function is to analyze (in visual terms) what the passage through the subject has done to a beam of plane polarized light. (In their form they may be identical; they differ only in the optical function that is performed.) Initially, the two polarizers are "crossed;" that is, their axes of polarization are placed at an angle of 90 degrees, so as to achieve maximum extinction of light. Thus, the field of view will be entirely dark, unless the subject affects some of the light passing through it in such a way that it can now pass through the second filter. After this initial right angle crossing, the analyzer is slowly revolved. Substances that fail to affect the light will continue to leave the field of view dark and without information, and are called "isotropic." Substances that can affect the polarization angle of the light in these circumstances are called "anisotropic." Anisotropic substances have the property of being able to rotate the plane of polarization of a plane polarized beam, as

shown in Figure 37. In some cases, the resulting images will be in shades of grey, if the original subject is colorless, and if there are varying densities in it that attenuate the light visually. In other cases, the image breaks up into patches of very brilliant color, even though the subject as normally viewed is colorless or nearly so. This is due to an effect known as wave retardance, within the subject, that results in changes of wavelength. In some cases where there is no inherent retardance it is useful to add this effect by introducing a "retardation plate" or "wave

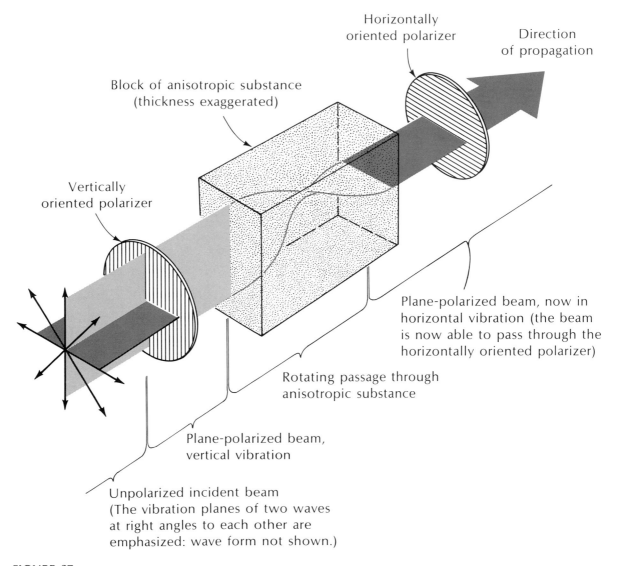

Horizontally oriented polarizer

Direction of propagation

Block of anisotropic substance (thickness exaggerated)

Vertically oriented polarizer

Plane-polarized beam, now in horizontal vibration (the beam is now able to pass through the horizontally oriented polarizer)

Rotating passage through anisotropic substance

Plane-polarized beam, vertical vibration

Unpolarized incident beam (The vibration planes of two waves at right angles to each other are emphasized: wave form not shown.)

FIGURE 37
The rotation of a plane polarized beam by an anisotropic substance. The direction of rotation is not the same for all substances. (This drawing is not a representation of what actually happens in a physical sense, but is an analogy presented for help in understanding.)

plate" between the first polarizer and the subject. For purposes of experimentation, a simple stepped retardation plate can be made by laminating a piece of glass with layers of cellulose tape, as shown in Figure 38. (See Stong, "Two Methods of Microscope Lighting That Produce Color" in the Bibliography.) The "shingling" of differing lengths of tape provides varying degrees of retardation, and thus varying colors.

Materials suitable for examination and photography in this manner include certain types of plant fibers, animal muscle tissue, thin sections of minerals (thin layers of mica are often used to make retardation plates), many chemical depositions, some tiny transparent or translucent insects or mites, unannealed glass, and certain transparent plastics.

The produced effects of birefringence and retardation can be very complex in their nature and their need for sophisticated analysis. Their most common pictorial use is in photomicrography, but some subjects are large enough to fall within the techniques of photomacrography and closeup photography. Extensive field use is too unlikely to justify more space here. If your needs and interests run in this direction, see the Bibliography for definitions of terms, explanations of physical principles, and descriptions of suggested photographic practices. (For an introduction, see Stong's previously noted article; for increasingly complex coverages, see Smith's series on "Color Contrast Methods . . . ," and Gahm's "Polarized Light Microscopy")

Neutral Density Uses of Polarizers Since polarizing filters are substantially without color transmission preference, they can be used as neutral density filters, either singly or in pairs, in cases where there are no polarization effects to interfere. A single polarizer is a neutral den-

Layers of cellulose tape, of unequal length

Glass plate

FIGURE 38
A simple stepped retardation plate.

sity filter just as is. Two together, one rotated with respect to the other, become a variable neutral density filter going from a maximum of about 16 percent transmission (for two standard photographic filters) to a minimum of less than one percent. This offers the possibility for a very fine calibration of exposures, because the change in transmission is continuous. It should be noted that the very last light that is passed by crossed Polaroid polarizers, or by a single Polaroid polarizer being used to eliminate a strong reflection, is definitely blue in color—the only noticeable deviation from neutrality of color. But this is only seen in extreme circumstances. If you plan to approach extinction (but not to complete it) stop just short of this sudden shift to blue, if you are using color film. Some of the newer polarizing materials are "sharper cutting"; that is, they do not allow this leakage of deep blue wavelengths. When two such polarizers are crossed they are also more efficient in eliminating all light transmission. Therefore, it is very important to know what material you are using. Fortunately, at least one piece of exposure information is packed with nearly all polarizing materials or devices. It may be the percentage of basic transmission, or it

may be the filter factor. Whichever information it is, reference to Table 18 will provide the rest.

Exposure Compensation with Polarizers Because polarizing materials are used both singly and in pairs, polarizers have two basic filter factors (more, if you combine unmatched materials). For commonly available materials, these are tabulated in Table 18.

WARNING: The figures in Table 18 are the basic neutral density factors for polarizing material. They do not take into account the exposure effect of eliminating reflections on otherwise dark surfaces in the subject area. If important subject matter is in that area, exposure data may be measured using a hand held light meter, with a properly oriented polarizer covering its sensing cell. Or, with built-in meters

of some types, exposure can be read with the correctly adjusted filter in place over the camera lens. Exceptions to this latter method are those cameras in which the meter is located behind a semitransparent mirror or wedge, as in certain Canons, Prakticas, and Mamiyas, and in the Yashica Electro AX, or the Leicaflex SL. With these cameras, use a separate hand held meter. (For details, see ''The Weird World of Polarizing Filters . . .'', Kimata and Keppler—see the Bibliography.) Both of these methods eliminate the need to figure in filter factors. The figures in Table 18 are for the *least* exposure compensation that will be needed under any circumstances. No one can predict in advance the exposure effect of removing a reflection. However, sky effect exposures are quite safely calculated from the tabulated figures.

TABLE 18
Exposure information for polarizing filter materials[a]

TYPE	PERCENTAGE OF MAXIMUM LIGHT TRANSMISSION		FILTER FACTOR[b]		NUMBER OF STOPS EXPOSURE INCREASE	
	SINGLY	PAIRS[c]	SINGLY	PAIRS	SINGLY	PAIRS
Photographic filters[d]						
Polaroid	40	16	2.5	6	$1\frac{1}{3}$	$2\frac{2}{3}$
Hoya	25	6.25	4	16	2	4
Polaroid sheet						
HN-22	22	5	4.5	20	$2\frac{1}{4}$	$4\frac{1}{3}$
HN-32	32	10	3	10	$1\frac{1}{2}$	$3\frac{1}{2}$
HN-38	38	14	2.5	8	$1\frac{1}{3}$	3

[a] Polarizing filters and sheet stock are available, in a variety of densities, from various sources. For densities other than those listed, see Table 10 (page 147) and Table 17 (page 170), to calculate approximate filter factors.

[b] Approximate figures, close enough for most purposes.

[a] Used, as discussed on page 178, for reflection control; or with polarizing axes parallel, for maximum light transmission. (If the axes are not parallel, the light transmission must be measured.) Figures in this table assume that paired filters are identical.

[d] Most, but not all, photographic filters approximate one of these two sets of figures. See the manufacturer's instruction sheet.

In the technique of polarization by transmitted light, exposure levels have little or nothing to do with the basic neutral density value of the filters in use. Exposures should be calculated by the use of suitable through-the-lens built-in meters, or at the ground glass. A spot ground glass reading will be the most accurate method.

FILTERS WITH ULTRAVIOLET RADIATION

The photographically useful spectrum extends past both ends of the visible spectrum. The ultraviolet region occurs at the short wavelength end, beyond blue. This region is made accessible to photography by means of filters. Ultraviolet photography is a broad field that I can do no more than outline here. Readers who wish to explore the field further are referred to the Bibliography (and especially to Kodak publication M-27).

Nature of Ultraviolet Radiation

The ultraviolet is that portion of the electromagnetic spectrum that lies between "soft" X-rays and the shortest visible blue-light wavelengths.

Wavelengths Involved The photographically useful portion of the ultraviolet region extends from a wavelength of about 200 nanometers (nm) up to 400 nm, the approximate limit of visible blue. For convenience, this region is usually divided into two or three subclassifications, depending upon circumstances. I will follow the common practice of using a two-level division, calling the 200–300 nm region the short wave or far ultraviolet, and the 300–400 nm region the long wave or near ultraviolet. Cutoff points are arbitrary and not especially significant.

Many minerals visibly fluoresce when under ultraviolet radiation. Ultraviolet sources for the examination of mineral specimens frequently have two filters, one for long and one for short wave emission. Photography of these materials is done with an ultraviolet-absorbing filter on the camera lens, with the film recording only the visible-light fluorescence. Photography by reflected ultraviolet is done with an ultraviolet-transmitting/visible-absorbing filter on the lens. Most reflected ultraviolet photography is done with long wave (near) ultraviolet, although there are exceptions.

Ultraviolet Viewers A television camera, being sensitive to ultraviolet, can be used as an ultraviolet viewer if a suitable ultraviolet-transmitting lens is used, in combination with an ultraviolet-transmitting/visible-absorbing filter. This practice has been described by Eisner, et al., by Barer and Wardley, and by Zworykin, et al., (see the Bibliography). They describe a method with a lens and filter combination that transmits in the near ultraviolet, between 330 and 400 nm, which allows continued observations of living subjects in the field.

Dangers of Ultraviolet Radiation It is the ultraviolet component of natural sunlight that produces sunburn. The use of artificial ultraviolet sources can cause severe burns, especially to the retina of the eyes. This includes ultraviolet that is reflected from surfaces as well as direct radiation from the source. Itching of the eyes is a sign of such damage. Another possible effect of long term exposure to ultraviolet is an increase in the probability of the formation of cataracts. *Always* use protective goggles when

using artificial ultraviolet sources. And, of course, watch out for sunburn when in the field. (We balding types have a special problem at the tops of our heads.) Since ultraviolet radiation has the ability to penetrate thin cloud cover, you are not safe from sunburn unless the sky is pretty thoroughly overcast.

Protective goggles for working with artificial ultraviolet sources are obtainable from Ultra-Violet Products, Inc., of San Gabriel, California. These are colorless, and can be worn over regular eyeglasses. Ordinary eyeglasses absorb most ultraviolet wavelengths. However, the longer wavelengths do pass directly through the glass. In addition, eyeglasses offer no protection around their periphery. Therefore, they are not in themselves sufficient for eye protection.

Reflected Ultraviolet As noted previously, there are two ways in which ultraviolet radiation is used photographically. In the first, subjects are photographed by reflected ultraviolet, much as they are normally photographed by reflected visible light. This can be done in various ways, some of which are as follows:

1. by using natural sunlight, with an ultraviolet-transmitting/visible-absorbing filter on the camera lens;

2. by using an artificial ultraviolet source, in daylight or roomlight, in combination with an ultraviolet-transmitting/visible-absorbing filter on the camera lens; or

3. by using an artificial ultraviolet source, in the dark, with an ultraviolet-transmitting/visible-absorbing filter on the light source.

Excited Fluorescence The second use of ultraviolet radiation in photography takes advantage of the fact that when some materials are illuminated by short wavelength radiation they re-emit the radiation as a fluorescence, at substantially longer wavelengths. Since these longer wavelengths fall within the visible spectrum (in most cases), it is possible to photograph them to very good effect on color films. Most commonly, this is done in darkness, using a filtered source to produce the appropriate ultraviolet wavelengths to excite the fluorescence. A second filter is then used on the camera lens to cut off all the reflected ultraviolet from the film, so that only the visible-light fluorescence is recorded.

Photographic Matters

Photography using ultraviolet radiation imposes special requirements on lenses, filters, films, and photo technique. These are presented in turn in the following sections.

Optical Transmission of Ultraviolet Because some optical materials transmit ultraviolet freely, and others more or less block it out, it is necessary to take a look at the materials that compose lenses and filters.

Lenses. Most optical glasses used for camera lenses will not transmit radiation shorter in wavelength than about 340 to 360 nm. If reflected ultraviolet photography at shorter wavelengths is to be done, the usual recourse is to quartz optics. Unfortunately, these are rather expensive, and may be hard to obtain. An interesting exception to the foregoing are the line of very short focal length reflecting optics produced by the Ealing Corporation (Cambridge, Massachusetts, and Ealing Beck, England). These are basically small reflecting telescopes, in focal lengths short enough to permit close range photography of small subjects. Since they are

completely reflective in construction—with no refracting optics in the system—the light does not go through any glass or other ultraviolet absorbing material. Therefore, even though they are made of glass, they can be used with ultraviolet, as well as with visible and infrared wavelengths. Although not cheap, they are within a price range appropriate to their qualities. (See Figure 39 for a cross-sectional diagram.)

In refracting optics, the glass itself may be only part of the problem, since the cement used

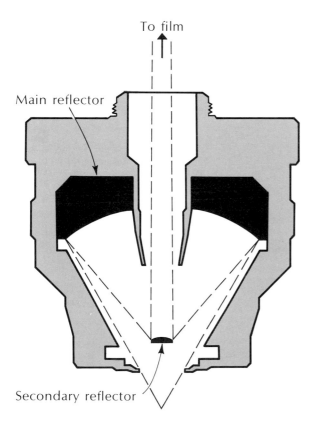

FIGURE 39
Cross sectional diagram of a reflecting optic suitable for small-object ultraviolet photography.

to fasten various elements together may fluoresce, and thereby cause additional problems.

Photography of excited fluorescence, which occurs in the visible wavelengths, does not require special lenses.

Filters. There are no gelatin filters suitable for the transmission of ultraviolet while simultaneously absorbing visible light. Therefore, special glass filters are made for this purpose. The Kodak Wratten 18A glass filter serves well in the long wave (near) ultraviolet, having a transmission band between 300 and 400 nm, with a peak at 365 nm. Being of high optical quality, it is the standard glass filter for use on camera lenses. Corning produces a number of glass filters (not of lens filter quality, but suitable for use over a light source), that transmit in the ultraviolet region. Perhaps the most suitable one is their #9863, which transmits between 225 nm and 400 nm, with a peak at about 330 nm. For a narrower band, peaking at 365 nm, use Corning #5874. For very limited uses, Corning's narrow band C.S. 7-83 offers a peak at about 360 nm, with very little other transmission. (See Figure 40 for graph plots of the transmission characteristics of these filters.)

Short wave (far) ultraviolet photography not only requires quartz lenses (or completely reflecting optics) for reflected ultraviolet work, it also requires special filters for either reflection or fluorescence work. Kodak recommends that workers needing to use wavelengths shorter than those passed by the Wratten 18A or the listed Corning glass filters should look into interference filters making use of thin vacuum-evaporated coatings on ultraviolet-transmitting substrates. These can be had from Baird-Atomic, Cambridge, Mass., and Oriel Optics Corp., Stamford, Conn., among other places. (See Kodak publication M-27, p. 6.)

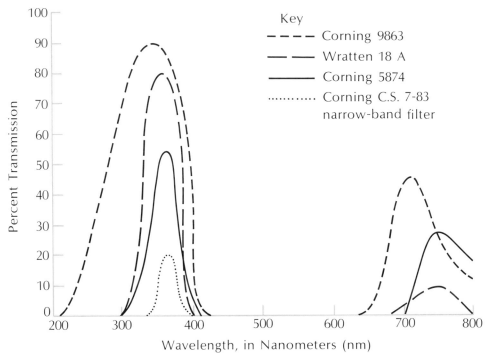

FIGURE 40

Filters for ultraviolet photography. All curves are approximations and were redrawn from various sources. The Corning filter data was derived from Catalog CF-3, *Corning Glass Filters,* 1965. The Wratten filter data was derived from Kodak publication B-3.

Sensitivity of Films No special films are needed for ultraviolet photography, as the silver halides in all standard emulsions are inherently sensitive to long wave ultraviolet. Only in extremely short wave ultraviolet is the emulsion itself a problem. Reflected ultraviolet photography in the shorter wavelengths, as when using quartz lenses, may present a slight difficulty, due to the absorption of some ultraviolet by the gelatin of the film emulsion in which the halide is suspended. If this happens, it may be necessary to use a fast film at a reduced exposure index, in order to compensate for the loss of film efficiency.

Ultraviolet reflection images are frequently low in contrast, so it may be useful to use high contrast materials and/or development. Color films will record reflected ultraviolet, but as the image will be monochromatic—limited entirely to shades of blue—you might just as well use black-and-white films, in which it is easier to raise contrast.

Radiation Sources for Field Work Quite obviously, field work involving photography in the ultraviolet region of the spectrum requires either existing natural radiation sources, or artificial sources that are portable and independent of electric power lines.

Sunlight. Direct sunlight is a rich source of natural ultraviolet radiation. Although we normally associate sunburn, the most commonly encountered consequence of natural ultraviolet radiation, with hot days at the beach, ultraviolet

radiation is partially absorbed by the atmosphere. Therefore, it is even more plentiful at high altitudes. This may be a satisfying thought for geologists who happen to be working in the mountains.

Mineral Lights. Portable battery-operated ultraviolet lamps, sometimes called "black lights," are on the market, and are readily available at stores that sell mineral collecting supplies. These lights often offer a built-in choice between long and short wavelengths of ultraviolet radiation, by means of a replaceable pair of filters, or by providing side-by-side filtered sources. Since the ultraviolet-transmitting/visible-absorbing filters are built in, these sources are most useful for night photography of excited fluorescence. These lamps can also be used as sources for reflected ultraviolet work. An optical-grade filter must then be placed over the camera lens to exclude all ambient visible light.

Among the best known makes is the Mineralight, which operates either on line current or from a battery pack. It is made by Ultra-Violet Products, Inc., of San Gabriel, California.

Electronic Flash. Probably the most convenient, versatile and portable source of ultraviolet radiation for photography is the common electronic flash unit, as shown by the spectral output curves in Figure 41.

Spectral outputs vary, depending on the power of the unit, the exact composition of the gases in the tube, and whether the envelope of the emission tube is made of glass or quartz. In addition, in a very few cases, transparent protective covers meant to be placed over some flash units may absorb ultraviolet radiation. However, most plastics that are so used do not. Basically, the more powerful the unit, the greater the output of all emitted wavelengths, including ultraviolet. If the tube envelope is glass, which absorbs ultraviolet, there will be less ultraviolet output than if it is made of quartz, which is transparent to ultraviolet radiation. If you plan to do much ultraviolet flash work, it is desirable to obtain a unit with a quartz tube. But, since the ultraviolet emission of the xenon flash is stronger in the long wave ultraviolet than in the short wave area, enough long wave ultraviolet does get through even the glass envelope to allow reasonable exposures for the excitation of fluorescence, and for photography by reflected ultraviolet. All of my own fluorescence photography of minerals has been done using a small, amateur-type electronic flash unit, with a Corning 9863 or a Wratten 18A filter mounted on it; and, the results have been very satisfactory. The only disadvantage is that the flash-to-subject distance must be very short with such low-powered units (probably down to three inches or less, even at wide lens apertures).

Bulb Flash. Photography in the ultraviolet region is also possible using ordinary flashbulbs or flashcubes as a basic radiation source. Although not especially efficient as ultraviolet radiators, flashbulbs do emit a significant amount of usably short wavelengths, as shown in Figure 41,B. As both plain and blue bulbs do so, there is no special need to pick and choose. More powerful bulbs emit both visible light and ultraviolet radiation more plentifully, so use the strongest ones available. Filtering is basically the same as was recommended for electronic flash. Wavelengths emitted by bulbs are limited to the long wave ultraviolet by the glass envelope.

Quartz/Halogen "Sungun" Lamps. The "sungun" portable lighting units used with cine cameras are rich in ultraviolet radiation, and the quartz envelope lets it get through to the subject. Although they are also high in heat output,

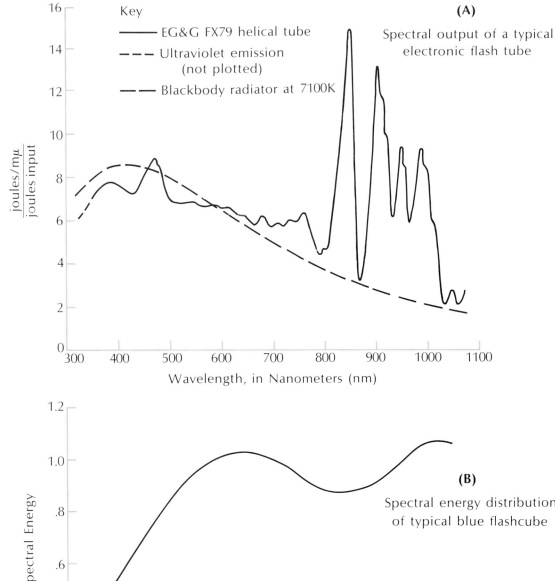

(A)

Spectral output of a typical electronic flash tube

Key

—— EG&G FX79 helical tube

--- Ultraviolet emission (not plotted)

— — Blackbody radiator at 7100K

(B)

Spectral energy distribution of typical blue flashcube

these lamps can be useful field lighting sources in this context.

Other Common Sources If you are working where there is access to an electric power line you are not automatically limited to portable sources of ultraviolet radiation. Descriptions of some other sources follow.

Fluorescent Lamps. Suitably filtered ordinary fluorescent tube lights can be used to excite fluorescence. Special "black light" fluorescent tubes are also made. These have ultraviolet-transmitting/visible-absorbing filtering built in and are suitable for long wave or "near" ultraviolet photography uses, either for the excitation of fluorescence or for reflected ultraviolet photography. They have the advantage of being cool sources, and will not damage filters, as hotter sources may.

Arcs. Both carbon and xenon arcs produce considerable amounts of ultraviolet, beginning at about the 200 nm wavelength, and gaining strength as the wavelength approaches 400 nm.

Incandescent Lamps. Photoflood bulbs can be used as ultraviolet sources, though cracking of filters from excessive heat may be a problem.

Photofloods actually may be more efficient producers of photographically useful ultraviolet than the commercially available ultraviolet "sunlamps", which are intended for therapeutic use.

Filters — Ultraviolet - Transmitting / Visible - Absorbing This type of filter is used in three basic ways.

Converting Light Sources to Ultraviolet Radiation. The placing of filters such as the Corning 9863 or the Wratten 18A over a light source will absorb the visible light emitted, and restrict its output to the ultraviolet wavelengths (with some minor leakage in the infrared area, as shown in Figure 40). Effectively, this converts the source to ultraviolet radiation. Care must be taken to see that visible light does not leak out around the filter. When artificial sources are used this way, the work is usually carried out in a darkened room, in order to avoid problems with ambient lighting. But it could as well be done outdoors at night. The resulting radiation can be used either for reflected ultraviolet photography, or for the excitation of fluorescence.

Excluding Visible Light at the Lens. If the work is reflected ultraviolet photography being done by natural sunlight, or if it is being done by the use of unfiltered artificial sources, the filter can be placed over the camera lens so as to exclude the visible light at that point. Again, care must be taken to prevent passage of visible light around the filter. This can be done by sealing around it with Scotch Black Photographic Tape #235. In this use the filter must be of optical grade or the image will be of poor quality.

Exciting Fluorescence. A source converted to produce ultraviolet radiation will produce fluo-

◄ **FIGURE 41**

The spectral output of typical flash sources: (A) electronic flash tube, (B) blue flashcube. These curves are approximations, and the shorter wavelength ultraviolet emission was not plotted (A), because it varies with the envelope construction. *Sources:* (A) was adapted from "Spectra of Pulsed and Continuous Xenon Discharges", Goncz and Newell (see the Bibliography). (B) was adapted from a plot provided by the General Electric Co. for a 1971 specification, ("Present G.E. Design On Flashcube, Blue Cover Clear Lamp, S.D.I. 0-2-3.")

rescence in certain kinds of materials. Excitation of fluorescence is, then, an application of ultraviolet radiation. Fluorescence itself can be defined as a temporary luminescence, in this context assumed to be in the visible spectrum, which exists as long as the subject is illuminated by the appropriate radiation. But bright ambient visible light will drown it out so that it will not be visible, either to the eye or to the camera. Therefore, the work space must be darkened, or the work undertaken outdoors at night. In this use, the filter is on the ultraviolet radiation source. Occasionally it may be useful to give a short supplementary exposure to white light, insufficient for correct rendition but enough to show the location of the fluorescing portions on the subject.

Filters — Ultraviolet - Absorbing / Visible - Transmitting Because there is often an overlap between long wave ultraviolet and short visible wavelengths in the filter and film combination, it is usually necessary in color photography of fluorescing subjects to place a second, different filter on the camera lens. This filter is for the purpose of absorbing reflected ultraviolet and minor excess visible blue, and is called a "barrier" filter. The standard barrier filter is the Wratten 2B. Other yellow color filters, up to the Wratten 4, 8, or 12, may be used where there is no blue fluorescence, but where visible blue light is being reflected by the subject.

Focusing the Ultraviolet Image When photography of excited visible-light fluorescence is the aim, focusing is no special problem. Simply focus with the barrier filter in place over the lens, and the filter thickness will be compensated for.

Photography by reflected ultraviolet, however, gives a double problem. One is that the wavelengths being photographed are shorter than any that you can see to focus by (and the ultraviolet-transmitting/visible-absorbing filter is opaque to the eye). The second is that the filter thickness has an appreciable effect on focus. Fortunately, there is a reasonably simple solution. Using white light illumination, place over the lens a deep blue filter of the same thickness as the ultraviolet-transmitting filter, and focus. Visible blue light is close enough in wavelength to ultraviolet that normal depth of field and depth of focus (the equivalent at the film plane of depth of field at the subject) should provide for the remaining error. In cases needing critical accuracy of focus, work as before but make several exposures—one focused as seen through the blue filter, and others focused at varying points slightly nearer to the camera than the desired point of critical sharpness. (Or, if focusing is done by moving the camera as a whole, as in much closeup photography, focus at points progressively further behind the intended sharpest point.)

Exposure Determination There are several methods for the determination of exposure when working with ultraviolet, depending upon your technical approach.

Metering Continuous Sources. Most ordinary photographic light meters are usable for metering long wave ultraviolet, up to a point. A Wratten 18A filter is placed over the meter cell, and the joint between them is rendered light tight. Figure 42 illustrates a method of fastening the filter to a meter. A reading can be made then in approximately the normal manner. Because the radiation is likely to be relatively weak, and because the meter sensitivity in the ultraviolet region is likely to be relatively low, as compared to visible light, incident readings may be easier

$\frac{5}{8}''$ hole, centered

$\frac{7}{8}''$

$1\frac{1}{16}''$

$2\frac{5}{8}''$ $3\frac{1}{8}''$

$1\frac{9}{16}''$

FIGURE 42
A device for mounting an 18A filter on a Gossen Luna-series light meter (medium-weight cardboard, interior painted black).

to obtain than reflection readings, though the latter are by no means precluded. Because of their greater breadth of general sensitivity, both CdS and silicon cell meters may be more useful than selenium cell meters. Additionally, the silicon cell has greater sensitivity to ultraviolet radiation, and is therefore potentially the best choice for use—depending upon meter design. (A meter that reads through a glass lens may be less useful, because glass absorbs ultraviolet; although it may read as much as the film is going to receive, even so.)

Obviously, the film speed is an important question, because films are speed rated for visible light. The sensitivity of a panchromatic film is in the neighborhood of five stops less for long wave ultraviolet than for visible light. However, no definitive statement can be made. The ultraviolet sensitivity of films varies with type, and the ability of a given meter to respond to ultraviolet radiation depends upon design and construction factors. But the foregoing should at least provide a starting point for exposure tests.

Ultra-Violet Products, of San Gabriel, Cali-

fornia, makes a meter that is especially designed for ultraviolet measurements, called the Blak-Ray ultraviolet intensity meter. This meter is insensitive to visible light, but has sensors that are capable of reading the intensity of either long or short wave ultraviolet. The readings obtained are in microwatts per square centimeter ($\mu w/cm^2$), but they can be correlated to the usual photographic exposure methods. The meter is completely portable. It has no need for electrical power of any sort, since the ultraviolet radiation being read generates the current that moves the needle, as is the case with the common selenium cell photo light meters.

Metering Flash Sources. At least some flash exposure meters can be used with the Wratten 18A filter to read long wave ultraviolet, in the incident light mode. Testing should be done to determine the correlation between meter response and film sensitivity.

Testing. A graded series of exposures should be made, with several exposures grouped on either side of an estimated exposure value. The exposure change between trials should initially be in one stop increments. For the initial estimate, I would suggest assuming a four to five stop decrease in film speed over that normal for visible light. For flash, guide numbers should be dropped by about the same amount. (In publication M-27, Kodak suggests a flashcube guide number of 24 for Tri-X film, which has a visible-light guide number of from 170 to 240, depending upon the type of flashcube used.) After initial testing, it may be useful to make a second test, with smaller increments grouped around the best exposure from the first group, in order to get a really accurate determination.

In testing for the proper exposure in reflected ultraviolet photography, the technique is quite straightforward. But when photographing ex-

cited fluorescence, things get a little bit more complicated. Various materials fluoresce at different intensities. Therefore, it is useful to use a test target made up of several materials that fluoresce weakly, moderately, and strongly. Then, prior to all subsequent photography, a prospective subject can be compared visually to these standard substances for a rough classification of exposure requirements. Final exposures should then be bracketed closely to insure accuracy.

Once the necessary initial tests are made, ordinary flash information taken from elsewhere in the text can be used to set up for unusual new circumstances, making adjustments as experience has indicated.

Field Applications Ultraviolet photography has many possible applications. Its best known uses are in medicine, geology, and document examination. Although many of the established practices in these areas are ordinarily laboratory procedures, some of them can be transferred readily to field situations. Therefore, an examination of the literature of related fields is always in order. Medical ultraviolet examination and research methods are widely applicable to the life sciences. Although the examination of questioned documents is often thought of as primarily useful to the police, it can have much value in any document-oriented research. The research possibilities in such fields as art history and archeology are considerable. Geological information is, of course, useful in any field where the characteristics of minerals become important.

A field use of ultraviolet that is coming to particular notice at present is black-and-white reflected-ultraviolet photography of flowers. Since bees and some other insects are able to see in the near ultraviolet, it is useful to be able to record plants as the insects can be presumed to see them. For instance, previously unsuspected nectar guide patterns have been recorded; and this finding has offered new insight into insect behavior. Both botanists and entomologists have interests here, and a literature is building.

The first source of information concerning ultraviolet photography is Kodak's *Ultraviolet and Fluorescence Photography,* publication M-27, 1970. In turn, it is also a reference source, having a small but very good bibliography. I have not quoted that bibliography in this text because of the ready availability of the booklet. But I call it to your attention. From there the ripples broaden.

FILTERS WITH INFRARED RADIATION

As with the ultraviolet, which is beyond the short wavelength end of the visible spectrum, there is, in infrared radiation (IR), a photographically useful region beyond the longest visible wavelengths. This can be recorded on specially sensitized films with the aid of filters. Again, since infrared photography is a vast field with its own extensive literature, readers with a serious deep interest are referred to the Bibliography, and especially to Kodak publication M-28, which is referred to in more detail later.

Nature of Infrared Radiation

Infrared is that portion of the electromagnetic spectrum that falls between the longest radiation in the visible reds and the shortest of the so called "Hertzian" wavelengths, which are used in radio, radar, and the like. Infrared is

often associated with the idea of heat, because hot objects not only radiate in the infrared, they can even be used as inefficient "light" sources for infrared photography, in some wavelengths.

Wavelengths Involved Visible red blends into the near infrared at a wavelength of about 700 nm. Although wavelengths somewhat beyond the upper limits of sensitivity of generally available infrared films can be recorded on very special materials, the infrared-sensitive films ordinarily available cut off at an outer limit just short of 1000 nm. Thus, for photographic purposes, the infrared region can be said to extend from 700 to about 900 nm. This text does not deal with "thermography" or the special situation of hot-object radiation, but describes only those techniques that are analagous to visible-light photography. The standard first-order reference is Kodak's *Applied Infrared Photography,* publication M-28, 1972. I consider it superior to all earlier general sources.

Infrared Viewers As far back as the early 1940's, the military made use of infrared viewers in night combat and for intelligence gathering. A model for viewing only, consisting of a battery-powered spot radiation source and an optical viewer, was called the Snooper Scope. A closely related model was mounted on a carbine and called a Sniper Scope. Such military designs are listed as available in the current catalog of the Edmund Scientific Co., of Barrington, New Jersey, which also offers a pamphlet on uses (*Infrared . . . and Its Uses,* Pedrick and Salisbury—see the Bibliography).

A self-contained commercial infrared viewer called the Find-R-Scope is available from FJW Industries, of Mount Prospect, Illinois. This firm also offers a broad line of accessories, including a camera attachment. Another commercial venture is called the Honeywell/Asahi Pentax Nocta. It is based upon a Pentax camera mounting a 300 mm telephoto lens, and includes both flash and continuous radiation sources. The continuous source is used for visual viewing, by way of an image converter. Photographic exposures are made on infrared film by radiation from infrared flash bulbs, which are effective at distances up to about 300 feet. For both viewing and photographing in the infrared I consider the Nocta to be the best integrated system that is commercially available at this writing. The price is fairly high; but, if much work is to be done, this would be quite rapidly amortized by its usefulness.

Kodak lists an Infrared Scope for photographic processing inspection, and calls it useful for wildlife observation. Additionally, Kodak suggests using a Kodak Safelight Filter No. 11 (*not* equivalent to a Wratten #11 camera filter), used with an incandescent lamp in an otherwise light-tight housing.

Dangers of Infrared Radiation Other than the possibility of being shot by a Sniper Scope user, there are no physical dangers in the use of infrared radiation comparable to those of ultraviolet.

The primary danger in infrared work is that the photographer may lose pictures through a failure to understand the nature of infrared transmission and of infrared film. Thin wood, fiberboard and many other materials may transmit significant amounts of infrared, even though they are opaque to the eye. It is, therefore, prudent to wrap any bellows to be used with aluminum foil. Beware of old sheet film holders. The dark slide may be made of infrared-transparent material. Modern holders do not have this problem. 35 mm cameras must be loaded and unloaded in total darkness, to avoid undue danger of fogging of the film. Loading infrared film

in the field requires the use of a light tight loading bag (see your dealer). The films themselves are subject to damage from heat to an extraordinary degree. They should be stored under refrigeration, and should be protected from elevated temperatures while in the field. Wrapping film packages in shiny aluminum foil will help, as will keeping them in the center of a large amount of insulation. If you are backpacking, films not in current use could be packed in the center of a rolled sleeping bag, for instance. Exposed infrared films should be processed as soon as possible, to avoid postexposure fogging.

Reflected Infrared As with ultraviolet, there are two ways in which infrared is usable in photography, the first of which is photography by reflected infrared radiation. The ways of doing this are similar to those which use reflected ultraviolet, and are summarized as follows:

1. by natural sunlight, which contains a sizable infrared component, with an infrared-transmitting/visible-absorbing filter on the camera lens;

2. by an artificial infrared source, in daylight or roomlight, with an infrared-transmitting/visible-absorbing filter on the camera lens; or

3. by an artificial infrared source, in the dark, with the filter on the radiation source, as in surveillance of ethnologic or criminal activities, or observation of nocturnal wildlife.

Infrared Luminescence As with ultraviolet, it is possible to photograph excited fluorescence. The similarity in principle is that short wavelength light striking a subject is re-emitted as a longer wavelength. The difference is that the excitation is usually the result of irradiation by a visible wavelength—most commonly blue-green light—and the fluorescence itself is invisible to the unaided eye, occurring in the infrared region. Colored filters are used over a source of visible light, in order to produce the light used for excitation. An infrared-transmitting/visible-absorbing filter is then used over the camera lens—its mounting carefully made light tight to prevent leakage of visible light—to record the excited luminescence on infrared film.

Photographic Matters

Although normal camera lenses pose no barrier to the passage of infrared radiation, thus releasing one from the special lens problem encountered in ultraviolet photography, it is necessary to use special films, filters, and techniques.

Infrared Films Normal photographic films are not sensitive to infrared radiation, as their emulsion sensitivity cuts off at about 700 nm wavelength, approximately the limit of light visible to the human eye. Thus, to do photography by radiation within the infrared region, it is necessary to use films that are especially sensitized. There are two basic types: black-and-white infrared films, and color reversal infrared films (sometimes called false-color films).

Black-and-White Films. An infrared sensitive black-and-white film is essentially a panchromatic film that has dyes and sensitizers added which extend its range into the infrared region. Owing to the exigencies of chemical design, such films are likely to lack response to wavelengths of green and yellow light. Used without a filter, infrared-sensitive black-and-white films will give a pictorial landscape result not very different from ordinary panchromatic film. Used with an infrared-transmitting/visible-absorbing filter, the Wood Effect is very apparent, resulting in light or white foliage. Blue skies will be very

dark, and the penetration of distance haze is impressive. Until fairly recently, Polaroid offered a black-and-white infrared-sensitive roll film that provided one-minute access to information in infrared photography. It was discontinued for lack of demand.

In Figure 43 infrared sensitivity is compared graphically to the spectral sensitivities of panchromatic and orthochromatic films (see also Plates 16 and 17, and Color Plate V, top).

Color Reversal Film. Kodak has recently introduced to the general market a color slide film called Ektachrome Infrared Film, which has two layers sensitive to two regions of visible light, and one that records both visible and infrared wavelengths. This "false color" film was originally designed for aerial reconnaissance and camouflage detection, but became recognized as having wide applications in science and medicine. Because of its special color charac-

teristics, this film must be used with special filtering, if it is to be exposed for scientific uses. (This film has been widely used with other filtering—or none—to achieve all sorts of peculiar pictorial effects, but for scientific work the recommended filters should be used.) Figure 44 compares the spectral sensitivities of this film to the normal Kodak color reversal films.

It should be noted that, owing to this film's partial sensitivity in visible light and the manner in which it is achieved, a black-and-white copy of an Ektachrome Infrared slide offers different information than does a direct black-and-white infrared record. There could be cases where that difference is important.

WARNING: Color infrared film must be stored at low temperatures, preferably frozen, to avoid changes in the emulsion over time, and by exposure to heat. Follow all of the manufacturer's instructions exactly, or your results will be inconsistent from roll to roll.

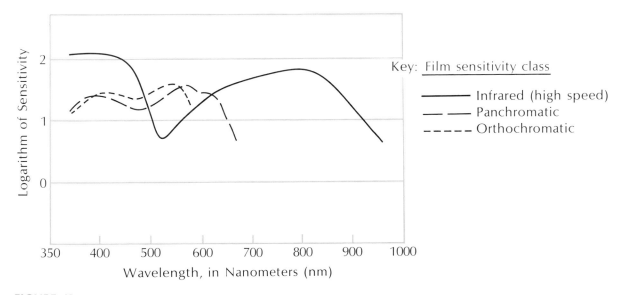

FIGURE 43
The spectral sensitivities of infrared, panchromatic, and orthochromatic films. These curves are approximations, and are only intended to be roughly comparative, for emphasizing differences in basic spectral sensitivity.

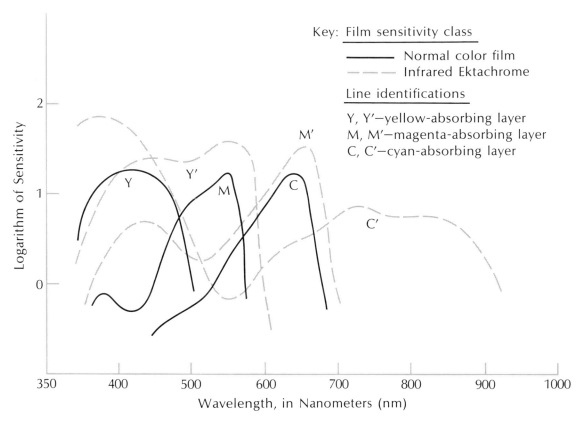

FIGURE 44
The spectral sensitivity of Ektachrome Infrared and normal color film. These curves are approximations. *Sources:* This graph is derived in part from Kodak publication N-17, "Kodak Infrared Films", 1971 (page 14), and in part from Todd and Zakia's *Photographic Sensitometry,* 1969 (page 189, Figure IX-19 B, C—see the Bibliography.)

Radiation Sources for Field Work As with ultraviolet, field work involving photography in the infrared region requires either an existing natural source, or sources that are portable and independent of power lines.

PLATE 16 ▶

Filters—Infrared closeup photography. Newly hatched bugs, colored deep red with dark markings (see Color Plate V, top for their natural appearance), with eggs on a leaf, photographed at ×3 magnification with a 55 mm Micro-Nikkor lens by the assistance of a 3× tele-converter, using closeup flash technique, and enlarged six times in printing to a final image magnification of ×18. (a) Panchromatic film, no filter. (b) Panchromatic film, with a Wratten 29 deep red filter placed over the flash head. (c) Infrared film, with a Wratten 87 visually-opaque filter placed over the flash head.

a

b

c

Sunlight. Direct sunlight is a rich source of infrared radiation, and is entirely suitable for either black-and-white or color infrared photography.

Electronic Flash. Electronic flash is often thought of as a cool source of light, so the possibility of infrared emission is sometimes overlooked. However, reference to Figure 41,A, on page 188, shows that there is a strong emission of infrared radiation from electronic flash. The effect of coolness is due primarily to the short duration of the output, which is too short to allow time for materials to heat up. But the infrared is there as photographically usable radiation; ready for use in a neat, portable package. It is in fact the most convenient artificial source, and is about the most efficient portable source of infrared. Although I have no specific reports on such matters, it is possible for certain plastics that could be used for the shielding of flash tubes to absorb nearly all the infrared. Some types of Lucite® and Perspex® plexiglass type plastics, whose original purpose was for aircraft window use, are specifically designed to be absorbers of infrared. Should your flash unit fail to produce significant infrared radiation, check this possibility.* None of my flash units have this problem.

Bulb Flash. Flashbulbs also emit strongly in the infrared region. It is possible to use them in any of three ways. First, there are flashbulbs on the market made specifically for infrared emission (the General Electric #5R, and the Toshiba Super 5R). These have an external coating, dyed to transmit primarily in the infrared region, that passes only a scarcely noticeable, momentarily visible, red glow at ignition. In effect, there is a built-in infrared-transmitting/visible-absorbing

*Personal communication from S.G. Ehrlich.

filter. Unfortunately, due to low demand, these bulbs tend to be both rather expensive and quite hard to obtain. They can be special-ordered, but this may involve purchasing a certain minimum number. Figure 45 is a graph of the spectral energy distribution of bulb flash sources.

It is more practical, if you can get the materials, to dye the existing plastic protective coating of ordinary clear flash bulbs. This has the additional advantage of allowing the use of any available bulb or cube, rather than being limited to the #5 size. At one time, the Jen Products Co., of Bethel, Vermont, offered a dip for this purpose. (At this writing they offer only blue and amber dips, for correcting clear flash bulbs—which are the least expensive sort—to daylight or tungsten color temperature, respectively.) It is possible to make up such a dye yourself. Morris and Spencer published a formula in the *British Journal of Photography* in 1940 (see the Bibliography).

PLATE 17 ▶

Filters—Infrared closeup photography. Other examples of comparisons between unfiltered panchromatic film and infrared film with the Wratten 87 filter; similar camera technique to that used in Plate 16, but without the tele-converter. (a) Immature grasshopper on morning glory vine, taken with panchromatic film and unfiltered electronic flash. (b) Same subject on infrared film, with the Wratten 87 filter on the flash head. Both pictures were made with the 55 mm Micro-Nikkor lens set at ×1 magnification, and were then enlarged to ×4.5 in printing. (c) Harvestman on zinnia flower, photographed with panchromatic film using an unfiltered electronic flash. Photographed at ×1, and enlarged in printing to ×6.3, here. (d) The same subject on infrared film, with the Wratten 87 filter on the flash head. This film is very grainy and has poor resolving power. Enlargements even this high are rather poor in quality; therefore, I recommend that the initial photography be done closer to the final print magnification wanted, with minimum subsequent enlargement.

a

b

c

d

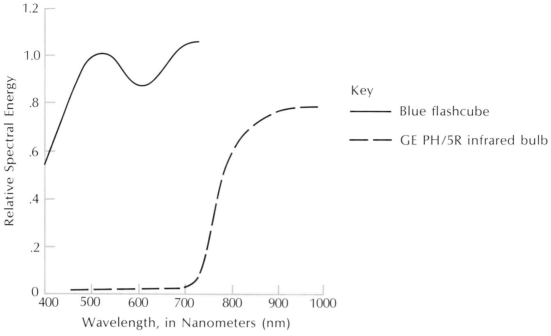

FIGURE 45

Spectral energy distribution of typical bulb flash sources, for infrared use. These curves are approximations. *Sources:* The blue flashcube curve was derived from a plot provided by the General Electric Co., from a 1971 specification (as noted earlier in Figure 41). The PH15R curve was derived from a plot provided by the General Electric Company in their informational leaflet *Infrared Photography with the GE #5R Flashbulb.*

Most practical of all, in terms of supplies, is the use of ordinary flash bulbs in conjunction with a suitable filter over the flash reflector, or at the camera lens. This practice also offers the possibility of using any size or type of bulb. It is operationally less convenient than the foregoing methods, for two reasons. If the filter is on the flash reflector, it must be removed and put back on each time the bulb is replaced. If the filter is on the lens, composing and focusing is a bother, and the flash is conspicuous to the subject. Either blue or clear bulbs can be used, but as the blue coating absorbs some infrared, the clear bulbs provide more infrared output.

Pentax Nocta. This is a completely integrated, self-contained unit for both viewing and photography, using infrared flash bulbs for the photographic exposure. Although it has been described earlier as a viewing device, it is much more than that. Its utility is great enough to be worth remembering. It is a versatile, portable device that incorporates both continuous and flash radiation sources with a telephoto capability.

Other Common Sources Laboratory-based or other indoor work allows the use of sources connected to electric power lines. These may be convenient for various reasons.

Photoflood Lamps. These are the most efficient incandescent sources of photographically useful infrared wavelengths, for infrared reflection photography. Neither household lamps nor therapeutic incandescent infrared sources are as good, since both put out more heat than photographically useful radiation. And excess heat is a problem. The necessary filters may be damaged, as may delicate subject matter.

When they are suitably filtered, photoflood lamps are also useful for the production of blue-green light for the excitation of infrared luminescence.

Fluorescent Tubes. Photography of reflected infrared is not practical with fluorescent tubes as a source, because they do not emit significant amounts of radiation in the infrared region. However, they are quite satisfactory when filtered to blue-green for the excitation of infrared luminescence. Their special value lies in their relative coolness of operation when long exposures are required. And they are more efficient in the use of electrical current than are incandescent lamps. Kodak's publication M-28 offers much good information on specific techniques.

Snooper Scopes and the Like. Infrared viewers, such as the Snooper Scope, and the Find-R-Scope, are also usable as sources for infrared photography. They offer a degree of portability, which varies with design and manufacturer. Turn back to page 193, the section on "Infrared Viewers," for further information.

Filters—Infrared-Transmitting / Visible-Absorbing This type of filter has two main uses, both involving photography by reflected infrared. The transmission qualities of filters commonly used in this type of work are graphed in Figure 46.

Conversion of Sources to Infrared Radiation. The placement of suitable filters over various artificial light sources will absorb all visible light, transmitting only the infrared radiation (and possibly a little ultraviolet). When filters are used in this manner, great care must be taken to make the mounting light tight, so that no visible light can pass around the filter. The usual filter for this purpose is the Wratten 87, but the Wratten 89B, or the Kodak Safelight Filter No. 11 (*not* equivalent to the Wratten 11 photographic filter) may be used, according to perceived needs and the filters available. These filters are opaque to the eye.

Excluding Visible Light at the Lens. The Wratten 87 is the barrier filter most commonly used to prevent passage of visible light at the camera lens. The Wratten 89B is similar in effect, but may pass some deep red visible light. For less exclusive effects in black-and-white photography, and particularly in landscape and related work, other red or orange filters may be used, running the whole gamut from the orange-colored Wratten 22 to the very deep red Wratten 29. The single filter most commonly used for visual-infrared combinations is the medium-red Wratten 25.

Special Methods for Closeup Flash. Closeup photography by flash illumination is a very useful and versatile method. It remains an interesting and useful technique when reflected infrared work is considered, but requires additional special techniques.

In reflected infrared technique, as described earlier, we have seen that two primary methods are used. The work is done outdoors or in lighted spaces, with a Wratten 87 filter on the lens. Or, it is done in the dark, with that or a similar filter over the light source. Since, in

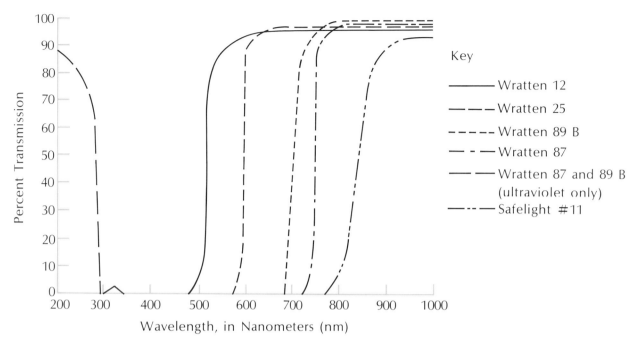

FIGURE 46

Filters for reflected infrared photography. These curves are approximations and are for comparative purposes only. The Wratten 12 filter shown is used with Ektachrome Infrared, a use that is described later. The ultraviolet transmission of Wratten 87 and 89B filters are closely similar, and are combined into one line here. *Source:* Kodak publication B-3.

handheld closeup work, it is necessary to focus visually, and to work at split-second speed, neither of these methods will suffice. Therefore, we must improvise something that will work.

Set up the camera, as for normal closeup flash photography. (See the section on this technique, following page 310, for details). Use an electronic flash unit as a source, because of its rich emission of infrared radiation, and because of its high speed action stopping ability. Tape a piece of a gelatin Wratten 87 filter over the lamp head, using the light tight Scotch Black Photographic Tape #235 to seal the edges. Photography is done by using the existing visible light for focusing. (See the section under "Focusing the Infrared Image" on page 209, called "Handheld Closeups"). A number of objections to this method will probably come to mind, so I will enumerate them in detail and explain why they need not apply.

1. Since the Wratten 87 filter is on the flash unit, sunlight or other ambient visible light will expose the infrared film and overpower the infrared image.

Not if you work as I do, at very small lens apertures. At ×1 magnification, with the lens diaphragm set at f/32, the effective aperture will be f/64 (or, with the compensating diaphragm on my f/3.5 Micro-Nikkor lens, f/45). At 1/60th of a second, the electronic flash synchronized

shutter speed of my Nikon camera, Kodak 35 mm High Speed Infrared Film, with a daylight exposure index of 80 when no lens filter is used, will be some four stops underexposed even in direct sunlight. With a barrier filter (see the answer to objection 2) on the lens, it will be even more underexposed in the visible-light area. Any methods that I would use to increase magnification further would serve only to increase the degree of ambient-light underexposure, but I need only bring the flash unit closer to the subject to achieve the correct infrared exposure.

2. Since the electronic flash unit emits ultraviolet, as can be seen by examining Figure 41, and the Wratten 87 filter transmits ultraviolet, as can be seen by examining Figure 46, this will make the results ambiguous.

Not if you put a yellow barrier filter on the lens, a Wratten 2B as a minimum, or even up to a Wratten 8. These filters will absorb the ultraviolet, as well as lowering the white-light sensitivity of the infrared film by their blue-light absorption. At the same time, they are virtually transparent to infrared, and they do not impede viewing or focusing.

3. With a visually opaque filter over it, a small electronic flash unit is hardly likely to provide enough radiation to be useful.

Well, the Wratten 87 filter is transparent to infrared in just the area where electronic flash has its richest infrared output. In fact, it is so rich there that the guide number, with Kodak High Speed Infrared Film and a Wratten 87 filter, will be just about the same as for a normal panchromatic film of equivalent basic speed, with no filter at all. With the flash unit used close to the subject, there will be no problem in getting enough infrared on it.

So, you see, the method will work after all. I recommend it highly as a way of investigating certain subjects which reference to the literature leads me to believe are largely untouched at present—especially infrared photography of living insects, whose chitinous outer surface is known to be penetrable by infrared. Figure 47 illustrates such a setup.

Filters — Ultraviolet - Transmitting / Visible - Absorbing The purpose of using such a filter here is to excite luminescence, where the exciting wavelength is in the ultraviolet region and the resulting luminescence is in the infrared.

Exciting Infrared Luminescence with Ultraviolet Radiation. This technique can present a problem, because many ultraviolet-transmitting filters also transmit somewhat in the infrared area (as shown in Figure 40) and much infrared luminescence is quite weak. Thus, it would be difficult to differentiate between actual luminescence and reflected infrared. Therefore, the logical choice of filter would be the Corning 9780—which transmits the near ultraviolet but not infrared until well beyond the infrared sensitivity of commonly available infrared-sensitive films. (See Corning catalog CF-3; transmission in the infrared occurs only beyond 1000 nm wavelength.) This filter should be placed over the radiation source, in such a manner that no radiation can pass around it, and should be used where there is no ambient light.

The choice of radiation source can affect matters here, also. Since electronic flash is an exceptionally rich source of infrared, but relatively meager in ultraviolet production (as shown in Figure 41), it would be a poor choice here. Fluorescent tubes, if practical in your work situation, would be a much better source, as they are rich in ultraviolet but emit no infrared at all.

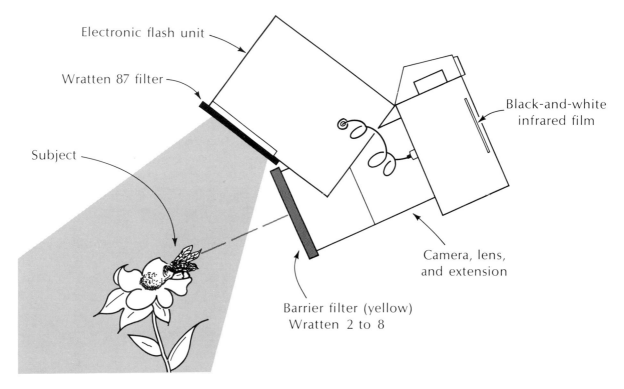

Electronic flash unit

Wratten 87 filter

Subject

Black-and-white
infrared film

Camera, lens,
and extension

Barrier filter (yellow)
Wratten 2 to 8

FIGURE 47
An infrared closeup flash setup.

When doing infrared luminescence photography, it is necessary to use a barrier filter on the lens that will transmit the excited infrared while absorbing all visible light. The usual filter for this purpose is the Wratten 87.

The transmission qualities of the filters commonly used in infrared luminescence photography are graphed in Figure 48.

Filters—Color Color filters are used in several contexts in infrared photography. It is important not to be confused about the purpose in each use.

Exciting Infrared Luminescence with Visible Light. The great majority of infrared luminescence is excited by visible light, usually in the blue-green wavelengths. In general, the photography of this luminescence is done in black-and-white, because the use of color infrared film—though quite possible—results only in a monochromatic image. The most common technique uses both a heat-absorbing filter and an exciter filter on the lamp, and a barrier filter on the camera lens. Another method uses a fluorescent tube as a cool light source, an exciter filter on the lamp, and the usual barrier filter on the lens. The basic arrangement for these two methods is illustrated in Figure 49.

Basic Light Balance—Infrared Color Film. Although Kodak publication M-28 does list methods for using Ektachrome Infrared film for photographing infrared luminescence, I will not

deal with it here because of insufficient data. Therefore, I have restricted my remarks about this film to photography by reflected infrared.

Ektachrome Infrared film is a reversal color film, with the end product being a direct color transparency, with no negative. It is available in 16 mm, 35 mm, and 4 × 5 inch sizes. As has been noted earlier, it is necessary to use a Wratten 12 yellow filter when using this film for any sort of infrared photography, if reasonably accurate biological color rendering is wanted. Of course, color accuracy in this context is a specialized concept. But the use of noticeably different filters will give drastically distorted color. The purpose of the filter is to exclude blue light, and thereby establish the basic skewed color balance typical of the film. The transmission characteristics of the Wratten 12 filter are shown in Figure 45.

The Wratten 12 filter provides the proper color balance for daylight conditions. For use with 3200 K or 3400 K tungsten lights, two additional filters would be needed; a Color Compensation filter (try a CC20C to start with); and a Corning 3966, for heat absorption. The Corning filter is placed nearest to the lamp, of course.

Other filters may be required for special uses. Nonstandard light sources, aging of the film, and other circumstances may all require other filtration. Testing will be needed. It should be

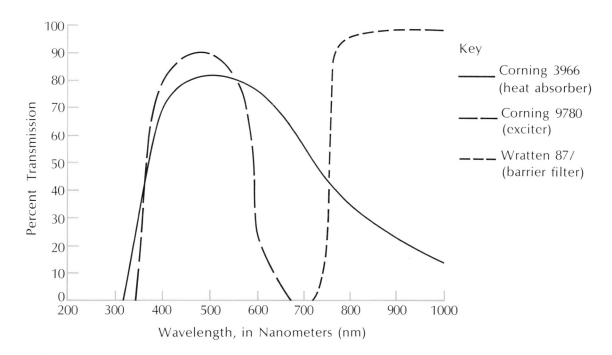

FIGURE 48
Filters for infrared luminescence photography. These curves are approximations for comparison purposes only. The Corning filters are for heat absorption and excitation; the Wratten filter is a barrier filter, to be placed over the camera lens. *Sources:* Curves for the Corning filters were derived from catalog CF-3; those for Wratten filters from Kodak publication B-3.

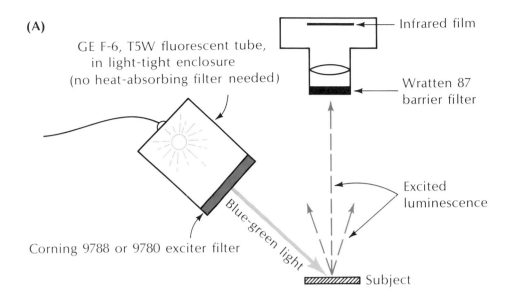

(A)

GE F-6, T5W fluorescent tube, in light-tight enclosure (no heat-absorbing filter needed)

Infrared film

Wratten 87 barrier filter

Excited luminescence

Blue-green light

Corning 9788 or 9780 exciter filter

Subject

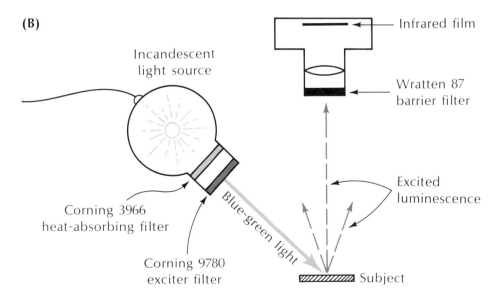

(B)

Incandescent light source

Infrared film

Wratten 87 barrier filter

Excited luminescence

Blue-green light

Corning 3966 heat-absorbing filter

Corning 9780 exciter filter

Subject

FIGURE 49
Alternative methods for photographing infrared luminescence. (A) Using an incandescent light source. (B) With a fluorescent light source. (No heat absorbing filter is needed here, because of the coolness of the source of light.) The transmission characteristics of the filters specified are graphed in Figure 48, above. *Sources:* This information was adapted from Kodak publication M-28. (M-28 also shows a method in which the lamp is not enclosed, but the subject is. Construction details are provided.)

noted that there is no point in using fluorescent tubes as a light source, since they produce no infrared.

Filters—Polarizing It is practical to use a polarizing filter as a supplement to the Wratten 87, or other barrier filter, for some uses in both black-and-white and color infrared photography.

Increasing Haze Penetration. In black-and-white landscape photography, the use of infrared film and a red or an infrared-transmitting/visible-absorbing filter usually results in an extraordinary degree of haze penetration—considerably greater than is the case with panchromatic films. This action results from the very complete absorption of the blue wavelengths of light involved in visual haze production (see page 156). However, in some cases, residual haze effects will remain a slight problem because of that portion which is produced by the partial polarization of other wavelengths of light (see page 174).

The use of a properly rotated polarizing filter, with a red or a Wratten 87 filter at the camera lens, will remove virtually all haze effects and will yield extreme clarity for subjects at great distances.

Reducing Specular Reflections. As in visible-light photography, so it is in reflected infrared photography; reflections from surfaces can be a problem. There are disagreements in the literature concerning just how useful polarizers are in the infrared—due, I suspect, to differences in the techniques and materials used—but all of the sources seem to agree that there is some useful affect on reflection control. Because the applicable literature is sparse and relatively little is positively known about the matter, experi-

mentation is in order. So far as I know, there is no theoretical reason as to why polarization techniques should not be as appropriate in the infrared as they are in the visible spectrum, providing that the photographer has an adequate prior knowledge of the subject and its limitations.

Focusing the Infrared Image Except when using an image converter, as with Snooper Scopes and the like, the infrared image is invisible to the eye. Therefore, direct focusing is impossible. It is necessary to focus using visible light, and then adjust for the difference in wavelength. There are several ways of approaching the problem. In order to eliminate filter thickness problems, by the way, it is desirable to use gelatin filters in the camera lens.

Visual Focus/Small Aperture. The usual casual advice, for those about to try photography using infrared film and the Wratten 87 filter, is to focus with the filter off the lens, and then use a small lens aperture for photography, hoping that the focusing error will fall within the depth of focus and depth of field. And, for casual work at moderate distances, this may indeed suffice (if you don't forget to put the filter back on before exposing). However, it is nicer to use a little more finesse.

Visual Focus/Red Filter. If infrared film is being used with a red filter, such as a Wratten 25, to photograph both some visible and some infrared wavelengths, the problem becomes simpler. Just focus with the red filter in place. And, it doesn't hurt to use a fairly small lens aperture.

On the other hand, if you are using the visually opaque Wratten 87 filter, and will thus neither see nor record visible wavelengths, the substitution of a Wratten 25 or 29, during focus-

ing only, is still a good idea. You are, at least, focusing with the longest visible wavelengths, those that are closest to the infrared. Again, you may depend upon depth of focus to come to your aid, if you then use a small lens aperture.

Although I have no such problem myself, there are some people who find it difficult to focus through a red filter.

Measured Correction. The assumed difference between normal and infrared focus is that the latter requires that the lens move further from the film by .25 percent (one-quarter of one percent) of the lens-to-film distance. The larger the camera the more important the correction becomes, because with the required long focal length lenses there is increased image magnification and therefore a reduced depth of field. At the same time, as the focal length of the lens gets longer, .25 percent of the lens-to-film distance becomes a larger finite measurement.

As a simple example, let us assume that we are using a view camera with a normal configuration 400 mm lens that is focused near infinity. If the camera is first focused visually with no filter, the lens should be moved further from the film by a distance of one millimeter. With a gelatin Wratten 87 filter placed over the lens, the infrared image would then be in focus.

The foregoing can be considered true, in a general sense, if the lens is of relatively simple design. However, many lenses used today are of complex construction, and at least some of these do not follow the one-quarter of one percent rule. Furthermore, the rule itself can be called into question, since at best it is only a rule of thumb with little real claim to accuracy. Before undertaking any extensive program of infrared photography with lenses of medium to long focal lengths in which critically sharp focus is needed, it is a good idea to test for

the true degree of lens displacement that is required.*

For photomacrography, the situation is a little different, because the lens is unusually far from the film. Therefore, the amount of adjustment will be correspondingly greater. As you move the lens closer to the subject in order to increase image magnification, you must increase the lens-to-film distance to maintain focus. (See section on photomacrography following page 324.) For example, if we assume the use of the same lens and camera as above, and also assume that the new lens-to-film distance at the required magnification is 1200 mm (as it would be, in order to obtain $\times 2$ magnification with a 400 mm lens), once the correct visual focus is obtained, the lens-to-film distance must be increased by 3 mm to a total of 1203 mm, to fulfill the one-quarter of one percent rule. And, as noted above, you may have to test for the rule's accuracy with a particular lens, or at least cover yourself by making several exposures at different points of focus. The focus shift should ideally be accomplished by moving the camera to the rear, rather than by advancing the lens, if the construction of your camera allows this procedure.

The Red Dot. This is where lens manufacturers come to our aid, at relatively little cost to themselves. Many lenses that come in focusing mounts have two reference marks for the distance scale. The first one, for general use, is a dot, line, or arrow in black or white, depending upon the color of the lens mount. The second one, slightly to one side, is a red dot. This dot is a reference mark for infrared focusing. To use it, come to a correct focus in white light using

*I am indebted to S.G. Ehrlich for calling this point to my attention.

PLATE I

Closeup photography and photomacrography
(*left*) Owl's Clover (*Orthocarpus*), Point Lobos,
California, by existing light on a cloudy day,
1/125th of a second, f/4, ×1 magnification. At the
slower shutter speeds that would be needed for
greater depth of field, camera movement will limit
sharpness. (*right*) Same subject by closeup flash.
Note that the colors look brighter. The overcast
light above resulted in incorrect color balance for
daylight color film. (See page 310.)

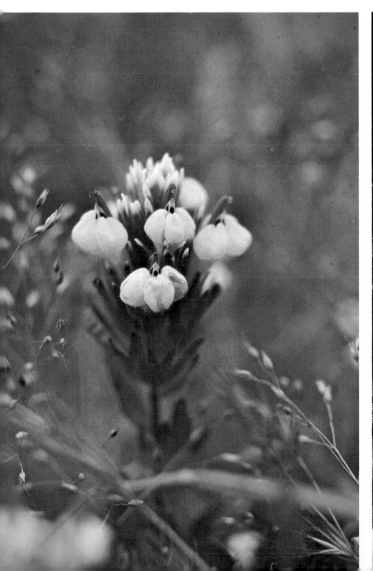
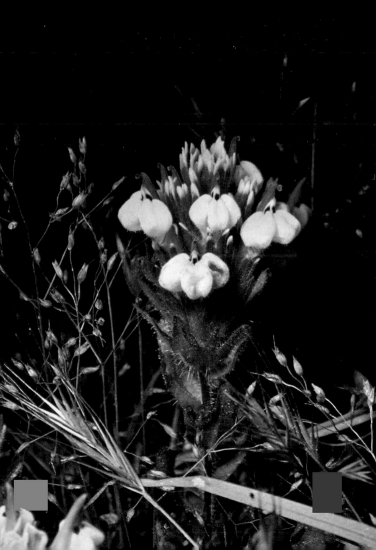

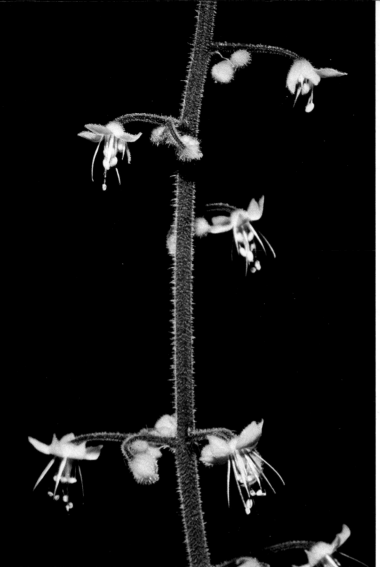

PLATE II

Closeup photography and photomacrography
(*left*) Sugar Scoop (*Tiarella unifoliata*), Fern
Canyon, Van Damme State Park, California,
photographed at ×1 by closeup flash in conditions
of deep shade. (*right*) Same subject, flower at
lower right, at ×3 magnification using a 3×
tele-converter. Note the increased visible detail,
especially the fringed edges. (See page 296.)

PLATE III ▶

Closeup photography and photomacrography Doubling
the linear magnification produces four times the area
magnification, and therefore looks like an impressive gain.
(*top*) Fly (not captured so not identified, but a muscoid
Diptera), Walnut Creek, California, on a leaf of Creeping
Myrtle (*Vinca major*), by closeup flash at ×1 on the
slide. (*bottom*) Same subject, at ×2 magnification, by
the aid of a 2× tele-converter. (See page 296.)

PLATE V ▶

PLATE V

Closeup photography and photomacrography—stereo (*top*) Newly hatched bugs (Hemiptera), and egg mass on a leaf, at ×3 on the slide using a 3× tele-converter. Compare to black-and-white Plates 16 and 35, which show the same insects. (See page 296.) (*bottom*) Weevil (Curculionoidea), at ×22 (subject deceased). This photomacrographic stereo pair was made by the shifting-subject method (see page 404) with an unusually wide separation for that magnification—about 5 mm—to exaggerate the stereo effect. It was photographed in the laboratory on Polaroid Land Polacolor print film.

PLATE IV

Closeup photography and photomacrography Flesh Flies (Sarcophagidae), Walnut Creek, California, photographed by closeup electronic flash at ×2 on the slide, using a basic magnification of × $\frac{2}{3}$ with a 3× tele-converter. This method increases depth of field, because it makes use of the tele-converter to get a smaller relative aperture than would otherwise be possible (See page 296.)

◄ PLATE VI

Color balance with electronic flash The color balance of
the light emitted by an electronic flash unit is easily
tested by making comparisons between natural sunlight
photographs and similar pictures done by flash. (See
page 317.) (*top*) A cactus flower, by natural noon
sunlight. (*bottom*) The same plant, by unfiltered
electronic flash. Note the incorrect steely blue look.

PLATE VII

Color balance with electronic flash Use of correct
filtration can match the light emission very closely
to that of sunlight. (*left*) A cactus flower (different
individual from that in Plate VI), by natural
sunlight. (*right*) The same flower, by electronic
flash that was corrected with a CC20Y gelatin
filter taped over the flash head.

PLATE VIII

Flash synchronization failures with 35 mm single lens reflex cameras (See page 317–319.) (*left*) Beetle (Coleoptera), on a Mariposa Lily (*Calochortus venustus*). Late ignition of a flash bulb, with the shutter set at 1/1000th of a second, resulted in a graded-off darkening of one end of the picture. (*right*) Monkey Flower (*Mimulus*). Electronic flash mistakenly used at too high a shutter speed results in a sharp cutoff of light part way across the film.

PLATE IX ▶

Reflection control with polarizing filters (See page 176.)
(*top*) Seaweed on a wet sand beach, no filter.
(*bottom*) Same subject. A polarizing filter was used, rotated to provide maximum absorption of the unwanted surface reflections.

◀ PLATE X

Telephoto photography Red-legged Frog (*Rana aurora*), "hiding" by clinging upright to the base of a redwood tree. A distant closeup, using a 105 mm telephoto lens on a short extension tube, in conjunction with flash lighting. Photographed in deep shade from a distance of about thirty inches. (See page 348.)

PLATE XI

Mirror-telephoto problems (See page 360–362 and Plates 43 and 44.) (*left*) Characteristic ring-shaped images of out-of-focus spots of light. (*right*) Sparrowhawk, or American Kestrel (*Falco sparverius*); note the uneven light distribution that is characteristic of mirror lenses.

PLATE XII (Overleaf) ▶

Wideangle photography El Capitan, a monolithic granite cliff in Yosemite Valley, during an April snow storm. Landscape subjects are frequently best shown when photographed with a wideangle lens. This one was done with a 35 mm PC-Nikkor lens, shifted vertically to allow photographing the top of the cliff without the convergence of vertical lines that would have occurred had the camera simply been tilted upward. (See page 396.)

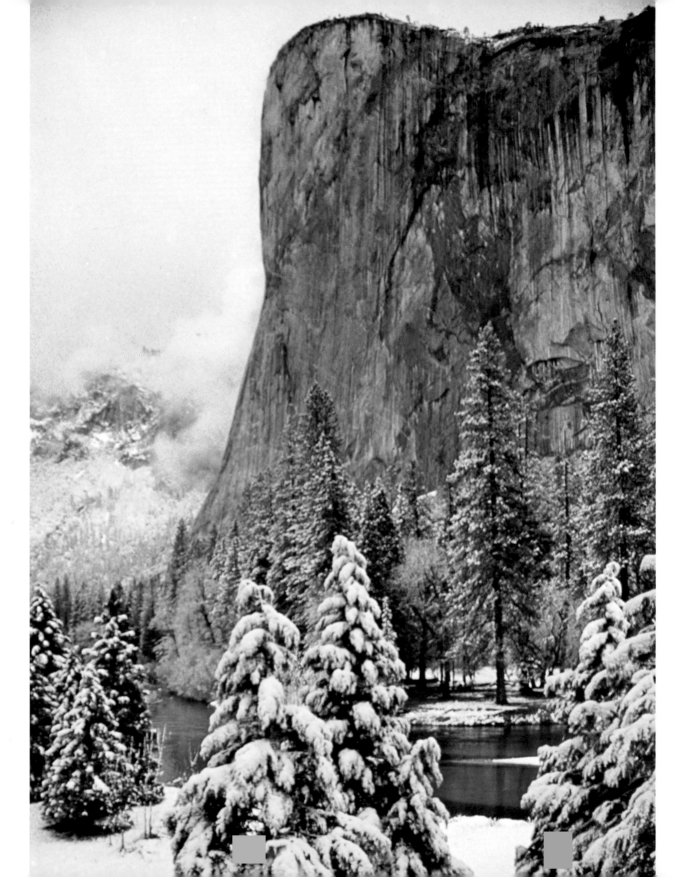

the general-use reference mark. Then turn the focusing ring slightly until the same distance market realigns with the red dot (as shown in Figure 50). Then put on the infrared filter and expose the film.

WARNING: In a significant number of lenses the red dot has doubtful accuracy as a focusing aid, because it is usually based on the one-quarter of one percent rule and the lens designs themselves may depart from that rule. Consequently, testing is in order if you suspect a focusing problem. With the short focal length lenses common to normal 35 mm cameras the problem is minor, but with long lenses you should be on the lookout.

Infinity Landscapes and Aerials. When using cameras whose lenses have focusing mounts, but no red dot, and there is no time for testing, the distance setting for infinity landscapes or aerial photographs should be reset at about 75 feet, when black-and-white infrared film and a Wratten 87 or 89B filter are being used. This will probably move the lens out by approximately the correct amount.

Handheld Closeups. When working with a hand-held 35 mm single lens reflex camera, as in insect or flower photography in the field (for the purposes described on page 311), with normal black-and-white or color films, probably the

(A) White-light Focus **(B)** Realignment of Focus for Infrared

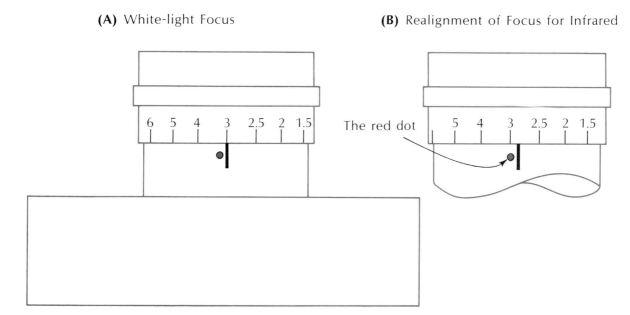

FIGURE 50
The red dot for infrared focusing. (A) White light focus. (B) Realignment of the focus for infrared. (Do not confuse the red dot for infrared focusing with the trade name of the Goerz Red Dot Artar lenses. In that use, the designation is a copyrighted trademark for a series of barrel- or shutter-mounted process lenses, with no built in provision for focusing, and the dot in the title has nothing to do with infrared focusing.)

best way of working is to use extension tubes to achieve a given, known image magnification, and then to focus the camera as a whole by moving it back and forth, rather than by adjusting the focusing scale. When working in the infrared with black-and-white film, a focus achieved this way will be wrong, because of the difference in wavelength. And in this work, depth of field is very shallow at best, because of the image magnification.

Since the focal length of the lenses likely to be used is short—usually in the neighborhood of 50 mm—the amount of correction needed is not great (with my 55 mm lens set at ×1, the lens-to-film distance is about 110 mm, so the correction is only about .25 mm by the rule given above). But needed it is, given the shallow depth of field. I would suggest moving the camera until the chosen point of prime focus is sharp, and then move the camera back—toward yourself—until that point just starts to go unsharp. Then expose. This method works quite well, as long as the image magnification is moderate and a small aperture is used.

Color Infrared. Since Ektachrome Infrared film has two layers sensitive to visible light, and only one layer sensitive to infrared (see Figure 44, page 196), the visible light image usually predominates and no focusing problems are likely to be encountered. If you have a special situation where the infrared image must predominate, use any of the methods described previously to correct the focus.

Resolution The resolution of fine image detail in infrared photographs may be less than in visible-light photographs made with the same basic equipment. There are several reasons for this.

1. Lenses are corrected for visible wavelengths, and may not perform quite as well in infrared.

2. Focus may not be quite exact in any given instance. If the focus is really critically important, it would be a good idea to make several exposures, each at a slightly different point of focus.

3. If the surface of a subject has been penetrated by the infrared, so that the actual infrared subject matter is underneath the optical light surface, the image may be optically disturbed in its passage through the overburden. If contrast has been reduced by scattering, some reclamation can be done by using a higher contrast printing paper.

4. Infrared-sensitive films in 35 mm size are very grainy, and inherently low in resolving power (see Plate 17).

Exposure Determination The correct exposure of infrared films is quite fully covered in the instruction sheets packed in each film package. Kodak provides much additional information in publications M-28 and N-17. Some of this information, plus certain of my own conclusions, are summarized in the following sections.

Metering Continuous Sources. Kodak publication M-28 suggests the use of selenium cell light meters, read through an orange or red filter, as a means of making readings that can approximate the infrared exposure needs. They report considerable inconsistency in results, and state that such metering is a guide only.

My own experience shows that at least some cadmium sulphide meters read quite well in the infrared, through a Wratten 87 filter. (My Gossen Lunasix meter has always shown exaggerated

sensitivity to visual reds in any case.) Reading by reflection on neutral-colored surfaces, the response through a Wratten 87 filter is five stops less in daylight and four stops less in tungsten light than a nonfiltered reading. The calibration of tests results to a particular meter can lead to quite consistent readings.

I use a light tight housing over the meter, similar to that shown in Figure 42 (page 191) with a piece cut from a gelatin Wratten 87 filter placed over the central hole. The interior of the box is painted black, the filter is sealed down, and the exterior of the box is covered with Scotch Black Photographic Tape #235, and in the interior the area around the center hole is covered with deep-pile black velvet. Thus, no visible light can get to the meter cell.

A possible second alternative is the use of a silicon cell meter, as described above for CdS meters. The infrared sensitivity of silicon cells is somewhat higher than that of CdS cells, so if individual meter design is compatible, you may be in luck. At least some units have built-in filtering to compensate for a natural oversensitivity to red and infrared (as compared to normal panchromatic films). For infrared metering it might be necessary to remove this corrective filtering. Simple testing should reveal the degree of an unaltered unit to function. Alterations should be done only by qualified technicians.

Metering Flash Sources. At least some flash meters, and probably most, can be adapted to read infrared radiation with reasonable accuracy. Some have built-in infrared-absorbing/visible-transmitting filters, which would have to be removed. Then the meter could be read through a Wratten 87 filter, and calibrated for infrared use by test. Probably the most effective type of reading would be by the incident meth-od—that is, by reading the amount of light falling upon the subject, rather than the amount reflected from it. The most sensitive flash meters might read reflected infrared satisfactorily.

Flashbulb Guide Numbers. Infrared film manufacturers provide some flashbulb information in their film data sheets and other sources, as do makers of infrared bulbs. Representative information is given in Table 19.

Electronic Flash Guide Numbers. Table 20 provides basic electronic flash exposure information for Kodak infrared films. The filters noted are to be mounted in a light-tight fashion over the camera lens, in most uses. If your flash unit's instruction booklet does not contain BCPS or ECPS figures, or if you lack the instruction booklet, you can determine these figures, and hence, the corresponding infrared guide number, by referring to Table 21.

Testing. Exposure information can always be derived from testing. As usual, the method used is to estimate the correct level of exposure, and then make a bracketed series of exposures on both sides of the estimated figure. Process the film as directed. When the film is dry, examine it to determine the correct exposure frame for a given subject, and then refer to your notes to obtain an actual correct figure for future work. The response of a light meter, filtered for infrared, can also be calibrated in this manner. Initial testing should always be followed by a second level test, using varying subject matter, to determine or refine its fundamental accuracy.

Field Applications Infrared photography is a widely applicable field investigation and recording technique, as well as being a way of

TABLE 19
Flashbulb guide numbers for Kodak High Speed Infrared film[a]

	BETWEEN-THE-LENS SHUTTERS						FOCAL PLANE SHUTTERS		
			BULB TYPE[b]						**BULB TYPE**
SHUTTER SPEED	**SYNCHRO. SETTING**	**AG-1[c]**	**M3[d] #5[e]**	**#2[f] 22[f]**	**5R[g]**	**SHUTTER SPEED**	**SYNCHRO. SETTING**		**#6[e] 26[e]**
Open/ 1/30	X/F[h]	190	290	390	230	1/30	FP/M		300
1/30	M	140	280	360	220	1/60	FP/M		210
1/60	M	140	250	340	200	1/125	FP/M		150
1/125	M	110	210	290	170	1/250	FP/M		105
1/250	M	90	170	180	130	1/500	FP/M		75
1/500	M	70	120	170	110	1/1000	FP/M		50

[a] No flashbulb figures are available for Ektachrome infrared, because of color balance problems. Use electronic flash for this film.

[b] Clear flashbulbs, used with Wratten 25, 29, 70 or 89B filter, except #5R which requires no filter. Bulbs in the left tabulation can be used with focal plane shutters on most small cameras, to some degree. See your camera's instruction sheet.

[c] 2
[d] 3
[e] 4-5
[f] 6-7 } inch polished reflector, bowl shaped { Divide the guide number by 2, if a shallow cylindrical reflector is used. Multiply the guide number by .7, if a folding fan reflector is used.

[g] 4-5 inch satin-finished or folding fan reflector.

[h] Designation depends upon the markings engraved on the particular camera. Check your instruction booklet.

SOURCE: Derived from the Kodak High Speed Infrared film instruction sheet, except for the 5R bulb, which was extrapolated from information provided by the General Electric Company.

TABLE 20
Electronic flash guide numbers for Kodak infrared films, as derived from Kodak publication M-28.

FILM	WRATTEN FILTER	OUTPUT OF FLASH UNIT (BCPS[a] OR ECPS[b]):									
		350	500	700	1000	1400	2000	2800	4000	5600	8000
High Speed Infrared	87	35	40	45	55	65	80	95	110	130	160
Ektachrome Infrared	12	45	55	65	80	95	110	130	160	185	220

[a] Beam candlepower seconds (the amount of light emitted by an electronic flash unit as measured in the center of the beam). Presently, this is the most commonly used method of rating flash unit power, other than by guide number alone.

[b] Effective candlepower seconds (a basically synonomous term, with the exception that the ECPS figure is an average of several readings made over the spread of the emitted beam). The ECPS of a given unit will usually be about ten percent higher than the BCPS, a difference of relatively little significance in terms of general photography. (For a reference, see "Effective Confusion Index," by Edwin Mosher, *Industrial Photography,* Nov. 1972, pp. 18–19.)

TABLE 21

Beam candlepower seconds (BCPS) output of electronic flash units

	GUIDE NUMBERS OF FILMS OF ASA:					
BCPS	25	32	50	64	125	400
350	20	24	30	32	45	85
500	24	28	35	40	55	100
700	30	32	40	45	65	120
1000	35	40	50	55	80	140
1400	40	50	60	65	95	170
2000	50	55	70	80	110	200
2800	60	65	85	95	130	240
4000	70	80	100	110	160	280
5600	85	95	120	130	190	340
8000	100	110	140	160	220	400

To use this table to find the BCPS output of a unit for which you have no information, other than what is given on its own calculator dial, take the following steps.

1. Set the flash unit calculator dial to any convenient film speed.
2. Look opposite the 10 foot mark on the calculator to see what f-number is listed.
3. Multiply that number by 10 (that is, multiply the f-number by the distance). This gives you a guide number for the chosen film speed.
4. On the table above, scan down the column under the chosen film speed until you find the figure closest to the guide number you have established for that film speed.
5. Scan to the left, and that figure is the approximate BCPS output of the unit.

SOURCE: Derived from Kodak publication AC-37, *Exposure With Portable Electronic Flash Units*, (1971), which offers a wider variety of film speed choices. The figures given are close approximations, suitable for virtually all photographic purposes. If greater accuracy is needed, refer to Edgerton's *Electronic Flash, Strobe* (see the Bibliography).

changing the appearance of landscapes, architecturals, and other pictures made for reasons not directly scientific. There is an extensive literature on the subject. (See Kodak publication M-28, listed in the Bibliography, for a sizable introduction to it.) Keep in mind that many references to laboratory techniques, practices, and applications can be transferred to the field situation either directly, or by minor adaptation.

Since infrared radiation will penetrate many surfaces that visible light cannot, its use in photography can give considerable insight into the internal processes of many subjects of inquiry. For instance, the chitinous exterior of arthropods, both the terrestrial and marine types, are infrared penetrable, and I feel that far too little work has been done in this field—especially with living subjects.

Some materials are highly reflective to infrared—fresh green vegetation, for instance. Since plant disease and insect attack can alter this characteristic by altering the structure of the plant material, there are many possible avenues of exploration here. There is an extensive, though somewhat fragmentary, literature here. Aerial photography, often combined with satellite photography into what is called "remote sensing," has been used to derive all sorts of information about such diverse subjects as rainfall, percolation of water in soils, forestry, crop research, and archeology.

Medical applications are plentiful, and many of them are readily adapted to zoological and other research areas.

The opportunity to observe and photograph nocturnal events and activities without disturbing the creatures being watched is not to be ignored. The use of such viewers as the Pentax Nocta or a Snooper Scope, with accompanying photography, is invaluable here.

Lastly, infrared luminescence, though a subject more easily explored in the laboratory than in the field, is a fascinating subject for inquiry. It is quite possible to do some types of luminescence work with electronic flash units under field conditions, either by working at night, or by using subject enclosures similar to the one shown in Kodak publication M-28. Although a great number of materials show infrared luminescence, this is a relatively undeveloped field of inquiry, and I could only guess at specific applications.

THE WRATTEN VIEWING FILTERS

It would be improper to leave the field of filter use without mention of the Wratten 90 viewing filter. This is a very deep-yellow filter not designed for photography, but intended instead for visual use. Looking through it, you will find that colors are subdued, and that light and shadow effects are made more obvious to the observing eye. Therefore, it is very useful for determining the approximate appearance, in terms of relative brightnesses, of a finished picture, while that picture is still in the process of being conceived.

I keep a Wratten 90 filter in my camera bag, protected from mishandling by being sandwiched between two pieces of thin glass, with taped edges. I suggest that others do the same.

Another useful viewing filter is the Wratten 44A, which is used to convert panchromatic black-and-white films to orthochromatic sensitivity. Used as a viewing filter, as suggested earlier, it serves to give the photographer a good idea of the effect of using orthochromatic film, again in terms of the relative brightnesses in the scene. So this filter can be used both as a viewing filter and a photographic conversion filter.

CHAPTER 6

Darkroom Procedures

Although I do not wish to write at length on darkroom photography, it is necessary to provide a reasonable amount of basic information about it. There are several limitations to this coverage. The first is that it deals primarily with black-and-white developing and printing, because it is this that requires the greatest participation of the photographer in the finishing processes. In doing so, only low volume processes are described. Factory operations are no part of my experience, nor are they likely to interest or involve most readers of this text.

A second limitation is that, in this general coverage, I do not relate the darkroom practices described here directly to the photography, in the way that they are in the Zone System. There are several excellent explanations of this

way of working already in print. I am only providing minimum adequate information on basic darkroom procedures.

Another way in which I have limited this coverage is by avoiding the discussion of esoteric solutions and processes. It has been said that any developer will develop any film. This is only true to a degree, since there may well be quality interferences. More to the point is that it is better to know what you are doing with a relatively small variety of materials and processes than it is to be constantly experimenting with unfamiliar information. I usually operate on the assumption that it is in the direct economic interest of a manufacturer to provide the best combination of films and developers that can be devised, and I deviate from this principle only when I am doing something that the manufacturer never intended. Therefore, my most common advice to beginners is to choose a film for its special qualities, and then to process it exactly as the manufacturer suggests. For that reason there are relatively few brand name references. An exception to the foregoing occurs during the later discussion of high resolution 35 mm technique, which is presented separately, following page 271.

I should say something at this point about why it is desirable at all for the individual to go into darkroom work, rather than turn it over to some competent professional photographer. The various reasons include such matters as speed of access, and the ability to reserve for oneself all decisions on quality and visual emphasis. In black-and-white photography it comes down to the final photograph being compounded of factors inextricably involving decision making in both the photography and the printing. Since matters of taste and intent exist in all steps, the concept of a photograph is not complete unless the same person carries out all of the operations from start to finish. In some of the more unusual practices, even a skilled professional photographer might be a little at sea without a specialized knowledge of the subject matter and a full understanding of the project.

In most color photography, the matters governing the reasons as to why a person should do his or her own processing are not so compelling. This is because color work is inherently more literal and less abstract then black-and-white photography. The making of a color photograph, for the purposes of this text, is primarily a matter of duplicating the appearance of the subject matter as closely as possible, subject to the laws of optics and the limitations of equipment, materials, and techniques.

With color slides, the most commonly used method of color rendition for scientific work, virtually all matters having to do with correction and control are done in the camera. The processing is a series of mechanical steps that can be done just as well by commercial processors. In fact, their quality controls will probably be superior to those of all but the most elaborate small setup. Color reproduction in books and periodicals is usually done from the transparency, with the aim being to have that reproduction resemble the original slide as nearly as is practical.

Prints made from color negatives are much less often used in scientific work, being mostly restricted to display use. If adequate built-in standards, such as color patches and grey scales, are included in suitable parts of the photographs, it again becomes pretty much a matter of following a careful routine for a competent professional photographer to make the prints.

Therefore, I prefer to leave technical matters of color processing out of this text. If you are interested in this subject I encourage you to

consult your supplier, who can acquaint you with the various available processes and methodologies.

An exception to the foregoing occurs when the photographer plans to attempt something that the film manufacturer has not intended. For example, it is possible to process color transparency films of the Ektachrome type, using C-22 color negative chemicals (instead of the E-series standard reversal processing chemicals), and end up with color negatives possessing special characteristics. You may not want to entrust this to commercial processors. (Or they may refuse to accept the job.) Therefore, you may have to do it yourself.

THE DARKROOM

The first consideration in photographic processing is the location where it occurs. If you are entirely involved in Polaroid-type photography, or are working with commercially processed color transparency materials, you have no problem. But if you are doing black-and-white negative/positive work, you need a darkroom. This facility can be very austere—even primitive. I have done perfectly adequate work in unconverted kitchens and bathrooms, working at night in order to avoid the necessity of room darkening, and at floor level so as to lessen the chance of outside lights spoiling my results. I have developed negatives in soup plates, and prints in glass baking dishes. I know of people who have developed films while sitting beside woodland streams, and I've heard of people using battery powered enlargers out in swamps. But, on the whole, you will work more quickly and efficiently in circumstances that are more convenient. However you do it, the best guarantee of

consistently good results is to work methodically in clean, comfortable quarters. A good basic reference here is Kodak pamphlet AK-3, *Darkroom Design For Amateur Photographers* (1973). It is quite complete.

Size Considerations

A darkroom need not be large if it is for the use of only one person at a time. It can be no more than a converted walk-in broom closet and still function perfectly well. My own present establishment is a converted closet, only 53 × 83 inches, yet it is suitable for the production of quality professional photography. One advantage of a small facility is that you need not reach far. Everything is right there.

When using a relatively small sink, it is both practical and convenient to use tray stacking devices, such as the Richards Tray Rak, which holds three trays, one above the other, with overlapping ends (stair-fashion) for ease of access. The developer should be in the top tray, and the fixer at the bottom, to avoid the possibility that accidental slopping will contaminate the developer.

Arrangement

You can set up a darkroom however you choose, but I prefer to do it in terms of a movement pattern. My preferred pattern is circular and clockwise. The first consideration is that there must be a clear differentiation between wet and dry areas. Wet must never intrude on dry. My setup involves the use of two enlargers, one for large and one for small negatives. Yours might use one enlarger and a contact printer. As a simple way of presenting things, I have included

a diagram of my own darkroom in Figure 51. You should feel quite free to deviate from its size or pattern, at will.

I built my own sink, on the pattern shown in Appendix 2, out of exterior-grade plywood, coated with marine epoxy paint. However, commercial sinks made of plastic, fiberglass, or stainless steel are available in a variety of sizes. The sink shown will take three 11 × 14 inch trays (more, if they are stacked), as well as a Paterson print washer. (This is a rectangular,

vertical plastic box in which there is a plastic basket capable of accepting 24 8 × 10 inch prints, 12 11 × 14 inch prints, or—without the basket—2 to 4 14 × 20 inch prints.)

Contents

In order to suggest to others what it takes to equip a small but good quality darkroom, I will list the contents of mine:

FIGURE 51
Design for a small darkroom. (See Appendix 2 for further details.)

Dry Side

1 5 × 7 inch enlarger	1 contact print frame
1 35 mm/2¼" enlarger	1 16" paper cutter
1 enlarger timer	1 scissors
1 enlarger easel, 11 × 14"	1 wirecutter pliers, for opening film cassettes
1 built-in ventilator fan	1 bulk film loader

Wet Side

1 11 × 14" Paterson washer	1 temperature control device, attached to plumbing
1 32 oz/1 liter graduate	
2 16 oz/500 ml graduates	1 2-level tray stacker
5 11 × 14" print trays	3 red bamboo print tongs (Short Stop and Fix)
3 8 × 10" print trays	
1 32 oz/1 liter steel developing tank	3 blue bamboo tongs (Developer)
1 16 oz/500 ml tank	2 plastic buckets (for mixing chemicals)
1 8 oz/250 ml tank	
4 35 mm steel reels	1 large neck funnel
2 120 size steel reels	1 thermometer, °C and °F
2 stirring rods (1 each for fixer and developers)	2 safelights

In addition to the above, of course, I stock spare and mixed chemicals, film of various sizes and types, enlarging paper in grades 1, 2, 3, 4, 5 and 6, contact printing paper in grades 2 and 4, spare bottles for chemicals, a roll of Scotch Black Photographic Tape #235, and pressure cans of Omit (for blowing dust off such things as negatives, enlargers, lenses, and cameras) and Prolong (an inert gas meant to be put into partly filled chemical bottles, in order to prevent oxidation). Other miscellany finds its way in and out, according to need.

FILM PROCESSING

Although I mention color photography here and there, my main consideration is black-and-white work. The materials and procedures are taken in the usual sequence of use.

Choice of Chemicals

Photographic chemicals* come in a variety of forms and for a variety of purposes. Most of these chemicals are compounded of several basic constituents, combined so that each one contributes its special qualities to the whole. (A good general reference is Eaton's *Photographic Chemistry . . .*—see the Bibliography.)

Wet Mixes Many chemicals are supplied either as premixed liquid solutions, or as a liquid "stock" solution needing only a last minute dilution with water for use. These are very convenient, but in some cases they may be more expensive than equivalent dry mixes.

Dry Mixes Developers, fixers, and some other chemicals often come packed as dry chemicals, either in cans or cardboard packages. Before use, these must be mixed with water, usually at elevated temperatures. Where a choice exists, these may be a little cheaper than wet mixes, particularly in the smaller sizes generally used in a moderate sized establishment. It does take some time and effort to do the mixing, but not enough to get excited about. The resulting mixture, after the initial process of dissolving, may be used directly, or as a stock solution with an additional specified dilution before use.

*In this context, the word "chemicals" refers to compounded complete formulas, unless otherwise specified, as in "individual dry chemicals."

There is a little myth attached to the use of developers mixed from dry constituents. I have heard it said by professional photographers that mixes designed for repeated use are too vigorous or "raw" to use for important work immediately after being compounded, and that the photographer should run a junk roll of film through them to take the edge off. I can only attribute the perpetuation of this story to repeated failures to cool the solution adequately after mixing and before use. It isn't a good idea to use hot developer.

Scratch Mixes Often the cheapest way of operating is to mix formulas "from scratch," from standard listings or personalized recipes, using individual dry chemicals. However, this process suffers from two limitations. You must have the particular raw materials available, and you must put in some time measuring and mixing. The major advantage—given present salary levels—is not cost, but the fact that (given the raw materials) you can mix any formula that you desire from the vast literature of photographic chemistry. If you have nonstandard needs, the value of this is obvious. Generally speaking, however, I recommend limiting this practice to those few formulas that cannot be purchased as mixes, unless your establishment is a very large one.

One-Time Use Some chemicals, particularly developers, are designed to be (or are) used only one time. The advantage here is that each use is exactly like the last, without the complications that can arise from the accumulation of such things as developer by-products. I prefer this practice for film development. However, since a single use often fails to exhaust the solution chemically, there is some chance of waste being involved. The choice does not always exist. Developers diluted from stock solutions cannot be reused.

Repeated Use Some chemicals, particularly fixers, are used until exhaustion, without the addition of new material. Follow the printed instructions on the packaging concerning capacity and testing.

Replenishment A number of common developers can be used continuously while maintaining development quality, by using a replenisher. This is a stock solution, which is chemically related to the original developer. It is added after each use in order to maintain the same amount of solution (since each film takes along some developer to the next processing step) and to keep the correct chemical balance (since each film uses up part of the chemical potential of the solution, which must be restored in order to maintain quality). In replenished developers there may be some slight change in development characteristics from batch to batch. These differences will be important only in circumstances requiring very rigorous quality control.

Timing

The correct time of immersion in each solution in the processing cycle is found listed in the film or developer instructions. Too short a development time yields results that somewhat resemble underexposure, in that the developed negative will lack density and contrast. Closer examination will reveal that all of the tonal areas are present—whereas, in underexposure, the darkest tonal areas will be missing—but that the overall density is too slight (see Plate 18,b). To a degree, underdevelopment can be corrected by printing on a higher contrast paper; but, the need can easily exceed the range of available papers. Overdevelopment tends to increase negative contrast.

Any film developer that acts in under three to four minutes is likely to produce uneven development, unless unusual care is taken, both to assure that the film is fully wetted immediately upon entry, and is then carefully agitated. Prewetting of films in plain water, prior to their development, may help. In a few cases, prewetting has the effect of reducing the vigor of development by an initial dilution. In order to correct for this, it may be necessary either to allow additional development time, or perhaps to change the original proportion of dilution of a diluted developer.

Temperature Control

There is a misunderstanding afoot to the effect that temperature control is less important for black-and-white film processing than for color development. Actually, the desired standard is the same for both—plus or minus one-half degree. Fortunately, this accuracy level is easy to attain and hold. The important thing is that all the wet processing steps should be at the *same* temperature, from first wetting through the final washing, and even for the drying. The particular temperature itself is less critical. Film and developer manufacturers provide standard tables listing a wide variety of time and temperature specifications. Choose the temperature level that you prefer, or the one you can most easily maintain, and use the development time that is specified for it.

The purpose in maintaining tight temperature control is to avoid what is called "reticulation," a wrinkling of the film emulsion caused by changes in temperature during wet processing. The effect is irreversible. In mild cases it looks (in the print) similar to excessive film grain. In really bad cases, the film emulsion surface takes on the appearance of the skin of a prune, and may even slough off in places (see Plate 18,a). Edge frilling of films usually stems from this same cause, though it may show up from film-to-reel abrasion in high temperature processing, when the emulsion is unusually soft because of the heat. Avoid reticulation effects by holding all temperatures close to one another. And do not dry films at elevated temperatures.

Agitation

In the photographic context, "agitation" refers to movement of films or papers relative to the immersing solutions, for the purpose of exchanging solution at the surface of the emulsion in order for the chemical processes to proceed evenly and efficiently. Insufficient agitation fosters uneven processing, because of the differential accumulation of processing by-products. Their presence inhibits further chemical action by acting as a liquid barrier to the presentation of fresh solution to the emulsion. On the other hand, extreme agitation can set up turbulences that produce a characteristic pattern of unevenness, particularly at the film edges, and near sprocket holes.

These processing faults show up plainly in both the negatives and in the resulting prints. They cannot be corrected after the fact. Specific agitation directions are given in the text following page 225. For roll films, the best method of agitation consists of an intermittent gentle inversion of the developing tank.

Normal Black-and-White Processing

The processing of films requires several chemical steps, and can be done by various methods. Regular agitation is required in the first three steps.

Chemistry Film processing, under usual circumstances, takes place in a series of steps. These are described in sequence, in the following sections.

Development. In the first step, the latent image formed by the action of light on the film is rendered visible by physical and chemical means; the silver halides that were exposed to light are converted into clumped grains of metallic silver that form the developed image. Generally speaking, although it is a visible image, the processing must be carried on in total darkness to avoid exposing and developing portions of the emulsion that were not affected in the camera. A red safelight can be used with orthochromatic films, as directed, but panchromatic films require total darkness.

Short Stop. In the second step, the action of the developer is stopped. This can be done by chemically neutralizing the developer with an acetic acid stop bath. However, most films do not actually require an acid stop; a simple water rinse is sufficient. Where an acid stop is required, this information will be listed in the processing directions for the particular materials in use. The common name for an acetic acid stop bath is "short stop." Short stop is usually purchased as a liquid stock solution, and diluted for use. It can be compounded, also by simple dilution, from glacial acetic acid, which is itself a liquid at room temperature.

Fixation. The purpose of fixation is to remove from the emulsion silver halides that were not exposed and developed, thus rendering the image permanent. At the end of fixation, the wet film can be examined by white room light. Overall cloudiness in the negative emulsion, or the presence of reddish or pale purplish staining,

indicates insufficient fixation and/or insufficient agitation in fixing. If any of these indications are present, repeat the fixation step, preferably with fresh fixer. Fixer is often called "hypo," a term derived from an early name for its primary constituent, now called sodium thiosulphate. Most commonly, the fixer is bought premixed in boxes, ready to be dissolved in water.

Washing. After fixation, the film is washed to remove from the emulsion all significant traces of the processing chemicals, thus making the image even more permanent. The primary material to be removed at this step is the fixer. Should significant amounts of fixer remain in the emulsion it will eventually bleach the image. Film washing is a leaching process, and does not actually require running water. It can be done very effectively by repeatedly filling and empty-

PLATE 18 ▶

Time and temperature in development. Processing must be done with some care if results are to be good. (a) This is a ×45 enlargement of reticulation in the emulsion of a 35 mm negative that was subjected to undue temperature changes during processing. The continuous lines represent unbroken ridges, while the short squiggles are prune-like wrinkles. (b) Cranefly (Tipulidae), photographed at ×3 on Kodak High Contrast Copy film, subsequently enlarged six times to ×18, here. The processing was in H&W Control developer (the old version, no longer made) that was accidentally partly oxidized. This resulted in substantial underdevelopment with a consequent drastic lowering of contrast in the negative. Although the print was made on super-contrasty #6 paper, the print contrast was still too low. Note, however, that shadow detail is not lost as it is in underexposure; it is just too low in contrast for adequate printing. Too short a development time could have somewhat similar results, and in addition might present a mottled pattern of uneven development.

ing the film container, if running water is not available, or if maintaining the water temperature is difficult. Films require about 20 to 30 minutes of washing in slowly running water or about five to six complete water changes. In still water washing, the container is filled and allowed to stand for about five minutes. Then it is emptied, refilled at once, and allowed to stand again, repeating this action five or six times.

Post-Wash Rinse. It is a common practice to immerse the washed films in a detergent solution, so that the surface tension of residual wetness will be reduced. Thus, when the films are hung up to dry, the water will sheet off evenly and without the formation of discrete drops which might leave spots when they evaporate. I consider that this is a valuable practice, although some photographers choose not to do it. Ordinary dishwashing detergent will do the job, but the material most commonly used is one of the photographic detergents, such as Kodak's Photo-Flo. It is important to use very little detergent. For a 32 oz/1 liter quantity of solution, I use the smallest sized drop that I can get out of the stock bottle. Thoroughly mixed, this is sufficient. Too much leaves a gummy surface film on the negative after drying. This, in turn, tends to hold dirt and dust particles, and is itself difficult to remove even by extensive rewashing. Do not immerse the film until the detergent solution is thoroughly mixed. Do not reuse the solution.

Drying. Sheet films should be hung from one corner, so that moisture takes the most efficient drainage course, collecting at and dripping from the low corner. Ordinary wood or plastic spring clothespins can be used, strung on a wire or fastened along the edge of a shelf over the sink.

Roll films are hung similarly, from one end with the low end weighted with a clip so that it will not curl in drying or swing into another roll. Partly dried films will stick together upon contact, so be careful.

To facilitate rapid drying, roll films can be wiped down with a sponge. Use a good photographic-grade artificial sponge, split open, washed out in fresh detergent solution and pressed nearly dry. The split is opened, and the hanging film entered. Then the sponge is lightly pressed closed over the film and wiped down its full length in one movement. Thus, both surfaces of the film are sponged simultaneously. After each use the sponge must be thoroughly washed, inside and out, squeezed out, and put in a clean, airy space to dry. Sheet films need not be sponged, but final drying is speeded if the last remaining drop to accumulate at the low corner is taken off with a tissue.

A film drying space should have clean air and a temperature near that of the processing chemistry. Air exchange should take place, but the area should not be drafty. Films dry very rapidly, and forced-air drying is more likely to be harmful than a help. Drafts can cause films to sway together and stick, and rapidly moving air readily carries dust and lint. Elevated temperatures can introduce reticulation.

Roll Film Handling Methods As with most things in photography, there are several ways to approach the processing of roll films.

Tray Development. You can get crude about things, and still develop films perfectly adequately, if you are careful not to damage them in handling. Only us old fogeys still remember it, and we mostly don't care to admit it, but roll films can be processed in trays or even in old cereal bowls.

In this technique, the film is opened in total darkness, and is held by thumb and forefinger at each end, the middle drooping sharply, with the emulsion side up. (The inside of the natural curl of a film is the emulsion side.) The drooping middle is immersed in the developer, the two ends are alternately raised and lowered, and the film develops. The procedure is repeated in each solution. The bottom of the droop must be kept immersed at all times, and motion must be constant. Keeping the emulsion side up prevents scratching from friction with the tray bottom. Figure 52 shows the details.

The method is suitable for 20-exposure rolls of 35 mm films and for 120 sized films. I can do 36-exposure rolls of 35 mm, but those with shorter arms find it difficult, because such a roll is about five feet long. This is a tedious procedure for processing, particularly if the development time is long. But it works and can be done in any darkened room. I've never had a roll developed this way show signs of uneven processing.

Spiral Reel Tanks. Most small quantity roll film processing is done in cylindrical tanks in which the film is held in spiral reels. This is a convenient method, and all operations except for the loading of the film are done in room light. (For that matter, it is even possible to obtain a daylight loading tank.)

There are three basic spiral reel types. The simplest is Kodak's "apron." An apron is a piece of flexible plastic the same length and width as the film to be processed, with dimples pressed into the edges at frequent regular intervals. The film is opened in darkness; it and the apron are held by one end, and then the two are laid together. Then they are rolled up together, in a spiral fashion, and placed in the tank. With the lid on the tank, the room lights are turned on

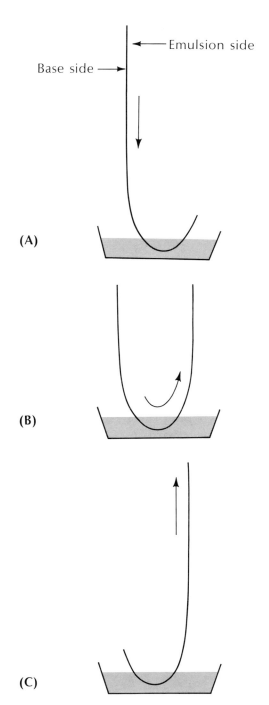

FIGURE 52
Tray development of roll films.

and processing is begun. Chemicals are poured in and out of the tank through its filling port in the correct sequence, and the job is quickly done. The purpose of the edge-dimpled apron is to separate the film in space so that it will not stick to itself when damp. This method of loading a tank is very nearly foolproof, and requires absolutely no skill. However, there are defects in the system. The tank provided cannot be inverted without spilling; agitation is by rotating the film within the tank, so that there is a possibility of uneven development of the film linearly (a film wound in spiral form moves faster through the solution at the outer end than at the center—additionally, fast spinning causes turbulence that concentrates at the film edges); the apron must be dried between uses; and only two rolls of film can be processed at one time.

The second spiralling method involves the use of a grooved plastic double reel, often adjustable for various film widths, and often with a quarter-turn rotational loading mechanism that is very easy and convenient to use. The disadvantages are approximately the same as with the apron. Agitation is done by turning a central knob and thereby spinning the reel. If the reel should retain any trace of moisture from a previous use, the film will surely jam in loading, so drying must thorough. Any significant heating of the reel will warp it beyond salvage. Only one roll of film can be developed at a time. Only a very few of this type of tank allow inversion agitation, and it is very difficult to avoid uneven development with agitation by spinning.

The third method uses a nonadjustable double reel made of stainless steel wire. Reels are made in various widths for different film sizes. It takes a bit of practice to learn to load film onto one, but once mastered this is a superior system. The tanks are capped, so agitation is by inversion. The reels should be dry for loading,

but the mode of loading renders a drop or so of moisture irrelevant. Drying of the reels is facilitated by putting them through a final rinse of very hot water. Moisture evaporates from the hot metal almost at once. Tanks are available in a variety of heights. Thus, several rolls of film can be developed together, one above the other; and if you have appropriately sized tanks and reels, the rolls can be of different film sizes. Conversely, small tanks can be used to develop a single roll at a time, with a consequent saving of chemicals. As noted earlier, I have three sizes of tanks, and two sizes of reels, and feel that the investment is well worthwhile. Costs are easily amortized, since these tanks and reels are so durable that it is almost impossible to damage them.

To load a wire reel—and this must be done in total darkness—the film cassette is opened, several inches of film are pulled off the roll and are held between thumb and forefinger so that the film is slightly bowed, longitudinally. This end is then pushed to the center of the reel and pushed under a spring clip (or in the case of a 120 sized reel, inserted into a slot). The reel is then rotated a quarter turn to start the film into the spiral passage between the wires of the reel. At this point the other hand should be used to feel and be sure that the film end is centered under the clip. If not, the film will go in crooked and will shortly crimp. When the film is centered, the reel is turned until you have wound the whole film on, sliding the thumb and forefinger along the film to keep it bowed for entry into the reel.

The most common error in loading a reel is to have the film slightly twisted, so that one edge goes into a turn of the spiral correctly but the other tries to enter a different turn. I find it convenient, after starting the film, to set the reel on edge and rotate it like a wheel on a table

top, resting the heel of my loading hand on the table as a reference point. As the reel is rotated by the other hand, the loading thumb and forefinger are simultaneously touched by the radial spokes of the reel if the film is not being twisted. There are thus four checkpoints per revolution.

The second most common error in loading a reel is to have the reel inverted when the film end is clipped on at the center. The result is that you will be trying to load clockwise into a counterclockwise spiral, or vice versa. It won't work, and the film edges will be damaged. Prepare for right-handed loading by laying the reel down, so that the spiral starts out from the center in a counterclockwise direction. Hold the film in your right hand. If you are left handed, lay the reel down so that it is spiralling clockwise. In either case, in order to load, rotate the reel opposite to the direction of the spiralling. That pulls the film in correctly.

If you consistently find it difficult to load wire reels correctly, devices for making it easier can be purchased. They work, but are not really necessary if you practice in the light with a blank roll of film.

Cassette Development. It is possible to process a 20-exposure roll of 35 mm film without taking it out of its cassette. Burleigh Brooks, Inc., of Englewood, New Jersey, purveys a very small tank for this purpose. It accepts one 20-exposure roll at a time, and is made in Japan. If you follow the directions carefully, you should be able to use this item without difficulty. After first trying the method at home, you might find this an acceptable practice for field use: particularly when it is necessary to see the negatives immediately, because of the unrepeatable nature of unusual circumstances. For most work, however, I prefer to use more conventional methods and chemistry.

This tank is intended only for use with Sigell Auto-Developer—a monobath, in which both the developing and fixing agents are combined in the same mix. There is a note on monobath processing on page 229.

Sheet Film Handling Methods In some types of work, and especially where the Zone System is in use, it is desirable to use sheet films so that one or a few exposures are developed at a time. I have used sheet films in $2\frac{1}{4} \times 3\frac{1}{4}$, $3\frac{1}{4} \times 4\frac{1}{4}$, 4×5, 5×7, 8×10 and 11×14 inch sizes, frequently using two or three sizes on a single job. The advantages can be considerable. As with roll films, there are several handling methods.

Tray Development. The quickest and most convenient method of handling small numbers of sheet films, particularly when their sizes vary, is by tray development. In this practice, developer is discarded after one use. Doing one film at a time offers few problems, but when you gang them you can get into trouble unless great care is exercised. The primary dangers are that the films will stick together in entering the first solution, before they are thoroughly wet, and that the corner of one film will dig into the emulsion of another during agitation. To avoid these problems I use a set method of working that produces very consistent results with little likelihood of damage.

Working in the dark (unless I am using orthochromatic films with a suitable safelight), I start out by fanning out the exposed films, playing card fashion, all with the emulsion side facing me. Corners are touched and counted to be sure that all the films are fanned out. Then a single film is taken from the bottom of the fan and placed, face up, in the tray of developer. It is

pressed under (be sure and thoroughly wet the fingertips of that hand at this point—if they are only just damp they may leave prints on the film). Then it is picked up and placed face down, turned face up and then again face down. The action of turning is leisurely but regular. This allows the emulsion to become thoroughly wet. The other films are then put in, one at a time and following the same sequence of turning as each goes in. At the end, all the films are in and all are face down, with the most recently entered film on top. Films are counted as they are entered. Then, for the whole period of development, a sequence of agitation is followed, counting through the series each time, so that the same film is on top at the end of each cycle. If this is so, and the transfer into each new solution is carried on at the same regular rate, each film will be in each solution for the same amount of time.

Agitation is accomplished by lifting one corner of the film bundle and drawing out the bottom film. It is held up by a corner momentarily, in order to drain, alternating corners each time. After draining, it is again placed face down in the tray, taking care to avoid digging into the top film with a corner. This action is continued for the whole developing time. Intermittent, similar agitation is done in passing through the rinse (there is usually no acid short stop used in the development of sheet films), and in the fixer. For washing, it is desirable to place each film in a metal frame hanger, and suspend it vertically, with the washing being done in a deep tank.

If these instructions are followed, there should be no damage to the emulsion side of the negative. Having the films face down throughout processing assures that any slight scratching that might happen will occur on the base side of the film. It will not be visible in a contact print, or in an enlargement made on a diffusion enlarger. Only rarely will such scratches show in enlargements made with a condenser enlarger.

Any tendency of negatives to stick together at entry is reduced by using a tray one size larger than the films (for instance, an 8 × 10 tray for 5 × 7 inch films), and by using fairly large amounts of solution. And, the more films that you develop at once, the larger should be the quantity of solution in the tray. For six 5 × 7 inch films developed in an 8 × 10 inch tray, half a tray of solution is quite sufficient, but for ten to twelve films a full tray is needed. The larger the film, the fewer should be done at one time. In 11 × 14 inch size I limit myself to two or three; for 8 × 10, four or five; for 5 × 7, eight; for 4 × 5 inch or smaller, ten to twelve. When first learning this process, keep the numbers low until you are sure you can develop the films evenly and without damage. Uneven development is usually due to the films sticking together at entry, or to insufficient initial agitation. The former produces straight-line demarcations, fairly obviously edged, between areas of lesser or greater density. The latter results in a mottled appearance.

Tanks and Hangers. Tray development may be undesirable where regular production of rather large quantities of sheet films is the practice. In this instance, the use of deep tanks is recommended, in which films are placed in frame hangers and developed in groups of from six to twenty at a time, depending upon the basic tank size. One-time use of developers is uneconomical, so replenishment is the normal practice. Since this approaches a factory operation, and usually involves regular hired personnel, I will

not go into detail. Check with your dealers, and the standard sources recommended by them, for the necessary information.

Compact Tanks. If you prefer to do tank development of the smaller sizes of sheet films, compact tanks are available in which the basic development technique is similar to that used in roll film work. Some tanks are designed specifically for sheet film use only. In other cases, sheet film holders of various sorts are made that will fit into standard stainless steel roll film tanks. At least one make is adjustable for various sheet film sizes up to 4 × 5 inch (and will accept metric as well as inch, sizes). These devices normally hold up to 12 films at a time. Either a one-time developer, or developer replenishment methods can be used. See your supplier for details of design and use.

Monobath Processing

In the so-called "monobath" process, both the development and fixation have been combined in the same solution, so that processing through fixation is done in a single step. There are limitations to the process, but there are also advantages. Some details of one monobath process were included in the section "Cassette Development," on page 227. Those who wish to explore this interesting field are referred to Haist's *Monobath Manual* (see the Bibliography), which offers a number of formulas and is the standard literature source.

BLACK-AND-WHITE PRINTING

Black-and-white photography is only half done at the conclusion of film processing. The material in the sections that follow completes the description of the rest of the process. (Probably the best single reference for this section is Adams' *The Print,* listed in the Bibliography.)

Normal Black-and-White Processing

Making the print is a process that is quite analogous to making the negative. It is generally subject to much the same matters of exposure and processing, but with certain variations.

Chemistry Print-making chemistry is closely similar to that of negative processing. However, the whole operation (as dealt with here) is usually carried out for a single print at a time (or, for small batches), only the wash including all of the exposures made in a given session.

Development. Paper print material is similar in structure to a simple film, except that the base material is not transparent. Developers can be varied according to one's desires, but most photographers do the great bulk of their work with one of the standard proprietary compounds. Perhaps the best known is Kodak's Dektol. You can mix a comparable solution from scratch, following Kodak formula D-72 (listed in a variety of standard sources). Various other manufacturers offer a number of comparable mixes, such as Agfa's Neutol, Duotol or Eikonal, or Dupont's 53-D or 55-D paper developers. Some paper developers are used straight from stock, others are diluted with water. Check the specifications of your chosen product. Dektol or D-72 are frequently diluted: one volume of developer to two volumes of water. Printing is nearly always carried out under safelight illumination. Check the specifications of the individual paper

being used for the proper safelight designation.

In actual processing, the sheet of exposed paper is slid into the solution so that the developer flows over its entire surface quickly and completely, as shown in Figure 53. Agitation can be accomplished by rocking the tray so that the developer sloshes gently back and forth across the face of the print. If you do this, use an irregular rocking pattern so as to avoid setting up standing waves, which do not actually transfer the developer around on the surface of the print. I prefer to pick up and turn over the print at frequent intervals, resubmerging it carefully each time. Avoid splashing chemicals while turning the print over.

It is practical to process as many as about six sheets of paper at a time, if each one is kept well separated from the others, and adequately agitated. Drain each print well, before transferring it from one solution to the next.

Developing time is important. Too little, and the print will be low in contrast, lacking in blacks, and very likely mottled from uneven development. Too long, and unexposed portions of the emulsion will tend to develop, causing highlight values to be muddied. Contact printing papers should be developed for a *minimum* of 45–60 seconds. It is pointless to develop them longer than about two minutes. Enlarging papers need more time. They should never be developed for less than one and one-half min-

utes, and can be left in for as long as three minutes. More is pointless. I have standardized my development times to one minute for contact papers and two minutes for enlarging papers. I find that shorter times lessen the print quality by slightly lightening blacks and diminishing contrast in the lightest areas. If a print becomes too dark in those times, less exposure is indicated. Standardization of times eases reprinting.

Short Stop. As with films, a simple water rinse will wash off residual developer and effectively stop image change, but I prefer to use an acid short stop. It serves to stop developer action very positively, thereby easing the making of exact duplicates; and it protects the fixer from developer contamination, thereby extending its useful life.

Fixation. Both the action and purpose of fixation is the same for papers as for films. In fact, it can be the same solution. If there is a difference, as some workers prefer, it is that fixers for film have a higher percentage of an additive that hardens the film emulsion, in order to guard against scratching. Too much hardener is detrimental to papers, if the surface is to be glossed, or if color toning is to be done. Fixing time is more important with papers than with films. The film base is impermeable, and so washing involves only the bare surface of the film base on one side and the actual emulsion on the other. With papers, the paper base absorbs fixer which must be washed out if the print is to be really permanent. Papers should fix in five minutes, with adequate agitation and reasonably fresh fixer; but they should not be left in the fixer longer, or washing will be made more difficult, more time-consuming, and possibly less thorough.

FIGURE 53
Method for putting printing paper into the developer.

Hypo Clearing Agent. It is possible to reduce washing time and provide a probable increase in print permanence by using a solution called hypo clearing agent after fixing and before washing. This agent acts to change the residual fixer into a form that is more readily soluble in water. Commercial mixes vary somewhat, and the directions for their use are found on their packaging. All prints intended for archival storage should have this treatment.

Washing. Normal black-and-white papers require a one-hour running-water wash for single-weight papers, and double that for double-weight papers. The use of a clearing agent reduces these wash times to ten and twenty minutes, respectively, or less. A new paper product on the market, called resin coated (RC) paper, has a waterproofed base material, and so it does not absorb chemicals. This paper washes and dries very rapidly, lies very flat when dry, and (if it is of the right type) glosses very well with simple air drying. See your supplier for information on types, use and availability. This material offers a major opportunity to sharply reduce your water use, without loss of quality.

Drying. After washing, papers are dried in any of several ways. In a moderately large operation it is useful to use a mechanical dryer. Previously these were all fairly sizeable, but a remarkably compact unit has been introduced recently. See your dealer for information concerning types, sizes, and capacity.

Prints can also be air dried. Your method can be as simple as hanging them on a line with clothespins (as I do), or you can place them face down on fiberglass mesh screens. Some prefer to put them into blotter books or rolls, but I consider this too slow, and too likely to contaminate the blotters, and—from them—later prints. Squeegeeing them onto ferrotype tins is another method (see the next section). Papers other than the RC type tend to curl when air dried. They can be smoothed and flattened by pressing them in a warm drymount press, or they can just be placed under a stack of books or other weighted flat objects.

Glossing. For purposes of publication it is often considered desirable to gloss your print surfaces to a high shine. This requires that a glossy-surfaced printing paper be used, and dried on a highly polished metal plate or drum. Mechanical dryers usually incorporate a chrome plated drum. For nonmechanical drying you can use ferrotype tins, which are smooth steel or brass plates with one or both surfaces chrome plated. Prints are squeegeed to them and left to air dry. They pop off when done. These glossing surfaces must be kept very clean, or the prints will either stick or develop an uneven gloss with a speckled look. If gloss drying proceeds too rapidly, as when a drum drier is overheated, the prints lift off in concentric portions, leaving permanent surface traces called "oyster-shelling." If this happens, reprint, and then dry them more slowly. As noted in the last section, glossy RC papers gloss and lie very flat with simple air drying, with no need for being placed on chromed surfaces.

Most publishers will accept for publication prints that have been done on glossy paper without being glossed. When air dried, these papers have an acceptably smooth semi-gloss appearance.

Contact Printing There are two basic methods of photo printing, the first of which is called contact printing. In this practice, the negative is placed in direct contact with the printing paper, with the two emulsion sides touching,

and light is passed through the negative to expose the paper. The two materials are held in close contact by physical pressure.

If you use a contact print frame, which looks like a picture frame having a glass front and an easy-access hinged back, any white light source can be used to make the exposure. This is also true for the increasingly popular book-form proof printers, especially designed for mass contact printing of roll films. You can use the overhead room light, or your enlarger, for a light source.

Even more simply, you can place the printing paper face up on a table, lay the negatives on it face down, and put a sheet of glass on them (preferably plate glass with smoothed edges, for weight and safety).

A more elaborate method involves the use of a printing box. This is a box containing one or more light bulbs, with a glass top. You place the negative on the glass dull side up, the paper on top face down, and close the hinged wood or metal flap top to apply pressure. This closes a light-switch, and makes the exposure.

All these methods work about equally well, and none offers significant advantages over the others in small volume work. If you do large repetitive print orders from single negatives, an elaborate printing box is best. I use a simple print frame for both sheet and roll films.

A contact print is itself the end product when you are using large negatives. With small negatives, the whole roll is ganged and is printed at the same time, to provide a series of small positive prints for the purpose of making appraisals of results, selections for enlargements, and decisions on image cropping. It is very useful to contact print each roll or sheet of film, and store a copy with the negatives, for future reference.

Projection Printing Enlarged prints of small negatives, or of portions of larger negatives, are made with the aid of a photo enlarger. This practice is properly called projection printing, because an enlarger is basically similar to a slide projector. I have not gone into the design details of enlargers, because the general photographic public seems to be quite familiar with them. However, there are a couple of points worth mentioning.

Condenser vs Diffusion Enlargers. For as long as I have been associated with photography I have been witness to a continuing argument about the comparative merits of the two main types of enlarger. As with many other equipment considerations it comes down to a matter of choice, based partly upon personal preference and partly on the technical considerations of the work being done.

According to Ansel Adams, in various published statements, the diffusion enlarger is superior for retaining fine print values. Although myth has it that diffusion enlargers do not provide as sharp a print as condenser enlargers, any difference here is so small as to be negligible in any but the most specialized uses. Personally, I use a diffusion-type enlarger for all of my larger negatives (usually $2\frac{1}{4} \times 3\frac{1}{4}$ inch, or larger). A plus quality of diffusion enlargers is that minor dust or scratches on the negative are less likely to show on the print. A small minus value is that print contrast is slightly lowered. Therefore, it may be necessary to use one level higher paper grades. A negative that contact prints well on number 2 paper may require number 3 paper in projection printing with a diffusion enlarger.

Condenser enlargers are usually recommended when the main aim is to retain the ultimate resolution of fine detail. This is not because the system projects a sharper image. Rather, it is due to the fact that the light beam

of a condenser enlarger contains less flare than that of a diffuser enlarger. Consequently, there is less likelihood that small differences in negative texturing will be lost in printing. In some extremes, such as the printing of negatives from transmission electron microscopes, it is a good idea to go to the finest system of condenser enlarging—basically to Kohler-system photomicrographic lighting—and use a point-source lamp house (commercial point-source lamp houses are available for a few makes of enlargers; directions for adapting ordinary 35 mm enlargers to point-source illumination have been published in several places, notably in articles by Stevens and Derkacy, Staugaard, and Kabe—see the Bibliography.) For most purposes, however, a normal condenser enlarger is entirely satisfactory. It should be noted that point-source enlargers cause dust marks and negative scratches to be remarkably visible on prints, thus introducing a considerable retouching problem. I use an ordinary good quality condenser enlarger for all but a minute portion of my small negative enlarging.

Enlarger Lenses. As was noted earlier, in the section titled "Equipment," enlarger lenses can be a problem. For ordinary print making, where the degree of enlargement is perhaps eight to ten times, almost any enlarger lens will suffice. But in cases where greater resolution will be required, and especially where significantly greater magnification is sought in printing, relatively few, even of the best known brands of enlarger lenses, are of sufficient quality. Often, quality control within a given line will be so broadly interpreted that supposedly high quality lenses will vary markedly in a random grouping as small as half a dozen. Both flatness of field and color correction are frequently most noticeable by their absence. Other defects also

tend to show up, if they are looked for. This is apparently a reflection of the fact that very few photographers are willing to pay anything like as much for an enlarger lens as they routinely expect to pay for the original camera lens, a piece of notable short-sightedness. However, not all the blame should be placed on the customer. Even when you pay for quality you don't always get it.

I have taken to using a high quality macro-type lens designed for camera use (my 55 mm f/3.5 Nikon Micro-Nikkor). It offers superb resolution, fine color correction, excellent flatness of field and freedom from distortion, and is corrected for approximately the right levels of image magnification. I recommend others to try the same route, with this or other similar lenses. Adaptors for mounting camera lenses on enlargers are commercially available for most well known makes, though not always made by the lens manufacturer.

Mythology states that camera lenses will be damaged by the heat of the enlarger. Actually, enlarger lenses are made using the same basic materials and construction as camera lenses. The negative would show heat damage well before the lens, and it has been many a year since I've seen an enlarger lamp house so poorly designed that it would overheat a negative. On the other hand, I've heard it seriously proposed that projecting through the same lens that made the original image will remove the effect of residual optical defects in that lens. Don't you believe it. If you use a poor lens it will produce a poor image.

Printing Controls For reasons not plain to me, quality photographic printing has gained the reputation of being a difficult and esoteric practice achieved only by a few shadowy greats, and unlikely to be mastered by the grosser elements

of photographic society. Actually, there are only two basic variables in black-and-white printing: exposure time and paper contrast. Perhaps the confusion arises from failure to understand the nature of print quality.

Print Quality. There are almost always exceptions to any rules that might be thought up in any field. However, where photographs for scientific purposes are the aim, and for most other purposes, I think that it is reasonable to say that a print should have barely discernible detail in both its lightest and its darkest areas, other than in portions that contain no important part of the main subject matter, or portions that serve solely as backgrounds. Detail should not be lost in blazing highlights, nor submerged in unnecessarily deep shadows. Middle tones should be well separated. The full reproduction range of the printing paper should be used, so that prints do not look "muddy"; but that range should not be exceeded. The main subject matter can contain tones that represent approximately 90 percent of the full range of the paper, between pure white and pure black, without loss of significant detail.

Exposure Time. The basic overall lightness or darkness of a print is determined by exposure time. More exposure makes the print darker. Less makes it lighter. The standard method of working is to make a test print, either of the whole print area or of a reasonably large and representative portion of it.

There are two basic test-print methods. The usual way of doing the first is to use a card to provide progressively less shading to a print, making intermittent exposures of equal length. Figure 54 illustrates this method. The timing interval is chosen arbitrarily, according to the

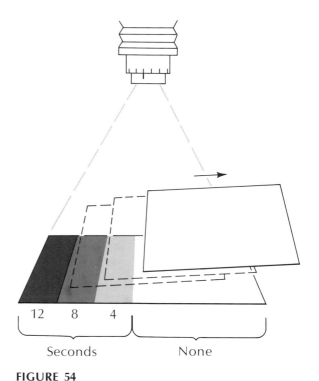

FIGURE 54

Test printing by progressive intermittent exposure. The method is shown in progress, with a four second interval being used. The graded appearance of the exposure will show only after processing the paper.

photographer's educated guess. The aim is to make a print in which, after processing, at least one strip will be definitely too dark, at least one will be too light, and the steps are sufficiently close enough in tone to provide real information as to the final correct exposure, which will fall somewhere in the middle. If what you estimate to be the correct exposure is found in one of the two end strips, your information is incomplete. One interval more or less might have been a little better. You don't have enough information to judge properly. The only flaw in this method is that intermittent exposures added up are not the *exact* equivalent of a single exposure

of the same aggregate length. An improved method is to make one relatively long exposure, with the covering card moved at the chosen interval of time. I normally use this method (see Plate 19, page 239).

The second test-print method involves the purchase of a graded-density negative made for the purpose, such as the Kodak Projection Print Scale. This is a sort of circular neutral density filter, divided into numbered pie-shaped segments, each with a different density. With this laid directly on the printing paper, a one minute exposure is made. The print is examined after processing, and the area of closest approach to correct exposure will have a number printed on it giving the approximate correct printing time in seconds. A new print is then made at or near that time interval, without the print scale, adjusting exposure as necessary to get the appearance exactly right (see Plate 20, page 241).

In order to determine the exposure times for larger or smaller prints, having determined a correct time for one size, apply the inverse square law. If you double the linear print magnification, four times as much exposure time must be given—assuming that the same lens f-number is being used. Halve the linear print magnification and you need only one-fourth of the exposure time. And so on. It is possible to work this out closely enough so that all further testing can be avoided.

It is also possible to determine the correct exposure time by using a print meter. Special meters are made for this purpose, and some normal light meters have conversion accessories available for this use. However, for relatively small volume photography, I doubt that very many people will go to the expense. It might be worth your time to see your dealer about this, though.

Contrast. Contrast is the measure of the difference between degrees of light and dark within the image. A low contrast negative will require a printing paper of higher than normal contrast, in order for the print to look right; and vice versa.

As was noted earlier, in the section on "Materials," printing papers are graded by numbers, with low contrast papers designated by low numbers (0 and 1), and high contrast grades by high numbers (4, 5, and 6). The area of "normal" contrast is represented by grade number 2, and to a lesser extent by number 3. Under usual photographic circumstances, the majority of negatives will print well on number 2 or 3 papers. But exceptions must be allowed for.

Variable contrast papers, such as Varigam, Polycontrast, and the like, are sensitive to changes in the color of the light used for exposure. Color filters placed over the enlarger lens, or in a filter drawer in the lamp house, are thus used to control the print contrast. Though numbering systems vary with the manufacturer, low numbers in filter designation—like low paper grade numbers—produce low contrast, and high numbers produce high contrast.

Whether graded papers or variable contrast papers are used, it is often desirable to make graded-exposure test prints of more than one contrast grade, in order to pin down both the exact exposure time and the print contrast levels to be used in the final print. As with exposure time, it is also possible to use a printing meter, properly calibrated, to determine the needed paper contrast. See the instruction sheet of the meter chosen, for details of procedure.

Differential Printing. Many negatives made under natural lighting circumstances will be found to have areas of greater or lesser general

density than does the negative as a whole. This is a consequence of uneven existing lighting. For instance, it is normal for the sky areas in a landscape to be considerably brighter than the land areas. Some subjects may be brightly lit in some parts, but in shadow elsewhere. It may also be the case that a negative that is printable as a whole has in it an important area that is lower in contrast than the whole. Thus, when a higher contrast paper is used to reproduce detail in that area, other portions of the image become unprintably lighter or darker. The accepted means for correcting these problems in printing is to give differential exposure to various parts of the image (see Plates 21–25, pages 243–251).

Differential printing requires testing in order to determine both the basic acceptable level of paper contrast and the various levels of correct exposure in the different parts of the image. There is a jargon in photography, and the common terms are "dodging," for shadowing an area so that it receives less exposure than the picture as a whole, and "burning in," for giving a relatively small area extra exposure time. These practices are illustrated in Figure 55. Since these terms describe what is basically the same proc-

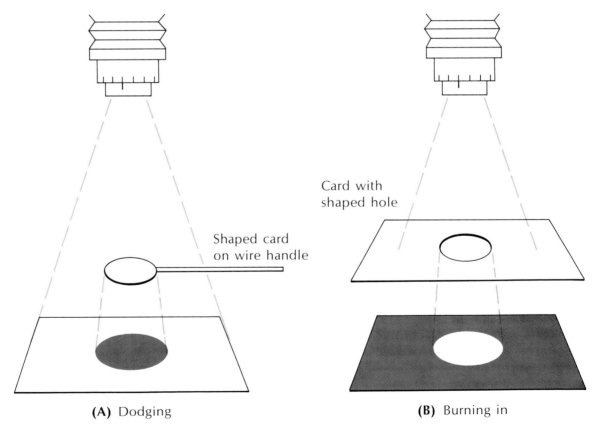

Shaped card
on wire handle

Card with
shaped hole

(A) Dodging **(B)** Burning in

FIGURE 55
Differential Printing.

ess in two ways, I prefer to unite them under the more general term "differential printing." The use of both terms implies that you determine a basic print exposure time, and then both add to and subtract from it in order to obtain a correct overall balance. I prefer a completely additive process, as it is easier to keep clear in the mind (when differential times are not used, the result is called a "straight" print).

I find it most profitable to determine a basic exposure time for the print, based upon the amount of exposure that will be correct for the areas of least negative density, and then to add exposure increments here and there, as needed, to bring the whole print to a satisfactory overall appearance. With prints of any complexity I will then make a simple sketch diagram showing the printing pattern, with exposure times listed in terms of percentages so that I need only determine a new basic time on the same paper grade to duplicate the print quality in any reproduction size at any later date. Typically, the information recorded on the sketch would include the following:

1. Enlarger lens f-number (e.g., f/5.6).

2. Paper grade and type (e.g., Kodabromide F-2).

3. Basic exposure (e.g., 10 seconds).

4. Percentage increments of additions (e.g., plus 10 percent at top right corner; plus 25 percent along whole top edge; plus 20 percent in a 3 inch circle at the center).

Thus, If I increase the print magnification by 50 percent, the following conditions should give a similar print:

1. Enlarger lens f-number (e.g., f/5.6).

2. Paper: Kodabromide F-2.

3. Basic exposure: 20 seconds.

4. Additions: plus 2 seconds at top right; plus 5 seconds along the whole top edge; plus 4 seconds in a 4.5 inch circle in the center.

Failure to record printing information will make later reprinting troublesome. Such information is useful only if it is filed with the negative, and will be good only if the processing of prints is similar. And, of course, providing that the manufacturer has not in the meantime changed the characteristics of the paper. (The most likely change is emulsion speed. In this case you need only establish a new basic exposure time, and from that you can easily figure new differential printing times, just as you would for changes introduced by a different image magnification.)

Mythology has it that during print development you can "bring up" small underexposed areas by breathing warm air on that spot, or by rubbing on it with a warm finger. Don't waste your time. Any change effected is so slight as to be undetectable. Make a new print and add a little exposure time at that particular spot, instead.

A practice that is recommended by some writers to "brighten up" certain highlight areas is to use a potassium ferricyanide bleach, sponged onto selected areas of the still wet print. This is difficult to control, and introduces the danger of unintentionally bleaching areas of runoff. And, if you go too far, the print is not salvageable. Furthermore, I consider the result to be false looking at best. The results of bleaching are never equivalent to the use of a little less exposure time. Therefore, I recommend that you avoid this method and "dodge" a little instead.

Cropping. It is almost too obvious to remark on, but you can affect a photograph's quality of appearance, and the degree of clarity with

238

FIGURE 56
Composing with L-shapes.

PLATE 19 ▶
Projection printing—testing. Rocks at the edge of a Sierra stream. (a) A test strip by intermittent graded exposure. The time chosen for printing was between the first two exposure intervals (three and six seconds) at the left. Since the test interval was three seconds, the print exposure time used was 4.5 seconds. (b) The finished product.

which it presents information, by a choice of composition; and the simplest means of changing composition is to delete some of the available image area when printing. This process is called "cropping," and can be done by changing the positions of the enlarger easel's boundaries, or by cutting up the print after it is dry. Unless you are unusually experienced or talented, it is a good idea to make a full negative print—either by contact or by projection—and use a pair of L-shaped framers on it to try various compositional effects before final printing. Their use is illustrated in Figure 56. It is worthwhile to do a little practicing with L-shapes on other people's pictures, such as magazine illustrations. With no built-in preferences, as occur with your own pictures, it is easier at first to come to fair conclusions this way. Compositional rules are far less important than teaching your eye to see the possibilities (see Plates 24 and 25, especially, on pages 249 and 251).

Cropping in printing can be overdone very easily. Overenlargement of a small negative area will introduce film grain effects and increase the visibility of small technical defects, and thereby lower the final print quality. If you find yourself frequently cropping down to a small portion of the available image, it is time to take a critical look at your camera work. Cropping is best when done as correctly as possible in the viewfinder of the camera, while taking into account the existing limitations of standard film proportions.

Divided Developer. Most prints come out perfectly well using ordinary print developers, but every now and then you will get a negative in which the tonal qualities just do not print well. This is especially the case where the negative was marginally underexposed. I have found that most such odd negatives can be printed very

well, using a two-solution developer that has all of the major developing components in the first solution, and the accelerator in the second. The paper used for this should be one contrast grade higher than that on which the best print obtainable with ordinary developer can be made. After exposure, it should be soaked for 30–45 seconds in the first solution; no visible change will take place here. It is then briefly drained, but not rinsed, and then transferred to the second bath, where the image will develop fully in another 30–45 seconds. Agitation in the second bath should be no more than the bare minimum that is required for spreading the chemicals once over the print surface. The remaining processing is standard.

The only disadvantage of the system is that only one print can be done at a time. Since the processing time in this method is inflexible because of the exhaustion of the limited amount of developer in the print emulsion, it is necessary to be very accurate in your printing exposure time. But this should be the case anyway. It is a generally poor practice to depend upon variation of development time to correct for inaccuracy of exposure in printing.

The effect is to retain the basic appearance of the highlights and middle tones, and to increase visibility and contrast in the dark areas (see Plate 23, page 247). Different papers re-

PLATE 20 ▶

Projection printing—testing. Rocks in association with a granite dome, Yosemite National Park. (a) A test strip that was made with a Kodak Projection Print Scale. The overall exposure was 60 seconds. The time chosen for printing was five seconds, on #3 paper. An initial test done on #2 paper was deemed to be too low in contrast. (b) The final print. In the original photography, a polarizing filter was used to darken the sky tones, thereby emphasizing the clouds.

a

b

spond differently to this treatment. I have found it very satisfactory with Kodak's Azo and Kodabromide papers, and with Agfa's Brovira, but less so with Dupont's Varigam and Velour Black papers (the last two are otherwise very fine papers).

I would not recommend this method for use for general purpose development, since I prefer the appearance produced by normal print developers with at least 90 percent of my negatives. But for the remainder, it is superb. The most accessible sources of suitable formulas are Paul Farber's two articles, both titled "Divided Development," one in *U.S. Camera,* and the other in *Dignan's Simplified Chemical Formulas . . .* (see the Bibliography). The Dignan article is an expansion and updating of the other.

There are a variety of specialized developer formulas in the literature, including the above and the Beers formula that comes well recommended by Ansel Adams in his book, *The Print.*

Stabilization Printing

For those photographers who simply cannot set up wet darkrooms, or whose need for rapid access to prints is compelling, there is stabilization printing. This involves using a desk-top processing machine surmounted by two inverted solution bottles. The exposed paper is placed in a slot in the front, and comes out the back, finished and damp-dry, in about 15 seconds. The print quality is very close to that of normally processed prints—entirely satisfactory for reproduction purposes. The advantages are obvious.

As the saying goes, there is no free lunch. The maximum print size is dictated by the capacity of the machine. Be sure to get one that is large enough for all likely needs, if you decide to use

this process. The processes that are available to date have not yielded archivally permanent prints without additional normal fixing and washing, though recent reports indicate that dramatic improvements may be on the way. The machine itself must be kept immaculately clean, in good adjustment, and perfectly level, or you will have problems. However, given all that, the convenience factor is not to be ignored for those prints whose life need not exceed a year or so, or that can be fixed and washed later and perhaps even elsewhere. You can literally go into the darkroom with a negative and come out 15–20 minutes later, with all of your printmaking operations completed, and a good quality print in hand.

See your supplier for information about types, sizes, and prices. And, if possible, look up Scardino's article, "Stabilization Processing: A Review" (see the Bibliography), before you go.

PLATE 21 ▶

Projection printing—differential exposure. Molted skin of a ladybird beetle (Coccinellidae) larva on a black walnut (*Jugrans nigra*) leaf, photographed by closeup flash at ×1.8 image magnification, using a reversed retro-focus lens (a 35 mm PC-Nikkor), and enlarged in printing to ×13.5, here. (a) A "straight" print (that is, one unaltered by differential printing), showing very one-sided lighting effects that have resulted from misplacement of the flash unit. These effects include the submergence of the subject into the shadows at right, and a distracting lightness of the leaf to the left of the vein. The print exposure time was four seconds. (b) Differential exposure was used to make the best of a bad job. The basic exposure was two seconds, with two seconds added to the left two-thirds of the picture, and four more seconds added to the area left of the leaf vein. Visual attention is now centered on the subject, rather than on the leaf. Since the right side of the negative is basically underexposed, the salvage possibilities there are limited, but some improvement can be seen. The improvement on the left is dramatic.

MOUNTING PRINTS

No treatise on printing is complete without a few remarks on mounting. For many uses, unmounted prints are quite satisfactory; but for wall display, for prints likely to receive heavy hand-to-hand passing around, and for some publication uses, it is very desirable to mount them on a supporting and protective backing.

Heat-Mounting

The most practical method of print mounting is called "dry mounting," and involves sandwiching a sheet of heat-sensitive tissue between the print and the mount. The sandwich is then pressed in a hot dry mount press. The heat melts the dry mount tissue, causing it to become adhesive. Prints so mounted lie very flat and neat. See your dealer for details about the equipment, materials, and technique.

Dry mounting can be done with a household iron, set at its lowest temperature, but great care must be taken to avoid having any drops of moisture left in a steam iron so used. One drop of water will irrevocably spoil a print, if it jets out as steam. Irons are difficult to use well. It is hard to get an even application of heat, and hard to prevent the formation of edge lines as the iron is moved. Fortunately, many camera shops these days provide a dry mount press for public use, either free or at a small fee. This is a solution for a very low volume operation, but if there is significant output it will be quite worthwhile to purchase a press.

The dry-mount process is essentially permanent if the mount surface is suitable, but normal black-and-white prints can be removed, if necessary, by soaking the sandwich in carbon tetrachloride. Once removed, the prints can be

rewashed, air dried, and remounted. Reglossing is usually impractical.

WARNING: Excessive exposure to carbon tetrachloride vapors is both a short and a long term health hazard. It is a dangerous chemical and should be used only in a well-ventilated area.

Normal Black-and-White Prints. There are very few real problems here. Take care to see that the dry mount tissue and the print are cut squarely and to exactly the same size. Attach them first at the center with a tacking iron (a small electrically heated device with a handle, used for this initial fastening, or "tacking") and then trim them together. Position the tissue and print carefully, before tacking the four corners to the mount board, so that when the print is pressed it will be mounted exactly as desired. Before typing labels or other text on a sheet of typing paper that is going to have a photo print attached to it, as in reports and theses, test a

PLATE 22 ▶

Projection printing—differential exposure. Cloudsrest, a granite peak in the Yosemite Sierra, photographed from the top of a granite dome along the Tioga Pass Road (Route 120), near Lake Tenaya. The lens used was a 35 mm PC-Nikkor wideangle, shifted off-center vertically. A Wratten 25 red filter was used to cut distance haze and darken a very pale blue sky. The "puff" clouds are ordinary cumulus forms, and the less distinct sky effects are smoke from a forest fire well beyond the peak. (a) A straight print, adjusted to print the middle distance correctly. Note that the foreground is too dark, and the clouds just above the horizon are poorly distinguished. (b) A relatively subtle differential printing effect. The foreground has been lightened to retain detail in the dark trees, and the sky from the horizon up has been printed marginally darker to make the clouds just above the peak more clearly visible. Darkening of the upper sky also heightens the general pictorial effect.

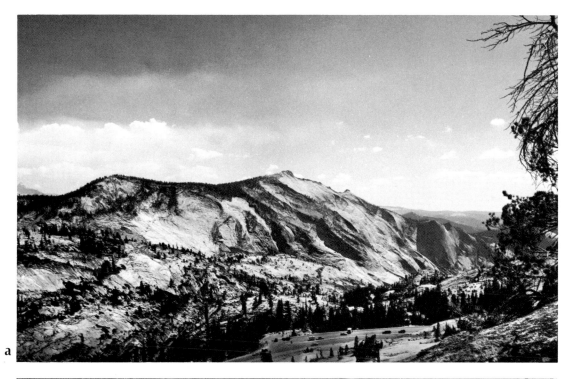

sample of the paper to see if the dry mount tissue will adhere to it. "Easy-erasable" bond papers will not usually accept dry mounting tissue because of their special surface coatings. Generally speaking, the cheaper the paper, the more likely it is that the tissue will adhere.

Color Prints. Unusually low press temperatures are needed if color prints are not to be damaged. Household irons are not suitable, as their lowest temperature settings are too high. It is often a good idea to use a special low temperature mounting tissue, a number of which are available from Kodak, Seal, and others.

Resin Coated Papers. Normal dry mount tissue will not stick to the new resin coated papers, which are in use today for some types of both black-and-white and color prints. Therefore, a special tissue must be ordered and used, and close attention given to press temperature. See the printed instructions on the package for details.

Polaroid Prints. Polaroid prints must never be heat mounted. The surface coating will peel off, and the picture will be ruined. See the following section for other mounting methods.

Pressure-Sensitive Mountings

For low volume work, or for work with difficult print-types, pressure-sensitive materials are very useful. I have no independent information concerning the ultimate permanence or freedom from detrimental effects of these materials on prints. They have not been available long enough for extensive testing. I am pretty sure that most presently available materials are fairly durable, but are not actually permanent. And I have unconfirmed nagging thoughts about their long term effects upon prints. So, until I hear more about this matter, I would not recommend their use with valuable collectors' items, or with prints made for archival storage.

However, for Polaroid prints and for other problem situations not involving long storage or extended wall display, pressure sensitive mountings are the way to go. With these, great care in the initial alignment of a print is needed, because once it is down it can seldom be removed without damage. Wrinkling must be avoided, because it cannot be corrected. It is best to apply a firm pressure at the center of the print first, and then to work out to the edges, in order to avoid having air bubbles form under the print.

PLATE 23 ▶

Projection printing—differential exposure/divided development. (Top) Insect larva, photographed in the laboratory, (a) A straight print, showing excessive shadowing along the right side. (b) A "dodger" (an ellipse of cardboard on a piece of wire) was used to limit exposure of the darkest area, with the result that significant detail is retained. This is a much less subtle effect than was shown in Plate 22. Plate 6,c is the same negative, printed slightly differently.
(Bottom) The Fox Theater, San Francisco, during demolition. This series was made as a test of the efficacy of divided development, and there is no differential exposure. All three are straight prints from the same negative, and in each case the light grey at the bottom has been printed as the same tone. (c) A print on #1 paper, normally developed. Shadow detail is good, but the overall contrast is low. (d) A print on #2 paper, normally developed. The overall contrast is good, but shadow detail is poorly rendered. (e) A print on #3 paper, given divided development. Highlight and middle tones are similar to (d), but shadow detail similar to (c) has been retained. Whenever I have a negative in which shadow detail is sparse, I consider using divided development to improve the final print quality.

a

b

c

d

e

Pressure Sensitive Boards. These are commercially available for general photographic use, and also come as part of the package with the older Polacolor. They have a protective cover sheet, which must be peeled off to expose the sticky surface for use. These boards require that the print go to the edge of the mount board, so if there is to be a wide white edging it must be provided as part of the print. Or this type of mounted print can be set into a mat for framing.

Spray Mounts. The most convenient and versatile of the pressure-sensitive mounting methods involves the use of pressure cans to apply an adhesive to the selected board. By applying a protective mask of tape and/or paper, it is possible to restrict the application of the adhesive to a predetermined area. Thus, provision can be made for a wide border. Applying tne spray to the back of the print may cause it to wrinkle, hence it is a poor practice.

Double-Stick Tape. In moments of need, parallel strips of double-stick tape can be applied to the back of a small or moderate sized print for temporary mounting on any selected surface. Do not overlap the tape. Avoid wrinkles. Be sure to carry the tape all the way to the edge of the print, to avoid lifting of those edges. Watch out for air bubbles when applying the print to the selected mount board. Used carefully, the method does work. Prints mounted in this manner will eventually lift off, but they will last long enough for most temporary purposes—at least several months, in most circumstances.

As a material, I prefer to use Scotch Double Coated Tape #666. This tape has a protective covering that can be left on during all preparatory work, and then stripped off at the last mo-ment. Because this is a particularly sticky tape, be very sure of the print position before pressing it down. I also use this method for attaching labels to print surfaces.

Taping Prints to Surfaces Ordinary cellulose tapes are frequently used to fasten photographic prints to report pages. This is a poor practice because the adhesive deteriorates with time: it oozes out around the tape, causing pages to stick together, discolors the print surface and the underlying page, and eventually loses all holding power. When this happens the photographs tend to drop out when the report is handled. Thus the valuable pictorial evidence is lost from the record.

Scotch brand "Magic Tape"® lasts longer than the ordinary cellulose tapes, and has little tendency to discolor. It can also be used directly on print surfaces as a labelling material, since it is virtually invisible when applied and will accept pencil or pen markings. But such use should be only in the most temporary of contexts.

A better method for either print mounting or label application is gluing (see the next section).

PLATE 24 ▶

Projection printing—differential exposure/cropping. A small mountain meadow in the Yosemite Sierra, showing the very delicate plant ecology. Just walking across it would do noticeable damage. This print was made to emphasize the tones of the dead wood (using Zone System technique to control the film exposure, and printing the negative carefully). The dark, backlit trees at the top received less exposure in printing than the rest of the picture area, to retain slight detailing. The actual placement of the camera resulted in a very careful job of cropping on the ground glass, and this print is of the whole $2\frac{1}{4} \times 3\frac{1}{4}$ negative. Kodak Panatomic-X panchromatic film was used, without any filtering.

Glue-Mounting

First of all, *never* mount photographic prints using rubber cement as an adhesive. It contains compounds that will migrate through the photo paper to the surface of the print, where it will cause severe early deterioration of the image.

Report Illustrations When you just need to "tip in" a photo print for a report, the quickest and simplest permanent method is to apply white glue (such as Elmer's Glue-All®) to the two top corners of the back of the print, and stick it directly to the typing paper. Use only the sparsest possible application, or severe wrinkling will result. The glued points will show through in most cases, but this should not matter in this context.

Very Large Prints Very large photographs intended for permanent or semipermanent wall display present a considerable problem in mounting. It is best done using water-soluble adhesives, such as white glue or ordinary wheat paste (available in hardware stores), since dry mounting is difficult to achieve without unsightly surface markings when the print is substantially larger than the platen of the mounting press. The most suitable substrate for very large prints is hardboard, such as Masonite®, although plywood can be used where greater thickness is needed.

Although not especially difficult to do, this method requires a little know-how if the result is to appear professional. The substrate surface must be sealed with a sizing compound, and the print to be mounted must be soaked with water and then sponged off to remove the excess. The adhesive is then brushed or rolled onto the back of the print, and the print is sqeegeed onto the substrate. Care must be exercised to avoid damaging the print surface. A good article giving full details of the process is Hal Denstman's "Print Mounting: The Finishing Touch," in *Industrial Photography*, February, 1969, pp. 18–20, 56–58, 62–63.

PLATE 25 ▶

Projection printing—differential printing/cropping. (a) The same subject as in Plate 24, but with the camera moved closer and lowered. The exposure and printing emphasize the living plants, so the tonal impression is different. No differential printing was done. Cropping was again done carefully on the ground glass, and virtually the whole negative area is shown here. This $2\frac{1}{4} \times 3\frac{1}{4}$ inch negative was on 120 size H&W Control VTE Pan film. (b) Fungus on a stump at the Botanical Garden, University of California, Berkeley (the fungus has since been removed). This is a handheld "grab shot," made quickly while leading a photo field trip. The use of a 105 mm telephoto lens compressed the spacial perspective a little. Differential printing exposure was used to print the stump slightly darker than natural, thereby giving visual emphasis to the fungus. Cropping was done in the enlarger easel during printing, and about two-thirds of the negative area is shown here. The film was 35 mm Kodak High Contrast Copy, exposed at EI 25, and developed as directed in the original H&W Control developer.

PART III

Field Photography Techniques

The first two parts of this text, for the most part, have broken down photographic technique to its constituent parts, in order to make it easier for the photographic beginner to comprehend unfamiliar material. In this part the emphasis is on the integration of systems, for the purpose of putting together the elements of photographic technique so that specific goals can be pursued in sophisticated ways. Where applicable, alternative means of accomplishing a given result will be explored, recognizing that different people will have different equipment available, and different preferences in their technical approaches.

In addition, some attention is paid to matters that are not strictly technical, but which have significance when they are associated with technique.

CHAPTER 7

Ecologically Sound Field Photography

Working outdoors is the only way to get nature and wildlife photographs of real authenticity. It is done primarily by people who have a real interest in the outdoors, and who are usually more than ordinarily aware of man's impact upon the world at large. Paradoxically, it often turns out that, of those who go into the wilds, photographers—both amateur and professional—are also among the worst offenders against nature. It seems that some are discerning and aware mostly when it is someone else who is under observation. I suppose that this attitude is related in part to the well-known urge to "get the picture" regardless of consequences, a heritage of old time working-press mores that has penetrated deeply into more generalized photographic and film making practices. Like many

other obsolete ideas, it has lived well past any period of real applicability into an era of very different standards. So it's about time someone blew the whistle, and stopped the game long enough to review the old rules and point out the need for a few new ones.

NATURE OF THE PROBLEM

Damage to nature resulting from the activities of photographers has a number of aspects, but tends to fall into several fairly simple classifications. There are those who indiscriminately scatter their empty film packages, Polaroid tabs, and spent flash cubes, as they go along their way. In order to find their spoor, just observe the slope in front of any publicized view spot. Less obvious are the few photographers who feel the need to process their films in the field, but who seldom think about the disposal of their wastes. Perhaps least thought of, and possibly the most harmful, is the damage wrought simply by people as they engage in the basic photographic procedure of taking the picture. A rule of operation frequently heard but often breached is "take nothing but pictures, leave nothing but tracks." It fits all of the foregoing problems, but requires a little elaboration for more complete understanding.

Waste Disposal

It is obvious to the point of banality that materials are no heavier to carry out of the woods than in. People do get tired, though; and besides, it is easier just to open the fingers and let something drop than it is to stow it away. And when the picture-getting urge is on, one's attention to "nonessentials" often evaporates. Unfortunately, the dropped items do not.

Film Packaging A little advance planning will cut the need for positive attention at critical moments, and for that matter, the amount of material to be stowed. For instance, film cassettes can be placed in zippered containers strung along the camera neck strap. In the process of thus preparing for the day's photography, the cardboard boxes and the individual data sheets can be left at home or at the base campsite. (One data sheet for each type of film used can be kept permanently in the gadget bag, for reference.) For emulsion identification, the end of the film box can be taped directly to the film cannister, or even to the little leather strap attached to the container.

Polaroid Wastes Polaroid Land film tabs and processing envelopes are a bigger disposal problem, both in terms of the amount of material and the size of each piece. Furthermore, some of them are coated with messy and rather caustic chemicals. Although the rumor, current in 1973, that sizeable numbers of deer, elk, and other animals were poisoned by eating Polaroid wastes is apparently not true, the wastes involved are not especially good either to eat, or to allow to percolate into the soil when rainfall washes over discarded materials. And, of course, they are decidedly unsightly. The parent company has made considerable efforts to bring the need for rational disposal to the attention of users, but not everyone has paid note.

There are two practical solutions for photographers using the Polaroid Land system for field photography. One is to change to the relatively waste-free SX-70 system. Or, if you want more flexibility of size and film types, carry a plastic-lined disposal container—*and use it.*

Flash Bulbs Another major source of litter is flash photography with flash cubes or bulbs. Paper and cardboard wastes are ultimately biodegradeable, although not readily so. Flash bulbs, being largely metal and glass, are not. A standing rule of flash bulb photography is to pick up your bulbs. My own practice is to carry a full package in one hip pocket and an empty carton in the other. When I eject a spent bulb I do it with the flash reflector pointing up and my hand over it, so that the hot ejected bulb remains in the reflector like a ball in a basin. I can then pick it up by the metal base, which is cooler than the glass envelope, and place it in the empty carton. The cardboard of the carton protects me from the nasty burning sensation that I would get from putting a newly fired bulb directly into the pocket. And if I forget and sit down, shards of glass don't pink me. In cooler weather I use the side pockets of my jacket rather than hip pockets, but the used bulbs still end up in the cartons they came out of.

If your stay in the wilds is extended, and many bulbs are used, limited recycling and a considerable reduction in bulk can be effected by carefully crunching each carton under foot, reducing the contained glass portions as nearly to powder as possible. The whole thing can then be burned. The plastic bulb-coating and the cardboard carton are consumed in the flames, and become part of your necessary cooking heat. The glass powder, usually further fragmented in the fire, mixes with the ashes mainly as silicon dioxide, a natural soil constituent. The metal parts should be sifted out, and placed with other metal wastes for subsequent carrying out.

WARNING: Do not put an uncrushed bulb in the fire, or you will get a nasty small and possibly dangerous explosion.

Other Solid Wastes Solid wastes that should be removed from the countryside when you go include depleted power cells from flash units, metal or metallized containers, and the flash bulb remnants noted above.

Wet Chemicals Those relatively few photographers who feel that they have to process films in the field in order to have a constant check on their results pose yet another problem.

Local Disposal. According to my own observations, most of these photographers just throw their wet chemicals on the ground after using them. This is a very poor policy for several reasons. The high concentration of unusual and possibly toxic chemicals is likely to kill plant life, and then remain localized in the soil to inhibit regrowth.

Local disposal is not advised, but if it must be done for small amounts of wet chemistry these chemicals should be disposed of in such a way as to keep to a minimum any possibility of damage. It can be put in places that are already apparently sterile—such as in rock clefts or sterile sandy places. Properly, the diagnosis of sterility should be left to a competent biologist. Let us say that a pint of used D-76 dumped in the middle of the Great Salt Desert is unlikely to harm much. But still, what about that tiny, obscure local life form that you didn't notice? A better method is disposal in water—but with due regard. Again, it is not advised, but if for some reason you must, there are ways that minimize the effects.

Kodak and other manufacturers have noted that since many commonly used photographic chemicals are ultimately biodegradeable, damage to the environment with these comes mainly from the oxygen demands of such degradation. Certain other chemicals are directly

detrimental to the bio-system unless oxidized prior to disposal. Still others are harmful only in that they act to encourage growth of algae and other aquatic plant life beyond normal levels, to the detriment of other life forms. Some few are just plain outright toxic. Disposal damage can be minimized or avoided by oxidizing all solutions as much as possible before discarding, and by diluting them well beyond normal use levels after processing. Fortunately, truly toxic chemicals are rarely found in the sort of solutions likely to be used in the field.

Oxidation can be promoted by letting the used solution stand for a day or so, with periodic vigorous shakings in order to aerate the liquid. The thoroughly oxidized solution then can be directly diluted by the addition of water, with further attenuation and aeration done by letting it drip or trickle slowly into copious amounts of turbulent water, at a rapid or small waterfall. Such treatment is not complete, but is better than disposal by direct, undiluted dumping. In all cases involving the field disposal of wet chemistry, be aware of the relevant laws and ordinances in your location. And do not do it at all unless quantities are small.

Evaporation. At this point I'll bet there are readers who will want to entirely avoid the foregoing field disposal methods, on the perfectly sound grounds of avoiding any possibility of local contamination. Fine. I agree. Short of carrying out all your liquid wastes, how could this be done?

The simplest method, requiring little human effort, is solar evaporation of the water, coupled with carrying out the powder residue. Place a suitably weighted square of plastic or aluminum sheet over a shallow depression, pressed down into it. Pour in a pool of developer or other waste solution, and let the sun do its work. Space and weight reduction will, in time, be

close to total, and the residual powders along with metallic wastes can easily be transported out for ultimate disposal in the environment of our industrial civilization.

Large quantities of chemicals obviously would need genuine industrial disposal methods, but such quantities are rather unlikely to be used in the field. This method should at least leave you with a clear conscience about your trip, whatever the circumstances at home.

Direct Human Damage

What about the more subtle, less tangible, effects on the environment engendered by the presence and basic photographic activities of the human intruder?

Things Under Foot. Even leaving only tracks, as advised earlier, can be damaging. Some plants—indeed, some whole small ecological communities—may be so sensitive that merely walking around can set up conditions unfavorable to their continued life. Soils compact under foot, delicate plants get crushed or abraded, insects and other small life forms get crushed. Short of hovering just off the ground, there are ways to minimize the destruction.

Know your circumstances! Learn to identify and avoid delicate life under foot. Just plain watch your step. If you have to work in areas of known ecological delicacy, as in tide pools, along shoreside bluffs, or in mountain meadows or tundra, move carefully and avoid excessive walking around. Try to repair necessary disturbances as you go (see Plates 24 and 25).

Disturbance of Faunal Habitats. In tide pools, if you turn over a rock to see what is under it, return it to its original position. Things that live under a rock cannot usually survive on top, and vice versa. By leaving it overturned you will kill

everything on both sides. On the west coast of the United States, for example, many of the richest tide pool areas are literally being studied to death by well meaning biological field trippers from schools and colleges. Failure to return the studied objects to their original circumstances is the prime killing agent. Have a care.

Other more vigorous appearing life can also suffer through the carelessness of photographers and other would-be naturalists. Nesting birds are particularly vulnerable. Many adult birds will abandon their eggs or young, if the human presence is too persistent. A tragic example is the California Condor, which cannot tolerate disturbance. It will probably become extinct by the end of this century, and one cause will have been certain persistent attempts to photograph the nesting activities. Avoid alarming adult nesting birds of any sort. If a branch is cut or propped aside to allow a camera to peer in, the temperature of the nest may get too high for sustained life, or the nest may be opened to predators. Do not cut branches. Do reposition any that you pull aside, and do not keep them pulled aside for an extended time. Realize and remember that predators such as foxes or other small mammals may track a human by scent, out of curiosity, and find a nest in the process.

It is no accident that there is rapidly increasing hostility toward wildlife photographers among the very people most directly concerned with wildlife conservation; park rangers and other conservators. Amateur and professional alike are to blame for this feeling, which limits the opportunities of those who follow. The notoriety and presumed financial rewards of wildlife filming for television and other publication, coupled with increasingly competitive markets, have led many photographers to become careless about preserving what they are photographing. (How many films have you seen in which birds or animals are relentlessly pursued, or otherwise harassed, to provide visual excitement and the illusion of conflict?) What is gained in recording something pictorially if the objects and activities being recorded die as a result?

Suggested Readings

Although elsewhere in this text I have referred readers to the general bibliography at the end, I am providing an associated reading list here, because of the special nature of the subject matter. My ability to do so is limited, because I know of nothing that is available in two of the three areas covered above. However, the photographic industry itself has become aware of many of the ecological problems of today's world, and has published a considerable amount on the subject, most particularly in the related matters of water use and chemical disposal for continuing operations. A partial list of some of the more prominent titles in this area of special concern follows:

DuPont Co. publication:

"Pollution Control of Photographic Processing Wastes", *The British Journal of Photography*, 10 November, 1972, Vol. 119, pp. 996–7, 999.

Eastman Kodak Co. publications*:

Our Share and More, #CR-5, 1971.
Disposal of Photographic-Processing Wastes, #J-28, 1973.

*These are pamphlets available at small cost upon request from the Eastman Kodak Company, Rochester, N.Y. Order by title and number, as listed above, through your photographic supplier or directly by mail from Kodak.

A Simple Waste-Treatment System for Small Volumes of Photographic-Processing Wastes, #J-43, 1971.

The Biological Treatment of Photographic Processing Effluents, #J-46, 1972.

In Support of Clean Water—Disposing of Effluents from Film Processing, Lloyd E. West, #J-44, 1972.

BOD₅—Five-Day Biochemical Oxygen Demand of Kodak Photographic Chemicals, #J-41, 1972.

Determination of Ferrocyanide in Photographic Waste Effluents, #J-40, 1972.

Recovering Silver from Photographic Materials, #J-10, 1972.

Water Conservation in Photographic Processing, Lloyd E. West, #S-39, 1971.

CHAPTER 8

Climatic Problems in Field Photography

All field photography, whether at home or abroad, involves the possibility of venturing out when the weather is in some respect hostile to photography. Conditions will vary from the relatively mild circumstances familiar to residents of temperate areas, to extremes of weather that are scarcely tolerable. The best overall reference to my knowledge is John's *Photography on Expeditions*.

TEMPERATE ZONE CONDITIONS

Nearly everyone is familiar with the normal problems of personal protection in ordinary conditions of wind and rain. (Well, there *are*

people who live where it rains so little that real familiarity with it has not been attained, and I hear that there are places in the Sahara where no significant wind has blown in twenty years.) Photographic gear must be protected even more carefully than your own body, if damage to it is to be prevented.

Precipitation

Relatively few photographers do much work in the wet, but field photographers may not have the choice. Indeed, the presence of rain may be essential to the process being recorded.

Rain　The primary problem in photography in the rain is to protect the camera. One camera, the 35 mm underwater camera called the Nikonos, can be used as is in the heaviest of rains, since it is completely sealed against moisture. But any roll film camera can be weatherproofed for these conditions quite easily, with no significant hindrance to its use.

The usual method of weatherproofing is to place the camera in an ordinary transparent plastic bag, somewhat oversized, the loose end of the bag being folded over and fastened with a rubber band. To provide a photography port, cut a hole in the bag the diameter of the lens shade. Place the shade partway through the hole, and tape it in place with water resistant plastic electrical tape. Cut a second, smaller, hole next to the eyepiece of the viewfinder, and tape the edges of the hole around the boundary of the eyeport. If much wind is expected, or spray from waves, a glass lens cover, such as a skylight filter on an optical flat, can be used to protect the camera lens, but in most circumstances the depth of the lens shade is sufficient protection. If the lens is not so protected, do not point it upwards. The plastic bag should be

loose enough to allow manipulation of all camera controls through its covering. The transparency of the plastic allows you to read the lens and shutter markings. Such protection is good against all but direct immersion. Figure 57 illustrates this setup.

There are similar commercially produced arrangements. Among these are the Spiratone Weather-All Camera Housing, a plastic bag with a lens hole cut in one side that has a gasket device for sealing around the lens mount. This is made in two sizes. With the smaller size you put both hands up into the inverted bag along with the camera. The larger one allows you to get your head and shoulders in, also. I would expect considerable stuffiness and some moisture condensation in the latter. Either could be adapted easily for use as shown in Figure 57, but you can get suitable bags free.

If a flash unit is used, it too can be protected with a similar bag arrangement. For an electronic flash, seal (with tape) an opening around the light-emitting port. For a bulb flash, seal around the reflector. Synchronization cords must enter the camera bag through a third sealed hole. Bulb flash units suitable for unprotected total immersion in water can be obtained in shops that specialize in diving equipment.

Snow　Camera protection similar to the above is recommended. If a flash unit is used next to the camera axis, snowflakes will reflect light back to the camera and the effect will be to obscure the picture. Use of a rather long extension synch cord will allow the flash unit to be held far enough to one side to lessen this effect considerably.

Mud　Any wet situation brings up the possibility of mud getting onto your hands, and from there to the camera. Be sure to avoid this or you will gum up the works. Do not set the camera

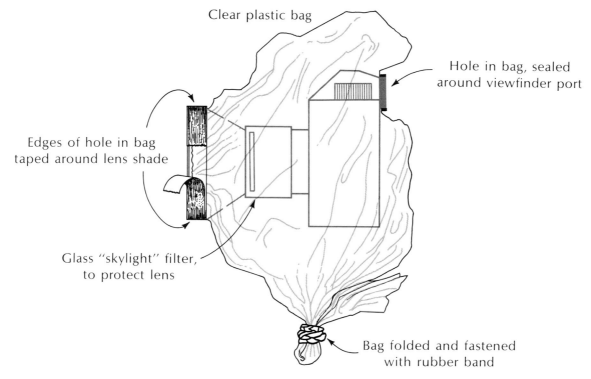

Clear plastic bag

Hole in bag, sealed
around viewfinder port

Edges of hole in bag
taped around lens shade

Glass "skylight" filter,
to protect lens

Bag folded and fastened
with rubber band

FIGURE 57
Rain-proofing a roll film camera.

down unless it is adequately protected. Caves are frequently muddy, and speleologists usually seal all photo equipment in watertight packages until the moment of use, to avoid the difficulty as much as possible. Bagging, as for work in the rain, is a good idea.

Wind

In itself, wind is usually no hazard. But, unfortunately, wind has a way of carrying things along with it.

Dust Windborne dust or sand is capable of scouring the surface of a lens in very short order. Protect the lens by using a clear or skylight filter glass over it whenever appropriate. Spiratone's

Opticap, a clear, hard, optical glass flat, is very useful here. If you are going to a desert area where windborne sand is common, you should carry two or three spares. Photography through a scoured glass surface will be poor in quality.

Sea Spray Salt spray is quite destructive to lenses and camera parts, and is not necessarily very noticeable. Any time you are photographing near the sea, and especially where there are constant onshore winds—as along the Pacific Coast of the United States—the use of a skylight filter or other clear glass port is recommended. After the day's work, the camera itself should be carefully cleaned, and the surfaces of the lens and protecting filter should be inspected for evidence of gummy salt deposits. If salt is present, it can be removed with ordinary

lens cleaners. Additionally, intermittent cleaning during the day may be needed.

Heavy spray, as when at sea in a boat or next to surf on shore, requires complete camera protection, as for rain. Underwater cameras, such as the Nikonos, may also be used. Remember that salt attacks aluminum with serious consequences. Protect tripods and other ancillary equipment, as well as the camera. If the legs of the tripod are immersed in seawater, flush them off as soon as possible with fresh water, following (if possible) with an alcohol rinse, and a thorough drying.

An unprotected camera dropped into seawater may be unsalvageable. Any attempt at washing it clean must begin at once, must be very thorough, and may still prove unsuccessful. The camera should be opened, the film removed (it will be useless to try to save it), and the whole works should be immersed sequentially in several pails of fresh water. It then should be transported to the nearest good repairman in the last bucket. Good luck. . . .

EXTREME CLIMATIC CONDITIONS

Temperatures below freezing (and especially below zero Fahrenheit), to temperatures above 80°F (27°C), or humidity over about 70 percent or under about 30 percent, all can be considered extremes of climate. Sustained use of equipment under each condition has its problems, and these increase with the combination of conditions. Basically, there are four types of climatic extremes: hot-dry, hot-wet, cold-dry, and cold-wet. (See John's *Photography on Expeditions* for a more complete exposition of this idea.) These combinations of conditions are covered, in order, in the following sections.

Hot-Dry

A sustained hot-dry condition is commonly described as a desert climate in the classic sense. It is a general characteristic of hot-dry areas that temperature drops sharply at night. This is a photographically useful phenomenon.

Film Handling The primary problem of field handling of film in hot-dry conditions is the prevention of deterioration due to heat. It is a particular problem with color films, and with black-and-white infrared emulsions, but cannot be ignored safely with any type of film. There are two ways of approaching this.

On short vehicular trips you can use a styrofoam ice chest to store all film not in actual use, both exposed and unexposed. Do not allow the film containers to get wet. Protection from wetting can be assured by using a perforated platform to hold the film above the level of the ice. Using only hand tools, a suitable platform can be cut and bent from perforated sheet aluminum, which is available in hardware stores. Or keep the ice in sealed containers. (The plastic bags in which ice is supplied in groceries nearly always leak, so I use two-pound coffee cans with snap-on plastic lids.) Refrigerated film should be taken out and the sealed package left in a shady spot to warm up for an hour before loading it into a camera. Otherwise, moisture will condense on the cold film surface when the package is opened, with detrimental results (such as causing the damp film to stick together in the camera). Keep in mind that moisture itself can be quite troublesome, so any film placed in such a cooler *must* be sealed against it.

On longer expeditions it is usually impractical to refrigerate films, so the best practice is to store all but daily-use films in the center of your dunnage. The bulk of the dunnage acts as insu-

lation. Daily-use film is taken out, and the previous day's exposed films put in, early in the morning, when the air is coolest. Backpackers can achieve somewhat similar protection by rolling up spare films in the center of a bed roll. It helps to paint any container used to store film either white or aluminum. A white bedroll cover might be good for backpackers, though it would make a significant difference only in really extreme conditions.

Dust Wind-driven dirt and dust has been covered earlier, but is not the only dust problem. Whether there is wind or not, dust gets onto cameras and lenses, and often into the works. Interchangeable camera viewfinder housings are especially penetrable by dust. The camera should be cleaned daily, using a soft, clean brush and—where practical—dry compressed air. Especially useful are pressure cans of gases such as Omit or Dust-Off. These feature a long, thin nozzle that can be placed in small corners and recesses for thorough cleaning. Do *not* blow compressed gas directly against fabric focal plane shutters, or damage may result. Lenses can be cleaned of dust with the brush and compressed gas method, too. In dry circumstances, liquid lens cleaners are seldom needed, except for removal of fingerprints. (What were you doing with your fingers on the lens anyway?)

Photography that is to be deliberately undertaken under extreme conditions of dust and wind, such as in sandstorms or near dust devils, will necessitate swathing the camera, as for work in rain. Special care must be taken to seal all bag openings, including the folded-over main opening, with carefully applied tape. A plane glass lens cover must be used, and it must be dust-tight. Cameras and similar equipment must be kept in sealed bags when you are driving open vehicles in heavy dust, as on dry dirt roads in forests. Sheet film holders should be placed in plastic bags, for protection from dust in transit. While working, if I set them down momentarily, I invert them so that dust has less tendency to settle in the light trap, and I set them down on a clean surface. Experienced field workers using large cameras usually give sheet film holders a sharp edgewise tap against the palm of their hand, just prior to inserting the holder into the camera back, in order to dislodge any dirt particles that may have settled on the film surface. Failure to do so may result in a fine speckling of transparent marks in the middle of your negative.

Static Any sort of low humidity situation tends to remove the natural residual water content from film emulsions. In hot-dry conditions, one result of this is the generation of static electricity in the film upon any movement. When the static charge arcs to a nearby surface, it will expose the film locally. The most common visual effect after development is one or more black lightning-like marks on the negative. It may also take the form of rows of tiny black specks across the width of the film, or of a single round spot surrounded by dendritic branchings similar to an aerial view of a tree. In very dry weather, there will be relatively fewer static marks with roll film cameras if the film is wound and rewound unusually slowly. Wherever you may be working, a noticeable drying of your lips is a cue to take precautions. Beware of the rapid-advance lever on your camera's film winder. It is a worthwhile technical achievement, but its rapid movement can lead to problems with static.

Of the commonly available color films, Kodachrome is said to be one of the least likely to show static marks, because it has a conducting

backing that usually bleeds off static before it can arc. But color films in general seem to have fewer static problems than black-and-white.

Sheet film holders sometimes generate static in dry weather when the dark slide is moved in or out. I've had this happen, but only when working fast in a studio. Cultivate a habit of deliberation in such movements, and you should have no problems.

The most useful reference that I know of concerning all photographic aspects of static electricity is Eisendrath's article "Some Comments On Static" (see the Bibliography), which covers far more detail than space allows here.

Hot-Wet

The classic example of hot-wet conditions is a tropical rain forest. This situation is rendered more troublesome because such conditions may persist virtually without relief for extended periods of time. Hot-wet circumstances may be encountered over lesser time periods in subtropical areas that are not necessarily forested— many Pacific islands have this problem periodically. The precautions for heat alone are the same as for hot-dry conditions, but the entry of moisture adds other problems.

Mold, Mildew, and Fungus Persistent hot-wet conditions are a made-to-order growth habitat for all sorts of molds, mildew, and fungi. I have seen leather shoes turn green in such a climate in just a few hours. Cameras, cases and covers, films, and other photographic items are similarly subject to damage. Kodak provides a good coverage of the problems and their solutions in publication C-24 (see the Bibliography).

The most effective defense is to store all sensitive equipment and materials (including exposed and developed films) in thoroughly dry places. Moisture-tight sealed containers should be used, and there should be a sack of dessicant, such as silica gel, enclosed within. Note that no dessicant has an unlimited capacity for moisture, so it must itself be renewed by periodic drying. Uncooked rice, heated at 200°F (95°C) until it is really dry, is a fairly effective dessicant, if you lack sufficient silica gel. Silica gel, however, is much more efficient, and can absorb as much as a quarter of its own weight of water.

Lack of Light Although this is often not thought of in advance, photographic work in a rain forest is sharply constrained by simple lack of light. The overmantle of vegetation shuts off access to normal skylight, and direct sunlight seldom gets through at all, so photography by natural lighting may be nearly impossible. This means that unusual numbers of power cells may be needed to keep electronic flash units going, and if you are using bulb flash you must take along plenty of bulbs. Fast films will be required for virtually all existing-light work.

Cold-Dry

Frigid desert conditions are the rule in both polar regions, as well as on most high mountains. However, remember that high altitude working conditions can move from desert dry to very wet quite rapidly, with the sudden onset of storms or of warm winds such as the Foehn or the Chinook. Cold-dry conditions bring up a whole series of unusual problems.

Other than John's *Photography On Expeditions*, which is excellent, there are several good references. These include Kodak's *Photography Under Arctic Conditions* (#C-9), published in 1966 and revised in 1973. The former has a good short bibliography. A recent supplemental publication by Kodak is called *Winter Photography—Better Pictures In The Snow*

(AC-65, 1974). See also Neider's article "Photography at the Edge of the World," and Most's article "Cold-Weather Photography" (see the Bibliography). The U.S. Navy, being responsible for logistical support of Antarctic research and other enterprises, should be considered a prime source of authoritative information on all classes of cold-related problems. Various Navy technical manuals contain useful information on cold-weather photography.

Physiological Problems Work in frigid desert conditions is frequently inhibited by sheer exhaustion brought about by exertion, exposure to cold, and—in any high mountains—by oxygen starvation due to altitude. Among the results will be physical clumsiness and a lessened ability to think clearly. In extreme cases, competent photography may be virtually impossible, as was the case with Cook on Mt. McKinley in Alaska in the early 1900s. At high altitudes, a period of rest and refreshment should precede all attempts at photography following physical exertion, if it is at all possible.

Lack of bodily warmth has a way of compelling one's attention. For myself, if my feet are cold I can scarcely think of anything else. In 1971 Eisendrath did a three-part article on cold weather photography in the magazine *Photo Methods for Industry* (see the Bibliography), in which he devoted the first two installments to clothing. He suggests as basic outwear a goose-down parka with a moisture-resistant ruff about the face, this to be coupled with down-filled under- or overpants. Under the parka should be a wool shirt, and beneath all, Duofold underwear—which has a woolen outside with a cotton inner lining. In extreme circumstances additional down underwear may be needed. Obviously, this is an area requiring really expert advice, and I urge that if you are going to really frigid places for the first time you seek it from people with much greater experience than mine.

A constant problem in really cold weather photography is the fact that bare skin may instantly freeze to any exposed metal surface. Various authorities recommend that exposed metal on the camera back should be covered with rubber foam or even cloth tape, to protect the facial skin while viewing and composing. Hands should never be completely bare. Fingertip skin may freeze to the camera's exposed metalwork while shutter and diaphragm adjustments are being made. Always wear at least a thin silk glove.

WARNING: A cold camera is a heat sink. Being highly conductive it may cause your fingers to freeze at contact points, even though your silk gloves prevent an actual sticking of the skin.

Equipment and Material Problems The basic selection of equipment for cold-dry weather starts with the camera. Recent writers, such as Most, have recommended the use of mechanically simple cameras, such as the Leica rangefinder model. Single lens reflex cameras are too complex, with too many moving parts that can hang up. Mirrors stick, cloth focal plane shutters freeze and break, automatic diaphragm mechanisms freeze wide open, etc. Press-type cameras are subject to jamming of their focusing tracks, either by the differential contraction of bimetallic contacts, or by the freezing of introduced moisture (such as your breath). Bellows may also freeze and crack. Roll films freeze, and then break when the film is wound. I know of no perfect cold weather camera. You must exercise constant vigilance if you are to do consistent, good photography in frigid places.

Cameras for use in polar-type regions usually require careful winterizing by a competent worker. This includes the removal of all normal lubricants (since their viscosity increases greatly

at low temperatures) and their replacement with special low temperature materials. Actual machining of some parts may also be necessary.

Electrical power cells suffer a great reduction of power output when temperatures go really low. Since fresh batteries do better than partly depleted ones, it is desirable to start each session with cells that are as fresh as possible, and to keep them warm for as long as possible. Wherever it is practical, use equipment with separate power packs that can be kept inside your clothing. Kodak (in their publication AC-65) notes that alkaline cells are preferable to the common zinc-carbon cells; and that for cold weather work, PX-13 cells, which are often used to power light meters and cameras, should be replaced by PX-625 cells. Keeping spare power cells in a warm pocket is also advised.

Flexible wiring and synchronization cords will lose their malleability at low temperatures, and may snap when they are flexed. Initially, the breaks may be internal and not immediately affect the insulation material, so an operational failure may not be noticed until it is too late. Watch for the possibility of breakage, and try to avoid it by reducing the need for the flexing of wires, as much as possible.

There are two basic schools of thought concerning cold weather photo technique: the "always warm" and the "always cold" groups. In the former, the method of avoiding difficulties is to keep all your equipment inside your clothing until the last moment, and then take it out, expose as expeditiously as possible, and get it back in before it freezes. I tend to prefer this method. The other way of working is to keep your camera at outside temperature at all times. It is stored in an unheated area, and is never warmed. Film is loaded and unloaded outside. The biggest difficulty here is that the residual water in the film emulsion freezes and makes the film brittle. It then snaps when advanced in

a roll film camera. Therefore, the "always cold" system works best with sheet film cameras (film being loaded and unloaded in a bag, or the holders taken in and out for loading). Both methods reduce the problems of intermittent warming and cooling. The "always warm" method makes winterizing of the camera less important, perhaps even unnecessary, though any accidental cooling could get you in trouble.

In so far as possible, it is a good idea to use manual equipment, rather than electrically operated items, because of the low temperature battery failure problem. Spring-wound cine cameras, though generally less desirable than powered models, may offer significant advantages in the cold. For flash photography, the percussion-fired Magicubes may be superior to electrically fired flash cubes, if power cells are very cold. Until recently, Kodak offered a generator flash gun, in which spinning a knob acted to charge a capacitor that, in turn, provided the power to fire the flash bulb. If you can locate one of these, it could have significant cold weather utility. In fact, it could be useful in any extended field photography situation.

Static As with hot-dry conditions, cold-dry circumstances introduce static problems. Roll films should be advanced slowly, and sheet film holder dark slides should be operated with deliberate speed.

Condensation The condensation of moisture can be a major cold weather difficulty. An "always cold" camera that is taken into a warm room will instantly be covered with condensation that will freeze upon formation, and which cannot be removed until the camera warms up. With any camera that is used outdoors at low temperatures, should you be so unwise as to blow on the lens to remove dust or lint (very likely to be present on cameras that

are kept inside your clothing) the lens will frost over. It must then be warmed for cleaning. So, many normal working methods simply cannot be used in polar conditions. Be careful not to breathe on the viewfinder port, or a similar frosting will result. In fact, whenever it is possible, avoid exhaling while viewing, or your breath may be forced up behind the camera and across the viewfinder port. Even in much less severe circumstances, the resulting condensation is at least a nuisance.

Color Temperature In polar regions, the use of color film may present problems, due to a double anomaly concerning color temperature. Very cold color film exhibits a slight drop in color temperature. In addition, when the sun never rises to the zenith the daylight does not rise to a "normal" color temperature, because the light is filtered at a shallow angle through a great mass of potentially obscuring atmosphere. The average daylight color temperature will be in the neighborhood of 4800°K, instead of the 5500°K that daylight films are balanced for. Light under these conditions is already dim, and corrective filtration may get you into exposure problems because of the filter factor. Therefore, the slower color films are not recommended.

As an example of the foregoing, I recently saw a color photograph of penguins, made on the Antarctic shelf. Both the white breasts of the birds and the snow had reproduced as the orange-yellow color characteristic of lowered color temperature.

Cold-Wet

By definition, cold-wet circumstances do not involve temperatures below freezing. The basic working range falls between about 32–50°F (0–10°C). These conditions occur most particu-larly in two very different habitats, in caves and underwater. (Ordinary cold rain can be considered as just another rain situation; see the applicable earlier section.)

Caves The primary problems here are dirt and mud as contaminants, camera damage from impact, and wetness as a condition so pervasive as to entail a degree of exhaustion of the photographer from physical exposure.

The purely photographic problems are those of protecting your equipment from impact shocks, general dirtiness, and from the shorting out of electrical equipment. Because they have traditionally been more easily shorted out, electronic flash units have been considered less desirable than bulb flash. Today's solid state units are much less troublesome in this way. It has been several years since I have seen a significant shorting problem while leading a field trip, though prior to that it was a common problem. However, the power of an electronic flash unit is directly related to its weight and size. Since cave photography frequently requires a large light output, flash bulbs are still the better choice.

Great care must be exercised to protect the camera from dirt, mud, and impact. It is recommended that they be packed carefully in sealed packages that are padded against shock damage from bumping against floors, walls, and ceilings when in tight circumstances. Some cavers prefer to carry photo equipment in padded, gasketed aluminum cases, capable of resisting total water immersion. This makes good sense, and allows for easy access.

Operations in caves involve many physical hazards, and should not be lightly undertaken, without expert advice and participation. As a first reference, see Halliday's excellent text, *American Caves and Caving.* Then be sure to team up with a party of experienced speleolo-

gists. Solo expeditions, and parties made up entirely of inexperienced people, are open invitations to disaster. Especially dangerous are underwater excursions into submerged caves. Even extensively experienced divers are likely to get into serious trouble (or die), if they do not get specialized instruction and assistance.

See Bögli and Franke's *Luminous Darkness* for unusually fine examples of cave photographs. This book includes useful photographic notes.

Both references are described in more detail in the Bibliography.

Underwater This is a special field with innumerable technical requirements all its own. Since I cannot even swim, I do not feel qualified to remark on it, except to pass on my recommendation for what I believe to be the best book on the subject: Mertens' *In-water Photography*.

High Resolution 35 mm Technique

The standard photographic materials and techniques of 35 mm photography do not suffice when unusual demands for the resolution of fine detail are present. It is necessary to go to some lengths to take full advantage of the existing technology in field photography, and this requires an integrated systems approach. No part of the technology is especially difficult, but all of it must be done with great care if the ultimate in quality is to be achieved.

PURPOSES

There is no particular point in going into specialized high resolution technique, unless unusual demands are being made. For general photography, quality needs are met quite adequately by simple adherence to standard practices, using ordinarily available materials. It is

only when extraordinary resolution is required for the given job that special solutions must be sought.

Extreme Enlargements, Small Portions of Negatives

It is sometimes necessary to do very great enlargements of quite small portions of negatives, enlargements of from 25 to 75 times the negative magnification, in order to exceed the basic image magnification ability of the camera equipment in use. The subject matter might range from distant nesting birds to extreme closeups of tiny plants or insects. What the subject matter is makes less difference than how it must be treated. The important point is to avoid all unnecessary loss of detail (see Plates 25, 26, 27, 28, and 32).

Very Large Prints

For wall display at meetings, in classrooms, or in museums, there is a fairly frequent need for very large prints, using a major portion or all of a 35 mm negative. At the same time it might well be necessary to maintain a high level of print quality. With presently available equipment and materials it is quite possible to make prints as large as 6 × 9 feet before the image quality deteriorates to the point of being noticeable, provided that the negative is conceived from the outset as needing this treatment.

EQUIPMENT AND MATERIALS

Quite obviously, not just any equipment and materials will serve these extreme needs. Both must be of very high quality.

Lenses

Most lenses found on good 35 mm cameras today are capable of resolving much finer detail than are the films commonly in use, at least in the center of the field. Most lenses produce much better resolution in the center of the image than at the edge or in the frame corners, because of residual optical aberrations. The most obvious of these are coma (in which points of off-axis image detail are rendered as short lines radiating out from the image center), and curvature of field (a rendering of the image as a portion of a sphere, so that if the center is sharp the frame edges are not, and vice versa). There are other lens defects, and for more information about them, see the Bibliography. The main point is that it is necessary to use well made lenses, in order to avoid as many aberra-

PLATE 26 ▶

High resolution technique. Scarlet pimpernel (*Anagallis arvensis*), photographed by closeup flash technique on Kodak Panatomic-X film, processed as directed in Microdol-X and enlarged in printing to ×15 image magnification. (a) The negative magnification was ×1, with a fifteen times print enlargement. The false appearance of sharpness is due to the presence of well-resolved grain in the film emulsion. (b) The negative magnification was ×3 (using the same camera setup as above, but with a 3× tele-converter added), with a five times print enlargement. Although the initial impression is one of less sharpness, a close comparison with (a) will show that much more subject detail has been resolved here. The depth of field is slightly less because of the increased basic magnification, but the loss is not serious. The use of the tele-converter has raised the magnification of fine subject detail into a size range at which less enlargement in printing is needed, and so the film grain is not noticeably affecting it. Panatomic-X, although it is fine for general photography, is not a high resolution film that is capable of great enlargement without loss of detail due to grain.

a

b

tion problems as possible. Not all expensive lenses are substantially free of problems, and not all less expensive lenses are poorer. It may well come down to individual testing. I would like to emphasize that for general photography most lenses now made are entirely adequate. But here we are talking about tough circumstances.

For closeup photography, the best of today's lenses are the macro-type lenses, such as Nikon's Micro-Nikkor, Minolta's Macro-Rokkor, and the Pentax Macro-Takumar. These lenses (and others of similar design) are very sharp, have unusual flatness of field, and are unusually free of general aberrations. Often, they are also a bit slower than other lenses of similar focal length, having maximum apertures of f/2.5 to f/3.5. It is best to avoid extremely fast normal focal length lenses for high resolution work, because it is more difficult to correct them in manufacture. For telephoto work, it is truly a matter for testing. I have seen considerable variation among different individual lenses of one of the most prestigious makers. My best quality telephoto lens is an f/2.5 105 mm Auto-Nikkor, and I feel free to recommend it particularly, because every one that I have seen was superb. Unfortunately, it is not a very long focal length. In any case, with very long telephoto lenses the biggest problem is not so much lens quality as it is camera handling. (See the section on telephotography.)

Films

Even the slowest and best of general-use films, such as Kodak's Panatomic-X or Agfa's KB-14, though entirely satisfactory for general photography, are not suitable for really high resolution work. It is necessary to go to the high contrast films used primarily for document photography. These panchromatic films include Kodak High Contrast Copy, Fuji Microfile, Agfa Gevaert Microfilm, and two H & W films, VTE Pan and VTE Ultra Pan. At this writing I know of no color films that offer the high resolution capabilities of black-and-white.

Some of the films just listed are available in 36 exposure cassettes. Others must be hand loaded from 100 foot rolls. Bulk loading, as this is called, is simple. The cost of the loader will be made up by savings in bulk purchases in the first 100 foot roll used. I bulk load the majority of my black-and-white 35 mm film.

The prime beneficial characteristic of these films is their extremely fine grain. The main reason why general films have less resolving power than these is that the finest details of the image structure gets lost in a welter of grain structure in the emulsion. Unfortunately, very fine film grain is associated with high contrast and narrow exposure latitude. Therefore, very special development is called for.

PLATE 27 ▶

High resolution technique. Praying Mantis (*Tenodera aridifolia sinensis*), photographed by closeup flash on H&W VTE Ultra Pan film, and processed as directed in H&W Control 4.5 developer. The Micro-Nikkor lens was set for an image magnification of $\times\frac{1}{2}$; the white bar equals one millimeter. (a) About two-thirds of the negative, printed by projection on Kodabromide F-4 paper, with contrast and exposure adjusted to give good overall visibility. (b) Further enlargement of the head, using the same negative, and with the same print contrast and tonality. (c) As above, but printed on Agfa Brovira 6 paper. The H&W Company recommends that when printing details at very high magnification a higher contrast paper be used for best results, as was done here. In addition, it has been printed lighter, to show the mouth parts to best advantage. Enlargement in printing of these insets was about $\times18$, and there is no sign of image degradation. They could have been printed considerably larger.

a

b

c

Chemistry

There are quite a number of developer formulas in the literature that will considerably lower negative contrast. However, these are not without their difficulties. Most cause reduction of film speed; not all are capable of sufficient contrast reduction for present purposes; and, some are short-development-time mixes that introduce agitation problems. The most effective developers for this purpose all seem to involve the Ilford chemical Phenidone (a registered Ilford trade name for 1-phenyl-3-pyrazolidone). Phenidone is made in several closely related forms, the one to be used in the formulas provided is Phenidone-A, a form that mixes readily with water.

The best known commercial developer in this class is H & W Control 4.5 Developer (available in some stores, and by mail from The H & W Company, Box 332, St. Johnsbury, Vermont, 05819). Used with great care, this developer can produce the highest quality negatives I have ever seen, on any of the films listed above. This developer, with the "4.5" designation on the box, should not be confused with the older H & W Control developer. That formulation was consistently underrated in the photographic press, although it was capable of remarkable results, if properly used. Some users did not like its rather long development time, its tendency to block up highlights unpleasantly (unless exposure was extremely precise), or the fact that oxidation in storage was a problem. Others apparently just did not follow the directions carefully enough—and any deviation from them could be most unfortunate.

These faults have been eliminated in H & W Control 4.5, so the exposure and development procedure is much less tricky. Development time has been reduced to a moderate $4\frac{1}{2}$ minutes at 68°F. (Times for other temperatures are also listed in the packaging.) The tonal range has been increased, and the tendency to highlight blocking has been eliminated. In its most convenient form the solution is supplied in sealed vials, each sufficient to process one roll of 35 mm film. Thus, the earlier tendency to deteriorate through oxidation in storage has been erased. Meanwhile, the good qualities of the earlier product have been retained.

I recommend using an exposure index* of 10 for High Contrast Copy, Fuji Microfile, or H & W VTE Ultra Pan, and an exposure index of 32–40 for H & W VTE Pan (nominally rated at 80 by the distributor). You can enlarge negatives from these films 50 to 60 times before you get the grain appearance of Panatomic-X enlarged 12-15 times. The tonal reproduction range is fully the equal of that of Panatomic-X, and (when carefully made) the negatives are of superb quality.

* Exposure index (E.I.) is a film speed rating based upon appearance of the negative rather than upon the type of testing used to establish ASA speeds.

PLATE 28 ▶

High resolution technique. Bird Island at Point Lobos State Reserve, near Carmel, California, showing cormorants (*Phalacrocorax penicillatus*) and brown pelicans (*Pelicanus occidentalus*), photographed with a 105 mm telephoto lens from the mainland several hundred feet away. The film used was 35 mm H&W Control VTE Pan, a moderately high resolution emulsion, exposed at E.I. 50, and developed as directed in the original H&W Control developer. (a) The whole negative, at ×4.2 enlargement. (b) The center portion of the same negative enlarged to ×27, showing the postures and gross feather detail of the main group of brown pelicans (and two cormorants). Further enlargement would be useless, because of atmospheric limitations. With this film, emulsion grain begins to cut into lens resolution at about 30–40 times enlargement. Finer-grained films, such as Kodak High Contrast Copy or H&W Control VTE Ultra Pan, exposed at E.I. 8–10 and processed in H&W Control 4.5 developer, would give distinctly improved enlargeability, if atmospherics did not limit basic image resolution.

For those who prefer to mix their own developers, there is a very simple formula, using only Phenidone and sodium sulfite, listed in Dignan. (See the Bibliography–"Extended Range Developer For High Contrast Copy Films," by Vance, p. 20–22 of *Dignan's Simplified Chemical Formulas*. This is the same formula published earlier by M. Levy in the more general article, "Wide Latitude Photography.") This formula requires an exposure index of 10 for High Contrast Copy film: nominally ASA 64, when it is used for fine line copying purposes. (I consider Kodak's own speed rating too high, even when used as originally intended; it should be about 20).

Another Phenidone formula, based on one that has been making the rounds here and there, was supplied to me by Charles Collins, and he jokingly calls it the Collins Two-Step:

THE COLLINS TWO-STEP

Solution A

350 cc water (preferably distilled), at 125°F
2 grams Phenidone-A
37.5 grams sodium sulfite, dessicated
4 grams potassium bromide
1 gram sodium carbonate
Water to make 500 cc

Solution B

500 cc water
20 grams sodium carbonate

To Use

1. Mix 1 part each of A and B with 2 parts water.
2. Develop Kodak High Contrast Copy film for 9-10 minutes at 68°F (20°C), agitating gently for 5 seconds per minute.

Collins reports good shelf life, and says that the dry chemicals can be pre-mixed and then added to water when it is convenient. One report says that this mixture causes some film speed decrease and brings some grain structure increase, compared to H & W Control 4.5 developer used as directed.

A second recommendation for a commercial developer to use with the films listed is ēthol T.E.C.®, a compensating developer for thin emulsion films, which differs from the previously described formulations in that it is not Phenidone based: ēthol T.E.C. is billed as a very high accutance developer particularly useful for retaining highlight detail, while providing good shadow detail. The manufacturer lists development recommendations for a wide variety of films. I have excerpted from this listing a series of recommendations for developing high resolution films, which are summarized in Table 22.

TECHNIQUE

The technique of high resolution 35 mm field photography includes three areas: camera handling, film processing, and printing. These are described in sequence.

Camera Technique

If the best possible results are to be obtained, the camera must be much more carefully used than is normally the case.

Vibration and Movement Control Extreme enlargement of the negative is somewhat analogous to the use of high magnification setups or telephoto lenses. The effect of any vibration or other movement of the camera becomes immediately visible in the print. Therefore, it is necessary to exercise extreme care to avoid this problem. There are several sources of difficulty.

TABLE 22
Developing recommendations for ēthol T.E.C.

FILM	RECOMMENDED E.I.[a]		FORMAT	DILU-TION[b]	DEVELOPING TIME (IN MINUTES)		
	DAYLIGHT	TUNGSTEN			65°F	70°F	80°F
Kodak High Contrast Copy Film	8	6	35 mm	1:30	5.25	5	4.5
Kodak Photomicrography Monochrome Film	80	80	35 mm	1:30	—	7	—
H & W VTE Ultra Pan	25	20	35 mm	1:45	23.5	20	14.5
H & W VTE Pan	80	64	35 mm	1:30	—	10	9
H & W VTE Pan	50	50	120	1:45	—	10	—

[a] Recommended exposure index is not necessarily the same as the manufacturer's stated ASA film speed.
[b] First figure is developer concentrate, the second is water.

Most focal plane camera shutters operate rather like roller window shades. The gear trains that operate them set up small vibrations in the whole camera. Under stringent circumstances these can adversely affect the recorded image. The effect is of general unsharpness, with a minute streaking, usually along the long dimension of the film (across the film, if that is the direction of shutter travel). Some cameras have one or more particular shutter speeds at which vibration is at its worst. With my Nikon F, that speed is 1/15 second.

Single lens reflex cameras are also subject to the phenomenon called "mirror flop." This is caused by the inertial forces acting on the internal moving mirror during its sudden starts and stops, and the effect is of a streaked or even a distinct doubled image, across the narrow dimension of the film. There is little or no problem at high shutter speeds, but it becomes more of a problem as the shutter speed is slowed down. Again, my Nikon F is at its worst at 1/15 second. It is possible to damp one of these vibration sources without materially affecting the other. The solution usually listed in the literature is to fasten down the camera to the sturdiest available tripod, and then use a cable release to operate the shutter. Unfortunately, currently popular metal tripods are at least as likely to resonate with vibrations as they are to damp them (see Plate 29).

For telephoto work using lenses with focal lengths not much longer than 300 mm, the best solution that I have found for the damping of internal vibrations in cameras is to use your own hands as absorbers, using a special method of camera holding. Fasten the camera to the tripod normally, but leave the pan and tilt head loose. The camera body is then held in both hands, so that the fleshy pads at the bases of your thumbs are pressed against the camera back at both ends, with your fingers gripping firmly around the ends of the camera. Your right forefinger and thumb are available to operate the shutter release and the film advance, respectively, without changing the general hand position. (Very few cameras are so constructed as to allow left-handed operation.) This handling method allows a free movement of the camera for following subject motion, but serves both

to steady the camera and to absorb its internal vibrations.

When using very long focal length telephoto lenses I prefer a different method of handling. When using lenses of from 500 to 1200 mm in focal length, place a sandbag on the tripod head. (Make a wooden platform for this purpose, if necessary, using a 1/4-20 tee nut as a tripod socket.) Make a groove in the sandbag with your hand, and set the lens in that groove. Then, to add mass, place a second sandbag, saddlebag fashion, over the top of the lens tube. Most very long lenses, especially mirror lenses, are quite light and very much need the extra mass. The lens and camera are thus not actually screwed down to the tripod at all, but the weight and the method of placement keep them quite firmly positioned. A cable release should be used to trip the shutter, to prevent transfering body vibrations to the camera. Some following of subject motion is possible, without introduction of body vibrations, if you grip the end of the camera lightly with the fingertips of one hand. But it is best, where possible, simply to position the camera correctly, focus it accurately, and then take your hands completely off it while using the cable release to expose.

The third problem is plain old camera movement. This accounts for the majority of unsharp pictures, even under normal photographic conditions. If the tripod is to be used, the method just described takes care of gross movement. However, you must be careful to follow any subject movement smoothly, and to avoid excessive general swivelling around.

For careful handheld closeup flash photography, operating at image magnifications of from $\times 2$ to $\times 6$, you hold the camera one-handedly, as usual, so that the other hand can hold the flash unit. It is useful to use some sort of front rest under the lens mount, if it is available and to do so is practical. Otherwise, since

the flash distances will be very short, press the thumb of the flash-holding hand against the side of the lens mount, to act as a steadying influence.

For other types of handheld camera work, where you have no tripod or other support available, or where it would be impractical to use one, you must work out a way of camera holding that offers maximum control of the camera. With my Nikon F, a type frequently used these days, this involves placing the bottom of the camera on the upturned palm of the left hand, so that the left thumb and forefinger can operate the focusing ring and the diaphragm control. With the hand in this position, the left elbow is forced down and forward so that it acts directly as a weight carrying support. The right hand grips the right end of the body of the camera, with the thumb pointing straight up and the three outer fingers anchored around the end to the self-timer on the camera front. (I have yet to use it as a self-timer, but it is well placed to serve as a gripping point.) The right forefinger is left free to operate the shutter release or the preview button, while the right thumb can operate the film advance without loss of grip. Both elbows should be a little away

PLATE 29 ▶

High resolution technique. A classic demonstration of "mirror flop" vibration effects. These are $\times 15$ enlargements of the centers of two negatives. (a) Nikon F camera at 1/15 second, reflex mirror in operation, camera on a heavy tripod (Davis & Sanford Model B), 105 mm Nikkor lens with a $3\times$ tele-converter. At this shutter speed the mirror flop effect is at its most obvious, and is rendered here as a double image. (b) Same setup, adjacent film frame, also at 1/15 second, but with the reflex mirror locked up. It is not always practical to lock the mirror up, but the text describes ways to hold the camera so that vibration effects are minimized.

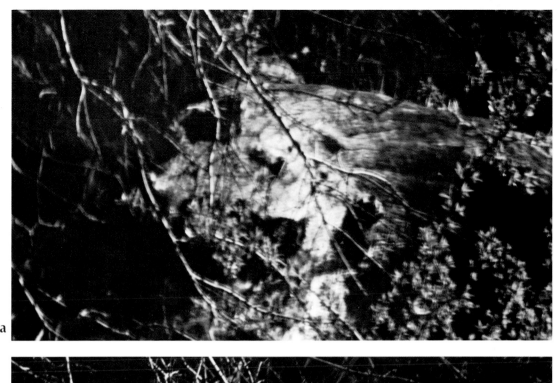

from the body, so as to avoid picking up and transmitting internal body movements and vibrations from the heart and lungs. Your feet should be somewhat spread apart and firmly set.

At the moment approaching exposure take in a normal breath; let out part of it, and hold the rest while the right forefinger *squeezes* the shutter release. Avoid an unduly abrupt shutter release by taking up the slack in advance. Then the pressure need only be slightly increased to accomplish the actual release. This shutter release method is no handicap in catching peak action. Subject motion can be followed by swivelling your body at the hips and shoulders. When following subject motion by swivelling your body, it is best to start with the body "wound up" and then swivel to a looser position. If you start loose and move so as to tighten up, you will find yourself becoming tense, and probably shaky, just as the shutter release point is being reached.*

Focusing Because enlargement from the negative will be so great, the focusing of the image must be done with the utmost care. Any type of eyepiece focusing device will work if it is properly adjusted. Split-image range finders, overlapping-image finders, micro-grids; they all work. But when I have a choice, I prefer a plain ground glass because it does not obscure any slightest part of the image. And many cameras do offer a choice.

The usual technique for careful focusing is to repeatedly focus back and forth through the intended plane of greatest sharpness, narrowing the range of movement until exact focus is obtained. If in doubt, repeat. The problem is less with high image magnification, because the depth of field with the lens aperture open is so very slight that little remains in doubt. The

*This is an old professional trick called to my attention by Zev Pressman—and it works!

chosen point is either sharp, or it is scarcely visible. Closing the aperture to the previously chosen f-stop takes care of the rest. For telephoto work, with lenses that are so short in focal length that a great enlargement in printing the negative is needed to bring the image up to size, there may also be a real need to use the widest practical aperture for exposure purposes to get the best image resolution. At the same time, the desired main image point may be so small that it is hard to tell if it is sharp or not. Care is required. Focusing will be aided, in this kind of telephoto work, by buying and using an auxiliary focusing magnifier that attaches to the eyepiece of the camera's prism housing. (See your dealer's listings, or see Spiratone's ads in camera magazines. Spiratone purveys a device that offers a considerable magnification of the center of the ground glass image, is adjustable for differences in individual's eyes, is hinged to swing away and allow whole-image viewing, can be fitted to many makes of cameras, and is usable separately as a 2.5 X 12 telescope, either visually or as an emergency auxiliary photographic device).

An additional problem may sometimes exist in the basic accuracy of the individual camera's focusing adjustment. With single lens reflex cameras, the lens to ground glass distance does not necessarily correspond exactly with the lens to film plane distance. In particular, it is wise to doubt the accuracy of "infinity" focus, and especially if you use telephoto lenses made by other than the camera manufacturer. They often are made so that they can focus slightly beyond infinity in order to be sure of being able to reach it on different makes and models of cameras. If in doubt, have the camera and lens checked by a competent camera repairman.

Exposure Accuracy One of the characteristics of high contrast films is narrowness of exposure

latitude. Put another way, the higher the contrast of the film, the more accurately it must be exposed, if shadow detail is not to be lost, or highlight areas blocked up. Unfortunately, lowering the negative contrast in development does not affect the basic film exposure latitude. Therefore, it is desirable to know your exposure technique very well.

Whenever it is practical, when using high contrast films, I bracket exposures over a range of five shots, in increments of $\frac{1}{2}$ stop. With the center shot at the calculated correct exposure, I then have a range of one full stop over and under to choose from. This takes into account any variations from the ideal in exposure reading circumstances. For flash exposures, I vary the flash distance over successive exposures; or if the exposure is a one-time deal because of circumstances, I adjust flash distance according to my estimate of the subject's brightness. With white subjects I lengthen flash distance by about 25 percent, and with dark subjects I shorten it about 25 percent (approximately a one-stop change over normal).

Film Processing Technique

In this section I deal primarily with H & W developer, which is the developer I have used most in this context. However, most of what is said (in terms of technique, rather than specific times and dilutions) can be assumed to be accurate for most other developers of the Phenidone-based group. The basic processing technique *must* follow the manufacturer's directions throughout. Refer, first of all, to those instructions.

Freshness of Chemicals This is a must with the Phenidone-based developers that have been listed. One of the prime difficulties in using these developers is their extreme affinity for combining with oxygen, with consequent loss of effectiveness. Therefore, a list of working rules is in order:

1. Do *not* mix a stock solution from H & W Control 4.5 developer concentrate in the expectation that it can be stored before use (see Plate 18, b).

2. Do *not* dilute the concentrate (or even open the concentrate bottle) until the film is loaded into the tank and all else is ready for action. If you mix it and then spend 20 minutes on the phone, it may well be useless when you get back.

3. Do *not* store unused concentrate in partially filled bottles containing air. Instead, do one of the following:

 a. decant it into smaller bottles, full to the top;
 b. cause the concentrate to rise to the lip of the bottle by dropping in *clean* glass beads;
 c. use a pressure can of inert gas, such as Prolong, to replace the air in the concentrate bottle; or
 d. more simply, use the commercially available six-packs of single-roll vials.

4. Do not, in any case, use a plastic container of any sort to store any phenidone-based developer because enough molecular oxygen passes through most plastics to cause problems with this active chemical. (The original H & W Control developer was provided in plastic bottles, and this required a change to glass.)

Agitation Agitation during processing should be gentle, and be done by tank inversion. Do it exactly as recommended by the developer manufacturer. This usually amounts to an initial

agitation period of ten seconds (five slow inversion-and-return cycles), followed by six seconds (three cycles) at each succeeding 30 seconds. See your instruction sheet for up-to-date information. Do not overagitate any 35 mm film, or there will be turbulence marks near sprocket holes, as well as other effects due to uneven development.

Streaking The most likely problem, but one that actually occurs rather seldom, is the appearance of amorphous dark streaks across large heavily exposed areas (such as the sky).

If you fear that these streaks may show up because of the types of pictures you have made, do not just pour out the developer at the end of the cycle, as is usual. Instead, add 4 milliliters of 28 percent acetic acid per 8 ounces to the developer in the tank, replace the tank cap and agitate by repeated gentle inversion for ten seconds. (To use a one-roll vial, just emptied in mixing the H & W Control 4.5 developer, as a milliliter graduate, fill it up to a line between the word "develop" and the phrase "one roll of" on the labelling, and you will have 4 ml.) Then pour out and proceed normally. This procedure generates gas in the process of converting the developer into its own mild stop bath—just hold the tank cap in place loosely, and the gas will vent readily. Fix and wash normally.

The streaking is caused by instantaneous oxidation from exposure to air in between development and fixing. In negatives not having large heavily exposed areas no such streaking will appear at all.

Printing Technique

The special aspects of printing technique come about because of the unusually thin base support material, and because of the frequent need for extremes of enlargement.

Negative Selection If only one exposure was made, as with nonrepetitive events, there is no selection problem. You use what you get. But if exposures were bracketed in order to insure the optimum exposure level, you must select the right one for printing or you will not get optimum quality.

Choosing the best negative from a given series is initiated by deciding what will be the most important tonal areas to be printed. If the highlights contain most of the pictorial interest, it will be appropriate to forget about detail in the shadow areas. On the other hand, if shadow detail is of the highest importance, you may have to accept some loss of contrast in highlight areas. In the former case, a slightly underexposed negative should be chosen; in the latter, a minor overexposure might be best. In most cases, however, a generally good overall exposure is needed. The negative strip is examined, preferably on a light box, and the most printable negative will be that one of the series with the most contrast in highlight areas consistent with adequate shadow detail. This may well be the center exposure, the one that was calculated as being correct. Or it may be the one on either side.

Enlarger Problems Enlarging negatives made for these high resolution purposes requires little other than normal printing skills. But these skills must be exercised with greater than normal care because of the unusual degree of print magnification.

Negative Holding. The very thinness of the negative stock is a problem, in that it is excessively subject to "popping" in some enlargers.

Heat causes the center of the negative to bulge up, and perhaps even to move slowly up and down. Getting and maintaining a good focus then becomes nearly impossible. The degree to which this is a problem depends upon the cooling efficiency of the enlarger lamp house. My present enlarger, a Prinz Craftsman, gives no difficulty; but the enlarger I used formerly—although it was of generally similar construction—caused nearly constant problems of this sort.

If your enlarger produces this effect, there are two immediately practical solutions. When you are going to use only a portion of the negative, sandwich it in a glassless negative carrier designed for a smaller film format. There are three standard glassless carrier types with openings smaller than the usual 35 mm (24 × 36 mm) camera frame size, available for enlargers such as the popular Simmon Omega series. These are single-frame, half-frame, and Minox size, in order of diminishing dimensions (18 × 24, 12 × 17, and 8 × 11 mm, respectively). You may have to remove the locating pins used to position the intended smaller films, but this is easy. The use of a smaller opening in the negative carrier will restrict the size of negative material available for popping, and thereby limit the amount of displacement that can occur. This usually solves the problem.

Should you need to make a large print of the whole negative area, however, the foregoing method will not serve. You should then use a glassed negative carrier. The obvious disadvantage is that you will have six surfaces to keep free of dust, instead of just the two of the film itself. The method does work, though. I have used two standard microscope slides as cover glasses (in 1 × 3 or 2 × 3 inch sizes). They are of convenient sizes, and are made of good quality glass.

Lens Choice. Normal enlarger lenses, even those of the best makes, are not designed for high magnification enlarging. Therefore, they usually do it rather poorly. However, probably the clearest exception to this statement is the Leitz 35 mm f/3.5 Summaron.

My own best results have come through using two camera lenses, the 35 mm PC-Nikkor (centered), and the generally magnificent 55 mm Micro-Nikkor. Adaptors for using these and other makes of camera lenses on enlargers are available commercially. Unfortunately, not all enlargers are big enough at the lens mount position to accept these lenses. Almost any well made macro-type lens designed for camera use should be a very good enlarger lens. The flatness of field (my Micro-Nikkor throws a flatter image than any enlarger lens that I have seen at any price), the correction for the right degree of enlargement, the generally good optical quality—all of these things are badly needed in enlarging lenses. The PC-Nikkor, though designed as a laterally shifting lens for architectural photography, is of very fine quality, and offers an unusually large circle of flat field when used centered. Image resolution is excellent, being best at about f/8, and there are no significant optical aberrations.

For extreme magnifications of small portions of negatives I have used Zeiss Luminar photomacrographic lenses very successfully, particularly the 16 mm focal length. Since normal enlarger condensers are not designed for such short focal lengths, supplementary condensers are needed. Probably the simplest method of operation for really high magnification enlarging, when the desired print size is not too big, is to set up a large-negative photomacrographic camera, at the correct magnification. The negative, emulsion side up in a suitable carrier, is placed in the subject position, and enlarging

paper is placed in the sheet film holder for exposure. The image is focused as usual, on the camera's ground glass screen. Underneath and very close to the negative is a simple plano-convex lens (with a focal length equal to that of the objective) with its flat side up. Lighting is provided by a microscope lamp, focused so that when the set up is complete the image of the lamp filament fills the diaphragm of the camera lens. This all sounds cumbersome, but if you have the photomacrographic set up already available for other uses, it is really quite quick and practical to do. Certainly more so than specially adapting an enlarger. A convenient optical setup is shown in Figure 58. The exposure determination can be done by meter-ing at the ground glass, if the speed of the paper is known. (Common enlarger papers frequently test out to an E.I. of about 2.) Otherwise, do a test-print by making a series of exposures while progressively pulling out the dark slide of the film holder.

Vibration Control. As in any high magnification setup, vibration can easily ruin the results. Therefore, care must be taken to see that none occurs. In general, no special procedure has to be followed, except to turn off any nearby motorized equipment that might cause a problem. Also, walk lightly if you have a wooden floor, and do not move at all during the actual exposure.

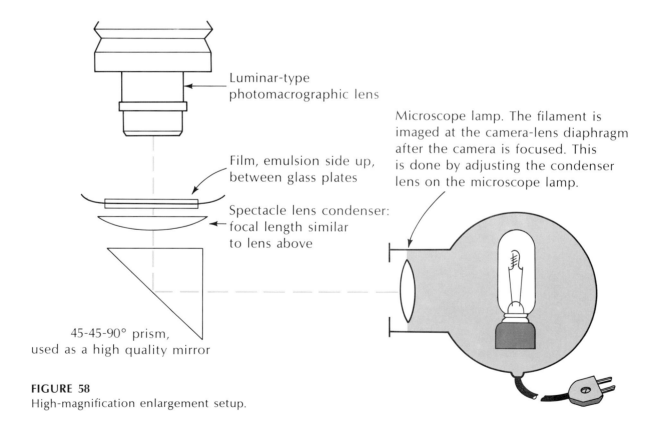

Luminar-type photomacrographic lens

Film, emulsion side up, between glass plates

Spectacle lens condenser: focal length similar to lens above

Microscope lamp. The filament is imaged at the camera-lens diaphragm after the camera is focused. This is done by adjusting the condenser lens on the microscope lamp.

45-45-90° prism, used as a high quality mirror

FIGURE 58
High-magnification enlargement setup.

Focusing. Again, high magnification increases normal problems. The use of a grain-focuser is recommended in all photo enlarging. In this context it is not quite so easy to use, due to the very fine grain of the films in use. But it should present no real difficulty.

The focusing knob on most enlargers offers too coarse an adjustment for really good work. However, if you use it to get close, and then change to the focusing mount of a camera lens such as the Micro-Nikkor, a sharp focus will be very easy to attain. Remember to avoid pulling down while making the adjustment, or the focus will be false; you cannot swing on the enlarger.

To avoid diffraction problems in imaging, it is desirable to use fairly large lens apertures. (For work at ×20 or over, you may want to use the lens wide open.) Whatever opening you decide to use, make your final focus at the aperture you will use for exposure. This avoids the possibility of any slight focus shift when you stop the lens down.

A NOTE ON 120 SIZED FILMS

There are very few films suitable for high resolution work available in 120 size. The H & W Co. does provide their VTE Pan film in this format. Nominally rated at E.I. 80, I suggest using an E.I. of 32–40 with H & W Control 4.5 developer. There is a recommendation for its use with ēthol T.E.C. developer in Table 22.

COMBINATION TECHNIQUES

It should be obvious that the techniques described in this chapter can be combined with others to produce unusually high quality results in various working situations. Mention of them will be made wherever appropriate in other portions of this text. They fit well with any of the closeup photography methods, with telephoto uses, and with stereo.

CHAPTER 10

Closeup Photography and Photomacrography

Space expands for the observer of small subjects. There are only a finite number of grand views in the portion of the world accessible to most of us. But for the person who sees the small vistas, an acre of woods or weeds offers as many possibilities as a good sized state or national park may offer to the seeker of larger sights. As Annie Dillard so eloquently puts it, ". . . Landscape is the texture of intricacy . . ." (in *Pilgrim at Tinker Creek*—see the Bibliography).

Whether the photographer wishes to record these vistas of the miniature world solely for the pleasures involved in the pursuit of a bloodless sport, or is seriously concerned with recording a new geography of details for science, the

technical approach is the same. In the following sections, the methods of working at initial image magnifications of actual size or less are explained first, under the classification of "closeup" photography. That is followed by a section on the field applications of photomacrography—photography with image magnifications greater than actual size.

In all subsequent text, magnifications are printed, for example, as follows: $\times\frac{1}{4}$, $\times\frac{1}{2}$, or $\times1$; pronounced, times one-quarter, times one-half, and times one, respectively. This practice avoids using proportions, as is frequently done in photographic literature, on the grounds that proportions tend to confuse. (The proportions 1:2 and 2:1 are less easily differentiated from one another than are the equivalent $\times\frac{1}{2}$ and $\times2$.) This practice also avoids referring to a closeup lens that "lets you approach to within four inches of the subject," a notation that gives no idea of object/image relationships.

BASIC CLOSEUP METHODS

There are a number of methods of doing closeup photography, the final image quality being roughly comparable throughout. I will describe all the methods that I am familiar with, so that you may choose techniques according to your own preferences, and with regard to the types of equipment that are available to you.

Achieving image magnifications that are greater than is normal with the closest focusing range of ordinary cameras is done by one of three basic methods. The camera lens that is used is moved further than normal from the film, so that it can be brought to a focus nearer to the subject; the focal length of the lens is changed so that image magnification increases;

or advantage is taken of the optical asymmetry of certain types of lenses. Since these methods are frequently combined and overlapped, I will describe the ways in which these changes of image size are brought about with various types of equipment. Although a number of things are described that are not included therein, the basic recommended reference for this section is Kodak's publication N-12A, *Close-up Photography*—see the Bibliography.

Standard Camera Lenses

Any standard camera lens can be used to do closeup photography if it can be removed from the camera and moved further than normal from the film plane, or if it is equipped with supplementary optics. The final results will vary, according to the basic lens quality. Approaching $\times1$ magnification with tubes or bellows with these lenses, it is usually desirable to reverse the lens in order to maintain image quality, for reasons that will be noted in more detail later.

Macro-Type Lenses

If you take a lens of approximately normal focal length, make it to unusually high optical standards, and encase it in a mount capable of a greater focusing range than is usual, you will have what is today called a "macro" or "micro" lens, such as Nikon's Micro-Nikkor or Pentax's Macro-Takumar. There is more than one type of macro lens.

Normal Configuration Lenses These come in a number of optical designs, but are often variations of basic Tessar or Planar lens designs. (Detailed descriptions of these basic designs appear

in texts on photographic optics.) They are not designed for particularly high magnification work, as are microscope lenses, but considerable care is taken to make them yield an image that is flat in field, low in distortion, high in resolution, and generally high in optical quality, of a close subject.

Typical of these is the previously mentioned Micro-Nikkor, a 55 mm lens made in two models, with a maximum aperture of either f/2.8 or 3.5. It is a Planar-type lens in a mount that allows focusing to a magnification of $\times\frac{1}{2}$ (one-half actual size), and comes with a short extension tube accessory that gives a focusing range of from $\times\frac{1}{2}$ to $\times 1$. The diaphragm is interconnected to the shutter release to provide an automatic stop-down to any f-number that you care to preset; the interconnect also operates when the tube is added. This allows the photographer to focus at close distances with the lens aperture wide open, thus providing lots of light for viewing and easy selection of a point of prime focus, coupled with automatic instant closure when the picture is taken. The particular model that I own also offers a built-in compensation of f-stop size, which operates automatically during magnification change. The diaphragm is cammed so that it opens up as the lens is focused out (and vice versa), thus automatically keeping the effective aperture equal to the marked relative aperture throughout the prime focusing range, which extends from infinity distance to $\times\frac{1}{2}$. This is a handy feature, and is especially useful in closeup flash photography. It is also found in the macro lens available for the Canon F-1 camera. Nikon makes a second version, without this feature, that is especially designed to operate effortlessly with their particular through-the-lens metering system. Reversal of macro-type lenses is usually not necessary until well past $\times 1$ magnification.

Macro-Focusing Zoom Lenses To provide greater convenience in highly versatile optics, the industry's latest entry on the market is the macro-focusing zoom, a variable focal length lens with a built-in closeup capability added. The mechanical and optical design details need not concern us here. (The most comprehensive general article that I have seen to date is Keppler & Kimata's "Macro Zooms: Gimmick or Worthwhile New Feature?"—see the Bibliography.) Typical of this type of lens are the 70–210 mm f/3.5 Vivitar Series 1 Macro-focusing Zoom (weighs 31 ounces, is six inches long, and is capable of almost $\times\frac{1}{2}$ magnification on the film), and the 35–100 mm f/2.8 Konica Varifocal Hexanon (26.4 ounces, five inches long, capable of focusing down to $\times\frac{1}{3}$).

All macro-focusing zoom lenses advertised so far are quite high in price, and most are somewhat on the heavy and bulky side. But, they offer convenience advantages that may be desirable in field circumstances, if your work varies rapidly in type and distance. For example, the Vivitar lens noted above is built to fit a wide variety of camera makes, offers basic focal lengths from not far above normal to quite long telephoto, and a pretty good macro capability, all in one chunk. And it is one of the less expensive models. Optical performance, though apparently not equal to lenses of the Micro-Nikkor class, is still very impressive. Reversal of these lenses is not advised. If your need for macro performance is primarily supplementary to your other photographic needs, you could do much worse than to select and use a satisfactory macro-focusing zoom lens. I would not call it capable of really high resolution work, but used carefully it should be able to handle most general photographic needs. Were I to consider such a purchase I would look long and hard at the 35–100 mm Konica, because of its basic

wideangle, through normal, to short telephoto design. But the Vivitar offers slightly higher macro magnification.

Reversed Retro-Focus Lenses

Many lenses used with small single lens reflex cameras are of what is called "retro-focus" design. This is especially so with wideangle lenses, but includes some normal lenses. If these lenses were of symetrical optical design, their rear element would be too close to the film plane to provide room for the necessary moving mirror. Therefore, the manufacturers have designed them so that the rear nodal point of the optical geometry is well behind the lens itself.

By using a simple reverse-adaptor ring to mount them backwards, it is possible to use retro-focus lenses for excellent quality closeup work, at a single magnification decided by the design of the particular lens. (Greater magnifications are possible by using additional tubes between the reversing ring and the camera body.)

For example, my 35 mm PC-Nikkor will give a magnification of $\times 1.8$ when simply turned around upon a reverse-adaptor. Even more interestingly, the working distance—between the point of prime focus and the nearest part of the lens mount—is about 60 mm, much more than would be normal with a 35 mm lens at that magnification. With the lens extended on tubes so as to give this magnification without reversal, the working distance is only about 15 mm. This great increase in working distance is very useful when working with such subjects as living insects, and allows more room for lights, and for better lighting angles, with any subject (see Plate 21, page 243).

My 55 mm Micro-Nikkor lens, although only slightly retro-focus in design, yields a magnification of $\times .86$ upon simple reversal without extension. However, the reversed working distance is about 110 mm, as opposed to the normal distance of about 62 mm, at the same magnification unreversed. The major portion of this difference is due to the built-in extension formed by the very deep recessing of the front element, which is a mechanical necessity with this lens design. The possibility of obtaining a greater working distance in this way should not be ignored.

However, there is a disadvantage in reversing lenses in this manner. In doing so you lose the operation of the automatic diaphragm. Nikon makes a device called the E-2 ring that helps retain at least an approximation of the automatic diaphragm. Some other manufacturers also offer substitute arrangements.

If the camera has a through-the-lens metering system, the exposure reading can be obtained directly. If not, exposure compensation is worked out in the same manner as if the magnification had been achieved by means of ordinary camera tubes or bellows extensions. Specifically, a $\times 1.8$ magnification would require three stops of additional exposure, and a magnification of $\times .86$ would need a one and two-thirds stop exposure increase. This method of determining exposure increase is given fuller coverage later, under the heading "Camera Extensions" on page 303. If you should find practical deviations from exposure expectations here, see "Reversal of Lenses", on page 308, for the probable explanation.

Add-On Lenses

There are several ways of using add-on lenses for the various types of closeup photography.

They are different enough to require separate descriptions.

Simple Lenses The easiest way of doing photography in the closeup range is to use simple, single-element closeup or "portrait" lenses. They are mounted in metal rings that either screw into the front of the prime lens mount, or slip on over it. These lenses are also called "diopter" lenses, since their focal length is given in diopters. (A diopter is a measure of the refractive power of a lens. The focal length, in millimeters, of a diopter-rated lens is found by dividing 1000 by the diopter value.) Although they are available in a variety of magnifying powers as high as 10 diopters (or more), and as low as $\frac{1}{2}$ diopter (or less), the most common practice among photographers is to buy them in sets of three, one each of +1, +2, and +3 diopters. The plus sign refers to its classification as a magnifying or positive lens. Diminishing or negative lenses of this type are called minus (−) lenses, and these will be covered on page 346, in the section "Telephoto Photography."

A late development offered by Spiratone, called the Macrovar, has a zoom focal length change capability, so that this one item offers a variety of strengths.

An interesting variation, also available in various strengths, is purveyed by both Tiffen (the Split-Field lens) and Spiratone (the Proxifar lens). This consists of an adaptor ring containing one-half of a diopter lens, cut right across the center. With it, you can have one half of a picture sharply focused very near, and the other half (the part shot through the empty half of the mounting ring) focused at infinity or at some other distance. This has real applications in nature recording, and one such lens is always with me.

The slip-on or screw-in diopter lens has the attraction of great convenience for single lens reflex camera owners. You just put it on, look through the camera viewer to compose and focus, and make your picture. No exposure corrections are needed. If you need more strength, you can stack them. The usual objection to them is that they reduce optical quality. Well, this depends. Their effect upon center sharpness is negligible in any normal use. But they do introduce some curvature of field and other peripheral defects. This is more noticeable as the strength of the lens is increased, more so yet when the lenses are stacked. Stacking is also likely to lower image contrast through the introduction of flare, especially if they are not perfectly clean. But they *do* work, and they *are* easy to use.

The cost of a set of three diopter lenses is roughly comparable to that of a set of extension tubes or an inexpensive bellows, depending somewhat on the manufacturer, and on marketing circumstances. (But, the maximum magnification that is obtainable is lower.)

I use diopter lenses occasionally for various purposes. At present I have two sets of +1, +2, and +3 diopter lenses, in two different sizes, and a +2 Split-Field lens.

When you buy diopter lenses, they come supplied with an instruction sheet listing working distances and field size dimensions for a number of lens focal lengths, and for various settings of the camera focusing scale. In Table 23 I have expressed things a little differently, because I feel that in closeup work it is useful to deal in image magnification figures. The prime lenses specified are two very commonly used focal lengths.

When using supplementary lenses as described in Table 23, you will approach closer to the subject than is normal for the prime lens. This may introduce perspective problems; near objects may appear grossly larger than objects that are only slightly further away.

TABLE 23
Magnification and field size with plus (+) diopter lenses

| PRIME LENS FOCAL LENGTH[a] | DIOPTER VALUE ADDED (+) | FOCUS OF PRIME LENS[b] | | | |
| | | INFINITY | | 1 METER (39.37″)[b] | |
		MAG-NIFICATION	FIELD LENGTH[c] (IN MM)	MAG-NIFICATION	FIELD LENGTH[c] (IN MM)
55 mm	0[d]	—	—	×.06	575
	1	×.055	650	×.12	300
	2	×.1	337	×.16	220
	3	×.16	220	×.22	160
	4[e]	×.21	165	×.27	130
	5[f]	×.26	135	×.32	110
	6[g]	×.32	110	×.38	95
105 mm	0[d]	—	—	×.12	300
	1	×.1	350	×.23	155
	2	×.2	175	×.34	105
	3	×.31	115	×.45	80
	4[e]	×.42	85	×.58	62
	5[f]	×.52	69	×.69	52
	6[g]	×.63	57	×.8	45

[a] It is generally pointless to use diopter lenses with wideangle lenses for closeup work, because the resultant magnification values will be so low as to overlap normal focusing range of the lenses listed in the table. The magnification obtainable with a given plus diopter lens increases rapidly as the focal length of the prime lens is increased.

[b] If your prime lens focuses closer than the figures given, maximum magnification increases.

[c] Field length refers to the maximum length of subject that is visible along the long dimension of a 35 mm frame. The magnifications and field lengths that are given are approximate, and may vary slightly with different equipment.

[d] No diopter lens added.

[e] +3 lens added to a +1 lens (diopter values are additive).

[f] +3 lens added to a +2 lens.

[g] +3, +2, and +1 stacked together.

Note: The actual focal lengths of diopter lenses are 100 mm for +1, 500 mm for +2, and 333 mm for +3, and are figured by dividing the diopter value into 1000 mm.

If you are using diopter lenses with other than ground glass viewing cameras, the framing of subjects becomes a problem. Since you cannot see the image in the viewfinder exactly as the camera lens sees it, and since close approach makes correct framing and focusing especially important, it is necessary to use some form of mechanical device to assure that the camera is correctly aligned, and at the right distance. Kodak publications AB-10 and AB-11 (*Close-Up Pictures with 35 mm Cameras,* and *Close-Up Pictures . . . Using Kodak Instamatic . . .*

Cameras, respectively), and booklet N-12A (*Close-Up Photography,* a larger and more general work) all have descriptions and diagrams of various such devices (see the Bibliography). Figure 59 illustrates a typical device for focusing and framing, similar to one I have used for photographing hovering insects. (See Plate 36, page 323.)

The dimensions of such devices will vary with each closeup setup, depending upon the lenses used and the exact image magnification. You can take the needed figures off the standard tables provided with your lenses, or you can open up your camera back, place a small ground glass at the image plane (a piece of ordinary waxed paper will do), and work by direct vision. Ideally, the frame should be just outside the area seen by the lens, and it should be located precisely at the principal plane of focus. Such frames can be made for any camera, from subminiature sizes right up to large press or even view cameras. I have used them for catching action too fleeting to allow normal framing and focusing, such as insects in midflight. (Coupled

FIGURE 59
Typical framing and focusing device for closeup photography. (1) The field of view is outlined on only two sides, to avoid casting a shadow on the subject. The L is the same height and width as the subject area covered by the given optical setup. (2) The support section is just long enough to place the L-frame at the exact plane of focus, and (3) is bent down slightly to allow for the wider viewing area of the lens as the distance increases. (4) The loop allows attaching the device to the base of the camera with a standard camera screw.

with a high speed flash unit, they can do it quite well.) The method also eases framing and focusing in places where the ambient light is so dim that ground glass viewing would be difficult.

Lester Dine, Inc. (2080 Jericho Turnpike, New Hyde Park, N.Y., 11041) purveys a readymade device incorporating a focusing/framing gadget, closeup lenses, and flash shield that is designed to fit Kodak's No. 104 Instamatic camera, slightly modified. There are complete kits available, camera included, in five variations, including one each for medical and dental use. Their use is featured in Kodak's publication N-9 (*Basic Scientific Photography*), which illustrates various amateur usages. Another commercial arrangement for similar cameras is Kodak's Ektagraphic Visualmaker—basically a device for document copying and other similar photography—which is designed for desktop use. These devices use flashcubes for lighting.

Custom Combination Lenses Somewhat similar in concept, but generally better optically, are add-on lens elements designed to match a particular prime lens. The outstanding example is Nikon's Medical Nikkor setup, which with all accessories makes up a well-integrated system for dental and other medical photography. The basic lens is a 200 mm closeup lens, with supplementary lenses to provide various degrees of image magnification.

Fisheye Attachment A very short focal length lens designed to have an acceptance angle in the neighborhood of 180 degrees is called a "fisheye" lens, because of its bulging, domelike front element. There is on the market a fisheye attachment lens, which is a multi-element supplementary optic that fastens to the front of other lenses (by any of a variety of available screw-in adaptors) to provide extraordinary wideangle possibilities. It can be used on almost any prime lens. Used on any camera with a lens of normal focal length, the image on the film is circular, and takes in the entire 180 degree hemisphere in front of the camera. With prime lenses of longer focal length, there is progressively less angular acceptance as the focal length increases. With a 35 mm camera, with about a 135 mm focal length prime lens, the full film frame is covered by the image. With a 105 mm prime lens, there is still curved vignetting at both ends of the frame. The effect of a fisheye attachment upon the effective focal length of the prime lens can be calculated approximately by dividing the prime lens' focal length by a factor of 6.2. (With a 210 mm prime lens, the aggregate focal length drops to about 34 mm; with a 105 mm lens it goes down to about 17 mm; and with a 50 mm lens it is about the equivalent of 8 mm.)

There is a great deal of linear distortion in such lenses. (After all, in a 180 degree view with the camera pointed straight up, the apparently straight horizon is rendered as a circle.) But where straightness of line is not important, and especially where the main subject matter is confined to the center of the field, they have their definite uses. In closeup photography they have a particularly useful characteristic. It is possible to have a subject that is in actual contact with the front lens element in good focus, and still have quite a sharp 180 degree view of its background. This extraordinary depth of field and breadth of coverage can be used to good advantage to place a subject visually within its environment. Try it. You may like it. The image quality so obtained is not what I'd call needle sharp, but on the whole it isn't really too bad.

There is an exposure correction required with the fisheye attachment, but the needed adjustment is built into the lens mount. The prime lens diaphragm is kept wide open, a ring on the attachment lens mount is set to the focal length

of the prime lens, and a secondary diaphragm built into the fisheye attachment is set to control the exposure.

Tele-Converters The most generally useful add-on lens is the tele-converter, a multi-element negative-magnification lens that fits between the camera body and the prime lens. Its effect is to magnify the prime lens' image by an amount equal to the power of the converter, and the intended purpose is to take a short focal length tele lens and convert it to a longer focal length (more details are given in the section on Telephoto). However, placed behind a lens already set up for close work, it magnifies the image here, too. So, if you have a lens that will focus as close as 18 inches, for example, use of a 2× tele-converter will make the image appear as though seen from 9 inches, thereby doubling the image magnification. A 3× converter triples the image size. This is a useful characteristic, and is especially so because working distance remains unchanged. (See Plates 26, 30, 34, and 35; and Color Plates II, III, and IV.)

Most writers dwell somewhat on the loss of image quality involved, but in truth there is little actual loss. According to Keeling (on page 412 of his article "Optical Design and Aberrations 15"—see the Bibliography):

> . . . resolving power in terms of angle remains practically unchanged . . . but in terms of . . . lines per mm the value falls in direct proportion to the magnification. In practical terms, however, taking into consideration the differing ability of lenses and films, the difference . . . is hardly significant.

People fail in tele-converter use because they use them with poor quality prime lenses, or they fail to handle them correctly. Sometimes both. Anything that increases image magnification requires more care in use. The only significant quality loss in most tele-converter use is

through the introduction of a minor curvature of field. A point to understand is that the image quality is basically set by the quality of the prime lens. If that is good, the tele-converter results can be correspondingly good. And if it is bad, converter results will be horrid. There is no significant quality difference between a 2× and a 3× converter attributable to the difference in magnification. Optically, they may even be identical except for tube length and spacing. For closeup work, in fact, I prefer the 3×.

Tele-converters are especially useful in closeup work where relatively long working distances are needed, and where lighting by flash can be used to counteract the built-in loss of light inherent to converters. The depth of field is increased because there is a two-stop relative

PLATE 30 ▶

Closeup photography and photomacrography—tele-converters. A series demonstrating the resolution capabilities of closeup and macro photography, using tele-converters to increase the basic image magnification. (a) Scales on the wing of a buckeye butterfly (*Junonia coenia*) photographed at ×6 magnification, using a 55 mm Micro-Nikkor lens set for ×1, with both 2× and 3× tele-converters stacked behind it, and with a final print magnification of ×65. In this frame the prime lens aperture was set at f/8, the optimum aperture for that lens. The image sharpness is good. Photographed on H&W Control VTE Pan film, at E.I. 40, and processed as directed in H&W Control 4.5 developer. (b) With the prime lens closed down only one stop, to f/11, the image resolution is significantly poorer. Opening up to f/5.6 gives closely similar results. The image sharpness is tolerable, but not great. With a lesser print magnification it would be all right. (c) With the prime lens closed down two stops, to f/16, the image resolution is very poor. (d) Bug (Hemiptera) eggshells, long hatched and now molding, photographed at ×6 with the setup described above, and enlarged in printing to ×29. The prime lens setting was f/11, to get maximum practical depth of field, consistent with reasonable resolution. A setting of f/8 would have been sharper, but this picture is close to the resolving capability of the Panatomic-X film used, anyway.

aperture change with a 2× converter, and a three-stop change with a 3× converter; but this is counteracted somewhat by the decrease in depth of field associated with the increase in image magnification.

For exposure determination, you can use a through-the-lens meter and do what it says. Or you can read a separate meter normally and then add stops of exposure equal to the power of the converter: plus two stops for a 2×, or plus three stops for a 3× converter. With closeup flash, use the formula given for exposure calculation, but be sure to use an effective aperture figure that includes the converter factor. (See the text following page 310 for closeup flash technique details. For an extension of this usage into the field of photomacrography, see page 336.) It is quite practical to obtain image magnifications on the film as high as ×6 or ×9, without significant quality loss, by stacking converters behind a basic ×1 setup (see Plates 31 and 32).

As an interesting sidelight, after reading Keeling's article (see the Bibliography) I noticed that my 2× and 3× converters seemed to be of the same negative focal length, but that the 3× tube was extended out 27 mm further back of the rear element than was the 2×. When I put a 27 mm extension tube behind the 2× converter I got 3× results in closeup work. (But not in telephoto work. I could not come to focus on a distant subject because there is also a slight difference in the frontal tube length of the two converter mounts, and I could not change this.) Basically, the way it works is that you can change converter power for closeup work simply by adding the appropriate length of extra tubing to the rear of your converter mounting. To go up one step (taking a 2× to 3×, or a 3× to 4×), add tubing equal in length to half the focal length of the prime lens. To go up two steps (taking a 2× to 4×, or a 3× or 5×), add

tubing equal in length to the focal length of the prime lens. And to go up three steps (taking a 2× to 5×, or a 3× to 6×), add tubing equal in length to 1.5 times the focal length of the prime lens. And so on. In all cases these notes refer to closeup use only. And, with makes of converters that differ from mine, there may be minor differences according to the basic design and construction.

Use of Camera Lenses As Supplementaries
Suppose that you went out one day to make landscape photographs, taking with you a camera and three lenses—one each of wideangle, normal, and telephoto type. Suppose also that you came across some very small object that you wanted to photograph, but found that you had brought no closeup equipment. Could you do the job? Yes, you could.

If you place the telephoto lens on the camera and then reverse either of the other lenses in front of it, as an add-on supplementary, you will

PLATE 31 ▶

Closeup photography and photomacrography—tele lens, plus reversed wideangle lens, plus 3× teleconverter. A series demonstrating the basic resolution capabilities of closeup and macro photography, when using a reversed camera lens as a supplementary. A 3× converter was used to increase image magnification. High speed films can be used, at low print magnifications (a) A dead icheneumon wasp (Ichneumonoidea), photographed at ×1 on Tri-X film, exposed at ASA 400 and processed for maximum sharpness in Microdol-X diluted 1:3, as directed. (b) Left compound eye of the same subject, photographed at ×9, using the optics described in the plate title. A moderate six-times print enlargement yields a final magnification here of ×54. The best compromise between resolution and depth of field occurs with the front lens aperture at f/11, as here. (The prime lens was a 105 mm Nikkor, the reversed front lens a 35 mm PC-Nikkor, and the converter was a Vivitar 3×.) (c) With the front lens aperture closed down one stop to f/16 a minor loss of sharpness is evident. (d) By closing down another stop, to f/22, the image loses all sharpness.

TABLE 24
Magnifications obtained with typical combined lenses

FOCAL LENGTH, IN MM, OF THE LENS ON CAMERA	FOCAL LENGTH, IN MM, OF THE LENS REVERSED IN FRONT	IMAGE MAGNIFICATION[a]	STOPS OF EXPOSURE COMPENSATION[b]
105	35	×3	+5
105	55	×1.9	+4
105	105	×1	+1
105	210	×$\frac{1}{2}$	+$\frac{1}{2}$
210	35	×6	+6
315	105	×3	+3
135	50	×2.7	+$2\frac{2}{3}$

[a] Magnification figured with both lenses set at infinity focus.
[b] Exposure compensation figures are those applicable to my lenses. Yours may differ somewhat. These compensation figures are for a setup using a marked aperture of f/4 on the front lens.

have a very satisfactory closeup attachment. The magnification obtained will depend upon the focal lengths of the lenses used. Table 24 lists some typical values:

You can see by the figures above that the image magnification can be determined in advance by dividing the focal length of the prime lens by that of the lens on front, provided that both are focused at infinity. (This is simply an inversion of Formula N, page 365, so that it reads: $m = f/F$.) If the prime lens is focused closer, its own basic image magnification will be greater, and thus the magnification obtained with the combination will also grow. For example, if you place a 26 mm extension tube between the camera body and a 105 mm prime lens, which has been focused at a distance of one meter (39.37 inches), the image magnification will be ×4, not the ×3 that is shown in the first line of Table 24. However this adjustment will also change the effective aperture.

A peculiarity of this technique is that the diaphragm used to control both exposure and depth of field is that of the *front* lens, *not* that of the prime lens. If the prime lens diaphragm is closed down at all, it will result in greatly reducing the image circle, until at the smallest apertures that circle will be less than a quarter inch in diameter on the film. At the same time, closing the prime lens diaphragm has relatively little effect on either the depth of field or exposure. On the other hand, the front lens aperture has a useful application in both areas. Unfortunately, since this aperture is calibrated only for its own focal length, it is not properly marked for the combination. Therefore, exposure calculation is easiest if you can make use of some

PLATE 32 ▶

Closeup photography and photomacrography—tele lens, plus reversed wideangle lens, plus 3× tele-converter. This is a continuation of the series in Plate 31, using the same optics. (a) The same negative as in Plate 31, b, enlarged 17 times to get a print magnification of ×153. Really fine detail has been lost in the Tri-X film grain. (b) A photograph under otherwise identical circumstances on H&W Control VTE Pan film. Note that the film grain is substantially smaller, and that the resolution of fine detail is much improved. Going to H&W Control VTE Ultra Pan, or to Kodak High Contrast Copy film, would improve resolution a bit more.

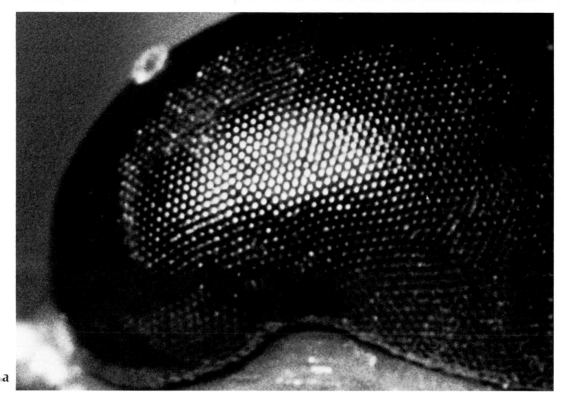

form of through-the-lens metering. In Table 24, as noted, exposure compensation is based upon the assumption of a marked aperture of f/4 on the front lens. Calculation of the effect of closing to smaller apertures—which may be necessary to gain depth of field—is hindered not only by the fact that the markings are not correct for the lens combination, but also because the f-stop progression may no longer be linear. That is, there is no guarantee that the change from mark to mark will be proportional to what it normally was. Thus, if you plan to use flash, or some method of metering other than through-the-lens, it will be wise to do some initial exposure experimentation. If time does not permit this, you had better bracket your exposures fairly widely. But, once you get past these minor exposure problems, you will find this technique to be very useful, and the image quality obtained well worth the effort.

Some questions remain unanswered.

1. Why use a telephoto lens on the camera body?

Because shorter focal lengths provide too small an image circle. This is especially true of lenses for 35 mm cameras, but it is also true to a lesser degree of sheet-film camera lenses. The prime lens need not actually be a true telephoto design, but could just as well be either a long focus lens, or a normal lens with a tele-converter attached. (These terms are defined in the section on telephotography following page 348.) The size of the basic image circle of a lens can be increased by focusing to a closer distance or adding extension tubes; but, as was previously noted, this complicates other matters to a minor degree.

2. Would a shorter focal length lens used with a tele-converter as a prime lens need additional exposure compensation?

Yes. The compensation would have to be an additional number of stops equal to the power of the converter. Otherwise, this setup is very close to the full equivalent of a telephoto or long focus lens of the same aggregate focal length.

3. Why reverse the lens on the front?

Most short focal length lenses designed for single lens reflex cameras today are asymmetrical in optical construction. If they were to be used the normal way around in this technique, the majority could not be brought to a focus at all; and, of those that could, nearly all would require a very close approach to the subject. Reversed, the focusing problem is solved, and the working distance will be quite adequate. A truly symmetrical lens would not require reversing, and could be used either way around.

4. How can the two lenses be connected?

Here is another reason, strictly mechanical this time, for reversing the front lens. With many makes of 35 mm and $2\frac{1}{4}$ inch cameras, the front ring of the lens mount is the same diameter on most lenses of the line. Thus, you can simply screw them together, by using a double male adaptor such as the Samigon Macro Coupling Ring (available in a variety of filter thread sizes from Argraph Corp., Carlstadt, N.J.—see your dealer). More simply, I just line them up carefully and fasten them together with Scotch Black Photographic Tape #235. This type of joint is rock firm, light-tight, and remarkably durable. It does require a new piece of tape each time, but the cost is low and the convenience high. Figure 60 shows the details.

If the two lenses are not similar in their front ring diameters, there are two other ways to handle the matter. If you have the time and money, you can go to your camera store and pick up

Black-tape coupler

Second lens, reversed

Camera with telephoto lens

FIGURE 60
Setup for combined-lens closeups.

a suitable array of "step-up," "step-down," and "reversing" rings, which will allow (in effect) the custom construction of a suitable connector. Otherwise, I have found it quite practical to produce a quick makeshift by cutting a cardboard disk the outside diameter of the front ring of the larger lens mount, with a central hole that is a tight fit for the outside diameter of the smaller lens front ring. (To cut such a hole, scribe a correctly sized circle with a compass, and then use the point of a sharp pocketknife to pierce through the card stock repeatedly and with a slight overlap all around the perimeter. The center can then be punched out.) The judicious use of some black photo tape will then render the two lenses compatible, and the joint will be quite square and strong enough for careful use.

If you find that the combination you are using does not fully cover the film size in use, you can increase the size of the image circle (and with it the image magnification) by focusing the prime lens to some point closer than infinity,

not forgetting to allow for some slight increase in the need for exposure compensation. Or, you can ignore the vignetting effect, compose within the area that can be seen in the viewfinder, and print the results, squaring off the ends of the picture in the enlarger easel. I have worked both ways satisfactorily. Another option, of course, is to ignore the vignetting even in printing, and just settle for a picture that has a couple of rounded borders (see Plate 33, page 305, for an example of this last effect).

The image quality obtained in combined-lens closeups is very good, and will allow substantial enlargement in printing. With really fine-grained films you can extend the technique into genuinely photomacrographic magnifications, usable under field conditions and capable of very fine results. (See page 336 for details, and Plates 31 and 32 for examples illustrative of the possibilities of fine grain film use.)

Camera Extensions

As was noted earlier, the classic method of doing closeup photography is to separate the lens from the film plane by a longer than normal distance. The distance required depends both upon the focal length of the lens and the amount of magnification wanted. A camera extension is interposed as the means of separation. The type of extension to be used is a matter for personal decision. The alternatives are described in the next section, after some more general information is given in this section on the technique itself.

The principle of camera extension is simple. First, you must determine the image magnification that is needed by dividing the dimensions of the intended subject area into the known dimensions of the film frame. For example, if the subject is three inches long (76 mm), and the

long dimension of the film frame is about 1.5 inches (36 mm), as with 35 mm films, the needed image magnification is about $\times\frac{1}{2}$ (also expressed as \times.5). Keep all dimensions in similar terms to avoid confusion. Another example might be where the subject was five mm long. With the same size film, the needed magnification would be about $\times 7$.

Next, multiply the focal length of the lens by the needed image magnification, and add one focal length. In the first example, if you were using a lens with a 50 mm focal length, the lens-to-film distance would be 75 mm (or about three inches). The lens-to-film distances can be calculated by Formula E, page 306, which uses the second example just given. This formula assumes the use of a lens with a reasonably symmetrical optical design, and assumes that the "optical center" is near the physical center of the lens. Actual designs deviate from this, so it is only an approximate way of determining the proper camera extension. However, use of the formula will get you into the ball park to the extent that you can tell whether you have enough bellows extension to do a job with that particular bellows, or whether it might be better to change to a shorter focal length lens. When this is done, don't forget to subtract the thickness of the camera body, and about half the thickness of the lens from the total extension needed. Remember that these quantities are both part of the total extension.

The foregoing process is simplified with small cameras by the fact that some commercial extension bellows have figures engraved upon their support bars, or are supplied with charts, which indicate the extension needed to get certain magnifications with lenses having commonly used focal lengths.

Regardless of the method used to achieve the extension of the lens away from the camera body, the method of exposure calculation is the same. This also applies to large cameras, where it is just a matter of using the existing bellows at longer-than-normal extensions, rather than one of adding extensions. It is based upon the following facts:

1. The lens f-number is a figure expressing the relative dimensions of the diameter of the lens aperture and the lens focal length. The diameter of the aperture is divided into the focal length to arrive at the "relative aperture" of the lens. (For instance, a lens of 50 mm focal length with an aperture that is 25 mm in diameter is said to have a relative aperture of f/2.)

2. The f-numbers engraved upon the lens mount are the relative apertures when the lens is focused at or near infinity.

3. When the lens is moved abnormally far from the film plane to focus upon a close subject, the lens-to-film distance increases significantly, but the diameter of the aperture remains the same. By reference to the inverse square law, you can see that if lens-to-film distance were to be doubled, the light intensity on the film would be one-quarter normal. In effect, the *relative* aperture has changed. (Continuing with the example used in 1, if the lens-to-film distance is extended to

PLATE 33 ►

Closeup photography and photomacrography—tele lens, plus reversed wideangle lens. Bug (Hemiptera) eggs, as in Plate 30, d, photographed at $\times 3$, using a 105 mm Nikkor telephoto lens as the prime lens, with a 35 mm PC-Nikkor reversed in front as a supplementary. This picture demonstrates the vignetting effect brought about by closing the prime lens aperture part way. With this setup, the front lens aperture must be used to control both exposure and depth of field, and the prime lens aperture must be kept wide open.

FORMULA E
Calculation of camera extension for closeup photography

SYMBOLS	DEFINITIONS	EXAMPLES
m	Image magnification needed	×7
F	Focal length of lens used	50 mm
E	Camera extension (lens-to-film distance)	? (unknown, to be calculated)

$$\text{Formula} \quad E = (m \times F) + F$$
$$E = (7 \times 50) + 50$$
$$E = 400 \text{ mm}$$

100 mm and the aperture remains the same (25 mm), the new relative aperture will be f/4—a difference of two stops.)

4. The relative aperture with the lens abnormally extended is called the "effective aperture." This quantity must be calculated arithmetically in order to get a correct exposure from flash technique or a normal meter reading. (The use of a through-the-lens meter bypasses the necessity for calculating effective apertures by reading the light that actually falls upon the film.)

5. Formula F shows how to calculate the effective aperture.

With magnifications of less than ×1 it is easier and quicker to refer to a set of standard figures, as in Table 25.

Although the necessary background material given in this section may have looked involved, the working procedure is simple and direct, as Table 25, page 308, indicates. The common types of camera extensions are described in the following section.

Tubes The simplest and cheapest type of camera extension is the extension tube, which can be used in any of several forms.

Commercial. Commercially made extension tubes are available for nearly all single lens reflex cameras. In their commonest form, they come as a set of three or four cylindrical metal tubes, each having a different length. When the whole set is used together, they will allow an image magnification of approximately ×1 with lenses of the normal focal length. Used singly or in lesser combinations, and making use of the normal focusing range of the lens mount itself, any magnification between infinity focus and ×1 can be obtained. Ordinarily well made tubes (I have yet to see a bad set) provide rigid, light-tight extensions.

In the more deluxe forms, there is provision for maintaining the operation of the automatic diaphragm found on most modern lenses, by means of built-in pushrods or levers. Some types retain the coupling of the lens to the common through-the-lens meters. Although the price is somewhat higher for auto-diaphragm tubes it is money well spent. Where it is available, this is a feature that you should not be without. Automatic diaphragm operation allows one-handed operation of the camera in closeup photography, with no need to fiddle with the f-setting at the last moment. You can focus and view with the lens aperture wide open, thus retaining a good and accurate view of the subject, and the

aperture will close down automatically to a pre-set opening upon actuation of the shutter release. In some uses, and particularly in close-up flash usage, quick and flexible one-person operation is not possible without auto-diaphragm tubes.

Improvised. Should you need to do a job that requires a camera extension, when none is available in commercial form, it is possible to work quite satisfactorily with improvised tubes. Cardboard tubes such as mailing tubes, or even toilet paper tubes, will work perfectly well. So will tin or aluminum cans, with the ends cut out. Even a rolled magazine will do, but it or a cardboard tube may require wrapping with black tape to make it fully light-tight. Any tube will require, at the very least, an inner surfacing with a black material, to cut internal reflections to a minimum. Flat black paint suitable for this purpose is available in handy pressure cans, one good type being Krylon Ultra Flat Black Enamel # 1602. The very best results in light absorption will come through lining the tube interiors with black velvet cloth.

If the ends are cut off square, if the lens is well seated on the tube, and the tube is well mated to the camera body, such an improvised extension tube will prove the technical equal of commercial tubes, in terms of picture quality. I use black photo tape to seal the lens to the tube, and the tube to the camera. Such sealing is light-tight and, if it is carefully handled, adequately strong. I have given surprise assignments involving this sort of equipment to students who have never attempted closeup work before, and they have always managed to do quite well. It isn't especially convenient, but it will work.

The most likely problem with improvised tubes, other than a simple failure to get all the joints light-tight, is a lowering of image contrast due to the use of an insufficiently light-absorptive inner surface. Really bad alignment of either or both tube ends could result in images being in focus only at one end of the frame, but reasonable care will prevent this.

The only real disadvantage of any sort of extension tube, whether it is commercial or improvised, is the relative slowness of any changes of image magnifications. But I don't think I

FORMULA F
Deriving effective aperture

SYMBOLS	DEFINITIONS	EXAMPLES
I	Indicated f-number (as engraved on the lens mount)	f/11
m	Image magnification	×1
1	A constant	1
EA	Effective aperture	? (unknown, to be calculated)

Formula $EA = I \times (m + 1)$

$EA = 11 \times (1 + 1)$

$EA = \text{f}/22$

TABLE 25
Effective aperture at magnifications of ×1 or less

IMAGE MAGNIFICATION	EFFECTIVE APERTURE	
$\times\frac{1}{4}$	$\frac{1}{2}$	
$\times\frac{1}{2}$	1	stops smaller
$\times\frac{3}{4}$	$1\frac{1}{2}$	than indicated
$\times 1$	2	

have ever lost a picture possibility to this fault alone. Bellows do allow for a more rapid image size change.

Bellows Many people prefer to use bellows attachments as camera extensions, rather than extension tubes, because of the speed and convenience of changes in image magnifications. There are two practical approaches.

Commercial. Any camera that can be fitted with commercial extension tubes can also be fitted with a commercially made bellows attachment. These come in various price ranges, from lightweight models competitive in cost with ordinary extension tubes, up to elaborate designs featuring such things as view camera movements. A few make some provision for retaining automatic diaphragm operation. Most do not. The cheaper models usually lack rigidity and may have soft, poorly made focusing controls. Rigid, well made types are likely to be quite expensive, rather heavy, and quite bulky. As such, they are more suited to laboratory use than to use in the field. But many people use them in field conditions quite happily.

Tandem Cameras. Photographers with more than one type of camera may find it convenient to mount one upon the other. A 35 mm single lens reflex camera, without its lens, can be fastened to the back of a press-type camera by means of a simple connector plate. The press camera is thus turned into a bellows attachment for the reflex camera. Any desired lens can then be used on the front to produce the needed image magnification. If your press camera has a 4 × 5 inch Graflok back, use a $4\frac{3}{4} \times 6\frac{3}{4}$ inch plate of one-eighth inch tempered hardboard with a suitable hole at the center. Mount a lens reversing ring (drilled for screws) over the hole. The reflex camera can be placed on this plate, and the plate will lock into the press camera back both quickly and easily. If, as I do, you have a $2\frac{1}{4} \times 3\frac{1}{4}$ inch Graphic press camera, make up a similar arrangement on a $3\frac{1}{16} \times 4\frac{3}{4}$ inch piece of one-eighth inch hardboard plate. The method works perfectly well. Similar connectors are commercially available from Burke & James, Inc., of Chicago (see your dealer). Figure 61 illustrates the home workshop model just described.

Reversal of Lenses

Nonsymmetrical lenses perform differently in closeup use, depending on which way around they are used. Most such lenses perform better at image magnifications nearing, at, or exceeding actual size, if the lens is mounted back to front. I will not go into the optical details, but it may help your understanding to use an oversimplification. In normal use, an asymmetrical

lens is designed to take a large scene and render it as a small image. Its built-in optical corrections are designed to operate best this way. When you want to do the opposite, and render a relatively small subject as a relatively large image, you may find that a better image is obtainable with the lens reversed. Lenses vary widely in their ability to do closeup work when they are unreversed. Macro-type lenses do not usually require or benefit from reversal until well past the ×1 level. But high speed normal lenses may present problems. Testing is simple. If in doubt, make duplicate test photographs under otherwise identical circumstances, with the lens used both ways. A simple examination of the resulting negatives should tell the story. The difference may be great enough to surprise you.

This description has not taken into account the additional effects of lens reversal that result from increased magnification coupled with the use of retro-focus lenses. See page 291 for that information.

Another matter that I will mention just briefly is the effect upon exposure of using pronounced telephoto (or retro-focus) lenses, with tubes or bellows, for closeup work. Because the entrance and exit pupils of these lenses are not the same size, you may get unexpected degrees of over- or underexposure. In most cases, all that is needed is to recognize the nature of the problem, and then make the obvious corrections. You can anticipate the situation by looking through a lens from each end, with the lens aperture closed part way down. If a given aperture looks noticeably different in size from the

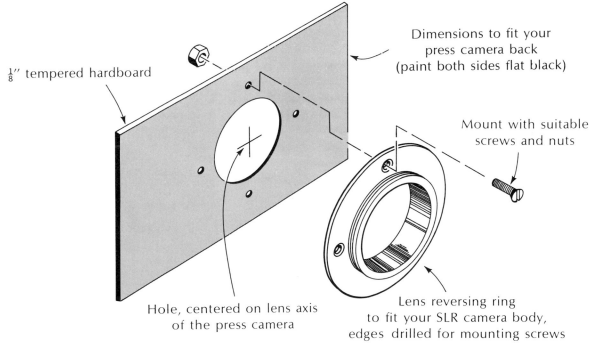

$\frac{1}{8}''$ tempered hardboard

Dimensions to fit your press camera back (paint both sides flat black)

Mount with suitable screws and nuts

Hole, centered on lens axis of the press camera

Lens reversing ring to fit your SLR camera body, edges drilled for mounting screws

FIGURE 61
An adaptor plate for attaching a single lens reflex camera to a press camera. Depending upon the construction of the SLR, a spacer may be needed between the hardboard plate and the reversing ring, in order to provide clearance for any protuberances.

two ends, you have a possible exposure problem. A telephoto design may require more exposure than would ordinarily be necessary in a particular use, and a retro-focus lens may need less. So bracket your initial exposures in series slanted toward the appropriate direction, keeping notes for interpreting the results. For an interesting and informative longer coverage of these pupillary oddities, look at Schwalberg's three-part series on the subject—see the Bibliography.

Closeup Flash Photography Technique

Of all the methods of field closeup photography, the single most useful and versatile technique in my experience is a combination method referred to as "closeup flash." It combines mobility, speed of operation, extreme depth of field, great action stopping ability, and the use of slow speed films to get quality image formation. Although it has a way of looking confusing at first sight, this method is actually very simple and easy to learn. It requires the use of a single lens reflex camera, 35 mm being the most practical size, coupled with extension tubes, and a small electronic flash unit (or a bulb flash setup). Nearly all of my students become reasonably adept after one class session and one or two short field trips.

In closeup flash as I do it, the camera is held in the right hand (left-hand operation is impractical with most camera designs) and a small flash unit is held in the left; the camera and flash are connected only by the flash synchronization cord. Speed and versatility come about through dispensing with the use of such things as tripods and gunstock supports. A short electronic flash duration, or a high shutter speed when using flash bulbs, stops both camera and subject movement, and the use of a short flash-to-subject distance allows extreme depth of field

when slow, high resolution films are used. Since the flash unit is not fixed to the camera, the angle of lighting is infinitely variable at a moment's notice. For example, you can follow the movement of an insect, and if it changes its angular position the lighting angle can be changed while it is doing so.

The technique is as useful in the laboratory as it is in the field. I, or my students, have used it in areas that are as varied as medical photog-

PLATE 34 ▶

Closeup photography and photomacrography—comparison of setups. A series that demonstrates the relative resolution characteristics of different optical setups. The subject is a monarch butterfly (*Danaus plexippus*) egg on a leaf. (a) Magnification on the negative, ×9; a 105 mm prime lens was used, with a reversed 35 mm lens as a supplementary, and a 3× tele-converter behind the 105. The front lens aperture was f/11. The final print magnification is ×77. (b) Magnification on the negative, ×18, achieved by adding a 2× tele-converter to the setup used in (a). The subject is a similar egg. The front lens aperture was f/5.6, which is optimum for that lens; though the depth of field is less, sharpness is slightly improved in the principal plane of focus. The final print magnification is ×77. (c) Magnification on the negative, ×5.14, using a setup that gives greatly increased lens-to-subject working distance: a 105 mm telephoto lens on extension tubes that were sufficient to give a base magnification of ×.85, with both 2× and 3× tele-converters being used, in order to bring that up to ×5.14. With the ×15 print enlargement required to get ×77, film grain disturbs resolution. (The film used was H&W VTE Pan; the use of H&W VTE Ultra Pan would have helped to alleviate this effect.) (d) The same negative used in (c), enlarged only to a ×38 final magnification gives a quite tolerable picture. (The print magnification is only a little over seven times.) And the improved working distance, over ten inches, could be very useful. (e) Prints (a) through (d) have been printed dark and to high contrast, to enhance the visibility of the surface sculpturing. This picture closely duplicates the actual visual appearance, since, when they are freshly laid these eggs look off-white to the eye. Pictures (a), (c), (d), and (e) are all of the same egg.

raphy during operations, botanical and entomological photography (in both field and laboratory), and in the photography of small subjects for aesthetic purposes. Virtually all of my own photography of small subjects, regardless of intent, is done this way. With a little practice, the whole process of composing, lighting, and exposing can be accomplished in two to five seconds, with quite predictable results and a very small percentage of failure—usually due to malfunction of the operator. (See the book jacket, Color Plates I, II, III, IV, and V and black-and-white Plates 3, 5, 10, 16, 17, 18, 26, 27, 30, 31, 32, 33, 34, 35, and 36 for examples of such work done under widely varying conditions.) The procedure breaks down into several steps, as follows.

Magnification The first step is to determine the necessary magnification. As was explained on page 303, since you know the size of the film frame (24 × 36 mm, or 1 × 1.5 inches, for 35 mm), you need only measure or estimate the size of the intended subject area and then divide that into the film frame size, to get the magnification. As examples: if a subject is 3 inches (76 mm) long, it will come out to about ×$\frac{1}{2}$; six inches would be about ×$\frac{1}{4}$; and three-quarters of an inch would be about ×2. When it is practical, I prefer to work at a variety of related magnifications for scientific photography, so that different size relationships can be easily visualized. Whatever the magnification of the picture that shows the largest portion of the subject, all detail pictures should divide into it similarly. I would prefer to use ×.25, ×.5, and ×1, rather than ×.23, ×.54, and ×1.2, as I feel that communication would be simpler. For similar reasons of clarity, as was noted on page 289, I prefer to use fractions or decimals rather than proportions.

The photographer can choose the setup or method for achieving the various magnifications from among any of those described earlier. However, I feel that the single most convenient method is to use a normal or macro-type lens with automatic-diaphragm extension tubes. For speedy and convenient operation the lens should be one that does not require reversal. The purpose of using an unreversed lens on auto-diaphragm tubes is to make camera operation completely one-handed, thus freeing the other hand for the manipulation of the light source. The camera is held in the right hand, as described on page 280, but without left-hand support. With magnification set, operation of the focusing mechanism would change it and therefore must be avoided: focusing must be done by moving the camera as a whole.

Depth of Field When doing closeup photography for scientific purposes, it is nearly always desirable to have the maximum depth of field that is possible (that is, to have as much of the subject rendered as sharply as is possible). Therefore, unless you wish to separate planes by selective focus, set the lens aperture at the smallest aperture that is available. Most normal lenses close down to no more than f/16 or f/22, but macro-type lenses frequently go down to f/32. If separation of planes through differential sharpness is desirable, choose any f-number

PLATE 35 ▶

Closeup flash photography technique. Examples of insect subjects photographed by closeup flash. (a) Newly hatched bug on egg mass (same species as Plate 16 and Color Plate V, top), photographed at ×3 magnification with the aid of a 3× tele-converter. A low viewing angle provides a dramatic view. Print magnification ×20. (b) Ants (Formicidae) "milking" aphids (Aphididae) of honeydew, on Fremont cottonwood (*Poplus fremontii*) leaf. Photographed as in (a), and enlarged in printing to ×22. This picture was originally done on color slide film, and was subsequently copied to black-and-white on Polaroid Land P/N film.

a

b

that gives the visual impression that you are after, using the preview button on your camera while viewing, in order to help make the decision.

Effective Aperture The nature of effective aperture is fully described on pages 304–306. Closeup exposures are calculated by using the effective aperture, unless you are exposing by existing light and using a through-the-lens meter.

With the magnification range usually covered in closeup flash photography the simplest way of determining effective aperture is to refer to Table 25, on page 308. For instance, if at a magnification of ×1, the lens aperture is set at f/22, the effective aperture will be two stops smaller, or f/45. (See Table 5, page 94, if you need to refresh your memory about the progression of diaphragm markings.) Effective apertures for the smaller common apertures, at frequently used magnifications, are listed in Table 26.

Exposure Computation Use Formula C to compute exposure. On page 127 the figure below GN was *f,* for f-number. As reprinted below, it is *EA,* for effective aperture.

As the formula indicates, dividing the flash guide number by the effective aperture yields the flash-to-subject distance in feet and tenths of feet (and 0.1 foot equals 1.2 inches).

With small electronic flash units and flash cubes (but not most flash bulbs) an adjustment to the guide number, as given by the manufacturer, is necessary—in closeup use only. More detailed attention is given to this point later, but briefly put, the guide number must be halved.

In terms of accuracy sufficient for photographic exposure purposes, a close approximation of the calculated flash distance is all that is needed. It need not be measured, but can be estimated closely enough. In the example below, a distance range of between 7 and 10 inches would be within an acceptable tolerance of plus or minus one-half stop.

Electronic Flash There are three matters that require attention when electronic flash is used in this context: the basic type and power of the unit, proper synchronization of flash and shutter, color correction, and the consequences of using flash units at ultra-close distances.

Type and Power. I recommend that others do as I do, and use the smallest, cheapest electronic flash unit that is available. Weight is important in the field, and so is a good relationship between power output and power need. The small

SYMBOLS	DEFINITIONS	EXAMPLES
GN	Flash unit guide number	22
EA	Effective aperture	32
FD	Flash-subject distance	? (unknown, to be calculated)

$$\text{Formula} \quad FD = \frac{GN}{EA}$$

$$FD = \frac{22}{32}$$

$$FD = .68 \text{ foot (about 8 inches)}$$

TABLE 26
Effective apertures for closeup flash photography[a]

AT MARKED f-NUMBER	EFFECTIVE APERTURE			
	AT $\times\frac{1}{4}$[b]	AT $\times\frac{1}{2}$	AT $\times\frac{3}{4}$[b]	AT $\times 1$
f/16	f/19	f/22	f/27	f/32
f/22	f/27	f/32	f/38	f/45
f/32	f/38	f/45	f/55	f/64

[a] The figures given here have sufficient accuracy for photographic exposure purposes.
[b] The f-numbers in these columns are intermediates and are not found on camera lenses. They are approximations for use in later steps of calculation.

units using alkaline AA cells are entirely satisfactory in terms of power need, and, since the weight of an electronic flash unit is directly related to its power, there is a penalty for carrying more than you need. These small units have flash durations averaging 1/1000th of a second, with some units as short as 1/3000th of a second. With reasonable care in handing the flash and camera, these speeds are high enough to stop all but the most extreme subject motion. Units using only two AA power cells will probably require frequent battery replacement, but units that take four such cells will get from 100–400 flashes per set of cells, if they are used economically. Economical use means that the unit is turned off when you are not actually stalking a subject, and that the batteries are removed before the unit is put back in your bag. If this is not done, internal electrical leakage could use up a substantial portion of the available electricity. In any case, spare cells should be carried.

I have a two cell unit that provides an unusually short flash duration, which I use for catching especially fast action. Unfortunately, it eats power cells. To provide longer life I have found it convenient to replace the two AA cells with two D cells. (They have the same voltage, but the D cells have a higher current rating, and

thus last much longer.) The battery container is filled with a properly wired wooden block, and the larger D cells are taped directly to the side of the flash unit case with plastic electrical tape. This can raise the number of flashes from 10–15 (with one unit that I have) to well over 100, again assuming economical use. The wiring diagram and general layout are shown in Figure 62.

It is neither necessary, nor particularly desirable, to use the new thyristorized automatic-feedback flash units for most closeup photography. If such a unit is used, it should be set on the "manual" setting to avoid exposure problems when it is used as described in this section. Since these units cannot think, if they are used in the automatic mode they will probably respond to the larger but more distant background, rather than to the actual subject, thus giving a massive overexposure. They can be fooled, but it takes a bit of planning. It is also undesirable to use units that are equipped with nickel-cadmium rechargeable batteries. Most units of this type give some 50 flashes per charge and then require quite extended recharging times. And no matter how quickly they can be recharged, in the woods there are no places to plug them in. In field conditions replaceable batteries are the way to go.

Since flash synchronization cords are a weak

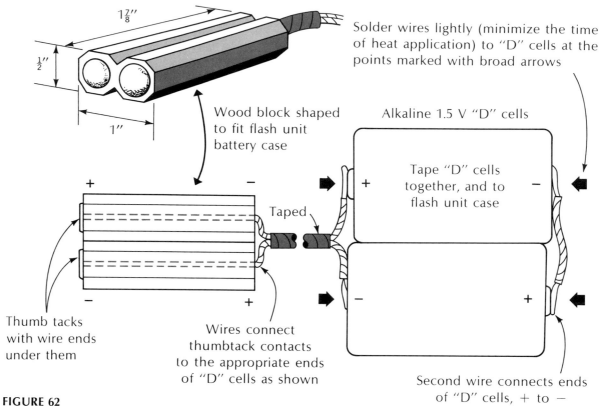

$1\frac{7}{8}''$

$\frac{1}{2}''$

$1''$

Solder wires lightly (minimize the time of heat application) to "D" cells at the points marked with broad arrows

Wood block shaped to fit flash unit battery case

Alkaline 1.5 V "D" cells

+ −

Taped

Tape "D" cells together, and to flash unit case

+ −

− +

Thumb tacks with wire ends under them

Wires connect thumbtack contacts to the appropriate ends of "D" cells as shown

− +

Second wire connects ends of "D" cells, + to −

FIGURE 62

A method for substituting "D" cells for "AA" cells in electronic flash units. Give due regard to the electrical "plus" and "minus" orientation required when inserting the block into the battery case. This method may not be appropriate to all two-cell units, but I have used it successfully with a Prinzlite S-1 and a Honeywell Strobonar 100. (The setup was originally described to me by John Ostrowski.)

point in the system, it is a good idea to use a unit that has a replaceable cord, and to carry a spare. With replaceable cords, I tape the cord directly to the flash unit so that it cannot come loose accidentally. Then I need only periodically check the end fastened to the camera to be sure that a good contact exists. To improve the basic contact, and to lessen the likelihood of accidentally loosening the connection at the camera, I crimp the end of a PC-type cord slightly. A few cords have replaceable tips for use with different types of camera connections. These often unscrew in use, thereby causing flash failure; so it is a good practice to wrap a layer of electrical or black photo tape around them as

an anchor. Some people question whether the short synch cords supplied with small flash units are sufficiently long to use in this context. If the power of the unit is related to film speed, as noted in the next paragraph, they are. But some flash uses require a longer cord. Therefore, it is a worthwhile idea to carry an extension flash cord (perhaps even a couple, each of a different length). The commonest cause of failure of flash units to fire is a minor buildup of corrosion in the PC-connector at the camera end. This is easily removed by rotating the end of the synch cord several times back and forth in the socket of the camera.

Basic flash unit power can be related to film

choice in quite a convenient manner. For ease of operation it is good to have the flash-to-subject distance similar to the camera-to-subject distance. A high powered unit used with a fast film will have an inconveniently long flash distance, and it will be difficult to control the flash distance during viewing and exposing, even to the point of producing muscular strain. If your flash unit has a light output greater than about 4000 BCPS (see Table 21, page 213), you should use the slowest available film—for color transparency work, Kodachrome ASA 25. The commonly available low powered units of 700 to 2000 BCPS (ASA 25 guide numbers of from 30 to 45) will be more satisfactory if they are used with films of about ASA 64, such as Ektachrome-X and the new Kodachrome 64.

Synchronization. Most 35 mm single lens reflex cameras will synchronize electronic flash only at slow shutter speeds, usually at about 1/60th of a second. (The synch speed may be indicated by a little zig-zag lightning stroke marked on the speed dial—see your instruction sheet). The exact speed at which the shutter will synch is not especially important as long as you have chosen the *correct* one. The use of a shutter speed that is too high, combined with electronic flash and a focal plane shutter, reduces the illuminated picture area in the direction of the curtain travel. With most such cameras, one end of the frame is visually shadowed by the advancing curtain at the moment of exposure, and is thereby underexposed (see Color Plate VIII, right).

Most 35 mm cameras provide two places to connect the flash synch cord. A few offer up to four dial or lever settings wired to a single connection point, to provide switching for correct flash synchronization under various circumstances. The correct connector or setting for use with electronic flash is usually marked "X"

or "FX". The other settings are for use with flash bulbs. (See your camera instruction book for details of synchronization.) Using the wrong connector or setting results in no picture.

Color Correction. As has been noted earlier, electronic flash units usually emit light at about 7000°K. Most commercial units claim emission in the 5500 to 6000°K area, but unless the flash tube or its covering are definitely yellowish in color the output of the unit will almost certainly be too blue to match daylight-type color films truly. Film manufacturers recommend corrective filtering with a Wratten 81A or 81B filter. My own tests, established by comparison with noon sunlight in my area, indicate a more exact correction using a CC20Y filter (see Color Plates VI and VII). Although filtering can be done at the camera lens, I prefer to cut a piece from a suitable gelatin filter and tape it directly over the light-emitting head of the flash unit, leaving it on as a permanent fixture. (One 3 × 3 inch square filter will be large enough to cover three ordinary sized units.)

Exposure Compensation. Two types of exposure compensation may be needed when an electronic flash is used as I have described. If the lamp is filtered for color correction, there will be a filter factor. Whichever of the three filters you decide to use, a one-third stop exposure correction is necessary. (The 81A, 81B, and CC20Y filters each have the same filter factor.)

The second need for exposure compensation will occur when a small, low-powered unit is used—one having an ASA 25 guide number of about 85 or less. These flash units will have very short flash distances when used with the suggested slow films and small apertures. Since they are designed for use at considerably greater distances, and for decidedly different purposes, it should not be surprising to find that their

efficiency is reduced when they are used very close up. With all small units that I have tested, the difference amounts to halving of the recommended guide number. (You should realize that it doesn't matter very much what the guide number is, as long as you *know* what it is.)

Going back to the "Exposure Computation" section on page 314, it is necessary to establish a working guide number before the formula given there can be used. For example, my Honeywell Strobonar 100 has a guide number of 40 for ASA 64 film. If I cut this in half I get a new guide number of 20. And when I use a CC20Y correction filter (which *is* needed), I must take off another one-third stop. This gives a final working guide number of about 17. Using Formula C, as on page 314, I get the following results with an effective aperture of f/45:

$$FD = \frac{GN}{EA} = \frac{17}{45} = .37 \text{ foot} \qquad (4.44 \text{ inches})$$

In practice, I get good results with subjects of average tonality when I use a flash distance of about $4\frac{1}{2}$ inches. Since, with my Micro-Nikkor lens, the lens-to-subject distance at ×1 is $2\frac{1}{4}$ inches, this is a very convenient flash distance. The flash should be exactly twice as far from the subject as the lens; or, figured another way, it should be $2\frac{1}{4}$ inches farther from the subject than the front of the lens mount.

Bulb Flash Closeup flash photography with flash bulbs is very similar to electronic flash practice. It has the disadvantage that there is a burst of heat that can damage a very delicate subject, but in most cases this is not significant. More harrowing to the nerves of novices is the fact that the relatively long burst of bright light disorients bees. Their response is to fly at the flash unit (but *not* at the photographer). This

is not an attack, and the bee will not sting unless you panic and swat at it. The disorientation is momentary, and before getting to the flash unit the bee will sheer off and go about its business. Neither I nor any student or associate of mine has ever been stung while photographing bees in this manner. Wasps seem to ignore the flash entirely.

Why use bulb flash at all? Well, the major reason is that you can get a change of guide number by merely changing shutter speed (whereas the guide numbers of electronic flash units do not change). This can be a great help at times. This possibility offers too much flexibility of technique to ignore. I nearly always carry some provision for using bulb flash when I go out in the field to do closeups with electronic flash, in case I come across a need for a higher guide number. (If you have to do long-working-distance closeups, you may need this provision.)

Type and Power. Focal plane shutters impose some limitations upon the use of flash bulbs. Because of the moving slit method of exposure that is used in curtain-type shutters, if the overall exposure is to be even, a relatively long burst of light is necessary. It must last as long as the total travel time of the slit across the frame. Fortunately, the travel time of most 35 mm focal plane shutters is within the flash duration of most types of bulbs, if the camera's synchronization is accurate. FP-type bulbs (such as #6 and #26) are specifically designed for focal plane shutter use, and have an unusually long duration; but, in most cases, other bulbs, such as the M3 and AG-1 and even ordinary flash cubes, can be synchronized quite well.

My own preference is to use types other than the FP bulbs because of their size. A dozen FP bulbs take up about the same space as a dozen

eggs, and represents a storage problem in your bag or backpack. Not only that, they are also harder to find in small towns, in case of a need for quick resupply. A dozen M3 bulbs come in a carton measuring about $1 \times 3 \times 6$ inches, and the light output at high shutter speeds is greater than that of a #6. (See Table 27, page 320, for comparative data.) If you can get by with a little less output, a dozen AG-1's are packaged in a space measuring about $\frac{1}{2} \times 1\frac{1}{2} \times 2$ inches, and three flash cubes (amounting to 12 flashes) fit within a space of $1 \times 1\frac{3}{8} \times 3$ inches. And a flash cube adaptor, which is in effect a tiny flash gun, usable with almost any camera, is the size of one more flash cube, complete. At this writing, my favorite backup unit is an adaptor and three packages of Hi-power cubes—the most powerful type—which provides 24 flashes in very little space, and weighs only 4 ounces.

Synchronization. The majority of 35 mm single lens reflex cameras offer a second flash cord connector labelled FP or M. The FP bulbs can be synchronized at any shutter speed. *Most* 35 mm cameras of this type will also synchronize M3 or AG-1 bulbs, or flash cubes, at any shutter speed, unless there is an electrical peculiarity about your synch cord. I do have one high quality cord that delays firing just enough to produce a dark end in flash pictures with my Nikon F. If flash synch is not quite correct, and especially if you are using a spring-coiled cord, try another make of cord. The visual effect of poor synching is a rapid, but not sharp edged, grading off of light at one end of the frame. If a change of cord does not help, see a qualified repairman (see Color Plate VIII, left).

My normal practice is to set the shutter at 1/1000th of a second when doing closeup flash with bulb sources, in order to get maximum action stopping. If I need a higher guide num-ber, I slow the shutter one speed at a time until I get it right, but I still maintain as high a speed as is practical. Remember that the slower the shutter speed, the more likely you are to experience loss of image quality through camera or subject movement.

Color Correction. Blue flash bulbs and flash cubes are the correct color temperature for daylight-type color films. Therefore, no color correction is needed. Blue bulbs are available any place that any flashbulbs at all can be had, so I have not provided recommendations for clear bulbs. I never use them.

Exposure Compensation. FP and M3 bulbs are used at the guide numbers listed on the package. (Some manufacturers, General Electric among them, offer expanded listings in specialized publications that are available by mail, upon request.) However, bulbs of lesser power, such as the AG-1 and flash cubes, must have the manufacturers' guide numbers halved when they are used in this method of closeup flash photography; just as small electronic flash units must, and for the same reasons. Table 27 lists adjusted guide numbers for several types of sources, at two very high shutter speeds, for use at close distances with most 35 mm single lens reflex cameras. Note that these listings are *already corrected* for closeup flash use. Once these corrections are included, the inverse square law applies right down to distances as close as a couple of inches or less.

Lighting There are two ways to approach the problem of where to put your flash unit so as to achieve good lighting for the subject being photographed. The first method is to duplicate the appearance of a satisfactory existing natural lighting situation. (Even direct sunlight is too weak to allow both very high shutter speed and

TABLE 27
Closeup flash bulb guide numbers for 35 mm SLR cameras[a]

BULB (IN ASCENDING ORDER OF POWER)	GUIDE NUMBERS			
	AT 1/1000TH OF A SECOND		AT 1/500TH OF A SECOND	
	ASA 25	ASA 64	ASA 25	ASA 64
Hi-Power cube (blue)	7	14	10	19
AG-1B[b]	9	16	12	22
#6B (FP-type)[c]	18	32	25	45
M3-B[d]	25	45	35	65

[a] Derived from GE publication P1-63P (1971), "GE Photolamp and Lighting Data"—with the figures for Hi-Power Cube and AG-1B corrected (as needed) for closeup use. Similarly designated bulbs from other manufacturers are quite comparable in performance.
[b] In a 2 inch polished reflector.
[c] In a 4–6 inch polished reflector.
[d] In a 3–6 inch polished reflector.

very small lens apertures, but if you like the way it looks you can duplicate the appearance so that the final picture will look as if it were taken that way.) This is very easily done by holding the flash unit so that it casts its shadow across the subject. The flash lighting *must* then be a close duplicate of the existing lighting effect. The primary difference is that the flash lighting will be significantly less harsh and contrasty than direct sunlight. Why? Because at close flash distances the light-emitting head of the flash unit is usually considerably larger than the subject itself, and will therefore give a lighting effect that is somewhat similar to that from a bank of studio lights or a skylight when they are used with normal sized subjects. (This is also another argument for not using powerful flash units, since the longer the flash-to-subject distance, the contrastier will be the lighting effect.)

In the second method the existing lighting is deliberately deviated from, in order to put light where it does not fall in the pattern present. You can direct light down the opening of a trumpet shaped flower, or into an animal's mouth; or you can use the light to indicate texture, to show significant shape, or to delineate an edge. Or you can bring it in from behind a translucent subject, in order to provide transillumination. In this last case, it is usually better to transilluminate obliquely, in order to obtain a one-sided dark field effect. It is best to avoid direct back lighting, since it tends to produce excessive glare. Since light travels in straight lines, it does not take more than a little thought and observation to tell where a light should be held for it to throw a shadow here or provide a highlight there.

With animate subjects, such as insects or small vertebrates, it is usually best to have the light come from the head end of the subject, unless you wish to direct attention specifically to posterior portions. With any subject, it is virtually always better to have the lamp axis somewhat above the lens axis, because light from below seldom looks right. In fact, humps tend to look like hollows, and vice versa. (It is worth it, as a self-teaching process, to deliberately try alternate pictures lit from above and below the camera axis, and compare the results for this visual effect.)

In field photography there is very seldom any need for a lighting setup with more than one lamp. After all, we see things outdoors by the light of but a single sun. Multiple-lamp setups tend to be complex and better suited to laboratory circumstances. Even there, I use them relatively seldom. Skill in placing a single lamp will suffice in nearly every condition, and this skill is best developed through conscious observation. Train yourself to look at objects and *see* how they look as the lighting changes.

Composition Train yourself to be aware of what is happening visually at the edges of the viewfinder, even as you are coming into a focus with a closeup subject. Avoid cutting off important parts of the subject, or including extraneous visual clutter. And remember that the 35 mm frame is rectangular. The subject area can be framed in either a horizontal or a vertical composition, simply by changing the camera position. You might be surprised at how often this fact is forgotten in the heat of photographic endeavor. As a rule, it makes a poor visual impression to run a vertical subject across a horizontal rectangle of film, or vice versa. So turn the camera to correspond to the configuration of the subject.

The ability to communicate an idea to another, by way of pictures, is affected quite strongly by the basic composition of the picture. A clean, uncluttered presentation is very quickly grasped, and hence is acceptable. A muddled concept in which points of possible interest are left out, and extraneous material is left in, may be taken unconsciously as a sign of muddled thinking elsewhere. (See pages 76–83.)

Summary of Procedure It is useful to summarize the whole closeup flash photography procedure. It is the same for either bulb or elec-

tronic flash, except for minor differences that are related to flash synchronization and shutter speeds.

1. Determine the needed magnification, and set the camera-lens combination so as to achieve it.

2. Maximize depth of field by using the smallest available lens aperture (unless selective focus is wanted).

3. Determine the effective aperture.

4. Compute the flash-to-subject distance, using Formula C: $FD = GN/EA$.

5. Decide upon the desired camera angle, and thereby the required lighting angle.

6. Hold the flash unit in your left hand at the correct distance and angle (do not move it while attending to the camera).

7. Hold the camera in your right hand (connected to the flash unit only by the synch cord); focus and compose by moving the camera as a whole.

8. Expose by *squeezing* the shutter release while slowly moving the camera toward the subject, releasing the shutter just as the intended point of prime focus becomes sharp.

Do not try to come to a focus and hold the camera still, while exposing. Your hand will become unsteady. Instead, teach yourself to trip the shutter release just as things become sharp, while the camera is still moving. This relative motion will be very slight, and the forward motion itself will tend to prevent the more destructive lateral camera movement.

One thing that you must train yourself to get used to is the need to hold the flash unit steadily in position while focusing and composing with the camera. Practice and attention are all

that it takes. Often, the initial tendency is to move the flash unit toward the subject while focusing, and to turn it somewhat out from the intended lighting angle. In extreme cases, the light beam may miss the subject altogether. The simplest remedy is to practice a little while someone watches you and corrects these tendencies. It won't take much practice to correct any poor handling methods.

Combination Techniques

It is possible to combine closeup flash (which by itself is a uniting of methods) with other techniques, so as to produce a variety of photographic possibilities. Some suggestions are given in the following sections.

Night Closeup Flash It is as practical to do closeup flash at night as it is in the daytime. In fact, the lack of daylight glare around the camera eyepiece makes viewing and focusing easier. And night brings out different kinds of subject matter. Many kinds of night-roaming creatures are dazzled by the light from a flashlight, and will readily sit for their portraits. (Refer to my article "Field Photography of Nocturnal Arthropods"—see the Bibliography.)

The simplest approach to night closeup photography makes use of two flashlights; a fairly powerful light carried in the hand for navigational purposes and subject location, and a penlight taped to the bottom of the camera for focusing and composing. The penlight should have a block between its back end and the camera bottom that will allow it to be held at an angle so that its beam crosses the lens axis at the principal plane of focus. The light that will be provided is even, and although it is bright enough for clear viewing it is not strong enough to have any effect upon exposure. It will look very bright, but that is due to the night adaptation of your eyes. The penlight's position on the bottom of the camera keeps it physically out of your way. A particularly handy type of penlight for this purpose has the bulb at the end of a flexible extension; the body of the gadget can be taped flat to the camera bottom, and the "gooseneck" can be bent up so that the light beam is correctly directed. These can be obtained from suppliers of outdoorsmen, such as L. L. Bean, of Maine.

The use of electronic flash at night produces little likelihood of spoiling your night sight, since the flash takes place while the camera mirror is up and blocking off your sighting eye. But flash bulbs will dazzle you, because of their relatively long duration. Therefore, you should cultivate the habit of blinking your eyes just as you release the shutter. The blink will last just about as long as the bulb's flash, and your eyes will be protected from loss of needed night sight. If you are working in a group, try to avoid shining your flashlight into another person's eyes, and do not fire your flash unit directly toward another person's face. Unless you are all careful you may find it necessary to sit and wait for night sight to return before you can go home safely.

PLATE 36 ▶
Closeup flash—focusing frame.
Photography of very transitory events may be impossible to frame and focus on the ground glass of a single lens reflex camera. The use of an auxiliary focusing frame will make it possible to frame and focus with good accuracy in a fraction of a second. Any camera can be used, with suitable accessories; even a view camera, if circumstances make it necessary. (a) Hover fly (Syrphidae), hovering in the open air, photographed at ×1 magnification using a Nikon F camera equipped with a wire frame. Copied from color on Polaroid Land P/N film, and printed here at ×10 final print enlargement. (b) Further enlargement of the same slide, to ×25, showing the accuracy of focusing—the faceting of the compound eye has been resolved.

Closeup Flash, Plus Focusing Frame In most closeup flash photography a single lens reflex camera is used, and the subject is composed and focused on the viewfinder screen. However, there are times when this is impractical. Suppose, for instance, you are trying to do ×1 pictures of a hovering insect, an insect moving rapidly along the ground, or a plant which is being whipped by strong breezes. You may find it virtually impossible to focus and expose quickly enough. You can usually accomplish the result wanted by adding to your closeup flash setup a wire focusing frame similar to that shown in Figure 59, on page 294. Ordinary iron baling wire is a satisfactory material for a small frame. It may help a little with animate subjects if the frame is painted flat black, rather than just left shiny (see Plate 36).

For this use, set up the camera as for normal closeup flash and use it the same way, except that you add to it the focusing frame, using the viewfinder screen to adjust it very carefully for accurate focus and framing. You will be able to reach out quickly with the camera and flash unit, and expose the instant that you see that the subject is correctly placed in the frame. This is a practical procedure at closeup magnifications up to about ×1, but higher than that it rapidly becomes more difficult. One problem is that as magnification increases the frame must be made smaller, and there is an ever increasing chance of scaring off shy subjects before you can frame them.

Obviously, a single lens reflex camera is not necessary for this use, but it is a way of increasing the versatility of your use of one. And its ease of adjustment, by the use of the viewfinder screen, is definitely handy. I consider this more an emergency supplement to normal closeup flash than a general-use alternate, as focus is necessarily less accurate. But it is a way of doing the near impossible quite conveniently.

Infrared Closeup Flash There are some fairly detailed suggestions for the application of closeup flash technique to infrared field photography in the section called "Handheld Closeups" on page 209, and under "Special Methods for Closeup Flash" on page 201. Except for the film and filter used, and a minor adjustment in focusing technique, the procedure is similar to the ordinary closeup flash.

Special Purpose Cameras

For those whose closeup needs are largely technically repetitive, there are several types of special purpose closeup cameras. Perhaps the most versatile and useful of these is the Polaroid Land CU-5 camera, a modular box-type camera, which allows a magnification range of from ×$\frac{1}{4}$ up to ×3. This camera provides rapid-access prints from a film pack arrangement in either color or black-and-white. See your dealer for details.

Somewhat similar in concept, but less versatile, is the Watson Holmes Fingerprint Camera from Burke & James. It offers a ×1 magnification only, but it could have its uses.

BASIC PHOTOMACROGRAPHY

The techniques of basic photomacrography are an extension of those used in closeup work. The most important difference is that the image magnification is greater, photomacrography being defined here as any photography in which magnification is significantly greater than actual subject size, but in which a compound microscope is not used. The best basic reference is Kodak's publication N-12B, *Photomacrography* (see the Bibliography).

Photomacrography, making use of a single

objective lens, as in normal photography, is practical as a laboratory technique at magnifications on the film of $\times 50$ or more. However, in actual field work it is generally conceded by anyone who has tried it that magnifications higher than about $\times 9$, on the film, are so difficult as to become impractical. Of course, there is nothing to prevent you from obtaining yet higher print magnifications by means of projection printing, providing that the basic image quality is good enough. Using really careful technique, therefore, final print magnifications of form $\times 50$ to $\times 100$ are quite practical.

In full scale expedition work involving photography of very small static subjects, there should be a satisfactorily flexible laboratory-type photomacrographic setup at the base camp.

Conventional Method

In most field photomacrography the most practical approach will be through the adaptation of normal cameras, particularly of the ever versatile 35 mm single lens reflex type.

Lenses One of the simplest means of achieving higher than normal image magnification is to use a lens of shorter than normal focal length, with camera extensions—either tubes or bellows. At any given level of camera extension, the shorter the focal length the higher the image magnification. Thus, if you set up an ordinary 35 mm camera to obtain a magnification of $\times 1$, using tubes or bellows to get sufficient extension, a normal lens of 50 mm focal length will have a lens-to-film distance of about 100 mm. A lens of half that focal length, 25 mm, will achieve $\times 3$ at the same extension.

As we have seen earlier, a basic rule of thumb for camera extension (calculated by means of Formula E, on page 306) is to say that the amount needed to get a given magnification can be worked out by multiplying that given magnification by the focal length of the available lens, and then adding one focal length. Thus, if $\times 10$ is needed and the available lens has a focal length of 25 mm, the lens-to-film distance will have to be a total of 11 focal lengths, or 275 mm. Because practical camera lenses have a finite thickness, and this formula is based upon the idea of the theoretical but fictional "thin" lens, and since camera lenses are made in a variety of optical configurations, this mode of calculation is only approximate. But it is a handy way of determining if you can actually obtain the needed magnification with a given lens and extension setup.

Special Photomacrographic Lenses. Lenses specifically designed for work at magnifications significantly over $\times 1$ are or have been made by several manufacturers. Examples are Zeiss Micro-Tessars, Bausch & Lomb Micro-Tessars (made under license from Zeiss), Leitz Micro-Summars, and Zeiss Luminars. This last series is typical of contemporary makes, and is the one most familiar to me: these lenses are available in focal lengths of 16, 25, 40, 63, and 100 mm, each with a matching spectacle-lens condenser for transmitted-light work. See your technical instrument dealer for further information. You can seldom purchase used lenses of these types, because owners tend to keep them.

Cine Lenses. Ordinary fixed focal length motion picture camera lenses of normal configuration, reversed for image improvement, fall in the right focal length range for photomacrography, and are frequently capable of impressive performance. The most likely significant fault will be minor curvature of field, but in photography of very small three-dimensional objects this is often of little importance. For example, I have

a 17 mm f/2.7 Wollensak Cine Raptar that does very well. Except for minor unsharpness in the image corners, owing to field curvature, image quality is closely comparable to the 16 mm Zeiss Luminar.

Macro-Type 35 mm Camera Lenses. Lenses of the macro-type designed for use at ×1 or less with 35 mm cameras are usually capable of excellent quality photomacrographic results at quite high magnifications, when reversed on long extensions. Their only real disadvantage is their relatively long focal length. But I have used my Nikon Micro-Nikkor on a tandem camera arrangement at magnifications exceeding ×10 with complete satisfaction, although its 55 mm focal length requires some 600 mm of bellows extension. Refer to page 308, and to Figure 61 on page 309, for details of tandem mounting of cameras.

Long Extensions Photomacrography at image magnifications exceeding several times actual size will require some form of unusually long camera extension. Frequently, though not always, the best solution is to use a long bellows—perhaps even a tandem camera. This sort of arrangement is cumbersome, and not very practical for true field photography, but is quite useful in a base camp or home institution. Convenience is often served by using larger film sizes, rather than roll film cameras, because such work is likely to require single exposures, or small numbers of them.

Tubes are more subject to the effects of internal flare, produced by light reflected from the relatively smooth inner surface, so that some form of baffling is necessary for best results. Bellows, having a somewhat convoluted surface, are basically less troublesome in this respect, but in the long run are likely to develop holes in the corners that are most frequently flexed. These require repair, or light will leak onto the film. Bellows are quicker and easier to adjust for length. However, either tubes or bellows will do the job.

Tubes. The rigidity of extension tubes is a cogent reason for wanting to use them in a photomacrographic setup. They are also easier and cheaper to improvise than are bellows. Stationery stores frequently stock long cardboard mailing tubes quite sturdy enough for this work. Cut off square to the right length, covered on the outside with light-tight black photo tape, and lined internally with deep-pile black velvet or some other adequately light-absorbent material, they are the full equal of commercial equipment in terms of picture quality. Internal light absorption can be obtained by painting the interior flat black, and then inserting doughnut-shaped cardboard baffle plates periodically down the length, if black velvet is not available.

There is nothing to prevent you from simply stacking multiple sets of ordinary commercial closeup tubes until you have sufficient length to do the job. (I stack up to 12 inches of such tubes routinely.) The expense runs a little high, but they are indefinitely reusable and conveniently break down to any desired length. Internal baffling is needed when long lengths are used. This can consist of a succession of rings of black paper, sized so that they can be sandwiched in the tube sections at the existing screwed joints, as shown in Figure 63. A setup of this sort is quite satisfactory for 35 mm work, though the commercial tubes are too small in diameter for large negative cameras. The cheapest tubes to get are nonautomatic tubes designed to fit the Pentax thread.

Bellows. In field work, bellows of sufficient size for significant magnification of the image with any but the shortest focal lengths of lenses are

clumsy and hard to manage. The most practical outdoor arrangement when you must exceed the length of common bellows attachments is the tandem camera, using a roll film camera at the back.

For large-negative work with very short focal length lenses you may find it convenient to use some length of tubing at the front of the bellows, in order to lengthen a too-short bellows or to allow room for more frontal lighting than · the larger front of the camera itself might allow. The tubing must not be so long that it vignettes the image at the film plane, and it may need internal baffling. See Figure 64 for details.

Magnification The need for magnification is calculated by deciding how big you want the image to be, measuring the actual size of the subject, and dividing the latter into the former, as with closeup work. If the subject is 5 mm long, and you want an image 150 mm long, you will need a magnification of ×30. Do not forget to take into account the film size being used, and whether projection printing will be done. If, for instance, you use a 35 mm camera, the frame size is only 36 mm in maximum length. Therefore, you cannot magnify a 5 mm subject more than about ×7, and you will need to enlarge about 4.3 times in printing to get a final

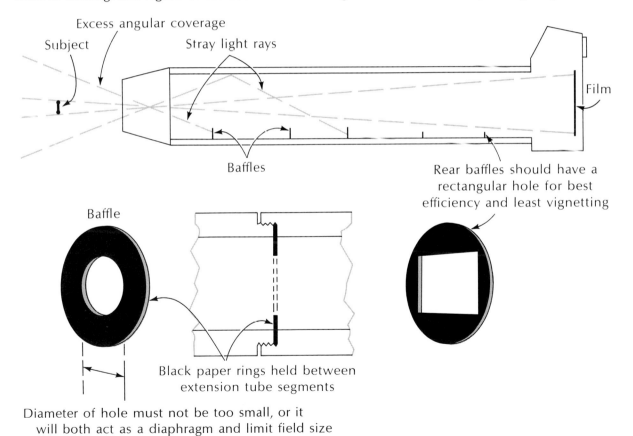

FIGURE 63
Internal baffling of long extension tube successions.

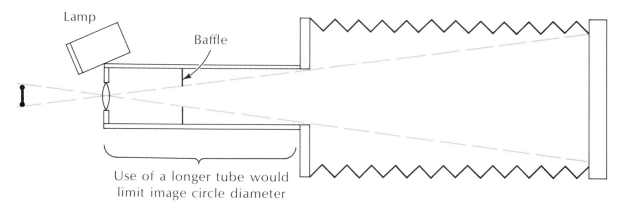

Lamp

Baffle

Use of a longer tube would
limit image circle diameter

FIGURE 64
Reduced-size camera front for large-negative photomacrography.

image size of 150 mm, with a total magnification of ×30.

As has been noted previously, it is both convenient and desirable to work at known exact magnifications. The best way to achieve a known magnification is to focus the camera on an accurate scale, measuring the resulting image on the ground glass or at the film plane, or comparing it to the premeasured size of your viewing screen. After setting up to an approximately correct lens-to-film distance, measure the image and correct the bellows length until you get what you want. If you must use improvised tubing that is difficult to bring to a predecided particular magnification, do the measuring to record exactly what you do have, for your records. You may have cut a tube to a length that was calculated to be correct for a ×10 magnification, and then find, upon measuring, that the magnification is ×9.9 or ×10.2—if so, record the fact, and live with it. If you need to, you can bring the magnification to an even figure by means of projection printing.

Where your circumstances require a considerable amount of photomacrography at widely varying magnifications, you may find it most economical, in both time and money, to use an easily adjusted bellows arrangement in conjunction with several lenses of different short focal lengths. If the whole arrangement is calibrated in advance, you need only swap lenses and/or change the bellows extension to previously recorded settings to get any of a variety of known magnifications. My own most flexible arrangement used the five focal lengths of Zeiss Luminar lenses, and provided a magnification of from ×1 to ×40, with additional subsidiary equipment for both lower and somewhat higher magnifications. The basic camera was a portable 5 × 7 inch view camera. Calibration was done by the cut-and-try method described above, taking each lens in turn and working out bellows length settings for as many of the predecided magnifications as the bellows length would allow, working from minimum extension to the maximum. As each magnification was achieved, the camera extension was measured between two arbitrarily chosen points at the front and back of the camera. The lens used, the length of extension, and the magnification were tabulated. Once this initial calibration was completed, I could set up for any listed magnification in seconds. I found that the following specific magnifications satisfied all of my nor-

mal requirements: ×1, 1.5, 2, 2.5, 3, 4, 5, 6, 8, 9, 10, 12, 15, 20, 25, 30, 35, and 40. Note that multiples of 2, 3, 4, and 5 could be carried out over a considerable range. This helps in doing a series of differing magnifications with the same or similar subject matter, as the multiples are easily visualized.

Depth of Field In photomacrography at significant magnifications the choice of f-number is not automatically the smallest one available, as it often is in closeup work. It is nearly always a matter for compromise between depth of field needs and the resolution of fine detail in the image. At very small apertures, diffraction of light at the diaphragm edge reduces resolution. Therefore, I adjust the lens aperture while observing the ground glass image with a good magnifier, and record (for later use) the setting at which I achieve the best compromise between depth of field and resolution. This setting will differ with different subjects, because of the varying importance of fine detail in the picture. Some subjects may be so smooth as to make really high resolution relatively less important in some contexts. Others may have important fine detail which is so small that closing the lens aperture even one stop below the maximum resolution opening will degrade the image enough to ruin the picture. You must test, in order to be sure. Minor adjustments of the principal plane of focus, made by moving the camera as a whole for focusing (or by moving the subject slightly), can assist in maximizing apparent depth of field.

Focusing Because of the very shallow depth of field available in photomacrography, focusing must be done with great care. The basic focus is obtained with the lens aperture fully open, in order to provide enough image brightness to see by. A few lenses change focus slightly when the aperture is closed down. If you have one of these, the final focus should be at the picture-taking aperture.

Where critical sharpness is necessary at a given level, this level must be the point of primary focus. But, where maximum depth of field is sought, the choice of the primary point of focus must be such that all of the desired subject depth becomes reasonably sharp at the necessary aperture setting. A fraction of a millimeter up or down may make a noticeable difference. After making a preliminary focus, use a good magnifier at the ground glass to check overall sharpness, and to make sure that the final focus is really accurate.

As with closeup photography, focusing in photomacrography is done by moving the camera as a whole, as any change in the lens-to-film distance will change the magnification. Devices for transporting cameras without changing this distance are available on the market, but sometimes it is better to make your own. It is possible to construct a good focusing mechanism using only a table saw and a drill press, equipment that is available in most institutional shops. Such a design is shown in Figure 65. This device can be made to any reasonable proportions desired. It can be made either to hold a short camera assembly on a tripod head, or to serve as a base for a long-bellows camera, and fixed to a bench or on a vertical wall mount. (I prefer the latter.) Similar but less bulky arrangements can be made quite easily by adapting and adding elements to a metal electronics drawer slide. (These are ball-bearing devices used as runners for unusually heavy sliding components, and are listed in catalogs of electronics supply outlets.) I have made and used both types. They work well and allow minutely accurate focusing without loss of rigidity.

Under makeshift circumstances, and especially in true field circumstances, you can bypass

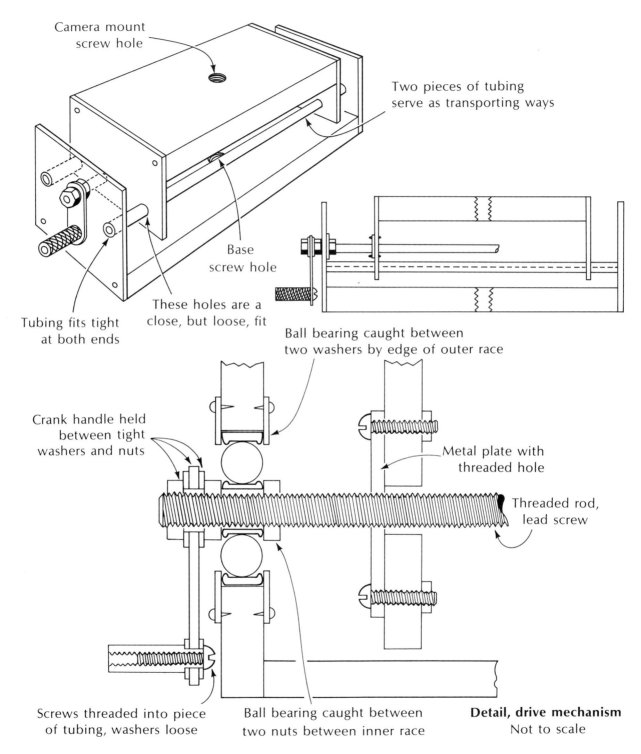

330

Camera mount screw hole

Two pieces of tubing serve as transporting ways

Base screw hole

Tubing fits tight at both ends

These holes are a close, but loose, fit

Ball bearing caught between two washers by edge of outer race

Crank handle held between tight washers and nuts

Metal plate with threaded hole

Threaded rod, lead screw

Screws threaded into piece of tubing, washers loose

Ball bearing caught between two nuts between inner race

Detail, drive mechanism
Not to scale

FIGURE 65
A photomacrographic focusing device.

the need for the foregoing by immobilizing the camera and moving the subject carefully by hand.

Working Distance Because the depth of field is so shallow in high magnification photomacrography, one of the first problems encountered is that no image can be seen unless you are already close to a correct focus. Therefore, you must know in advance approximately how close the camera should be to the subject. As a brief shorthand method, you can say that at any significant magnification the lens-to-subject distance will be a little more than the focal length of the lens, and that the higher the magnification the more nearly it will approach that value (though it will never quite reach it with normal configuration lenses). Figure 66 gives a more accurate picture of the relationship.

There are advantages in using the longest practical focal length lens in closeup photography and photomacrography; two that come to mind are related directly to working distance. The first of these is that longer focal length lenses have longer working distances. The longer this distance, the less the image distortion (or the better the perspective). The outline of a three-dimensional subject will be more accurately rendered, and portions of the subject nearer to, or further from, the lens than the principal plane of focus will be more nearly the same magnification, as shown in Figure 67.

In addition, the longer working distance allows more room between the front of the lens and the subject for the placement of lighting fixtures, and hence a closer approach to frontal lighting. Use of very short focal length lenses may require either very broad lighting angles with contrasty lighting resulting, or elaborate lighting setups to bypass the problem.

As mentioned earlier, if a retro-focus lens is being used, reversing the lens in mounting it will result in a considerable increase in working distance. The reversal of my 35 mm PC-Nikkor results in a lengthening of the working distance by four times at a ×1.8 magnification level (see page 291 for more detail).

Lighting Artificial lighting of photomacrographic subjects can be a complex and trying matter if not well understood. My earlier book, *Photography for Scientific Publication,* has a sizeable section on this subject, as does Kodak publication N-12B (see the Bibliography). In this text I will provide only a very brief statement, because field circumstances will probably sharply limit the practical possibilities.

There are four primary lighting problems likely to be encountered in field photomacrography.

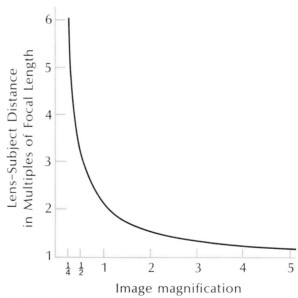

FIGURE 66

Working distance. This illustration assumes the use of a symmetrical "thin" lens. Normally configured lenses of common photographic types will have a similar curve. True telephoto lenses and retro-focus wideangle lenses will vary somewhat from this pattern, according to their individual optical designs.

These, and their suggested solutions, are:

1. *To record general appearance:* Use a fairly frontal lamp position, with the lamp axis anywhere *above* the lens axis that will place highlights and shadows where they will assist in delineating shapes and textures as desired.

2. *To emphasize surface textures or low relief:* Use a broad lighting angle that causes the light to graze along the surface of the subject, thereby exaggerating surface irregularities.

3. *To light faceted subjects, such as crystals:* Use a moving penlight to illuminate the subject while observing through the camera viewfinder. When a good lighting angle is found, duplicate it with your main lighting source.

4. *To photograph translucency effects:* Place your lamp behind the subject, but about 30 degrees to one side of the lens axis, to achieve a one-sided dark field effect. This is very effective with mined leaves, etc. Straight-through back lighting usually requires something approaching a laboratory setup. Attempting it in the field usually produces glare.

The foregoing assumes that for simplicity's sake a single light source will be used, probably without reflectors or diffusers. In the first two cases listed, some subjects may be photographed more clearly if the light is diffused with a single sheet of thin white tracing tissue or one thickness of cleansing tissue. (But, remember that this will reduce the light intensity by about one stop.) Alternatively (or in addition), light

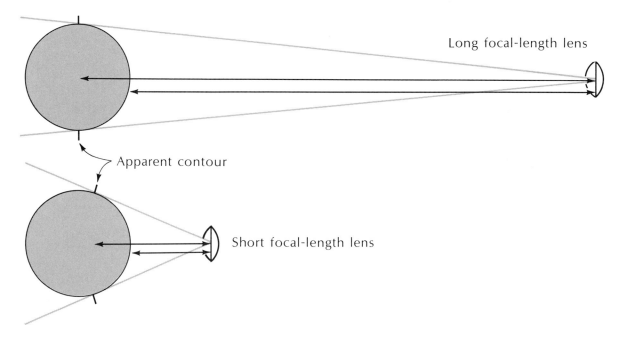

FIGURE 67
Perspective effects of varying lenses. At top the near and far focusing distances are nearly equal. (The short distance is 91 percent of the long.) At bottom the near and far focusing distances are proportionately quite different, so sizes of various subject parts will differ. (The short is 72 percent of the long.)

can be thrown into shadowed areas by the use of a small white card used as a reflector.

Composition I prefer to avoid listing specific rules for achieving aesthetic effects, but some general remarks are useful. There is no reason why photographs made for scientific (or any other) purposes should be dull to look at, so it is worthwhile to keep a close eye on the way that the frame edge excludes, includes, and interacts with the subject matter. With very small discrete objects there may be little practical purpose in doing anything other than centering the subject in the image space, in order to avoid inadvertently cutting off parts at the frame edge, and to take advantage of the central resolution capabilities of the lens. But with more complex arrangements of subject matter the way in which it is arranged, the choice of camera angle, and the placing of the frame boundaries all affect the way a viewer sees the picture, for better or worse. Just as you should not cut off portions of the subject that are important, so you should also avoid including extraneous material that will serve mainly to introduce visual clutter and possible ambiguity. A clean, uncluttered, tightly composed picture should be the aim, regardless of size or magnification factors. If you are aware of these needs, you can easily train yourself to see the possibilities and the compositional errors while you are framing and focusing, without any need to put significant conscious thought into it.

Positioning Subjects Very small subjects may be difficult to position unless a mechanical device is used to move them about. Much time and effort can be saved by adapting a microscope-stage micrometer for the purpose of providing easy two-dimensional manipulation. By this means, the various parts of the subject can be composed within the film frame in any way that is desired. It may also be useful to make up a small clamping device by means of which a small static subject of irregular shape can be aligned three-dimensionally in space, in order to allow the main subject plane to coincide with the image plane, thus minimizing depth of field problems. (Substantially large out-of-focus areas in an otherwise sharp picture tend to be visually disturbing.) A device for this purpose is shown in Figure 68, page 334. It can be made with hand tools from brass or other suitable material. All joints clamp friction tight; the spring clamp is constructed to have a tendency to remain open, and the screw is used to close it. This allows an exceptionally delicate grip. The vaguely similar commercial designs that I have seen are all inferior.

Exposure Determination The determination of photomacrographic exposures by calculation is based upon working out the effective aperture, as in closeup photography, by Formula F. Because the degree of magnification and the setting of the lens aperture are not as likely to be as fixed as in closeup photography, it is necessary to use the formula in each instance rather than to make up a table. For the sake of convenience, Formula F is reprinted here.

SYMBOLS	DEFINITIONS	EXAMPLES
I	Indicated f-number (as engraved on the lens mount)	f/16
M	Image magnification	×15
1	A constant	1
EA	Effective aperture	? (unknown, to be calculated)

Formula $EA = I \times (m + 1)$

$$EA = 16 \times (15 + 1)$$

$$EA = f/256$$

Arrows indicate movement possibilities

All joints friction tight

Screw with fixed nut closes jaws

Clearance holes

Solder

Second fixed nut, on lower jaw

Spring jaws, tend to remain open

FIGURE 68
Small-subject positioning device. (After an original design by Victor G. Duran.)

Once the effective aperture is known, exposure can be worked out either for a time exposure, using a light meter (ideally, by reading at the ground glass), or for a flash exposure, using Formula C (*FD = GN/EA*), as shown on page 314. The use of flash is recommended when you use color film for high magnification photography,

because it avoids the reciprocity failure problems associated with long time exposures. And, with an effective aperture of f/256, as was just calculated in the example, long exposure times can be expected.

It is obvious at a glance that, in this example, the effective aperture is so extreme that a small electronic flash unit simply will not have adequate light output, unless it is used in conjunction with quite complex optical arrangements. However, a reasonably short exposure time will result when ordinary flash bulbs are used in the "open flash" method; the shutter is opened, the flash is fired manually, and the shutter is closed. (With most 35 mm single lens reflex cameras, open flash results when flash bulb synchronization is done at shutter speeds of 1/30th of a second or slower.) The purpose in open flash technique is to use the entire light output of the bulb, rather than taking a slice out of it as is done at faster shutter speeds. For example, the open flash guide number of an M3-B bulb is 200 for a film of ASA 64. Using Formula C, the figures given for the current example work out thusly:

$$FD = \frac{GN}{EA} = \frac{200}{256} = .79 \text{ feet (about 9.5 inches)}$$

(In Formula C, as given on page 127, the symbol beneath the *GN* was *f*, for f-number. Here it must be *EA*, for effective aperture, because of the image magnification involved.)

A #6B FP-type bulb has an open flash guide number of 180 for the same film, and even a Hi-Power cube will go to 120 (or 60, at very close flash distances—a flash distance of about 2.75 inches in this case, which is close but not impractical). There is always the possibility that a given flash unit reflector will lose efficiency at distances less than about three feet, although this is not too common. Therefore, exposure bracketing (by making several exposures at vari-

ous distances) is recommended at first, and until you analyze any inconsistencies.

To summarize the reasons for using flash lighting for photomacrographic exposures, consider the following:

1. Short exposure time lessens motion and vibration effects (even open flash has a duration of only about 1/50th of a second).

2. Short exposure times avoid long exposure reciprocity failure effects. (The need for even more exposure than calculated; the need to correct for upsets in color balance when using color films.) Even full sunlight, in the example given, would require an exposure time of about four seconds, already well into the area of color imbalance with transparency films.

3. Flash of any sort, and especially cube flash, is much easier to carry (and use) under field or field-related conditions, than are incandescent or other continuous sources.

A primary difficulty arises in exposure calculations when using Zeiss Luminar lenses, or any others that are similarly calibrated. The aperture markings of these lenses do not follow the usual f-number patterns, but are calibrated in Stolze numbers. Table 28 provides a list of equivalent f-numbers, for exposure calculation purposes.

Summary of Procedures As was done with closeup flash photography, I will summarize here the basic procedure of conventional photomacrography:

1. Determine the needed magnification, and set the camera to achieve it.

2. Determine the f-number to be used by observing the ground glass image with a magnifier while slowly closing the lens aperture. Record and use the f-number at which the

TABLE 28
Equivalence of Zeiss Stolze numbers to f-numbers[a]

STOLZE NO.	f-NUMBER
1	3.5
2	4.5
4	6.3
8	9
15	12.5
30	18

[a] The f-numbers listed are approximations, which are adequate for photographic use.

depth of field is adequate, and at which diffraction of the image is not too destructive.

3. Calculate the correct exposure, by one of the following methods:
 a. Bypass effective aperture calculation, (b) below, by reading the exposure with a through-the-lens meter, or by reading a CdS meter at the image plane. (See the text following page 108, for method.)
 b. Calculate the effective aperture by the formula: $EA = I \times (m + 1)$; then meter the light and use the effective aperture to determine exposure time (see Formula F, page 333). Correct for reciprocity failure, as needed (see manufacturer's notes).
 c. Calculate effective aperture as in (b) above; then expose by flash, determining the proper flash distance by the formula: $FD = GN/EA$ (see Formula C, pages 127 and 314).

The beginner will find it very useful, where the equipment is available, to use Polaroid Land film, either to make the final picture or to test the setup before using conventional films.

Combination Techniques

When the need arises to do relatively high magnification photomacrography under genuine field conditions, it is usually most practical to use a 35 mm camera in conjunction with some of the techniques already described, combining them for maximum effect.

Closeup Flash, Plus Tele-Converter, Plus High Resolution Technique A particular problem that can arise is the need to do photography of such things as very small living insects, or small parts of flowers, undisturbed in their natural surroundings. The best method that I have found is the use of a 35 mm single lens reflex camera equipped with a macro-type lens, set up to yield a $\times 1$ magnification. To this I add a $3\times$ tele-converter to obtain $\times 3$, or two converters of $2\times$ and $3\times$ powers combined to give $\times 6$ magnification. Don't knock this combination until giving it a fair trial, because it is capable of quite remarkable results (see Plates 34 and 35 and Color Plates II–V).

With this setup, I do closeup flash, using a small electronic flash unit having a flash duration of only 1/3000th of a second to help compensate for the added effects of camera or subject motion found at these higher magnifications. Flash distance will be extremely short if the prime lens is used at apertures small enough to result in sufficient depth of field. I usually set up to work at effective apertures (including in the aperture calculation the corrective factor for the converters) in the neighborhood of from f/32 to f/180, in order to get substantial depth of field without really excessive diffraction problems.

Finally, I make use of high resolution films and techniques, as described in the text following page 271, in order to be able to enlarge in printing as much as possible without loss of image detail due to film grain. Although every step must be carried out with great care to avoid or minimize loss of detail, it is possible to obtain high quality black-and-white photographs at final print magnifications as high as $\times 100$. With fine-grained color transparency films, the initial magnification of $\times 3$ to $\times 6$ is sufficient to yield comparable visual effects when the slides are projected at normal screen sizes and viewed at normal distances.

The resolution obtainable is decided by the quality of the prime lens. With my Micro-Nikkor lens it is entirely satisfactory for showing such difficult subjects as the sculpturing on insect eggs, and very fine details of insect and plant materials. My best tests to date indicate air image resolution of approximately 90 lines per millimeter with a $3\times$ tele-converter, in the center of the picture. Actual pictorial resolution is dependent upon the ability of the film to resolve fine detail, and upon the photography being done under circumstances that do not cause loss of quality through undue movement. Even electronic flash won't completely stop all motion, so you do have to be careful.

There are two reasons for using tele-converters, rather than just reversing the prime lens and using long extensions to get the desired magnification directly:

1. By using converters you maintain the operation of the automatic diaphragm of the lens, thus allowing the use of the very fast and versatile two-handed closeup flash camera technique—with minor modifications in handling the equipment for the purpose of cutting down camera movement.

2. Obtaining magnification by means of the converter keeps the working distance un-

changed, where use of extensions would sharply limit that distance as magnification exceeded ×1.

For example, my Micro-Nikkor when set at ×1 has a working distance (subject to front of lens mount) of 2.25 inches, allowing a 30–40 degree lighting angle. At ×6, using both 3× and 2× tele-converters on a basic ×1 setup, these conditions remain the same. But at ×6, using long extensions, working distance drops to about one-half inch with the lens reversed. This produces a 90 degree lighting angle, a very poor situation. If I use my 105 mm Nikkor on tubes to produce a magnification of ×$\frac{3}{4}$, the working distance is about ten inches. Adding both 2× and 3× converters to this setup obtains a magnification of ×4.5, and retains the 10 inch working distance. This allows almost perfectly frontal lighting, because I can place the flash unit right in front of the lens, only slightly off the lens axis. In one situation I used two flash units with this arrangement and took the picture through a space that was roughly one-quarter of an inch wide, between the lights. Alternatively, and using a longer flash distance, it allows field photography of portions of living subjects which are too shy to let you get ordinarily close. Because of light loss when using converters I have found ×6 to be a practical maximum for magnification for outdoor work. At anything higher, the ground glass image becomes too dark for satisfactory viewing and focusing, even in sunlight. In addition, it becomes exceedingly difficult to hold the camera still enough to keep the subject centered in the viewfinder. Working at ×3 or ×6, hand held, is difficult, and requires extraordinary concentration, but is technically quite practical.

As noted in the text following page 296, there is a necessary exposure compensation when using tele-converters. You must correct by adding a number of stops equal to the power of the converter. Thus, if you start with an aperture setting of f/11, going to ×1 gives an effective aperture of f/22. Introducing a 2× tele-converter changes that to f/45; or a 3× converter makes it f/64. This same need for correction applies when converters are stacked, so that 2× and 3× converters used together add up to a need for five stops of correction and would bring the effective aperture to f/128. It is important to remember that when you stack converters the powers multiply (so that 2× times 3× gives ×6 from a basic ×1 setup), but that the exposure compensation is additive (two stops plus three stops equals five stops).

If you know your standard flash distance for a ×1 setup, it is quite easy to figure the distance for work with converters where you wish to maintain the use of the same indicated f-number (rather than open up the aperture to keep a similar effective aperture). With a 2× tele-converter, halve the flash distance of a ×1 setup. (There is a two-stop correction to make, and halving the distance does it.) With a 3× converter, use one-third of the normal ×1 flash distance; or, alternatively, halve the distance and open the lens aperture one stop.

It is important to remember that when a converter is used, its placement is a significant factor. If you want to get the magnification indicated by its power, use it next to the camera body, and place the prime lens and its attendant extension tubes out in front. Putting all of the extension tubes required for a ×1 setup behind the converter, so that the latter is sandwiched between the tubes and the prime lens, results in drastically lowered magnification for the prime lens, and thus for the combination.

This does *not* mean that tubes should never be used behind converters, however. If you have

a 2× converter and two sets of extension tubes (or a ×1 macro-type lens plus a set of normal tubes), but no 3× converter, you can do yet other things. A ×1 setup with a 2× converter gets you ×2, as we have seen. With a 55 mm prime lens, if you put 27 mm of extension tubes behind the 2× converter in this setup you get ×3—or the effect of a 3× converter. Furthermore, if you place 55 mm of extension tubes behind the 2× converter, you get ×4, or the effect of a 4× converter. A similar increase in basic magnification occurs with a 3× converter behind this ×1 setup. With no tubes behind the converter the image magnification is ×3; add tubes with a total length of 50 percent of this prime lens focal length and you get ×4; add 100 percent and you get ×5—the effects of 4× and 5× converters, respectively. You may point out that the same magnification could be obtained by placing all of the extension tubes in front of the converter. That is true, but there is a difference. With the extra tubes behind the converter, the working distance remains at the ×1 value (2.25 inches, with my Micro-Nikkor); but, when they are placed in front, working distance becomes that of the magnification obtained without the converter, a figure that varies according to the magnification, but is always substantially shorter.

This method of increasing the power of a tele-converter works only in closeup or photomacrographic practice. As a way of increasing telephoto magnification it fails, because, in order for it to work, the negative lens of the converter would have to be moved further forward in its own tube (see Keeling, in the Bibliography). And it cannot be so moved. Without this forward movement the prime lens cannot be brought to an infinity focus. The actual ability to come to a sharp focus depends upon the construction of the prime lens, but the furthest point of sharp focus will probably be only one or two feet out in front of the lens.

When dissimilar converters are stacked, it makes a slight difference which one goes where. The tele-converter with the largest exit pupil should be at the rear, for maximum light transmission efficiency. With my equipment, the 2× converter has a larger exit pupil than the 3×; so the 2× goes next to the camera body, the 3× comes next, then the regular extension tubes, and out in front of all of them is the prime lens.

There may be some tele-converter/prime lens combinations that interact to produce a center flare spot, when used with closeup technique, due to internal reflections. My Micro-Nikkor does this with a 2×, but not with a 3× or with 2× and 3× stacked. My 105 mm Nikkor works well in closeup technique with either singly, or with both stacked. But in telephoto work, the 105 mm has a center flare spot when both are stacked, but not when either is used by itself. It is well worth your time to do trial photography with all possible combinations of lenses and converters available to you, in order to locate any such problems in advance of serious work. These flare spots are not apparent to the eye, but show up quite disturbingly on the film. (Do not confuse this effect with the visual impression, sometimes noticed in the viewfinder of a 35 mm single lens reflex camera, where the center of the ground glass may appear more brightly lit than the edges. This is a purely visual phenomenon introduced by the ground glass, and has no effect on the film.)

When maximum resolution is needed, it does make a difference which prime lens aperture is used. You should run a test in which all of the apertures on your prime lens are used, with the camera mounted firmly so that its movement will not affect the results. When this is carefully done you will be able to examine the negative strip and tell which is the best single aperture

to use for high resolution work. I have found that with my Micro-Nikkor set at ×1 magnification I can use the smallest aperture, f/32, to obtain maximum depth of field without significant quality loss. In fact, I can do quite well indeed at this small aperture even when using a 3× tele-converter to get a ×3 magnification. But there is one aperture that does give definitely superior results when I add a 2× converter to the 3×, to get ×6. With my setup this single best prime lens setting is f/8, an effective aperture with the ×6 setup of f/90. Results nearly as good will be had at either f/5.6 or f/11, but other larger or smaller apertures yield distinctly unsharp images, by comparison. This does not mean that you cannot use smaller apertures where additional depth of field is essential. It just means that the overall sharpness will be diminished. In the projection of color slides the difference is seldom detectible, but in extreme enlargements in black-and-white printing it can be seen (see Plates 31, 32, and 34).

In closing this section, I should note that there is a minor exposure penalty in using stacked converters instead of going directly to ×6 by means of long extensions. With 2× and 3× converters stacked to produce ×6 with a basic ×1 setup, there is a total of seven stops difference between indicated and effective apertures. If you get the ×6 magnification directly with long bellows there is a little under six stops difference. However, I feel that the extreme mobility of the stacked converter method more than compensates for the minor disadvantage in effective aperture. (And, a smaller effective aperture carries with it a slight increase in depth of field, all other factors remaining the same.)

Closeup Flash Using a Reversed Camera Lens as a Supplementary, Plus a Tele-Converter, Plus High Resolution Technique In my experience, this is the single most satisfactory method of photographing really small subjects under field or field-related circumstances. The basic method of using a reversed camera lens as a supplementary lens is quite fully covered in the text following page 298, and in Table 24, on page 300. The following presentation is an expansion of that material, using additional fixtures and techniques to get higher image magnifications.

My most favored setup is to reverse a 35 mm PC-Nikkor lens in front of a 105 mm Nikkor. With both lenses set at infinity focus, the image magnification is ×3. Addition of a 3× tele-converter at the camera body, behind the 105 mm lens, provides ×9. Image quality is excellent. With this setup, a series of tests demonstrated that the very best resolution was obtained when the front lens aperture was set at f/4. (Remember that the rear lens aperture remains wide open throughout this usage in order to avoid vignetting the image.) Nearly equal results were obtained at both f/5.6 and f/8, and f/11 gave the best overall compromise between resolution and depth of field. At f/11 the resolution is very nearly as good as at f/4, and the depth of field is markedly increased. At f/16 there is a noticeable loss of sharpness, at f/22 the resolution is poor, and at f/32 there isn't any.

This method has several limiting features not present in the technique described in the last section.

1. The automatic diaphragm action is lost.

2. Working distance is rather short—about $1\frac{7}{8}$ inches (48 mm) in the setup described above.

3. The high image magnification makes hand holding of the camera impractical.

The loss of the automatic diaphragm is not crucial, since handholding is impractical anyway. But it does help if there is a preset feature

on the front lens aperture adjustment that allows rapid stop-down to the preselected opening without any need to look at the setting ring. The relatively short working distance does restrict lighting angles somewhat, but not really importantly. At times it is useful to use two flash units, one at either side of the lens axis, especially if the subject is fully three-dimensional and heavy shadowing would otherwise be present.

The most important consideration in field use of this technique is camera handling. I don't find a tripod very useful. Instead, I just place the whole affair on a reasonably smooth, clean surface (such as a table or a smooth fallen tree trunk). Focusing and framing are done by moving either the camera assembly or the subject. A positioning and holding device for manipulating the subject, as shown in Figure 68, is handy but not essential. Very often, a spring clothespin will serve. If one flash unit is used, the lamp can be held in one of your hands. But when two lamps are used, and especially when there is subject movement, it is more convenient to set them down. Elaborate holding devices for the flash units are seldom needed. Just use any practical means for putting them where you want them. For a two-lamp setup, I place a one-meter flash extension cord on the camera and use a two-outlet connector on its end to plug in the flash synch cords. With small flash units, the flash distance will be very short (using an ASA 32 film, a basic aperture setting of f/11 gives an effective aperture of f/128 at ×9; with my flash units there is a flash distance of about one inch). When all is ready, after focusing, the front lens diaphragm is closed down to the preselected point, and the shutter is released. I use a cable release in order to avoid moving the camera—which is not fastened down—during the exposure.

On really fine grained films the image is of very high quality. I have successfully enlarged in printing as much as 17 times, when using this photographic technique. Starting with a ×9 magnification on the negative, this gives a final aggregate magnification on the print of ×153. My film of choice is H&W VTE Pan (nominally rated at E.I. 80, but exposed at E.I. 32 to 40), processed as directed in H&W Control 4.5 developer. Slightly finer grain is obtained by using H&W VTE Ultra Pan (nominally rated at E.I. 25, but exposed at E.I. 10), again processed as directed in H&W Control 4.5 developer. With my small flash units, the needed flash distance was too short to be practical with this very slow film, so I placed a plano-convex lens of 80 mm focal length directly on the front of the flash head. This concentrated the light beam sufficiently to allow a one-inch flash distance.

Extended Camera, Plus Tele-Converter If the basic resolution of fine detail is good enough in the projected image, you can handily increase the magnification of *any* photomacrographic setup in which you are using a 35 mm single lens reflex camera, by adding a tele-converter behind the extension, next to the camera body. It doesn't matter whether you are using bellows, tandem camera, or long tubing arrangements. Do not forget to include the exposure compensation needed for the converter in all calculations. A through-the-lens meter will take this into account automatically, so no extra figuring will be needed when one is used.

Special Purpose Devices

For use in relatively stable circumstances, such as at well-established base camps or in home institutions, a number of useful special purpose

photomacrographic arrangements are commercially available. Although only two of the better known devices are described here, your technical instrument supplier will be able to provide information on others.

Polaroid Land MP-Series Cameras The Polaroid Land MP-3 and MP-4 vertical copy cameras are useful in photomacrography, and their equipment lists take this into account. They can be operated directly to produce Polaroid prints or slides, or you can use them as the basis for a good tandem camera setup with your 35 mm single lens reflex camera on top. See your dealer for details.

Zeiss Tessovar One of the more ingenious and versatile specialized photomacrographic devices is the Zeiss Tessovar, a zoom optic modular design capable of using 35 mm films with the Zeiss Contarex, Zeiss C-35 CS-matic, Leica, Exakta, or Pentax-type cameras; 120 sized roll films with the Hasselblad single lens reflex, or with Linhof, Super-Rollex, or Rada roll film holders; with 6.5 \times 9 cm sheet films; or with the Polaroid Land film pack back making $3\frac{1}{4} \times 4\frac{1}{4}$ inch pictures. The basic magnification range is from \times.8 to \times12.6, with intermediate levels infinitely adjustable by means of the zoom lens feature. There are four different stands, and a provision for integrated lighting systems including both incandescent and flash illumination. Although it is rather expensive, a look at this item may be well worth your time. See your Zeiss representative.

Focal-Length Variation Techniques

There is a great deal of utility to be derived from the use of lenses other than those of normal focal length. The two extremes, telephoto and wideangle, extending on either side of the normal, are grouped together in this section because they share certain attributes. To a degree, they are the opposite sides of the same coin.

USEFUL FORMULAS

There are four formulas that have been used for many years, in one variation or another, that relate to the selection of lenses by focal length. These are of particular use in field photography. Their usefulness lies in the ability that they confer to determine in advance (or, in some cases, after the photography has been done) the

answers to such questions as how big an unknown subject was, what the image size can be expected to be, what is or was the lens-to-subject distance, or what focal length of lens will be needed to accomplish a given result. If all but one of the basic variables is known, that one can be readily calculated. The degree of accuracy of the result is determined by the accuracy of the "known" figures. There are times when one or more of these will be an estimate based upon knowledge of such things as the average sizes of subjects.

In their traditional forms, all of the formulas use the same five variables, and all are two-step algebraic calculations which first require the determination of image magnification and from that the determination of any one of the other four variables. The most compact reference on this subject is Kodak publication AA-26, *Optical Formulas And Their Applications* (see the Bibliography).

Although it has not been done in other texts known to me, it is possible to express the object/ image relationships in these formulas as simple proportional fractions. When this is done, the variables are reduced to only four, making it practical to do the figuring in a single operation on a pocket calculator (without the need for a "memory" feature), or by similarly simple means.

The basis of the proportional fraction approach lies in the fact that object/image relationships can be described as consisting of two similar right triangles laid apex to apex, as shown in the figure at the bottom of the page. The variables are: h, the subject size; h', the image size; F, the lens focal length; and v, the lens-to-subject distance. Of course, all of the variables must be in similar units of measurement (that is, all in inches, feet, millimeters, or meters, etc.) The basic proportional fraction is

$$\frac{h'}{F} : \frac{h}{v}.$$

To solve for any one unknown variable, it is only necessary to multiply together the two known figures that are diagonally opposed, and then divide the result by the third known figure. In the following section I take one variable at a time, provide an example that relates to wildlife photography, and demonstrate how it can be worked out in terms of a simple formula. Keep in mind that although the examples given will all concern the use of telephoto lenses, all could equally well apply to the use of normal or wideangle lenses. Even though in field photography some of the stated figures will be estimates of sizes that are subject to natural variation, these formulas are extremely useful, if only

as a means of arriving at approximations, and can save you a lot of trouble. They are particularly good for determining the limits of the possible. And if the known figures are accurately determined, this degree of accuracy will carry over to the calculation of the unknown.

Determination of Lens Focal Length Needed

The first of these formulas is applicable during the planning stages of a field trip or expedition. It can allow you to determine the lens focal length that will be needed to produce a given image size from a subject of known size. In other circumstances, it could be used to tell how big a room would be needed to do photography of objects of certain known size with a lens of any specified focal length. Or, it could also be used to tell you what focal length of wideangle lens would be required to photograph a subject of known size where the lens-to-subject distance will be very restricted.

For this first example let us assume that we are to photograph a Great Blue Heron, a bird that stands approximately four feet tall, so as to yield an image on the film one-half inch long, from a distance of 300 feet. See Formula G. (Metric equivalents are provided in parentheses.)

By this calculation we have determined, before leaving our study, what lens to take along (or perhaps even what lens to buy). This is a matter of no small importance when equipping for a jaunt, as there are few things more frustrating than to arrive in the presence of the subject lacking an essential piece of equipment.

Determination of Camera-to-Subject Distance

This formula is usable in either of two ways. You can determine in advance how close you will have to approach a subject of given size, in order to obtain a given image size with a particular lens; or, you can determine after the fact what the approximate camera-subject dis-

FORMULA G
Determining focal length of lens needed

SYMBOLS	DEFINITIONS	EXAMPLES	
h	Subject size	48″	(1219 mm)
h'	Image size	.5″	(12.7 mm)
v	Lens-to-subject distance	3600″, or 300 feet	(91440 mm, or 91.44 meters)
F	Lens focal length	? (unknown, to be determined)	

Formula $$F = \frac{h' \times v}{h}$$

$$F = \frac{.5 \times 3600}{48}$$

$$F = 37.5'' \ (952.5 \text{ mm}) \qquad \left(\frac{12.7 \times 91440}{1219} = 952.6 \text{ mm} \right)$$

FORMULA H
Determining subject distance

SYMBOLS	DEFINITIONS	EXAMPLES	
F	Lens focal length	12″	(304.8 mm)
h	Subject size	15″	(381 mm)
h′	Image size	.5″	(12.7 mm)
v	Lens-to-subject distance	? (unknown, to be determined)	

Formula

$$v = \frac{F \times h}{h'}$$

$$v = \frac{12 \times 15}{.5}$$

$$v = 360'', \text{ or } 30' \left(\frac{304.8 \times 381}{12.7} = 9144 \text{ mm, or } 9.14 \text{ meters} \right)$$

tance was. In this example, let us assume the use of a 12 inch focal length lens to achieve a one-half inch image of a subject 15 inches in size (the approximate wingspan of a White-tailed Kite). Formula H works this out.

The primary value of such a calculation is to determine whether it is likely to be possible to approach close enough for photography by stalking, if the normal approach distance (the "charge or flee" distance) of the chosen subject is known; or to determine whether—and where—you would have to place a blind. Obtaining a distance measurement after photography is less likely to be of importance, but such a possibility should not be forgotten. The value of keeping a full record of all photographic circumstances for each picture should now be getting obvious.

Calculating Image Size

Another place in the planning stage where these formulas are useful is in the advance calculation of the image size, when the other three variables are already known. For this example let us go back to the Great Blue Heron, and find out how big an image we would get if we knew that we could approach to 150 feet, and have a 500 mm lens available to photograph this four-foot-tall bird. This is worked out in Formula I, page 346.

In this manner it is possible to determine whether the equipment at hand will do the job under the given circumstances. If not, either the equipment must be changed, or the technique must be improved (e.g., get a longer focal length lens, add a tele-converter to the prime lens, stalk better, or change to the use of a blind). It is helpful here to stop and consider that the relation of both the lens focal length and the subject distance to the image size is direct. To double the image size, you can either double the focal length of the lens or cut the lens-to-subject distance in half. Which one of these two methods will prove to be more practical in a given situation is a matter to take into serious consideration.

FORMULA I
Calculating image size

SYMBOLS	DEFINITIONS	EXAMPLES	
F	Lens focal length	19.68″	(500 mm)
h	Subject size	48″	(1219 mm)
v	Lens-to-subject distance	1800″, or 150 feet	(45720 mm, or 45.72 meters)
h′	Image Size	? (unknown, to be determined)	

$$\text{Formula} \qquad h' = \frac{F \times h}{v}$$

$$h' = \frac{19.68 \times 48}{1800}$$

$$h' = .5248'' \qquad \left(\frac{500 \times 1219}{45720} = 13.33 \text{ mm}\right)$$

Measuring Subject Size

There are times when it is necessary to measure the subject size remotely, and after photography: for example, when a distant unknown subject is photographed, and you are unable to approach it to measure it directly. If you record the lens-to-subject distance, and note the lens focal length, you can measure the size of the image on the film, after processing, and then use a formula to derive the actual subject size, to within reasonably close limits. Let us assume an unusual subject has been photographed with a 400 mm lens, at a distance measured as being 120 yards (360 feet) and, upon developing the film, we find that the image size is three-quarters of an inch. See Formula J.

Not only can information be gathered about single unknown objects this way; if sufficient information has been kept, the salient parts of a whole scene, photographed with the camera mounted either horizontally or pointed obliquely down, can be reconstructed as a plan view. The measurements may not be critically accurate, but—depending upon the care that was taken in both the photography and the record keeping—they should be close enough for most purposes. A method for deriving measurements directly from photographs which have been produced to a given set of standards by means of an overlying grid and scale is described in Hyzer's article "How To Measure With A Camera." (See the Bibliography.)

TELEPHOTO PHOTOGRAPHY

In this text, the term, "telephoto" photography refers to photography done with lenses of longer than normal focal length. Before getting into actual optical matters, it is useful to come to an understanding of some underlying principles, and these will be the subjects of the immediately following sections. All standard photography texts offer some remarks on telephoto work. In shorter published works, the Edmund

Scientific Company's booklet *All About Tele-photo Lenses* (of special interest for those who like to do it themselves), and Schwalberg's article "What You Should Know About Tele-photo Lenses" are helpful. (See the Bibliography.)

Quality of the Image

Lenses of long focal length are used to obtain a relatively larger image when you cannot, or do not wish to, approach a subject closely. Very often the question of image quality is properly determined not by whether you have the best possible equipment available, but rather by whether the equipment you do have will exceed the image quality of any other approach that is open to you. And, of course, the resulting image must be of sufficient quality to reveal useful information. Thus, although you may not be able to obtain the use of a 750 mm lens, you may very likely be able to get better results with a 250 mm lens and a 3× tele-converter than you can get with the 250 mm lens alone, combined with the necessary three times extra enlarge-ment in printing, to get the needed image size.

The circumstances of use may actually be the controlling factor in image quality. For instance, atmospheric disturbances may produce more loss of image quality than the resolution differ-ence between a superb and a medium quality lens. It may all come down to making the best use of the equipment that you have available. The following sections are intended to help you do so.

Purposes

There are three basic reasons for using long focal length lenses, all of which concern the resulting enlarged image size, but not all neces-sarily concerned specifically with photography of distant subjects.

FORMULA J
Determining subject size

SYMBOLS	DEFINITIONS	EXAMPLES	
h'	Image size	.75"	(19 mm)
v	Lens-to-subject distance	4320", or 360 feet	(109728 mm, or 109.7 meters)
F	Lens focal length	15.75"	(400 mm)
h	Subject size	? (unknown, to be determined)	

Formula

$$h = \frac{h' \times v}{F}$$

$$h = \frac{.75 \times 4320}{15.75}$$

$$h = 205.7'',$$

$$\text{or } 17.142 \text{ feet} \left(\frac{19 \times 109728}{400} = 5212 \text{ mm, or } 5.21 \text{ meters} \right)$$

Apparent Near Approach The first reason for long lens use that comes to the minds of most people is for the magnification of the image that is obtainable from a given camera position, so that there is an apparent near approach to a distant subject, as in bird and other wildlife photography, or in the enlarged-image photography of distant land features (see Plate 37). A telephoto lens is *not* the *equivalent* of a close approach, because of atmospherics and other factors, but is a *substitute,* imposed by necessity.

Distant Closeups Allied to the foregoing, but different because atmospherics should have no significant effect, is the making of "distant" closeups of small subjects, taking advantage of the long working distance of long focal length lenses. Thus, it is easier to get good photographs of timid creatures such as butterflies, dragonflies, snakes, or frogs; or of dangerous animals, such as poisonous reptiles and small fierce mammals. (See Plate 38 and Color Plate X.)

Perspective Adjustment The third long lens use is more subtle, and requires understanding of the optical circumstances. First of all, there is the optical fact that, at a given f-number setting, there will be less depth of field when image magnification is increased. Second, if the image magnification on the film and the f-number of any two lenses are equal, the depth of field will be the same in any given situation. But the maintenance of equal magnification will require different camera-to-subject distances for lenses with different focal lengths. Therefore, there are relative size differences between foreground and background subject matter. If size comparisons are to be indicated between subjects at various distances, the longer the focal length of the lens the less the scale difference between the subjects, because of the increased working distance, as shown in Figure 67, page 332 (see also Plate 39, page 357).

Types of Lenses and Attachments for Tele Work

There are a number of ways to vary focal length through the choice of lens type or lens attachments. Not all of these methods use what are known as "true" telephoto lenses.

Long Focus Lenses Any lens whose focal length is longer than that which is considered normal for the film size in use can be used to obtain an image magnification greater than that of the normal lens. A lens of normal configuration—that is, one whose "optical center" is at or near the physical center of the lens or lens aggregation—is called a "long focus" lens when used to do enlarged-image photography with a film format that is smaller than would be considered normal for that particular focal length. The next three sections discuss three categories of long focus lens types, together with certain details of their use.

Pinholes. The very cheapest solution to the problem of achieving long focal length (or any other focal length, for that matter) is the pinhole —which is, strictly speaking, not a lens at all. The place of the lens is taken by a very small round hole. However, it acts enough like a lens to have real utility, and the possibility of using one should not be discounted. There are times when it might be quite satisfactory (see Plates 40 and 41, pages 359 and 361).

PLATE 37 ▶

Telephoto photography—apparent near approach. Common egret (*Casmerodius albus*), photographed with a 105 mm telephoto lens, backed up with a 3× tele-converter, with the camera handheld. I mistakenly approached up sun, and the resulting back lighting gives a poor idea of coloring. The bird was frightened off by approaching children before I could circle around it.

"Focal length" in pinhole photography is simply the distance between the hole and the film plane, and can be varied at will. Photographically, though, the best quality is obtained when the size of the hole is correctly matched to the intended focal length. With an excessively small hole the image will appear unusually unsharp because of excessive diffraction, and an unnecessarily large hole will also not give as sharp an image as the optimum size because the light beam passing through will not be sufficiently restricted for the hole to act as a lens. The optimum size pinhole is one that is as small as it can be without having the unwanted excess diffraction effects of one that is *too* small. This matter is investigated further, shortly.

There are several useful sources of information on pinhole photography. The technique is rather widely used at present in teaching certain aspects of basic photography. It also fits into the current vogue for exploration of antique photographic procedures. Among the best sources are Shull's *The Hole Thing,* Kodak publications AA-5 and T-23, and —for theoretical background—Kingslake's *Lenses in Photography,* pages 60–63 (see the Bibliography).

As a lens for 35 mm photography, the pinhole is not very satisfactory, since its resolution is not good enough to allow significant enlargement in printing. However, if you are working with larger negative sizes, which require no enlargement in printing, a pinhole may very likely satisfy some of your photographic needs. In fact, the larger the film size used, and therefore the larger the size of a contact print, the more satisfactory pinhole photography will be. With increased print size (assuming the use of contact prints rather than enlargements), the comfortable viewing distance for the picture as a whole increases faster than the definite but lesser increase in the size of the smallest resolvable details.

As a guide to expectations, you can assume that a print that resolves five line pairs per millimeter (using standard testing charts) will look sharp to the naked eye on ordinarily close examination. A contact print from a correctly made pinhole negative will resolve something like two line pairs a millimeter, depending on the focal length and thus the size of the hole. (The resolvable detail recorded on the film will have a minimum size of about twice the diameter of the pinhole.) Thus, it will not be quite as sharp as a picture made with a lens of ordinary quality.

PLATE 38 ▶

Telephoto photography—distant closeups. Hyla, the Pacific tree frog, (*Hyla regilla*), photographed in a marsh, shown about actual size. Original photography was on 35 mm Ektachrome-X color slide film, later copied onto Panatomic-X sheet film and contact printed—thus the black-and-white film does not contribute to the grain problem. This series demonstrates the value of tele-converters in distant closeups. All frames have been enlarged to a common final print magnification, indicating that it is better to have enough magnification to start with, than to overenlarge in printing. (a) Photographed at about a 40 inch (1 meter) distance with a 55 mm Micro-Nikkor lens. Excessive enlargement gives poor results. (b) Made with a 105 mm Nikkor lens at the same distance as (a). It is somewhat better, because less magnification was required in printing. (c) The same individual in the act of calling. Photographed at the same distance as (a), with the 105 mm Nikkor lens supplemented by a Vivitar 3× tele-converter. The image magnification on the film is almost six times as great as in (a), and film grain is no longer a problem. Soft ground prevented the use of a tripod, and the light was so dim that the shutter speed had to be 1/60 second since I had no flash unit with me; but, this is still a useful picture. Keep in mind that the equivalent focal length was 315 mm, and that 300 mm focal length prime lenses can seldom be focused as close as 40 inches. The 105 mm prime lens used here was opened to f/2.8, its widest aperture, which, when used with the converter, gave an effective aperture of f/8.

a

b

c

However, it will approach the ability of a printer's half-tone screen to reproduce it, unless an unusually fine screen was used (as in this text). The resolution may even exceed the reproduction capacity of newspaper half-tones.

Photographic pinholes are commercially produced, but may not be readily available. Therefore, you may find it most convenient to make them yourself. Materials are quite easily obtained. It is important that the material that is pierced in order to make the pinhole be very thin and absolutely opaque to light. Ordinary lightweight household aluminum foil will do, but the material usually recommended is shim brass, used in garages and machine shops to fit loose parts in metal work. You can get shim brass at automotive supply houses. The thickness to ask for is 1/1000th of an inch (.001"), though .002" will do. The actual holes are made by piercing with an ordinary sewing needle (*not* a sewing *machine* needle). Fortunately for us, needles are made to close tolerances in standard numbered sizes, the size referring to the full shank diameter. An assortment that contains several each of all the sizes likely to be needed can be purchased for well under a dollar.

You cannot just stab the needle through, or you will get a basically square hole, somewhat oversize, and with burrs of metal curling up around it. Because of induced diffraction and other effects, such holes produce poor image quality. The needle should be "drilled" through, by rotating it as it goes. For best results, start a minute hole from one side, then reverse the piece of brass and drill the rest of the way through from the other side. This minimizes burring, and keeps the hole both round and to the correct size. Any remaining burrs can be removed by gentle sanding with crocus cloth (a fine abrasive material available where you get the brass).

The size of the hole is important for two reasons. It is related to the focal length at which it is to be used in order to give an optimum compromise between basic image sharpness and introduced fuzziness due to diffraction; and it is the basis for the f-number determination that you will use for calculating exposure times. There is no advantage in varying from the stated optimum size, because the image quality worsens as you depart from that size in either direction. Therefore, you must vary either the film

FORMULA K
Determining optimum size for pinholes

SYMBOLS	DEFINITIONS	EXAMPLES[a]
F	Intended focal length	12 inches (304.8 mm)
D	Diameter of hole	?(unknown, to be calculated)

		English system	Metric system
	Formula	$D = .006 \sqrt{F}$	$D = .032 \sqrt{F}$
		$D = .006 \sqrt{12}$	$D = .032 \times \sqrt{304.8}$
		$D = .006 \times 3.465$	$D = .032 \times 17.46$
		$D = .02079$ inches	$D = .558$ mm

[a] For reasons not apparent in Kingslake's text, there is a slight disagreement in results. It could be resolved by substituting .03 for .032 in the metric calculation.

FORMULA L
Computing f-numbers for pinholes

SYMBOLS	DEFINITIONS	EXAMPLES
D	Diameter of pinhole	.021 inches
F	Focal length	12 inches
EA	Effective aperture	?(unknown, to be calculated)

Formula
$$EA = \frac{F}{D}$$
$$EA = \frac{12}{.021}$$
$$EA = f/571$$

speed or the exposure time to adjust for a correct exposure.

Kingslake, in *Lenses in Photography,* offers two formulas for calculating the optimum pinhole size, one for use with inch measurements and the other in the metric system. I will work out an example with the former, and provide the latter along with it. (See Formula K.)

It happens that a #9 sewing needle has a shank diameter of .021 inches.

Calculation of the f-number of a pinhole, for purposes of exposure computation, requires another calculation, as shown in Formula L.

Quite obviously, this is a very small aperture. Therefore, it is a good idea to use a very fast film. You can use Table 29 to work out the correct exposure, using your light meter to obtain the basic information, or using the methd of estimation, as shown in Table 6 on page 100 and its accompanying text.

In order to reduce the need for calculation, I have made a combined tabulation of all of the foregoing, worked out for a number of focal lengths and including sunlight exposure estimates for three common film speeds. This information is given in Table 30, page 354.

To mount a pinhole aperture as a lens, use an opaque lensboard with a center hole about one-eighth of an inch (3 mm) in diameter. The pinhole is securely fastened down over this hole. For convenience, when variable focal lengths are used, you can scribe a circle around a center pivot hole in a piece of shim brass, and then pierce the pinholes around that line, marking each one with the f-number and focal length. The piece of brass can be trimmed round, and pivoted on the lens board so that any pinhole can be centered, as shown in Figure 69, page 355. Use a regular leaf-type shutter if you wish, but any sort of lens capping will do at the expected long exposure times (hang your hat

TABLE 29
Extended list of f-numbers for pinhole exposure calculation[a]

5.6	22	90	360
8	32	128	512
11	45	180	720
16	64	256	1024

[a] As you proceed up the scale (e.g., from f/90 to f/128) double the previous exposure time at each step, to maintain reciprocity.

TABLE 30
Pinhole aperture and exposure information

FOCAL LENGTH INCHES	(CM)	PINHOLE DIAMETER NEEDED (INCHES)	NEAREST DIAMETER AVAILABLE[a] (INCHES)	STANDARD NEEDLE SIZE[b] NUMBER	EFFECTIVE APERTURE (f-NUMBER)	SUNLIGHT EXPOSURE TIME ESTIMATES (IN SECONDS)[c,d] ASA 32	ASA 400	ASA 1200
1	(2.54)	.006	—[e]	—	166	4	$\frac{1}{2}$	$\frac{1}{8}$
2	(5.08)	.008	—[e]	—	250	8	1	$\frac{1}{4}$
4	(10.2)	.012	.012	13	333	14	$1\frac{3}{4}$	$\frac{1}{2}$
6	(15.2)	.014	.014	12	428	25	3	$\frac{3}{4}$
8	(20.3)	.016	.018	10	444	30	$3\frac{1}{4}$	1
10	(25.4)	.019	.018	10	555	40	5	$1\frac{1}{4}$
12	(30.5)	.021	.021	9	571	45	6	$1\frac{1}{2}$
14	(35.6)	.0225	.021	9	666	50	7	$1\frac{3}{4}$
16	(40.6)	.024	.024	8	666	50	7	$1\frac{2}{3}$
18	(45.7)	.0255	.024	8	750	75	9	$2\frac{1}{4}$
20	(50.8)	.027	.027	7	740	75	9	$2\frac{1}{4}$
25	(63.5)	.030	.030	6	833	85	10	$2\frac{3}{4}$
30	(76.2)	.033	.0335	5	895	90	11	3

[a] These are actual micrometer measurements from a number of needles, of the sizes noted, made halfway up the parallel sided part of the shank.

[b] The needles I used were Scovill Clinton Sharps No. 56S, except for numbers 12 and 13, which were Scovill Clinton Beading Needles No. 56BD.

[c] Table 6, page 100, lists the changes needed for other outdoor lighting circumstances.

[d] The exposure times listed are close approximations, except that they do *not* include compensation for reciprocity failure. As a rule of thumb, increase exposure time by one stop at 1 second, by two stops at 10, or by three stops at 100 seconds. (See Kodak booklets N-12A and N-12B.)

[e] These holes are made by trial and error, using only the point of a needle. Compare the sizes with a magnifier. For .006, make a hole half the diameter of that produced by the full shank penetration of a number 13; for .008, half the number 10. All the other holes listed require penetration to the full shank diameter of the sizes listed.

over the front, for instance). Chemical blackening—not painting—of the pinhole aperture plate is recommended, though not absolutely required.

As previously noted, the image resolution of pinhole photographs is quite satisfactory for many purposes. What is not commonly realized is that image sharpness can be optimized through the use of relatively long "focal lengths" —though most photographers first coming to pinhole use are intrigued by the wideangle effects that are possible. This possibility occurs because the size of the pinhole that is optimum for the longer focal lengths is not greatly larger in diameter than that needed for the shorter ones. For example, if the "focal length" of a pinhole is doubled, the linear magnification of the image is also doubled; and thus, smaller subject detail becomes more clearly visible. However, this gain is not completely realized because doubling the focal length requires using an optimum pinhole diameter that is ap-

proximately 50 percent greater (see Table 30, facing page); and, as was noted on page 350, detail resolved on the film is related in size to the actual diameter of the pinhole. Nevertheless, there will be a distinct gain in the apparent sharpness when longer focal lengths are used with optimum sized pinholes (see plate 41, page 361). In the viewing of contact prints this impression is increased again when relatively large film sizes are used, since comfortable viewing distance is longer with the larger picture sizes.

In publication use, pinhole photographs will be more acceptable if the picture is to be reduced in reproduction, since this reduction will itself increase the impression of sharpness. And the visual impression of greater sharpness that is produced by this size reduction during reproduction is independent of the "focal length" used in the original photography.

The last remaining matters concern focusing and composing with pinholes. The former is easy, since there is none needed. Just set the camera extension for the focal length wanted and place the appropriate pinhole in place. The depth of field is close to infinite. Composing the image is a greater problem because of the very small relative aperture, and the very dim image that results. The most ingenious method for large cameras is simply to remove the ground glass back, rotate the camera exactly 180 degrees front to back, and sight through the one-eighth inch center clearance hole. The edges of the frame, where the ground glass normally sits, will delineate the edges of the material that will be included in the picture. When you get the framing exactly right, rotate the camera 180 degrees, so that it again faces the subject area, replace the camera back, put on the appropriate pinhole, load the film, and expose. Things may go a little more quickly if the aperture wheel has a one-

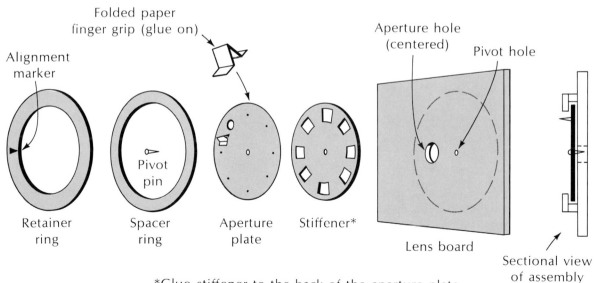

*Glue stiffener to the back of the aperture plate with contact cement. A paper circle, marked with the focal length and f-number markings can be glued to the front of the plate.

FIGURE 69
Construction details of a revolving adjustable pinhole.

eighth inch sighting hole, as shown in Figure 69.

As an alternative, you can use the one-eighth inch hole for framing and composing. This avoids the need to turn the camera twice, both times very accurately. The image will be dim, since this is a relative aperture of about f/80 (for a 10 inch focal length), but the use of a focusing cloth over your head should make it visible. The image will be grossly unsharp, but adequate for framing purposes. Don't try to focus it—it won't work.

This may seem like a lot of space to have devoted to a relatively esoteric technique, but since most texts provide little or no information on this matter I felt it worthwhile to go into detail. Try it. You may like it. The very long exposure times in themselves offer an interesting possibility. People and objects passing in front of the camera will not be recorded on the film, unless they stand still for significant portions of the exposure. In conjunction with the deliberate choice of slow films, pinhole cameras have been used to record busy streets as though almost entirely devoid of traffic, and the interiors of cathedrals have been photographed using exposure times running to several days in length, so that whole church services pass unrecorded. You may find analogous situations in the field.

Simple Lenses. A step up from the pinhole is the simple one-element lens. The most practical one to use is a slip-on closeup lens of +3 diopters, which has a focal length of 333 mm, or about 13 inches. The +1 diopter lens has a focal length of one meter (1000 mm, about 39.4 inches); the +2, one-half meter (500 mm, about 19.7 inches). Since in a given set of supplementary lenses the diameter is the same for all, the longer the focal length the smaller the relative aperture. Thus the +1 and +2 lenses, used

by themselves with no prime lens, would require very long camera extensions, and would be very slow. The +3 lens can be used with a reasonable amount of extension, and has a reasonable relative aperture (Plate 45, a, page 375).

If a simple lens is used at maximum aperture, the image will have a serious lack of sharpness, due to uncorrected lens aberrations. However, the use of a small aperture, so that the picture is made only with light that has passed through the center of the lens, corrects enough of these to provide a quite usable image, even with 35 mm cameras. (The reason for image quality improvement is less that you get benefit from using only the central part of the lens, than that the resulting small aperture minimizes the effect of several types of aberrations.) Provided that they are used with effective apertures of f/16, 22, or 32, surprisingly good results can be achieved with simple lenses. Best results will be achieved at f/45. Rings of black paper fastened to one side of the lens will make adequate single stops. (For a +3 closeup lens used by itself as a long focus lens, f/16 is a hole 21 mm, or 53/64ths of an inch, in diameter; f/22 is 15 mm, or 19/32nds of an inch; f/32 is 10 mm or 25/64ths of an inch; and f/45 is 7.5 mm, or 19/64ths of an inch. These measurements are

PLATE 39 ▶

Telephoto photography—perspective adjustment. Rocks along the trail between Porcupine Creek and the north rim of Yosemite Valley. (a) A lens of 8¼ inch (210 mm) focal length was used, with an 8 × 10 inch view camera. (b) Here a 12 inch (305 mm) lens was used, but the camera was moved back so that the fallen tree in the foreground remained at about the same image size. Note that the background rocks are rendered substantially larger. The result is a change in perspective. The difference achieved is, in 35 mm camera terms, equivalent to going from a 35 mm lens to a 50 mm, or from a 50 mm lens to a 70 mm.

a

b

close approximations, which are adequate for photographic exposure purposes.)

For operational convenience, I have at times fastened my +3 lens to an old shutter with an iris diaphragm in it, using the ubiquitous black photo tape, and then recalibrated the aperture dial. To hold the shutter, I stack a series of ordinary commercial extension tubes to get sufficient length, and use an adjustable length tube at the front end as a focusing mechanism. An inexpensive bellows attachment would serve as well, but would be bulkier and possibly less rigid.

Image quality is quite adequate for a color slide as a supplement for a series, or for black-and-white pictures not requiring excessive enlargement. In black-and-white photography, the use of deeply colored filters increases the image quality by limiting color aberrations. Focusing should be done with the filter on the lens. Such a lens could be used reasonably satisfactorily with film sizes up to about $2\frac{1}{4} \times 3\frac{1}{4}$ inches. Above that, edge effects, such as coma, rapidly become apparent. There is no exposure compensation needed when such lenses are used as telephoto lenses out on tubes, because the tubes are simply spacers to get the lens out to its required normal position.

Complex Lenses. Image quality in long focus lenses rises sharply as their optical quality and complexity increases. The next step up from a single-element lens is a two-element cemented achromat, available in various forms and sizes from such firms as Edmund Scientific Co. of Barrington, New Jersey. The advantage lies in color correction, and the lens is mounted and used as previously described for simple lenses. Small apertures are still recommended, but the f/16 to f/22 range is more practical here than with the single-element lenses.

Beyond that, we get into the use of any lens designed for use with a larger film size. The 12 inch (300 mm) Goerz Dagor is an excellent normal lens for an 8 × 10 inch view camera, for example. It can also be a surprisingly good long focus lens for smaller film sizes, right down to 35 mm. The mounting methods that I use are those previously described. As a matter of principle, I try to make all items of equipment do at least one thing that the manufacturer never intended, in search of maximum versatility at minimum expenditure.

Telephoto Lenses A true telephoto lens is one whose optical components result in a lens and lens mount that is shorter and more compact than an ordinary lens of the same focal length; or that, like those used with press and view cameras, are normal in size, but allow the use of substantially shorter camera extensions than would otherwise be the case. Although any given lens may have quite a number of glass elements, a telephoto lens is basically made up of a magnifying lens with a diminishing lens placed behind it, somewhat similar to a Galilean

PLATE 40 ▶

Telephoto photography—pinholes. Pinhole photography can have genuine utility in nature photography if the primary need is a rather good impression of the overall view, rather than razor sharp detail. It is most practical with the larger film sizes. (a) A high quality lens of $8\frac{1}{4}$ inch (210 mm) focal length was used to give a sharp, clear rendering on 8 × 10 inch sheet film. (These pictures are contact prints of portions of negatives.) (b) A pinhole .021 inch in diameter was placed $8\frac{1}{4}$ inches from the film plane. The view is the same, but there is a softer, less harsh, look to things. This can be a very pleasant visual effect, and is being used to a considerable degree in some types of contemporary art photography.

a

b

telescope. In terms of the optical situation, a normal lens with a tele-converter behind it becomes a true telephoto lens.

Mirror Optics If you want to have very long focal length combined with great compactness, the ultimate example is the mirror optic—which is basically a form of reflecting telescope, with some refracting elements. These optics literally fold the light path back on itself twice, so that they are physically very short for their focal length. For instance, the Celestron 5, with a 50 inch focal length, has an overall length of only 12.5 inches ahead of the camera body. This instrument, fundamentally a Schmidt-Cassegrain celestial telescope, is also available in a version for terrestial camera use, and is optically somewhat like the Questar, which is a Maksutov-Cassegrain design. These extreme long focal length devices are difficult to use well, because of the absolute necessity to exercise knowledge and care at all times. Focusing shifts tend to be slow. Vibration control is a severe problem, as are atmospherics at long subject distances. More practical for photographic use are the mirror optics specifically designed as camera objectives. These are frequently of 500 mm focal length, although both shorter and longer ones are made, and good examples are made by Zeiss, Nikon, and others. Their major advantage is in their speed of focusing, due to a different mode of construction. (See Plates 43, 44, 48,b, and 49, and Color Plate XI for examples of mirror optic photography.)

All mirror optics suffer from certain basic design factors that tend to limit their utility. These include the following:

1. Fixed aperture: a necessity with mirror optic construction. All exposure adjustments are made by changing either the shutter speed or the film speed, or (in a few cases) by the addition of neutral density filters.

2. Ring aperture: the secondary mirror at the front of the system blocks out center light. Although this does not affect the in-focus image, out-of-focus specular reflections may be rendered as characteristically doughnut shaped. Actually, this is noticeable only when the specular reflections are out of focus to a certain specific degree. In most pictures this is not the case. Usually, the reflections record as shapeless blobs. (See Plate 43, and Color Plate XI, left.)

3. Critical adjustment: centering of all elements and accuracy of optical manufacture must both be to unusually high standards, because any slightest failure in these respects is substantially more detrimental to image quality

PLATE 41 ▶

Telephoto photography—pinholes. Longer "focal length" pinholes may give better results, so the usual wide-angle use of pinholes might not be the most appropriate application of the technique. (a) A .021 inch pinhole was placed 12 inches from the film plane. The resulting image magnification equals that of a 12 inch (300 mm) focal length lens. (b) The pinhole here was .024 inch in diameter, and the distance between it and the film plane was 16 inches (400 mm). These pinhole sizes were figured to be "optimum" for their equivalent "focal length." Since the size of the pinhole is related to the size of the smallest detail that can be imaged, since this size increase is proportionately less than the increase in both the focal length and appropriate film size, and since larger pictures are normally viewed from a greater distance, the visual perception is of greater sharpness as the "focal length" goes up. If the work done is for publication, there is an advantage in working in large film sizes and then having the picture size reduced in reproduction.

a

b

than a corresponding amount would be with refracting lenses.

4. Light distribution: a very frequent characteristic of mirror optics, especially visible in terrestial use, is an uneven distribution of light. The usual effect is one of a circle of even distribution in the center of the film, which grades off noticeably around the edges. Though relatively unimportant in biological recording, it is disturbing in some other uses. This effect is noticeable mainly when there is an even-toned background, as with birds photographed against the sky. If there is any clutter in the background, the uneven light distribution is much less apparent. (See Color Plate XI, right.)

However, for their designed purposes, notably the distant recording of birds and other unapproachable small subjects, these optics are hard to equal. (See Plates 43, 44, and 49.) With single lens reflex cameras, the best results will be obtained with the camera mirror locked up, so as to minimize vibration problems. Only a few makes of cameras allow this. But, the nature of the photographic situation may preclude locking up the mirror, anyway. The use of sandbags, for both support and the addition of mass (as described on page 378), is always desirable and often necessary, when mirror locking is not practical.

Add-On Lenses As with closeup photography, you can increase image magnification through the use of various types of auxiliary lenses.

Simple Lenses. The least expensive approach to increased focal length, and one that is both quite practical and versatile, is through the use of double concave, or plano-concave single element slip-on lenses of negative power (also known as diminishing, or minus lenses). These are sometimes available in diopter ratings similar to the closeup lenses described earlier, but usually are not as easily obtainable. A convenient selection would comprise -1, -2, -3, and -4 diopters, but you may have to make do with intermediate values. Negative lenses, in a variety of focal lengths and diameters, are available through the Edmund Scientific Company, of Barrington, New Jersey, but are likely to come in focal lengths that correspond to odd diopter values such as -1.25 or -4.2. You can determine the diopter value by dividing the focal length (in mm) into 1000. Thus, a -157 mm lens has a diopter value of -6.3, and so on.

Placed over the front of your camera lens, these minus lenses increase the overall focal length of the system. They then require that the lens assembly be placed out on extension tubes or be mounted, more conveniently, on a bel-

PLATE 42 ▶

Telephoto photography—tele-converters vs prime lenses. There is near unanimity among photographic writers in saying that a lens augmented by a tele-converter is inferior to a prime lens of the same equivalent focal length. Except for minor unsharpness at the picture corners because of induced curvature of field, I have not found this to be so. Compare the equal-magnification pictures shown here. (a) Scene on the lower slopes of Mount Diablo, California, east of San Francisco Bay. The lens used was a 105 mm Nikkor of excellent quality. (b) The same photographic situation, but with a Vivitar 3× converter added, giving an equivalent focal length of 315 mm. (c) A 300 mm Astragon of proven fine quality. (This lens itself can serve as a good prime lens for use with tele-converters.) Note that there is no significant difference between (b) and (c), except for minor field curvature. Because of film grain interference, picture (a) is inferior. (The film used was Kodak Panatomic-X, and the enlargement in printing was about three times as great for (a) as for (b) and (c).

a

b

c

FORMULA M
Determining combined focal length with add-on minus lenses[a]

SYMBOLS	DEFINITIONS	EXAMPLES
f	Focal length of prime lens	210 mm
f'	Focal length of minus lens	−333 mm (−3 diopters)
d	Distance between lens centers	25 mm
F	Equivalent focal length of the combination	? (unknown, to be calculated)

Formula

$$F = \frac{f \times f'}{f' - f + d}$$

$$F = \frac{210 \times 333}{333 - 210 + 25}$$

$$F = \frac{69930}{148}$$

$$F = 472 \text{ mm}$$

[a] The minus lens must have a numerical value larger than that of the camera lens, or it will not be possible to bring the combination to a focus. The assembly would then be a minus lens as a whole, and thus be unfocusable. In the formula, the minus sign of the lens is ignored arithmetically, since it cancels out.

lows because of focus changes. Formula M shows how to calculate the combined focal length when minus lenses are added on.

For general information, as well as for use in calculating exposure compensation, an additional simple formula (Formula N) provides the degree of magnification that is gained with the combination.

It should be noted that, with a given minus lens, the magnification that is achieved is proportionately greater with camera lenses of longer initial focal length.

Having determined the foregoing, it is now both possible and necessary to calculate the compensation to be used to obtain a correct photographic exposure. Compensation is needed because, although you have increased the focal length of the lens, the actual size of the lens aperture has not changed. Thus, you must determine the effective aperture; this is done by using Formula O.

In order to simplify matters for the reader, I have tabulated the results of calculations for some of the more likely lens combinations. See Table 31, page 366. (If your lenses differ from these, it will be wise to make your own table and keep it with your equipment.)

Because all use of supplementary lenses introduces some degree of lens aberration, work with minus lenses should be done at reasonably small apertures, for best results. A little experimentation will tell you what aperture yields the sharpest results with your lenses. As a starting point, I would suggest closing your camera lens aperture to at least f/8 with 35 mm camera lenses, and to f/11–16 for lenses designed to be used with large cameras.

Tele-Converters. More complex in optical construction, but simpler to use, tele-converters (or telextenders) are a popular solution to telephotography problems. A tele-converter is a form

FORMULA N
Determining magnification gain with add-on minus lenses

SYMBOLS	DEFINITIONS	EXAMPLES
F	Combined focal length	472 mm
f	Focal length of camera lens	210 mm
m	Image magnification achieved	? (unknown, to be calculated)

Formula $\quad m = \dfrac{F}{f}$

$$m = \frac{472}{210}$$

$m = \times 2.24 \qquad$ (that is, the image size is 2.24 times greate than it is with the camera lens alone)

of extension tube that carries within it a multi-element optical system, usually composed of four glass elements. In the aggregate it is a minus lens basically similar to the Barlow lens (usually only a two-element system) that is used to increase magnifications at the eyepiece of astronomical telescopes. It is placed behind the camera lens (hereafter referred to as the "prime" lens), next to the camera body.

The effect of a tele-converter, as has been noted earlier, is to magnify the image produced by the prime lens, by an amount equal to the "power" of the converter. Thus, a $2\times$ converter doubles the magnification, and a $3\times$ triples it. Commercial models are available in $1.5\times$, $2\times$, and $3\times$ powers, and in adjustable variations that offer both $2\times$ and $3\times$ powers. There is also a zoom model that goes continuously from $2\times$ to $3\times$. These devices, looked at from another point of view, are also said to "extend" the focal length of the prime lens by an amount equal to the power of the converter. A 105 mm lens used with a $2\times$ converter has an equivalent focal length double normal, 210 mm; with a $3\times$

FORMULA O
Determining effective aperture, using add-on minus lenses

SYMBOLS	DEFINITIONS	EXAMPLES
I	Indicated f-number	f/16
m	Image magnification	$\times 2.24$
EA	Effective aperture	? (unknown, to be calculated)

Formula $\quad EA = I \times m$

$EA = 16 \times 2.24$

$EA = f/36.8 \qquad$ (This represents an exposure increase of about $3\frac{1}{3}$ stops.)

TABLE 31
Add-on minus lens tabulation, for telephoto effects[a]

CAMERA LENS[b]	MINUS LENS		INTER-LENS SPACING[c] (IN MM)	EQUIVALENT FOCAL LENGTH (IN MM)	ACHIEVED IMAGE MAGNIFICATION	REAR SPACING[d] (IN MM)	CORRECTION, STOPS NEEDED[e]
	DIOPTERS	FOCAL LENGTH (IN MM)					
105 mm telephoto	−1	−1000	0	117	×1.11	12	$+\frac{1}{3}$
	−2	−500	0	133	×1.26	28	$+\frac{2}{3}$
	−3	−333	0	153	×1.45	48	$+1$
	−4	−250	0	179	×1.6	74	$+1\frac{1}{3}$
135 mm telephoto	−1	−1000	0	157	×1.16	22	$+\frac{1}{2}$
	−2	−500	0	185	×1.37	50	$+1$
	−3	−333	0	226	×1.67	91	$+1\frac{1}{2}$
	−4	−250	0	293	×2.16	158	$+2\frac{1}{3}$
135 mm long focus, 4 × 5″ or 6 × 9 cm normal	−1	−1000	12	153	×1.13	18	$+\frac{1}{3}$
	−2	−500	12	179	×1.32	44	$+\frac{2}{3}$
	−3	−333	12	214	×1.58	79	$+1\frac{1}{3}$
	−4	−250	12	265	×1.96	130	$+2$
210 mm long focus, 5 × 7″ or 13 × 18 cm normal	−1	−1000	25	257	×1.22	47	$+\frac{1}{2}$
	−2	−500	25	333	×1.58	123	$+1\frac{1}{3}$
	−3	−333	25	472	×2.24	262	$+2\frac{1}{3}$
	−4	−250	25	808	×3.84	598	$+3\frac{2}{3}$
300 mm long focus, 8 × 10″ or 18 × 24 cm normal	−1	−1000	35	408	×1.36	108	$+1$
	−2	−500	35	638	×2.12	338	$+2\frac{1}{3}$
	−3	−333[f]	35	1469	×4.89	1169	$+4\frac{1}{2}$
	−4	−250[g]	—	—	—	—	—

[a] Figures are close approximations, suitable for general photographic purposes.

[b] The first two camera lenses are moderate length telephoto lenses likely to be used in 35 mm work. The remaining three are common normal lenses for the sheet film sizes listed.

[c] Spacings listed are approximate. With telephoto lenses, the point to be measured from is at or near the front of the lens mount, so no spacing was listed.

[d] This is the approximate distance of forward motion of the lens that is required to refocus at infinity, after placement of the minus lens.

[e] At infinity focus. Significant additional image magnification through closeup focus would require a different compensation.

[f] Probably not practical, because of the very long additional bellows extension that is needed.

[g] Not applicable, as the minus lens figure is smaller than that of the camera lens, and thus the combination can not be brought to a focus.

converter the 105 mm lens becomes a 315 mm lens.

Virtually all tele-converters have a built-in interlock that retains the automatic diaphragm operation of the prime lens aperture. Converters are available for most makes of 35 mm single lens reflex cameras. I have seen them advertised for many larger single lens reflexes, but not for sheet film cameras. For large cameras, simple minus lenses are usually sufficient. The single best source of information that I know of concerning the optical design and capabilities of tele-converters is Keeling's "Optical Design and Aberrations 15" (see the Bibliography).

The performance capability of tele-converters is an interesting subject. Due to substantial misunderstandings of the nature of optics and of the optimum modes of tele-converter use by the majority of photographers, these devices seem to exist under a cloud. Many professional photographers dismiss them out of hand, without an adequate trial. But, in Keeling's discussion of theory he states that,

> . . . rear converters are well underrated and merit serious consideration by professional photographers and not only budget-conscious amateurs.

My own practical and pragmatic experience confirms this statement. It all comes down to putting tele-converters to use in a way that will take advantage of their virtues, to the maximum degree (see Plate 42, on page 363).

A point frequently lost to sight is that modern camera lenses designed for small cameras will usually resolve finer detail than the commonly used films can record. The true optical capability of the lenses is then masked, because the usual mode of listing lens performance involves combining lens and film data in the formula:

$$R_e = \frac{n}{\sqrt{(1 + n^2)}}$$

where R_e is the effective resolution, and n is the number of times by which lens performance exceeds the film's recording ability. Thus, the film is the real limiting factor.

For example, if a lens that is capable of air-imaging 200 line pairs/mm (not unusual with today's good lenses) is used with a film capable of recording 50 line pairs/mm, the effective combined resolution (R_e) should be calculated as follows, using the formula printed at the bottom of the left-hand column:

$$R_e = \frac{n}{\sqrt{(1 + n^2)}} \qquad n = 4 \ (200 \div 50 = 4)$$

$$R_e = \frac{4}{\sqrt{(1 + 4^2)}}$$

$$R_e = \frac{4}{\sqrt{17}}$$

$$R_e = \frac{4}{4.12311} = .97$$

Thus, the combination—in ideal circumstances of use—should resolve about 97 percent of the basic capability of the film. And 97 percent of 50 line pairs/mm is about 48 line pairs/mm.

To provide a little more background, I will point out Keeling's remark on the effect of tele-converters on basic lens resolution:

> The resolving power [of a lens] in terms of angle, remains practically unchanged by the addition of a converter lens, but in terms of . . . line pairs per mm . . . the value falls in direct proportion to the magnification [of the converter].

Thus, use of a 2× tele-converter with the lens described above will give a value for n of 2. Working the formula with this figure yields a figure of .89, and 89 percent of 50 is about 44 line pairs/mm. Changing to a 3× tele-converter alters the value of n to 1.33, and use of the formula shows that combined effective resolu-

tion will be 80 percent of 50, or about 40 line pairs/mm. All of these levels of performance can be considered as being quite respectable.

But this is still not a final resolution figure for the lens, or for the lens/converter combination. Simply shifting to a film that can record 100 line pairs/mm will change the optimum R_e values to 89, 70, and 55 line pairs/mm, respectively (using the same formula), since using the new film changes the value of n to 2 for the prime lens, 1 for the 2× converter, and .66 for the 3× converter. Changing to a film that can record 200 line pairs/mm again changes the value of n (to 1, .5, and .33, respectively), and the optimum resolution figures become 140, 88, and 62 line pairs/mm, respectively. So, it can be seen that even a 3× tele-converter can be made to produce very fine pictorial results, if a good prime lens and high quality films are used—always provided that impeccable technique is used throughout.

The primary detrimental effects of the use of tele-converters show up in two ways. Some curvature of field is introduced, so that image sharpness at the film edges is somewhat below that at the center. This is partly correctable by closing down the prime lens diaphragm. However, this is often not necessary in field photography of discrete three-dimensional objects, as the subject frequently occupies only the center of the field anyway. In addition, and more importantly, the faults of a poor prime lens are made more apparent when a converter is used. This effect can be cured only by the use of better prime lenses.

The acid test of any piece of auxiliary camera equipment is whether it will enable you to do something that you could not do otherwise. In this respect, tele-converters look good. It is worthwhile to own two or three, of various powers. My basic equipment for 35 mm work includes three lenses, each as good as I can get: a 35 mm PC-Nikkor wideangle lens, a 55 mm Micro-Nikkor macro-type lens, and a 105 mm Nikkor telephoto lens. I use tele-converters with the 35 mm PC lens to provide myself with additional focal lengths of lenses that will shift off center to allow me to keep parallel vertical lines parallel in the pictures (more about this lens, in the text following page 384). With a 1.5× converter this lens goes from 35 mm to 52.5 mm; with a 2× it goes to 70 mm; and with a 3× converter it comes to 105 mm focal length. That provides four choices of shifting lenses, all capable of professional quality results, if used carefully. With that prime lens, small apertures are necessary to retain good optical quality, but these are normal in shift work anyway.

Obviously, this focal length versatility works with any prime lens. As I have described elsewhere, I use tele-converters extensively in closeup photography with the 55 mm Micro-Nikkor as the prime lens. The 105 mm Nikkor is a superb basic telephoto lens, and performs very well as a prime lens for tele-converters. By using three types of tele-converters with three different prime lenses I get the effect of having eleven focal lengths (with one overlap—the 3× with the 35 mm lens comes to 105 mm), with

PLATE 43 ▶

Telephoto photography—mirror lenses. Examples of bird photography, using a 1250 mm Celestron 5 mirror lens (similar to the Honeywell Lumitran). (a) House sparrow (*Passer domesticus*) at 40 feet, enlarged six times in printing. (b) Willet (*Catoptrophorus semipalmatus*) at 140 feet, enlarged 11 times from the negative. There are hints of the characteristic ring-shaped out of focus aperture effects, but nothing significant. (See Color Plate XI, left, for a particularly obvious example.) The greater enlargement of the willet photograph brings the Tri-X film grain into visibility.

a

b

twelve setup possibilities, each with its own characteristics. The total weight of the three converters is about 16 oz., about the same as the 105 mm lens by itself. Total cost of the converters, for a Pentax-type mount, is at this writing under $60. Other mountings cost a bit more. But, even so, the price is low for such versatility.

One of the main useful purposes of tele-converters is to provide initial image magnification on the negative or slide, so as to avoid a need for after-the-fact overenlargement in printing, in which detail tends to get lost in the film grain. In black-and-white, it is demonstrably better in much scientific work (as well as in other contexts) to work at three times increased basic magnification and then enlarge only one-third as much, in order to maintain print quality. For example, if you obtain a one-half inch image on the film with a given prime lens, it will require an enlargement of 14 times in printing, in order to obtain a seven inch print image. At this degree of enlargement, fine image detail is definitely degraded even with such slow films as Kodak Panatomic-X. The use of a 3× tele-converter with the same prime lens will give an initial 1.5 inch image under similar conditions, and this will require only about 4.7 times print enlargement to get a seven inch print image. This degree of enlargement is well within the limits of apparent grainlessness, even for reasonably fast films.

With color slides, later enlargement is generally not practical. Therefore, getting the image large enough in the first place becomes a priority matter. Converters have obvious utility here. And, in projection, a carefully done converter picture usually can't be told from one done with an expensive telephoto prime lens.

A use for tele-converters that is not commonly realized is to obtain greater than normal depth of field. The introduction of the con-verter into the optical train reduces the relative aperture of the system by a number of stops approximately equal to the power of the converter. A side benefit of the exposure penalty is the greater depth of field, if the image magnification is held constant. For example, if the prime lens used for a picture has a minimum aperture of f/22, the effective aperture will be f/45 at ×1 magnification. But, if you set up the same lens at $\times\frac{1}{3}$ and use a 3× tele-converter to get ×1, with the prime lens set at f/22 the effective aperture will be about f/80, a considerable change.

Tele-converters frequently offer a considerable advantage when doing telephoto work at close distances, as with shy wildlife. One of the more interesting converter characteristics is that when a converter is added to a prime lens the lens-to-subject distance does not change. As an example, let us take a small frog that can be approached to a distance of 40 inches. Assume that we have two lenses, a 105 mm and a 300 mm, and that at 40 inches distance the 105 mm lens yields an image one-third of the size that is wanted. The 300 mm lens would give an image the right size—if it could be brought

PLATE 44 ▶

Telephoto photography—mirror lenses. Other examples of 1250 mm Celestron mirror lens bird photography. (a) Belted kingfisher (*Megaceryle alcyon*), an offhand picture demonstrating that even a quick shot that is relatively unsharp may be good enough for species confirmation. (b) Black-necked stilts (*Himantopus mexicanus*) at about 140 feet, enlarged 5.5 times in printing. Note the very shallow depth of field. The bird on the right is sharp, but the one on the left is out of focus, except for its bill. Although the relative aperture of this lens is f/10, (and a photographically effective f/16), which sounds like a moderately small stop, the high image magnification, 25 times as great as the normal lens of a 35 mm camera, results in little depth of field.

a

b

to focus. But most such lenses will not focus much closer than 15–20 feet. Most 105 mm lenses can be focused to at least four feet, and some right down to 2.5 feet. So, we can use the 105 mm lens with a 3× converter, and thereby accomplish what we simply could not do otherwise (see Plate 38).

As has been said earlier, the quality of the image obtainable with tele-converters is dependent upon that of the prime lens; therefore, put your money into good quality prime lenses.

It is a false concept to compare a lens-plus-converter directly to a prime lens of the same overall focal length, in simple telephotography. The prime long lens would normally win out in basic overall sharpness, and would probably have a small speed advantage. Obviously, if you had the choice you would use the long lens. But if you can't afford that long focal length lens, if you need the versatility that converters offer so richly, or if you need to do things that only a converter can do, then tele-converters are great. I don't leave home without them.

Photography Through Binoculars and Telescopes For some people, the most practical way of doing telephotography is to hook up their camera to their binoculars or telescope. This is easy enough to do, and the pictorial results vary from adequate to quite good indeed. There are two particularly good printed sources: Cooper's *Photography Through Monoculars, Binoculars and Telescopes,* and Kodak's publication AC-28, *Picture-Taking Through Binoculars,* the latter a brief but fine leaflet (see the Bibliography).

Photography through a binocular or other such instrument is possible with any camera, but is most practical with a single lens reflex where you can see directly what you are framing and focusing. With any type of camera you must first find the approximate "eyepoint" of the binocular. (I will assume binocular use, because it is what most people have, but the technique is the same for all other similar instruments.) The eyepoint is that position behind the ocular where the emerging light rays converge to their smallest diameter bundle, and it is usually close to one-half inch in back of the rear ocular surface. With nonreflex cameras, a simple and quite adequate procedure is to focus the camera at infinity (if it focuses at all) and place the front of the camera lens at or immediately outside the eyepoint, with the camera axis centered on the axis of the chosen binocular tube. If the binocular has been correctly aimed and focused beforehand, the camera will see and record what your eye would have seen. When looking through a binocular or telescope your eye is focused at infinity, so with the camera lens also at infinity the focus should be correct.

With single lens reflex cameras you have two choices. You can leave the camera lens on or take it off. There are advantages both ways. If the lens is left on, you get a bright circular field approximately centered on a dark ground, the image being insufficient in size to fill the film frame. But by using different camera lenses you can get a variety of image magnifications. With the camera lens removed, you can move the camera body further to the rear and fill the film frame. All focusing must be done on the camera ground glass, with the binocular acting as a telephoto lens, instead of as a supplementary optic. But there is much less image magnification flexibility. I will take these two methods separately, and describe how each is used, with the lens-on method first.

The greatest confusion in binocular telephotography centers about getting the correct exposure. With the camera lens on, the lens aperture must be left wide open, or the edges

FORMULA P
Computing effective aperture of camera-lens/binocular combinations

		EXAMPLES	
SYMBOLS	**DEFINITIONS**	**(A)**	**(B)**
F	Camera lens focal length[a]	50 mm	105 mm
P	Power of the binoculars[b]	8	8
D	Diameter of binocular objective	35 mm	35 mm
EA	Effective aperture, combined[c]	?	?

Examples (A) and (B) assume 8 × 35 binoculars.

For EA: (unknown, to be calculated)

Formula

$$EA = \frac{F \times P}{D}$$

(A) $\quad EA = \dfrac{50 \times 8}{35}$ \qquad **(B)** $\quad EA = \dfrac{105 \times 8}{35}$

$\qquad\quad EA = f/11$ $\qquad\qquad\qquad\qquad EA = f/24$

[a] Changing the camera lens varies both the f-number and the image magnification.

[b] Binoculars and telescopes are rated by power and by the diameter of the objective lens, so that an 8 × 35 instrument is of 8 power and has a 35 mm objective lens diameter. Larger diameters give brighter images, as with camera apertures.

[c] Note that for each lens/binocular combination the effective aperture is invariable, so exposure variation must be based upon shutter speed or film speed changes.

of the lens diaphragm will sharply reduce the size of the recorded circular image. Therefore, the effective aperture must be calculated from a combination of camera lens and binocular factors, as shown in Formula P.

As just noted, the image magnification depends in part on the choice of the camera lens. This is related to the equivalent focal length of the camera-lens/binocular combination, and is calculated as shown in Formula Q, page 374. (Again, two examples are given.) The use of the double examples indicates the value of leaving the camera lens in place on the camera. Changing the camera lens provides a simple way of changing image magnification.

Working with the camera lens removed is another matter, and is most easily done using a through-the-lens meter to determine the correct photographic exposure. Telescopes designed for use in this manner, such as the Bushnell Tele Var or Spacemaster, are provided with instructions concerning the available focal lengths and f-numbers, which vary according to the eyepiece used. When using ordinary binoculars it is necessary to extend the camera out with tubes or bellows, because they do not have sufficient focusing range to come to focus when the eyepiece is close to the film. Given the variability of the mechanisms I do not see a way to give any formula to calculate the film-to-eyepiece distance, or even a reliable table. Therefore, all I can do is quote my experience with two typical instruments, which are representative of low cost types in wide distribution.

FORMULA Q
Computing equivalent focal length of camera-lens/binocular combinations

		EXAMPLES	
SYMBOLS	DEFINITIONS	**(A)**	**(B)**
P	Power of binoculars	8	8
F	Lens focal length	50 mm	105 mm
EF	Equivalent focal length of the combination	?	?
		(unknown, to be calculated)	

Formula $\qquad EF = P \times F$

(A) $\quad EF = 8 \times 50 \qquad$ **(B)** $\quad EF = 8 \times 105$

$\qquad\qquad EF = 400$ mm $\qquad\qquad\qquad EF = 840$ mm

One is a Sears 7 × 35 wideangle binocular, and the other is a Prentiss 8 × 30 binocular.

The Prentiss 8 × 30 glass required a film-to-eyepiece (*not* eyepoint) extension of 110 mm to get it to a point where there was adequate range of focus. At that extension it provided an image magnification closely approximating a 945 mm lens, and the exposure indicated by a through-the-lens meter for ASA 400 film was one-tenth of a second, which suggested an effective aperture of f/64. The size of image circle that was projected was large enough to cover a $2\frac{1}{4} \times 3\frac{1}{4}$ inch film completely.

The Sears 7 × 35 binocular required a 165 mm extension, because it had less focusing range. At that point image magnification was about equal to a lens of 1100 mm focal length. The indicated exposure for ASA 400 film was 1/10 second, at an effective aperture of f/80. So there was about a one-third stop speed difference (see Plate 45,b). In both cases the image circle was large, and—at least in the center part that I used—it was quite good.

Whatever your method, this sort of photography requires that the camera and the binocular be fastened together and placed on a tri-pod. Binocular/camera clamps for the lens-on method are available commercially in camera stores, but you may find it more practical to make your own holder for the lens-off method. In both methods you must take care to align the camera and binocular axes as well as possible, or you will be making pictures with the less satisfactory peripheral image rays. And in both

PLATE 45 ▶

Telephoto photography—simple lenses/binoculars. Examples of makeshift telephotography, to demonstrate the types of quality that can be expected. (a) A fallen tree at 85 feet. The lens used was simply a +3 single element slip-on closeup lens fitted with a makeshift diaphragm, put on my 35 mm camera by means of a long array of tubes. The focal length was 333 mm (no actual camera lens was used). Quality is adequate for many needs, and superior to a pinhole by a noticeable margin. And a lot faster; the setting used here was f/16, but best sharpness would be at f/45. Negative enlargement was ×8.25. (b) This picture was made by removing the lens from my camera and substituting one tube of my Prentiss 8 × 30 binoculars, which approximated a 940 mm lens with a speed of f/64. The image quality is quite adequate. The negative enlargement was ×8.25, and the distance was the same as (a).

methods you must make the camera/binocular joint completely light-tight. If you use a 35 mm camera, place extension tubes on the front to make up the necessary amount of extension; then wrap the join area with black cloth, held by a clothes pin. It may help to front the foremost extension tube with a circle of cardboard that has been pierced to accept the binocular eyepiece. The cloth wrapping is then less likely to leak light.

Aside from limitations imposed by such things as vibration and malalignment, picture quality is most strongly affected by the basic quality of the binocular. With the cheaper instruments, minor to substantial color fringing is likely to be apparent in off-axis areas.

Telephoto Techniques

Whatever your chosen equipment approach, the practice of telephotography requires the use of some rather general techniques if the work is to be of optimum quality, and it is these that are discussed in the following sections.

Choice of Lens Type Given the possibility of choosing among several equipment options, there are what might best be called areas of special competence.

General Telephotography. The most convenient tool for general telephotography not involving extreme technical demands is a good true telephoto lens of moderate focal length, some 2–2.5 times that of your normal lens. Such lenses can be used in much the same manner as normal focal length lenses, without great need for special handling. Really good lenses of this sort, such as the 105 mm Nikkor, can be used to do high resolution telephotography producing negatives capable of astonishing

degrees of printing magnification. I have made prints enlarged as much as 25 times from H & W Control VTE Pan negatives, and only then begun to pick up minor signs of image degradation (see Plate 28, page 277).

Large sheet film cameras do not usually require as much telephoto capacity as is frequently used in 35 mm work. The nature of the subject matter likely to be approached with such equipment seldom requires it. Mostly, it is possible to get along well enough by using simple add-on negative (minus) lenses. For instance, with an 8 × 10 inch (20 × 24 cm) view camera mounting a 12 inch (300 mm) normal lens, −1 and −2 supplementary lenses will yield aggregate focal lengths of about 16 and 25 inches (408 and 638 mm), respectively, a range that about uses up the available bellows length. Using a 5 × 7 inch camera (13 × 18 cm), the preferable supplementaries would be −2 and −3 diopters, providing focal length extension of the normal 8.25 inch (210 mm) lens to about 13 and 18.5 inches (333 and 472 mm), respectively.

Portraiture. Although not especially thought of as a field photography practice, occasional portraiture comes to us all (and to ethnologists very frequently). To preserve the kind of perspective that is familiar to most of us (because of our culture's normal social approach distance), and which will therefore avoid undue apparent distortion of the sitter's features, it is necessary to preserve a certain distance between the camera and the subject. This is especially true for 35 mm camera users, when the intent is a head-and-shoulders portrait. Filling the viewfinder frame with this portion of the anatomy when using the standard 50 mm lens will bring you too close for good perspective, and so close that the sitter will feel a sense of encroachment. My preferred focal length for this use is the 105 mm telephoto. It doubles your working distance, and

makes everyone happier (see Plates 54 and 55).

The larger the film format the longer the focal length of the normal lens, and so the greater the working distance. Thus, distortion and social distance are both less of a problem. With the $2\frac{1}{4} \times 3\frac{1}{4}$ inch format, which has a normal focal length of about 110 mm, I prefer to use a short telephoto lens of from 127 to 150 mm focal length; and with a 4×5 inch (9×12 cm) format, about 180 mm works out well. Beyond that film size, normal lenses are quite acceptable for head-and-shoulders portraits.

Great Distances. Photography of small, active subjects, such as birds or small mammals, at significantly great distances, is a really special problem. If you have it available, one of the best lens choices for this work is the modern high speed mirror optic, such as the f/5.6 or f/8 lenses of 500 to 1000 mm focal length, put out by several manufacturers. These are compact, light, maneuverable, and very high in quality. The comparable refracting lenses are much heavier, much bulkier, and most versions are considerably slower to operate.

Landscape views of very distant subjects do not make the same demands upon equipment or photographer. Any available lens or combination setup of adequate focal length and optical performance will do nicely. Since the subject is static there is no special need for speed and convenience of operation. Mirror lenses are a poor choice for this use because of the characteristically uneven light distribution, the limited ability to adjust the aperture, and the unattractive ring-shaped rendition of out-of-focus points of light.

Distant Closeups. My preferred tool for small camera photography of shy, small wildlife is a moderate length telephoto lens coupled to a tele-converter, particularly the 105 mm Nikon and a 2× or 3× converter. Add to these a set of auto-diaphragm extension tubes and a compact flash unit, and you have a really versatile, fast operating setup for pursuing such things as frogs, lizards, and butterflies. Longer telephoto lenses and mirror optics usually don't focus close enough for handy use with this sort of subject.

Large Mammals. Larger wildlife, such as game animals and big carnivores, again require a fast-acting, convenient type of lens, if you are to get consistently good pictures under genuine field conditions. (Conventional zoos don't count. There, almost any telephoto lens will do, because the animal can neither approach nor run away.) I would recommend, for 35 mm work, two lenses, a 135 mm telephoto and a 500 mm mirror optic, preferably on separate camera bodies.

Working Rules

There are three general principles applicable to telephotography:

1. *Always close the distance* between camera and subject as much as is practical. Halving the distance has the same effect on image magnification as doubling the focal length, and is a lot cheaper. In addition, the less the distance, the less the problem of atmospherics.

2. *Use the shortest focal length* of lens that will do the job. The longer the focal length the harder it is to get good results that are free of atmospherics, vibration effects, etc.

3. *Avoid atmospherics,* such as the burbling of heated air, by avoiding photography over surfaces that produce them: such as heated

surfaces, asphalt paving, bare earth, and the like. The earlier it is in the day the fewer are the atmospheric disturbances. If you are photographing across cool surfaces such as water, get as close to the water's edge as possible, to avoid atmospheric disturbances from the intervening earth. If you must photograph across radiating surfaces, use a camera position that is as high as possible. The closer your line of sight is to the plane of the surface the worse will be the disturbances. For instance, standing is far better than lying down, but even a few inches can make a substantial difference in quality (see Plate 46).

Camera Handling

The method of using the camera has a lot to do with the quality of your photographic results. The two most serious matters are the control of motion and care in focusing.

Motion Control As has been mentioned earlier with regard to high resolution photography and closeup work, control of motion has two primary aspects: the reduction of gross camera movement, and the avoidance of unnecessary vibration. (See pages 278–282 for detailed notes on control of vibration and movement in camera handling.) With telephotography I like to emphasize the value of using a bag of gritty sand as a camera support, rather than tying things down to a tripod, with a second sandbag draped over the top of the lens to provide mass. A big tripod is nice to have, but by itself it is not a guarantee of freedom from motion. Particularly for bird photographers, the sandbag method is convenient when photographing from automobiles. Drape the bag over the ledge of the open window, and use it as a camera

support. Don't forget to turn off the car engine, or vibration will *really* be a problem.

Another problem in telephotography is dealing with subject motion. This has two aspects: the following of linear movement, and the anticipation of sudden bobs, turns, or flights. In the former case, you usually pan the camera along the line of movement, exposing when ready. The subject will be quite sharp, but the background may be streaked (see Plate 47). Do not "lead" the subject, as in shooting. Do not stop the following motion at the moment of exposure, but follow through so as to avoid possible timing inaccuracy. With unexpected motion, your best defense is an intimate knowledge of the subject matter (see Plates 48 and 49). Couple this with studied alertness, and your chances are good.

Focusing This subject has also been considered elsewhere at some length, notably on page 278. No method of camera handling or other photo technique will be very useful in telephotography unless the focusing is critically accurate. A 500 mm lens at f/8 has so little depth of field that you may have to choose which side of a distant bird to focus on. You must make a conscious decision as to the placing of the principal plane of focus, and then see carefully to its accomplishment.

PLATE 46 ▶

Telephoto photography—atmospherics. These photographs demonstrate the severity of atmospheric effects in telephotography. (a) Mustard plants (*Brassica*) at 45 feet, photographed with the lens axis passing a few inches above a sun-heated wooden beam only 5 inches wide. Printing enlargement was ×15. (b) An identical picture, except that the lens axis was raised two feet. These results are repeatable. Both photographs were taken at mid-morning on a fairly cool, cloudy day.

Combination Techniques

It is frequently useful to combine two or more of the general techniques described in this book, in order to obtain a picture of optimum quality for particular purposes. Some suggestions follow.

Telephoto, Plus High Resolution Technique If your camera handling technique has been sufficiently perfected, your lens will frequently outperform the resolution capabilities of general-use films. You can increase the amount and quality of information recorded in telephotography by using 35 mm high resolution technique in conjunction with high quality telephoto lenses. This will provide a generally sharper picture, as well as the opportunity to enlarge to unusually large print sizes, without encountering obscuring film grain effects. (See the text following page 271 for details.)

Tele-Converters, Plus High Resolution Technique The same remarks apply to situations where tele-converters have been used carefully with very good quality prime telephoto lenses. High resolution technique allows you to get the ultimate performance from your optics.

Telephoto, Plus Projected Flash There will be times when the existing light at the subject position is insufficient for good photography, or when the angle of existing light is unsuitable to your purposes. Carefully aimed projected flash lighting will solve these problems. In particular, photography of birds and small mammals can be aided in this manner. Birds are much more likely to alight and perch in the shade or among bushes than they are to stay in full sunlight. (See the text following page 132 for details of technique.) You might even want to add high resolution technique into this system, too.

WIDEANGLE PHOTOGRAPHY

The other side of the coin from telephotography is wideangle work, where the need is to increase rather than to decrease the optical acceptance angle. Wideangle photography makes use of lenses with shorter than the normal focal length. Good information on wideangle photography was included in a pair of articles in a recent issue of *Petersen's PhotoGraphic:* Laurance's "Wide Angles", and Cornfield's "The Conceptual Use of the Wide-Angle Lens" (see the Bibliography).

Purposes

There are four basic reasons for using lenses of unusually short focal lengths in photographing subjects of ordinary size. Not all of these are concerned primarily with the *idea* of increased acceptance angle, but all use it.

Wider Acceptance Angle A lens of normal focal length has an acceptance angle of from 45 to 60 degrees, give or take a little, according to the practices that are usual with the various

PLATE 47 ▶

Telephoto photography—motion control. Examples of following action by panning the camera along the paths of flying birds. (a) Little blue heron (*Florida caerulea*), at Caspar Creek, near Mendocino, a coastal town in northern California. A surprise picture in that the bird flew suddenly while I was stalking it. Note the streaked appearance of motionless highlights in the background. A copy from a color slide, done on Polaroid Land P/N film. (b) Turkey Vulture (*Cathartes aura*), soaring above the slopes of Mount Saint Helena in northern California. With this slower, more deliberate motion there is less problem in getting acceptably sharp pictures. But considerable enlargement in printing this type of photograph may be needed.

a

b

common film formats. But, from a given camera position, not all subjects will fit into this acceptance angle. Examples of subjects that are likely to require wider angles are landscape and habitat views, architectural studies, and any other field situation where the terrain is such as to force you to position your camera much closer than a distance about 120–140 percent of the width of the subject area, measured either horizontally or vertically, according to the intended camera orientation. To assist in visualizing the relations, see Table 32.

Hemispheric Studies Occasionally there is a need to use a lens coverage of 180 degrees, in order to record everything in a complete hemisphere in front of the camera. This is really just an extreme example of a need for a wider than normal acceptance angle, but it is so special a case that it deserves separate consideration. As examples, take whole-sky studies of cloud formations for meteorological research or other studies that require monitoring of cloud cover (see Plate 50, page 393). Or take a need for a photograph, made from the mouth of a shallow cave or rock shelter, that must include all aspects of the floor, walls, and ceiling, to serve as a survey picture prior to entry or excavation. (This latter example might be lit by a bare flash bulb placed next to the camera, just behind the area covered by the lens, and as nearly as possible equidistant from all major surfaces.)

Apparent Distance A use for wideangle lenses that does not directly involve the concept of increased angular view occurs when you desire to make it appear that a given camera-to-subject distance is greater than it actually is.

Perspective Arrangement Another such use occurs when you wish to exaggerate the relative

sizes of subjects at different camera-to-subject distances. See the related remarks concerning telephotography, on page 348.

Briefly, if you have two similar subjects to photograph, one placed very near the camera will appear larger than the one that is further away. By changing lenses you can change the relative size difference: if you vary the camera-to-subject distance after changing lenses in such a manner that the image size of the nearer subject remains the same, the shorter the focal length of the lens the smaller the further subject will appear to be—even though the actual distance between the subjects is unchanged (see Plate 39, page 357, for an example). This technique can be used to place visual emphasis on the nearer subject, when there is no need for direct size comparisons. It is quite an effective technique.

Types of Lenses and Attachments for Wideangle Work

As with telephotography, wideangle work can be done with a variety of types of lenses; however, the types of lens specializations differ considerably from those used in telephoto work.

Conventional Wideangle Lenses Not just any short focal length lens will do for wideangle photography. It is necessary for any lens that will be used with a given film size to be able to cover that film format completely, with one exception, noted later. With lenses of shorter than normal focal length, this requires a wider than normal angle of acceptance—or, put another way, the lens must project a larger than normal image circle.

Wideangle lenses of really good quality, therefore, are frequently quite expensive. It is a

TABLE 32
Relation between focal length and subject width

FILM FORMAT	FOCAL LENGTH[a] (IN MM)	PERCENTAGE OF THE NORMAL FOCAL LENGTH	ANGULAR ACCEPTANCE[b] (IN DEGREES)	UNITS OF SUBJECT WIDTH COVERED[c]	UNITS OF CAMERA-SUBJECT DISTANCE[d]
35 mm	50	100	46	70	138
(24 × 36 mm)	35	70	64	104	98
	28	56	75	128	78
	21	42	92	178	60
$2\frac{1}{4} \times 2\frac{1}{4}$ in.	85	100	52	66	148
(6 × 6 cm)	65	76	65	88	113
	50	58	80	114	88
$2\frac{1}{4} \times 3\frac{1}{4}$ in.	110	100	49	74	133
(6 × 9 cm)	75	68	68	110	91
	60	54	80	136	73
4 × 5 in.	135	100	62	94	106
(9 × 12 cm)	90	66	85	140	70
	65	48	105	194	57
5 × 7 in.	210	100	54	84	122
(13 × 18 cm)	150	71	72	114	88
	120	57	82	146	68
8 × 10 in.	300	100	56	82	120
(20 × 24 cm)	210	70	65	120	83
	165	55	85	140	70

[a] The focal lengths listed are those frequently used with the film formats shown.
[b] Across the diagonal of the film. (This does *not* include excess coverage, as is available in lenses designed for corrective displacement, as with view cameras.)
[c] Across the long dimension of the film, when the lens-to-subject distance is 100 units.
[d] When the subject width is 100 units.

costly matter to design and manufacture a wideangle lens offering flatness of field, low distortion, substantial freedom from coma and other optical aberrations, and sufficient speed to be widely useful. Table 32 incorporates a listing of the wideangle focal lengths that are most commonly used with the various film sizes. Other, much wider, lenses are provided in considerable variety, especially for the smaller camera sizes, but these—like nearly all wideangle lenses for 35 mm camera use—are not conventional designs (that is, optically symmetrical).

Retro-Focus Lenses In physically large cameras, the construction of the camera itself imposes no particular restraints upon the design of wideangle lenses. However, cameras smaller than about the 4 × 5 inch often do. In particular, the 35 mm and other small single lens reflex cameras impose design limits, because there must be room behind the rearmost lens element to permit the movement of the necessary swinging mirror. For instance, my Nikon F requires approximately 45 mm between the back of the lens and the film surface for this purpose. Therefore, a wideangle lens designed for such a camera, or for any other camera in which a short lens-to-film distance is not wanted, must be optically asymmetrical—that is, the point from which the focal length is measured must be located behind the rear lens element, just as it is located forward of the center of the lens in a true telephoto design. Wideangle lenses for small single lens reflex cameras are thus, in effect, reversed telephoto designs,* and are called *retro-focus* lenses. This fact has little to do with the technique of wideangle photo-

*A retro-focus lens cannot actually be used as a telephoto.

graphy, but has application in closeup photography (see page 291).

Shifting Lenses Distortion of subject matter is one of the most obvious problems in wideangle photography, because of the very close approach that is required to produce a large image size. The photography of parallel lines in a subject is also a special problem. If the camera axis is not precisely level, all vertical parallel lines will converge; this distortion increases as the off-horizontal tilt is increased, and as the focal length becomes shorter. Such convergence of vertical parallels also occurs in other lenses, but the effect is less apparent. The human eye also sees the effect, but the brain acts to discount it. Because the brain cannot "correct" a picture, and since a picture is usually contained within parallel edges that provide direct lines of comparison, it is frequently desirable to do something about the problem when the original photograph is being taken.

A simple leveling of the camera will assure that vertical parallels will be so recorded on the film, but a level camera also assures that there will be as much picture below the lens axis as above it. In most cases, this yields a photograph with an excess amount of foreground, and serves to cut off the tops of tall subjects. With press and view cameras excess foreground is diminished and the cut-off tops of main subject matter are restored by shifting the lensboard upward. The way in which this shifting of the lens operates to shift the image is illustrated in Figure 70. (For details of view camera operation, refer to Stroebel's excellent *View Camera Technique*—see the Bibliography; or see Keppler's "Does It Pay to Tilt & Shift With 35 mm?," for notes on 35 mm practices.)

Notice first that the angle of acceptance of the lens must be great enough to produce an

Film remains unshifted,
so image moves on it

Image circle also
displaced upwards

Film

Lens

Lens acceptance angle

(A)

Image circle

Lens displaced
upwards

(B)

FIGURE 70
How lens shifting results in an image shift. (A) The original position. (B) With the lens moved up.

image circle considerably larger than the film area, in order to allow room for the shift without cutting off the corners of the picture at one edge. (The inverted image is, of course, characteristic of all projected images that are not subjected to optical reinversion; in a 35 mm single lens reflex camera it is erected optically, in the viewfinder.)

Small single lens reflex cameras normally have no provision for shifting the lensboard. However, three lens manufacturers, Schneider, Nikon, and Canon, make wideangle lenses that incorporate a provision for a lateral shift in the lens mount. Schneider makes the 35 mm PA-Curtagon, with a 7 mm lateral shift, in mounts that will fit a variety of cameras. Nikon makes both a 28 mm and a 35 mm PC-Nikkor, with an 11 mm lateral shift, in the Nikon mount only. Both makes rotate in their mounts to allow the shift to be made in any lateral direction. The initials in the lens names refer to "perspective

adjustment" and "perspective control." Nikon was first on the market. The most recent market entry in this field is the 35 mm S.S.C. Canon TS lens, offering an 11 mm shift *to either side* of center, plus an eight degree tilt in a plane perpendicular to that of the shift. (See page 29 for additional notes on shifting and tilting lenses for 35 mm and other small cameras.)

With these lenses it is possible to make single pictures with the image shifted, or to combine two or four pictures after printing so as to greatly increase the angular coverage. To give an idea of the possibilities, the 28 mm PC-Nikkor has an acceptance angle across the 24 × 36 mm film diagonal of about 76 degrees when it is used for a single frame. If the lens mount is rotated to a 45 degree angle, and four exposures are made (each separated from the next by 90 degrees of rotation) at the 11 mm maximum displacement, a combined print can be made that represents a total negative area of

40 × 51 mm and which has an effective diagonal acceptance angle of 96 degrees. This is a really impressive performance (see Plates 51 and 52).

Fisheye Lenses The descriptively named "fisheye" lens has a bulbous glass front lens that accepts light from an angle of at least 180 degrees. The usual focal length for a fisheye lens for a 35 mm camera is a mere 8 mm, and is an extreme example of the retro-focus design. These lenses record the entire 180 degree hemisphere in front of the camera as a circular image on the film, and are well suited for whole-sky and other similar records. At least some models require that the camera mirror be locked up before the lens can be mounted. In scientific field photography the fisheye lens is definitely a special purpose item. But, if you need it. . . . (see pages 34, 295, 382, and 390 for other references to fisheye lenses.)

Add-On Lenses There are three basic types of add-on lenses that can provide considerable flexibility in field photography.

Simple Lenses. The simple slip-on positive (+ diopter) lenses, used for closeup photography, act by shortening the focal length of the prime lens. In some circumstances these lenses can be used to allow wideangle photography with a prime lens of normal or somewhat longer than normal focal length. Owing to the construction of the lenses and cameras involved, this is not practical with 35 mm cameras. But with press or view cameras it is a real possibility.

If wideangle photography is to be done, the use of positive supplementary lenses over the front of a prime lens to shorten its focal length depends upon two factors:

1. The camera must be constructed so as to allow moving the lens closer to the film than is normal, or the image cannot be focused to infinity.

2. The prime lens must, by itself, project an image circle substantially larger than is necessary to cover the film, because the film area covered decreases in diameter as the lens-to-film distance is shortened.

I first used this technique on a 5 × 7 inch view camera whose 210 mm normal lens was capable of considerable lens shifting, and in fact was capable of covering an 8 × 10 inch film while still allowing some minor shifting. By adding a plus diopter supplementary lens I was able to use the lens as a wideangle quite successfully in the 5 × 7 inch format.

To calculate the new combined focal length of such a supplemented system, use Formula R.

PLATE 48 ▶

Telephoto photography—motion control. Anticipation of repetitive action is a commonly used method of motion control. (a) Mockingbird (*Mimus polyglottos*), in the act of taking off on a short looping flight during a territorial proclamation session. (b) Male and female American Kestrels (Sparrowhawks) (*Falco sparverius*). In the pair observed, the male made no attempt to mount the female until she had signalled by lifting her tail, as shown here. (c) The pair mating, an act completed in about two seconds and done only once on each day observed. Watching for the female to tilt her tail allowed anticipation of this fast action. All photography on this plate was done using a 1250 mm Celestron 5 mirror lens, with Tri-X film exposed at ASA 400 and processed as directed in Microdol-X developer, diluted 1:3 with water, for best sharpness. Shutter speed was 1/500th of a second, with an effective aperture of f/16. Note the very shallow depth of field. In each case the birds were at a distance of 85 feet (25.9 meters), at the top of a 30-foot (about 9.14 meters) tree.

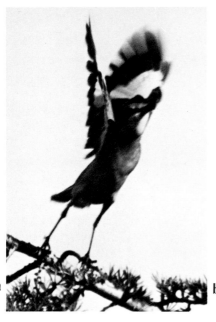

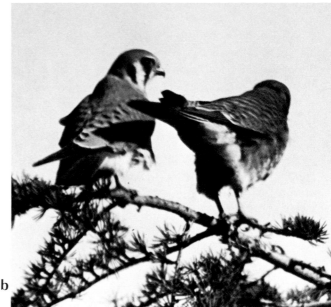

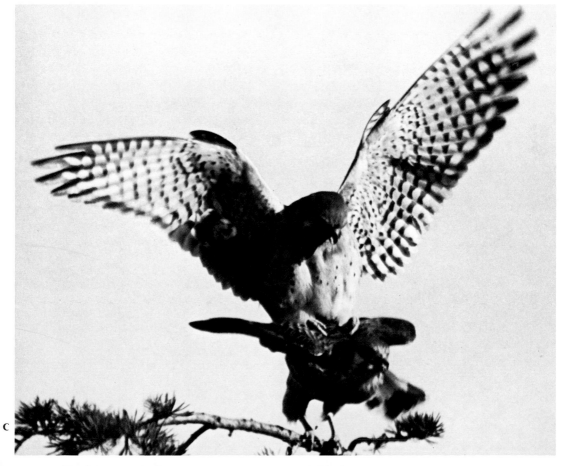

Should you wish to calculate the achieved diminishment of the image magnification, use Formula N, on page 365, which will also work in this context. The answer will, of course, come as a decimal with a value of less than one. Another course would be to refer to Table 32, on page 383, if your lens combinations are among those focal lengths listed, in order to obtain the change in subject width covered at a given camera-subject distance.

For those who like simplification, I have tabulated the results of calculations for some of the more likely lens combinations, in Table 33. This table includes corrections for the minor change in the relative aperture that is produced when the lens is moved back toward the film to focus the combined system. Because the effect of supplementary lenses increases with an increase in prime-lens focal length, and since the problems with their use also increase, the longer focal lengths are represented by fewer choices.

Since the addition of supplementary lenses introduces various optical defects, particularly a curvature of field, you must use small lens apertures to get good picture quality. I would suggest closing down to at least f/16, and preferably smaller. And, when using the stronger powers of supplementary lenses (or stacked supplementaries), for wideangle photography in this manner, you should choose a focusing point a little to one side of the center of the ground glass image, to take the best advantage of depth of focus in getting the picture sharp overall. The use of stronger powers also introduces "pincushion" distortion, an optical defect that reproduces a rectilinear grid with its lines curved inwards to produce a wasp-waisted effect, as shown in Figure 71, page 390.

This effect is important if you are photographing rectilinear subjects, if you must reproduce irregular outlines with great accuracy, or if you are trying to derive measurements from photographs. It should be realized that a certain amount of either pincushion or barrel distortion is present in many commercial camera lenses, particularly in fast wideangle lenses designed for 35 mm cameras. Extreme designs of wideangle lenses, such as the PC-Nikkors, achieve rectilin-

FORMULA R
Determining combined focal length with add-on positive lenses

SYMBOLS	DEFINITIONS	EXAMPLES
f	Focal length of camera lens	127 mm
f'	Focal length of positive lens	333 mm ($+$3 diopters)
d	Distance between lens centers	25 mm
F	Equivalent focal length of the combination	? (unknown, to be calculated)

Formula

$$F = \frac{f \times f'}{f' + f - d}$$

$$F = \frac{127 \times 333}{333 + 127 - 25}$$

$$F = 97 \text{ mm}$$

TABLE 33
Add-on positive lens tabulation, for wideangle effects[a]

| CAMERA LENS | POSITIVE LENS | | INTER-LENS SPACING[b] (IN MM) | EQUIVALENT FOCAL LENGTH (IN MM) | EFFECTIVE APERTURE IS *FASTER* (IN STOPS) THAN MARKED APERTURE BY: |
	DIOPTERS	FOCAL LENGTH (IN MM)			
127 mm	+1	1000	25	115	$\frac{1}{4}$
	+2	500	25	105	$\frac{1}{2}$
	+3	333	25	97	$\frac{1}{2}$
	+4	250	25	90	1
	+5	200	25	84	1
135 mm	+1	1000	25	121	$\frac{1}{3}$
	+2	500	25	110	$\frac{2}{3}$
	+3	333	25	101	1
	+4	250	25	93	$1\frac{1}{3}$
210 mm	+1	1000	35	179	$\frac{1}{2}$
	+2	500	35	155	1
	+3	333	35	134	$1\frac{1}{2}$
300 mm	+1	1000	35	238	$\frac{2}{3}$
	+2	500	35	196	$1\frac{1}{3}$

[a] Figures are close approximations, which are suitable for general photographic purposes.
[b] Based upon the lenses that are available to me, and may differ with lenses by other makers.

earity only at considerable monetary cost, and these are not really high speed lenses, having maximum apertures of f/3.5 to f/4.

When using relatively thin prime lenses for wideangle photography with press or view cameras, distortion and curvature of field can be reduced markedly if, instead of stacking the supplementary lenses two at a time on the front, the two can be mounted separately—one on the front of the prime lens, and one on the rear. It is sometimes worthwhile to deliberately use two supplementaries where one might do; for instance, if you need to use a +3 supplementary, use a +1 and a +2, and mount them separately on the front and rear.

Multi-Element Wideangle Attachments. Although relatively uncommon as compared to tele-converters, it is possible to obtain multi-element wideangle attachments. Unlike tele-converters, they are attached to the front of the prime lens. The Spiratone Curvatar is a device that uses a Series VII holder as an adaptor, and screws into the filter ring of 35 mm single lens reflex cameras. It has the effect of doubling the angular coverage of the prime lens. Spiratone

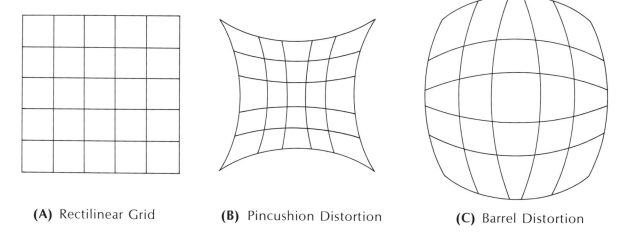

(A) Rectilinear Grid **(B)** Pincushion Distortion **(C)** Barrel Distortion

FIGURE 71

Types of image distortion. (A) A rectilinear grid with no distortion. (B) The same grid with pincushion distortion. (C) The same grid with barrel distortion.

says that there is no need for exposure compensation. The attachment is said to be usable with larger cameras, too.

Front element attachments are also made for twin-lens reflex cameras that do not have interchangeable lenses (telephoto attachments of a like type are also made).

Fisheye Attachments. Of greater basic versatility than prime lens fisheyes, auxiliary fisheye attachments have achieved quite wide amateur and professional use in recent years. These are bulbous, multi-element devices that screw into the front of your prime lens. Such an attachment can be used on virtually any camera lens, even with view cameras, and will greatly affect the appearance of the image. When they are used with a prime lens of normal focal length for the film size in use, the result is a 180 degree view, rendered as a circle on the film similar to the image from a prime lens fisheye. With prime lenses of longer than normal focal length for the film, the image provided will increasingly tend to fill the film frame. With 35 mm cameras full

frame coverage commences with about 135 mm focal length. When used with shorter tele lenses the ends of the frame are lost.

Barrel distortion is very noticeable, but the angular coverage is impressive, and you may not be in a position to achieve it otherwise. Exposure compensation is needed, but it is built into the lens mount. The diaphragm of the

PLATE 49 ▶

Telephoto photography—motion control. Birds move quickly, and seldom predictably. (a) A young gull—probably an immature ring-billed gull (*Larus delawarensis*)—in flight. The timing of the exposure was such that the bird's head was completely obscured. You must be aware of action patterns in order to avoid this. (b) Young male scrub jay (*Aphelocoma coerulescens*). Just as I tripped the shutter he moved his head. The very shallow depth of field of the 1250 mm Celestron 5 lens was unable to contain this degree of movement, so the head was rendered unsharp. At the same time, the new position placed it across a confused background of similar tonality. Without a relative tonal differentiation from the background there was a tendency for it to blend in.

a

b

(A) **(B)**

FIGURE 72

A curved film plane for wideangle pinhole photography. Drawing (A) shows a pinhole camera with a flat film plane. The distance A–C is 1.3 times as long as the distance A–B. In drawing (B) these distances are equal. The film dimension C–D is the same. All that is required to hold a sheet film reasonably correctly curved is to place grooved catchments at points C and D. If the distance between them is correct, the shape of the curve and all pinhole–film distances along it will be correct. Roll films are much thinner and less sturdy, and would require a more complex holding structure.

prime lens is left wide open throughout. A ring on the attachment is set to correspond with the focal length of the prime lens; then a secondary diaphragm in the fisheye attachment lens mount is used to control the exposure. Very ingenious.

The effect of a fisheye attachment upon the focal length of a prime lens is similar to dividing the prime lens focal length by a factor of 6.2. (See pages 295–296 for further information on fisheye attachments and their varying uses.)

Pinhole Cameras Wideangle photography can be done with pinhole cameras, if the pinhole-to-film distance corresponds to a wideangle focal length for the film size in use. The text following page 348 has an extensive description of pinhole photography technique.

Simple Wideangle Cameras. The image projected by a well-made pinhole reveals that there is an exceptionally broad acceptance angle. At very short equivalent focal lengths, however, there is a considerable difference in the distance from pinhole to film center, and the distance from pinhole to film edge. Therefore, with rectangular formats it may be advantageous to have a curved film plane, to keep image magnification reasonably constant. (The film plane would have to be a section of a sphere for the image magnification to be really constant.) The film can be bent into a cylindrical shape by fabricating a film guide for holding the film in place. Unless you want to get quite complex, this comes down to building a single-shot camera or camera back that must be loaded in darkness. This is diagramed in Figure 72.

As is noted above, the details of pinhole technique were described earlier. Table 30, page

PLATE 50 ▶

Wideangle photography—meteorological studies. Two ways of studying atmospheric conditions photographically. (a) Cloud cover over the whole sky can be recorded in a single film frame by using a "fisheye" wideangle lens, which is capable of encompassing a 180 degree angle of view, with the camera lens pointed straight up. The picture used a Kenko fisheye attachment placed over the front of my 50 mm Micro-Nikkor lens. A Wratten 25 red filter emphasizes the contrast between sky and clouds. (The filter used was a very thin gelatin, sandwiched between the prime lens and the back of the fisheye attachment.) (b) Compare the effect in (a) to this moderate telephoto view, made with a 127 mm Ektar lens on $2\frac{1}{4} \times 3\frac{1}{4}$ inch film, illustrating the path of air movement over a ridge, as revealed by the smoke from a small fire. It is also effective, but on a more restricted scale.

a

b

354, gives aperture and exposure information that is applicable to wideangle photography.

Wrap-Around Pinhole Cameras. For really extreme angular coverage it is possible to approach an acceptance angle of 180 degrees, but linear distortion is a real problem. If you could coat the interior of a hemisphere with photo emulsion (and this could be done with a commercially available product), you could get coverage that is very similar to a fisheye lens, but you could not reproduce it as a flat print.

Figure 72,B illustrates an acceptance angle of about 100 degrees. For a greater coverage, use a relatively shorter equivalent focal length, and wrap the film around into a half circle. This is a satisfactory solution for the making of a panoramic view of the horizon, if you use a relatively narrow horizontal strip of film to minimize the lateral distortion in the vertical direction, which has not been corrected by bending the film in this manner.

Keppler's article "The Hole Thing Exposed!," shows a homemade camera that can approach a 180 degree coverage, which is made from half of a cylindrical oatmeal box. (This article is based upon and is an extension of Shull's book *The Hole Thing,* referred to earlier). A more extreme approach, using a tubular "camera" that exceeds 180 degrees in one direction—though at a considerable cost in image distortion—is described in Floyd's "The Fantastic Floydmar Camera: The Pinnacle of Pinholery." (See the Bibliography to complete these references.) Although these gadgets may seem like mere gimmickery, they should not be entirely discounted. They work, and there may come a time when one of them turns out to be the very thing you need. Knowing about the mere possibility of an idea puts you part way down the road to solving some future (or even present) problem.

Choice of Lens Type

Ideally, the choice of lens for making a given picture should depend upon the nature of what you wish to do. The text in the following sections assumes the existence of alternatives.

General Use Just as every serious photographer should take a medium capability telephoto lens along on each field session, so should he or she take a moderate wideangle lens. It is not extreme demands that cause us trouble in most circumstances; it is the thing we cannot quite do. For general field photography, I have found the most useful wideangle lens to be one with about 70 percent of the normal focal length. In 35 mm work, this would be a 35 mm focal length, and I find the shift feature of the 35 mm PC-Nikkor very handy, even in the woods. For corresponding work in 8 × 10 inch (20 × 24 cm) size, 70 percent of the normal focal length is

PLATE 51 ▶

Wideangle photography—mosaics. In some cases an available wideangle lens might not encompass a sufficiently wide angle of view. A mosaic can be made by mounting together several pictures made from various camera positions. For best results, the position of the lens axes along which these pictures are made must all be parallel. This is easier to do if the lens can be shifted off center in various directions, as with a view camera. This picture is such a composite (mosaic), assembled from four exposures made with a 35 mm PC-Nikkor lens. In this case, the lens has been shifted off center in four directions. No attempt has been made to conceal the joints, so that you can see how the mosaic is put together. The upper left portion is virtually a full film frame, and thus gives an idea of the amount of overlap that is available. You would not normally use so large a portion of one photograph, supplemented with such small parts of the others. Compare this mosaic to Plate 52,a.

represented by a 210 mm lens, a length that I have used very frequently.

Landscapes Landscape photography is somewhat of a special case, in that many workers agree that the "normal" lens for this purpose, in the sense of being the one most frequently used, is the 70-percent-of-normal wideangle. Lenses of actual normal focal length simply do not have enough breadth of view for many landscape photographs. In fact, I used an 8 × 10 inch view camera in the mountains for several seasons with only a 210 mm lens, before I even bought the 300 mm normal lens.

Something that gets missed quite often is the desirability of using lens shifts when there are numbers of trees in the scene that is being photographed. This is especially true in 35 mm photography, where the working distance is quite short. A group of trees makes up a vertical parallel line situation technically similar to architectural work. If the camera is tilted up to bring in the treetops, the trunks converge. A shifting lens will solve this problem nicely (see Color Plate XII).

Architecturals Everyone knows that this is the classic area where shifting wideangle lenses are used. My own rule of thumb is that if I cannot correct the convergence of parallels by shifting the lens, then it is better to try for an increased effect, so as to create visual drama. The real offender is the moderate convergence: enough to be disturbing to the eye, but not enough to be attractive in a design sense.

Panoramas and Mosaics There are times when it is necessary to record all, or a large portion, of the 360 degree horizon. There are special panoramic cameras that rotate to do this, but most people do not have one. The best method,

using ordinary cameras, is to make a series of overlapping individual photographs, that you can mount side-by-side to make up the whole view needed. For this purpose, the best lenses are those that offer the lowest degree of pincushion or barrel distortion. In 35 mm work, the PC-Nikkors are especially good, but there are many fine choices.

Sometimes the scene to be recorded is simply too big and too close to be recorded in one exposure with any lens available at the time. It could be a rock face, a waterfall, a building, or anything else large and near. In this case, make serial rows of photographs, with all pictures in each row overlapping, and with the rows themselves doing the same. This prevents any possibility of losing part of the subject. It is good to overlap about 25–30 percent, because the most distortion-free portion of any lens is in the center. The actual joint, when the mosaic is mounted, should be in the center of the overlap area, rather than at one end. Typical overlap

PLATE 52 ▶

Wideangle photography/stereo effects. This picture should be compared with Plate 51. (a) This is the effect, in terms of angular coverage, of a single exposure of the subject in Plate 51, with the lens centered, from the same camera position.

Stereo photography is one of the most useful photographic tools available to a naturalist, and one of the least used. (b) A normal-separation stereo pair showing the valley of Yosemite Creek, above Yosemite Falls. It was made by shifting the camera three inches sideways between the two exposures. (I just picked up the tripod and moved it over.) Note that the clouds moved in the interim. The foreground shows the stereo effect vividly, but the distant background gives little impression of three-dimensionality. In order to show distant hills in stereo effect you must use a wider separation than is normal (see Plate 53,b).

a

b

(A) Panorama, overlapped 25 percent
(horizontal format)

(B) Mosaic, overlapped 25 percent in both directions
(vertical format)

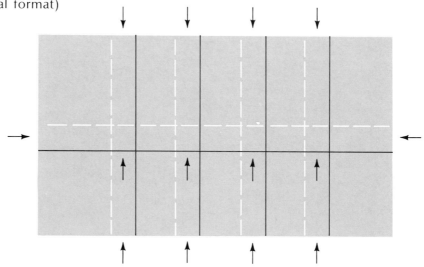

FIGURE 73
Panoramas and mosaics. In both (A) and (B) arrows mark the approximate appropriate location of the joints.

patterns for panoramas and mosaics are shown in Figure 73.

When doing overlap photography, it is a good idea to mark the ground glass at either side, so that the actual point of joining will be the same distance from the lens axis on both sides. This also helps to insure that the two joining images will be the same magnification. (See Figure 74.) Do not change the focus after beginning a panoramic or mosaic series, or image magnification changes will prevent a good match from being made.

When rotating a camera for series pictures, the axis of rotation must be directly under the

Solid lines indicate overlap limits

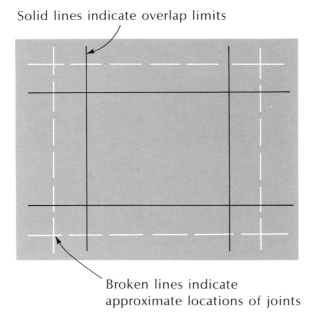

Broken lines indicate
approximate locations of joints

FIGURE 74
Marking the ground glass for mosaics.

optical center of the lens, or the edges will not match. Further, a panorama will not line up correctly unless the camera is truly level. If it is at all tilted, the series will be stepped up or down. If possible, any vertical layering should be done with the camera body kept level and the image displaced up or down by means of shifts of the camera lensboard or the film back. (View cameras can shift at either end.) Panoramas are most conveniently done, in the smallest number of exposures, when the camera is in the horizontal format position. Mosaics, involving vertical layering, are usually done easiest when a vertical camera format is used.

CHAPTER 12

Stereo Photography

One of the most useful characteristics of human sight is binocular vision, which enables us to perceive the world around us in three dimensions. Using derivations from the Greek, three-dimensional vision comes out as "stereoscopic" vision. Stereo photography is the making of pictures that can be viewed so as to appear three dimensional.

There are a number of publications that provide good information on the theory and practice of stereo photography. Most are out of print, but those that I mention are available in many libraries, if not in stores. Two of the better book length texts are McKay's *Three-Dimensional Photography,* and Kaiser's *Make Your Own Stereo Pictures,* both written for the general photographer. The best theoretical text, to

my knowledge, and one that includes much well described information on practical applications, is Valyus' *Stereoscopy*. (A translation from the Russian original is published by The Focal Press.) You might also check Frank's 4-part article, "Stereopsis and Stereoscopy." (See the Bibliography for details on all of these references.)

UTILITY IN SCIENCE AND SCIENTIFIC PUBLICATION

During the 1950s there was a short lived but widespread public interest in stereo photography that resulted in a temporary proliferation of equipment and literature; but this passed, as most fads do. In the world of science, where interest in stereo work did not rise as high as the public wave at that time, there has been a degree of revival in recent years, due to two widely divergent developments: the scanning electron microscope (SEM), and laser holography.

With the SEM you cannot view the subject directly, so you must depend upon stereo photography for a permanent three-dimensional record of the subject's shape and surface characteristics. It has been found many times that a two-dimensional photograph of an SEM subject is likely to foster a thoroughly wrong impression of the nature of things.

Holography, in which you effect a fully three-dimensional optical wave front reconstruction of the object, so real in appearance that you can—to a large degree—walk around and see changes in subject visibility and perspective around the edges of objects, in a way that cannot be done in standard stereo photography, is so different in nature that I cannot do more than mention it here.

Another and more perennial use of stereo photography is the ever widening field of photogrammetry, where it is possible to make remote records of subject shape so accurately that their surfaces can be reconstructed as tangible models. This technique finds its greatest use in map making from aerial surveys, but is being used increasingly in other sciences and in medicine.

None of these subjects is more than touched on in this text, since they all require the use of highly specialized equipment and techniques not falling within my conception of "field" photography. You are encouraged to survey the plentiful literature in these areas, and make such use of it as you care to.

In this book I will deal with stereo photography as it applies to and clarifies the perception and communication of characteristics of surfaces, shapes, and layerings. We have all had the experience of seeing and photographing something of great interest or beauty in the field, only to find that the resulting two-dimensional print or slide is simply a mass of unintelligible clutter. My purpose here is to point out that through stereo photography you can surmount this limitation, that it can be done quite simply, and that the resulting photographs can be reproduced and viewed much more easily than is generally believed. You can separate a tree from the forest, you can tell which branch (vein, or nerve) overlies what trunk (capillary, or sinew). You can determine the exact shape of a sculptured subject, and communicate that information, with full accuracy, to your peers. And, if it is necessary, you can do all of this with the ordinary photographic equipment in your possession, without resorting to any special items whatsoever, and with no very great effort on your part, aside from a little planning. Stereo photography is used far too little in general

scientific photography and publishing. The scanning electron microscope has done much to impress many people with the utility of stereo. I hope that this text will help to further the idea in more general applications.

BASIC PRINCIPLES

There is a great deal of quite complex theorizing attached to stereoscopy that I have no intention of repeating. My intent here is only to tell you, as briefly as possible, how you can make stereo photographs that are adequate to the purposes of visual understanding and communication. With that in mind, describing the principles is very much simplified.

The basis of stereo photography is the making of two similar but not identical photographs from lens positions so spaced as to simulate the separation of your two eyes. Ideally, the axes of these two lens positions are parallel, as are your eyes at infinity focus. "Toeing-in" is done at times, but is less than perfect as a technique. The resulting photographs are viewed in such a manner that each eye sees only one picture, the two having been positioned for viewing in correct left/right sequence, with good alignment and equal lighting. When so viewed, the two pictures—seen separately by your two eyes—will merge in your brain so as to produce the three-dimensional effect. Relief can be exaggerated, for emphasis or ease of interpretation, by increasing the separation of the taking lenses, and this is done with special frequency in telephotography. Photography at magnifications in which, in effect, the eyes are being brought unusually close to the subject, requires the opposite approach—the lens separation must be decreased.

EQUIPMENT AND SETUP CHOICES

There are several ways in which stereo photography can be done, some with both pictures exposed simultaneously, and others with the two made separately. Mobile subjects obviously require simultaneous exposure; but static subjects, including most landscapes, can be done by any method.

Stereo Cameras

A stereo camera has two lenses that are arranged side-by-side, and an interior partition to keep the images separate. The images then appear serially along the roll of film. These cameras are quite small and easy to use. A number of models are currently available, new or used. Some, like the Stereo Realist or the Edixa Stereo camera, use 35 mm film. Others, such as the Duplex Stereo camera, use 120 size film. Stereo cameras have a fixed inter-lens distance, and so they offer rather little flexibility in use. But they *are* convenient, and they do allow stereo photography of moving subjects.

The makers of the Stereo Realist camera also supply an integrated system of attachments that permit limited closeup photography with their camera. The operation is semi-automatic, and there is no need for any calculation or specific stereo knowledge on the part of the user. The setup is intended for making paired color transparencies on standard 35 mm films, and suitable viewers are also available. See your dealer for further details.

Stereo Attachments

It is also possible to obtain mirror or prism attachments which, when they are placed over the

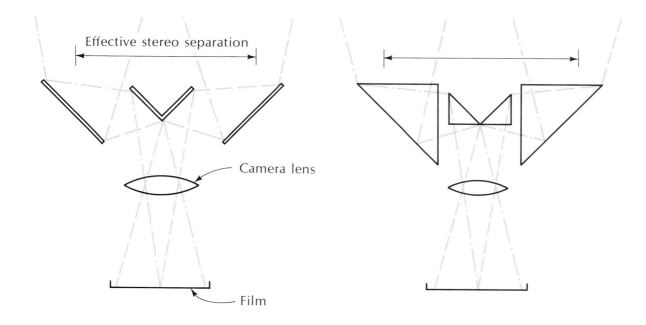

Effective stereo separation

Camera lens

Film

(A) First-surface Mirror Type

(B) 45–45–90° Prism Type
(Other types of prisms can
also be used for stereo viewers)

FIGURE 75
Two types of stereo attachments.

front of an ordinary camera lens, bring two parallel images through the lens to form a split field, two side-by-side pictures on one film frame, allowing simultaneous exposure. Most such units have a fixed separation. Typical of currently available devices is the Miida Stereo Lens System, an attachment for 35 mm cameras, which is usable with any prime lens up to 300 mm focal length. Figure 75 illustrates two types of stereo attachment construction.

Normal Cameras

Any type or size camera can be used to make stereo pairs of photographs without special equipment, if the two pictures are made on separate frames or sheets of film and are exposed serially. Two basic methods are used to do so, one method having several variations. Unless simultaneous exposures are necessary, I much prefer to use the single-camera approach.

Paired Cameras By using two identical cameras mounted together on a bracket, stereo pairs can be made with unaltered ordinary equipment. There is considerable flexibility in this system, because the inter-lens spacing can be expanded at will. Simultaneous exposure is made possible by using a double cable release.

Single Camera A single camera can make stereo pairs by sequential exposure, with a change in the setup corresponding to inter-lens

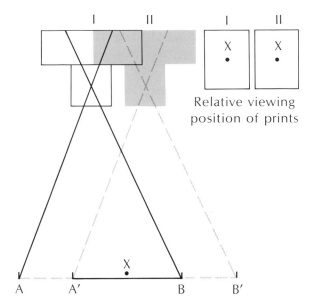

Relative viewing
position of prints

A A' B B'

FIGURE 76
Shifting-camera stereo method.

separation being made between the two exposures. There are three ways in which this is commonly done.

Camera Shifted Between Exposures. In the first method, the camera is shifted sideways, between exposures, over the inter-lens distance that has been decided upon. Since the lens axes should be parallel, it helps to place a guide strip behind the camera body perpendicular to the lens axis. Shifting tripod plates are made for this purpose, for use where a standard "normal" inter-lens distance is used, as shown in Figure 76.

For viewing, exposures I and II are placed side-by-side in the same order as they were taken. Note that only two-thirds of each exposure overlaps, in the example given. It is only in the area A'–B that the stereo effect will be present, so A–A' and B–B' are discarded. This means that in both exposures the center of the

intended subject area must be at point X, the center of A'–B. Results will be improved, especially in pictures of relatively close subjects, if you determine the locations of points A'–B and X on your ground glass, at least approximately, before exposing. (See Plates 52,b, and 53,b.)

Subject Shifted. Alternatively, the camera can be fixed in place, and the subject shifted. This is a convenient method when work is being done at moderate to high magnifications, and is entirely practical even in photography through the compound microscope. Usually, only half of the frame overlaps in the two pictures, and so the subject is centered on that portion of the ground glass for each exposure, the other part of each print being discarded. This system has a peculiarity, in that the prints must be transposed for viewing. The diagram in Figure 77 shows this.

The reason for the transposition is that in exposure I, with the subject in position B–A and the image at A'–B', the image is at the left end of the film and the angle of view is as though it was being looked at with your left eye—but it was done with the subject shifted to the right-side position. In exposure II, the opposite occurred. It is as though the views of your two eyes crossed over one another. Unless the prints are transposed, hills will look like valleys, and vice versa.

If you wish to achieve an exaggerated depth effect in high magnification stereo pictures when using a small film format in this manner, you can do so by moving the camera body in the direction opposite to that of the subject shift. But be sure to keep the lens fixed in position. (See Plate 53,a, and Color Plate V, bottom.)

Subject Revolved or Tilted. A theoretically improper but workable method often used in

stereo photography at magnifications is that of rotating or tilting the subject between exposures. This is the method usually used when making stereo pairs with the scanning electron microscope, where it is the most practical approach because of equipment limitations. The technique is illustrated in Figure 78, page 406.

In this method, the image magnification varies across the subject, in opposite directions in the two pictures. Thus, it is harder to accommodate your eyes when viewing, and the view never seems quite comfortable. But the eye-brain combination can manage it, if the tilt or rotation is not too great: usually not more than 5–7½ degrees. In photomacrography or photomicrography the greatest difficulty is insufficient depth of field. The defects of this method are not present in the shifting-subject method described above.

TECHNIQUES OF STEREO PHOTOGRAPHY

Other than the normal demands of whatever type of photography you are attempting, there are several special technical considerations that are peculiar to stereo work.

Base Separation

The basic appearance of subject relief is determined by the inter-lens distance, called the "base separation." If you are using a normal camera or cameras, rather than a fixed-separation stereo camera or stereo attachment, this distance can be varied according to your needs and desires. A less than normal separation gives an appearance of abnormally low relief, except in cases where the apparent viewing distance is inordinately short, as in photomacrography. A greater than normal base separation (or one proportionately great for the apparent viewing distance) exaggerates relief, and is frequently used in telephotography.

The degree of base separation that is appropriate for a given use has been the subject of argument and conjecture in many published writings. This is due partly to the great ability of the human eye-brain combination to adjust to, and accept, abnormal vision effects, and partly to a failure to connect the idea of base

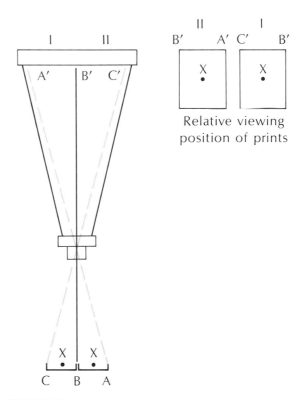

Relative viewing position of prints

FIGURE 77

Shifting-subject stereo method. In small formats, it may be necessary to shift both the subject and the camera body, in opposite directions, to achieve sufficient relief effect. If so, the camera lens must remain fixed. This is most easily done using a tandem camera arrangement.

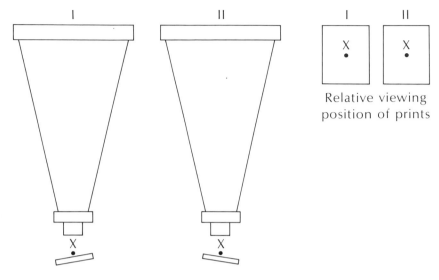

Relative viewing
position of prints

FIGURE 78
Rotating-subject stereo method.

separation appropriately to normal vision, in optical terms. Formula S is a formula for determining base separation that takes into account the way that you want subject relief to appear.

This formula is not immutable, since the eye-brain is capable of a great deal of accommodation; but, it does allow the establishment of a stated "normal" separation on rational grounds. Further, it allows deviations from that normal to be turned into controllable factors, which are related to the photographer's intention in each case. The following sections explain the examples given in Formula S.

Normal Stereo "Normal" relief appearance in stereo viewing occurs when base separation is equal to the separation between your eyes; or, returning to Formula S, when B equals N, as in Example **A**. When these separations are equal, the relief that is perceived when viewing a stereo pair will resemble that perceived when looking at the original subject (see Plate 52,b).

It is not practical to use a normal base separa-tion for all stereo photography. Human eyes are so close together that at distances beyond a few hundred feet the scenes recorded by your eyes are so similar that no stereo effect is obtained. Conversely, when you approach closer to a sub-ject than about 16 inches (400 mm), you have an increasing difficulty in fusing the two images in your brain; until, at very close distances, you cannot do so, because the eyes are simply not seeing the same thing, and a double image re-sults. Normal base separation, then, is appro-priate only at ranges between the near limits of comfortable binocular vision and the point where the physiological stereo effect severely diminishes because of distance.

Telephoto or Other Distant Stereo As has been noted, when the eye-to-subject distance in-creases, stereo vision effects decrease. Thus, you actually see little or no three-dimensional effect when looking at a distant mountain. Only light and shadow gives a clue to its shape.

If you want to show the three-dimensional

shape of a distant subject by means of stereo photography, you must increase the base separation beyond the normal, as is done in Example **B** in Formula S. There are no hard-and-fast rules, because the separation that is chosen will be dependent upon how distant you wish to have the object appear (see Plate 53,b, page 411).

It should be realized that a visual effect of exaggerated surface relief is obtained by causing the subject to appear as though it were closer to you, and therefore smaller in size than it really is. If the separation is too great, the subject will appear to be a model, seen up close. (Valyus' suggestion that a good formula for distant stereo would be $B = R/50$ seems wrong, because it would cause a mountain four miles away to appear to be a model only 12.5 feet away.) This might be appropriate in some uses, but I wouldn't care for it as a general practice.

Table 34 is a tabulation of my suggestions for the stereo photography of distant subjects, in which the base separations shown will make stereo effects usefully visible, but will not so exaggerate them as to reduce the subject to the stature of a model (see page 408).

When abnormally wide base separations are being used, remember to exclude all near objects from the scene, or they will appear so dissimilar in the two pictures as to produce a very confusing mass of overlapping but unrelatable foreground effects.

Closeup Stereo There is even more confusion in the literature concerning closeup stereo than there is in distant work. However, it is actually no harder to work out. The necessary reduction of base separation again results in the subject resembling a model when the photos are

FORMULA S
Determining base separation for stereo effects

SYMBOLS	DEFINITIONS	EXAMPLES			
		(A) NORMAL	(B) TELEPHOTO	(C) CLOSEUP	(D) MACRO
N	Normal eye separation	75 mm[a]	75 mm	75 mm	75 mm
D	Apparent subject distance	2000 mm (2 m)	35,000 mm (35 m)	400 mm	400 mm
R	Range (lens-subject)	2000 mm (2 m)	150,000 mm (150 m)	110 mm[b]	27 mm[c]
B	Base separation	?	?	?	?
		(unknown, to be calculated)			

Formula $\dfrac{N}{D} : \dfrac{B}{R}$ (This is a proportion, or fractional equation; to solve it you multiply N by R, and divide the result by D to obtain B)

(A) $\dfrac{75}{2000} : \dfrac{B}{2000}$ (B) $\dfrac{75}{35,000} : \dfrac{B}{150,000}$ (C) $\dfrac{75}{400} : \dfrac{B}{110}$ (D) $\dfrac{75}{400} : \dfrac{B}{27}$

$B = 75$ mm $B = 321$ mm $B = 20$ mm $B = 5$ mm

[a] The separation given, 75 mm, is my interpupilary distance; you can, if you wish, use your own.
[b] Assuming the use of a 55 mm lens, at an image magnification of ×1.
[c] Assuming the use of a 25 mm lens, at an image magnification of ×12.

viewed, but this time it will be seen as though the subject were somewhat enlarged. I prefer to work toward an apparent viewing distance of 16 inches (400 mm), this being a comfortable viewing distance for moderately sized models.

The definition of what is "closeup" in this context is based upon image magnification, and upon what is a normal viewing distance to human eyes. Since you can comfortably view objects that are as close as 16 inches, I see no need to change from a normal base separation until the lens-to-subject distance will be less than that, which occurs at about ×.2 magnification with a 50 mm focal length lens. At the other extreme, I will arbitrarily call anything over about a ×3 magnification photomacrography, and treat it separately.

The lens-to-subject distance, or range, in closeup work is a function of image magnification. Therefore, we come to a need for a two-step calculation:

1. Establish the range, using Formula H, on page 345, which involves knowing the image magnification and the lens focal length.

2. Determine the base separation, by using formula S, on page 407.

Table 35 is a tabulation of my suggested approach.

When doing closeup photography in stereo, try to avoid having foreground or background material in the picture, as the dissimilarity of the two views may produce disturbing effects and thus take emphasis from the main subject. It is a good idea to supply a nontextured background yourself (and then avoid throwing shadows on it).

Photomacrographic Stereo Stereo photomacrography differs from stereo closeup photography mainly in that after the magnification exceeds about ×3, the rate of change in range, or working distance, diminishes (see Figure 66, page 331). With this decrease in the amount of variance in range comes a concomitant decrease in the change of base separation. Therefore, it is practical to treat base separation as being static, unless the lens focal length is changed, for only with a change in focal length is there any significant change in range. As an example, with a 25 mm lens at ×8, range is 28 mm, while at ×15 it is 26.8 mm, hardly more than a millimeter different for almost a doubling of magnification.

Again, and for the same reason as in closeup

TABLE 34
Suggested base separations for distant stereo photography

Actual range (R)	50 m[a]	100 m	150 m	200 m	300 m	1 km[b]	2 km	5 km
Apparent distance (D)	25 m	25 m	35 m	50 m	75 m	150 m	150 m	150 m
Normal eye separation (N)	75 mm	75 mm	75 mm	75 mm	75 mm	75 mm	75 mm	75 mm
Base separation (B)	150 mm	300 mm	321 mm	300 mm	300 mm	500 mm	1 m	2.5 m

[a] Since one meter equals about 39.4 inches, you will get closely similar results by converting this measure to yards, for use with English measurements.

[b] One kilometer equals .621 miles, if you wish to convert. Such long ranges are best worked out by referring to contour maps.

TABLE 35

Suggested base separations for closeup stereo photography (using a lens focal length (F) of 55 mm, an eye separation (N) of 75 mm, and an apparent distance (D) of 400 mm.)

Image magnification (m)	×.2	×.25	×.33	×.50	×.75	×1	×2	×3
Range (lens-subject) (R)[a]	330 mm	275 mm	220 mm	165 mm	128 mm	110 mm	82 mm	73 mm
Base separation (B)[b]	61 mm	52 mm	41 mm	31 mm	24 mm	21 mm	15 mm	14 mm

[a] Calculated as though for a theoretical "thin" lens, but adequate for this use.

[b] These separations are appropriate regardless of how you got the specified image magnification for ×2 and ×3 (i.e., whether you got it by such methods as tele-converter use, or bellows extensions.)

work, I prefer to maintain the apparent viewing distance at 16 inches (about 400 mm). Table 36 tabulates my suggestions (eye separation is again assumed constant at 75 mm).

In photomacrography, the depth of field is very shallow at best, and may be limited further by the need to avoid the diffraction effects that accompany the use of small apertures. I have found it helpful to focus at two slightly different levels when making stereo pairs. This tends to extend the range of apparent sharpness, since the eye tends to give prominence to that which is sharp, and to dismiss that which is out of focus. The practice does produce slight magnification variations, but if not overdone this is accomodated by the eye-brain combination.

The analysis of very small overlapping structures is often eased if the stereo relief is exaggerated by using a wider base separation than the recommended in Table 36. I have used the subject-shifting method of base separation very successfully in photomacrography with large film formats, using the maximum shift possible without losing the relevant parts of the image off the two ends of the film. Physical limitations of the equipment will stop you well before the visual impression can get grossly unbalanced. I have used the same method for the photomicrography of stained slides, using 8 × 10 inch films, with good results. (See Plate 53,a, Color Plate V, bottom, for examples of stereo photomacrography.)

As a final note, it is possible to make stereo photographs through a stereo dissecting microscope, a microscope with two objective lenses and two oculars. (But don't confuse this with

TABLE 36

Suggested base separations for photomacrographic stereo

Image magnification (m)	×5	×8–15	×20–50
Lens focal length (F)[a]	40 mm	25 mm	16 mm
Range (lens-subject) (R)[b]	48 mm	28 mm	16.5 mm
Base separation (B)[c]	9 mm	5 mm	3 mm

[a] The choice is based upon the lengths of bellows that are commonly available.

[b] Calculated as for a "thin" lens, but adequate for this purpose.

[c] These base separations can be accomplished, as noted earlier, by shifting the subject, rather than the lens or camera.

photography through the two oculars of a binocular research microscope, which uses only a single objective lens—it won't work.) Indeed, some makes of dissecting microscopes provide for this practice in their equipment list. On the whole, however, better results will usually be obtained by using the methods described here.

Axis Alignment

It is necessary in stereo photography of any type to have good alignment of the horizontal axes of the two pictures. In work at ordinary or long distances this is achieved by a careful leveling of the camera. If widely separated base positions are used, they must be as nearly as possible at the same altitude. If they are unevenly placed on a slope, the resulting pictures will overlap in a stepped manner, instead of joining straight across. The same will occur in closeup or photomacrographic stereo pairs, if the base separation is at an angle to the edge of the film frame. Leveling should be done in three dimensions. That is, not only should the camera be leveled *across* the camera axis, it should also be leveled *along* that axis. (See Plate 53,b.)

Effects of Magnification and Focus Change

Any change of focus produces a magnification change. As noted earlier, the eye-brain can accomodate to very minor magnification variations. But if these are more than minute, it will become more and more difficult to fuse the images during viewing, ending with an eventual failure to fuse them, if the change is great enough. Therefore, when using a two-position base separation for distant subjects, do not refocus between pictures.

VIEWING

Stereo pairs can be viewed so as to produce a three-dimensional effect in any of several quite different ways. There is one feature that all methods have in common: the need to align the pictures with one another. There must be a common base line, so that both pictures are on the same level, and the vertical axes of the two must be parallel. If the pictures are cocked, or not at the same level, it will be difficult (or impossible) for the brain to fuse the two images into one three-dimensional impression. There are times when it is necessary to view rapid-access (Polaroid Land) stereo pairs as soon as you get them off the camera, and before there is any chance to mount them on a card. This can be done easily with a standard stereo print viewer. Place one picture under the viewer, cen-

PLATE 53 ▶

Stereo effects. Very close subjects require an abnormally small lens separation, while distant subjects need wider separations. (a) A photomacrographic stereo pair, made by the shifting-subject method, of nerve fibers in a cleared block of animal tissue at ×58.5 magnification (originally photographed for Dr. Hugh Rowell). Note that the relative positions of overlapping and adjacent fibers are clearly shown. (b) A deliberately drab-looking choice of landscape view of the eastern face of Mount Diablo, California, which was made to demonstrate that stereo effects can improve pictorial interest. Use of an unusually wide stereo separation exaggerates the stereo effect, and makes it possible to show the modeling of the distant hills. The 12 inch (305 mm) distance used is great enough to give some indication of the hill masses, without being too great for realistic appearance in the foreground. (I was careful to exclude any really close material.) Note that a failure to have the camera base laterally level will result in a stepped pair, with an incomplete vertical overlap. Compare this effect to that of Plate 52,b.

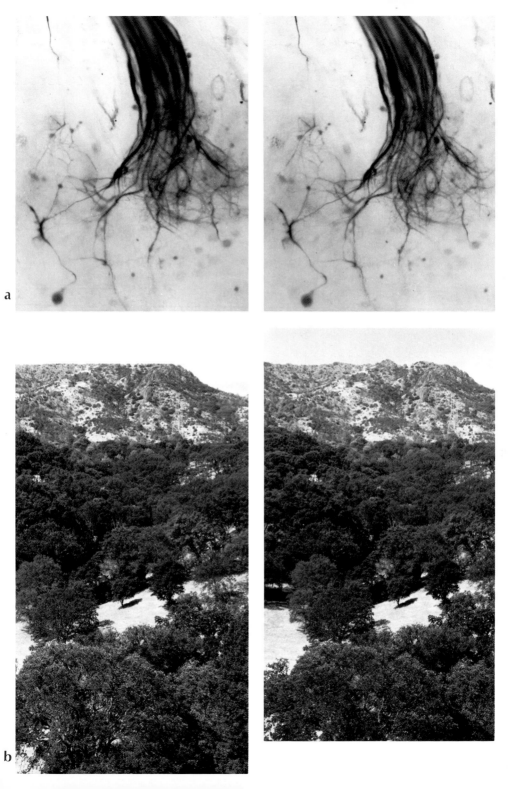

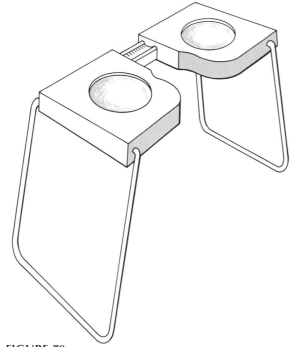

FIGURE 79
Typical stereo viewer.

raphy for detailed explanations of how these devices work.) The device familiar to most people is the old fashioned parlour viewer (the Stereopticon) used by our parents and grandparents to look at romantic tableux and foreign scenes, mounted as stereo pairs on $3\frac{1}{3} \times 7$ inch cards, with informational text printed on the back.

Current models of stereo viewers that are suitable for general use range from inexpensive folding pocket viewers (see Figure 79) or molded plastic Sawyer's Viewmasters to the complex devices used in interpretation of aerial stereo photographs. The fusing of the two images is eased if the viewer has an eyepiece separation (interpupillary distance) adjustment, so that each person can adjust it to an individual fit.

The difficulty with compact stereo viewers is that the pictures must be produced in a given size. The center-to-center distance of stereo pairs must be 65–75 mm, in order not to exceed the separation distance of human eyes. The most common recommendation is to use a 65 mm separation, and this imposes a 65 mm maximum picture width. Thus, photography for this sort of viewing must aim at a final print width that is no larger. (With viewers of the type shown in Figure 79, the print height is not limited, since the print pair can be pushed through the viewer and examined in sections.)

tered under one of the viewing lenses. While viewing, place the second print under the other lens. A double image will be seen. Move the second print so that it slides into coincidence with the first. As it does so, the stereo impression will pop into effect.

As to modes of viewing, I will not get into projection viewing because it is rarely done at present. (See the Bibliography, if you need to do it.) The viewing of either prints or slides is possible (depending upon how the pictures are mounted) either directly, or by any of three methods using optical devices.

Commercial Viewers

There are several types of commercial stereo viewers, most of which incorporate two lens assemblies in a frame holder. (See the Bibliog-

Mirror Viewing

There is a rather ingenious method of putting stereo pairs together so that no optical device other than a small mirror is needed. This involves printing one of the pictures reversed. In viewing, one eye looks directly at one of the pictures, and the other looks at a reflection in the mirror of the second, reversed, print. When

the angles of head, mirror, and prints are correctly aligned, the images fuse and a good stereo effect is obtained. (See Jackson's article "Stereo Macrophotography," in the Bibliography.) This method is illustrated in Figure 80,A.

Other than the lack of need for an optical viewer, the primary advantage of this method is that the prints can be of any size. However, there are five disadvantages. The first is that the use of an ordinary second-surface mirror will produce a double image, one from the glass front surface and one from the silvered back surface, unless the prints are quite widely spread and thereby take up quite a lot of room. This double image effect leads to visual confusion, so you should use a first-surface mirror. And these are hard to come by and expensive (especially in large sizes) and require careful handling for durability. The second problem is that even with first-surface mirrors the prints must be mounted with abnormally wide separations. Thirdly, you must keep clearly in mind which is the reversed print, so that you can be sure to use the mirror on the correct one. Otherwise, the whole stereo impression will be laterally reversed into a mirror image of the real scene. Fourth, you have to train each new viewer in the method, as it is not widely known or understood. And fifth, pictures mounted this way cannot be viewed by any other method. Therefore, I don't consider the method widely useful.

Tube Method

The best and simplest nonoptical viewing device, suitable for any print size, requires only two paper or cardboard tubes (toilet paper tubes do nicely). The tubes are held in front of your eyes, like binoculars. Each tube is adjusted

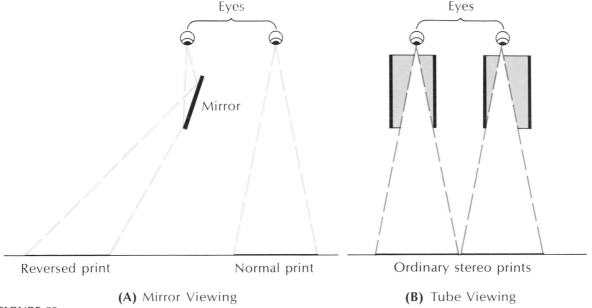

(A) Mirror Viewing

(B) Tube Viewing

FIGURE 80
Stereo viewing without lenses.

so that it restricts vision to the single print that should be seen with that eye. The images fuse easily and without any feeling of eyestrain, and anyone capable of ordinary two-eyed vision can do it at least as readily as by the use of lenses or mirrors. Best of all, the materials are available anywhere. You can make tubes by rolling sheets of typing paper or magazines, or you can see your local custodian for supplies. (You can even curl up your fingers tube fashion, though longer tubes are a little easier to use.) I personally prefer this method over all others, since I have reached the age where my eyes do not accomodate easily. With tube viewing there are no optics to trouble me, and no interpupillary adjustments to make. (See Figure 80,B, for an illustration of the technique.)

Direct Viewing

There is a method of stereo viewing that requires no equipment at all, other than control of your eye movements. The stereo pair is held out at arm's length, and you look just over the top of it at a distant wall. Seen in peripheral vision, the stereo pair is out of focus. Wait a moment until a third image appears. Then move your eye attention to the center image. It will have a stereo depth. Once you have got this effect you can move the pair nearer and view it in three dimensions at your leisure.

The trick is to keep your eyes from converging as you redirect your attention from the far wall. Stereo effect here is dependent upon keeping the eye axes parallel, and the natural tendency is for them to converge as the viewing distance shortens. So this method requires a little skill, which must be developed by practice. Some people can do this easily, and tend to become positively smug about it. I can do it with moderate concentration, but find it far easier to use the tube technique. A few people seem unable to do it at all. Feel free to choose your method at will.

CHAPTER 13

Balanced-Ratio Flash Applications

Flash photography technique seems to intimidate many people, for reasons having more to do with fear of the unknown rather than anything else. This is unfortunate, because flash lighting is the simplest and least troublesome form of artificial lighting for photographic purposes, and learning it isn't all that hard. Knowledge of balanced-ratio flash technique adds very greatly to the versatility of your technical abilities. The following text briefly describes some of the ways in which this technique can be of use in field photography. (See the text following page 135 for details of the method.)

FILL-IN FLASH

This is the best known form of balanced-ratio flash. Since it can be done in various ways, I will only suggest three representative uses.

Synchro-Sunlight Flash

Using a flash unit to fill in deep shadows is an easy way of salvaging, and even making excellent, an otherwise dead loss lighting situation. Suppose you are working in a forested area on a sunny day. Except in deep rain forests the usual visual impression is of "dappled" sunlight, with spots of direct sunlight interspersed with quite deep general shade. Photographically, this is an almost impossible situation for existing-light technique, because the sunlit areas are at least three stops brighter than the shaded places. Fill-in flash can bring the contrasts into a reasonable relationship with the film's capabilities, without doing away with the general existing pattern of light distribution. I would suggest aiming for a one-stop difference.

Multiple Flash

The need for multiple flash technique arises when you must work where the existing light is too dim for photography; where you need to have a definite main lighting direction to establish the mood of the picture or the shape of the object, and where a single flash unit would leave major portions of the subject area in darkness. For instance, you might be working in a cave or rock shelter in which you need to delineate the shapes and textures of a subject, but where full detail must be shown in shaded areas. In most cases it is desirable to diffuse the light of the unit or units that provide the fill lighting.

Portraiture

We all end up having to make an occasional portrait for one reason or another. It may be that the sitter is a colleague needing a publicity picture, or an exotic tribal character whose facial scarring, hair arrangement, and head costume are being recorded for the benefit of science. Doing the job well leaves you with a better feeling, whatever the purpose (see Plates 54 and 55). Multiple lighting such as is done in portrait studios is not especially difficult, requiring only a little application, and access to a good literary source. (Kodak's new publication O-4, *Professional Portrait Techniques,* is both good and inexpensive, with well diagrammed and illustrated examples of a number of approaches.)

There is one standard setup, using a minimum of three and a maximum of five lights, that almost always yields excellent results. It is often called "triangle" lighting, and it gives an accurate and pleasing impression of the sitter's face. The camera is placed on a tripod so that the lens axis is about 45 degrees off the sitter's body axis, and the sitter's head is turned toward the lens. The camera should be at about head height. The setup is illustrated, as seen from directly above, in Figure 81, page 420.

PLATE 54 ▶

Balanced-ratio lighting—portraiture. Captain Jacques Cousteau, with Campus Diving Officer Lloyd Austin, at a press conference following an appearance at the University of California, Berkeley. Lighting was provided by television lights, which were grossly unbalanced when this exposure was made. Such imbalances are common in photography by existing light. If I had used a flash unit I could have balanced the lighting contrast to any level desired, but the intermittent flashes would have been disturbing to the television filming.

In this setup, an undiffused main light is placed about 45 degrees off the camera axis, 90 degrees to the sitter's body axis, and a little above his or her eye level. The fill light, diffused, is placed near the camera axis, but on the other side of it from the main light. It should be at or only slightly above the lens axis, never below it. The hair light, undiffused, is behind the sitter and possibly a little to one side, and is high above, pointing down at about a 45 degree angle at the back of the sitter's head. Its purpose is to provide hair highlights, and to delineate the shoulder contour so that it will not sink into the background shadows. The lighting ratio between the main light and the fill should be 1:2 or 1:3. The hair light can be as strong as the main light, and only two-thirds to one-half the distance if the hair is dark. For blond or balding people, 1:1 is a good ratio between the main light and the hair light.

You can profitably add two more lights, at will: a second hair light, the two being placed behind, above, and to either side of the sitter's head; and a background light, whose purpose is to illuminate only the background. It is located behind the subject, and can be below the lens axis or anywhere else that lights the background adequately. The sitter should be placed far enough from the background that the shadow thrown by the main light falls to one side of the picture area. Now, if you can coax a satisfactory expression onto the sitter's face at the moment of the exposure, you should have a good portrait.

EQUAL-BALANCE FLASH

The purpose here is to equal the existing light exactly, and thereby remove all trace of shadowing. This method is especially useful when you want to record color patterns only (like those of lichens on rocks), without the confusion introduced by shadows.

DOMINANT FLASH

Flash technique in which the power of the flash unit is balanced so that it slightly exceeds the existing light strength, and is thus dominant to

PLATE 55 ▶

Balanced-ratio lighting—portraiture. Performance portrait of Juanita Oribello, classical guitarist and singer who works in the San Francisco area. An example of rather traditional formal portraiture, using multiple lighting to achieve a studied effect. At first, it may look like a difficult effect to try for, but in fact is quite easy to do. This lighting style is based upon a standard setup often referred to as "butterfly" or "Paramount" lighting. (The former term refers to the small but symmetrical shadow under the nose; the latter is a reference to the technique's usage by movie studios for publicity stills.) The main light axis coincides with the fore-and-aft axis of the sitter's head, and this gives emphasis to the shaping of the cheek bones. In the present example, three other lights were also used: (1) a fill light of low intensity, next to the camera axis; (2) a light somewhat behind, above and to the left, to outline the right side of the face against the dark background; and (3) a hair light above and to the right, that also served to outline the tops of the shoulders. A completely similar setup could be used very satisfactorily to show such features as hair styling, head dress, or facial cicatrices, in ethnological investigations. All four lamps used here were small inexpensive electronic flash units (Capro FL-4), which were fired simultaneously by means of ordinary flash extension cords and Y-connectors, all ultimately synchronized with the camera shutter at the single outlet on the camera body. Slave units could have been used, but would have cost more. With such simple lighting equipment it is quite practical to make high quality publicity pictures, or scientific records in the field for any purpose.

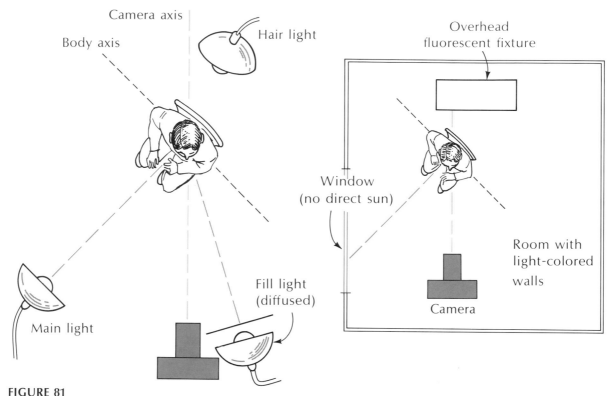

FIGURE 81
Triangle portrait lighting.

a known degree, is relatively little used, and yet it is of potentially significant value.

The single most useful application lies in the visual isolation of subject matter. Suppose, for example, that you wish to photograph one bush against a background of similar bushes. In normal existing-light two-dimensional photography, the one bush will disappear into a welter of confusion. If you use a carefully directed flash unit to illuminate only that one bush to a level about one stop brighter than its surroundings, it will be visually set off from its companions. Work out shutter speed and aperture settings so that the existing light will be one stop underexposed and the flash exposure will be correct. To do this well, it might be necessary

to place a card in front of the flash unit, with a hole in it that is the basic shape of the bush, so that *only* the subject bush gets the extra light. I think the possibilities for this technique are obvious.

As an alternative, you could do it the other way around, using flash to light the surroundings, and using a shaped card—similar to the "dodger" used in differential printing—to hold the flash lighting off the area to be lit only by existing light. If the flash lighting was marginally brighter than the existing light, and the latter was the "correct" exposure, the finished print would be slightly too light all over, but with the intended main subject printed at the correct exposure.

Final Note

In books on nature photography, a lot of space is usually devoted to the details of how to photograph particular classifications of subjects, such as large mammals, birds, or insects. I have not done so here, because the assumption behind this book is that the reader is a naturalist, defined in my dictionary as "one who is versed in or devoted to natural history."* The essence of successful field photography—after the basic photographic technique has been learned—is knowledge of the subject matter. If the reader is a naturalist, either amateur or professional, I feel ill qualified to advise. I am a photographer, not a zoologist, entomologist, botanist, or whatever.

For the reader who would like to see what

*The American College Dictionary, Harper & Brothers, New York, 1948.

is said about how to deal with particular subjects, there is the index. But I do not feel that dipping through this book is going to do anyone a lot of good. A more profitable approach would be to determine, in advance of need, the body of photographic technique that would be of most use in the particular case, and then to take the time and trouble to learn enough about it so that primary attention in the field can be given to the events being recorded. Poor results are the legacy of a hesitant approach. Good results are produced by forethought and diligence.

Field photography of nature subjects is itself a satisfying and rewarding activity—a bloodless sport, a contemplative art, and a fine and private entry to the wonders that lie all about us. Enjoy the hunt.

Appendixes

Film Speed Equivalence

Historically, a number of systems have been developed for calibrating film speeds, several of which are still in use. Since there are differences in the mode of calculation for the speed of films, Table 37 is a tabulated series of approximate equivalences.

Except in a few areas it appears that the ASA speed is approaching the status of an international standard, but for those who use other systems, this table should provide sufficient information to make the text more intelligible.

TABLE 37
Film speed equivalences

ASA/BSI (US & UK)	BSI (LOG) (UK)	GOST (USSR)	DIN	SCHEINER (EUROPE)
3	16°	6	6	17°
4	17°	8	7	18°
5	18°	10	8	19°
6	19°	12	9	20°
8	20°	16	10	21°
10	21°	20	11	22°
12	22°	25	12	23°
16	23°	32	13	24°
20	24°	40	14	25°
25	25°	50	15	26°
32	26°	65	16	27°
40	27°	80	17	28°
50	28°	100	18	29°
65	29°	125	19	30°
80	30°	160	20	31°
100	31°	200	21	32°
125	32°	230	22	33°
160	33°	320	23	34°
200	34°	400	24	35°
250	35°	500	25	36°
320	36°	650	26	37°
400	37°	800	27	38°
500	38°	1000	28	39°
650	39°	1250	29	40°
800	40°	1600	30	41°
1000	41°	2000	31	42°
1200	42°	2400	32	43°
1600	43°	3200	33	44°

APPENDIX 2

Darkroom Sink

On page 218 there is a design for a small darkroom, which is based upon the one I have in my home. The sink was homemade, and has proved so satisfactory that I am providing the construction plan for use by readers. The dimensions can be changed at will, but in the size shown it can be cut from a single 4 × 8 foot sheet of one-half inch exterior grade plywood, with only a few other parts being needed. Figure 82, A, illustrates the cutting pattern.

All joints were both nailed, and glued, for strength. The sink interior was painted with three coats of marine epoxy paint, with great care exercised to see that all of the interior joints are fully sealed against water. The large hole for the sink drain was made by drilling a circumferential circle of small holes, joining them with a keyhole saw, and then using a wood rasp to size it to fit standard plumbing fixtures. With the gasket provided, the seal is watertight. Such a sink will give years of trouble-free use, and if leaks eventually develop they can be sealed by repainting.

(A) Cutting Pattern for Sink,
From One 4′ × 8′ × ½″ Plywood Sheet,
Exterior Grade

8′

4′

Bottom 22″ × 52″ 1

Back 18″ × 52″ 2

Front 52″ × 6″ 3

5

Legs [4]

30½″ × 5″ × 3″

Legs [4] 6

30″ × 5″ × 2″

Ends [2]

4

22″ ×

18″ × 6″

Shelf support [2]

23″ × 3″ 7

9

22″ × 6″

10

8

Shelves [2]

Shelf back [2] 2″ × 22″ 11

Pegs for holding and draining
graduates, funnels, etc.

Drain hole

Surface these edges
with ½″ half-round
molding for comfort

Cove molding

Shelving

4

2

1

3

4

5

5

5

5

5

7

8

11

6

7

11

8

9 all four corners

6 two others
at rear corners

10 all four corners

(B) Assembly Diagram

FIGURE 82
Darkroom sink.

APPENDIX 3

Copying Color Slides to Black-and-White

A number of the black-and-white plates in this text were originally photographed as color slides, and were translated in their present form by copying. The single most convenient method of doing such copying—which is quick and easy, immediately correctable, and produces a negative of good quality and relatively low contrast—is by placing the transparency in the negative carrier of an enlarger and projecting its image onto the film plane of a Polaroid 545 Land Film Holder. This holder accepts single-sheet packets of 4 × 5 inch Type 55 Positive/Negative film.

In this use you sacrifice print quality in order to get an optimum quality negative, for later reprinting by conventional means. An exposure time that produces a good print overexposes the

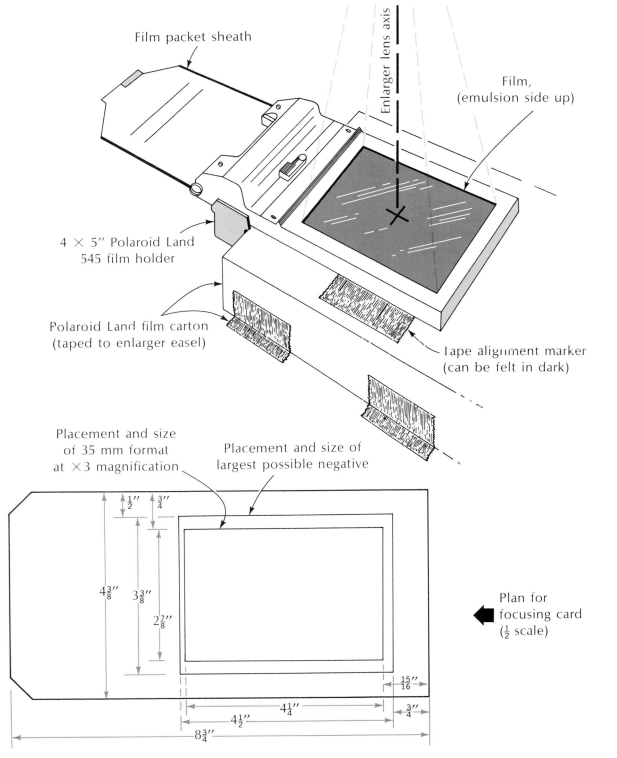

FIGURE 83
Slide copying on Polaroid Land P/N film.

negative, with considerable loss of highlight contrast. A correct exposure for the negative is one that just barely records the darkest tones of the slide. I do not recommend using the print itself for reproduction purposes, as it will have substantially less resolution than the negative. And it may not be large enough to suit your purpose anyway. A contact print or an enlargement from the negative will be of better quality.

No exact exposure data can be given, but with my Prinz Craftsman enlarger set to give a ×3 image magnification (this just fills the length of the film with the image of the whole 35 mm frame), a good basic exposure is 1–2 seconds with the enlarger lens set at f/16. Following the inverse square law, halving the image magnification requires one-quarter of the previous exposure (two stops less), and doubling the magnification requires four times as much exposure (two stops more). Finer exposure calibration can be done by trial-and-error with repeated exposures, by test stripping as in normal projection printing, or by print metering.

Do not plan to enlarge the new negative image more than three or four times in printing, or a quality loss will ensue. If you need greater detail, make a new negative at a higher basic magnification. A little advance planning of needs will be beneficial here. For copying portions of slides at ×15 enlargement, I have found an exposure of 12–20 seconds at f/11 to be a good starting point.

In using this method for copying, the film holder is inverted under the enlarger, and the film packets must be put in with the emulsion side up (this is marked on the packet). Because the holder has a raised end it cannot just be laid on the enlarger baseboard, but requires blocking up. The film carton serves nicely as such a support. Composing the image is done by inserting a piece of white card into the empty holder, to be used as a projection screen. When the image is correctly composed and focused the card is withdrawn and a film packet is inserted. All darkroom lights must be turned off; since the film is panchromatic, no safelight can be used. After this is done the packet sheath can be pulled out, the exposure made, the sheath returned, the lights turned on, and the exposed film processed in the normal manner, by pulling it between the rollers in the holder.

No details of processing are given here, since they are printed on the film holder and in the film instruction sheet. But some remarks are in order. The film holder must be kept scrupulously clean. If improper handling ruptures a packet the caustic interior chemicals will contaminate the holder. It must immediately be opened, and the rollers and other contaminated surfaces carefully wiped off with cleansing tissue. After the basic processing has been completed, the negative is made permanent by soaking for a short period in a sodium sulphite solution (as per the instructions) and then washing it in water for five minutes. The whole process is quick and simple, and substantially less trouble than normal film processing. The resulting negative is of good quality, if it is not overenlarged in printing. See Figure 83 for additional detail.

Bibliography

This section is a comprehensive selected bibli ography, which is divided into five categories: basic general references, books, miscellaneous pamphlets, Kodak publications, and articles. Most were directly referred to in one place or another in the preceding text, although a few were not. The general references were chosen with an eye to presenting the reader with a sufficient variety of approaches to satisfy nearly any likely need. Throughout the Bibliography notes are appended to entries wherever I felt that the reader would be helped thereby to choose readings that would further certain par ticular interests. This collection of titles is far from being a complete listing of works on pho tography and related subjects, but it has been carefully chosen over a long period of time. Each item has something significant to offer. Most of the sources listed should be available in any reasonably large library, but I cannot vouch for the availability of particular items.

Basic General References

(This section is arranged from the general to the particular, by subject.)

Swedlund, Charles, *Photography: A Handbook of History, Materials and Processes* (Holt, Rinehart & Winston, New York, 1974). This is a general text designed for the beginning photographer. Anyone who is not already an expert photographer will almost certainly benefit from reading it. The book, a large paperbound volume, is very well organized, and the choice and presentation of the line and half-tone illustrations is very well thought out. In my opinion, it is the best general beginning photography text now on the market.

Neblette, C. B., *Photography: Its Materials and Processes,* 6th ed. (D. Van Nostrand Co., Inc., Princeton, N.J., 1966). Since the publication of the first edition in 1927, this text has been the standard technical introduction to photography. It is still unexcelled in its area of coverage, and remains a very useful shelf reference.

Adams, Ansel, *Camera and Lens: The Creative Approach* (Morgan & Morgan, Inc., Hastings-On-Hudson, N.Y., 1970). This is a completely new version of the first volume of Adams' basic photography series, other volumes of which are listed in the next section. It is a fine book for the person particularly interested in landscape photography (though by no means limited to that area), whether this interest is aesthetically oriented, or incited by scientific or other recording needs.

John, D. H. O., *Photography on Expeditions* (The Focal Press Ltd., London and New York, 1965). I do not know of any other book that has addressed itself to the special problem of expedition photography. It is not only close to being unique, it is a good book, and is based upon solid experience and a closely reasoned organizational plan. It should be in the basic library of every institution likely to field any research party, either locally or abroad.

Blaker, Alfred A., *Photography for Scientific Publication* W.H. Freeman and Company, San Francisco, 1965). This is a compact handbook designed to assist scientific researchers in preparing their own laboratory research illustrations. For those who need to do laboratory oriented photography, and who do not wish to resort to the use of bulky volumes aimed at professional photographers, this is a useful text.

Angel, Heather, *Nature Photography: Its Art & Techniques* (distributed in the U.S. by Morgan & Morgan, Hastings-On-Hudson, N.Y., 1972). I consider this the single best book on the applications of photography to nature subjects. It is an excellent companion volume to the present text. The author is a fine technician and an unusually good photographer.

Ettlinger, D. M. T. (ed.), *Natural History Photography* (Academic Press, New York and London, 1974). A work consisting of chapter-sized sections by eighteen specialists in nature photography, and organized by subject matter. A basic reference for any library.

Clauss, Dr. Hans and Meusel, Heinz, *Filter Practice* (The Focal Press Ltd., London and New York, 1964). There are a number of general works on the use of filters in photography, and I consider this to be one of the best organized and clearest presentations. It is a translation from the original German. I have used it in teaching for a number of years.

Dunn, J. F., *Exposure Manual* (John Wiley & Sons, New York, 1958). There is no equal to this book on the theory and practice of photographic exposure.

Dillard, Annie, *Pilgrim at Tinker Creek* (Harper's Magazine Press, New York, 1974). This book has nothing to do with photography, but a great deal to do with seeing nature. Its prose is positively enthralling, and I can see no finer way to address yourself to the problem of acquiring sensitivity to the world around you. Get this book.

Feltz, Michael R. and Jasek, James F., *Total Photo Computer Manual* (Waco, Texas, 1973). A 6 × 9

inch paperbound manual accompanied by a four inch diameter circular calculator. The calculator is two-sided affair with six inter-related dials, carrying 16 scales and a table. The manual gives clear and concise instructions for using the calculator to solve a very large variety of photographic problems in its first 54 pages. This is followed by 14 pages of useful photographic formulas, with instructions for their use in problem solving, and examples. This is the most comprehensive photo calculator that I have seen, and both it and its manual should be carried along on any but the simplest of field explorations. It will add only six ounces to your load, and will be well worth carrying. (It is obtainable from Total Photo Computer; P.O. Box 7770; Waco, Texas, 76710.)

Books

Adams, Ansel, *Artificial-Light Photography* (Morgan & Morgan, New York, 1962). This is Volume 5 of the Adams basic photo series, and is an excellent source on the handling of artificial light, including flash.

————, *The Negative* (Morgan & Morgan, Hastings-On-Hudson, N.Y., 1964). Volume 2 of the basic photo series, this introduces the Zone System.

————, *The Print* (Morgan & Morgan, Hastings-On-Hudson, N.Y., 1964). Volume 3 of the series, this book carries the Zone System into the making of the print, and is the finest text on black-and-white photo printing.

————, *Polaroid Land Photography Manual* (Morgan & Morgan, New York, 1964). The single most comprehensive source on Polaroid photography up to and including Polacolor (but not including the SX-70 process).

Amphoto, *Official Depth of Field Tables for 35 mm Cameras* (Amphoto, New York, n.d.).

Bauer, Erwin A., *Hunting With A Camera* (Winchester Press, New York, 1974). Subtitled *A World Guide To Wildlife Photography*, this book specializes in telling you where to find good photographic opportunities in the wildlife field.

Bomback, Edward S., *Manual of Photographic Lighting* (Fountain Press, London, 1971).

Bögli, Alfred, and Franke, Herbert W., *Luminous Darkness,* 2nd ed. (Rand McNally Co., Chicago, 1968). Although primarily a book on caves and caving, this work is unusually well illustrated, and has a section of worthwhile photographic notes at the end.

Cooper, Joseph D., *Photography Through Monoculars, Binoculars and Telescopes,* 3rd ed. (Universal Photo Books–Chilton, New York, 1965).

Dalton, Stephen, *Borne on the Wind* (Reader's Digest Press–E. P. Dutton, New York, 1975). A superbly illustrated work on insect flight.

Dignan, Patrick D., *Dignan's Simplified Chemical Formulas for Black & White and Color* (Dignan Photographic, Inc., N. Hollywood, Calif., 1972).

Dowdell, John J. III, and Zakia, Richard D., *Zone Systemizer* (Morgan & Morgan, Dobbs Ferry, N.Y., 1973). Ever since Adams first conceived and published the Zone System everyone else has tried to make it easier to use. This is one of the better efforts, and includes a useful dial calculator.

Eaton, George T., *Photographic Chemistry—in Black-and-White and Color Photography* (Morgan & Morgan, Hastings-On-Hudson, N.Y., 1957).

Edgerton, Harold E., *Electronic Flash, Strobe* (McGraw-Hill Book Co., New York, 1970). The summation of his life's work, by the inventor and major developer of electronic flash and strobe. An important and useful book, it includes wiring diagrams for specialized flash units, and for such ancillary items as electronic shutter tripping devices for wildlife photography.

Gassan, Arnold, *A Handbook of Basic Photography* (The Center of the Eye, Inc., Aspen, Colo., 1969).

————, *Handbook for Contemporary Photo-*

graphy (Handbook Publishing, Athens, Ohio, 1970). These two books are not duplicates, but cover two different approaches to instruction in photography.

Haist, Grant, *Monobath Manual* (Morgan & Morgan, Hastings-On-Hudson, N.Y., 1966). The only comprehensive source on monobath chemistry and technique.

Halliday, William R., *American Caves and Caving* (Harper & Row, New York, 1974). The single best book that I have seen on the technical aspects of caving. The chapter on "Headlamps" (pp. 94–120), includes an exhaustive coverage of electric power cells, much of it applicable to photography. The book also includes much useful information on clothing for cold-wet situations, and a first rate chapter on medicine and first aid for caving and other similar circumstances.

Kaiser, Julius B., *Make Your Own Stereo Pictures* (The MacMillan Co., New York, 1955).

Kingslake, Rudolf, *Lenses in Photography* (A.S. Barnes & Co., Inc., New York: Thomas Yoseloff, Ltd., London, 1963). A useful text aimed at and comprehensible by the general photographer.

Kinne, Russ, *The Complete Book of Nature Photography* (A.S. Barnes—Ziff-Davis, New York, 1962). One of the standard general works on nature photography, this has recently been rereleased.

Maye, Patricia, *Fieldbook of Nature Photography* (Sierra Club Books, San Francisco, 1974). A pocket sized field guide. Some field photographers of my acquaintance consider it somewhat too fragmentary to be of great use, but it should be looked at to see if it fits your particular needs.

McKay, Herbert C., *Three Dimensional Photography: Principles of Stereoscopy* (American Photography Book Dep't., New York, 1953). Out of print, but available in many libraries. A very useful text.

Mertens, Lawrence E., *In-Water Photography* (Wiley Interscience, John Wiley & Sons, New York, 1970). In my opinion, unquestionably the best single book on underwater photography.

Nachtigall, Werner, *Insects in Flight* (McGraw-Hill Book Co., New York, 1974). A good translation of a 1968 German Text. Anyone doing insect photography, whatever their background, should see this book. It is clear, concise and as complete as its date allows.

Picker, Fred, *The Zone VI Workshop* (The Zone VI Workshop, Conn., 1972). An excellent new book on Zone System photography.

Shull, Jim, *The Hole Thing: A Manual of Pinhole Photography* (Jim Shull, Mt. Angel, Ore. n.d. [1972]). A small paperbound, this $2.00 publication is the only recent addition of note to the literature on pinhole photography. It is well illustrated. (Obtainable from the author c/o Mt. Angel College, Mt. Angel, Ore., 97362.)

Shurcliff, William A., *Polarized Light: Production and Use* (Harvard University Press, Cambridge, Mass., 1962). A standard source.

Shurcliff, William and Ballard, Stanley S., *Polarized Light* (D. Van Nostrand Co., Inc., Princeton, N.J., 1964). A very useful paperbound.

Stroebel, Leslie, *View Camera Technique* (The Focal Press Ltd., London and New York, 1967). I consider this the very best book on the subject.

Strong, John, *Concepts of Classical Optics* (W.H. Freeman and Company, San Francisco, 1958). For those times when you need to go back to first principles.

Todd, Hollis N., and Zakia, Richard D., *Photographic Sensitometry: The Study of Tone Reproduction* (Morgan & Morgan, Hastings-On-Hudson, N.Y., 1969). A basic text for all serious photographers.

Valyus, Nikolai Admovich, *Stereoscopy* (The Focal Press Ltd., London and N.Y., 1966). A translation of a Russian original, this text is the most comprehensive source on the principles and practice of stereoscopy that is now in print.

White, Minor, *Zone System Manual* (Morgan & Morgan, Hastings-On-Hudson, N.Y., 1968, 4th

ed.). The standard explication of the Zone System.

Wood, Robert W., *Physical Optics* (Dover Publications, New York, 1967). A paperbound reprint of a MacMillan publication of 1934. A useful text.

Zakia, Richard D., and Todd, Hollis N., *101 Experiments in Photography* (Morgan & Morgan, Hastings-On-Hudson, N.Y., 1969). This little paperback is one of the most useful self-teaching devices ever published on photography.

Miscellaneous Booklets and Pamphlets

American Standards Association, *American Standard Photographic Exposure Guide* (American Standards Association, New York, 1966). A remarkable compendium of odd and peculiar photographic exposure advice.

Edmund Scientific Company, *All About Telephoto Lenses* (Edmund Scientific Co., Barrington, New Jersey, 1960). This 33 page pamphlet is a jewel for the gadgeteer who likes to do it himself, and for the general photographer in search of a working understanding of telephoto optics.

———, *Applied Infrared Photography* (Edmund Scientific Company, Barrington, New Jersey, n.d.)

Fishback, Glen, *The Glen Fishback Exposure System* (The Glen Fishback School of Photography, Sacramento, Calif., 1967). A good basic introduction to Fishback's modification of the Adams Zone System. (Available from the Glen Fishback School of Photography, 3307 Broadway, Sacramento, Calif. 95817.)

General Electric Company, *GE Photolamp & Lighting Data* (General Electric Co., Cleveland, Ohio, 1971). This is Publication No. P1-63P, referred to in the text, a compendium of flashbulb information that is useful for working with any similarly designated bulbs, regardless of manufacture, and well worth the dime GE asks for it. The small format, only $3\frac{1}{2}'' \times 4\frac{5}{8}''$,

makes it a gadget bag reference manual. (Available from General Electric Co., Nela Park, Cleveland, Ohio 44112.)

Pedrick, A. R., and Salisbury, J. T., *Infrared . . . and Its Uses*, rev. ed. (Edmund Scientific Co., Barrington, N.J., 1958).

Thomas Instrument Company, *Thomas Strobemeter Instruction Manual* (Thomas Instrument Co., Inc., New York, n.d. 196?). A surprisingly general publication on flash metering.

Allphin, Willard, *Color Photography Under Electric Lighting* (Sylvania GTE Lighting Center, Danvers, Mass., n.d. 197?). Engineering Bulletin 0-334.

General Electric Company, *Infrared Photography with the GE #5R Flashbulb* (General Electric Co., Cleveland, Ohio, n.d. 197?).

Kodak Publications

No honest writer and bibliographer can ignore the massive output of technical booklets and pamphlets from the Eastman Kodak Company, of Rochester, New York. The quantity and quality of these publications is legendary among photographers, and is part of the reason why Kodak is known as "The Great Yellow Father." A surprising number of them are the standard reference sources in their particular fields. And so, though I am in no way connected with the Eastman Kodak Co., a listing of the publications that I found most useful in writing this text is provided below, with publication dates as listed in the 1974 "Index":

No.	Title	Date
AA-5	*How To Make and Use a Pinhole Camera*	1972
AA-26	*Optical Formulas and Their Applications*	1972
AB-1	*Filters for Black-and White and Color Pictures*	1973

AB-10	Close-Up Pictures with 35 mm Cameras	1973
AB-11	Close-Up Pictures of Flowers and Other Small Objects Using Kodak Instamatic and Brownie Star Cameras	1973
AC-2	Flash Pictures	1967
AC-10	Photographing Television Images	1971
AC-28	Picture-Taking Through Binoculars	1973
AC-37	Exposure With Portable Electronic Flash Units	1973
AC-44	Adventures in Existing-Light Photography	1972
AC-65	Winter Photography— Better Pictures in the Snow	1974
AE-3	Color Photography Under Fluorescent Lighting	1973
AK-3	Darkroom Design for Amateur Photographers	1973
B-3	Kodak Filters for Scientific and Technical Uses	1972
C-9	Photography Under Arctic Conditions	1966 and 1973
C-24	Notes on Tropical Photography (An earlier version published in 1951 has a good short bibliography.)	1970
L-6	Index to Kodak Information	Annually
M-27	Ultraviolet and Fluorescence Photography (A standard.)	1972
M-28	Applied Infrared Photography . (A standard. M-27/28H is a hardbound combination of both M-27 and M-28.)	1973
N-9	Basic Scientific Photography (This booklet is aimed at the bare beginner, and emphasizes the use of very simple cameras, such as the Instamatic.)	1970
N-12A	Close-Up Photography (Uncredited, but known to be the work of H. Lou Gibson.)	1972
N-12B	Photomacrography (This and the above are available in a single hardbound volume; they are now the standard references in their fields.)	1972
N-17	Kodak Infrared Films	1972
O-4	Professional Portrait Techniques (A very good source)	1973
P-114	Kodak Neutral Density Attenuators	1971
T-17	A Survey of Motion Picture, Still Photography and Graphic Arts Instruction (A study of the incidence of these sorts of instruction in U.S. institutions of higher learning—by Dr. C. William Horrell.)	1972
T-23	How to Make and Use a Cartridge Pinhole Camera	1973

Periodicals

There are a considerable number of magazines and journals that are well worth reading regularly. The list provided here is partial, and is only

intended to provide some general notion of what is available. It is slanted heavily toward United States publications (though not limited to them). Residents of other countries will probably find a similar variety of useful sources locally. The addresses listed are those that are current at the time of writing. Inquire of the individual publisher for details of current price and availability.

Mass-Circulation Magazines Many people discount the value of these sources on the grounds that they are too amateurish and general in nature to be of real use. This is an error. Today's amateur photographers are becoming increasingly sophisticated, so a significant amount of what is published for them is equally so. Watch especially for articles on the general aspects of optics and other technical topics, written so as to be intelligible to the technical layman. The writings of their regular columnists also are of value, frequently, for the light they shed on specific problems too limited to be expanded to full article length. The best known American mass-circulation photographic magazines are:

Popular Photography, published monthly by Ziff-Davis Publishing Co., One Park Ave., New York, N.Y., 10016. Subscription service: P.O. Box 2775, Coulder, Colo., 80302. Intended for the large, general audience.

Modern Photography, published monthly as a subsidiary of ABC Leisure Magazines, Inc. Editorial offices: 130 East 59th St., New York, N.Y., 10022. Subscription service: 1 Picture Place, Marion, Ohio, 43302. Directly competes with the foregoing.

Camera 35, published monthly, except for the combined February/March and August/September issues, by the American Express Publishing Co. Editorial offices: 61 W. 51st St., New York, N.Y., 10019. Subscription service: P.O. Box 9500, Greenwich, Conn., 06830. For the 35 mm camera user, oriented primarily in

a pictorial, aesthetic direction, but with frequent technical articles and columns.

Petersen's PhotoGraphic Magazine, published monthly by Petersen Publishing Co., 8490 Sunset Blvd., Los Angeles, Ca. 90069. This is the most "how-to" oriented of the mass-circulation magazines, and is aimed at the advanced amateur. Though very much "gee whiz" in editorial tone, it is an excellent source of technical information.

Technical Magazines Each of these is designed to meet the needs of a very specific audience of selected readers, so neither the editorial content nor the advertising appeal of these magazines overlaps significantly. All have something useful to offer to the readers of the present text. Typical American magazines in this field are:

Industrial Photography, published monthly by United Business Publications, Inc., 750 Third Ave., New York, N.Y., 10017. Intended for in-plant industrial photographers, but the problems of industrial people are technically similar to those of biological photographers.

Functional Photography: Photographic Applications in Science, Technology and Medicine, published six times annually as a subsidiary of PTN Publishing Corp., which also puts out a variety of other magazines on subjects such as professional photography, cinematography, and microfilming. Editorial offices: 250 Fulton Ave., Hempstead, N.Y., 11550. The title describes the contents.

Photomethods (formerly called *Photo Methods for Industry,* or just *PMI*), published monthly by Ziff-Davis Publishing Co., One Park Ave., New York, N.Y., 10016. A general coverage of the technical aspects of professional and scientific photography.

Technical Photography, published monthly by In-Plant Photography, Inc., 250 Fulton Ave., Hempstead, N.Y., 11550. Subtitled "The Publication for Industrial, Military and Government

Still, Cine and AV Professionals," it is less technically oriented than the title indicates. It is more of a news magazine. But there are occasional articles of real interest—enough to warrant regular perusal. The magazine is published in an oversized format ($10\frac{1}{2} \times 14$ inches), so it is not as readily filed as most others.

Journals There are several photographic journals in international circulation which should be in the library of any scientific institution. (In addition, most scientific journals sooner or later publish some articles having to do with photography and/or its application to science.) The leading photographic journals include:

Journal of the Biological Photographic Association, the quarterly publication of that organization. Editorial offices: Box 333, Station A, Ottawa, Ontario, Canada, K1N8V3. Subscriptions: BPA, P.O. Box 1057, Rochester, Minn., 55901. During its 41 years of publication, this journal has put out a steady stream of useful articles on all aspects of biological photography. Its back file is an essential research resource.

Medical and Biological Illustration, published quarterly by the British Medical Association, Tavistock Square, London WC1H 9 JR, England. This journal serves both photographers and artists. Its articles are similar in nature to those of *JBPA,* above.

bio-Graphic Quarterly, published quarterly by the bio-Graphic Unit, Scientific Information Section, Research Branch, Canada Department of Agriculture, Ottawa. It also is similar in content to *JBPA.*

British Journal of Photography, published weekly by Henry Greenwood & Co., Ltd., 24 Wellington St., London, WC2E 7DG, England. The grand-daddy of them all, this journal goes back to the earliest years of photography. It overlaps all of the periodicals mentioned earlier, yet resembles none. The style is dry for

American literary tastes, but its articles positively drip authority. It is surely the premier photographic publication. Any institutional library ought to have it, and serious photographers should see it regularly.

Articles

Barer, R., and Wardley, J., "Ultraviolet Television Microscopy," *Nature,* 192, (1961): 1060.

Blake, Donald P., "Covering Vietnam: It's A Battle For Survival," *Technical Photography,* Jan., 1970, pp. 24–25. (Contains useful information on tropical photographic practices.)

Blaker, Alfred A., "Field Photography of Nocturnal Arthropods," *J. Biological Photographic Ass'n,* 37, (Jan., 1969): 60–62.

———, "Photography of Marine Life in Shallow Tide Pools," *J. Biological Photographic Ass'n,* 38, (Jan., 1970): 20–24.

Cornfield, Jim, "The Conceptual Use of the Wide-Angle Lens," *Petersen's PhotoGraphic,* Jan., 1974, pp. 40–41.

Eisendrath, David B., Jr., "Eisendrath on Filters: Everything about Filters Except When to Use Them," *Photo Methods for Industry,* Sept., 1965, pp. 37–40.

———, "Polaroid Land 4," *Photo Methods for Industry,* June, 1972, pp. 50–52.

———, "Working Photographer," *Photo Methods for Industry,* Jan., 1971, pp. 10, 14, 16; Feb., 1971, pp. 14, 70–71; and Mar., 1971, pp. 10–12, 14, 17. (A monthly column—this a three-part series on cold weather photography.)

———, "Some Comments On Static," *Photo Methods for Industry,* Dec., 1962, pp. 42–44, 46–48, 50–51.

Eisner, T. (et al), "Ultraviolet Video-Viewing: The Television Camera as An Insect Eye," *Science,* 166, (28 Nov., 1969): 1172–1174.

Farber, Ed, "Photo-tronics," *Modern Photography,* March, 1974, pp. 118, 122. (A regular column—this one is about sequence flash,

using auto-feedback flash units for ultra-high speed.)

Farber, Paul R., "Divided Development," *U.S. Camera,* June, 1962, pp. 46, 86. (With an earlier, but less interesting, part in the previous issue.)

———, "Divided Development," in *Dignan's Simplified Chemical Formulas for Black & White and Color,* Patrick D. Dignan, *et al,* (Dignan Photographic, Inc., No. Hollywood, Calif., 1972). An updating of the *U.S. Camera* article.

———, ed., "How To Meter Electronic Flash," *Petersen's PhotoGraphic,* Sept., 1974, p. 29.

Fishback, Glen, "A Practical Zone System," *Camera 35,* Feb./Mar., 1968, p. 26.

———, "Why Spotmeter?," *Camera 35,* June/July, 1968, p. 48.

———, "How To Use A Spotmeter," *Petersen's PhotoGraphic,* Jan., 1973, pp. 21-25.

———, "Zonal Color Exposure Control," *Petersen's PhotoGraphic,* May, 1974, pp. 71-74.

Floyd, Bill, "The Fantastic Floydmar Camera," *Petersen's PhotoGraphic,* Sept., 1972, pp. 42-45.

Franks, E. Harvey, "Stereopsis and Stereoscopy" (a four-part series), *The British Journal of Photography,* 119, (15 Dec., 1972): 1086-1088; 119 (22 Dec., 1972): 1110-1113; 119 (29 Dec., 1972): 1136-1139; and 120 (5 Jan., 1973): 20-21.

Gahm, Josef, "Polarized-light Microscopy & Two-beam Interference Microscopy by Transmitted Light," *Zeiss Information,* 61, (1966): pp. 89-95.

General Electric Company, "Camera Filter Recommendations For Color Photography With Discharge Lamps," *Industrial Photography,* Nov., 1969, pp. 24-25.

Goncz, John H., and Newell, P. Bruce, "Spectra of Pulsed and Continuous Xenon Discharges," *J. Optical Soc. of America,* 56, (Jan., 1966): 87-92.

Gutenstein, Hanns, "Tilting Lens Makes 35 mm SLR Into A View Camera," *Technical Photography,* March, 1974, pp. 12, 27.

Hyzer, William G., "How To Measure With A Camera," *Photo Methods for Industry,* Jan., 1963, pp. 24-25, 36-37, 48.

———, "Optimum Techniques Of Photomacrography," *Photomethods* (formerly *Photo Methods for Industry*), February, 1975, pp. 25-29, 44.

Jackson, Ross, "Stereo Macrophotography of Biological Material," *J. Biological Photographic Ass'n.,* 26, (Aug., 1958): 125-128.

Kabe, H., "Use of a Low-voltage Bulb for Printing Enlargements of Electron Microscope Plates," *J. Biological Photographic Ass'n.,* 34, (Aug., 1966): 97-101.

Keeling, Derek, "Optical Design and Aberrations 15" *The British J. of Photography,* 12 May, 1972:411-413. (One of a long series of articles, soon to be published as a book by Henry Greenwood & Co., Ltd., London.)

Keppler, Herbert, "Does It Pay to Tilt & Shift with 35 mm?," *Modern Photography,* Nov. 1974, p. 114-118.

———, "The Hole Thing Exposed," *Modern Photography,* July, 1974, pp. 112-113, 132.

———, and Kimata, Hiroshi, "Macro Zooms: Gimmick or Worthwhile New Feature?," *Modern Photography,* pp. 76-83, May, 1974.

Kimata, Hiroshi, and Keppler, Herbert, "The Weird World of Polarizing Filters & How to Live in it," *Modern Photography,* June, 1974, pp. 96-99, 134.

Laurance, Mike, "The Kelvin Scale," *Petersen's PhotoGraphic,* June, 1973, pp. 35-39.

———, "Wide Angles," *Petersen's PhotoGraphic,* Jan., 1974, pp. 32-39, 42-43.

Levy, Marilyn, "Wide Latitude Photography," *Photographic Science & Engineering,* 11, (Jan-Feb, 1967): 46-52.

Martin, Stephen P., "Jiffy Calculator For Night-Light Exposures," *Popular Photography,* March, 1964, p. 163, and reprinted in the April, 1968 issue.

Morris, R. B., and Spencer, D. A., "Dazzle-free Photoflash Photography," *The British J. of Photography,* 87, (1940): 288-289. (An article on infrared flash technique.)

Most, Bruce W., "Cold-Weather Photography," *Technical Photography*, Nov., 1970, pp. 16–17, 23–24.

Neider, Charles, "Photography at the Edge of the World," *Industrial Photography*, July, 1973, pp. 20–25, 42, 44. (About photography in Antarctica.)

Pressman, Zev, "Photo-optical Instrumentation at Stanford Research Institute," *J. Soc. of Motion Picture & Television Engineers*, 76, (July, 1967): 651–658.

Rothschild, Norman, "Offbeat: Fungus? Scratches? Dirt? Here's A Way To Preserve And Protect Your Slides," *Popular Photography*, March, 1975, pp. 16, 18.

Roudabush, Robert L., "Insect Damage To Color Film," *Photographic Applications In Science, Technology And Medicine*, March, 1975, pp. 28–33.

Scardino, Mike, "Stabilization Processing: A Review," *Petersen's PhotoGraphic*, July, 1973, pp. 26–31. (See also the column "On The Scene," p. 80, in the same issue, for an updating note.)

Schwalberg, Bob, "Things You Should Know About Depth of Field and Depth of Focus," *Popular Photography*, August, 1971, pp. 26–28. (The following two entries are, along with this, a three-part series in the column "Schwalberg At Large.")

————, "Pupillary Problems: More About Depth of Field and Depth of Focus," *Popular Photography*, Sept., 1971, pp. 24, 164.

————, "Pupillary Problems: More Data for Close-up Photography," *Popular Photography*, Oct., 1971, pp. 28, 136.

————"What You Should Know About Telephoto Lenses," *Popular Photography*, July, 1974, pp. 75–81.

Scully, Ed, "Tele Flash? You Bet!! It's Simple," *Modern Photography*, Aug., 1972, pp. 78–79.

Seymour, Jim, "A Little Heresy Under Fluorescents," *Industrial Photography*, Nov., 1973, pp. 15–17.

Smith, Robert F., "Color Contrast Methods In Microscopy And Photomicrography," *Photographic Applications in Science, Technology and Medicine*, May, 1970, pp. 24–28, 48; Sept., 1970, pp. 19–24, 36; May, 1971, pp. 19–23; and May, 1972, pp. 21–24. (A four-part series.)

Staugaard, Burton C., "Enlarger Modification to Produce Electron Micrographic Prints of Highest Definition," *J. Biological Photographic Ass'n.*, 37, (Jan., 1969): 25–33.

Stevens, Warren D., and Derkacy, David, "Point Source Enlarging," *Petersen's PhotoGraphic*, Jan., 1974, pp. 64–67.

Stong, C. L., "Two Methods of Microscope Lighting that Produce Color," *Scientific American*, 218, (Apr., 1968): 124–130. (A contribution from Mortimer Abramowitz in Stong's column "The Amateur Scientist.")

Vance, Adrian, "Extended Range Developer for High Contrast Copy Films," p. 22, in *Dignan's Simplified Chemical Formulas . . .*, Patrick D. Dignan, *et al*, (Dignan Photographic, Inc., No. Hollywood, Calif., 1972).

Waterman, Talbot H., "Polarized Light And Navigation," *Scientific American*, 193, (July, 1955): 88–94.

Yob, Parry C., "A Free Zone System Calculator," *Petersen's Photographic*, May, 1974, pp. 50–53.

Zworykin, V. K., *et al*, "The Ultraviolet Colour Translating Television Microscope and Its Applications," in *Proc. III International Conf. Med. Electronics*, London, 1960, pp. 52–53.

Index

 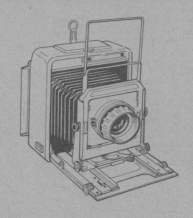

 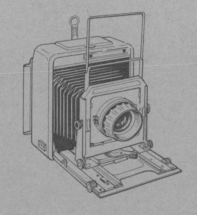 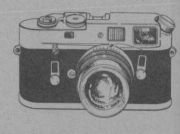

 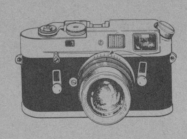

 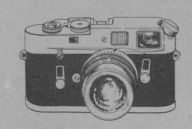 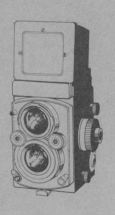